GODS IN THE BAZAAR

OBJECTS/HISTORIES:
Critical Perspectives on Art, Material Culture, and Representation

A series edited by Nicholas Thomas
Published with the assistance of the Getty Foundation.

GODS IN THE BAZAAR

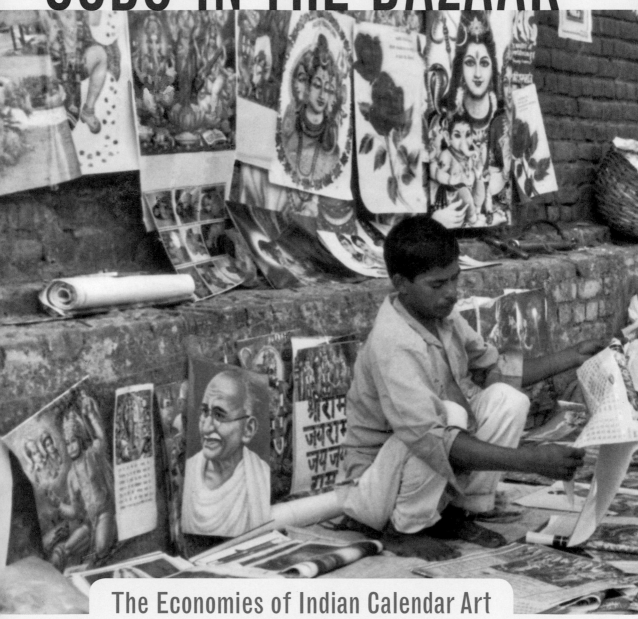

The Economies of Indian Calendar Art

●

KAJRI JAIN

Duke University Press | Durham and London | 2007

© 2007 Duke University Press

All rights reserved

Printed in Canada on acid-free paper ∞

Designed by Heather Hensley

Typeset in Adobe Jenson Pro by
Tseng Information Systems, Inc.

CONTENTS

NOTES ON STYLE

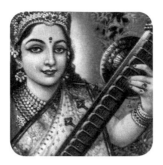

Wherever Hindi words and terms specific to South Asia appear for the first time, I either provide a brief translation immediately following the word, or, where a longer explanation is required, in a footnote.

Transliterated spellings of Hindi words generally follow accepted conventions wherever they exist (as in the case of *bhava*), while others have been kept as simple as possible in order to provide an accurate sense of the way they sound (as in *shringar* or *darshan*).

In the captions accompanying the figures, titles of images assigned by publishers are in italics, while my own descriptors are in quotation marks. Artists, publishers, and dates are only specified when known. Every attempt has been made to locate and obtain permission from copyright holders of images where applicable. Unless specified otherwise, images are from the collection of the author.

ACKNOWLEDGMENTS

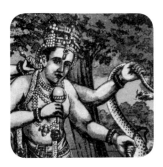

First I want to thank my teachers at the University of Sydney. Laleen Jayamanne and I shared many sessions of what she calls "loose talk," an epithet that belies her example of tight thinking and beautiful writing. Her interventions (or, more accurately, the contagion of her intensity, which is all the more powerful for its unobtrusive register) were important to me. John Clark has been unfailingly supportive and generous; Mick Carter always reinjected my thinking with delight; and Yao Souchou provided the critique and ongoing engagement only a good friend can. Without Julian Pefanis and Terry Smith I don't think I would have embarked on this project at all. Gyorgy Markus would probably be horrified, but I must also acknowledge my debt to his legendary course on German aesthetics.

Another person without whom I would not have started any of this is Shalini Puri: she and Carlos Cañuelas have been constant, affectionate mentors and *compañeros*. As with them, merely to thank Patricia Uberoi would be a travesty: she has been a godmother to this project, a long-distance guardian *yakshi* watching over it from Delhi. I have also benefited greatly from the comments of my thesis examiners, John Frow, Tapati Guha Thakurta, and Michael Taussig, as well as others who shared their work and ideas or took time to comment on mine: Can Bilsel, Christiane Brosius, Richard Davis, Whitney Davis, Laura Diamond, Sandria Freitag, Jacqueline Lichtenstein, Philip Lut-

gendorf, Monika Mehta, Anand Patwardhan, Christopher Pinney, Kalpana Ram, Sumathi Ramaswamy, Anne Rutherford, H. Daniel Smith, Sanjay Srivastava, and Sally Stein. I was privileged to hold fellowships at Macquarie University and the Getty Research Institute, which changed the shape of my thesis and turned it into this book. I thank these institutions and my fellow fellows and scholars for their stimulus, example, and encouragement. In Los Angeles the manuscript was also nurtured in a wonderful writing group by the sensitivity and critical acumen of Saloni Mathur and Susan Seizer.

I wish I could list all the people who gave generously of their time to talk to me as I hung out at markets and printing presses, in publishers' offices and artists' studios, or who invited me into their homes and offices to look at their walls and shrines. Among the calendar manufacturers of Old Delhi, I particularly want to thank Vikram Rai of the Calendar Manufacturing Company, who patiently and good-humoredly put up with me breathing down his neck day after day. All the artists I met and interviewed are very busy people, and I can only hope that this book does some justice to the time they took to talk to me: Raza Abbas, S. V. Aras, S. Courtallam, Damodar Gaud, R. Janardhan, Bhupen Khakhar, S. T. Mali, G. D. Mulgaonkar, S. Murugakani, K. C. Prakas, Yogendra Rastogi, Ravi, Baburao Sadwelkar, Venkatesh and Maya Sapar, Vishnu and Bharat Sapar, S. S. Shaikh, B. G. Sharma, Indra Sharma, Narottam Sharma, Raghunandan Sharma, Ram Kumar Sharma, Vijay and Ranjit Singh, J. P. Singhal, and Ram Waeerkar.

I am greatly indebted to Shafi Hakim, Indu Krishnan, Bari Kumar and Samantha Harrison, Priya Paul, H. Daniel Smith, and Patricia and Jit Singh Uberoi, who shared their collections of images with such large-hearted enthusiasm. Dan Smith also very graciously shared the field notes from his own research on calendar art, a project far ahead of its time. Nalini Pandit and K. S. Pandit kindly made an exception in allowing me to document the S. M. Pandit museum in Gulbarga; Ambika Dhurandhar showed me her archive of her father's work; G. D. Mulgaonkar generously shared newspaper cuttings and old issues of Diwali magazines; S. S. Kshirsagar was a mine of information; Kishore Ranadive took me to see Ram Kumar Sharma; and Professor and Mrs. Venugopal at Jawaharlal Nehru University supplied me with old issues of the *Bhavan's Journal*. Among those who went beyond their job descriptions to help out was a kind librarian at the Asiatic Society, Bombay, whom I'm sorry I can't thank by name. Namrata Satdeve did the translations from Marathi, and Suparna Singh helped with transcribing taped interviews.

My field trips were made doubly pleasurable by generous hospitality and excellent

company. The Ramanathans in Sivakasi took in a complete stranger and were soon treating me as family; Indu and M. M. Jain *are* family, and I was grateful to come back to them after the sensory saturation of Old Delhi. The same goes for Pushpa and Dharmvir Bharati in Bombay: I was fortunate indeed to experience the wisdom, affection, and mischievous charm of my late uncle. Having Sameera Jain and Jan Gillbank with me in Madurai, Madras, and Bombay was both enjoyable and enriching. This book is an extension of something that started a long time ago with my dear friends Ramu Dhara, Shalmali Guttal, and Karuna Krishna at National Institute of Design and (of course!) Pachisi. Since then, many others have shared my enthusiasm for Indian popular culture; I want to thank all the friends and relatives in various parts of the world who have helped with images, readings, news cuttings, ideas, advice, conversations, and all manner of resources and support—particularly Himman Dhamija, Simryn Gill, Indu Krishnan, Bari Kumar, Amrita and Arjun Puri, Aradhana Seth, Puja Sood, Safina Uberoi, and Elizabeth Weiss.

I thank the Australian taxpayers, who funded the bulk of my thesis research by way of the Australian Postgraduate Award; I also gratefully acknowledge receipt of a Baillieu Grant for research from the University of Sydney.

Several portions of this book have appeared in earlier versions. Parts of chapter 3 appear in "New Visual Technologies in the Bazaar: Naturalist Techniques and the Reterritorialisation of the Sacred in Popular Print Culture," *Sarai Reader 03: Shaping Technologies* (2003) and "Figures of Locality and Tradition: Commercial Cinema and the Networks of Visual Print Capitalism in Maharashtra," which was originally published in Raminder Kaur and Ajay Sinha, eds., *Bollyworld: Indian Popular Cinema Through a Transnational Lens* (New Delhi: Sage, 2005). (Copyright © Raminder Kaur and Ajay Sinha, 2005. All rights reserved. Reprinted with the permission of the copyright-holder and the publishers, Sage Publications India Pvt. Ltd., New Delhi, India.) Parts of chapter 4 appear in "Producing the Sacred: The Subjects of Calendar Art," *Journal of Arts and Ideas* 30–31 (December 1997): 63–88. An earlier version of chapter 5 was originally published in Sumathi Ramaswamy, ed., *Beyond Appearances?: Visual Practices and Ideologies in Modern India* (New Delhi: Sage, 2003). (Copyright © Institute of Economic Growth, Delhi, 2003. All rights reserved. Reprinted with the permission of the copyright-holder and the publishers, Sage Publications India Pvt. Ltd., New Delhi, India.) Portions of this chapter also appear in "When the Gods Go to Market: The Ritual Management of Desire in Indian 'Bazaar Art,'" *Communal/Plural: Journal of Transnational and Crosscultural Studies* 6 (1998): 187–204.

(My thanks to Taylor and Francis Publications, http://www.tandf.co.uk). Portions of chapter 6 appear in "The Efficacious Image: Pictures and Power in Indian Mass Culture," *Polygraph 12: World Religions and Media Cultures* (2000): 159–85; a version of this, with the same title, is also included in Richard H. Davis, ed., *Picturing the Nation: Iconographies of Modern India* (New Delhi: Orient Longman, 2006). (I am grateful to Orient Longman for permission to reproduce them here.) An earlier version of chapter 7 was originally published in Sanjay Srivastava, ed., *Sexual Sites, Seminal Attitudes: Sexualities, Masculinities and Culture in South Asia* (New Delhi: Sage, 2004). (Copyright © Sanjay Srivastava, 2004. All rights reserved. Reprinted with the permission of the copyright-holder and the publishers, Sage Publications India Pvt. Ltd., New Delhi, India.)

Cutting across all the categories above are "debts" so constitutive that they cannot be expressed in the language of accounting and exchange, cannot be met by gratitude. Without Abhay Puri and our daughter Iravati I would not be the person who wrote this book; without Amrita and Arjun Puri—and Uttarayan—I may not have finished it. Likewise, to say of my parents, Ravindra and Shobhita Jain, that they accompanied me to the "field," or discussed their work and mine, would not begin to describe what they have been to this project. Perhaps the most rewarding thing about this project is the way it has inadvertently brought me closer to understanding the incredible journeys into modernity made by my late grandparents, Kuntha and Lakshmi Chandra Jain, and Sharmishtha and Raghunandan Prasad Sharma, emerging from the communities of the bazaar: the Banias of Delhi/Uttar Pradesh, the Bazaar Choudhrys of Chhatarpur, Madhya Pradesh, and the Saraswat Brahmins of Uttar Pradesh's Aligarh and Bulandshahr districts.

So, my grandparents, my mother and father: this work is yours.

INTRODUCTION

CALENDAR ART AS AN OBJECT OF KNOWLEDGE

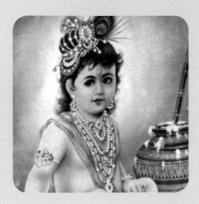

If we confined ourselves to terms that referred directly or centrally
to the physical object we would be confined to concepts like *large*,
flat, *pigments on a panel* . . . perhaps *image*. We would find it hard
to locate the sort of interest the picture really has for us.

MICHAEL BAXANDALL, *PATTERNS OF INTENTION:*
ON THE HISTORICAL EXPLANATION OF PICTURES

Aapko Madam is se aur koi ganda topic nahin mila?
[Madam, were you unable to find a worse topic than this?]

CALENDAR PUBLISHER, OLD DELHI

Their gaze is everywhere, its benevolence suffusing cash registers, government offices, factory floors, laboratories, schools, buses, kitchens, streets, tea stalls, dining halls, temples, dams, missiles. If you have lived in or visited India, or indeed an Indian shop or restaurant anywhere in the world, you are unlikely to have escaped the purview of the cheap, mass-produced icons known as "calendar" or "bazaar" art (figs. 1–7). While the majority depict Hindu deities, there are also images from India's many other religions, including Islam, Christianity, and Buddhism, which are often placed for worship in personal shrines. There

1. A laminated bazaar print depicting Lakshmi, the goddess of wealth, and a circular plastic calendar depicting Krishna and Arjun on the battlefield of the Mahabharat, above the cash register in a shoe shop, Sarojini Nagar market, New Delhi, 1991.

2. A calendar print of Lakshmi watching over a vegetable seller, Sarojini Nagar market, New Delhi, 1991.

3. A calendar from Mount Shivalik Breweries Ltd. depicting the infant Krishna, family residence, Munirka, New Delhi, 2000.

are movie stars, chubby babies, and seductive women; patriotic figures and personifications of the nation; animals, landscapes, and cityscapes, all in vivid, saturated colors often further embellished with gold dust, sequins, glitter, or flowers. Everyone has access to these images in some form, whether bought, given, or salvaged: as large, fancy, high-gloss calendars given to favored clients and associates; as smaller prints bought at roadside stalls; as inexpensive stickers, postcards, magnets, key rings, and pendants; as "antiques" in the collectors' market; as cutouts lovingly gleaned from printed incense or soap packages and "framed" with colored insulating tape. So they appear in all manner of contexts: chic elite living rooms, middle-class kitchens, urban slums, village huts, crumbling feudal mansions; hung on walls, stuck on scooters and computers, propped up on machines, affixed to dashboards, suspended from trees, tucked into wallets and lockets.

What first drew me to these images was, I think, a fascinated envy. As a student of visual communication at India's National Institute of Design in the 1980s I was deeply

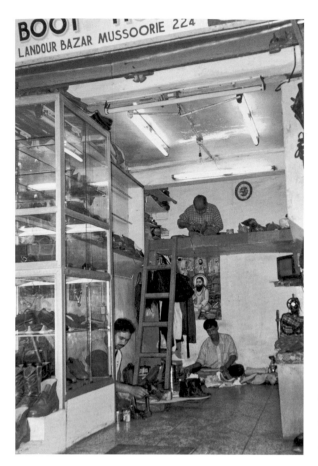

4. A poster of saint-poet Guru Ravi Das (also known as Raidas) watching over workers at a shoe repair shop, Landour Bazaar, Mussoorie, 2000.

invested in the visual media as powerful tools of social change: the need of the hour, as my cohorts and I saw it, was to use professional design skills to foster education, primary health, social justice, environmentalism, cultural heritage, and so on. However, we were keenly aware that our skills had been developed at an institution that V. S. Naipaul had called "a finishing school for the unacademic young, a playpen . . ." (Naipaul 1979, 123). We also had a strong suspicion that the spare, streamlined, internationalist design idiom we were schooled in was inadequate to the task of "communicating" to the constituencies in need of these crucial "social messages." Our top-down developmentalist self-righteousness was confronted by the sheer abundance and luscious visual force of what — our envy whispered to us — those constituencies *really* wanted: the intense colors, lavish ornament, compassionate smiles, and clear gazes of calendar art. To communicate with this audience, we needed to engage with these images: to find out what people saw in them, and how, why, and when they came so profusely to inhabit the everyday spaces

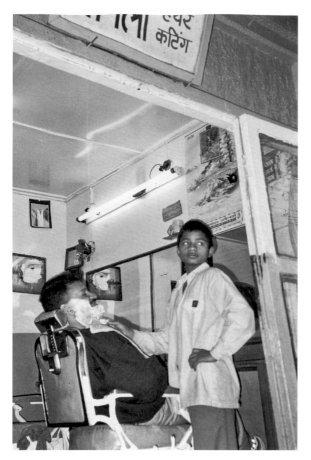

5. A landscape calendar distributed by a Hindu jewelry store on display in a Muslim-owned barbershop, Landour Bazaar, Mussoorie, 2000.

of modern India. So, swearing under our breaths at Sir Vidia, we put down our Letraset catalogues (it was that long ago) and Pantone swatches and, for better or worse, took ourselves off to university.

As I write this, many years later, that envy has only intensified, even as my youthful confidence in "social communication" has diminished. This intensification is a response to the spectacular reappropriation of the calendar art idiom within the political arena from the late 1980s onward. My envy now is directed not so much at the images themselves but at those who do not wait to conduct any academic soul-searching before blatantly harnessing the visual idioms of calendar art to their political projects—Hindu nationalism in particular. One arguably productive consequence of the ease with which such political projects harness these forms to their agendas is that many on the left in India have had to reassess their own basis of authority in the secular-modernist language of

6. Posters depicting nationalist leaders decorating a roadside tea stall, Sarojini Nagar market, New Delhi, 1991.

7. A 1996 calendar advertising candidates for the Bharatiya Janata Party, neighborhood shrine, Varanasi, 1995. Ganesh is seated on a lotus, which is the BJP's election symbol.

history versus myth, reason versus desire and faith, objective facts and realist representations versus seductive narratives (although this quandary is by no means confined to the Indian context). The following example should clarify why such a reassessment should be necessary.[1]

"NOT A JUST IMAGE . . ."

The print on the following page (fig. 8a and b) is one instance of the images this book is about. It depicts the eighteen-year-old Roop Kanwar, who was burned as a *sati* on her husband's funeral pyre in 1987 in Deorala, Rajasthan. The print consists of two images, each assembled as a mix of photomontage and painting. The top one shows Roop Kanwar calmly smiling on the pyre with her husband's body across her lap. In the bottom one she is being consumed by flames as her hands are joined in prayer over her husband's body; in the air, in front of a tree, hovers the mother goddess (*devi/mata*), who is sending a beam of light toward Roop Kanwar's haloed head; in the background on the right is a temple.

This picture figures in an intriguing exchange in *Trial by Fire*, a documentary centering on this *sati* incident made by the pioneering activist-filmmaker Anand Patwardhan in 1994. A male voice off-camera, presumably Patwardhan's, is directing questions at a woman who is working on the floor. We know by now that this woman, Godavari, is a cook and belongs to the Rajput or *kshatriya* community, as do Roop Kanwar's in-laws (who initiated the burning). The voice asks Godavari whether she thinks the picture has been faked using photographs of the couple's faces: Look at it carefully, he says. No, she answers, that's the way it is in the "photo" (Godavari uses the English word "photo" to describe the picture). The voice then asks how it is possible to take a photo of god (*bhagwan*), since no one else is able to see him. She replies flatly that it is possible, that even though we can't see god, the "photo" can show him: "Others can't see him, but he'll definitely come in the photo. He lives up in the trees, nearby. He hides and then appears in the photo—even the photographers [*photowale*] don't realize that it contains this— god. He comes on his own. . . ." As she continues, she too adopts the discourse of evidence but with her own lethal twist: "If you couldn't see god [in the photo], how would people know how she was burned, that it was god's rays?"

This exchange unfolds at the scene of a crime in which, as the film frames it, the picture and its dissimulations are implicated. But the picture's status as evidence is subject to a *differend*, a radical incommensurability between two positions with respect to

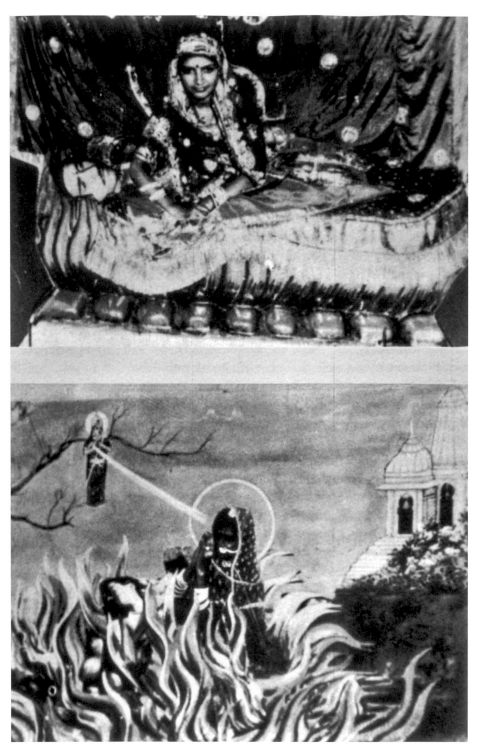

8a and b. A bazaar print depicting the *sati* of Roop Kanwar in 1987. (Collection of Rajeswari Sunder Rajan)

each other's frameworks of intelligibility or legitimacy (Lyotard 1988).[2] The disembodied male voice, appealing to secular reason, seeks to establish the falsity of the image on the basis that its human fabrication invalidates its putatively divine authority. Bringing the image into a juridical frame in order to institute the victim *as* a victim (unlike Roop Kanwar's in-laws, who had clear material motives in instituting her as a goddess, an embodiment of *shakti* or divine power) ties it to a realist regime of authority hinging on a distinction between truth and falsehood. However, for the woman on the floor, shown working as she considers these questions, the very existence of the image invalidates the terms of truth and falsity. Indeed, on the contrary, her claim that the "photo" itself renders the god-figure visible imbues the technology that produces the image with an extra charge.

Notwithstanding the neat binary oppositions in my glossing of this discursive encounter, the terms of debate are of course more complex and less plainly polarized. The incommensurability between these two frames of viewing does not imply that the people deploying them are primordially wedded to those frames, or that they have no recognition of each other's positions. This exchange indexes the filmmaker's collision with a limit of secular reason: a limit that reason identifies as "blind" faith. Here the refusal to subscribe to a regime of provable truth and falsity is tantamount to blindness, an inability to see at all. This clear ascription of incapacity underpins the inclusion of this encounter in the film as part of a dialectical process of "conscientization"; no auto-critique is intended here (although I did initially read it that way).[3] For this exchange also makes growingly evident the Rajput woman's defensive recognition (as a member of the community that perpetrated the *sati*) of what is, quite literally, at stake. This recognition is indexed by her rapid mimetic adoption of the filmmaker's deployment of the image as evidence: If it weren't for the "photo" how would people know whether Roop Kanwar's burning was a matter of divine or human instrumentality?

While the above exchange indexes the filmmaker-activist's confident (and certainly well-earned) moral authority, another critic sensitively registers a certain duress in her own endorsement of a certain type of *image juste* (just or correct image). In her analysis of visual representations of *sati*, including the same bazaar print from Deorala, Rajeswari Sunder Rajan writes: "I am therefore *obliged* to endorse, *admittedly in a certain idealizing and prescriptive way*, the forms of agitprop representations in theatre, film and posters as bringing us closer to the 'reality' of sati than does either the liberal discourse denouncing it or the popular and religious discourse glorifying it. It is not naturalistic or symbolic

images, but a certain specific mode of stylization that points to the idiom of pain" (Sunder Rajan 1993, 31; emphasis added).

Although the formal idiom Sunder Rajan supports is not naturalistic, here again the ultimate aim is to engender an accurate apprehension of reality. Again, as in the previous exchange, the overarching frame is a juridical one: in bearing witness to the reality of the victim's pain in order to do justice to it, the image must accurately communicate the affective essence of that pain. As an example of an image that does communicate "the essence of pain," as opposed to the bazaar print, Sunder Rajan cites a poster produced by a local activist organization. This is a stylized, starkly graphic, single-color painted image intended to depict a woman struggling to escape the *sati* fire, "restoring" her subjectivity by simultaneously instituting her as victim and agent. The artifice of religious propaganda is fought here through the artifice of secular counterpropaganda, with the difference that while the former's mode of seduction refuses the issue of dissimulation altogether, the latter operates in an economy of truth and falsehood. Although the secular counterpropaganda's grim agitprop literalism signals its own artifice through its crude execution, it is still legitimized for the critic by its greater representational fidelity to the reality of *sati*: that is, the woman's pain. Note, however, that this poster relies heavily on the mediation of large written text to contextualize its image: again there is a sense here that the image is potentially treacherous, that it cannot be trusted to do the job on its own. The reliance on text means that unlike the calendar print, the poster does not directly address those who are illiterate (particularly many rural women such as Godavari).

These two instances illustrate how the default mode of critical thinking about the role of images in social and political change has tended to be a juridical one, but, ironically, one that often fails to do justice to the work of the image. At times, as we have seen, this approach appeals to the evidentiary status of images as witnesses (true or false) or as evidence per se (real or fake). At others it implicates images as perpetrators of the crime (good/bad, innocent/guilty), so for instance "objectifying" (wrong) depictions of women perpetuate patriarchal practices (fig. 9) while more positive (right) models engender desirable social change. Thus the initial driver of scholarly attention to mass-cultural images has tended to be their implication in various forms of regressive politics and social practices: Marxist and feminist scholars, critics, and cultural practitioners have taken the lead in seriously examining various forms of popular visual culture everywhere. In India this is certainly true of calendar art (see Guha Thakurta 1991; Rajadhyaksha 1993b; Sunder Rajan 1993; Uberoi 1990). As with this book, the resurgence of a violent, repres-

9. Calendars on sale on the pavement in Chandni Chowk, Delhi, 1992.

sive Hindu nationalism from the late 1980s onward has been another defining context for analyses of the political efficacy of visual mass culture and particularly of religious imagery—although of course it is hard to separate the injustices of religious absolutism from those of class, caste, and patriarchy (see Bharucha 1993; Brosius 1999; A. Kapur 1993a; Kaur 2000; Lutgendorf 1995; Pinney 1997a, 2004; A. Rajagopal 2001).

As often as not, analysts tend to approach these images juridically, as evidence from a crime scene. Maybe this is not a problem per se, for it has been the self-declared role of critique (at least in the Frankfurt school version) to identify the relationships between cultural forms and economic, social, and political practices, with the ultimate aim of articulating this analysis with revolutionary agency. The problem is more with the forensic mode of analysis that this juridical context tends to foster. To put it succinctly, the more explicitly politically invested the critical analysis of an image, the likelier it is to resort to the representational realism that has come to us epistemically and institutionally bundled with the modern discourse of justice (including social justice). As a result, the

less likely it is to be able to engage—to apprehend or to counteract—the other forms of power available to the image. Particularly unhelpful here is the casting of subjects who do not participate in an economy of truth and falsehood as variously inadequate: as gullible, "blind," and inarticulate, their agency surrendered to pernicious forms of superstition, fetishism, and seduction.

Underpinning the forensic-juridical mode is a particular formulation of the power and authority, treachery and seduction of the image as primarily residing in its representational capacities, which in turn primarily inhere in its visual appearance—as opposed, for instance, to its other qualities as a circulating object. Epistemologically, this formulation draws on a positivist formation of knowledge in privileging the authority of visual evidence. At the same time, in terms of its moral economy, it draws on a Platonic notion of mimesis—and mistrust of images—in positing that the primary ethical locus of an image is its adequacy or inadequacy to truth or reality. To the extent that this formulation emphasizes the meaning of signifiers within the picture frame, apprehended through a primarily visual engagement with the image, and fails to take adequately into account the efficacy of images as circulating objects or of viewers as embodied beings (or rather denigrates this as fetishism, as a lack in the subject), it belongs to an "ocularcentric" discursive field (Jay 1993). In all these respects, as postmodernist and poststructuralist critiques have variously demonstrated, such default ideas about the work of images belong to a specific post-Enlightenment epistemological and ethical lineage emanating from bourgeois Europe: a lineage that also strongly informs modern ideas of subjecthood, agency, and routes to social justice. The self-descriptions of bourgeois-liberal modernity have rested on particular formulations of subjects and objects and the relations between them, as well as about the public sphere, property, rights, the proper place of religion, art, commerce, and so on, all of which have come to bear in various ways, and with varying degrees of force and consistency, on the discursive frames within which images circulate. A number of ideas pertaining to images have thus come to be closely interlinked: ideas about the efficacy of representation; the authority of visual evidence; the imaging of identity; the notion of "fine art"; taste as an arbiter of social distinction; the institution of authorial property; and the denigration of fetishism, of technological mass production, and of commodity relations.

In the following study I explore how this "epistemic bundle" that ties the work of images in with particular formulations of subjectivity, agency, and justice is both unraveled and reconstituted by the multiple image practices and discourses that have come

to coexist in postcolonial India. In doing so, I do not intend to discredit the evidentiary analyses of images mobilized in struggles for social justice; to the extent that they have become part of a certain common sense, shared by state institutions and civil society, these realist strategies may still offer a potent mode of immanent critique. But in order to specify the terms of negotiation between the epistemic bundle I have described and other regimes of image value and efficacy, I do seek to resituate it within the institutional legacies of colonialism and their attendant epistemological, moral-ethical, and aesthetic formulations. More specifically, I deploy a historically and ethnographically grounded approach to Indian "calendar" or "bazaar" art to locate this epistemic bundle in the colonial and postcolonial careers of the modernist, bourgeois-liberal public sphere — or, more accurately, of the normative terms in which it has described itself both to itself and to its others.[4]

RE-FRAMING THE VERNACULAR

I began with the *sati* print as an extreme instance of the way in which bazaar images can be implicated in matters of life and death. This example shows how the politics of the image is primarily approached through a juridical frame. Simultaneously, the exchange I described also demonstrates how the deployment of such a frame in a postcolonial setting can — and perhaps must — elide other ways of valuing and engaging with images. In particular, it highlights the tensions between traditions of secular and devotional reason: between the ocularcentric treatment of images as vehicles of linguistic ideation and the "blindness" of faith or the power of facticity. To the extent that the latter practices refuse a secular juridical frame based on an economy of truth and falsehood, their difference from this economy is not quite of the same order as that of those reactive postmodernist critiques whose temporality — coming *after* the modern, both announcing and orchestrating its demise — is inherently nostalgic.[5] And yet their relationship with this economy is not that of pure otherness, either. As I hope to show, these economies themselves, as well as the relationships between them, have been constituted through ongoing encounters and exchanges, stemming from exploration, migration, trade, and conquest. Further, as we saw in the case of Patwardhan versus Godavari, these engagements are characterized by the complex coexistence of acknowledgment and disavowal, of "mimesis and alterity" (Taussig 1993b).

In this book I describe some of these coexisting regimes of value and efficacy across which bazaar images have come to circulate in modern India, examining how the relation-

ships between these economies have varied, in different registers, between articulation, exchange, and incommensurability (here I am using the term "economy" in its broadest sense as a system of value within the context of exchange). Taking my lead from conversations with consumers and people in the Indian calendar industry, firsthand observation of the industry's structure and functioning, and an analysis of images themselves as well as their contexts of circulation, I situate calendar images at the intersection between the aesthetic context of a commercial or mass-cultural form defined in opposition to "fine art" and the ethical context of what historians have called the "bazaar" (Bayly 1983; R. Ray 1984, 1992; A. Yang 1998).[6] In doing so, I seek to make three, related, interventions.

First, I use calendar images as an entry point for mapping a certain aspect of what Akhil Gupta has called the "postcolonial condition" (Gupta 1998, ix, 10–11). Specifically, I describe how, in the context of these images, postcolonial subjects function across *epistemically disjunct yet performatively networked* worlds: the worlds of bourgeois-liberal and neoliberal modernism on the one hand and those of "vernacular" discourses and practices on the other. Of all the fraught categories—"traditional," "native," "indigenous," "local"—that might be deployed for the specificity of the forms of postcolonial experience I seek to describe, I want to suggest that "vernacular" comes closest to resisting the pitfalls of primordialism and romanticism.[7] Vernacularity is not pure, systemic, temporally primordial, or territorially bounded; it speaks to the heterogeneity of postcolonial idioms and forms of experience while addressing their contemporaneity and currency, and their implicitly subordinate relation to hegemonic forms of discourse and practice (in short, their subalternity). In the Indian instance it is particularly useful as a category that can be associated with location but is not tied to it, steering clear of both the valorization of the "Indian village" characterizing South Asian studies and cultural practice for the better part of the twentieth century and the equally ideologically loaded "urban turn" (Prakash 2002) being celebrated at the turn of the millennium.

If the dictionary defines "vernacular" as both a "*nonstandard* language or dialect" and "the *normal* spoken form of a language" (emphasis added), this contradiction is already embedded in its etymological root, the Latin *verna*, meaning "slave born in the master's house" (Merriam Webster Online). Vernaculars are normal but not normative; they can be modern but not modernist. This implicit, indeed inherent, power relation is perpetuated in the more vernacular uses of the word itself: for instance, a friend who studied in a Marathi-language school in Powai (on the outskirts of the city formerly known as Bombay, now Mumbai) recalls being denigrated as a "vernac" by children from the city

who were taught in English. And yet, unlike "subaltern," which speaks exclusively to a position of subordination within a given power relation, rendering itself vulnerable to romanticization, the "vernacular" can be simultaneously subordinate within one set of power relations and dominant in another. As I argue in chapter 3 in relation to the bazaar, this is a useful corrective to overly polarized binary constructions of postcolonial difference.

Like "vernac," the terms "calendar art" and "bazaar art" come to us loaded with connotations of a vernacular denigration of the vernacular, within a hierarchy of vernacularity.[8] In common usage these terms describe not just the illustrated calendars that businesses distribute annually to their customers and associates, but also wall posters and the smaller images known in the industry as "framing pictures," as well as the ephemeral objects such as key chains and magnets that are both gifted and sold. These categories are often extended to include the visual idiom sometimes deployed in comics and book illustrations, advertising, packaging, theater, film, and television (particularly mythological epics). Even though "calendar art" refers to a particular function and "bazaar art" to an arena of circulation, both have come to be used as properly generic terms in that they refer both to a set of expectations on the part of consumers and critics of a specific range of subjects and their visual treatment and to a set of imaginings on the part of producers of who these consumers are and what they want.[9] Here the use of the Hindi word "bazaar" works to align this form with a vernacular, non-English-speaking audience: "bazaar" art is not the same as "commercial" art, as I elaborate in chapter 1. Still, as I explain in chapter 2, this is not a primordial difference but one born out of exchange: it is essential to keep in mind the relational nature of the bazaar's vernacularity and the particular form taken by the bazaar as a part of the colonial economy and its post-independence legacy.

Given that this genre of printed images catering primarily to the South Asian market emerged in the second half of the nineteenth century, at the peak of colonial rule, it could be described as having been "born in the master's house" (although one of my aims in the first three chapters is to provide a nuance to this narrative of its origins). Not only did it emerge in a physical space under imperial occupation, it also, at least in part, emerged from institutional contexts such as art schools and princely courts that championed visual technologies introduced from Europe: printing, photography, naturalist modeling, and perspective. Despite its initial warm reception by "native" and colonial "master" alike, for the better part of the twentieth century this genre was either reviled or ignored by scholars and critics. Within the industry, too (as I describe in chapter 4,

and as the publisher in my epigraph reveals with some flair), people continue to subscribe to the idea of its inferior status. On aesthetic grounds, it has been condemned for its derivativeness, repetition, vulgar sentimentality, garishness, and crass simplicity of appeal; on nationalist grounds, for being a western-influenced, hybrid, inauthentic, un-"Indian" idiom as opposed to the rich classical and folk "traditions"; and on ideological grounds, for being part of a commercial culture industry that feeds off the credulity and ignorance of "the masses" as opposed to an "autonomous" critical modernist art practice, and in particular for reinscribing patriarchal, feudal, caste-based, and Hindu nationalist structures of representation.

Some scholars have shed the baggage accompanying the labels "calendar art" and "bazaar art," seeking different terms to describe these images. For instance, H. Daniel Smith (1995) has called them "god posters," given his interest in the religious subjects depicted by the overwhelming majority of prints, while Christopher Pinney's (1997a, 1999, 2004) use of the term "chromolithographs" foregrounds the technology of mass reproduction and an earlier, pre-Independence context. I want to argue, however, that the vernacular terms "calendar art" and "bazaar art" should be central to the way in which we conceptualize these forms. My adoption of these terms speaks directly to the central themes in this book, to its methodological and theoretical-rhetorical approach, and from there to its disciplinary affiliations. Thinking about calendars *as* calendars made me interested in the way that calendar images circulate in the bazaar, which in turn meant examining the notion of the "bazaar" itself, and how (as I describe in chapter 5) this arena of circulation has inscribed images in an economy where sacred, commercial, ethical, aesthetic, and libidinal forms of value are closely intermeshed. Just as this avenue of investigation was opened up by paying attention to vernacular categories of description, my analysis relies heavily on interviews to map the discursive fields of art, commerce, religiosity, and visuality within which views about calendar prints are formulated, replete (if I might be permitted the oxymoron) with disjunctures, elisions, excesses, and expressions of lack.[10] Central to my approach to the politics of bazaar images, which I address most explicitly in chapters 6 and 7, is the thesis that power relations are not only maintained but can also be challenged through performative reiteration (Butler 1990a, 1993, 1997a; Case 1990; Sedgwick 1990). Accordingly, holding on to and repeating denigrated categories such as "calendar art" and "bazaar art" in order to confront and reframe their terms of subordination — that is, the terms of modernist self-description — becomes an expropriative move, a means of productively countering the weight of "lack" they carry.

THE SUBJECTS OF ART HISTORY,
THE OBJECTS OF VISUAL CULTURE

Similarly, I want to hold on to the "art" in "calendar art" in order to ask how that might relate to—and reframe—the "art" in "art history." What happens when ungraspable numbers of lurid, pungent, frequently tatty, often undatable, questionably authored, haphazardly archived, indeterminably representative, hitherto undisciplined Indian bazaar pictures come crowding into the chandeliered baroque halls and immaculate modernist spaces of art history: Do they render "the master's house" unrecognizable? If my own experience of often being thought of as an anthropologist rather than an art historian is anything to go by, there must be ways in which they do. Of course, if Indian bazaar images are seen not as art historical but as anthropological objects, this is largely due to their status as mass culture. It is also in some part because of the disciplinary geopolitics according to which art history has lavished its most granular attention on finely differentiated Euroamerican periods and places ("northern Renaissance" as against "Asian art"), in inverse proportion to anthropology's "other" spaces and times. Bazaar images, in their abject modernity, are doubly peripheral to the spatiotemporal categories of the world according to art history, which in its teleological predilections has tended to terminate the narrative of "Indian art" with the messy inauthenticity engendered by colonialism (although the work of Geeta Kapur, Tapati Guha Thakurta, and Partha Mitter has done a great deal to redress this).

In keeping with its vernacular status, however, calendar art—as I hope to demonstrate, particularly in chapters 3, 4, and 5—has more to do with "art" than art might be willing to admit. But here I must emphasize that despite my enjoyment in acknowledging bazaar artists, and its possible side effects in terms of constituting a countercanon, my aim is not to protest their marginalization by the terms of art history or the art system, or to seek their inclusion within those terms. It is quite the reverse: to see what might happen to art history and *its* terms if they acknowledged the porosity of their interface with realms that aren't quite "art" and aren't quite "history." Here I am concerned in particular with the ways in which calendar images interrupt modernity's narrative of art's supersession of the sacred: a narrative that is deeply embedded in the practice, history, and criticism of art, as well as in modernity's secular self-image. This narrative is itself an index of the mutually constitutive relationship between Europe and its others, for as I suggest in chapter 5 the modern theorization of the aesthetic developed in conjunc-

tion with that of the fetish, which was informed in its turn by trading encounters with "primitive" others cast as anterior within a civilizational telos (see in particular Pietz 1985, 1987).[11]

Underlying my second set of interventions, then, is the issue of the relationship between (the self-image of) art, which sets itself apart from commodities, the sacred, and the ethical arena in general, and image cultures such as that of the bazaar, in which images have a primarily ethical charge, and which does not claim such clear distinctions between the arenas of commerce and the sacred. This coexistence of disjunct frames of image efficacy and value has methodological ramifications, which I seek to explore through my analysis. In attending to the networks in which calendar prints circulate, I attempt to think together their representational or visually signifying aspects and their efficacy in their capacity as objects: as sacred icons, commodities, gifts, items of ritual exchange, and items of libidinal investment, or "fetishes." Mass-cultural forms such as calendar art demand a mode of analysis that can address the levels of signification mobilized by multiplicity, repetition, and circulation, while icons — again, like calendar art — demand attention to forms of auratic objecthood that do not stem from authorial originality but from performative practices in the realms of circulation and reception. Such images require something more than textual readings that treat them as static and singular, with successive iterations of the "same" image collapsing into the "original." By addressing the corporeal aspects of images and of the ways in which people engage with them, I seek to provide a processual account of their power and efficacy. Here I deploy a reproductive rather than productive model of mimesis, which aims to capture the differences engendered through reiteration.

For many the idea of "visual culture," drawing heavily on anthropology, cultural studies, and film and/or media studies, has represented the kiss of either life or death for art history (see, for instance, Bryson, Holly, and Moxey 1994; Crow 1996; Jay 1996; Mirzoeff 1999). However, despite — or, rather, because of — my allegiances to a certain (primarily British/Australian) strand of cultural studies and my use of anthropological concepts and methods such as "ethnographic" interviews, my approach here also seeks to expand and refine the understanding of what "visual culture" entails. For a start, one of my aims is to show how bazaar prints problematize the very notion of visuality as the definitive modality of the image. My consistent use of the word "image" rather than "visual" does not, therefore, signal the dematerialized virtuality implied in formulations of visual culture that address the prevalence of digital technologies in a postmodern age.

On the contrary, it is an attempt to speak to those aspects of objecthood that are often seen as peripheral, if not irrelevant, to "the sort of interest the picture really has for us" (Baxandall 1985, 6; see epigraph). While the notion of visuality in "visual culture" already considers the corporeality of the viewer and the multiple sensory modes of engaging with images, it has had relatively little to say about the corporeality of the image itself. Art history, in contrast, has had a great deal to say about the corporeality of images, but these descriptions have tended to privilege their formal expressive characteristics, or their location within a specific context, over significances generated through their movement and temporality, their circulation and exchange, their rhythms and orchestrations, their enfolding into habit and ritual (for an exemplary text that does address the latter aspects, see Asendorf 1993).

In addition, "visual culture" is often deployed as a rubric for everything outside the purview of the "fine art" system: popular or mass culture and the visual phenomena pervading everyday life, and what might be called non-Western systems of image making. Calendar art is patently both (although I will argue in chapter 4 that it also problematizes the mapping of aesthetic onto social distinction, affecting the very terms on which high culture is distinguished from low). However, as I have already suggested, in both of these capacities (though not in all contexts) calendar art has had, and continues to have, a relationship with the "art" against which "visual culture" is defined. "Fine art" is part of the genealogy of calendar art, and to this extent calendar art can be seen as part of a wider history of art—even though, like even the most canonical objects of art history, it is not fully containable within the terms of the fine art system. To recognize these leaky interactions across what might otherwise be seen as disconnected, hermetically sealed cultural worlds is to problematize the charge of cultural relativism that is often leveled against visual culture, along with that of populism (see, for instance, Crow 1996, 34–36; Jay 1996, 44), as well as visual culture's oppositional relation to art history. In other words, designating "visual culture" as a category separate from art history forecloses the opportunity for a reevaluation of the terms of art history itself.

My final point about visual culture also relates to the problem of working with loaded categories of analysis such as the "visual": in this case, "the subject" itself. Visual culture has been positioned as "a tactic with which to study the genealogy . . . of postmodern everyday life from the point of view of the consumer, rather than the producer" (Mirzoeff 1999, 3). Similarly, albeit in criticism of this approach, a survey of opinions on visual culture in the influential journal *October* addressed the suggestion that visual

studies, through its putative disinterest in the material conditions of production in spe-
cific media, was "helping, in its own modest, academic way, to produce subjects for the
next stage of globalized capital" ("Visual Culture Questionnaire" 1996, 25). Leaving aside
the universalist, teleological underpinnings of both of these positions, they both address
visual culture's attempt to attend to subjective modes largely downplayed by art history:
"consumption" or "reception" rather than "production." Tracing the various forms of
efficacy of bazaar images suggests that the production of subjectivity and the genealogy
of everyday life are neither solely a matter of the "production" or the "consumption" of
objects/images, nor of both thought together, but also of their circulation (if indeed it
is possible to make such a clear distinction between these arenas in the first place: see
Deleuze and Guattari 1977). In part, my foregrounding of the *networks* inscribed by cal-
endar prints through their production, distribution, and use takes up Georg Simmel's
suggestion, as elaborated by Arjun Appadurai, that value emanates from the arena of
exchange (Appadurai 1986, 4). But it also proceeds on the intuition that taking an object-
centered (rather than properly ethnographic) approach might help to address the incon-
sistencies, disjunctures, and motilities *within* "the subject" or "culture." Furthermore, it
would address those processes and forms of efficacy located not solely within individual
"agents" but also in a trans-subjective arena, in an interstitial realm between and across
subjects and objects (or even, far more tenuously, in abjection). In this respect, then, if
"reception" refers to the engagements of "end-users" with images on the model of con-
sumption, this is not a book about "reception"; my aim, however, is to work with a more
expansive notion of reception that addresses the wider fields of significance of images
generated through every stage of their careers.

POSTCOLONIAL GRANULARITY

Thinking in terms of the various overlapping networks traced by the object offers the
possibility of exploring questions of value, efficacy, and power without relying too heavily
on the much critiqued fictions of either the transcendental sovereign subject or the sub-
ject of historical or structural determination. It would promise instead to address more
directly the multiplicity of fields of power traversing the subject, as well as the proces-
sual modalities of subjecthood emanating from the transformative and/or reconstitutive
encounters between bodies, be they objects, images, or living beings, mortal or divine
(for one critique of the "continuist narrative of identity," see Gupta and Ferguson 1997,
20–21).

At stake here is the recognition of modes of political subjectivity and political processes that are not reducible to participation in "civil society" in the bourgeois-liberal sense (to take up Partha Chatterjee's distinction between the delimited arena of civil society and a wider, more inclusive notion of "political society"; Chatterjee 1997). Also at stake is the related issue of characterizing the subjects and processes of capital in a manner that does not assume the homogeneity of moral and political economies, albeit within a regnant order of global capitalism. As we will see, the plural genealogies of bazaar art come together in ways that show how mass culture and commodification—and indeed "capitalism" itself—have unfolded as much through protean articulations with varying social formations and political, symbolic, and moral economies as they have through formal attempts to impose a homogeneous "globalized" code of conduct in the marketplace. The calendar image, as commodity, business gift, sacred object, decoration, advertisement, keeper of secular and sacred time, and commuter on pan-national, transnational, and varyingly "local" circuits, is an index par excellence of the polymorphous intimacies between capital, formal and informal institutional arrangements, and multiple sites and registers of identity formation.

The third intervention this book seeks to make, therefore, is to steer a path between the "cultural imperialism" thesis and overly romantic valorizations of local resistances to the spread of capital. Indeed, I contend that the institution and maintenance of disjunct yet coexisting worlds is integral to capitalist expansion. Here I describe how the bazaar formation can be seen as a site for what I want to call the vernacularization of capitalism. I argue that processes of globalization, including colonialism, have depended on mobilizing the differentials between "formal" and "informal"—or what I prefer to call vernacular—economies. So while these processes foster homogeneity in some respects (as the cultural imperialism thesis would have it), in others they necessitate the continued coexistence of the disjunct worlds that postcolonial, globalized subjects must negotiate. While this analysis is grounded in the Indian context, to the extent that the postcolonial condition is not geographically confined to the postcolonies it should also be pertinent to thinking about the cultures of capitalism more generally.[12]

My method in tracing these productive differentials between economies is primarily ethnographic, taking its main impetus from the contestations, partial adoptions, reconfigurations, and elisions of bourgeois-liberal formulations by those using, producing, and circulating popular images in late-twentieth-century India (see in particular chapter 4).[13] Here areas of stress that might from one point of view appear as disjunctures and

"failures" in the postcolonial public sphere and everyday life become indices of the complex coexistence between the genealogies of a colonially introduced modernity and of vernacular realms of experience that stand in a fraught relation to notions of primordial cultural identity. My approach here takes its cue from the ongoing scholarship on India that has sought to track the postcolonial unraveling and reformulation of a number of modernist categories: nationalism (Chatterjee 1986), culture (Dhareshwar 1995b), historicism (Chakrabarty 2000), art (Guha Thakurta 1992), development (Gupta 1998), the public sphere (Freitag 1991a, 1991b), civil society (Chatterjee 1997), scientific reason (Prakash 1999), childhood (Kumar 2000), and aging (Cohen 1998). I see this as a second moment of postcolonial studies, which builds on critiques of colonial constellations of power, knowledge, and desire in order to describe how the very categories available for thinking and operating within postcolonial modernity continually reinscribe its alterity.

This project of mapping postcolonial modernity in its non-self-identity is not quite the same as those strands of postcolonial studies, now relatively well-represented in the transnational academy, whose preoccupation is with critiques of Orientalism and narratives of the colonial moment, or with discourses of hybridity and inter- or transculturalism framed by multicultural identity politics. To the extent that these latter versions of postcolonialism can work at a performative level to recenter colonizing subjects, metropolitan locations, or the anteriority of "India" at the expense of engaging with the messiness of the postcolonial present in postcolonized spaces, such as modern India, they can serve to reinstitutionalize colonial power relations within the academy.[14] In one sense the distinction I am making simply has to do with the objects of study. But this difference in focus translates into a matter of *interest*, in all its senses. This interest acquires its force in the illocutionary register of performance, concretized at the institutional sites of knowledge production: it is a matter of what forms of knowing, belonging, and being in the world are affirmed, enhanced, perpetuated, made possible, or denied, by whom and for whom. One general example here is the impact of postcolonial studies on the teaching of literature: even as English departments were revitalized in the 1980s and 1990s, revising their canon to include translations and writing in English from the postcolonies, programs in Hindi language and literature dwindled and in some cases (such as at the University of Sydney) disappeared altogether. Again, as this instance illustrates, the aim here is not to endorse a nativist valorization of location but to address vernacular forms of knowledge that may or may not be associated with location, and are sites for minoritarian potentials.

This is not to deny that understandings of colonialism and of multicultural identity politics—that is, of metropolitan formations—are *also* crucial to an engagement with postcolonial modernity. Colonial and neocolonial forms of knowledge and institutional structures are inextricably folded into contemporary everyday life and self-reflexivity in the postcolonies, as are the forces brought into play by transnational networks (Appadurai 1996). This imbrication renders futile nativist attempts to "re"-claim precolonial or "local" "tradition" and pushes postcolonial specificity toward more elusive fragments and fault lines. Equally, alternative formulations of postcolonial modernity must continue to be informed by the many contestations of, and variations on, bourgeois modernity from within "Europe" or the "West"—including postmodern and poststructuralist critiques, with their reanimation of counterhegemonic philosophical traditions. What is more, as I myself argue in chapter 5, demonstrating how the postcolonial arena renders modernist categories inconsistent—even as they continue to have social and institutional force—cannot but serve to clarify how bourgeois modernity's self-image has disavowed its own constitutive heterogeneities.

However, it is only at a certain level of descriptive granularity or detail that "postcolonial difference"—and the differences *within* that overarching category—make their presence felt, resisting existing theoretical frames. I see this as the strength of the ethnographic approach, as a process of description that aims to estrange its own terms of analysis in productive ways. A key aspect of this act of description is the identification and acknowledgment of various putatively a-modern, aberrant, lacking, backward, or contradictory forms of everyday experience. The performative recognition—not to mention the textual sanction—of lived experience and memory at this level of granularity is accompanied by a particular kind of enjoyment, one that I sense in myself when reading the literature on and from India that plays back, without exoticism or irony, familiar terms that recognizably conjure very specific ways of being in the *modern* world: *mastipan*, a certain kind of enjoyment (Kumar 1988); *bazaar*, a certain kind of economic organization (R. Ray 1992); *adda*, a certain kind of social gathering (Chakrabarty 2000); *satthhiaana*, a certain kind of ageing (Cohen 1998). This is not the same as saying that all forms of postcolonial experience deserve to be affirmed or celebrated: I could add to my list communalism, a certain kind of social conflict (Pandey 1990); riots, a certain kind of crowd violence (Das 1990); and *sati*, a certain kind of murder (L. Mani 1998). What is enjoyable is the rare resonance between formal academic or institutional knowledge and forms of experience hitherto unacknowledged in such "official" domains (even as this reso-

nance must also provoke a critical analysis of how and why the ideological ground might have shifted to enable such an acknowledgment). There is also an enjoyment in being relieved of the guilt of inauthenticity through the further recognition that the specificity of these forms of experience lies not in their "traditional" consistency, purity, and self-presence but in their entanglements and (dis)identifications with other, modernist, modes of modernity.

It is this performative vein of enjoyment in granular description, in its difficult difference and not-quite-sameness, that I hope to work as I examine the practices and discourses of artists, printers, publishers, and agents in the calendar industry and outline a genealogy of bazaar images in their various contexts of circulation. Given, however, that my account inhabits the same disjunctive spaces as its subject, it remains vulnerable to internal contradictions—such as its professed distance from the logic of canonization even as it performatively constitutes a countercanon. Even as my analysis problematizes the institution of authorship, it indulges in the pleasures of saying and hearing largely unacknowledged names in the proper places of art and academe, and of seeing them in print: not just Raja Ravi Varma and M. V. Dhurandhar but also Aras, Courtallam, Mulgaonkar, Narottamnarayan, Nirmala, S. M. Pandit, Kondiah Raju, Rangroop, Rastogi, Sapar, Sardar, Shaikh, Indra and B. G. Sharma, Singhal; not just Calcutta, Bombay, Madras, and Lahore but also Sivakasi, Nathdwara, Gulbarga, Kolhapur, Gorakhpur, Nagpur, Meerut.

". . . JUST AN IMAGE"

In looking at calendar art as a network inscribed by reiterative flows of objects and people, I have chosen to concentrate on its pan-national aspect rather than exploring a particular region, tradition, subgenre, or theme (here my approach differs from that of Guha Thakurta 1991; Inglis 1995; McLeod 1991; or Uberoi 1990). My main focus, therefore, is on the centralized production and distribution system that, since the 1960s, has converged on the small town of Sivakasi in the southern Indian state of Tamil Nadu. However, I cannot pretend to offer a definitive description of what is an extraordinarily extensive and intensive, complex, mostly informal, and (therefore) rapidly mutating system. The "Bengali market," for instance, is a huge regional market (also catered to by Sivakasi), which I do not address in any detail, as is the case with other, smaller segments, such as the locally produced calendars for "Muslim" markets. My attempt here can only be to provide a broad sense of the lineaments of this system, with Sivakasi as a major node

from which I map a few pathways in thinking about the interpenetrating webs of circulation of calendar prints. My hope is that this account might generate some interest in the many other pathways, connections, and genealogies that remain unexplored.

The first section of the book traces a genealogy of calendar art in relation to its commercial contexts. Chapter 1 ("Vernacularizing Capitalism: Sivakasi and Its Circuits") starts in the present with the printing industry based in Sivakasi, describing its organization as the major centralized site for the production of calendars and prints, which are distributed pan-nationally through an extensive and intensive network of publishers and mobile agents. I outline how this constitutes a parallel realm of image production not only to fine art and folk art or craft but also to the largely English-medium arena of agency advertising: it is primarily a vernacular arena of family businesses whose ethos has been quite distinct from the corporate model adopted by multinationals with a majority Indian ownership and state-run enterprises. While both secular and religious nationalisms work with transcendent ideas of nation based on an essential cultural commonality, the networks of the calendar industry inscribe an intervernacular arena that is able to work both with and across religious, communitarian, and linguistic differences. In this context the networks of circulation of images often function in a performative register to counteract representational messages inscribed within the picture frame.

Chapter 2 ("When the Gods Go to Market") situates the genealogy of this vernacular commercial realm in the colonial "bazaar": the "informal" or "indigenous" sector of the economy delineated by the historians Christopher Bayly (1983), Anand Yang (1998), and Rajat Kanta Ray (1984). Rather than seeing the bazaar as evidence of continuity with a precolonial Indian "proto-capitalism," I approach it in terms of the specific form it acquired under colonial rule. Here I examine how the deterritorializing movements engendered by colonial trade, conquest, and missionary activity configured the bazaar as an arena for producing and circulating images, and how these nomadisms registered in the images themselves. I then describe the reterritorializing movement whereby images were harnessed toward defining or actualizing a proto-nationalist vernacular "cultural" domain in the colonial period up until the 1920s. In this context I discuss the artist and print entrepreneur Raja Ravi Varma, reading his lithographs not just as pictorial actualizations of a nationalist myth of origin but also as one of the first mass-manufactured "Indian" commodities, objects that traced the two-way traffic between the colonial public sphere and the bazaar.

Chapter 3 ("Naturalizing the Popular") continues the chronological trace of images

in the commodity realm, positioning calendar art in relation to other twentieth-century culture industries such as the cinema and illustrated magazines as well as to commodity aesthetics as such: labels, packaging, and advertising. Against accounts of Indian popular aesthetics that see this as an iconic realm distinct from and resistant to Western canons of naturalism and realism, I argue for a more historically informed understanding of the "popular," which acknowledges its constitution via the commodity realm and its appropriation of new image-making techniques. I suggest that naturalism and other pictorial technologies served to reconfigure or recontextualize existing forms and thereby expand the domain of commodity address, bringing hitherto segregated constituencies into a common arena of consumption and thereby instituting new imagined social configurations. However, these "imagined communities" instituted via "print capitalism" belie Benedict Anderson's predication of nationalism on a post-sacred scenario (Anderson 1991). This chapter describes some of the many ways in which modern, commercial forms of religious and mythological imagery became a primary site for the production and reconfiguration of various forms of identity, including the national.

The next section, "Economy," addresses the frames of value in which bazaar images circulate, examining what the continued presence of religiosity in the public arena has meant for the trajectory of post-Enlightenment aesthetics in the postcolony. In chapter 4 ("The Sacred Icon in the Age of the Work of Art and Mechanical Reproduction") I rely substantially on interviews to examine how discourses and practices of the aesthetic have been adopted but in a contradictory, disjunctive fashion. For instance, people in the calendar industry say that calendar icons are meant for the rural, uneducated masses even as they themselves pray to them every day; artists sign their names to paintings even though customers do not choose images according to the artist but according to the subject; calendar artists paint gods and goddesses and say that what they are doing is "realism." These disjunctures problematize key categories in post-Enlightenment discourses of aesthetic value: artistic judgment and taste; autonomy as opposed to commercial and other forms of interest; authorship and originality. In doing so they provide clues as to the heterogeneous frames of value that are brought to bear on, and are reinforced by, these images. Chapter 5 ("The Circulation of Images and the Embodiment of Value") seeks to specify the terms of negotiation between the different moral and libidinal economies within which bazaar images circulate. Here I relate post-Enlightenment ideas about the image to a moral economy where value is seen as deriving from production, while images in the devotional-cum-commercial ethos of the bazaar emanate from a moral economy

where value is based in circulation and exchange. In this context I revisit the notion of the fetish—one of the few concepts that speaks to the nomadism or animation of images as objects, as well as to corporeal engagements with them—looking at the significance of its denigration in bourgeois moral economy.

The last section, "Efficacy," seeks to develop an approach to the politics of images that takes into account the trans-subjective arenas in which images circulate, problematizing "reception" studies that primarily focus on the responses of individual subjects. Chapter 6 ("The Efficacious Image and the Sacralization of Modernity") looks at the highly mediated relationship between mass-cultural images and the political arena, and the notions of efficacy that are mobilized in relation to public images—including the idea of auspiciousness and its "secular" equivalents. I explore how the very publicness and mass mediatedness of an image gives it an added valency for its viewers, through their awareness that the image is exposed to a public gaze—or rather, to the gaze of an other or others imagined in historically specific ways. Here I discuss the ways in which not just the Hindu nationalist Bharatiya Janata Party (BJP) and Shiv Sena but also the avowedly secular Congress Party sought moral legitimation for their rule by recourse to the ethical framework of the bazaar.

Chapter 7 ("Flexing the Canon") is an experiment in applying the approach to images outlined above to the writing of cultural critique. Here I revisit an earlier set of debates around the emergence of a new figure in calendar art, that of the god Ram in a muscular, violent form, with the resurgence of a militant Hindu nationalism in the late 1980s. What I both argue and try to demonstrate is that what is required from critique in this context is not so much the condemnation or censorship of particular kinds of images, which chiefly serves to shore up their power and efficacy, but a creative, expropriative reframing within the context of alternative narratives.

My conclusion offers some thoughts about how the analysis of calendar art might illuminate the cultural aspects of globalization in post-liberalization India. It also considers how such an analysis might be relevant for thinking about art history, critique, and practice, present and future.

If one organizing principle of my narrative is its object-centeredness, another is to remain mindful of the chasm between the work of the image and the work of language (and the academic text in particular), allowing my argument about the performative aspects of the image to inform the performative aspects of the book itself. Accordingly, the images are not intended as illustrations as such but constitute a parallel thread to the dis-

cussion, even as they maintain a resonance with what is being said within the text. If this at times produces an effect of disjuncture, this is an invitation to apprehend the possible encounters with the image not only within the registers and contexts that I describe, but also in others that I do not. It is also a way of gesturing, from within the harnessing of images to one particular narrative, toward the heterogeneity of the image: its irreducibility to a visuality mediated exclusively by language. Within the text, too, I somewhat polemically maintain a relative abstinence from close formal analyses, although it would be absurd to abandon this procedure altogether. As with my substitution of "image" for "visual," keeping "reading" in abeyance is an experiment in slowing down what are often all too hasty links between what images seem to be saying, what they mean, and what they do.

PART 1 GENEALOGY

1

VERNACULARIZING CAPITALISM:
SIVAKASI AND ITS CIRCUITS

After Raja Ravi Varma, if an artist has attained such great fame,
it is our Raghuvir Mulgaonkar.

VASANT BHALEKAR, "CHITRA SAMRAT RAGHUVIR MULGAONKAR"

With [S. M.] Pandit, Raja Ravi Varma's style was reborn and modernized.

SHIRISH PAI, "CHITRAKALECHE 'PANDIT' — S. M. PANDIT"
["PANDIT" OF FINE ARTS — S. M. PANDIT]

My informants . . . generally agreed that the artist
who had the greatest influence on art in this century
after Raja Ravi Varma was C. Kondiah Raju.

STEPHEN INGLIS, "SUITABLE FOR FRAMING:
THE WORK OF A MODERN MASTER"

One of the quintessential images of Indian calendar art is a picture of Saraswati, the Hindu goddess of wisdom, painted by the nobleman artist Raja Ravi Varma in 1881 and reproduced as a chromolithograph by his own well-known picture press later that decade (fig. 10). If there is one artist whom lay people, those in the industry, artists, and art historians alike readily associate with calendar art, it is Raja Ravi Varma. He

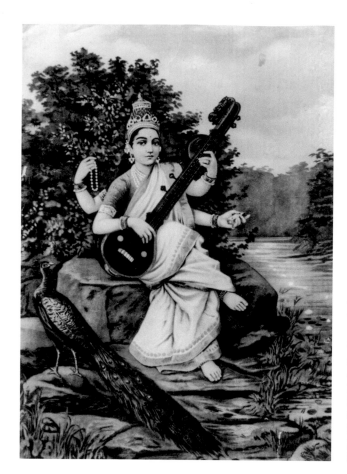

10. *Saraswati* by Raja Ravi Varma, chromolithograph, based on originals painted when the painter was in residence at the court of the maharaja Sayaji Rao III of Baroda in 1881. Ravi Udaya-Vijaya Offset, Ghatkopar, distributed by M. A. Joshi and Co., Mumbai. (Collection of Shafi Hakim)

is often referred to as the "father" of calendar art, with the assumption that those who came after him have been mere imitators. The implication here is that the story of Raja Ravi Varma encapsulates the most important things that need to be known about calendar art, so the question of attending to a diverse, multi-layered, mutating constellation of sources, influences, and pictorial agendas does not arise. And indeed, if we compare Varma's 1880s Saraswati with a mid-twentieth-century image of the goddess from Studio S. M. Pandit (fig. 11) and another print from the 2001 stocks of the Delhi picture publishers S. S. Brijbasi and Sons, *Shri Saraswati* by M. C. Jagannath (fig. 12), this view would appear to be justified. It would seem as though almost nothing has changed in over a century of calendar art: some of the background elements might have been moved around a bit, the landscape treated a trifle differently, or subtle changes made in the facial features, clothing, and ornaments of the central figure, but little else. To this extent these two prints attest to the conventionality, repetition, and copying that characterize the genre, and to the lasting influence of Raja Ravi Varma.

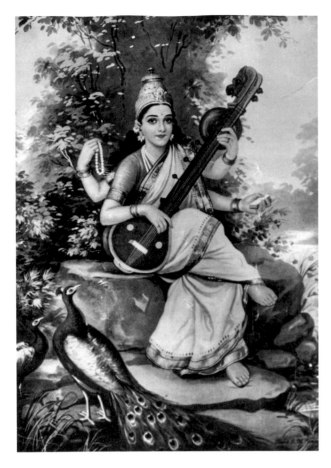

11. "Saraswati," from Studio
S. M. Pandit, offset print,
ca. 1945–85. (Collection of
Shafi Hakim)

However, if we now compare these two framing pictures with two calendar designs for 1995, also depicting Saraswati, one by Sapna Ads (fig. 13) and one by S. Murugakani (fig. 14), the similarities with the image by Ravi Varma begin to dissolve—and with them the static understanding of calendar art outlined above. The translucent drapery and sinuous, flowing lines of the Sapna Ads version (though not its luminescent flushes of pink and yellow) draw on what is known in the trade as the "Indian art style"; such neo-traditionalist elements had initially been positioned as an explicit repudiation of Ravi Varma's "westernized" work by the early-twentieth-century Bengal school. In the Muru-gakani version, the brass lamps flanking the goddess, typically used in South Indian prayer rituals, indicate that this design is specifically aimed at the South Indian market. Such departures from the Ravi Varma "template" appear more commonly in designs for calendars rather than framing pictures, suggesting that the annually produced calendars have a greater need for "new" designs catering to a range of specific market segments than the more conventional, slower-moving framing pictures.

12. *Shri Saraswati* by M. C. Jagannath, offset print, in the 1995 stocks of the publishers S. S. Brijbasi and Sons, Delhi. (Courtesy of Brijbasi Art Press Ltd.)

Despite these differences, however, all five images still share certain common visual elements. They all provide a figurative rendition of the deity with the requisite iconographic identifying symbols, prominent faces with fair complexions, large eyes gazing directly out of the frame, and plenty of golden ornamentation. They also share a "frontality" and centrality of composition: a figure in the foreground against a lush mythic landscape or anonymous decorative background, with very little middle ground.[1] The four more recent, post–Ravi Varma, offset-printed versions use pre-press techniques to achieve characteristically intense, saturated colors and strong highlights. (I describe these techniques in more detail in chapter 4.) Most of these formal elements are also present in calendar art depictions of other iconic figures, both secular and divine. Other stylistic features of bazaar images, and the themes they depict, have been subject to both continuity and variation as well as recursive reinterpretation since the early days of chromolithography.[2]

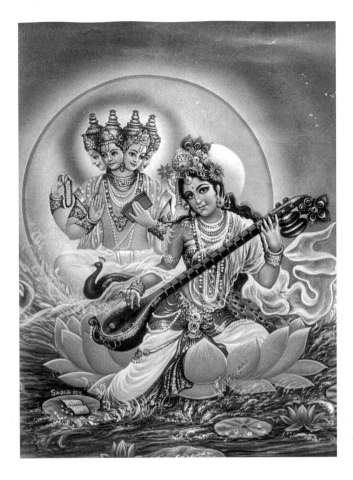

13. "Saraswati" by Sapna Ads, 1995 calendar.

TOWARD A GENEALOGY OF CALENDAR ART

These images of Saraswati diverge from the Ravi Varma myth of origin through their heterogeneous layering of artistic sources, printing techniques, and marketing considerations. They point, instead, to the negotiation between novelty and familiarity that is a classic feature of the serial economies of the culture industry, from commercial cinema, television, popular music, and literature to fashion and product design. What has enabled the sheer prodigality of output maintained by the culture industry is its canny negotiation between novelty that does not necessarily imply difference and repetition that does not merely signal the return of the same.[3] So even a mass cultural form that is characterized by convention, schematism, copying, imitation, and reproduction—such as calendar art—can have a history, or rather a genealogy in the Foucauldian sense: it cannot be accounted for by simply projecting forward in time from some conception of

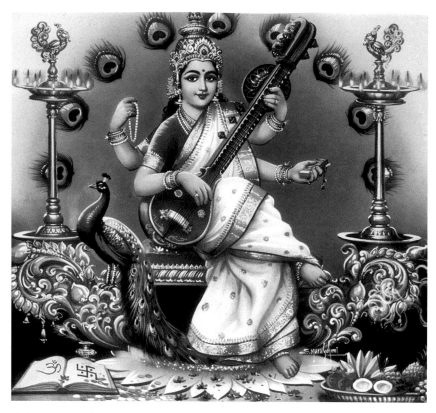

14. *Saraswathi* by S. Murugakani, 1995 calendar printed by Coronation Arts and Crafts, Sivakasi. (Courtesy of Coronation Arts and Crafts)

an originary moment.[4] This chapter and the next identify and address some of the issues neglected by privileging a singular moment, site, and agent of production such as the late nineteenth-century Ravi Varma. Building on the premise outlined in the introduction that images are as much objects as they are signs or representations, my account centers on the circulation and production of bazaar art *across* both space and time. This chapter starts with a description of the circuits of calendar art as they have come to converge on the production center of Sivakasi in Tamil Nadu a century *after* Ravi Varma, while the next chapter traces some of present-day calendar art's diverse lineages, some of which go back a century *before* him. However, my narrative does not seek to marginalize Raja Ravi Varma but to provide a place from which to reconsider (in chapter 2) what is at stake in the multiple mobilizations of this figure.

One of the reasons for the somewhat static conception of calendar art post–Ravi Varma is, I think, the assumption that the story of the commodification of culture is well

known: that, as with mass culture developing under conditions of Euroamerican "monopoly capitalism," the culture industry in India is a manifestation of, and a means of instituting, the reified relations characteristic of middle-class or bourgeois society. The presupposition here seems to be that the culture of capitalism is singular, and that it is necessarily accompanied by the creation of liberal subjects (bourgeois and proletarian) on the European model. Take, for instance, Ashish Rajadhyaksha's seminal discussion of Ravi Varma in relation to the Indian culture industry's early encounters between precolonial image-making practices and Western artistic and reproductive technologies (Rajadhyaksha 1993b). Rajadhyaksha tantalizingly leaves Varma's work, its particular construction of the past, its surface properties, and its proliferation throughout the "entire indigenous small-scale consumer industry" in the hands of a "middle-class," about whose modes of engaging with objects and images no more needs to be said, for we are assumed to be familiar with what being middle-class entails (Rajadhyaksha 1993b, 65). As a result, there are two sets of issues that remain unaddressed in relation to mass-produced prints, and indeed to commodities in general (although studies of commercial cinema have touched on them: see, for instance, Prasad 1998). The first set of issues pertains to the varied processes by which heterogeneous constituencies of people are brought into networks of centralized commodity manufacture, circulation, and consumption. The second pertains to the distinctive character that these capitalist networks take on through being forged in articulation with existing economic, political, and social formations.

I would like to refer to this two-way process as one of *vernacularizing capitalism*. One component of this two-way movement is the incorporation of vernacular constituencies into a regnant capitalism enmeshed with bourgeois-modernist ideology: the imposition of a singular "global" capitalist order. The other is the protean adaptations of the "axiomatics" of capital (Deleuze and Guattari 1977, 1987) to varying "local" circumstances: or in other words, the proliferation of multiple cultures of capitalism. Such two-way movements have become increasingly apparent with the intensified globalization occurring from the late twentieth century onward, but, as the following description of the calendar industry's networks will show, such processes have also characterized earlier moments of capitalist formation. And while my concern here is to describe processes of vernacularization in relation to the calendar industry in India, I would suggest that images and the culture industry have played a crucial role in such processes everywhere and continue to do so through a set of fine-grained articulations between "formal" and "informal" modes of industrial and commercial organization; between commercial, religious, politi-

cal, and social institutions; between disparate technologies and contexts of image making and consumption (including those of fine art and modernism); and between centralized and decentralized inscriptions of national and local identity.

As I said in the introduction, "bazaar" art is not the same as "commercial" art: the Hindustani word "bazaar" works to locate this form in a vernacular, non-English-speaking realm. This chapter unpacks the idea of vernacularizing capitalism through a description of the calendar industry as a commercial arena that exists in parallel with centralized industrial mass manufacture and the corporate service sector. Through a broad overview of the industry's networks, I show how it has optimized manufacturing processes according to the prevailing relative costs of labor, materials, and machinery and adapted the economy of centralized mass production to cater to a wide range of consumer preferences across disparate locations. These negotiations unfold both through the industry's systems of production and through its modes of distribution and marketing (its classification of consumers, its range of themes or "subjects," its styles and production values). Attending to processes of circulation helps us to see how the calendar industry's ingeniously flexible, semi-informal systems complicate the notion of the "mass" in "mass culture" and "mass production" by simultaneously working both to reinforce and reconfigure regional or local differences. It also alerts us to the differences within the types of commercial ethos being negotiated by the post-independence Indian "middle class," introducing the "bazaar" as a key context for calendar images, which I take up in detail in chapters 2 and 5. And finally, attention to circulation brings into focus a performative matrix of nationhood, enacted in a register which is congruous with, but not reducible to, explicitly articulated ideologies of nationalism or the boundaries of the nation-state.

My emphasis on pan-national circulation, coupled with the rapidly mutating and largely "informal" nature of this domain, has meant that this is a broad, synthetic account, based on a set of fragments: snapshots, as it were, from contingent moments, angles, and sites. It is largely based on fieldwork I carried out between 1994–96 (with short follow-ups until 2001), but it also draws on H. Daniel Smith's invaluable research and collections, particularly his field observations from 1988 (see also H. D. Smith 1995).[5] There is immense scope for further detailed work on the industry, including whatever can be gleaned from company records and government archives. Rather than installing a singular myth of origin, I see this synthetic account as a way of opening up multiple contexts and pasts for calendar art, albeit from the point of view of a specifically post-liberalization present. If this genealogy based on circulation situates calendar art within

the context of the post-independence culture industry, that context in turn invokes a much broader lineage of the commerce in pictures on the subcontinent—particularly of the trade in religious icons—as well as of a very particular form of commerce, the "bazaar." And again, this paves the way for attending (particularly in chapters 2 and 5) to the very animation or nomadism of the image, whether in recognized circuits of commercial and ritual exchange or other contexts of physical displacement, both actual and virtual.

SIVAKASI, "MINI-JAPAN"

Sivakasi is a tiny town in the Virudunagar (formerly Kamarajar) district of Tamil Nadu, about 70 kilometers southwest of Madurai; its population according to the 2001 census was 72,170 (although that of the urban agglomeration was 121,312, and these numbers swell further due to the influx of workers from surrounding areas). However, its extraordinary success in three industries, matches, fireworks, and printing, supposedly inspired Jawaharlal Nehru to call it a "mini-Japan" ("*kutti* Japan" in Tamil). This one town bears the major weight of print production on the subcontinent. In 1980 it was claimed that Sivakasi housed 40 percent of India's entire offset printing capacity, with an annual turnover of Rs. 13 crores (Rs. 130 million), coming from 75 companies running 300 offset presses (Anantharaman 1980). A 2001 estimate put Sivakasi's offset printing share at 60 percent, with 373 presses (www.kuttyjapan.com). Residents I spoke with, men, women, and children alike, readily recounted the Sivakasi story: of how its peculiarly hot, arid climate is well-suited to the storage of chemicals and paper, and how this, combined with the low cost of labor and the entrepreneurship of the local Nadar community (which I describe below), has been conducive to its intensive industrial growth.

Unlike in the north and west where merchant capital, and subsequently indigenous industry, came to be concentrated in the hands of traditional business communities or castes such as the Marwaris, Banias, and Parsis, in colonial Madras from the 1870s onward several "non-business" castes—including both Brahmins and "backward" castes such as the Nadars—were able to take advantage of the increasing trade in commodities and cultivation of cash crops (Mahadevan 1984). The Nadars, whose community occupation at the beginning of the nineteenth century was the ritually polluted one of toddy tapping, accumulated wealth through trade, particularly in cotton and tobacco. By 1821 Sivakasi was described by a British surveyor as "a considerable merchant town," where the Nadars had constructed their own temples (Hardgrave 1969, 97–98). In fact, the

Nadars are a textbook case of social mobility across the caste system, enabled by wealth and strong community associations (Hardgrave 1969; see also Templeman 1996).

Thus the legendary cousins, P. Aiya Nadar and A. Shanmuga Nadar, who went to Calcutta in 1922 to learn about match manufacturing, came from a well-to-do background and were able to supply the capital to set up a unit in Sivakasi. But after eighteen months the Nadars sold their machinery to a buyer in Ceylon, finding it was far more lucrative to substitute mechanized processes with cheap, readily available manual labor.[6] This strategy of de-mechanization would characterize all three industries in Sivakasi up until the late twentieth century. Capital investment and government subsidies only tell part of the story when it comes to Sivakasi's industrial success: a major factor has also been cost reduction through the use of informal manual workers, who work on the basis of daily wages or piece rates.[7] Sivakasi's match industry in particular has been notoriously dependent on its exploitation of child labor, while according to my observations in the late 1990s all three of its major industries remained largely untouched by ideas of occupational health and safety.[8]

Printing in Sivakasi began in 1928 with lithographed labels for the match and firework industries and soon extended to packaging and labels for other industries in the region, followed by advertising posters, calendars, and framing pictures. The first press in Sivakasi was the Nadar Press Limited, set up by K. S. A. Arunagiri Nadar in 1928; this was followed by other presses such as the National Litho Press, Coronation, Chidambaram, and Premier, so that by Independence (in 1947) there were about nine or ten stone lithography presses in Sivakasi. These subsisted on trade labels and occasional film posters for Tamil and Malayalam films, employing artists to separate and transfer the designs, which mostly came from the major centers of Bombay, Calcutta, and Madras or were copied from foreign labels (although some were also designed by these local artists). After independence, the presses began to acquire offset machines, many of them bought second-hand or from East Germany, which accepted payment in rupees. By the mid-1960s, Sivakasi's color printing industry had optimized its production costs to the extent that it could compete with local presses in major metropolitan centers such as Bombay (now Mumbai), Delhi, Calcutta (now Kolkata), and Madras (now Chennai). By 1980, three presses from Calcutta had packed up and moved their operations to Sivakasi; in that year A. M. Saundara Pandian, the secretary of the Sivakasi Master Printers' Association, was quoted as estimating that, excluding the cost of paper, production costs in Sivakasi were about 40 percent less than those in Delhi, Bombay, Madras, and Cal-

cutta (Anantharaman 1980, 16). The substantial cost reduction achieved by the Sivakasi printing industry has largely been due to the lower relative wages of skilled personnel and its adoption of a decentralized system of "ancillarization," where as many processes as possible are contracted out as piecework to informally hired, unorganized workers on daily wages, thus ensuring flexibility and low overheads.[9] However, as with the match and firework industries it has also been aided by ingenuity, self-reliance, and thrift in the use of technology and materials. For instance, where there might have been a few inches of wasted space on the printing plate in the margins of a packaging job, I have seen rows of tiny god-pictures to be sold to key ring or locket manufacturers.

Sivakasi has also made substantial savings through its optimal mix of manual and mechanical processes, and of locally manufactured and imported materials. While most presses in the 1990s had imported scanning equipment, many were still using locally manufactured printing inks or zinc printing plates that could be ground down and re-used instead of the more expensive ready-made synthetic plates (the zinc plates were coated with an emulsion made of egg albumen, for which truckloads of eggs arrived every day from nearby Salem). And while making color separations for printing is usually an entirely photographic process, Sivakasi is well known for its extensive manual work on color separations. This is how the prints acquired the characteristic look that has come to be associated with Sivakasi: strong, deeply saturated, contrasting colors with bright highlights. (I discuss this further in chapter 4.)

Up until the mid-1990s, Sivakasi's particular strength was non-urgent, high-volume work using thin, low-grade paper, at the bottom end of the offset printing market: packaging labels, calendars and framing pictures, lottery tickets and exercise books. So for a good three decades of the post-independence period, from the mid-1960s until the mid-1990s, Sivakasi was the major hub for the calendar industry, with picture publishers and calendar manufacturers nationwide finding it worth their while to send print jobs all the way to the southernmost tip of the country. By the turn of the millennium, however, as players in the post-liberalization economy sought to invest in higher quality advertising and corporate gifts, Sivakasi's printers were saying they were no longer able to rely on the calendar and framing picture trade with its diminishing profit margins. In 2001, most printing firms in Sivakasi were upgrading their operations and diversifying into areas such as books, more upmarket stationery, and packaging cartons, and some were considering moving out of printing altogether.

The instance of Sivakasi and its Nadar entrepreneurs demonstrates that even as

imported technologies have been adopted by indigenous capitalists, the technologies themselves have not necessarily determined the mode of industrial organization within which they came to be used. Sivakasi's emphasis from the 1920s onward on substituting mechanized processes with ancillarized manual labor conforms more to the mixed arrangements of "disorganized" or "late" capitalism than to the classic model of centralized Fordist mass manufacture in the "monopoly phase" of capitalism, which accompanied the growth of the Euroamerican culture industries. But this would be something of a circular description: "late" capitalism cannot be thought of outside of a long history of global appropriations of such local forms of exploitation. Similarly, the "localness" of these forms of exploitation does not simply stem from precolonial modes of social and economic organization but from their selective reconfiguration under colonialism and neocolonialism.[10] The continuing legacy of these forms of localized domination is a global economy where the cost of human labor can still be lower than that of buying and maintaining a machine.

DIFFUSION

So far we've seen how production in the Sivakasi print and calendar industry has straddled the "formal" and "informal" sectors of the economy through its use of unorganized casual labor and small-scale ancillary providers. This kind of mixed organization has extended to its distribution networks as well, in the form of self-employed agents and small-time peddlers working on a flexible, seasonal basis.

The first level of diffusion in the circuits inscribed by calendar prints, however, has mostly been that of formally established picture and calendar publishing firms. "Picture publishers" have mainly dealt in framing pictures and posters (fig. 15). Those operating in the late 1990s still included some of the older concerns established in the first half of the century during the heyday of chromolithography — although a spate of picture publishing firms also appear to have opened, or expanded, soon after independence.[11] The calendar publishers or "manufacturers," in contrast, have mainly collected orders for calendars. Several of the companies still active in the late 1990s emerged after Sivakasi's offset printing boom, largely displacing the earlier calendar companies operating locally in the busier trading centers before 1960.[12] In practice, despite the distinction between them the Sivakasi connection has made it relatively easy for both picture publishers and calendar manufacturers to carry stocks of various types of printed products: calendars, framing pictures, posters, and postcards. The larger publishers have mostly been based

15. The Delhi branch office of S. S. Brijbasi and Sons, picture publishers, 2000.

in the four metropolises (often with branches in more than one city), dividing their print orders between Sivakasi and more local presses. However, many towns have had their own publishers, who also use local print shops and artists to produce prints and calendars on subjects with limited currency, such as local deities and pilgrimage maps. So the stocks in any given retail market typically include prints geared toward both a pannational and a local or regional audience. Publishers are often clustered together in the older bazaar area of a town alongside the paper market, as is the case with Delhi's Nai Sarak (and the adjacent Chandni Chowk and Fatehpuri).[13] Alternatively, like one of the largest southern picture publishers, J. B. Khanna, on Chennai's Devaraj Mudaliar Street, they might be located near the framing shops that, apart from picture wholesalers and the publishers themselves, are the most stable retail outlet for prints.

Like the picture publishers, many framing shops sprang up either in the early days of chromolithography or soon after independence, and most Indian towns would have had at least one that dealt primarily in bazaar prints (as well as frames and sometimes mirrors), as distinct from fine art reproductions and paintings. However, bazaar framers have also carried other kinds of images: certain kinds of tourist art, pilgrim souvenirs, exemplars of a local craft, or mixtures of these. For instance, in the mid-1990s the framing shops on Chennai's Devaraj Mudaliar Street had become outlets for the revival of

the Tanjore (or Thanjavur) painting tradition, so old and new Tanjore-style paintings hung there next to their bazaar print cousins (a kinship that will be elaborated in the next chapter). Framing shops have also come to stock a cornucopia of more elaborately encased images: golden plastic bas-relief statuettes mounted in glass cases with flashing electric lights, icons dazzlingly laser-etched into metallic backgrounds, prints set into clocks or decorated with plastic jewels, sequins, glitter, or glass beads. While the laser-etched images come from overseas, framing and decoration with sequins, glitter, and beads can be carried out locally at a very small scale, often by women working at home, to add value to printed framing pictures (fig. 16). This sort of value addition can be critical for small-time hawkers, for whom every extra avenue for profit makes a big difference, as in the case of Sonu, a young man I spoke with in Delhi's Ramakrishna Puram, whose mother framed and decorated the prints that he brought to market. Sonu is part of a large informal constituency of pavement hawkers and small stallholders trading at pilgrimage sites, weekly markets, and the busier bazaars, or itinerant peddlers working the rural hinterlands (fig. 17). These informal hawkers often have other occupations too; Sonu, for instance, was training to become a bus driver. A few posters, framing pictures, and postcards (mostly of film stars) are sometimes also stocked by smaller neighborhood stationery and grocery stores, while secular posters depicting sport or film stars, landscapes, animals, flowers, and so on (often accompanied by textual homilies in English; see fig. 18), can also be found in more upmarket department stores.

As with its chromolithographic predecessors (about which more in the following chapter), the Sivakasi offset print trade has not been confined within national boundaries (fig. 19). In this respect bazaar prints and calendars can be seen as indices of the continuing circulatory flows characterizing migration from the subcontinent (as opposed to a unitary notion of "diaspora": see Markovits 2000). H. Daniel Smith reported in 1988 that several Sivakasi printing companies had been supplying prints to the South Asian diaspora in Burma (now Myanmar), Malaysia, Singapore, Sri Lanka, South Africa, and Fiji. (In fact, a Sree Lakshmi Agencies letterhead from 1984 carries the self-description "Manufacturers & Exporters.") In these countries, as in the United Kingdom, Canada, the United States, Australia, and New Zealand, religious calendar prints produced in Sivakasi are often sold at South Asian grocery shops.[14] Prints are supplied overseas by publishers as well as printers, often via small-scale traders (such as the agent from Sri Lanka I encountered looking for pictures of Indian film stars in the Delhi office of the publisher S. S. Brijbasi and Sons). Dana Rush, citing Henry Drewal, describes how

16. Printed framing pictures decorated with sequins, for sale at a pavement Diwali market, Sarojini Nagar market, New Delhi, 1995.

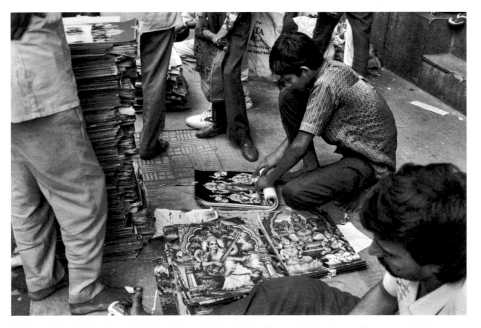

17. A small-scale hawker of prints rolling up his selection from a wholesaler on the pavement at Delhi's Nai Sarak, 1994.

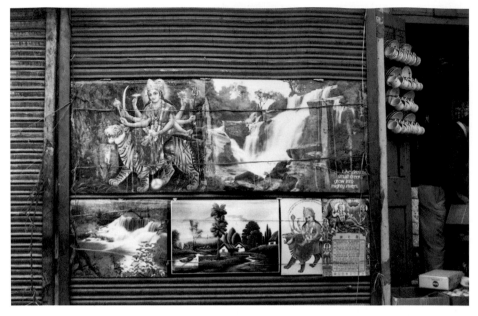

18. Secular landscape posters for sale alongside religious images, Nai Sarak, Delhi, 1995. The text on the waterfall poster (upper right) reads: "Like dreams, small creeks grow into mighty rivers."

prints of Hindu deities have circulated in west Africa since around World War I, catering not only to Indian traders but also to local adherents of religious practices such as *vodun*. According to Drewal, in 1955–56 Bombay's Shree Ram Calendar Company reproduced twelve thousand copies of a calendar depicting the *vodun* spirit Mami Wata for traders in Kumasi, Ghana (Drewal 1988, 183 n. 6, cited in Rush 1999). Rush's example of a 1995 calendar from Benin closely resembles those produced in Sivakasi, suggesting either that Sivakasi's trading networks extend to the west African market, or that Sivakasi prints are being replicated locally, or both.[15]

Religious prints have also acquired a vast virtual presence on the Internet at various Hinduism-related sites (including celestial screen savers from www.ePrarthana.com). In another avowedly "spiritual" context, Sivakasi-style imagery of Hindu deities has been adopted by youth subculture, coinciding with (or indeed, leading to) the appropriation of the calendar art "look" by global fashion through the 1990s, with reproductions of bazaar prints and matchbox and firework labels from Sivakasi appearing on CDs, postcards, diaries, calendars(!), wrapping paper, coffee-table books, T-shirts, jeans, handbags, lunchboxes, even underwear and—it is rumored—toilet seat covers. This is not a strictly Euroamerican phenomenon: in 2000–2001 fashions based on calendar art could

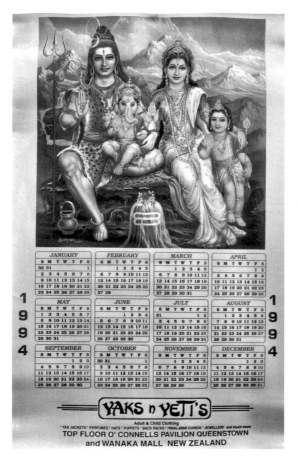

19. A 1994 calendar for Yaks n Yeti's clothing store, New Zealand, featuring Shiva and Parvati in their Himalayan abode.

be found in boutiques in New Delhi as well as in New York. Through the 1990s the older chromolithographs also came to be part of a collectors' market, with Ravi Varma prints becoming a common feature of elite Indian interiors. The growth of this market has led to systematic attempts on the part of dealers, curators, and collectors to create and set standards for the value of "antique" or "historical" prints.[16] This collectors' market was almost certainly boosted by a major retrospective of Ravi Varma's work at the National Gallery of Modern Art in New Delhi in 1993, and to some extent also by the 1996 show From Goddess to Pin-Up (Eicher Gallery, New Delhi) curated by the sociologist Patricia Uberoi, the first gallery show of calendar art qua calendar art, focusing on representations of women. Both shows, in their turn, arose out of a growing scholarly interest in Raja Ravi Varma and popular visual culture from the late 1980s onward (G. Kapur 1993b [1987], 1989; Guha Thakurta 1986, 1991, 1992; Rajadhyaksha 1993b [1987]; Uberoi 1990).

In addition to their appropriation by fashion and art, and their collection by elite or

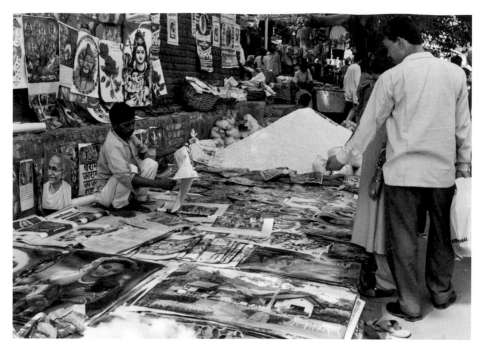

20. A poster stall at pavement market, Sarojini Nagar, New Delhi, in the run-up to Diwali 1995.

scholarly communities, contemporary religious pictures continue to sell throughout the year at pilgrimage sites and places of worship in India and overseas. At more general markets, the various regional festive seasons have been the peak sales periods for both framing pictures and posters, sacred and secular, as these have typically been the times when people refurbish their domestic shrines and redecorate their homes (fig. 20). In Delhi, for instance, the lead up to the festival of Diwali in October-November is accompanied by a roaring wholesale picture trade on the pavements of Nai Sarak, where retailers and small-time peddlers come from all over the city and nearby regions to buy stock to sell at local Diwali markets. In November 1995, posters that cost Rs. 500 per *saikda* (hundred) inside the picture publishers' stores sold just outside on the pavement for Rs. 590 or 600, and were then resold to shopkeepers and consumers at local markets at Rs. 10–15 per piece. That season, one hawker with a large pavement poster stall at the Diwali market in the middle-class New Delhi neighborhood of Sarojini Nagar estimated that he would make about Rs. 5,000–6,000 over and above the nominal official rent to the market committee and unofficial payoffs of Rs. 700–1,200 to the police. Here again, informal arrangements characterize not just manufacturing in the calendar industry but processes of distribution as well.

Like the market for prints, the calendar trade also peaks between Diwali and the secular New Year in the north, west, and south, and in Bengal around the Bengali New Year in mid-April, since this is when businesses and other institutions give out complimentary calendars to their clients, customers, associates, and employees. Because of this difference in annual schedules, as well as its highly specific subjects and iconography, the "Bengali market" is considered entirely distinct from the more pan-national circuit that is known, interestingly, as the "English market." On the face of it, this rubric stems from the titles of the calendar designs for the pan-national market, which are written in English. This attests to the industry's extensive national reach and possibly also to its preeminent location in Tamil Nadu, a state with a history of antipathy to the national language, Hindi. (The earlier chromolithographs produced in the north and west often had Hindi or Gujarati titles, while the Bengali market calendars often have titles written in Bangla.) Toward the end of this chapter, however, I will return to why I think this use of the national—but not nationalist—lingua franca is both revealing and paradoxical.

THE "ENGLISH MARKET"

The calendar industry in particular has owed its remarkable market diffusion to its extensive, mobile network of self-employed agents or middlemen working on commission, and to an ingenious mix of centralized and decentralized technologies that enables it to cater to a wide range of budgets and tastes. Every year, starting as early as August (in the case of the English market), agents begin the rounds of local companies in their particular sector, armed with catalogues or "files" containing a range of "ready-made" calendar designs for the following year (figs. 21, 22). At various times, and depending on the company, these files have carried anything from thirty to four hundred designs (although many firms count matte and glossy versions of the same designs separately, so in effect the number of designs in the larger files is more like two hundred). On the basis of these files, which the agents must buy from the calendar manufacturers, they garner orders for the calendar companies in the major centers, adding a markup of around 6 to 8 percent. Most of these agents combine other kinds of business with this strictly seasonal collection of calendar orders. For instance, in 1996 Khurana Traders, in Delhi's Sadar Bazar, listed "Rakhi, Baloons [sic], Fire Works, Holi Goods, Election Badges, Rubber Bands" in its advertisements along with calendars and posters (see fig. 114).[17]

Calendar files are produced annually by Sivakasi's printers, who have tie-ups with particular calendar companies. The files come in a range of sizes, paper stocks, and options as

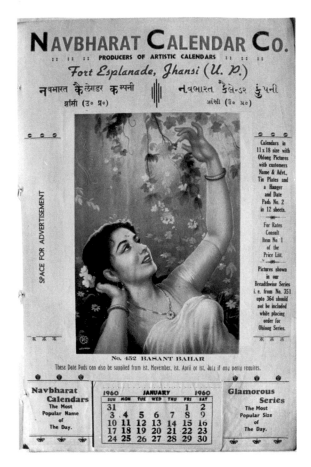

21. A page from a 1960 sample file for Navbharat Calendar Co., Jhansi. (Collection of JPS and Patricia Uberoi, Delhi)

to how many images are included: the choice is between "single-sheeter" calendars with all twelve months appearing on one page, four- or six-sheeters, or—obviously the most expensive option—twelve-sheeters, with one image per month.[18] Calendar publishers also display these files in their offices, from which the proprietors or marketing managers of businesses can come and choose their calendars directly, saving on the agent's markup. The publishers pass these print orders on to the presses in Sivakasi, along with those collected by the agents. The calendar designs in the files, particularly the cheaper single-sheeters, usually appear with the bottom one-third left blank, and this is also how the calendar companies' orders of the required offset-printed color designs are supplied to them by the Sivakasi presses. This is because, in another ingenious optimization of technologies, the calendar publishers or agencies then use local letterpresses to overprint the blank area at the bottom (or sometimes, as in fig. 23a and b, at the top) with the name of the company that ordered the calendar, as well as any other text required

22. A 1995 file for Coronation Arts and Crafts, Sivakasi; on the cover is *Om Ganesh* by V. V. Sapar. (Courtesy of Coronation Arts and Crafts, V. V. Sapar)

("With Compliments," "Seasons Greetings," and so on), and often also the actual days and dates. This system cleverly uses economies of scale: offset printing only makes sense for runs of a thousand and above, while letterpress printing is well suited to runs of a few hundred.[19] So the ready-made designs in the catalogues are produced in all their vivid glory using full-color offset presses, while the text, which only needs to be in one color, is printed locally by letterpress.[20] The calendar publishers organize the letterpress printing, manual typesetting of the text (with companies supplying their own logos on "blocks" if required), and approval of proofs. They then supply the finished calendars either to the company's headquarters or to a list of representatives at various locations, who distribute them to the company's customers and associates in time for Diwali or the relevant New Year.

Decisions as to the range of subjects and their treatment for the various categories of files are made by senior people from the printing companies (mostly the partners them-

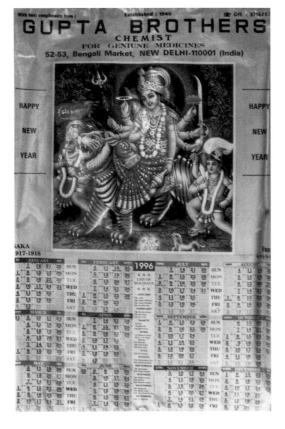

23a and b. A 1996 ready-made calendar with overprinting, featuring Vaishno Devi, a mother goddess or *mata*.

selves) on the basis of sales figures and informal feedback from publishers on the market performance of that year's calendars, of which they have a fairly good idea by the beginning of January. From January through to March the printers travel to meet publishers and artists, getting a sense of market demand from the publishers, personally chasing up payments, and briefing artists on new designs or selecting from those the artists present for their approval. The artists represent another translocal circuit of the calendar print industry, supplying paintings to the Sivakasi printers from home-based studios all over the country, in cities and towns such as Mumbai, Delhi, Kolkata, Chennai, Madurai, Meerut, Agra, Jabalpur, Pune, Kolhapur, Sholapur and Nathdwara, as well as Sivakasi itself and (until the early 1990s) the neighboring village of Kovilpatti. By April the finalized paintings are sent to the presses so that the albums are ready for distribution to agents and publishers by July-August. Sivakasi's presses are thus mostly occupied with calendar work from June to December as files are prepared and orders come in from around the country, although a number of them continue to produce calendars for the Bengali market until the Bengali New Year around mid-April.[21]

By choosing from a file of "ready-made" designs a company has the option to order any number of full-color calendars, from a few hundred to tens of thousands, and in a variety of designs, without a significant variation in the unit cost. At the same time, the use of local letterpress machines provides the component of personalization, so essential both to the advertising aspect of the calendar and to this form of gift-giving as a reinscription of social relationships. This ability to avail of a centralized economy of scale while retaining an element of personalization is what has made calendars an affordable and desirable form of publicity for businesses of any size, from small retailers, traders, and service providers to manufacturers, from the corner chemist's or tailor's shop to industrial giants. In part this is enabled by the mixing of old (letterpress, which is less mechanized, smaller in scale, and requires low capital investment) and new (offset, which is highly mechanized and higher in volume) printing technologies. But it is also enabled by the mixing of decentralized and centralized operations, formal and informal economic transactions, and the industry's own deployment of personal, face-to-face relationships in keeping close tabs on the marketplace. So far the calendar industry has not used professional market research organizations to gauge consumer preference, relying instead on the direct interactions and physical mobility of individual agents as they scour local markets for orders, or of printers as they do the rounds of artists and publishers. Here the printers' files or catalogues work as a microcosm of the nation-as-market, annually inscribing and fine-

tuning what might be thought of as imagined communities of consumption. But unlike commodities that are *bought* by "end-users," the Sivakasi calendars are mostly advertisements, given out for free. To this extent the calendar files are not direct indices of market demand but represent several layers of second-guessing and self-projection. At one level the files index what publishers think will interest their clients (those responsible for their firm's publicity); this in turn indexes not just what these clients think will please their own customers (the "end-users"), but also how these clients want themselves to be seen. If a calendar is primarily a commodity from the point of view of the publishers, from the point of view of their clients it is primarily the formal expression—and the vehicle—of a *relationship*. This relationship is expressed both through the "subject" or theme of the calendar, as well as through the material qualities of the calendar itself.

SUBJECT, STYLE, SPEED, LOCALITY

For a start, one of the considerations in choosing a calendar is the "level" of people to whom the calendar will be distributed, which affects how much a client is willing to pay per unit. Several of the publishers' clients I spoke with ordered two different levels of calendars, a cheaper option for their run-of-the-mill customers and an expensive one for more "exclusive parties": government officials, important business associates, family, and friends. The cost of a calendar depends on how many images or "sheets" a calendar will have, its size, paper quality, and finish. With the introduction of newer offset machines over the 1990s there has been an increasing range of options with respect to size. Many more formats are now commonly available beyond the earlier standard 20" × 30" and 30" × 40", notably the smaller 16" × 22" and the 11" × 36", whose longer, thinner proportion frames a full-length figure. (Earlier this elongated format was used exclusively for "girlie" calendars, but it is now also used for deities such as Krishna, either alone or with his consort Radha [see fig. 24].) Then there is the question of whether it is to be matte (printed on map litho paper), glossy (printed on art paper, usually with gold stamping), or printed on foam or other forms of plastic sheeting. Foam and plastic, introduced in 1993–94, have been marketed as a "quality" option, in part for their greater durability but also for their sheer novelty. Sivakasi's cheaper calendars are printed on thin, low-grade paper that would tear if simply hung on the wall by a hole in the paper, so small ancillary industries have sprung up to provide "tin mounting," or the addition of thin strips of tin with a string in the middle (known in the north as *pattis*). Additional extras at the upper end of the market are the option to use a *dandi*, a decorative wooden or plastic rod, instead

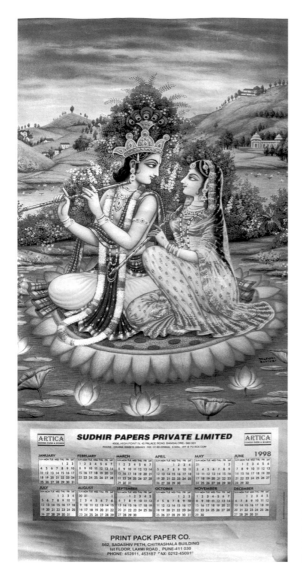

24. "Radha and Krishna" by Yogendra Rastogi, a 1998 calendar for Sudhir Papers Private Ltd., in a neotraditionalist Rajasthani miniature style. (Courtesy of the artist)

of the cheaper *patti*, and a *dabbi*, a cardboard box in which to put the rolled-up calendar. All of these options are for the wall calendars; there are also the more expensive desk calendars, or more "fancy" designs with various types of innovations such as gimmicky ways of marking dates, as well as the increasingly popular, cheaper wallet calendars or "pocket cards" with a picture on one side and the calendar on the other.

Concerning the files themselves, calendar publishers' clients, and their customers in turn, are primarily interested in the "subject" of a calendar and are unconcerned about other issues of provenance. Artists' names, for instance, almost never register in con-

versations between publishers and their clients (although they are crucial to publishers and printers). Accordingly, the classification within the publishers' files is based on subjects, with designs arranged serially in roughly decreasing order of estimated popularity. In the case of the single-sheeter calendar files, the *dharmic* (religious) calendars come first. Roughly 80–85 percent of these depict various Hindu deities and saints, with 5–10 percent based on Muslim themes and the rest catering to a more regionally inflected assortment of other religions and cults (such as that of Sai Baba). So, for instance, through the 1990s Sikh images were the next most numerous category in the north, and Christian images in the south. Some files I saw in 2000–2001 appeared to be assembled to target specific regional markets, again using a mixture of technologies to achieve maximum flexibility. Here different sets of designs (for instance, all the northern deities without the southern ones) are stapled together rather than properly bound, with design numbers manually rubber-stamped beneath them for reference, fronted by a separately printed index page.

The files also carry a range of secular subjects on a variety of themes that have tended to come and go, proving less enduring than the religious images. (This is not to say that there have been no transformations within the religious category: indeed, shifts in canonical iconographic representations are particularly significant, and I will return to these in more detail in chapters 5, 6, and 7.) One of the more lasting secular subjects has been landscapes or "sceneries." The latter English phrase has been so thoroughly absorbed into vernacular discourse that the anthropologist Renaldo Maduro, in his study of artists in the temple complex at Nathdwara (several of whom have also painted for calendars), mistook it for a Hindi word and spelled it *sinriz* (Maduro 1976, 61). The Sivakasi sceneries have predominantly been photographic, depicting foreign rather than Indian landscapes (fig. 25); other popular photographic subjects are flowers and animals. Among the painted subjects that were popular in calendars from the 1960s through to the 1980s but appeared less frequently through the 1990s are "babies" (children, often with mothers), "beauties" (women), "leaders" (statesmen and figures involved in the Indian independence movement, such as Gandhi, Nehru, Indira Gandhi, Chandrashekhar Azad, Bhagat Singh, and so on, again with regional variations) and "*filmi*" (pictures of film stars, which have largely been displaced from calendars to posters and postcards). Similarly, images depicting the soldier and the farmer uniting in defense of an Indian socialist modernity, evoked by Lal Bahadur Shastri's phrase "Jai Jawan, Jai Kisan," were popular from the mid-1960s on through the 1980s but appeared only sporadically

Design No. 564 SPRING SEASON SWITZERLAND

25. *Spring Season Switzerland*, a "scenery" calendar from the 1992 file of
Ideal Products, Sivakasi. The captions for such calendars are not necessarily
accurate about either location or season.

through the 1990s (fig. 26).[22] Even more short-lived was a subgenre prevalent in the 1970s
that depicted women with various modes of transport (usually bicycles, but also buses;
see fig. 27) or other signs of modernity such as consumer goods, street scenes, or living
rooms with televisions.[23]

 According to the publishers I spoke with, most clients are usually fairly clear as to
what subject(s) they want on their calendars. Some order a new design every year depict-
ing the same deity, of whom they might be a particular devotee, so printers are obliged
to provide fresh designs for the same subjects from one year to the next (thus the reli-
ance on so-called "copy masters" or hack artists to make minor modifications to existing
designs; I return to issues of authorship in chapter 4).[24] Others pick an assortment of
subjects according to their perceived appeal to various constituencies. As long as they are
from the same file, clients can choose as many different subjects as they like, in varying

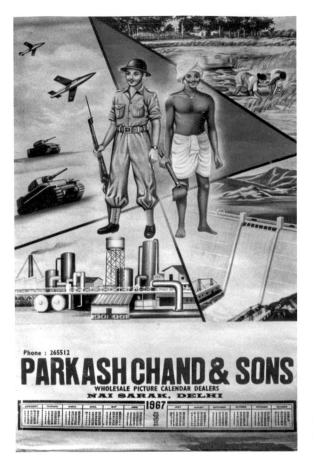

26. "Jai Jawan, Jai Kisan," a 1967 calendar by "R. Arts." (Collection of JPS and Patricia Uberoi, Delhi)

quantities (above a certain minimum), for the same unit price. For instance, a footwear dealer from Madhya Pradesh placing an order with an agent in 1995 was able to specify that he wanted one Muslim and one Hindu "pose" for his calendars. Similarly, the proprietor of a photography studio in Delhi in 2000 and a sari merchant in Lucknow in 2001 could give their customers a choice between a Hindu religious calendar and a secular "scenery" (the "scenery" here comes to do double service, collapsing non-Hindu religiosity into secularism). Similarly, clients might tailor their choices to the various regions where their product is sold: Sikh gurus for Delhi and Punjab, Balaji or Murugan for Tamil Nadu, Ganapati for Maharashtra, Shiva or a *mata* (mother goddess) such as Vaishno Devi for the north.

Artists, printers, distributors, and clients alike spoke of a well-defined regional iconography characterizing preferences in the north, south, east, and west. This does not merely operate at the level of themes, determining which deities (or stars or leaders) are

27. A 1973 calendar by Yogendra Rastogi for New Glass House, Sadar Bazar, Sangrur, Punjab. The calendar is a poignant cross between the genres of women-and-vehicles and women-and-commodities. (Courtesy of the artist; collection of JPS and Patricia Uberoi, Delhi; also included in Fukuoka Asian Art Museum 2000)

favored in a particular region, but also at the level of their iconographic attributes and formal treatment. For instance, deities such as Lakshmi and Shiva are supposedly preferred standing up in the north and seated in the south; the eyes of Shiva and Hanuman are wide open in the south and often half-closed in the north; Ganesh's ears and trunk are longer in the north, while he has a paler face in Bengal; Lakshmi is accompanied by an owl in Bengal and nowhere else; in the north Radha is often portrayed with her garments askew, while in Bengal all goddesses are well covered, to the extent that even their ears are hidden behind their ornaments (fig. 28). These regional distinctions are also mapped onto a discourse of taste: Bengali taste in calendars is considered the most refined, which means that the colors used are softer, tending toward pastel shades; the northern and western markets are seen as preferring lighter colors; while the most intense and contrasting color schemes are used in calendars intended for the south. (For a detailed discussion of color and taste in calendar art, see chapter 4.) Artists develop

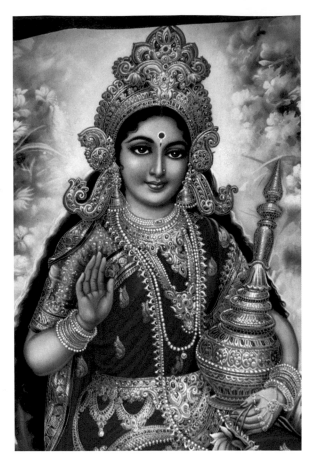

28. A detail from a 1995 calendar by V. V. Sapar for the Bengali market depicting Lakshmi. (Courtesy of the artist)

a thorough knowledge of these iconographic codes, as accuracy in following them is a particularly stringent requirement; most cited this as the main area where they might be asked to make changes before a design is approved to go to press.

This regional conventionalization means that an artist need not necessarily physically inhabit or even culturally identify with the community whose images he or she is producing. In other words it enables the "production of locality" (Appadurai 1995) from dispersed sites, channeled through a centralized system of commodity manufacture: indeed, this is not just the production but the commoditization of locality. Thus Venkatesh Sapar in Sholapur, Maharashtra, creates Durgas and Krishnas that come to represent Bengaliness while Nirmala in Calcutta paints a "northern" Shiva-Parvati (see figs. 28 and 29); and Yogendra Rastogi in Meerut, Uttar Pradesh, figures a south Indian cultural identity through his Lakshmis at the same time as he perpetuates north Indian "tradition" in his miniature-inspired Radha-Krishnas (fig. 24). Similarly, Muslim and Hindu

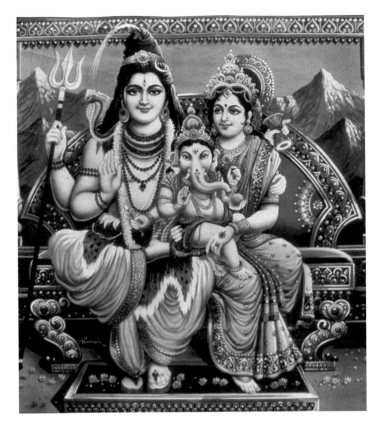

29. A calendar design by Nirmala depicting Shiva, Parvati, and Ganesh. (Smith Poster Archive, Special Collections Research Center, Syracuse University Library)

themes are painted by artists of either religion, and both Muslim and Hindu artists are part of the collaborative process by which many calendar images are made (for instance, most of the paintings signed by Yogendra Rastogi have a major input from his associate Liaqat Ali). This cannot, however, be taken as evidence of a capitalism-led erasure of communal difference, for the participation of Muslim artists in this domain dominated by Hindu imagery has also been characterized by various degrees of "passing." Rastogi's largely collaborative works are not signed by Liaqat Ali, while those well-known Muslim artists who have signed their work, such as H. R. Raja and the late P. Sardar, have adopted names that are not easily identifiable.[25] Significantly, the major exception here is S. S. Shaikh, who predominantly works on landscapes and other secular subjects (see fig. 35 and 36, both later in this chapter).

While certain artists are well known for their depictions of particular themes, most resist typecasting, preferring to attempt the full gamut of designs that printers and publishers require (an arrangement that suits the latter as well). This has meant that in the

30. *Holy Ajmer* by Rastogi Studio, a Muslim calendar from the 1992 file of Ideal Products, Sivakasi.

designs for the centrally mass-produced files, certain types of highly elaborated image-making practices can give way to the more generic visual idioms deployed by calendar artists. For example, the Muslim calendars for the "English market" deploy a more or less similar idiom to that of the Hindu god-pictures, usually with holy shrines such as Ajmer Sharif or Mecca and Medina taking the place of the iconic figure, surrounded with decorative candles, roses, angels, and typography (fig. 30), or occasionally featuring human figures (usually women or children at prayer). These designs, created by artists and studios that regularly supply paintings to the Sivakasi printers, are in marked contrast to the Muslim calendars produced locally in cities such as Aligarh, Mumbai, or Delhi, which place a much greater emphasis on the decorative use of calligraphy—as might be expected from artists well versed in the Perso-Arabic script and its use within anti-figurative traditions (fig. 31). However, Muslim framing pictures, such as the ones produced in Sivakasi for the Delhi publishers S. S. Brijbasi and Sons, also display a richer range of designs and subjects than the "ready-made" calendars, catering as they do to a slower moving market where the emphasis is less on novelty-within-familiarity than on

31. Specialized Muslim calendars on sale around the Jama Masjid, Delhi, 1992. The picture area is much smaller than in the typical Sivakasi ready-made calendars, and typography dominates.

continuing ritual significance (fig. 32). Apart from their highly elaborated use of calligraphy, these prints on Muslim themes often achieve their visual intensity through the important symbolic element of light (*noor*), which suffuses the images in the form of rays, sparkles, highlights, and glowing gems.

In general, framing pictures tend to be used more within relatively formal religious contexts than calendars: they are often bought at pilgrimage sites or on ritual occasions and then instated in domestic prayer rooms or workplace shrines. To the extent that framing pictures are generally religious or secular icons, they exhibit both a greater iconographic conventionality and a richer, more locally inflected range of subjects and formal treatments than the ephemeral, annually produced calendars.[26] If the Muslim framing pictures in northern India are one example of such specificity, another striking instance is the work produced in the south by the Madras artist known as "Silpi" (P. M. Srinivasan, from a lineage of *sthapati* icon sculptors) and his followers in the 1960s and 1970s, who developed a distinctive style of rendering specific *in situ* temple icons in illusionist detail, replete with their liturgical accoutrements (H. D. Smith 1988, 56–57; see also fig. 33). The indexical medium of photography is a frequent choice for such highly localized icons. Since the widespread introduction of computerized processing labs for color

32. A "framing picture" print aimed at the Muslim market, produced by S. S. Brijbasi and Sons, on sale in 2000. (Courtesy of Brijbasi Art Press Ltd.) Here the name of the Prophet floats above the Dome of the Prophet at Medina; the dove's note reads "Muhammad Kamli Wale" (the one with the blanket).

photographs in the late 1980s, mounted and laminated photographic prints of shrines have become a cost-effective solution for souvenirs at smaller pilgrimage spots, where print runs would be too low to justify offset printing. These are often sold alongside mass-produced prints depicting the major deities from the Hindu pantheon. One instance of this situation is the *baithaka*, or seat, of the Bundela folk hero Lala Hardaul at Orchha, where photographs of a recently installed statue of Hardaul were being sold in 1998 along with other bazaar prints.

The Sivakasi calendar trade is sometimes able to cater to smaller cults within the Hindu fold by drawing on such locally produced framing pictures. For example, in 1995 a solvent manufacturer in Dhuri (Punjab), a keen devotee of Mansa Devi (whose shrine is near Chandigarh), wanted a calendar depicting the goddess although it didn't exist in the agents' files; the agents were able to get hold of a local "photo" (framing picture) of Mansa Devi and organize its conversion into a calendar through the Delhi publishers with whom they have regular dealings. Conversely, religious designs that have done well as calendars or are seen as having staying power might be produced in Sivakasi and elsewhere as framing pictures, posters, or postcards, as with some of the spin-off imagery from the televised *Ramayan* and propaganda for the Ramjanmabhumi movement (fig. 34).[27]

ಶ್ರೀ ಗಣಪತಿ ದೇವರು ನೆಂಪು ದ.ಕ.

33. A "framing picture" of a Ganesh icon created using a combination of photography and painting.

While the formal aspects of framing pictures are closely tied in with their ritual contexts, and those of the single-sheet "ready-made" calendars are characterized by a certain iconographic conventionalism, the up-market four-, six- and twelve-sheeters (often simply referred to as "sheeters") are somewhat more diverse both in their subject matter and their treatment. Aimed at a higher "level" of customer (though not those who work through advertising agencies), these files have tended to carry a wider range of secular subjects, the assumption here being that wealthier, better-educated customers are less likely to prefer religious icons. "Sheeters" often use the cultural-geographical space of the nation or the temporal divisions of seasons or months as "natural" divisions: "Festivals of India," "Brides," "Village India," "Four Seasons," "Temples," "Ancient Entertainment" (fig. 35). Most calendar artists prefer working for the "sheeters," or, better still, for "special parties," that is, creating custom-made calendars for the larger companies, both of which are better paid and allow for greater creative input and a self-reflexive experimentation with styles.[28] This is particularly evident in the work of Venkatesh Sapar from

अयोध्या राम - 739

S. S. BRIJBASI & SONS
32/1, FATEHPURI DELHI-6.

34. *Ayodhya Ram*, a framing picture in the 1995 stocks of S. S. Brijbasi and Sons, Delhi, portraying the god-king Ram in a martial posture against the background of the projected temple at the site of the Babri mosque in Ayodhya. (Courtesy of Brijbasi Art Press Ltd.)

Sholapur, the art-school-trained young star of the calendar industry in the mid-1990s, who appeared to seize every opportunity to try out new approaches: what he called "modernization" in his 1996 *Folk Dancers* (see fig. 82) and *Om Ganesh* (see fig. 22), or a replication of the style of nineteenth-century colonial lithographs in his *Ancient India* series (see fig. 155). Another arena for formal experimentation and testing of new designs is provided by wedding and greeting cards (particularly Diwali cards), where the demand for novelty often outweighs considerations of expense, allowing for a greater degree of creative risk taking than with the calendars.[29] The subject matter of these cards often hinges around depictions of the elephant-headed Ganesh, who as Vighneshwara, the Remover of Obstacles, is the increasingly popular god of beginnings. It is not inappropriate, then, that images of Ganesh have become privileged sites for "modern" styles in the calendars as well (as in the case of Sapar's *Om Ganesh*), perhaps because Ganesh's animal form and humorous or informal status have lent themselves to unconventional

The crowds have come to witness a brave spectacle of two cocks fighting. With daggered claws, without a pause, they fight because they are so trained. It would appear that nothing in the whole wide world is more exciting. They rip each other without ruth until with blood their wings are stained.

JANUARY							1981	FEBRUARY						
SUN	MON	TUE	WED	THU	FRI	SAT		SUN	MON	TUE	WED	THU	FRI	SAT
				1	2	3		1	2	3	4	5	6	7
4	5	6	7	8	9	10		8	9	10	11	12	13	14
11	12	13	14	15	16	17		15	16	17	18	19	20	21
18	19	20	21	22	23	24		22	23	24	25	26	27	28
25	26	27	28	29	30	31								

JSI INDIA

JAYA SHREE INSULATORS
Works: RISHRA-712248 (West Bengal)
& HALOL-389350 (Gujarat)

35. *Ancient Entertainment* by S. S. Shaikh, a six-sheeter calendar for 1991 depicting "traditional" games. (Courtesy of the artist)

and proliferating interpretations, and because of the association of new beginnings with formal novelty.

VERNACULAR, ENGLISH, NATIONAL

Calendars have been used as a form of publicity by an enormous range of businesses and other types of institutions in India, from Vohra Furniture House in Delhi to Everest Homeo Laboratory in Calcutta and Balasore (Orissa); from Deepak Sewing Machines and Parts in Dhuri (Punjab) to Madresa Islahul Muslemeen and Darul Yatama (a school and orphanage in Raipur, Madhya Pradesh); from Bharat Heavy Electricals Limited to Japan Airlines. Not all of these companies' calendars have been produced in Sivakasi, however. The more upmarket calendars (like the renowned series for Air India) are increasingly produced by advertising agencies and processed through "quality" presses in the metropolises.[30] With the development of Indian-owned industries under the Nehru

government's Soviet-inspired first and second Five-Year Plans, and the attendant growth of Indian advertising, there appears to have been a divergence between the cosmopolitan, primarily English-speaking corporate culture of advertising agencies or in-house publicity departments dealing primarily in mass media such as the press and cinema, on the one hand, and the "vernacular" arena of printers, publishers, and their agents dealing in posters and calendars on the other. This divergence between corporate advertising and calendar art as forms of commercial imagery is not just a matter of the different types of publicity required in relation to the types of goods produced or the consumer segments being addressed; it also has to do with the types of firms involved, their corporate cultures, and commercial and institutional relationships that hinge on differing notions of "publicity" and the "public."

During the colonial period British "managing agencies" or firms such as Woodwards and Mellins penetrated the Indian market by using mythological themes in their posters, calendars, and labels. After independence some majority Indian shareholding multinationals continued with this strategy, as did indigenous manufacturers of goods intended for a broad base of "vernacular" consumers, both urban and rural: confectionery, matches, textiles, incense, *beedies*, flour, soap, toothpowder, tobacco, cosmetics, hair oil, tonics, and medicaments. (I discuss these advertising and packaging strategies further in chapter 3.) However, the corporate advertising agencies servicing Indian businesses in the post-independence era have had little use for calendar artists' skills. Most of the press, billboard, and television advertisements that I remember seeing while growing up in Delhi as a speaker of English and Hindi in the period just before liberalization were for brands produced not so much by local family businesses but by state or cooperative concerns, such as Amul Butter and Modern Bread, or, more often, by transnational firms: Britannia (ABI/Nabisco), Vicks (Richardson Hindustan), Horlicks (Beecham India), Lux, Lifebuoy, Liril, Pears and Surf (Hindustan Lever), Nescafe (Food Specialties Ltd./Nestle), Cherry Blossom (Reckitt and Colman) — and of course, Bournvita (Cadbury's India), the sponsor of the English-language Bournvita Quiz Contest on the radio, a beloved Sunday ritual for the Indian technocracy-to-be.[31] While some of these were in-house campaigns, others were produced by advertising agencies, several of which were also linked to multinational firms such as J. Walter Thompson or Ogilvy and Mather.

These multinationally linked manufacturers and advertising agencies have broadly followed the formal structures of their affiliates or models in Britain and the United

States, instituting pockets of "organized" capitalism in the metropolises, with salaried professionals operating within an English-speaking—or, more to the point, English-educated (Viswanathan 1989)—managerial ethos. In contrast, unlike the corporate firms of organized capitalism, "disorganized" systems such as the Sivakasi calendar industry have revolved around mobile agents or traders working on commission, home-based artists or ancillary providers, and family businesses with distinct patterns of management, consolidation, and expansion. Typically, family businesses have not separated ownership from control, at least in the first few generations while consolidating their capital and assets within kin and, in the Indian context, caste or *jati* networks. (On the importance of such networks, see Bayly 1983; Rudner 1994; Templeman 1996.)[32] As with the Nadars of Sivakasi, the majority of Indian family businesses amassed their capital through trade, and to this extent they have tended to retain certain elements of the colonially mediated trading ethos that historians and anthropologists have delineated as the "bazaar" (Bayly 1983; R. Ray 1984, 1993; A. Yang 1998). I shall develop this assertion in chapter 5, but for the moment I want to signal four aspects of the bazaar ethos that I suggest are catered to and perpetuated by the calendar industry: (1) its mediation between formal and informal economies; (2) its maintenance of an extensive network of personalized, reciprocal relationships through a gift economy; (3) its explicitly religious or communitarian affiliations (hence the division of the calendar files into predominantly religious categories); and (4) its ability to work *both with and across* communitarian, regional, and linguistic differences to inscribe an extensive web of circulation.

The different types of commercial ethos, modes of production, and distribution and forms of address of calendar art and agency advertising have worked in various registers to make available—indeed, to create—different ways of participating in capitalist modernity. This is not to say that these varying forms of participation necessarily pertain to distinct constituencies of people. The recipients of calendars (say, a government school principal in Coimbatore, a chartered accountant in Nasik, and an auto service station owner in Gauhati) are also very likely to be readers of magazines and newspapers carrying corporate advertising—even though, as I discuss in chapter 4, publishers and artists I spoke with often referred to the audience for calendar art as "illiterate." Similarly, several firms (such as Parle [biscuits and confectionery], Mafatlal [textiles], Dabur [ayurvedic products], and the Bangur family companies) have deployed both calendars or posters on mythological themes and the range of media provided by advertising agencies. These different modes of address, however, reflect and reinscribe the power relations

between different aspects of postcolonial subjectivity, in particular through the ways in which language—English vis-à-vis the vernaculars—maps onto the spaces and forms of pan-national publicness.

After independence and at least up until the economic liberalization of the 1990s the key personnel of advertising agencies based in the metropolises have been drawn from an English-educated Indian elite. Referring in particular to its self-representation through the English-language press, Arvind Rajagopal has described how this avowedly secular, technocratic elite constituted itself as the vanguard of modernity in post-independence India, as against the more fragmented vernacular constituencies marked by linguistic, religious, and regional cultural differences (A. Rajagopal 2001, 158–60). Here again, though, I would caution against mapping what Rajagopal calls a "split public" onto discrete constituencies; instead I suggest that the term is best used to describe the different registers of performance available to individual subjects, albeit with varying degrees of access. In the context of claims over a pan-national public sphere, "English-speaking" as a primarily linguistic category articulates with a broader set of attitudes and modes of social performance, where vernacularity is consigned to the realm of the private and the particular. A prerequisite for the public performance of English-medium modernity has been a certain level and type of education, and an attendant range of cultural references and social connections. These prerequisites depend in turn on factors such as wealth, social capital, caste privilege, and location (metropolitan as opposed to rural or provincial) without being reducible to any one of these.

Until the post-liberalization marketplace began to exert pressure on the industry to remedy the situation, advertising agencies by and large addressed an audience comprised of people like themselves, with similar aspirations to being not just economically middle class but "English-speaking" in this broader cosmopolitan sense.[33] Most male advertising professionals I know leave their vernacular selves at home when they go to work, along with their hair oil and their *lungis* or pajamas. But often the reverse is true for the younger printers, publishers, and artists in the calendar industry, although they are often fluent in English and several have traveled overseas. In the calendar industry, business interactions have not typically been conducted in the lingua franca of English but in combinations of Hindi and the regional vernaculars: Tamil, Punjabi, Marathi, Bangla. Many of the key personnel in this industry have either been non-English speakers or work closely with them, and (unlike other mass media professionals) are linked to their "end-users," mostly imagined as "vernacular," by less than five or six *direct, interpersonal* degrees of separation (along the chain artist-printer-publisher-agent-manufacturer-trader-consumer).

A calendar arrives in the mail, or is offered to a customer, rolled up: it is first a thing, a gift given by a company to a particular individual, and then it is an image offered up to a more generalized gaze. Advertisements mediated through the press, radio, television, and billboards, in contrast, address a relatively anonymous aggregate of consuming individuals: the "public." To the extent that English-speaking advertisers working through the mass media identified this public collectivity with a modernizing nation, they took on the ethical burden of enforcing state-sponsored secularism. One of the most significant differences between the modes of address of agency advertising and those of calendar art has therefore hinged on the use of religious imagery. Unlike colonial advertisers who deployed a range of religious imagery to target vernacular consumers, post-independence corporations and agencies took it upon themselves to stake the "native" claim to modernity through their enactment of a secular, pan-national, nonvernacular Indian subjectivity.[34] So in contrast to the explicit and finely differentiated religious and communitarian address of calendar prints, post-independence corporate advertising has largely been subject to a secular-modernist taboo according to which sacred icons cannot be deployed in the public sphere—or at least not in their ritual modality. That is, while religious imagery might appear as a signifier of "tradition" or "culture," it does not directly partake of the sacred aura of the gods in the frontal, iconic manner of bazaar images, which are often actually used in worship. (I discuss this moral-aesthetic taboo in greater detail in chapters 4 and 5.)

While the modernist Nehruvian technocracy eschewed the public deployment of religion, traders and small manufacturers emanating from the ethos of the "bazaar" have been strongly associated with pre-independence and post-liberalization Hindu nationalism, comprising the core constituency of parties such as the Bharatiya Janata Party (BJP) and its predecessors the Jan Sangh and Hindu Mahasabha. I will have more to say about Hindu nationalism's mobilization of calendar art to forge a modern and pan-national but vernacular and nonsecular public sphere; it is in this context that I will revisit the figure of Raja Ravi Varma as calendar art's mythic origin. But I want to conclude this discussion of calendar art's networks by foregrounding an aspect of "vernacular" commerce that is not entirely assimilable to transcendent ideas of nation based on an essential commonality or even territoriality. This aspect is its ability to work both *with* and *across* religious, communitarian, and linguistic differences. This ability cannot be read from the individual images themselves but only emerges through attention to their contexts of production and distribution. Thus even if certain bazaar images propagate the Nehruvian slogan of "unity in diversity," and others appeal to an explicit Hindutva (literally, "Hindu-ness,"

a term associated with Hindu nationalism), the successions of designs in the calendar printers' ready-made catalogues also demonstrate that the industry has thrived on the commodification of cultural difference.

While Hindu nationalism has sought to reduce vernacular diversity to a primordial Hindu commonality, the accommodation of locally and regionally inflected consumer preferences by the "English market" demonstrates that the arena of the vernacular(s) cannot be reduced to a singular common essence. Nehruvian secularism, in contrast, has effectively held that vernacular idioms are too local, "private," and specific to represent a pan-national public arena. (I return to the question of private and public religiosity in chapter 4.) But as we have seen, in the calendar industry the vernaculars have not been mutually insulated but have been talking to each other; they have not been spatially confined but form pan-national and indeed transnational networks. As we will see in the following chapter, these images have from their very inception had a breathtakingly wide territorial ambit, even though their wide circulation has not necessarily meant a unified or homogeneous address. So the idea that media aimed at vernacular audiences have a restricted sphere of production and circulation is perhaps more pertinent to the language- and text-based print media of books and newspapers than to image-based print media such as calendar art and illustrated magazines.[35]

In other words, then, in its image-based avatar, print capitalism, like other forms of commodity manufacture, is not just about one *imagined* community called the nation (Anderson 1991); it can also be about many *enacted* communities and their *intervernacular* interactions. The extensive trade networks inscribed by calendar art's mobile-yet-vernacular arena engender experiences of the nation-space that are not necessarily processed through the overarching ideational and affective registers of nationalism, whether those of a secular-modernist, English-medium public sphere or a vernacular Hindutva. The "English market" operates in an immanent, corporeal register that is connected in parallel, as it were, with transcendent nationalist imaginings and expressions, even as the nation-state institutes an enabling matrix for this transactional realm. This is a register of pragmatic performance and sensory-kinesthetic apprehension of the nation-space as commodities and people move, or are sent and received, across or beyond its semi-permeable membranes. These movements inscribe a systematicity that is partly organized and partly informal, unfolding across an interstitial web of trains, timetables, and booking offices; banks, post offices, and money orders; buses, trucks, potholes, and traffic jams; STD booths (for long-distance phone calls and faxes) and cell phones; hotels and lodges; eating places and tea and liquor shops; *paan* (betel-leaf) and cigarette stalls.

36. A plastic tray with a "foreign subject" by S. S. Shaikh, intended as a corporate gift, Bombay, 1994. By the mid-1990s such objects were increasingly replacing calendars as corporate gifts. (Courtesy of the artist)

Here the mediating physical and conceptual infrastructure of the nation-state, with its orderings of identity via the centralized abstractions of "census, map, museum" (Anderson 1991, 163–85), is supplemented by the parallel taxonomies of the market and by its ongoing translocal circuitry. Take, for instance, the way the various types of public eating places in a town like Sivakasi become arenas for the performance of class, caste, region, ethnicity, and gender: Nadar, Udupi Brahmin, Marwari, generic north-Indian-and-Chinese, with separate vegetarian and nonvegetarian sections, air-conditioned and non-air-conditioned (with prices to match), with and without "family" booths (for ladies). But even as public dining reinscribes certain social distinctions, there is also a distinct set of affects, neither "local" nor nationalist, that characterizes this zone in its interstitiality: the peculiar intensity of conversations with strangers, the relief at the relative respite from the gaze of family and community, the pleasure of a Sivakasi printer in being able to sleep in the no-place of a train for thirty-six hours all the way to Delhi, the security of a Bihari agent for a Bengali publisher in knowing he will find Marwari food in Sivakasi, the curiosities, fascinations, anxieties, and discomforts attendant on encounters with difference — in my own case, attendant on being utterly out of place in this relentlessly male and socially unfamiliar arena of trade-driven comings and goings.

Over the 1990s, as an increasing number of Indian businesses began to effect a tran-

37. A 2001 calendar for Esdee Paints Ltd., Mumbai, featuring a recycled painting of Lakshmi superimposed on a photographic background. Such recycling and interchanging of foregrounds and backgrounds, enabled by the adoption of computer technology, was prevalent by the late 1990s, indexing the reluctance of calendar printers to invest in new designs.

sition to a post-liberalization corporate culture, either merging with or attempting to compete with multinationals, advertising budgets were pushed up and the agencies came into their own. Even within the calendar market, the demand for better quality products available from local presses seems to have rendered the Sivakasi industry's lower-end "English market" unsustainable (figs. 36 and 37). However, this has not spelled the disappearance of a vernacular arena; on the contrary, the mutations in the culture industry have given it an even stronger voice — or rather, as many voices as there are major regional languages (fig. 38). With the proliferation of satellite television channels over the 1990s, advertising agencies have been increasingly forced to reckon with the vernacularity of consumers and manufacturers and with their claims to a modernist technocracy. In 2001 there were forty-four regional-language television channels, not including Hindi, catering to viewers not just nation-wide but, again, all over the global South Asian diaspora. The television-led targeting of vernacular consumers has reinvigorated the regional-

38. A page from the 1996 English edition of the *Kalnirnay Utility Calmanac*. In 2006, Kalnirnay appeared in English (Indian and United States-United Kingdom editions), Marathi, Gujarati, Hindi, Tamil, Telugu, and Kannada. It also had a website providing astrological forecasts and details of religious observances for various communities, as with the early block-printed calendars; its "USA Panchang" covered San Francisco, New York, and Chicago. (Courtesy of Jayraj Salgaokar, Sumangal Press: "Sumangal" means "auspicious.")

language press, as well as spurring the development of regional-language Internet sites and software (a *Business Today* report has even provided us with the hip diminutive "vern sites": Ramalingam 2001). Advertising agencies have been scrambling to adapt a transnational consumer culture to vernacular idioms, both verbal and visual, and to easily recognizable markers of regional or linguistic identity: in other words, taking over and intensifying the process of the commodification of difference begun by the calendar industry (a process I shall describe further in the conclusion). Precisely how the ethos of a global corporate culture and the constraints of transnational manufacture and circulation will affect this process, and to what extent that culture might itself be undergoing a process of vernacularization with respect to its modes of production and distribution, are issues that demand further critical examination.

In this chapter I have described the post-independence calendar industry as a space of vernacular commerce whose finely differentiated pan-national circulation problema-

tizes the secular-modernist terms of an address to a national "public." In this light, the calendar industry's own descriptor for its network, the "English market," emerges as both paradoxical and revealing. It is paradoxical because the production, distribution, and consumption of bazaar images is a largely vernacular enterprise. But it is also revealing because there seems to be no other means available to describe such an arena of mobile, wide-ranging, and nonlocal modernity than in terms of the colonial language, English. "English market" becomes a cipher for one of the constitutive repressions of secular-modernist nationalism: that is, the disavowed privileging of English and Englishness as the effective modality of the pan-national. At the same time, the "English market" embodies a parallel arena of pan-national practices that is neither secular nor, in fact, English-based. It would be a mistake to overstate the hegemony of this secular, technocratic Englishness in the context of larger processes of nationalism and nation building. The following two chapters examine some of the ways in which calendar art came to connect with a range of nationalisms and other identity formations, popular and elite, secular and sacred, explicit and implicit. In doing so, they also trace the various ways in which bazaar images have come to look the way they do.

2

WHEN THE GODS GO TO MARKET

Bazaar, ganj, katra, mandi, nakha; chauk, dukan, kothi; gali, kucha, dariba, sarak. All of these words have been used to designate the physical spaces of the markets of Old Delhi, or what used to be Shahjahanabad: trading areas of various sizes and levels of permanence; squares, shops, firms; alleys, lanes, streets. Most of Delhi's calendar and picture publishers are clustered in this bazaar area, all within a couple of miles of each other along the busy thoroughfares of Chandni Chowk and Nai Sarak: Bharat Picture Publications, S. S. Brijbasi and Sons, Calendar Manufacturers Pvt. Ltd., Hem Chander Bhargava, Kawality [sic], Khurana, Mahalakshmi, Subhash, Sunshine (to name a few). Their shops are often barely visible amid the tumult of signboards, people, traffic, and all manner of wares being traded in the biggest wholesale market in the country, from grains and spices to books and stationery, from pearls

and sitars to pharmaceuticals, from kites and masks to bicycles and stethoscopes. Consignments of goods—such as calendars and prints—arrive at the publishers' offices in trucks or motorcycle-driven "tempos" and are then disseminated to retail outlets in varying quantities, piled up in autorickshaws, stacked on the backs of scooters or bicycles, or simply carried, in a bag, on the head, in the hand. The bazaar's cacophony of merchandise, its sensory intensity, and this kind of small but in both senses high-volume traffic, crammed into the narrow streets of the old city, continue to provide tourists with the *frisson* of a chaotic immersion in the exotic: an expectation built up by Orientalist descriptions of the "native quarter," from the dispatches of Rudyard Kipling or Lovat Fraser, to Hollywood films such as *Indiana Jones and the Temple of Doom* or *Octopussy*, to the six separate websites that all (presumably except for one) plagiarize the same passages extolling Chandni Chowk's "mixture of splendor and squalor."

THE ANIMATION OF THE BAZAAR

But the bazaar is more than a place: it can also be seen as a node of convergence in space and time. On the one hand it is a cyclically repeated event—like the daily tumult of activity in Old Delhi, steadily building until noon and (depending on the time of year) dying down only late at night. On the other hand it is a web of relationships extending beyond and between individual sites, like the network described in the previous chapter linking printers, publishers, agents, artists, and consumers in the calendar industry. These wider connotations are embedded in some of the place-related terms listed above. Take the word *kothi*, for instance: it means a mansion or residence, but it also connotes a major banking "house" in the bazaar network, such that a mercantile firm might expand its operations by instituting a new *kothi* or branch of the family (and the business) in another city. Similarly, if the physical spaces and sensations of the bazaar have fed a romantic imaginary emanating from the colonial encounter, the bazaar also appeared in official colonial reports as a more technical descriptor for the "indigenous" sector of the colonial economy, its "informal" money markets and trading systems forming a continuum between "native" banking, trading, and money-lending communities, peasants and artisans (Ray 1992, 11–12).

Up until a series of critical reevaluations by historians of South Asia from the 1980s onward (Bayly 1983; Perlin 1983; R. Ray 1984, 1992; Subrahmanyam and Bayly 1990; A. Yang 1998; Markovits 2000) accounts of this indigenous "sector" were dominated by the notion of a "traditional India" primarily located in self-sufficient, isolated, unchang-

ing, rigidly caste-bound village communities (see A. Yang 1998, 5–14). As the more recent scholarship convincingly demonstrates, in their exclusive focus on the realm of production these idealizing accounts overlooked a vital, dynamic, and sophisticated arena of mercantile exchange, characterized by an unacknowledged degree of mobility for people, goods, money, and credit instruments.[1] In the revised schema, then, the bazaar during the colonial period is no longer a uniform and essentially static "indigenous" arena in a dual economy. Instead it emerges as a social formation and credit complex both distinct from and forming a crucial interface with the colonial administration, managing agencies, and foreign trade on the one hand, and the agrarian subsistence economy of peasants, artisans, and petty money-lenders on the other (Ray 1992, 10–18).

Trading networks run by *mahajans* (merchants) and *arhatiyas* (commission agents), intersecting with an extensive, well-integrated banking and credit complex based on *hundi*s (promissory notes or credit instruments) and run by *kothiwals* (bankers) and *shroffs* (money-changers or money-lenders able to trade on *hundi*s) have existed since at least the seventeenth century.[2] Participating at different times in global trade extending in every direction—across the Himalayas to Afghanistan, Persia, China, and Central Asia, south and east to Ceylon, Burma, Siam, the Malay Peninsula, and Java, and west to the Arabian Peninsula, Mozambique, Zanzibar, East Africa, and, of course, Europe—by the mid-nineteenth century the *hundi* network was "pressed by the imperial regime" into a "fragment" of the earlier system, largely confined to the inland trade feeding into the railway lines between Bombay and Calcutta (Ray 1992, 13). Bazaar merchants and money-lenders linked foreign traders and then colonial industrialists to the pools of credit available in the inland markets, financing private European traders from the late seventeenth century to the late eighteenth and then the East India Company itself (Subrahmanyam and Bayly 1990, 262–63). With the establishment of colonial "managing agencies" in the port cities of Calcutta, Bombay, and Madras from the 1830s onward, the privileged access of the bazaar communities to inland markets meant that the more mobile among them were able to position themselves as indispensable brokers and guarantors (known as *banians*, *dubashes*, or guarantee brokers) for export produce supplied by inland merchants.[3] Among the communities migrating to Bombay and Calcutta over the nineteenth century to take advantage of this colonial trade configuration were the Aggarwals, Marwaris, and Jains from the "Bania heartland" (Gujarat, Rajasthan, Bundelkhand, Delhi, and the Hindi-speaking upper Gangetic region); the Khatris and Aroras from Punjab; and the Bhatias, Lohanas or Multanis, Parsis, Bohras, Memons, and Khojas from Kuchh,

Gujarat, and Sind (R. Ray 1984, 244). Multanis in particular also moved to the south, forming a network with the Nattukottai Chettiars of Chettinad (in the Madras Presidency), which extended to southeast Asia and had its headquarters in Rangoon; Marwari Jains also moved to the interiors of Hyderabad and the Madras Presidency (R. Ray 1984, 254–57).

I spell out these migrations to provide a sense of the personnel and contours of an intervernacular, pan-Indian commercial arena, both configuring and configured by the colonial economy yet at the same time occupying a distinct space within it. As indigenous capitalist manufacturing started to emerge, it sat at the interface between the "official" colonial economy and the "informal" networks of the bazaar. While the Parsis on the west coast, and then some members of the Bengali aristocracy in the east, conducted early forays into industry in close social and economic contact with British firms, from the late nineteenth century onward Indian entrepreneurs and industrial capitalists began to emerge from the trading and banking communities of the bazaar (R. Ray 1992). All the accounts characterize these entrepreneurs as socially and culturally conservative, their success dependent on the maintenance of kin, caste, religious, and commercial networks (see in particular Rudner 1994). This arena of Indian entrepreneurship, articulating to different degrees with the "formal" economy, was an important context for the emergence of cultural forms of varying "degrees of vernacularity" (see the introduction). In this chapter and the following I examine how the financing, production, distribution, and consumption of images maps onto the narrative of mobility and entrepreneurship in this varyingly vernacular arena. It is seldom acknowledged that culture industries were among the earliest forms of domestic manufacture in India: a "print capitalism" producing both texts and images (Anderson 1991). These culture industries, as well as an emergent commodity aesthetics, became interrelated sites for the formulation and enactment of national, regional, and religious or communal identities. It is through this optic that I identify some of the diverse image-making practices and artists that came to inform the post-independence calendar art network centered on Sivakasi.

One of my concerns here is to discern historical and generic distinctions within what has sometimes been seen as an undifferentiated realm of "the popular." Attending to the bazaar as a subordinate yet distinct, even semi-autonomous context of image production and circulation sheds light on the variously selective appropriation of Western image-making technologies by Indian artists working for local markets. These technologies include perspectival space and the proscenium stage, modeling, foreshortening, sfumato, anatomy, landscape, oil painting, glass painting (via China), photography, printing, the

museum, cinema, television, and digital technologies. They have in turn been associated with particular ways of seeing or relating to images, aligned to particular complexes of subjectivity, knowledge, and power, commonly recognized in Western contexts through shorthand terms such as Renaissance humanism, Cartesian perspectivalism, bourgeois realism, the clinical gaze, surveillance, spectacle, *flânerie*, distraction, absorption, theatricality, and so on. I hope to show how the relationship of Indian artists to the ideologies associated with the development and use of these techniques in Western contexts ranged at different moments and in different registers between disengagement, "contestation, alliance and miscegenation" (Chakrabarty 2000, 35).

Attending to the arena of image production also helps us to see how a similarly selective interface characterized the practice of capitalism as it developed in the bazaar. I begin this chapter by tracing how some of the deterritorializing movements set in train by colonial trade, conquest, and missionary activity configured the bazaar as an arena for producing and circulating images, and how this registered in the images themselves (here deterritorialization refers both to spatial movement and to the reconfiguration of social, symbolic, and political-economic formations).[4] I then describe the reterritorializing movement whereby images were harnessed toward defining or actualizing a proto-nationalist, vernacular, "cultural" domain in the colonial period up until the 1920s. This domain of image circulation was in part overdetermined by its emergence within the context of a colonial discourse of cultural and national authenticity, both in its primarily "spiritual" basis and "classical" content, as well as in its very confinement to a "cultural" domain. For colonialism did not simply mix together preexisting "cultures," "races," "civilizations," or "culturally" equivalent arenas of practice: commerce, religion, art, society, politics; painting, photography, printing. It actively *produced* these categories, and—more to the point—the distinctions between them in the discursive terms of the dominant party. Many of the practices of image making encompassed within this account could ostensibly be described as "hybrid," not just in terms of their mixing of formal strategies and techniques ("Western" and "precolonial" or "Indian") but also in terms of their crossing of the boundaries between media and between arenas of patronage and artistic practice. Unfortunately the biologistic connotations of this term have tended to blunt its deployments, losing much of the nuance of Homi Bhabha's formulations (Bhabha 1994). Again the danger is one of presupposing (and thereby performatively reinscribing) a conceptual schema in which the categories being "mixed" in a hybrid relation are seen as distinct, self-consistent, and mutually opposed, *even as* they are thrown into question (indeed, in order to throw them into question). In other words, there is

a risk of seeing these categories as equivalent within an overarching universal schema rather than as radically different. What I would want to hold on to is a sense of the incommensurabilities between the categories being thought together in a "hybrid" relation, and the recognition that these categories are not preexisting but are produced *retroactively* through an encounter marked by power relations.

If categories such as "Western" and "Indian" or "photography," "painting," and "printing" came to acquire a certain epistemic force and ideological currency, this occurred through active, ongoing, performative work—conducted, for instance, through the art schools, the "fine art" system, and Orientalist scholarship. So how did this ideological work fare in its interface with image production in the bazaar? On the one hand, the "cultural" domain inscribed through the address to new consuming publics became a site for the formulation of national, regional, religious, and other community identities. Here both technical mass reproduction and "fine art" functioned as culture industries that manufactured not only cultural products but also the very category of culture itself. On the other hand, as objects circulating in the bazaar, commercially mass-produced images also spoke in other registers to practices and ways of being that variously refused, adopted, and expropriated the colonialist ideological accoutrements of specific image-making techniques, particularly the problematics of authenticity, representation, and cultural identity associated with naturalism or "realism." In the process, both colonially instituted and "vernacular" practices of image making and commerce were transformed under the sign of a modernity marked by colonial power relations. I trace some of these transmutations by revisiting the artist Raja Ravi Varma, whose attempt to forge an Indian national identity through visual strategies both formed within and subverting colonial aesthetic terms has been rehabilitated as a key moment in the genealogy of Indian modernism. Here I recontextualize Varma's pictorial enterprise in terms of its articulation with the late-nineteenth-century bazaar, placing together Varma's "paternity" of Indian modernism and of Indian calendar art: a conjunction that was both enabled by and further enabled the animation of the bazaar.

IMAGES, ARTISTS, AND PATRONS IN
AN ERA OF DETERRITORIALIZATION

The available art historical accounts suggest that patronage for image making in late precolonial India was largely confined to temples and courts and to the seasonal artisanal production of festive and votive images. This was supplemented in the urban centers by

the commissioning of images by merchants and professionals, either for meditation and worship in domestic shrines or in order to accrue religious merit, as with the Jain practice of commissioning books that were then donated to *bhandaras* (libraries) in temples and monasteries (Rossi 1998, 148–50). Barbara Rossi also enumerates a variety of mid- to late seventeenth-century forms produced by artists in the court centers for sale to a wider clientele, often in bazaars, or by village artisans emulating court traditions: she terms these "Bazaar Mughal," "Popular Mughal," and "folkish miniatures" (Rossi 1998, 166–68). Images were—and indeed still are—also often produced by or for communities deploying them in a variety of professional contexts: priests, astrologers, and fortune-tellers using almanacs, horoscopes, and fortune-telling cards; healers and ascetics using sacred diagrams; itinerant storytellers using narrative scrolls. The creation and expansion of markets for pictures beyond these contexts of production and patronage maps onto the period of colonial trade and territorial infiltration from around the mid-eighteenth century. This period was characterized by political instability and the uncertainty of court patronage for artists, as well as the simultaneous rise in importance of the trading communities of the bazaar as intermediaries in colonial trade. As with other forms of commerce, the expansion of the market in images was aided by the development of pan- and transnational travel links under the colonial regime. This changing scenario witnessed the increased physical mobility of artists, traveling in search of work opportunities; of customers, journeying for trade or as pilgrims; and of pictures themselves.

An instance of the latter is the circulation of glass paintings from China (where the technique came from Europe via the Jesuits), often on Indian themes, in the latter half of the eighteenth century.[5] The "reverse glass" painting technique was quickly adopted in southern and western India. In particular, Tanjore (now Thanjavur, in what is now Tamil Nadu), already a strong artistic center, soon developed a distinctive tradition of relatively inexpensive glass painting.[6] Tanjore glass paintings are thought to be one of the earliest manifestations of commercially available framed pictures produced in India (Inglis 1995, 57), providing devotional images to a clientele that extended to merchants and professionals. Artists with a grounding in the Tanjore painting tradition were to be crucial to the development of chromolithographs and later calendar art: not just Raja Ravi Varma, who started his own press in 1894, but also Kondiah Raju and his followers, who were associated with the Sivakasi calendar industry as it developed in the 1950s (Inglis 1995). Prints produced under the Ravi Varma imprimatur as well as later prints from Mysore, Madurai, and Sivakasi often drew directly on the iconic compositions and

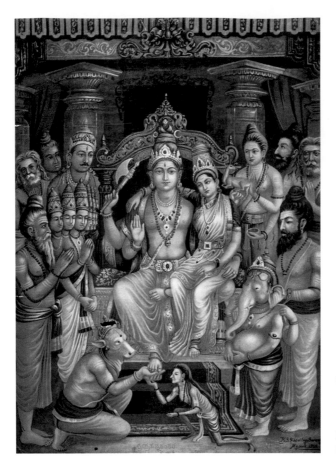

39. *Prasanna Shankar* by
K. S. Siddalinga Swamy, dated
"Mysore, 1932," printed at the
"Ravi Varma F.A.L. Works,
Malavli" for a framing company
in Chickpet, Bangalore.

ornamental treatment of Thanjavur wood and glass paintings. This is evident, for in-
stance, in Raja Ravi Varma's *Rama Patabhisheka* or *Shiva and Parvati* (Sharma and Chawla
1993, 139, 15), the print *Prasanna Shankar* by K. S. Siddalinga Swamy published by the
Ravi Varma Press (fig. 39), in the many popular depictions of the child Krishna, depicted
with a stylized plumpness (fig. 40), and more generally in the lavish rendition of gold
and heavy ornamentation. It is also plausible that the technique of reverse glass painting
adopted by the artists of Thanjavur informed the practice of retouching film negatives
in the Sivakasi calendar industry.

An example of the movement of artists during this period is the eastward migration of
painters from the declining Mughal courts of Delhi, Lucknow, Murshidabad, and Patna.
Forced to seek patronage from British residents and visitors, many of them eventually
settled in Calcutta (Guha-Thakurta 1992, 13–18). If the Mughal courts of the sixteenth
and seventeenth centuries had appropriated elements from European art on their own

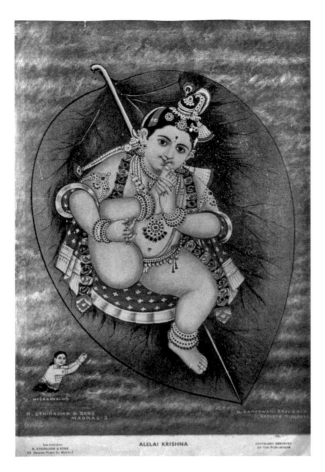

40. *Alelai Krishna* by
N. Ramaswami Raju and Son,
Tirupati. This Tanjore-style print
was published by R. Ethirajiah
and Sons, Madras. Artists
from the Raju community
have been practitioners of
Tanjore painting, carrying
elements from this tradition to
other forms of image making.
(Collection of Bari Kumar and
Samantha Harrison)

terms, with the institution of Company raj in 1757 the encounter of Indian artists with European practices and discourses of art was marked by the new balance of power between them.[7] The so-called Company style was a direct expression of this equation: documentation drawings and genre paintings in watercolor that made exotic souvenirs and catered to the taxonophilia of the colonial administration. According to Anand Yang, however, the *kalam* or school that developed in the busy trading center of Patna from around 1760 catered to both Indian and colonial patrons. This school flourished until the late nineteenth century, when the shift from road and river to rail transportation began to affect Patna's economy (A. Yang 1998, 60–61). Among the subjects of the Patna school were scenes from the bazaars from which it indirectly derived its support, including the great Sonepur *mela* (fair) where trade was combined with pilgrimage (A. Yang 1998, 127).

Similarly animated by mobility on the part of both consumers and artists, driven by both pilgrimage and trade, have been the images produced by the community of painters

41. Painted cloth *pichhvai*s (votive backdrops) for sale alongside printed framing pictures, Shailesh Art Studio, Nathdwara, 1995.

attached to the temple of Shrinathji (Krishna) at Nathdwara near Udaipur in Rajasthan. These artists were attracted to settling there, again from around the late eighteenth century onward, from Jaipur, Chittorgarh, Bundi, and Kishengarh, and possibly further afield as well (Ambalal 1987, Maduro 1976).[8] The Shrinathji temple is the main pilgrimage center of the Vallabha or Pushtimarg sect, whose primary devotional constituency has been the Vaishya-caste trading communities of the bazaar poised along the busy northern and western trade routes: "Marwaris," Banias, Bhatias, and Lohanas. Patronage for the Pushtimarg temples came increasingly from these wealthy mercantile pilgrims, as well as from local rulers who also benefited from the pilgrim economy (Peabody 1991). Artists were initially engaged by the Nathdwara temple to paint murals, *pichhvai*s (decorative cloth backdrops for the Shrinathji idol), and other ritual decorations, portraits of the order's high priests (the *goswami*s or *gosain*s), manuscript illustrations, and various types of miniature paintings. However, they also found a market among pilgrims for souvenirs depicting Shrinathji and scenes from Krishna's life (Ambalal 1987, 75–84; fig. 41).[9]

As with the Tanjore paintings, images from Nathdwara provided formal, iconographic, and thematic reference points for many of the later bazaar prints, as Nathdwara

artists came to work for the print and calendar industries in the early twentieth century (fig. 42). Here it is also worth pursuing the possibility that the significant eastward migration of Marwari and other followers of Pushtimarg over the nineteenth century might have had some impact on image production in Bengal through the circulation of Nathdwara images and Pushtimargi patronage of local painters and printers. For instance, Nathdwara images may well be the source of the ornamentation through tiny dot patterns that Tapati Guha-Thakurta points out as an "interesting innovation" in nineteenth-century Bengali oil paintings (Guha-Thakurta 1992, 39). We do know, however, that the grandfather of the currently practicing calendar artists Nirmala, Ramakrishna, and Balakrishna, who live in Calcutta, migrated east from Nathdwara in the first half of the twentieth century. He was an artist, as is their father Ramu Singh, who was born in Varanasi and moved to Calcutta around 1960 (H. Smith 1988, 133–34).

The production of pilgrim souvenirs and devotional images was a commercial image-making practice aimed primarily at Indian consumers (in contrast to the Company-style bazaar pictures). What distinguished such practices from earlier forms of patronage was their address to relatively anonymous or interchangeable pilgrim- or devotee-consumers *imagined in advance* as having certain requirements, some of which were more constraining than others. To this extent they can be seen as precursors to mass culture, where the relationship between producers and consumers is mediated by systematized (albeit malleable) generic expectations.[10] But these practices did not all lend themselves equally to mass reproduction. Here there is a distinction to be made between the different contexts in which new technologies were adopted: on the one hand, the commercial production of icons emerging from *existing* patronage by relatively affluent pilgrims and devotees, as in the cases of Tanjore and Nathdwara, and, on the other hand, the newer, more demotic forms in the nineteenth century, such as the Kalighat *pat* paintings and Battala woodblocks of Calcutta and the *janamsakhi* woodblock prints of Amritsar and Lahore.

The embeddedness of Nathdwara and Tanjore icons in a context of affluent religious patronage meant that despite their iconographic systematization neither form readily lent itself to mass reproduction via woodblock printing (although Nathdwara's artists are known to have used stencils for drawing serial images of the Shrinathji figure).[11] Colors and materials were an important component of the value and devotional effect of these images: Nathdwara paintings used an extraordinary range of colors, and the wood-based Tanjore images were often embellished with gold and gems, while the glass paintings used gold leaf and rich, flat colors to approximate the luminous surface of the more expensive

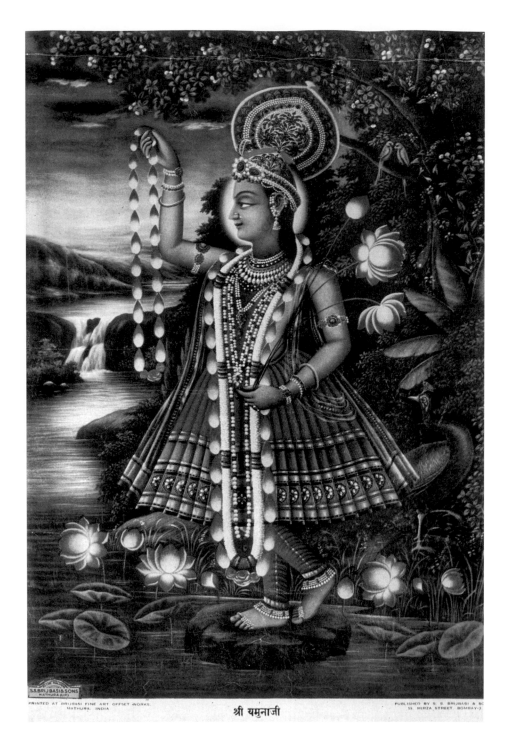

श्री यमुनाजी

42. *Shri Yamunaji*, print, S. S. Brijbasi and Sons, Bombay. (Courtesy of Brijbasi Art Press Ltd.)

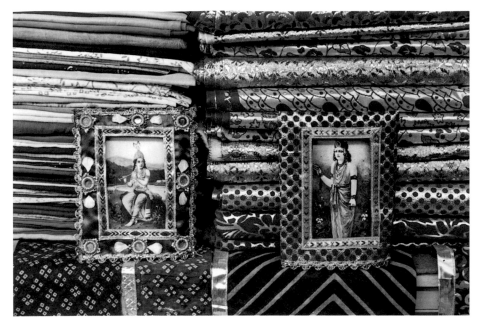

43. Photographic Krishna images, early twentieth century, now used as displays for photo frames, Nathdwara, 1995.

jeweled paintings. Also, in both traditions, but particularly in Nathdwara, images often incorporated depictions of priests or patrons and their families worshipping a central icon: evidence of proximity to the deity and direct participation in the temple's economy that a mass-produced image would not provide. So if the technique of photography was adopted in the votive "*manoratha*" images of Nathdwara around the end of the nineteenth century, this was due to its ability to provide accurate likenesses of priests and patrons rather than its ability to deliver multiple copies.[12] In this sense photography served as an extension of the image-making process on a continuum with painting, although this aspect of photography also formed the basis of its use as a technique of mass reproduction. Images using a mix of painting and photography, such as the images in fig. 43, where a young boy poses as Krishna, were replicated photographically for sale. Such images paved the way for the chromolithographic replication of Nathdwara images from the 1920s onward: a similar Krishna image was one of the first printed images from Nathdwara (Pinney 2004, 86, illus. 61). But by this time, as we will see in the following chapter, a new set of aesthetic, economic, and social factors were at work within the contexts of patronage of Tanjore and Nathdwara artists.

Both Tanjore and Nathdwara icons were almost certainly used as votive images in

domestic shrines. Their central deities are therefore fully frontal, directly facing the worshipper, in accordance with the ritual imperative of *darshan*: both seeing and being in the presence of the iconic figure; a reciprocal encounter of gazes where being seen or blessed by the deity is as important as having votive access to it (Babb 1981; Eck 1985; Prasad 1998). This frontality still characterizes the Nathdwara- and Tanjore-derived prints produced in Sivakasi. However, a new set of bazaar forms emerging over the nineteenth century catered to — and indeed created — a less affluent consumer market ranging from rural householders to a "neo-urban petty bourgeoisie" (P. Ray 1983, 100–102). These images did not derive primarily from domestic or temple icons. What we see in the formulation of those genres for which we have accounts are local movements of de- and reterritorialization in which saleable single-sheet images are disembedded from one set of narrative or performative contexts and reinstated in others. So, for instance, the *pat* paintings and clay statues sold at Calcutta's Kalighat temple were isolated from narrative scrolls produced by itinerant painter-storytellers (*patuas*) performing in rural Bengal (Rajadhyaksha 1993b, 57; J. Jain 1999, 24–42), and the woodblock prints on Sikh themes sold at markets, fairs, and temples in Punjab were initially illustrations for the *janamsakhi* booklets containing written hagiographies of the Sikh gurus (McLeod 1991).

The images produced as single-sheets bear the traces of these earlier contexts, both in their formal treatment and in their choice of subject matter. The *janamsakhi* woodblock images are peppered with captions, labels, and sacred mantras; a similar use of text characterizes the later Sivakasi images on Sikh subjects, as might be expected for a religion emphasizing texts and teachings rather than the worship of an anthropomorphic deity (see illustrations in McLeod 1991). And accordingly, the heads of the Sikh gurus in the *janamsakhi* woodblocks are depicted in profile or three-quarter view, consistent with Mughal miniatures as opposed to the fully frontal, *darshanic* Tanjore and Nathdwara icons. However, many later Sivakasi renditions of Guru Nanak (though not the other gurus) adopt a more frontal blessing posture, suggesting that these deterritorialized single-sheet images were readily reterritorialized or incorporated within a hegemonic Hindu devotional schema by artists working for multiple markets under the centralized Sivakasi system (an issue to which I will return in chapter 5; fig. 44). In the Kalighat paintings the process of creating discrete single images also enabled the introduction of new topics, like the caricatures of the Calcutta *babu* (westernized "native" gentleman) that have so endeared the *patuas* to later art historians: a flash of popular critique, inflected by moral disapproval, class tensions, and anti-colonial sentiments.[13] This

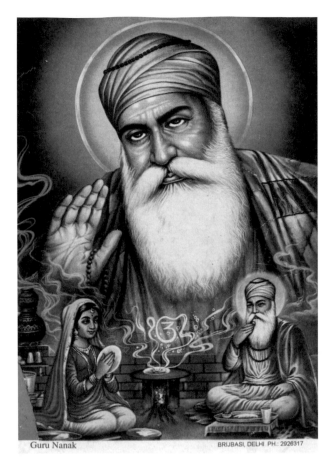

Guru Nanak

BRIJBASI, DELHI PH.: 2926317

44. *Guru Nanak*, artist unknown, published by S. S. Brijbasi and Sons, Delhi (in stock at their Delhi warehouse in 1995). The blue left hand bottom corner is a flaw in the print, which the publishers evidently did not deem worth correcting. (Courtesy of Brijbasi Art Press Ltd.)

could well have been a translation of hitherto oral critique into imagery, stemming from the narrative tradition from which the *patuas* emerged and its incorporation of topical commentary within the performative retelling of familiar mythological epics. The sharpness and local topicality of this critique would have been enabled by the proximity of these painters to their clientele, an immediacy that receded as mechanical reproduction opened up wider, more highly mediated networks of distribution.

If mass production for the bazaar meant that images were separated from existing contexts, it also meant that they were re-embedded in new ones, such as the printed almanacs of Serampore (the site of the Reverend William Carey's press for printing vernacular Bibles) and Battala in north Calcutta.[14] From the mid-nineteenth century onward woodblocks illustrating religious festivals—including depictions of deities—shared space with the kinds of information earlier found in handwritten almanacs produced by Brahmins: the calendar, astrological information, the dates for festivals and

ceremonies, and instructions for ritual observance. In addition, they also came to carry agricultural advice, information on fairs, railway timetables, court fees, weights and measures, postal rates, and so on (Pattrea 1983, 53). In the early twentieth century they were joined by illustrated advertisements depicting various everyday commodities: face powder, perfume, hair oil, ink, tonics, gramophones (Pattrea 1983, 56). The printed page was becoming a space—and, as almanac, was providing a format of time—where bureaucratic and commercial modernity could coexist with other ritual practices, as would be the case in the later chromolithographed and offset-printed single-sheet calendars. And, like the later calendars, the almanacs were distributed from Calcutta to the rural interiors by a network of agents, their physical pathways between urban and rural modernity reiterating the juxtapositions on the printed page.

Despite their differences of address across varying contexts of patronage, the common element in the images described so far is their inscription of "vernacular" markets where devotion, aesthetics, commerce, social relations, and bureaucratic-technological infrastructures came together—or rather, where they were not necessarily treated as distinct. Here patronage mapped onto pilgrimage and social-commercial networks, mapping in turn onto technologies and circuits of movement variously influenced by colonial trade, conquest, and missionary activity. Techniques such as reverse glass painting, woodblock printing, photography, and elements of perspective and modeling were not simply reincorporated into preexisting iconic schemata but were used to create devotional and secular forms that instituted new modes of address to—and brought into being—new constituencies of vernacular consumers. In the process these techniques and the specific formal properties associated with them in other contexts were themselves subject to adaptation to this marketplace.[15] But the extent to which the meaning and value of specific techniques were overdetermined by colonial ideology was a matter of degrees of vernacularity, varying with the distance from the interface with colonial institutions. The advent of chromolithographs, the direct forerunners of contemporary offset-printed calendar art, occurred in a milieu where colonial discourses of civilization and the institution of "fine art" in its nineteenth-century colonial avatar imparted a particular prestige and significance to certain aspects of image making. These valorized aspects included the medium of oil painting, the mastery of naturalist techniques, and, perhaps most saliently, the artwork's embodiment of an authentic civilizational essence. In this new aesthetic frame, the colonized painter as professional "artist" was to create new contexts of circulation and use and to bring new agendas to bear on the imagined communities

of consumption being forged through the proto-mass-cultural forms I have discussed so far.

"CULTURAL" RETERRITORIALIZATION

These new agendas stemmed from the idea that a picture was not the indexical embodiment of a divine presence, nor simply a narrative representation of its subject matter, but that it embodied a civilizational or cultural essence incarnated in the artwork via the artist as a privileged medium or vehicle of that civilization. While this idea subtended British colonial notions of fine art in the nineteenth century, its adoption in relation to images produced by Indian artists was far from straightforward. From the colonial point of view, at least around the mid-nineteenth century, Indian images were precluded from indexing "civilization" by their insufficient naturalism and lack of "taste." In contesting this view Indian scholars did not challenge the centrality of naturalism as an aesthetic criterion but instead sought to show that naturalism had in fact been achieved in ancient art (Guha-Thakurta 1992, 118–27). Paradoxically, therefore, it was not until Indian artists displayed a mastery of European naturalist methods that they were seen as capable of a fine art that embodied the essence of Indianness. From the point of view of the growing vernacular publics, a discourse that harnessed images to the expression of civilization or community required the *self-reflexive* articulation of what we might now call "cultural identity." This was, in fact, the primary aim of many competing projects in vernacular and English-literate public spheres over the second half of the nineteenth century. Paradoxically again, these formulations of identity, many of them positioned in resistance to Western culture, often deployed categories and ideas derived from colonial administration, missionary activity, and Orientalist scholarship—although the translation of these ideas often made for significant and productive differences.

The exigencies of patronage and the muddied agendas of the colonial art schools meant that a number of Indian artists learned the naturalist techniques of "fine art" and oil painting by copying or through informal apprenticeships, while artists trained in art schools often ended up with one foot in the bazaar. These artists therefore bridged the realms of "fine art" and a wider commercial arena of vernacular circulation and patronage, as many more would over the coming century. Informal encounters with European art had already been occurring for over half a century by the time the first art schools were established in India in 1854. Princely courts from the late eighteenth century onward and wealthy urban Indians such as the Calcutta aristocracy or the Parsis of Bombay from

the early nineteenth century onward patronized visiting European oil painters, and the appreciation and collection of European art became an indicator of wealth and status. Through visiting painters, circulating prints and copies of European art, and the exhibitions organized by European residents from around the 1830s, Indian artists and patrons came into increasing contact with portraiture, landscapes, genre scenes, history painting, and neoclassical work of the kind endorsed by the British Royal Academy.[16] Among the early Indian patrons of "fine art" were Jamsetji Jeejeebhoy (who funded the Bombay art school named after him) and Dwarkanath Tagore in Calcutta, both of whom were merchant-entrepreneurs with equal partnerships in British firms in the 1830s, before the segregation of the economy along effectively racial lines from the 1850s onward (R. Ray 1992, 18–26). Neither represented the trading communities of the bazaar, whether in terms of social background (Jeejeebhoy was a Parsi, and Tagore started his career as a legal agent for Bengali *zamindars*; N. Sinha 1992, 77) or in terms of the character of their interface with European commercial and social culture. Their participation in the realm of fine art resembled their participation in the British banking system, in that these were both westernized domains distinct from but nevertheless interfacing with the bazaar, its trading culture, and its culture of images.[17]

While there was enthusiasm for European art in India, in the 1850s the official colonial point of view on "Indian" art, expressed by art administrators such as George Birdwood, was that Indians did not possess the fine arts of painting and sculpture, although they excelled in the decorative arts and handicrafts (Mitter 1977, 245, 269). This racial-cultural distinction, the administration's need for skilled technicians and draftsmen, and the prevailing ideology of the industrial arts movement in Britain, which sought to develop or revive local manufactures, led to an initial emphasis on the industrial arts in Indian art education. It was not until the 1870s, well after the establishment of the art schools, that oil paintings by Indian artists (art school and non-art-school painters alike) were received into fine art exhibitions, within the categories set aside for "native" artists. The first government art schools in India, instituted in Calcutta and Madras in 1854, were initially called schools of "Industrial Arts," their curricula developed in relay with that of the Central School of Industrial Art at South Kensington. (These were followed by the Sir Jamsetji Jeejeebhoy, or "J. J.," School of Art in Bombay in 1857 and the Mayo School of Arts, in Lahore in 1878; on the colonial art schools see Guha-Thakurta 1992, 57–68; Mitter 1994, chapter 2). The Government School of Art in Calcutta was located in the midst of the indigenous picture industry and focused on subjects such as lithography, modeling, and wood engraving. The Royal Lithographic Press, the first on record, was

started around 1857 by four men trained at the Calcutta school; known as an "art studio," it provided paintings as well as lithographs and engravings.

However, colonial art education also bore the burden of refining "native" tastes, and given that Europe was seen as representing the pinnacle of achievement in fine art, this meant instructing Indian art students in the naturalist techniques of Western "fine art." Also, the Victorian valorization of manual crafts and design as a reaction against industrialization had little resonance for Indian art school students seeking social mobility. On the contrary, the distinction between "fine" art and "technical" or "craft" skills de facto mapped onto a distinction between artisan caste students and those from the salaried or professional classes who preferred draftsmanship to working with clay, wood, and plaster. The Mayo School's first principal, John Lockwood Kipling, complained about this "silly prejudice" against manual labor but noted that students from the professional classes did have an advantage in gaining employment because of their greater command of English (Kipling 1876–77, quoted in Choonara 2003).[18] If the early intake of the art schools was mostly geared toward students from artisan communities, in the 1870s, with the increasing attendance of students from middle-class backgrounds, the emphasis of art schools shifted toward "fine" art and the profession of artist acquired a new respectability (Mitter 1994, 30). But conversely, too, middle-class artists also found themselves infiltrating the non-"fine art" market for images. The Calcutta Art Studio, for instance, was established in 1878 by middle-class, art-school trained artists with wealthy patrons on the exhibition circuit; one of them, Annada Prasad Bagchi (1849–1905), also taught at the Government School of Art in Calcutta. Initially set up to serve "the Gentry and the Nobility" with painted and photographic portraiture, as well as lithography and other kinds of painting work (including stage sets), its main source of income soon became its lithographed "Hindu Mytho-Pictures" (on the early Calcutta presses, see Guha-Thakurta 1992). The "Mytho-Pictures" included both iconic, frontal renderings of deities and more naturalistic depictions of *pauranic* tales, mostly narrative episodes from the Mahabharata and Ramayana or the life of Krishna (fig. 45), many of them already popular subjects for theatrical productions.[19] These came to compete in the market already created by the Kalighat *pats* and the Battala woodblocks, dislodging those earlier forms (Mitter 1994, 175). Several chromolithographic studios producing images for this market sprang up in Calcutta, creating a continuum between "fine art" and artisanship, and between the gentry and rural and "neo-urban" consumers, much as the later Sivakasi images would do.[20]

This is not to say that there were no attempts at the time to distinguish between the

45. "Durvasa's Wrath against Shakuntala" by Bamapada Banerjee, 1903. Printed in Germany for Roy Babujee and Company. (Smith Poster Archive, Special Collections Research Center, Syracuse University Library)

aesthetic and political impulses driving different kinds of chromolithographic production. The elite valorized the naturalism of the (self-taught) "fine" artist Raja Ravi Varma as an alternative not just to the literalism of the Calcutta "Mytho-Pictures" but also to the "Poona pictures," most likely the products of the Chitrashala Steam Press in Poona (now Pune), which was started at about the same time as the Calcutta Art Studio around 1878.[21] These pictures were harnessed to the anti-colonial and Maratha revivalist agenda of Chitrashala's founder, the essayist and educationist Vishnushastri Chiplunkar (also referred to as Vishnukrishna Chiplonkar), who was a major influence on his fellow Chitpavan Brahmin, the militant Hindu nationalist B. G. Tilak, and was involved with him in the newspapers the *Kesari* and the *Mahratta*. Chitrashala produced portraits of popular figures of local resistance such as Shivaji and Nana Phadnavis, as well as mythological and secular pictures that sometimes served as anti-colonial allegories, as did certain Calcutta Art Studio prints such as the famous Kali cigarettes advertisement proscribed by

the British government (Pinney 1997a, 836; see also Pinney 2004).[22] Toward the turn of the century, as the nationalist movement gathered momentum, political meaning in chromolithographs became increasingly explicit through the labeling of figures, taking a cue from the cartoons in magazines such as *Punch* that were by now published in a number of Indian languages. Cartoons were partly responsible for the government's introduction in 1878 of censorship of the vernacular press, including lithographs (Mitter 1994, 137). Theater and film were to follow, with the banning of Tilak's associate K. P. Khandilkar's 1909 play *Kichakavadha* and Kanjibhai Rathod's 1921 film *Bhakta Vidur*, both of which used episodes from the Mahabharata as anti-colonial allegories (Rajadhyaksha and Willemen 1994).

In these respects, over the second half of the nineteenth century lithographs occupied a liminal zone between "industrial" and "fine" art, between artisans and the gentry, between woodcuts and oil paintings, and, significantly, between devotional, political, and "cultural" or "aesthetic" images. On the one hand these prints addressed a consuming public that was buying pilgrim souvenirs, hagiographic images, icons for domestic worship, and secular, satirical, or allegorical images for decoration, amusement, and, increasingly, political participation. On the other hand, in their use of Western naturalist techniques such as perspective, anatomy, modeling, and shading, they also lent themselves to the reformist repudiation of idolatry that accompanied several nineteenth-century reformulations of "Hindu" identity (Guha-Thakurta 1992, 127). Here naturalism, or the "scientific" approach to pictorial representation, replaced the idol's ritually imbued embodiment of the sacred with the artwork's aesthetically imbued embodiment of Hindu "culture." This resonated with the reformist use of rationalist, post-Enlightenment categories to recreate an ideal Hinduism as the cultural and spiritual basis for an Indian polity. So for certain sections of consumers, in a certain register of subjectivity, images took on extra layers of signification by being harnessed to the self-reflexive definition of community identity via the explicit articulation of a "cultural" domain.

This address of mass-produced images to a range of modalities, from the devotional and hagiographical through the political and satirical to the aesthetic, "cultural," and identitarian, articulated with and extended the address of the vernacular textual print culture with which they partially overlapped. In the last decades of the nineteenth century, after the uprisings of 1857 that saw the consolidation of British rule in India, writers, thinkers, and activists across the country were engaged in intense reflections on—and performative inscriptions of—difference and identity: racial, civilizational, religious,

caste, ethnic, linguistic. These were expressed in books and articles primarily written in the vernaculars for the literate elite and middle classes, taking the form of histories, religious and philosophical tracts, polemical essays, (auto)biographies, recollections, scientific treatises, satires, pleas for reform, retellings of epic or *pauranic* narratives, plays, poetry, novels, stories, and (significantly for the process of vernacularization) combinations of any or all of the above. A great deal of energy was focused during this period on articulating the essential characteristics of Hinduism or Hindu "civilization": in Bengal for instance by Bankimchandra Chattopadhyay, then Ramakrishna and Vivekananda; in Maharashtra by Chiplunkar, then Tilak; and in the northern Hindi belt through the debates between the Arya Samaj reformists led by Dayanand Saraswati and the traditionalist image-worshipping followers of "orthodox" Hinduism or *sanatan dharma*, represented in particular by Bharatendu Harishchandra, a Pushtimargi from the Aggarwal trading community (that is, a man of the 'bazaar'). Similarly, Indian Islam was formulating multiple competing self-representations ranging from the orthodox pan-Islamicist Deobandi movement to Sir Sayyid Ahmad Khan's modernizing Aligarh movement; struggles over Sikh identity were expressed in influential publications such as *Ham Hindu Nahin* [We are not Hindus, 1898] by the Singh Sabha's Bhai Kahn Singh.[23]

Here religious or sectarian agendas were not clearly separable from caste, regional, linguistic, or anti-colonial, nationalist ones, as with Chiplunkar's and Tilak's assertion of Maratha identity alongside Hinduism and nationalism, Harishchandra's promotion of Vaishnavism as "the only real religion of the Hindus" (Dalmia 1995), or the heady mix of neo-Shaivite (religious), non-Brahmin (caste), and Dravidian (racial) sentiments in the southern pro-Tamil (linguistic/devotional/nationalist) movement (Ramaswamy 1997). What is striking in many of these identitarian and reformist writings is how, as Partha Chatterjee has described them in relation to the Bengali writer Bankimchandra Chattopadhyay (1838–94), religion became the primary site for "cultural" identity formation. Modernizing reformist projects within this domain resisted the intervention of the colonial state and thereby formed the basis for proto-nationalist claims to sovereignty (Chatterjee 1986; 1993, 6–7). Insofar as this identitarian space was constituted in the vernaculars, the terms in which it was invoked were not quite congruent with "culture" and "civilization." In Hindi for instance, the preoccupation in writings of that period was with *sanskriti* (akin to "heritage"), *dharm* (religion, moral order, or ethos), *samaj* (community or society), *itihas* (akin to "history"), and *sabhyata* (civilization, but with the connotation of good civil conduct).

At the same time, in their quest for civilizational, moral-religious, and historical rather than political-economic explanations and solutions for India's subordination and "backwardness," such identity projects were overdetermined by the evolutionary categories of colonialist discourse (Chatterjee 1986, 58–66). Similarly, in seeking the essence of that civilization in a Sanskritic and untaintedly "Hindu" "golden age," they took on the terms and methods of Orientalist scholarship, pursuing textual and archeological evidence to fashion an "Indian civilization" in the image of classical Greece and Rome (Uberoi 1990, WS 41–48; also G. Kapur 1989, 64, 68). Here the epic narratives of the Ramayana and Mahabharata and the mythological stories of the Puranas, mediated by Sanskrit playwrights such as Kalidasa, provided pan-national, "Indian" counterparts to the Greco-Roman subjects of academic neoclassicism. Literary texts in particular were open to reinterpretation using the techniques of "fine art" and became privileged sources for visualizing or actualizing a proto-nationalist imaginary. These visualizations developed in close relay with existing pictorial and performative interpretations, particularly the vernacular theaters burgeoning during this period.[24]

The civilizational narrative tied in with the discourse of anti-colonial nationalism by inscribing the "classical," or mythic Hindu past as the origin of the vector of a national history for India. Indian artists' mises-en-scène of figures from epic narratives within historicizing "frozen moments" thus entailed the simultaneous mise-en-histoire of Indian viewers as the subjects of a nationalism that had to revive and restore the great civilization now in decline. In what is by now a familiar paradox stemming from the "derivativeness" of colonial nationalism (Chatterjee 1986), this enterprise was endorsed by colonialists and elite nationalists alike. Take, for instance, the resonance between the following two oft-cited exhortations to Indian image makers. In a speech in 1871 the governor of Madras, Lord Napier, urged that "with the powers of European Art, [the Ramayana and the Mahabharata] should engage the service of the national pencil as they have fastened on the national memory and animated the national voice" (Venniyoor 1981, 13). In 1884, Madhava Rao, the *dewan* (advisor) to the ruling *gaekwad* at Baroda wrote to his friend, the celebrated painter Raja Ravi Varma, urging him to have his naturalist reinterpretations of mythic themes reproduced in Europe, adding "You will thereby not only extend your reputation, but will be doing a real service to your country" (Chaitanya 1984, 3, quoted in Rajadhyaksha 1993b, 65).

Note here that mechanical reproduction was seen as amplifying rather than diminishing the efficacy of the artwork as the authentic embodiment of a national cultural

essence. Lithographs were not yet subject to the distinction between an "autonomous" realm of art, represented by painting, and the commercial interests of the "culture industry," represented by technologies of mass reproduction such as printing, photography, and the cinema: this distinction depends on a later, twentieth-century modernist critique of commodification, following Marx, Lukács, and Adorno.[25] At this late nineteenth-century moment, no contradiction was perceived in the use of European naturalist means or technological mass reproduction to press (both literally and metaphorically) mythic themes into the service of national-cultural authenticity. "Authenticity," as it was invoked in the growing critical discourse on art in the vernacular press, referred not to modernist autonomy, nor to a romantic conception of authorial genius, but to the expression of "Indianness" as embodied in the "classical" texts. Given that the mastery of Western-style neoclassical naturalism in painting and sculpture was seen as a prerequisite for artistic civilization, aesthetic authenticity lay in the successful communication of the spirit, mood, and feeling of these texts through naturalist means — not, at this stage, in the deployment of specifically "Indian" formal approaches (Guha-Thakurta 1992, 127–35). Just as the articulation of a "cultural" domain in the image of European "civilization" but with Indian ("spiritual," textual) content was crucial to the formation of an elite nationalist consciousness, the production by Indian artists of works that qualified as "art" according to Western aesthetic ideals was essential to the further possibility of constituting an "Indian" art centered on a modernist conception of authenticity. Indian artists' "mimicry" of naturalism can therefore be seen as a productive mimetic encounter (rather than a reproductive one; see Taussig 1993b; Bhabha 1994), creating the formwork, as it were, for a nationalist subjectivity. This was a crucial moment for the reterritorialization of images onto the nation-state, through artistic modernism on the one hand and a vernacular bazaar aesthetic on the other. This moment can be most clearly understood through the career and critical reception of the artist and print entrepreneur Raja Ravi Varma, embodying as he did a node where fine art, mass reproduction, nationalism, and the bazaar briefly intersected to actualize a pan-national visual imaginary.

RAJA RAVI VARMA: A HYBRID AUTHENTICITY

During his lifetime, Ravi Varma (1848–1906) was a highly successful artist.[26] He was celebrated by both the colonial administration and the Indian elite, not only for his famously self-taught mastery of the foreign medium of oil painting, his portraits of European and Indian high society, and genre paintings of "types" of women from various regions, but also for his appropriation of naturalist techniques to the self-conscious project of

representing "Indianness" through mythological and iconic subjects.[27] His aristocratic connections (his family's men were affines of the ruling house of Travancore in Kerala) paved the way for commissions that took him—and his brother, C. Raja Raja Varma—to cities and courts all over India to paint princes, colonial officials, priests, merchants, businessmen, and their families (on Varma's travels, see R. Rajagopal 1993).[28] As a mobile, pan-Indian presence with a pan-Indianist agenda, Varma drew the realm of fine art together with several of the strands of bazaar image making discussed so far. His upbringing in close contact with the Travancore court gave him a grounding in the Tanjore painting tradition, as well as opportunities to observe and copy European paintings. He also had some contact with Nathdwara: among his subjects of portraiture was the Pushtimarg high priest or *tilkayat* Govardhanlalji. On the other side of the subcontinent, in 1894 the Bengali critic Balendranath Tagore favorably contrasted the naturalism of Ravi Varma's reinterpretations of the "classics" to the Kalighat *pats* and the Calcutta Art Studio's "Mytho-Pictures." That same year, at the height of his artistic success, he set up the Ravi Varma Fine Art Lithographic Press in Bombay, which continued to churn out popular and much imitated prints for decades after he himself washed his hands of it in 1903.

In their interface with "fine art" patronage and criticism, Varma's mythological and religious images were taken up by a nationalist discourse that sought authentically "Indian" content to flesh out a national spirit or essence, thereby taking on colonial terms of aesthetic distinction. Varma was one of the first artists to be discussed within the emerging realm of Indian art criticism: Balendranath Tagore enthused over Varma's grasp of anatomy, color, composition, and most of all his ability to express *bhava* or emotion, an essential component of "Indian"—that is, classical Sanskrit—aesthetics (Tagore 1894, cited in Mitter 1994, 230–33 and Guha-Thakurta 1992, 128–32).[29] However, it was the same quest for the authentic essence of classical Indian aesthetics that was to consign Ravi Varma to the rubbish heap of Indian art history for about eighty years through a series of critical writings appearing in Calcutta in 1907–8, shortly after his death. These polemics against Varma issued from the art critic and scholar Ananda Coomaraswamy, the British art school administrator Ernest Havell, and the Irish-born nationalist, activist Sister Nivedita. They championed an "Indian style" in art, embodied in the neotraditionalist formal experiments of the Bengali artist Abanindranath Tagore and what came to be known as the "Bengal renaissance" or "Bengal school" (Coomaraswamy 1907/1993; Nivedita 1993; Havell 1908).

If Varma's naturalism provided the formwork for constituting a national civiliza-

tional imaginary in art, in the neo-Platonic view of his critics it represented a third or fourth order imitation, a second-rate, colonial mimicking of Western techniques (although again, Varma's press and the issue of commodification do not come up in their critiques). What had eight years earlier been the perfect vehicle for Indian feeling was described as a "smoky mirror (held) to the art of other men"; one of Varma's "fatal faults" according to Coomaraswamy was the "*lack* of Indian feeling in the treatment of sacred and epic Indian subjects" (Coomaraswamy 1907/1993, 155, emphasis added). In denigrating Varma's naturalism in favor of an "Eastern" artistic sensibility Havell and Coomaraswamy were taking on a colonial establishment that had awarded Varma an imperial medal in 1904. But for evidence that this new renaissance of "Indianness" was no less westward-looking than Varma's academicism we need only examine the footnotes to Coomaraswamy's essay on Varma: "one would like to ask those who will not exercise their own capacity for artistic judgment, to reflect on the significance of the appreciation given to Tagore in Europe, and the absolute indifference of European artists to the works of Ravi Varma" (Coomaraswamy 1907/1993, 155).

Again, the final arbiters of what was and was not authentically Indian resided, of course, in Europe; the Orientalism of content personified by Varma was simply replaced here by a new Orientalism of form. The delicious irony, however, is that the stereotypes that emerged from the Bengal school's earnest explorations of the essential differences between "Eastern" and "Western" sensibilities have left their most enduring mark not in fine art, but in calendar art. The "Indian art style," as it is known in the calendar trade, was introduced to the Sivakasi industry through the work of artists such as "Rangroop" (Ram Singh; fig. 46) and Gondhalekar, and lives on with Venkatesh Sapar. It is instantly identifiable in its decorativeness and fine, florid lines (defined as "Indian," in contrast to "Western" mass and form) and sinuous romantic heroines with elongated Ajanta-esque fingertips.[30] Each year sees new calendar renditions of deities in this style, or of the Omar Khayyam theme, inspired (though by now indirectly) by Abanindranath's Mughal miniature-style illustrations of the *Rubay'yat*.

The quest for authenticity in art, at the same time, would continue well beyond the Bengal school to form the basis of post-independence nationalist modernism. Thus, for instance, the artist J. Swaminathan declared in the 1963 manifesto of the Group 1890: "We reject the vulgar naturalism of Raja Ravi Varma and the pastoral idealism of the Bengal School, down through the hybrid mannerisms resulting from the imposition of concepts evolved by successive movements in modern European art" (Swaminathan 1963).

46. Artwork for a calendar depicting an *apsara* (divine nymph) in the "Indian style" by Rangroop (Ram Singh), ca. the 1970s.

It was not until a series of essays by the art critic Geeta Kapur, beginning in 1987, that Indian art history began to reclaim Ravi Varma from its margins—indeed to reinstate him as nothing less than "the indisputable father-figure of modern Indian art" (G. Kapur 1989, 60). Working against the grain of accounts that cast Varma as an indigenous practitioner of naturalism, Kapur traces disjunctures in his work that index the collision between his "surrogate realism" (G. Kapur 1989, 61), aligned with a historical temporality, and his attempt to figure the putative mythic origins of Indian national identity. In this collision Kapur identifies a *formal* resistance from those elements of his work that are informed by the indigenous iconic and theatrical traditions, including Tanjore painting and Kathakali and Parsi theater. Here the narrative tableau, as "frozen moment" addressing the subject of history, is subverted by its superimposition onto an iconic or epic format that addresses an abstract gaze and indexes a transcendental referent (G. Kapur, 1993b, 96–103). This is evident in most of Varma's attempts at composing or situating more than two or three figures, where the somewhat uneasy play of glances invokes what

Kapur identifies as an "ideal spectator who prefigures rather than follows the events," and in his use of the threshold (staircases, doorways) as a way of evading problems of perspective (G. Kapur 1989, 67). Here technical problems of representation take on the ideological burden of the nation's paradoxical struggle for self-definition within the terms of colonial Orientalism. But rather than seeing the "lapsed commitment to history" as a failure or lack, Kapur is able to glimpse in this aporia an "aesthetic of resistance" that becomes available as a strategy for Indian modernism (G. Kapur 1989, 60).

Establishing Ravi Varma's paternity of Indian modernism depends on demonstrating that his work finds properly formal solutions to expressive problems, and in particular to the highly contentious problem of adequately embodying or representing "Indianness." Note that the discursive schema in Kapur's analysis is one where the work of embodiment is done by the work of representation as signification *within* the frame of the image. Specific meanings are assigned to specific elements and representational strategies: the qualities of Indianness, mimicry, anti-colonial resistance, and so on must be assumed to be located within the work itself, and it is the critic's task to show us what these qualities are and where to find them. Arguably, to the extent that Kapur's redemption of Ravi Varma issues from the discursive field of fine art and is addressed to the project of a national modernism it must still hinge on finding an irreducible kernel of authenticity within the work, however diminished, fragmentary, interstitial, and elusive. In this case, it is the very contestedness of the national embodied in Varma's work that makes it an authentic—because authentically hybrid—index of the colonial condition and hence of a constitutively fraught Indianness. The specific forms taken by this contestation are what mark it as specifically Indian. Debates within the realm of fine art have circled around this ever more elusive yet obdurate residue of authenticity, not just because of modernism's investment in a definable locus of authorial subjectivity (whether "pure" or "hybrid," singular or collective), but also because fine art's primary concern has been with the work of signification *within* the frame of the image as a located, static object.

In the commercial realm of the bazaar that is my concern here, however, the modernist question of whether or not Varma's printed images truly embodied or represented "Indianness" is obviated by their undeniable *performance* of "India" as an enacted as well as an imagined community: as a market, a network of transactions, and as the space of a shared, pan-national visual idiom. Varma's paternity of Indian calendar art (as opposed to that of Indian modernism) has been largely uncontested, even though his was not the first lithographic press on the subcontinent, nor (as I showed in the previous chapter)

is his influence unequivocally evident in all subsequent calendar art. Varma's canonical status as the father of calendar art has not been the subject of critical debate but a matter of practically universal, undisputed common sense, not just within the industry but also across both vernacular and English-medium public spheres. I would suggest that this is a function of the unprecedentedly pan-national nature of Varma's work and reputation, and of the way in which Varma's name and persona — indeed, his "brand identity" — embodied the intersection between "fine art" and a wider public culture, particularly that of the bazaar.

"THE REQUIREMENTS OF THE THINLY LINED PURSE"

Here I want to read Varma's images not just as pictorial actualizations of a nationalist myth of origin, but also as objects that traced the two-way traffic between the colonial public sphere and the bazaar. In part this traffic was conducted by entrepreneurs, emerging from trading communities, who had moved to Bombay and Ahmedabad and by the late nineteenth century had established an Indian-owned textile industry. This bazaar constituency joined the feudal and administrative elite in patronizing Varma's fine art practice, as well as providing financial backing and a market for Varma's own entrepreneurial venture with his press. Sitters for Varma's portraits included Chinubhai Madhavlal, the adopted grandson of the first cotton mill owner in Ahmedabad, and Ambalal Sarabhai, whose family emerged from a background as Jain shroffs to become one of the largest textile combines in Ahmedabad by the turn of the century (Ray 1992, 44–45). Govardhandas Khatau Makhanji, a co-financier for the Ravi Varma Press, was in all likelihood the elder son of Khatau Makhanji, a leading member of Bombay's Bhatia trading community and the founder in 1874 of the Khatau Mill, one of the first Indian-owned cotton mills and the cornerstone of what continues to be a major business house.[31] The fit between the artists as gentlemen-professionals and their associates in the bazaar was not always an easy one: Ravi Varma's press ran at a loss, and his partnership with Makhanji only lasted until 1898 (when Varma moved the press inland to Malavali, between Bombay and Pune).[32] On the "fine art" front, too, Raja Raja Varma complained in his diary about the difficulty of extracting fees from *banias* (Mitter 1994, 198).

If the emergent industrialists and *banias* of Bombay and Ahmedabad represented one part of Varma's multivalent interface with the bazaar, another was the distributional infrastructure provided from the 1890s onward by a new breed of picture merchants from the trading communities that catered to the new market for images. While merchants

such as Anant Shivaji Desai and A. K. Joshi were the agents for the Ravi Varma Press in Bombay, Poona, and other Maharashtrian cities, others extended the distribution network across the country: the Hem Chander Bhargava firm of Delhi (established in 1900), Harnarayan and Sons of Jodhpur, and, Nathmal Chandelia of Calcutta and Jaipur, which worked the Rajasthan-Calcutta nexus (Ambalal 1987, 90). This network, and the market for Varma's pictures, also extended to the south: in 1902 Ravi Varma's brother, Raja Raja Varma, wrote in his diary of seeing their prints for sale in Visakhapatnam (Mitter 1994, 213); a painting entitled *Prasanna Shankar* by K. S. Siddalinga Swamy, dated "Mysore, 1932," was printed at the "Ravi Varma F.A.L. Works, Malavli" for a framing company in Chickpet, Bangalore (see fig. 39).

The *Prasanna Shankar* print is an instance of the way in which the Ravi Varma name continued to function as a brand attached to the work of other artists, well after Varma himself stopped owning the press or supplying it with images. The fame, popularity, nationalist significance, and artistic legitimacy adhering to Ravi Varma's name and work meant that both were perpetuated and imitated by others, artists and publishers alike, remaining in circulation up until at least the 1940s and continuing to evoke nostalgic associations long afterward.[33] There is a productive slippage here between the value adhering to Ravi Varma as an individual artist and the Ravi Varma brand name as a generic descriptor for a new kind of commodity, the printed mythological image. I would suggest that the instant association between "Ravi Varma" and calendar art in the public imagination largely flows from his role as one of the earliest "Indian" brand names (that is, for a mass-manufactured product made in India and aimed primarily at the domestic market). The "Ravi Varma" name appeared both as a signature within his images, as an index of artistic authorship, and in the margins of the prints, where the phrase "Ravi Varma Fine Art Lithographic Press" signaled proprietorial rights in a manner that, like his own practice, did not distinguish between the domains of "Fine Art" and "Lithographic" mass reproduction.[34] Conflating artistic and entrepreneurial personae in the signature, or brand name, "Ravi Varma" became an easily remembered, pan-national yet vernacular synecdoche for chromolithographic production in general (unlike, say, "Calcutta Art Studio," an abstract, unwieldy, and unfamiliar formulation, overly local in its scope). Such metonymy has often characterized brand names strongly associated with the first commodities of their kind: "Dalda" for the cooking-medium *vanaspati* in the 1940s and 1950s, "Surf" for washing powder in the 1970s, "Maggi" for noodles and pasta in the 1980s (some Euroamerican examples would be "Band-Aid," "Kleenex," and

"Hoover"). In Varma's case, as we have seen, this new commodity was not just an Indian product but a producer of Indianness — and, for people such as Lord Napier and Dewan Madhava Rao, embodied Indianness itself.

The circulation of Ravi Varma's chromolithographs in the vernacular public sphere actualized a nationalist cultural imaginary, fashioned through a selective engagement with the colonial discourse of "civilization" and the practices of fine art. In doing so under the Ravi Varma brand name it also simultaneously introduced into the bazaar the idea of authorial ownership of images and a related strategy associated with Euroamerican industrial capitalism: the personalization of consumer-oriented, mass-manufactured commodities. These humanizing procedures would prove to be sites of instability in the bazaar's frameworks of value as it negotiated its styles of capitalist practice over the twentieth century. (I elaborate on this in relation to authorship in chapter 4 and in more general terms in chapter 5.)

Naturalism, as a procedure that sought to "humanize" the gods (A. Kapur 1993b), thereby challenging or deterritorializing iconic modes of signification, was subject to a similar instability. Something of this instability can be found in Ravi Varma's paintings (as in Geeta Kapur's analysis discussed above), but more markedly in the prints issuing from his press, not all of which were necessarily originally painted by Varma. At one pole of "successful" naturalism are ambitious versions of academy-style paintings such as *Release of Vasudeva and Devaki* (fig. 47) or the more frequent *pauranic* or "classical" compositions involving two or three figures, such as *Arjuna-Subhadra*, *Nala-Damayanti*, *Shakuntala Patralekhan*, *Jatayu Slain* (fig. 48), and so on. Intermediate categories are the "puranicized" genre paintings of women with the names of mythological or theatrical characters (*Hansa Damayanti*, *Rambha*, *Vasantasena*, *Manorama*, and so on, fig. 49) and "naturalized" iconic depictions such as those of the goddesses Lakshmi and Saraswati (see fig. 10), where a frontal figure is combined with naturalist modeling and a landscaped backdrop. At the other pole is full-blown Tanjore-style frontality, as in *Vishnu and His Followers*, *Shiva and Parvati*, or *Rama Patabhisheka* (fig. 50). Then there are allegorical images, such as the *Chaurasi Devataon Wali Gai* ([Cow containing 84 gods], discussed in Pinney 1997a, 844–46); this anti-Muslim image used in the cow protection agitation indexes the role of allegory in mapping "communal" identities onto the nation-space.

So the social, geographical, and semiotic ambit Varma's prints inscribed in the early decades of the twentieth century encompassed modes of engagement with images that were not reducible to the aesthetic terms of fine art or to a self-reflexive assertion of

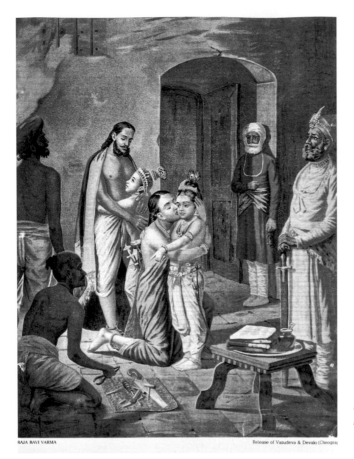

RAJA RAVI VARMA Release of Vasudeva & Devaki (Oleogra)

47. *Release of Vasudeva and Devaki* by Raja Ravi Varma, print published by the Ravi Varma Press.

cultural identity—even though the unprecedented pan-national circulation of Varma's images may have been enabled by his brief period of celebration in fine art as the vehicle of an authentic national culture. Varma's critical excoriation by the champions of the Bengal school had little impact on the market for prints, resonating as they did with other forms of popular culture with varying relationships to the terms of the colonial and elite nationalist and reformist public spheres. If "fine art" painting and literature became part of the interpellation of Indian subjects into history by a colonial civilizational narrative, through lithographs and vernacular theaters they also interfaced with multiple ways of performing "Indianness" by a wider audience that did not need to be literate, wealthy, or male to participate in a nationalist arena (lithographs, in particular, were available to women whose access to a public arena was otherwise limited). Significantly, both the theater companies and the printed lithographs traveled widely (particularly the Parsi theater and the Ravi Varma prints), both within the subcontinent and beyond, inter-

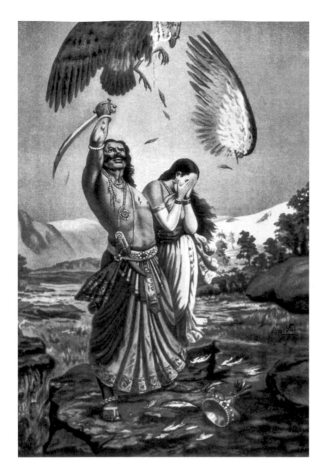

48. "Jatayu Slain" or "Death of Jatayu" by Raja Ravi Varma, print published by the Ravi Varma Press, Karla-Lonavla, distributed by Anant Shivaji Desai, Bombay. (Smith Poster Archive, Special Collections Research Center, Syracuse University Library)

acting with local forms in a process of mutual adaptation. Particularly in the case of the traveling theater companies, the regional urban styles also interfaced with rural or "folk" forms (Hansen 2001, 89–90).

The work of signification in image making and theater during the late colonial period ranged across a broad continuum, paralleling but also exceeding written texts: engendering affect through the melodramatic orchestration of elements in mythic narratives; cultivating the visual pleasures of instituting the figure of woman as the object of the gaze; symbolizing "Indian civilization" or national identity within a historical narrative; allegorizing anti-colonial sentiments; engaging in more explicit caricature, critique, and intervention in topical political debates—but also evoking a ritual relationship in the "frontal" mode of devotional icons. These varying registers were not always split into separate genres, nor did they necessarily appeal to different audiences. For instance, the narrative flow of proscenium-style stagings in the Parsi theater was punctuated by ex-

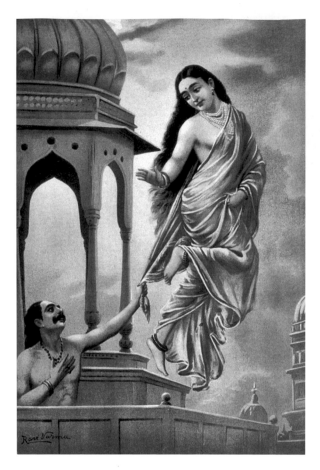

49. *Urvashi* (the mythic nymph of dawn) by Raja Ravi Varma, print (14" × 20"), published by the Ravi Varma Press, Karla-Lonavla, distributed by Anant Shivaji Desai, Bombay. (Smith Poster Archive, Special Collections Research Center, Syracuse University Library)

pressive melodramatic tableaux, devotional rituals, and spectacular effects (A. Kapur 1993b).[35] Or, as we have seen in the case of Ravi Varma, paintings and prints ranged between the suspended mythic, devotional duration of iconic frontality, the vectoral temporality of a historicist, melodramatic narrative, and an allegorical shuttling between the two. Mythic narratives and religion provided a rich resource of familiar themes that could be given a topical spin, but images in both printed and theatrical form could also engender a devotional relationship in their capacity as embodiments of a sacred presence.[36] The ability to slip between narrative-representational, iconic-indexical, and political or topical registers was a quality shared by other cultural forms where ritual and social arenas coincided, such as religious processions or mobile theatrical performances such as the Ramleela of Banaras. Religious processions entailed the public animation of otherwise static and firmly situated temple icons; conversely, the mobility of Ramleela performances was punctuated by *tableaux vivants* called *jhankis* where the audience

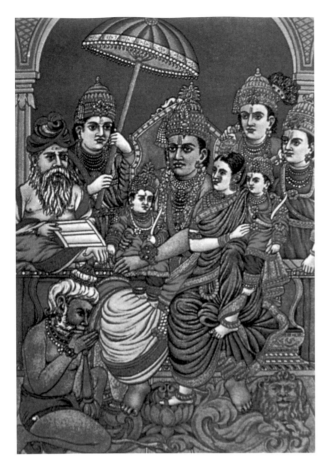

50. *Rama Patabhisheka* [Ram's coronation] by Raja Ravi Varma, print.

worshipped the actor-deities (the *jhanki* was also a performative genre in its own right; Freitag 2001, 46–47). Such public events took on a political valence, performatively reinscribing connections between members of a community and the community and its leaders, as well as reasserting ownership or control over space in a way that often made processions sites for conflict (see Freitag 1991a, 1991b). If the procession of sacred images or symbols through the streets established a direct connection between the symbols of a community and a physical territory, it also simultaneously mapped onto human territory and human bodies the orders of sacred time and space—those of a mythological diegesis and of an abstract, eternal, cosmic divinity.

Here it is important to remember that many religious processions and community festivals were introduced or revived and reworked during the colonial period by a range of sectarian groups.[37] In these forms of community life, as in the commodified forms of the commercial theater and printed images, the mapping of the sacred onto the commu-

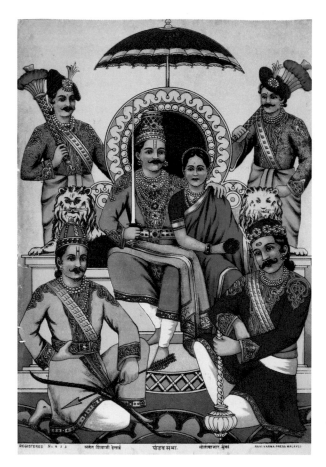

51. *Pandava Sabha* [The council of Pandavas], print published by the Ravi Varma Press, Malavali, distributed by Anant Shivaji Desai, Bombay.

nal body in the late nineteenth century did not signal the persistence of an archaism but the reterritorialization or reharnessing of earlier codes. However, one difference between the reconfiguration of community festivals or processions and the mobile, commodified forms of the theater and prints was that the latter now carried a figure of territory with(in) them, in the form of stage sets in the theater and the very similar pastoral and palatial backgrounds of chromolithographs and paintings. (I return to this territoriality in the next chapter.) Another difference was the work they did in constituting consuming subjects within this national "cultural" ground. Writing in the context of theatrical productions of the *Indar Sabha* from 1853 onward, Kathryn Hansen describes how "the imagined self of the new consumer of popular culture" was constructed on the model of the monarch as patron-viewer-enjoyer of the work, as relayed from within the theatrical diegesis: the figure of Indar "instructed his audience in the art of ocular consumption" (Hansen 2001, 77, 88). If the theater was one site of instruction in ocular (and importantly,

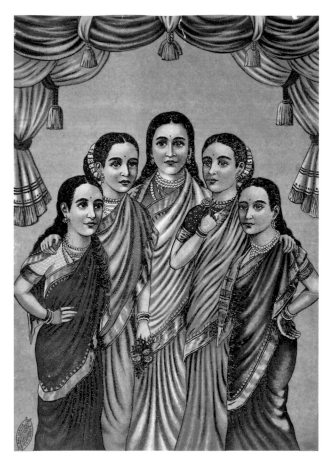

52. *Ahilya, Draupadi, Sita, Tara and Mandodari* (female characters from the Ramayan and Mahabharat), print published by the Ravi Varma F.A.L. Works, Malavali, distributed by Anant Shivaji Desai, Bombay.

I would add, auditory) enjoyment, the lithographs had a similar component, particularly in the case of Ravi Varma's preponderant and immensely popular images of women. The fascination engendered and intensified by the very availability of naturalist depictions of women to the gaze is evidenced in a letter in which one of Varma's patrons, Sir Seshayya Shastri, prefaces a request for paintings on particular themes by saying *"By constantly looking at your paintings*, I have started admiring the pretty faces of your women" (Nair 1953, 66, quoted in Ramachandran 1993, 18, emphasis added). Or again, the conjuncture of naturalist means and iconographic themes recast the discourse of *bhava* (feeling) in terms of the interiorized emotional life associated more with the modern novel and a "psychological" bourgeois subjectivity than with the epic forms of mythology. Something of this productive anachronism is evident in the prints in which characters from the Mahabharat or Ramayan are posed in the manner of bourgeois family portraits and photographs (see figs. 51, 52). This resemblance between the poses found in prints and

photographs has to be seen in terms of a relay, for the prints must also have worked as a model for the subjects of photographs and/or for the photographers choreographing them. (I return to the theme of mimetic relays between images and bodies in chapter 7.)[38]

So while many of these cultural forms claimed continuity with "prior" traditions, they did so in ways that engendered new forms of experience and subjectivity. They also deployed new formulations of cultural identity with which to think about these traditions, albeit partially, "inadequately," and therefore productively, as is the case with any translation—particularly translation across a power divide. My attempt in this chapter has been to provide a sense of how these processes were both enabled and necessitated by the animation and deterritorialization of the sacred image from its moorings in precolonial feudal traditions through the movements of artists and consumers, the formal reinterpretation and reconfiguration of mythic narratives and iconic images, mechanical reproduction, and the beginnings of commodity distribution by, in, and for a vernacular market. In the following chapter I argue that a significant shift occurred in the realm of commercial image making with the increasing recognition, from the second decade of the twentieth century onward, that Indians constituted a sizeable domestic market. If Raja Ravi Varma is to be considered the "father" of Indian calendar art, it is because his lithographic prints, one of the first mass-manufactured "Indian" commodities, mapped the national public as a political-cultural entity onto a pan-national arena of consumption, thereby paving the way for a "vernacular" aesthetic for the domestic marketplace in the twentieth century.

3

NATURALIZING THE POPULAR

If one wants to create something which gives the eyes heavenly
pleasure, then . . . there is no better teacher than nature. . . .
Nature is the supreme God. . . . On seeing works of western artists
of the past, like Michelangelo, Leonardo da Vinci, Raphael, Rembrandt,
El Greco . . . Renoir, Manet, Degas and many of the contemporaries
like Norman Rockwell, Tom Lovell, Andrew Wyeth, Harry Anderson
and others . . . one finds that their study of human figures, animals,
birds, trees, flowers, water, leaves, mountains, waterfalls and all
other natural objects was complete and thorough. This is the reason
that their creations are immortal.

S. M. PANDIT

In 1912, Bhavanishankar Atmaram Oza moved to Bombay from a village in Saurashtra and opened a chemist's shop on Princess Street. In 1922 he was joined in this venture by Vamanbhai Kapadia, who opened a branch of their dispensing chemists' firm in Calcutta; they later extended their operations to Dacca and Rangoon. Oza was one of the many Gujarati businessmen in Bombay to respond to Gandhi's call for Swadeshi, and was imprisoned several times.[1] On one such occasion,

in 1928, the Gandhian activist and doctor Jivraj Mehta (who went on to become Gujarat's first chief minister) suggested to Oza that he start manufacturing a product that would compete with a foreign brand. Oza rose to the challenge, pitting his own Babuline (pronounced Babu-leen) Gripe Water against Woodward's, the popular British brand of infant digestive.

This tale of entrepreneurship, nationalism, and modern medicine is recounted at the beginning of the "History" section of the Babuline Pharma website (http://babuline .com).[2] Its home page currently provides a choice of three links: the first to B. A. & Bros. (Bombay) Pvt. Ltd., distributors of pharmaceutical and diagnostic products; the second to Indo-German Laboratories, producers of colored tablet coatings (now a wholly owned subsidiary of Colorcon USA); and the third to Shri Nathalia Uneval Sevak Mandal, a philanthropic educational trust located in Una, Junagadh that was funded by families from the region including the Ozas. The profile of the Oza family business that emerges from these links is consistent with that of others from the Lohana community to which Oza belonged: migrating from Saurashtra to Bombay, starting out in trade, and then venturing into manufacturing and even multinational partnerships after the First World War, but without relinquishing their bazaar-style trading base, and all the while actively participating in a community ethos and maintaining links with an ancestral place of "origin." Such features also characterize family businesses emerging from other bazaar communities: keeping one foot in bazaar-style trade or speculation while venturing into modern manufacturing, and maintaining close ties with the community and "giving back" to one's place of origin while also expanding geographically and forging new associations. A particularly well-documented instance is that of the Marwaris (R. Ray 1992, 58–59; O. Goswami 1992; Timberg 1978; Hardgrove 2002).

NATURALISM, THE "POPULAR," AND THE BAZAAR

The Swadeshi gesture of B. A. Oza and other manufacturers like him constituted the nation as both market and locus of production. In doing so, these manufacturers added the mediating category of the nation-space to the bazaar's networks of commerce and community. If, as we saw in the previous chapter, Raja Ravi Varma's prints actualized the spiritual-civilizational imaginary of late-nineteenth-century nationalist thought, early twentieth-century Swadeshi deployed domestically produced commodities in general to posit economic autonomy as a basis for the claim to nationhood. Taking issue with Benedict Anderson's emphasis on the literary manifestations of "print capitalism" in forging

a sense of national identity, Satish Deshpande points out that in the Indian instance not only written texts but also commodities came to be imbued with a nationalist charge, serving as "mnemonics" of nationalist philosophy and the nation-space, and delineating the nation as an "imagined economy" (Deshpande 1993; Anderson 1991).[3] By positioning calendar art within the context of commercial culture in twentieth-century India, I want to build here on the characterization of mass-produced commodities as vehicles for imagining and performing community and identity: not only national but also regional, linguistic, sectarian, and caste- or class-based. This chapter examines printed images as commodities in the culture industry, along with what I will argue are the crucial intertexts of the cinema and illustrated magazines. It also looks at images in their capacity as part of the shiny skin, the *schein* (Benjamin 1985, 40), of other commodities: as labels, packaging, and advertisements, including calendars.

My attempt here, as throughout, is to work at the switching point between the "textual" or representational register of the visual idioms of commerce and the performative efficacy of these images in their animated and animating capacities as objects: as *things* produced, circulated, and used in the marketplace. In the first half of this chapter I look at the different kinds of signifying schemata deployed by commercial images in a growing domestic market. My particular concern here is how the characterization of the bazaar in the previous chapter (as an image field at the interface between colonial or European-style corporate cultures and a primarily vernacular commercial arena) has an impact on the way the category of naturalism has figured in the discourse about Indian popular images. Attending to the deployments of naturalism in the twentieth-century genealogies of calendar art shows how visual print capitalism worked through heterogeneous modes of signification, variously ranged (contra Anderson, as well as some of his critics) between the religious and the secular, to shore up a range of identity formations both supplementary to nationalism and forged in its image. The second half traces how local entrepreneurship directed at regional markets, and visual media aligned with specific vernacular languages, both tempered and reinforced the overarching pan-national aspirations of Swadeshi print capitalism, and then of Sivakasi's more widely inclusive post-independence reconfiguration of the national popular. Here I mainly focus on the regional context of Maharashtra as a site for the rise of a set of vernacular culture industries, briefly sketching some of the ways in which the address of images was informed by multiple arenas of patronage and production. If my aim in the previous chapter was to de-naturalize the category of a national popular that has tended to underpin the discourse

on images in the Indian culture industries, here I suggest that the formation implied by this primarily retrospective term can be located in a specifically post-independence configuration of the pan-national market.

As we saw in the previous chapter, scholars seeking to distinguish between "Indian" and colonial or "Western" image traditions have had an ongoing investment in the issue of naturalism (the use of techniques such as perspective or the modeling of volumes using light and shade, with the aim of providing an accurate pictorial imitation of nature). While Havell and Coomaraswamy condemned Ravi Varma's adoption of naturalism as inauthentic (because it was "Western"), more recent analyses have read the obdurate iconic frontality, temporal recursivity, and indexicality of Indian images in terms of a "popular" negotiation with colonial ideologies of space, time, and signification. Particularly emblematic of the colonial episteme is the stilled or frozen perspectival frame, with its implied linear temporal continuum and unitary viewing position. As the sign of a limit to colonial power the "popular" resistance to naturalism shores up a subalternist postcolonial politics (Pinney 1997a, 1999); as a repository of "tradition" it is appropriated by the marketplace (Rajadhyaksha 1986, 1993b); however, it also holds out the hope of providing the aesthetic resources for a national, cultural avant-garde (G. Kapur 1993b). While these accounts differ significantly, particularly over the question of subaltern subversion (Rajadhyaksha 1993b, 53), they are also marked by some shared terms, notably the category of the popular. Again, the way this term is used varies significantly. It can be an arena implicitly defined in opposition to the elite and/or colonial (Pinney 1997a); an informal, noncommodified realm of cultural practice (Rajadhyaksha 1986, 28–29), which is then recognized as an idealizing, retrospective construct (that is, as capitalist nostalgia for precapitalism: Rajadhyaksha 1993b, 52–53); or an art historical "catch-all . . . an eclectic impulse accompanying social change" (G. Kapur 1993b, 20–21). However, to the extent that they all—I think rightly—link the forms taken by the negotiation with naturalism to the ritual and devotional components of image traditions in India, they implicitly characterize the popular in terms of an homogenizing religiosity. They also tend to cast the popular in terms of an urban-rural divide, so that popular resistance is aligned with rural markets (Pinney 1997a, 860), while the culture industry is associated with urbanization (Rajadhyaksha 1986, 27).

How do these assumptions about the "popular" square with the characterization of the bazaar as a vernacular network of production, consumption, and circulation of images, mediating *between* elite and popular, colonial and native, urban and rural, formal

and informal, bourgeois and feudal—a network whose valency has persisted well after independence? Or again, more specifically, how might an homogeneous "popular" as a site of social change, co-option, or resistance register the kinds of distinctions I argued for in the previous chapter, such as those between the Nathdwara or Tanjore traditions with their relatively affluent patrons, and the cheaper woodblocks or *pata* paintings?

The bazaar emerged in the previous chapters as a realm of both subordination and semi-autonomy vis-à-vis the colonial state and then the post-independence English-medium technocracy. But with the growth of the domestic market for locally produced consumer goods, including the products of the culture industries, it also developed as a realm of relative cultural hegemony vis-à-vis other vernacular constituencies. In this intermediate role, vernacular and nonbourgeois yet dominant, the bazaar problematizes bipolar accounts that counterpose the Indian "popular" to the "colonial"/"Western" or "capitalist," thereby causing each of these domains to congeal into singular, fixed entities (for a critique along similar lines, see Ahmed 1989 on Jameson 1986). As I seek to demonstrate, *neither* of these domains is homogeneous, consistent, or ontologically given; both are sites of "mutually conditioned historicities" (Chatterjee 1993, 13). What has come to constitute the category of the "popular" or "mass" in India is not simply an undifferentiated site of subalternity in relation to colonial/elite ideologies or capitalist institutions but also a site of hegemony and contestation *within* an arena of "vernacularizing" capitalism (see chapter 1).

At the same time, powerful as they have been, the European post-Enlightenment ideologies informing colonialism, capitalism, nationalism—and indeed naturalism—are not necessarily consistent with the high degrees of fluidity that these phenomena have demonstrated in practice, both "internally" and at their interface with heterogeneous moral, political, and aesthetic systems.[4] As we will see, the story of commercial image making in the twentieth-century bazaar is not just one of a resistance to naturalism but also of an irrepressible fascination with it, and hence of an *ongoing* negotiation between naturalism and iconicity. And to this extent it also reminds us that naturalism everywhere has not only served the Enlightenment's will to instrumental reason but also its dialectic (Adorno and Horkheimer 1972): the West's own enchantment by mass culture and commodities; the irrational forms of its desire for community; its indispensable entanglement in heterogeneous economies.[5]

My argument, therefore, is that in calendar art and other forms of commercial imagery circulating in the bazaar it is not entirely useful to understand the contest simply as

one between popular Indian and colonial/Western "visual cultures" and their attendant modes of subjectivity, or between precapitalist forms and a singular culture of "capitalism." For it is also a contest between the expansive, deterritorializing aspect of capitalist mass production, with its implications of social linkage and mobility, and that aspect which both nurtures and thrives on the reterritorializing, stratifying logic of social power (to follow Deleuze's and Guattari's characterization of the "axiomatic" of capital: 1977, 1987). As I suggested in the previous chapter, the hybridity of commercial imagery as an arena of power is better understood not in terms of a contest between distinct, predefined "cultures" but in terms of the multiple articulations that actively *produce* categories of identity such as the popular, national, Indian, Western, international, regional, local, communal, and so on. Here I extend this argument to show how the problematics of hybridity are not confined to the relationship of colonizer and colonized or to "intercultural" exchange. They are also relevant to the reconfiguration of social relations "within" what now emerges as a national culture: a culture that in turn provides a model for other forms of identity.[6] In this light, I contend, the deployment of new image-making techniques, including technological mass reproduction and elements of "Western" naturalism, helped mass-manufactured images to forge an arena of common address across varying social constituencies — that is, to "naturalize" an expanded category of the popular. These "cultural" linkages had a certain strategic efficacy in providing shared or hegemonic ideological resources, notably for anti-colonial nationalism and then for the resurgent Hindu nationalism of the late twentieth century. At the same time, however, these primarily virtual links forged by print capitalism across deep social divisions were not necessarily consciously acknowledged or reinforced in everyday social interaction. The tenuousness, ambivalence, and indeed disavowal of such mass-mediated social articulations (which I examine in detail in the next chapter) militate against positing a homogeneous category of the popular, or a straightforward narrative of technologically determined social change.

So the following account attempts to chart a course between the existing positions on naturalism and the popular in the bazaar, seeing each of them as valid components of a processual understanding of mass culture and social change. Claims about the resistance to naturalism, while justified, need to be supplemented by a consideration of the processes that were *enabled* by those elements of naturalism (and indeed of modernism and neotraditionalism) that *were* appropriated across a range of mass-cultural forms, even if this expansive movement was only a means toward reinstituting a conservative, generic holding pattern. One such process, in the register of representation, was the forging of

new social and symbolic configurations through formally innovative reinterpretations of familiar themes and objects. Another such process, at the level of social organization, was the culture industries' institution of relatively socially indeterminate professional arenas. In what follows, I introduce three sites where these performative processes of reconfiguration have been particularly in evidence, which I develop in my discussion of the economies of calendar art from chapter 5 onward: the use of iconic bodies in commercial images, the figure of territory in and around images, and the socially and geographically mobile persona of the artist.

TRADING IN IMAGES (OR, CONSUMPTION AND ITS CONSEQUENCES)

To make these rather abstract issues more easily digestible, and to get my roughly chronological narrative of the twentieth-century genealogies of calendar art under way, let me briefly recourse once again to that indispensable commodity, gripe water.

The Swadeshi culture of domestic manufactures emanating from the bazaar, such as Babuline Gripe Water, developed alongside the concurrent formulation of consumer identity by Euroamerican companies such as Woodward's. In 1932, around the time B. A. Oza started producing Babuline, Woodward's published a calendar advertising its gripe water; it was printed in England but illustrated by an Indian artist, Mahadev Vishwanath Dhurandhar (1867–1944). Dhurandhar, like Raja Ravi Varma, used illusionist techniques in oil and watercolor to illustrate Indian mythological, historical, and literary themes. Thus, also like Varma, as we will see, he had to negotiate the "representational dilemmas" inherent in depicting timeless divinities and moments from epic narratives within a historicizing, naturalist still frame (G. Kapur 1989). Located squarely within the mainstream of "fine art" activity, Dhurandhar was trained at Bombay's J. J. School of Art and went on to enjoy the highest level of success that a "native" artist at the time might hope to achieve, regularly winning awards at exhibitions and eventually becoming J. J.'s first Indian headmaster. His work testifies to the fact that despite the criticisms of the neotraditionalists in Bengal, Indian fine art, particularly in Maharashtra, continued its involvement with European-style naturalism. As Calcutta celebrated its "Bengal Renaissance," the J. J. School remained a bastion of naturalism, with W. E. Gladstone Solomon, its principal from 1919 onward, centering his own "Bombay Revival" of Indian art on the idea that "Indian Art is *permeated* with Realism" (Solomon 1926, 117; emphasis in the original).

Dhurandhar's illustration for the Woodward's calendar (fig. 53) depicts a smiling in-

53. A calendar for Woodward's Gripe Water by M. V. Dhurandhar, 1932. (Collection of Ambika Dhurandhar)

fant Krishna standing in the center of the frame resplendent in his peacock feather crown and ornaments, one hand full of butter and the other on his stomach, subtly signaling the threat of indigestion. Immediately behind Krishna, unusually, are *two* naked male babies (the conventional depiction is only of Krishna and his brother Balaram), notably fairer and relatively unadorned, also tucking in to the butter pot. Their faces, like Krishna's, are frontally directed at the viewer, although only the baby on the right engages the viewer's gaze. Central to textual descriptions of the famous *makhan-chori* (butter-stealing) episode is the discovery of this mischief by Krishna's doting foster-mother Yashoda. Yashoda is a rural cattle-herder's wife; here, however, a modern, middle-class, sari-clad mother is peeking out pensively at this scene from an elaborately carved doorway, her eyes lowered toward the children, combining a "frozen moment" narrativity with the frontal tableau of the oblivious butter-eaters. It is almost as though the Krishna figure has a doubled presence (in keeping with his mythic ability to reveal himself in multiple

aspects). One Krishna appears in realist, narrative mode as an ordinary, everyday (albeit fair and middle-class) infant about to suffer indigestion, with an ordinary sibling and a concerned mother. The other appears in an iconic, frontal, explicitly godly (and explicitly racialized) form, as a materialization from another dimension, or from a happy future, free—thanks to Woodward's—from gripes.

This calendar is unusual in its simultaneous deployment of two distinct registers of signification. One is a representational register that uses perspectival naturalism to develop a narrative and (as I discuss below) to evoke an allegorical reading. The other is an indexical register whose frontal address acknowledges the viewer and institutes an iconic (that is, divine) presence. Also, while the calendar's theme evidently derives from Hindu traditions, its copy, extolling the virtues of Woodward's Gripe Water for keeping babies healthy, is in English and Portuguese. The calendar's peculiarly doubled address could be read as soliciting a domestic market comprised of both European residents and a modernizing Indian elite.[7] To this extent it represents something of an aberration, a path not taken: we now know, as Woodward's and Dhurandhar did not, that colonial residents as a constituency and their social articulation as consumers with an Anglophone Indian elite were not to last. However, it is not exceptional in demonstrating that it is more than likely that Western firms took the lead in mobilizing "Indian" mythic and religious themes in the domestic commercial arena (I develop this claim below). Also, however aberrant and fleeting the particular social articulation it enacts, the calendar serves to demonstrate how commodity aesthetics provided a ground for reformulations of community and locality, in this case by drawing colonial residents and the Indian elite into a common frame of address.

These processes of reformulation were driven by the opposing expansive and conservative imperatives of mass production: to solicit the largest possible audience while also drawing on familiar frames of reference, value systems, and modes of signification. In this particular image, Dhurandhar's mediation of mythic references and an iconic figure via a secular, narrative naturalism enabled Woodward's to use the same image to reach "native" and European Indian audiences. At the same time, mass reproduction and commodity culture also fostered social mobility and new social articulations *within* and *between* "native" constituencies: the feudal gentry and caste-based elites; the emergent entrepreneurial and professional-technocratic middle classes; the trading communities of the bazaar; the rural and urban working classes and castes. The market's address to domestic consumers of varying degrees of vernacularity both created com-

monalities and reinforced distinctions between them, constituting an expanded arena of the "popular" while reformulating sectarian, linguistic, and territorial identities (an instance of the latter is the Sivakasi industry's production of regional iconographies, described in chapter 1). What is more, the professional opportunities provided by a growing industrial-commercial arena were often a source of significant social mobility for the artists themselves, many of whom (again, like Dhurandhar) came to embody an intersection between different economic and geographical contexts of production, between varying political agendas, and between different visual media within the culture industries.

According to Rajat Kanta Ray's periodization of industrial development in India, the First World War was critical to the growth of domestic manufacturing (R. Ray 1992, 50–63). This was due in part to a reduction in imports and in part to the lucrative futures trading (*futka*) in the bazaar during that period, particularly by the Marwaris, which simultaneously disrupted internal supply lines to the expatriate managing agencies and provided bazaar firms with large windfalls of capital to invest in industry. Ray, picking up on a comment by the Marwari historian Balchand Modi, observes that "trader-industrialists" such as the Birlas who maintained their speculative and trading activities in the bazaar fared better during this period than the "Westernized" textile firms of Bombay (R. Ray 1992, 58–59; Modi 1940, 559–61); according to Timberg (1978, also 1992) the Birla brothers made substantial speculative profits from opium during the war. While the Birlas pushed into the existing export industry of jute and the Tatas mounted an ambitious and successful foray into steel, other firms emerging from the bazaar after World War I focused on products for the domestic market such as cotton textiles, sugar, and paper that required relatively simple technology. This market already carried a variety of commodities for mass consumption such as matches, soap, *beedies*, ink, oils, tonics, non-allopathic remedies, incense, and candles: the kinds of products advertised in the first decades of the twentieth century in the woodblock-printed Bengali almanacs produced at Battala and to a limited extent in the vernacular press.[8] One instance of the latter was Amrutanjan pain balm, produced from 1893 onward by the freedom fighter, reformer, and journalist Nageswara Rao Pantulu and advertised on the front page of his Telugu newspaper, the *Andhrapatrika*, which he established in Bombay in 1908 and moved, along with the Amrutanjan factory, to Madras in 1914 (see fig. 54; note the association of the product with the figure of a woman and a map of India: on the feminized "bodyscape" as a common trope of early nationalism, see Ramaswamy 2003).

Unlike the export market on which the managing agencies depended, the domestic

54. An advertisement for Amrutanjan balm featuring prominently on the cover of the Telugu language newspaper *Andhrapatrika*, ca. 1910. (Reprinted with permission from M. Chalapathi Rau, *The Press* [New Delhi: National Book Trust, 1974].)

market weathered the instabilities of the war and the Depression. However—and this is where firms like Woodward's came into the picture—the interwar period, starting around the mid-1920s but increasingly through the 1930s, also saw the entry of multinational corporations into the domestic market for middle-class consumer goods and technology-intensive products. Companies setting up manufacturing operations in India during this period include Lever (Sunlight soap), Wimco (matches), Associated Biscuit Manufacturers (Britannia biscuits), Dunlop (tires and rubber goods), Bata (shoes), and General Electric and Philips (light bulbs). At the same time, overseas-based commodity manufacturers also sought to "Indianize" their products through advertising or, as British textile mills and managing agencies had done, through labeling (figs. 55 and 56). In what is by now a familiar operation, a set of signifiers that developed in the context of resistance, in this case anti-colonial nationalism, were seized on by what we might think of as the repersonalizing logic of commodity marketing. If, as we saw in the previ-

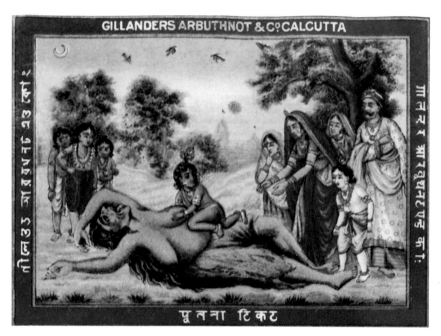

55. *Putana Ticket*, product label for Gillanders Arbuthnot and Co., Calcutta, depicting Krishna's victory over the demoness Putana. Founded in Calcutta in 1819, Gillanders Arbuthnot was a managing agent for jute mills, tea estates, collieries, railways, insurance, timber, and building and engineering companies; it was also involved in shipping indentured labor from India to Mauritius and Guyana. The company survives in India as part of the Calcutta-based Kothari Group, a family firm founded by merchants who emigrated from Bikaner (Rajasthan) to Calcutta in 1875, rising to prominence during the First World War as traders in jute, hessian, oil, seeds, and bullion. (Collection of Priya Paul)

ous chapter, *pauranic* imagery was used to forge an Indian cultural identity that formed a basis for the independence movement, it was also quickly adopted as an instant cipher of Indianness, particularly by foreign firms seeking to tap into the "native" market.[9]

Indeed, it was most often *pauranic* images from the Ravi Varma Press and elsewhere that were directly reproduced as labels and advertisements, primarily (if not exclusively) by foreign-owned firms (compare figs. 53, 55, and 56 with figs. 54, 57, and 58). Small colored labels featuring popular imagery were directly affixed to commodities intended solely for the "native" market, such as mill cloth and matches (fig. 59, the latter produced by Japanese as well as European firms), while products whose labels needed to reflect a more global corporate identity used advertising posters and calendars to target Indian consumers. Surviving instances include a 1914 calendar advertising hair dye and tonics from the London drug and chemical firm of Burgoyne, Burbidges and Co., with a *Gangavatarana* image featuring a Shiva with thick and lustrous locks, captioned "After the

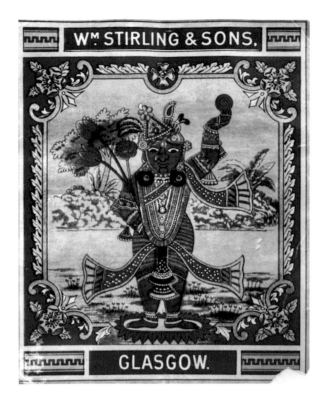

56. Cloth label or "ticket" from William Stirling and Sons, Glasgow, calico printers who were also, from 1890 to 1920, among the major producers of the popular Turkey red dye (which does not fade in bright sunlight). The company later became part of the conglomerate United Turkey Red Company (UTR). The label depicts Krishna as Shrinathji (one of the forms worshipped by the Pushtimarg sect). The uncharacteristic convex curve of the upper eyelids and the rose that appears with his usual lotuses suggest that this Shrinathji might be a British artist's reinterpretation. (Collection of Priya Paul)

picture painted by the late Raja Ravi Varma" (Tuli 2002, 47 fig. d); a 1930 advertisement for Sunlight Soap whose baleful Krishna was probably derived from a Nathdwara or Calcutta print (Tuli 2002, 48, fig. a); and a poster for Mellin's Food for Infants and Invalids (produced in Boston, Massachusetts) featuring a version of Ravi Varma's *Birth of Shakuntala* (Mitter 1994, fig. xx), depicting the sage Vishwamitra's refusal to accept the baby daughter that Menaka is presenting to him. Another poster for Woodward's Gripe Water (artist unknown, but very likely Dhurandhar again) similarly has the product and logo tacked on to the corners of the picture, which features a gentrified, sari-clad mother and naked infant son with a cow (or bull?) and calf, again reminiscent of Krishna and Yashoda, like the company's 1932 calendar discussed above.

It is hard to tell whether this Woodward's poster used a specially commissioned painting or adapted an existing print, as in the Mellin's Food and Burgoyne, Burbidges posters. Like Dhurandhar's 1932 calendar, however, it uses the mother-child relationship as the common contour in mapping the everyday concerns of a modernizing Indian middle class (including European residents) onto mythic narratives. To this extent the Mellin's, Woodward's, and Burgoyne, Burbidges posters all deploy naturalism to establish a the-

57. *Hindi Bala* (meaning "Indian maiden," or, more accurately, "maiden from Hind"), a secular label for Sindhi Vaishnava merchants with kin-based affiliates in Bombay, Karachi, and Sind. Note that the picture caption, with its nationalist flavor, is in Hindi, while the trade name is in English. (Collection of Shafi Hakim)

matic relationship between the product and the image used to promote it. They thereby create an allegorical, if not playfully ironic (or simply clueless, as in the Mellin's poster), correspondence between gods and mortals. The schema of signification here, as in neo-classical painting, is one in which gods and heroes from a "classical" past are deployed as figures with lessons for present human conduct. This is consistent, for instance, with the adoption by Woodward's of *The Infant Hercules Strangling the Serpents* (1786–88) by Joshua Reynolds as the trademark for their gripe water (this appears on one of the butter pots in Dhurandhar's calendar). But this schema of allegorical correspondences with a mythic past belongs to an Enlightenment working hard to achieve and maintain a secular, "post-sacred" universe (Brooks 1975), as opposed to a system that seeks to maintain the sacred as ever present, integrally inhabiting everyday life. If Dhurandhar's butter-stealing cal-endar — which was expressly commissioned as an advertisement — is particularly strange and compelling, it is because of the doubled Krishna figure's simultaneous submission and resistance to this kind of allegorization, its struggle against consignment to a mythic

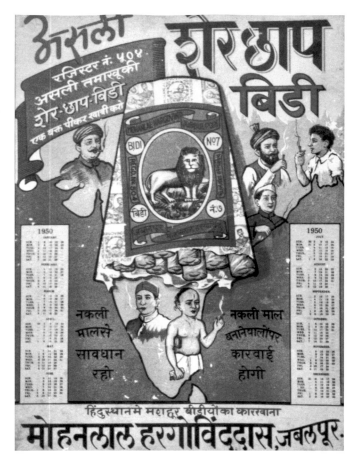

58. A 1950 calendar for Sher Chhap (Lion Brand) *beedi*es (hand-rolled cigarettes), manufactured by Mohanlal Hargobind Das, Jabalpur, its secular, nationalist imagery depicting (male) smokers from an assortment of communities (caste, regional, religious). The text carries the warnings: "Beware of imitations" and "Imitators will be prosecuted." While this text is in Hindi, the names of the months are in English, and the numbers in Roman script. (Collection of Priya Paul)

past. It oscillates uncannily between an allegorical mode aligned to a bourgeois historical consciousness, which seeks through *representation* to ennoble a mortal act of consumption, and an indexical mode that seeks to imbue the body of the *image itself* with the eternal, timeless cosmic presence depicted therein. To cite a later (or rather retrospective) instance of how this indexicality affects the image as an object: according to the current Babuline management, the company decided from the outset to use an image of the infant Krishna only in its calendars and other publicity but not on its packaging because a package is meant to be thrown away (a disrespectful and inauspicious act).[10]

The use of "motivated" thematic or representational links establishing an allegorical correspondence between the actions of mythic and human figures was readily adopted to political ends during the colonial period by vernacular cartoons, chromolithographs, theater, and film (see Mitter 1994; Pinney 1997a). However, my sense is that this mode of signification was relatively unusual in the bazaar's commodity aesthetics, where the

59. Ravi Varma prints reproduced on matchbox labels made in Austria and Sweden depicting Krishna vanquishing the demon Dhenukasur (left), and Arjun and Subhadra (right).

use of mythic imagery has tended to invoke ethically and sacrally invested objecthood rather than allegorical resemblance. Images of deities (or indeed, secular images) that were featured on woodblock labels for early-twentieth-century domestic manufactures, as well as subsequent lithographic labels and advertisements, did not necessarily draw attention to the specific qualities of the product or the benefits of its use (see, for instance, the woodblock illustrations in P. Ray 1983, 103 and fig. 60, another Dhurandhar advertisement, this time for a locally made product). In such instances of labels, trademarks, and calendars with apparently arbitrary connections to their products, the association with a divinity would have worked in an indexical register to seek the deity's blessings and to impart auspiciousness not only to the calendar or image itself but also to the product, its use, its manufacture, and the transactions in which it was involved. (I elaborate on the idea of auspiciousness in chapter 5.) Similarly, associating products with maps of India, as in the Amrutanjan and Ashokarishta advertisements (figs. 54 and 61), served to imbue products, their manufacture, and their use with an ethical aura via the nationalist ideology of Swadeshi, which itself had a libidinal-sacral appeal through the divine and/or feminine bodies inhabiting these maps (Ramaswamy 2003).

Still in the indexical mode, yet linking a product with the use of an icon in its marketing, labels and advertisements also often traded on an association between the product's

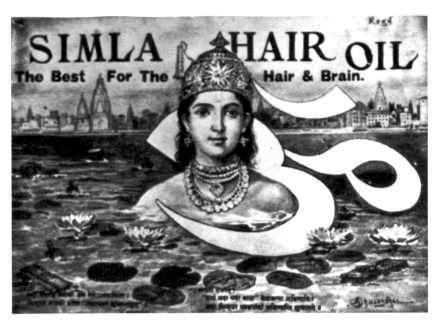

60. Advertisement for Simla Hair Oil, "The Best For The Hair and Brain," by M. V. Dhurandhar. (Collection of Ambika Dhurandhar)

61. A label for Ashokarishta tonic, "an unfailing remedy for all female trouble and general debility," depicting Krishna against a map of India, manufactured by Bharatiya Aushadhalaya, Mathura (Mathura is an important center of Krishna worship). (Collection of S. Courtallam)

use and the invocation of a deity. For instance, the use of Saraswati as a trademark by the Calcutta firm of P. M. Bagchi and Co. in the early twentieth century (Pattrea 1983, 105) may have been linked to the firm's primary business as government ink contractors because Saraswati, as the goddess of learning, is associated with writing (hence also the preponderance of iconic imagery on contemporary incense and candle packaging). Or again, in a roughly contemporaneous color poster (fig. 62) the Asiatic Petroleum Co. (India) Ltd., the Anglo-Dutch forebear of Burmah-Shell, makes an elaborate textual case for metaphorically linking the appearance of the goddess Lakshmi to their Rising Sun Oil (kerosene used for lamps and cooking).[11] Here, as in the Dhurandhar calendar, there is a doubled idiom at work, in which a frontal, iconic Lakshmi appears in relation to a narrative scene of small, very dark natives in a verdant rural setting hailing the rising sun and the goddess, her bounty falling from the heavens in the form of boxes of kerosene.

Crucially, however, the distinctions I am making here between modes of signification in commodity aesthetics do not necessarily correspond to images produced by overseas and/or colonial firms as opposed to Indian firms. While it is possible to think of Woodward's and Mellin's as expressing a post-sacred, "Western" sensibility in their posters (Woodward's is a British firm, and Mellin's an American one), the same does not go for the British managing agencies, who were among the first to use iconic Hindu imagery on brand labels.[12] Early textile labels occasionally featured depictions of cloth merchants' shops, but by and large the imagery on textile and matchbox labels seldom had a representational association with the product or its use (as in figs. 54–61). The choice of mythic themes for many of these labels, particularly by European firms, may have derived from an Orientalist characterization of Indians as "superstitious," or simply from the ready availability of printed images with proven commercial success, or both. Either way, far from enforcing a post-sacred or secular ideology, or maintaining the divide between "this-wordly" and "other-wordly" realms organizing the "Protestant ethic" (Weber 1976), at this particular interface with Indian consumers colonial expansionism served to inscribe a space where the workings of commerce and the sacred were indissociable. If *pauranic* imagery in the style of Ravi Varma had a history of mimicking Western naturalism, in replaying this imagery back to Indian consumers as part of the *schein* of the commodity it was now the colonizers who mimicked (their version of) the colonized. The bazaar was a phenomenon of the colonial economy and the colonial state: a buffer zone whose mediation, and indeed maintenance, of arenas of difference from the avowedly liberal, post-Enlightenment ideology of the colonial state was crucial to the exercise of colonial

62. A poster advertising Rising Sun oil (kerosene) produced by Asiatic Petroleum, by M. A. Joshi and Co., published by the Ravi Udaya and Vijaya Fine Art Litho Works, Ghatkopar, ca. 1903-28. Translated, the Devanagari text reads: "Holy men say that Lakshmi only appears in the light. Illuminate your soul with service and love; illuminate your mind with wisdom; illuminate your homes with Sun brand (*Suraj chhap*) oil; Sun brand oil is the radiance of darkened homes." (Collection of Shafi Hakim)

power.[13] The managing agencies' use of *pauranic* images to penetrate the domestic market demonstrates the extent to which they, too, were creatures of the bazaar, co-opting "cultural" difference to their own ends and thereby furthering its institutionalization. There is, after all, no basis on which to expect the agents of colonialism, nationalism, liberal-bourgeois capitalism, or any other such system to behave consistently with their own self-representations, that is, not to "cheat": indeed, on the contrary, the forked tongue is a common and well-earned trope (see Chatterjee 1997 on the slippery "rule of colonial difference"). What this implies, then, is that while "messianic" image traditions might be seen as proffering resistance to a certain manifestation of colonial ideology at a particular moment, they cannot necessarily be seen as resisting colonial power in all its forms, particularly those protean, mimetic, incorporative forms associated with capitalist expansion.

By the same token, if the bazaar adopted naturalism to "humanize" the gods and locate them within a quotidian mise-en-scène (A. Kapur 1993b), this did not necessarily entail the triumph of the historicizing allegorical universe implied by images like the Mellin's and Woodward's posters, which were relatively short-lived. As Geeta Kapur has observed, the term "realism" was construed in nineteenth-century Indian discourse "to mean an *enabling technique* rather than a philosophically accredited style of representation within a specific historical context" (G. Kapur 1989, 60; emphasis in the original). Right from the outset, then, there was a distinction to be made between naturalist *techniques* — perspective, anatomy, modeling, the rendering of light and shadow — and the institutionally sanctioned "post-sacred" schemata of signification through which they entered the colonial context: romanticism and the picturesque, neoclassicism, bourgeois realism, ethnographic documentation. The divergence between the two has been a source of tension, particularly for artists who have had to negotiate between the pragmatically "enabling" and "philosophically accredited" versions. (I address this tension in the following chapter.) But here I want to explore what the selective adoption of naturalist techniques enabled, through their relative (but not complete) disentanglement from the specific ideological baggage that accompanied them into the colonial realm.

NATURALISM, NATIONALISM, TERRITORIALITY: THE CASE OF NATHDWARA

One thing that the adoption of naturalism enabled, at least in the context of commercial image making in the bazaar, has been the management of the relationship between

community and territory with the growth of domestic markets and the formation of the nation-state. It is in this light that I want both to support and to qualify Christopher Pinney's assertion that "the impact of western representational schemata was confined—with some exceptions—to what might be termed a 'naturalist blip' between 1878 and 1927. Rather than some inevitable disenchantment there is a contest between different schemata and a complex process of negation, contradiction and critique" (Pinney 1997a, 866).[14] The "inevitable disenchantment" here refers to Benedict Anderson's account of the spread of secular-bureaucratic nationalism (Anderson 1991), which Pinney contests by arguing that Indian chromolithographs demonstrate the persistence of messianic or sacral orders of temporality, signification, and transcendental power, engaging in a non-elite visual "print capitalist" performance of nationhood. A key example here is the inscription of an idealized nation-space by the fecund mythic landscapes serving as a backdrop for the iconic figures in a new phase of Nathdwara art, which began around the turn of the century and was mass reproduced from 1927 onward (fig. 63). These prints, Pinney argues, came to figure a more "subliminal" and thus more "innocent"—but no less subversive—sense of locality than that of elite nationalism, through their refusal of the terms within which the nation was defined by "a colonial order of signs" (Pinney 1997a, 840).

Here the colonial order is characterized by arbitrary linguistic signification, as opposed to sacral indexicality, and a "realist chronotope": the "meanwhile" of "homogeneous, empty time" (Benjamin 1969, 254; Anderson 1991). The latter entails the deployment of linear perspective and "photographic" framing that suggests a truncated continuum, as opposed to the unified, self-contained, frontal space of the "elsewhere" figured in the Nathdwara icons. These colonial devices, Pinney argues, were consciously isolated by chromolithograph artists, who either used them to depict malign, gridded colonial bureaucratic spaces featuring clocks and calendars (his examples here are prints from Calcutta of Khudiram's execution; Pinney 1997a, figs. 12–14) or rejected them in favor of the idealized, timeless landscapes that went on to provide one of the dominant modes of figuring nation and locality from the 1930s onward. The "example par excellence" of this figure of sacralized national territory is the much reproduced *Murli Manohar* (1934) by the Nathdwara artist Narottam Narayan Sharma (1896–1986), whose versions of Lakshmi, Saraswati, Ganesh, and Shiva were also taken up for chromolithography by the (then) Karachi-based firm of S. S. Brijbasi (see fig. 63).

These claims can be further nuanced in ways that actually shore up the broader cri-

No. 201 • S.S.Brijbasi and Sons सत्यनारायण Bombay, Mathura and Delhi

63. *Satyanarayan* (a form of Vishnu), by Narottam Narayan, Nathdwara, published by S. S. Brijbasi and Sons, Bombay, Mathura, and Delhi, ca. 1930s. (Collection of Shafi Hakim; courtesy of Brijbasi Art Press Ltd.)

tiques in Pinney's important essay: the critique of Anderson's emphasis on totalizing, technical-bureaucratic forms of nationalism; of overly "physiognomic" and predetermined readings of the political efficacy of images; and of a "sedimentary" or temporally stratified, historicist account of image production and use. Pinney's own persuasive account of the complex temporal recursions of printed images as they have been created, appropriated, and reused through copying, montage, and adaptation militates against isolating the impact of Western schemata to a singular, specifiable "blip." Indeed, I would argue that chromolithograph artists' redeployment of imagery from both Western and Indian sources complicates the alignment of Western-style naturalism with a "disenchanted," modernist space-time that is clearly negated and contradicted by the forms of an Indian "messianism" (exemplified by the "Nathdwara aesthetic"). For instance, the landscapes appearing in Raja Ravi Varma's *Lakshmi, Saraswati* (fig. 10) or *Vishwamitra and Menaka* and then as a backdrop to the Nathdwara icons, are as much derived

64. Print from the Ravi Varma Press, possibly depicting the demon Kaliya's wives interceding on Krishna's behalf. Rather than providing a "realist" depiction of the landscape around Mathura-Vrindavan, its pastoral backdrop of mountains, cows, and a hamlet draws on the mythic realism of European prints circulating at the time.

from Western representational schemata—picturesque, romantic, pastoral, allegorical, utopian—as are the brutal grids of linear perspective that chromolithographs putatively reject. Landscapes in German and Austrian prints and postcards would have been a direct source (fig. 64), not only for Ravi Varma but also for Nathdwara painters such as Narottam Narayan, via the collections at princely courts such as Udaipur and Jhalawar with which these artists were closely associated (Narottam Narayan's initial training was at Udaipur, and that of his mentor Ghasiram at Jhalawar).[15] In refuting Anderson's totalizing characterization of techno-bureaucratic nationalism it is not necessary to accept the alignment of "Western" representational schemata with disenchantment: to do so would be to ignore those compelling analyses that posit a certain libidinal-sacral element, whether adhering to a "messianic" schema of time and signification or a "post-sacred" variant thereof (Brooks 1975), as a structural feature at the kernel of modern nationalism in general (Coronil 1997; Laclau and Mouffe 1985; Lefort 1986; Taussig 1997, 1999; Žižek

1993; and, in the Indian context, T. Hansen 1999). Positing that no nationalism has been of a solely technical-bureaucratic order allows for the possibility that European landscapes, too, might have been doing their own work of sublime, romantic, or indeed (as in the North American and Australian cases) melodramatic nationalism, with each of these modes of signification indexing a repressed or putatively superseded "messianism."

Conversely, Nathdwara's lithographic engagement with Western representational schemata was a matter not only of "negation, contradiction and critique" but also of incorporation and appropriation. The chromolithographs produced by S. S. Brijbasi from 1927 onward represented a new phase of Nathdwara art, initially associated with Ghasiram Hardev Sharma (1868–1930: Dhurandhar's contemporary), his illustrious apprentice Narottam Narayan, and his associate Hiralal Udayaram.[16] Ghasiram was both chief painter and head of photography for the Shrinathji temple under Tilkayat Govardhanlalji, doing his own developing and printing (Ambalal 1987, 85–90).[17] It is clear that by this time photography was not only setting the standard for naturalism in portraiture but had also become an acceptable part of the image-making process: Narottam Narayan is known to have adopted the practice described in the previous chapter of combining painting and photography (Pinney 1997b, illus. 44, 81). The work of Ghasiram, Udayaram, Narottam Narayan, and later Nathdwara painters such as Kamladevi (Lyons 1997, 107–111) is characterized by a photographic treatment of figures, and in particular of faces: photographic not in the sense of hyperrealism but in the literal replication of the monochrome tonalities of black and white photography, as in the grayish tinge that Narottam Narayan gives his *Murli Manohar, Umapati Shankar,* or *Satyanarayan* (see fig. 63), or that Ghasiram imparts to the Shrinathji figure (Ambalal 1987). There is, of course, an iconographic appropriateness in such a rendering of the dark (*shyam*) Krishna (though later copies of *Murli Manohar* revert to the more familiar blue), but the technique must also owe a great deal to Nathdwara's (quite literal) brush with photography. So this was an appropriation of naturalism, not in its techno-rationalist aspect, but in its personalizing, affective, libidinal aspect, making the divine accessible to devotees as an empathetic presence: as the contemporary Nathdwara calendar artist Indra Sharma put it, the aim of images is to make the viewer *mohit* or *mugdh* (enchanted, seduced).

Even those techno-rationalist devices intimately associated with a "realist chronotope" have been subject to similar selective reappropriations in calendar art. If the Nathdwara icons, addressed predominantly to a Hindu devotional context, rejected the perspectival grid and the time of clock and calendar, the later Sivakasi calendars deploy

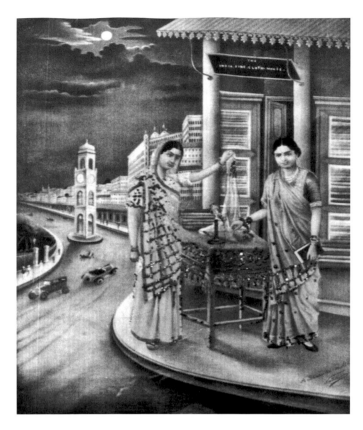

65. Poster advertising the India Fine Cloth House, Nathdwara, publisher unknown. (Collection of Priya Paul)

perspective to mesmerizing decorative effect in their depictions of floor and wall tiles at Muslim shrines. Here clocks also figure prominently, but to "messianic" ends, recalling the five daily prayer times. What is more, signs of bureaucratic modernity and western-ization themselves take on a utopian aura, as in the occasional framing pictures and calendars featuring painted city views. In an early instance from Nathdwara (fig. 65), a soaring perspectival view over a modern city (possibly modeled on Bombay's Marine Drive) swoops in a baffling curve past two Gujarati women buying cloth at "The India Fine Cloth House," such that stacked bales of cloth echo the proportions of high-rise buildings; a telephone features prominently in the shop, while one of the women holds a book. Here naturalist technique and an iconography of modernity speak to the Nehruvian interpretation of Swadeshi as a home-grown version of modern development, while the figures of sari-clad women serve to anchor that vision in a national culture. (On this oft-repeated strategy, see Uberoi 1990; Guha-Thakurta 1991; contrast this to the all-male visualization in fig. 66, also from Nathdwara, of the alternative Gandhian utopia of a rural

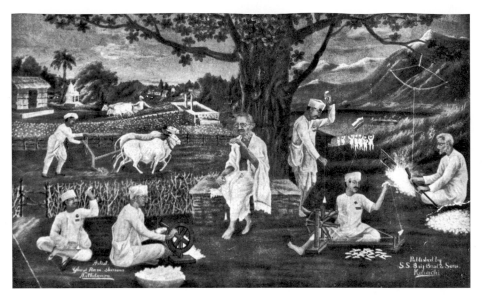

66. *Way to Swaraj* by Ghasi Ram Sharma, Nathdwara, published by S. S. Brijbasi, Karachi, ca. 1930s. The imagery refers to Gandhi's call for Swadeshi self-sufficiency emanating from village-based communities and his advocation of the symbolic performance of manual labor. (Collection of Priya Paul; courtesy of Brijbasi Art Press Ltd.)

Ramrajya that does not need women to assert its indigeneity.) Signifiers of Western-style modernity are also incorporated in later prints as part of the regalia of modern forms of transcendental power, as with the watches that are de rigueur even in sacralized depictions of "leaders" in the struggle for independence (figs. 67 and 68; I return to the resacralization and eroticization of emblems of modernity in chapter 6).

But whether it involved negation or reappropriation, on whose behalf was this pictorial engagement with naturalism being conducted? The Nathdwara images were taken up for reproduction by the firm of S. S. Brijbasi, which went on to become arguably the most successful, enduring, and influential publisher in the framing picture and poster market. However, while most publishers in the 1990s, including Brijbasi, described themselves as catering to a rural, poor, "uneducated" constituency, it is unlikely that Brijbasi's early chromolithographs reached the kind of rural mass market that its post-independence offset prints did, particularly once the use of Sivakasi presses brought prices down even further. My own sense, based on what can be gleaned of the provenance of chromolithographs in the collectors' market and my observations of the prints displayed in rural homes, is that the devotionalism or "messianism" of pre-independence chromolithographs catered more to bazaar trader-entrepreneurs and professionals based in rural

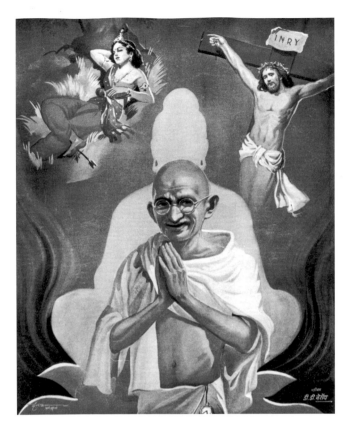

67. *Vande Mataram* ([Mother, I bow to thee], a reference to the famous nationalist anthem by Bankimchandra Chattopadhyay), by Dinanath Dalal, Bombay (the image also bears the imprimatur "Blocks: D. D. Neroy"), ca. 1970s. Here Gandhi, with a watch dangling from his dhoti, is encased within the silhouette of a Gandhara-style Buddha; a further association with Krishna and Jesus is established through the ritual elements of flames and wafting smoke. (Collection of Shafi Hakim)

and urban centers (or circulating between them), and to rural landowners, than to the rural poor.[18] It is more likely to have been the later, post-independence expansion of this market, particularly via centralized mass production in Sivakasi, that instituted a realm of common address between the vernacular constituencies of the bazaar and the rural and urban poor. So the selective adoption of naturalist techniques embodied in the Nathdwara imagery needs to be understood in terms of this earlier configuration of the "non-elite" market, and of the bazaar as a third term mediating between the elite and/or colonial and the "popular."

In fact I would argue that the social context of the bazaar's trading communities is particularly pertinent to the embrace of landscapes, and to the specific form of object-hood of framing pictures and posters (as opposed, say, to books, magazines, or films). It is no coincidence that the intense elaboration of landscapes as portable figures of territory in iconic prints should emanate from the image culture of Pushtimarg, with its increasingly mobile, largely mercantile followers (as described in the previous chapter).

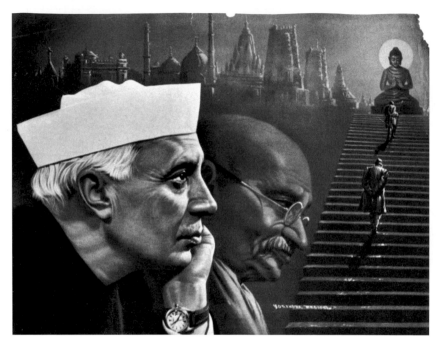

68. A calendar design by Yogendra Rastogi depicting Nehru and Gandhi ascending toward the Buddha and enlightenment (with Gandhi leading). Both figures are shown twice, once in the foreground, looking meditative, and then again ascending the steps in the background; it is as though they simultaneously inhabit two different registers of time. Note the watch prominently displayed on Nehru's wrist: in this context it appears to connote *kala*, time overshadowed by fate, rather than the "empty, homogeneous" time of modernity. (Collection of JPS and Patricia Uberoi, Delhi)

Indeed, this artistic source was tapped by S. S. Brijbasi through its own combination of mercantile mobility and religious affiliations with Pushtimarg.[19] Brijbasi's prints, like the Nathdwara pilgrim souvenirs, were geared toward the personalized worship made possible by portable images, providing a self-sufficient embodiment or housing for a divine presence. This worship was personalized both in the sense of catering to the individual devotee (as opposed to a large congregation in a temple), and in the sense of imagining a humanized divinity. Individualized worship was enabled by the mass reproducibility of icons, while the humanization of the divine was aided by the naturalist depiction of benevolent affect, echoed in the fecundity of the landscape. Abstracted and deterritorialized from the spatial specificity of particular temples, the control of priests, or pictorial association with particular patron-devotees, these mobile, mass-reproduced icons begged the question of their location. Ravi Varma provided his frontal, iconic Lakshmi and Saraswati, and Narottam Narayan his bucolic Krishna, with their own auratic loci

to accompany them on their travels, situating them within imaginative landscapes that were limitless, replicable, and portable even as they evoked specific quasi-mythic territories: Braj and Vrindavan from the Krishna-lila narratives; Mount Kailash and the Himalayas in the Shaivite images; the forests of Panchvati, Ayodhya, Lanka, and other sites from the Ramayana; Vishnu's cosmic ocean; and so on.

The miniature traditions of Nathdwara, Bundi, Kota, and Mewar were already characterized by their use of lush, overwelling landscapes to intensify devotional desire and affect in narrative contexts, for instance when illustrating devotional poetry. However, these narratively bound landscapes did not accompany liturgical figures: the gaze they engendered was too mobile to evoke the frontal convergence said to characterize the engagement with the devotional icon (Rajadhyaksha 1993b, 54–55; G. Kapur 1993b, 23). I would suggest that what the Nathdwara artists took from the naturalist landscapes of indifferently painted European picture postcards was precisely their perspectivalist spatiotemporal *stilling* of the viewer and the viewed, which worked to counteract both the mobile gaze of the miniature tradition and the mobility of the image itself as an object (see, for instance, fig. 64). Perhaps the migration of naturalistic backgrounds into iconic imagery was also facilitated by the replaceable and portable painted backdrops (*pichhwai*) of Pushtimarg rituals, which instituted a certain flexibility in "locating" the liturgical icon. In a sense, then, the Brijbasi prints reterritorialized "landscape" itself, appropriating it from the narrative contexts of both miniature painting and Western academicism to instate it as the backdrop for mobile icons to be worshipped in domestic shrines. In a reversal of Walter Benjamin's account of the artistic aura (Benjamin 1969, 211–44), this appropriative move worked to harness exhibition value (landscapes from contexts of aesthetic contemplation) back to the service of cult value (devotional ritual).

If the Nathdwara landscapes demonstrate the persistence of the "messianic" in the face of secular-modernist nationalism, they also register the ways in which the sacred or messianic took on its own forms of modernity, deploying colonial modes of signification to manage the new conditions of viewing and use accompanying the mobility or deterritorialization of people and images. In their capacity as mass-produced, mobile objects in a commodity economy — as commodities in themselves, as visual heralds for commodities, or as emblems of locality that accompanied traders on their travels — printed icons in the first decades of the twentieth century came to be twinned with highly charged figures of territoriality. Traversing the intra- and international circuits of the bazaar in the form of printed images and thereby establishing a material presence inassimilable

to the boundaries of the state, the naturalistic yet mythic landscapes of the Nathdwara-style icons made it possible to delink communal belonging from both "feudal" and national territory or locality. While this delinking was particularly pertinent to the mobile communities of the bazaar, the personalized worship these icons fostered came to have an appeal well beyond the bazaar's trading communities. At the same time, other kinds of printed images were also working to (literally) map nationally or linguistically defined community identities onto a cartographic imaginary. Yet here too, as Sumathi Ramaswamy (2003) has described, "disenchanted" techno-rational maps of India were supplemented by and enmeshed with somaticized, sacralized, and libidinalized "body-scapes" such as those of Bharat Mata (Mother India) and Tamilttay (Mother Tamil). In these double movements of de- and reterritorialization, vernacular commodity aesthetics worked both to inscribe a new space of mobility and to re-anchor its meaning and efficacy in reconfigured, *re*-sacralized notions of community.

VISUAL PRINT CAPITALISM AS AN INTERTEXTUAL FIELD: THE CASE OF MAHARASHTRA

As the maternal bodyscapes of Bharat Mata and Tamilttay demonstrate, reharnessing identity to an abstracted and resacralized notion of territoriality in the first half of the twentieth century occurred both at the level of the nation and at that of region or language. They also demonstrate how regional identity was often forged literally "in the image" of national identity, in this case through the use of the same trope of woman/mother/goddess as a site of territorial belonging. I have just suggested that the class specificity of a certain strand of early "popular" print culture might have been obscured from our view by the broad-based address enabled by later technologies, and that one of the sites for this later common address was the centralized calendar industry operating out of Sivakasi. This convergence, which did not occur until the 1960s, drew on and reconfigured a number of different strands of the regional, pan-national, and transnational culture industries developing since the early decades of the century. Here and in the next section I continue to problematize the notion of a singular popular consciousness aligned to messianic, anti-rationalist, visual schemata by tracing how naturalism as an "enabling technique" was pressed into the service of subnational as well as national agendas: regional, local, and sectarian identity formation and caste-based political alliances. Along the way I also show how fine art, the print culture of vernacular books and magazines, the cinema and its publicity, the popular theater, and studio photography

can all be considered as intertexts for calendar art. This is the case not only for its reception (as the standard "readerly" interpretation of intertextuality suggests) but also for its production, through artists working across a range of arenas and thereby effecting a cross-fertilization of visual idioms. In what follows I provide a very broad descriptive sketch of these processes mostly as they unfolded in Maharashtra, with its mix of continuing feudal patronage, bureaucratic-institutional consolidation, and commercial-industrial development.

In contrast to the nationalist repudiation of naturalism in Bengal, as I mentioned earlier, Bombay's J. J. School of Art under Dhurandhar and Gladstone Solomon sought to foster a distinctively "Indian" naturalism.[20] As Dhurandhar's multifaceted career attests, in Maharashtra at the time there was no shortage of demand for this reindigenized naturalism: in the art school, the exhibition circuit, and art journals, in commissions for history paintings for local rulers such as the maharajas of Kolhapur and Aundh, and in commercial illustration for British and Indian firms and government departments.[21] His most prolific outpouring of work, however, was for covers, illustrations, and advertisements for the publishing industry: for textbooks, literary works such as G. M. Tripathi's *Saraswati Chandra* or Kalidasa's *Meghdoot*, and magazines such as *Suvarnamala* or *Masik Manoranjan* published in Hindi, Marathi, Gujarati, English, and combinations of these. If naturalism in the sense of frozen-moment narrativity was a mere "blip" in the market for chromolithographs, it continued to flourish in these lively illustrations. Their subjects ranged from *pauranic* themes and romantic visualizations of the months of the year to historical episodes (particularly depictions of the Maratha hero Shivaji) and scenes from everyday life. Although the latter occasionally included idealized rural themes, their main preoccupation was with the western Indian urban elite and middle class: domestic and marital relations, interactions between Indians and Europeans, moral issues such as the dangers of alcoholism, and so on.

Mostly reproduced in black and white, accompanied by text and intended for an increasingly literate middle-class audience (including women), the primary context of these images was narrative rather than liturgical and/or prestational, unlike the iconic framing pictures and calendars. While his calendar for Woodward's may have displayed a certain ambivalence, Dhurandhar's treatment of religious and mythic subjects in his magazine illustrations did not partake of the auspiciousness and indexicality that was becoming a dominant feature of chromolithographs and labels. Nor did it adopt the Bengal school's neotraditionalism. Instead, in keeping with his close association with the colo-

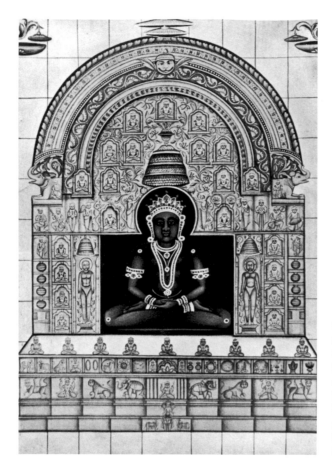

69. *Shri Kesharianathji, Dhulewa, Mewad* (a form of Rishabhdev or Adinath, the first of the Jain *tirthankara*s or saints; Dhulewa is near Udaipur in Rajasthan), published by Nathmal Chandalia, Jaipur and printed by the New Gaya Art Press, Calcutta. (Collection of Shafi Hakim)

nial art establishment, these images were essentially naturalist illustrations of themes from textually defined "culture" and "civilization," though when called upon he did cater to the demand of local manufacturers for frontal, iconic magazine advertisements such as the one for Simla Hair Oil (fig. 60).[22] By and large, even though these images were sometimes cut out by readers and framed or pasted in scrapbooks, they belonged to a different economy from the bazaar chromolithographs. The chromolithograph market in western India at this time dealt in *pauranic* prints, icons, and various types of nationalist images from publishers such as Ravi Varma, Chitrashala, and Brijbasi. However, it also catered to local shrines and cults, often incorporating elements of the artistic traditions associated with specific temple images (figs. 69 and 70). Dhurandhar appears to have maintained his distance from this market: the only chromolithograph by him I know to have been published by the Ravi Varma Press (Karla-Lonavla), entitled *Manoranjan* [Enjoyment] (fig. 71), deals with a secular, domestic subject and is not signed.[23] However,

70. *Shri Madiwal Machideo* by Chandra Varma (note the no doubt deliberate similarity to Ravi Varma's signature), published by V. B. Swami, "Frame Maker," Sholapur. Also mentioned on the print is "Gangappa Jirage, Sholapur," possibly the printer. Madiwal Machideo (also Madival Machayya), a washerman (that is, from the working castes), was a follower of the twelfth-century devotional saint-poet and social reformer Basava (also Basaveshwara or Basavanna) from what is now Karnataka. A major figure in the *bhakti* movement, Basava revived the Shiva-worshipping Lingayat or Virashaiva sect.

as we will see, while Dhurandhar may have been able to afford a certain aloofness from this market, later artists with a similar ardor for "realism," including his students, could not. They would bring Dhurandhar's "realist" legacy to bear on a particular strand of commercial calendar art, negotiating the kinds of tensions that we have seen prefigured in his own work.

The narrative mode Dhurandhar adopted in his work for magazines was not necessarily a function of these magazines' address to a modernizing urban vernacular elite and middle class in western India. Other illustrated magazines emerging around the same time, and adopting a similarly narrative mode, forged broader "cultural" identities that cut across regional and class identity and even transnational location. For instance, the religious magazine *Kalyan*, reported to have featured illustrations by Dhurandhar's contemporary Ghasiram (Ambalal 1987), came to play an essential role in the delineation of a "Hindu" imaginary of nationhood. Like the Brijbasi chromolithographs, *Kalyan*'s mass address extended the religious and social concerns of the northern and western

71. *Manoranjan* [Enjoyment], print by M. V. Dhurandhar, published by the Ravi Varma Press (Karla-Lonavla). (Collection of Ambika Dhurandhar)

bazaar communities to a wider audience, ranging from literate Brahmins to neoliterates and semi-literates. The Geeta Press, founded in 1926 by Hanuman Prasad Poddar in the sugarcane producing center of Gorakhpur (in what is now Uttar Pradesh), was a largely Marwari-Aggarwal initiative, enjoying the support of prominent nationalist entrepreneurs such as Jamnalal Bajaj and Ghanshyamdas Birla (recall that sugar was among the more successful early domestic industries). Its charter, emanating from the socially reformist but religiously conservative culture of urban Vaishnava community organizations (Bayly 1983; Dalmia 1995), was the mass dissemination of its version of "Hindu" religion and morality through cheap and widely distributed publications such as *Kalyan*. A major part of *Kalyan*'s appeal was its color illustrations. These publications became staple reading for Hindi-literate families: Geeta's budget edition of the Bhagwad Gita and *Ramcharitmanas* are still sold, along with its other publications, in stalls on railway platforms across India. Beginning in 1934 the Geeta Press also produced an English ver-

sion, the *Kalyana-Kalpataru*, for overseas Indians (Horstmann 1995, 295), an indication that the close link between Hindu nationalism and the diaspora can at least in part be traced back to this early Vaishnava formation extending beyond national boundaries.

Chromolithographs and product labels were only one way in which mass culture figured religion, myth, politics, and history, imbuing images with a ritual performativity as sacred and commercial objects. The address of magazines and their illustrations to literate, semi-literate, and neoliterate publics supplemented this engagement with a more explicitly self-reflexive, "culturalizing" if not historicizing sensibility, often using mythic and religious materials in an allegorical mode to address the moral-ethical dilemmas of modern everyday life. Illustrated magazines were to become a preeminent site for the consolidation and expansion of sectarian and regional identities, and for the elaboration of what constituted "Western" modernity and "Indian" tradition. Meanwhile, the cinema, emerging in the 1920s and 1930s, also mobilized a broad range of modes of signification and address. In Maharashtra these included the techno-magical spectacle of D. G. Phalke (1870–1944, another contemporary of Dhurandhar and Ghasiram); the social realism and political allegory of the artist and filmmaker Baburao Mestri, better known as Baburao "Painter" (1890–1954); and, with the introduction of sound—and therefore music and song—the intensification of romantic and devotional affect, particularly in the Prabhat Film Company's "saint films" or "*bhakti* biographicals" of the 1930s and 1940s.[24] So the field of "reception" of chromolithographs, and in particular the "popular" religious consciousness they inscribed, has to be seen in relation to the various overlapping—and disjunctive—cultural and political modalities made available across the entire range of mass-cultural forms. Between them, these forms presented a continuum of possibilities for formulating modern subjectivity in relation to changing social, political, and economic arrangements: through their content, their modes of signification, and the forms of experience or spatial, temporal, and sensory perception they made available. As I elaborate in chapter 5, people—"subjects," particularly postcolonial subjects—inhabit several different frames of value and signification, switching between them depending on the context. Accordingly, the forms of politics and communal belonging enabled across the range of print capitalist forms drew on—and inscribed—a multifaceted religious consciousness whose performative messianism variously coexisted with, obviated, supplemented, and was supplemented by the modernist categories of "history" and "culture."

Similarly, in terms of their contexts of production, even within the overarching frame

of Swadeshi anti-colonialism these emergent mass-cultural forms embodied intersections between a range of political affiliations and class interests. Indeed, often the alignment of these forms with a broadly supported Swadeshi nationalism, as well as their ambivalent status as both art and commerce, meant that they were initially fostered through a mixture of artistic patronage and entrepreneurial investment (like the early Calcutta Art Studio and the Ravi Varma chromolithographs). This was particularly true for the cinema, with its need for large sums of capital and other resources. Many of the early filmmakers—Phalke, Painter, and Painter's associate Fattelal (who founded Prabhat along with other former members of the Maharashtra Film Company, Damle and Shantaram)—were either formally or informally trained as artists and benefited from fine art's cultural capital among the "native" elite, particularly the local Maratha rulers.[25] Painter, for instance, enjoyed the patronage of Kolhapur's Chhatrapati Shahu Maharaj and his successor Rajaram (whose portrait he painted)—as did Dhurandhar, the landscape artist Abalal Rahiman, who was trained at the J. J. Art School and served as Fattelal's mentor, and the mythological painter A. M. Mali, whose work (such as *Basavanna*, 1914) was reproduced by the Ravi Varma Press. Under the Marathas' encouragement of Western-style history painting, portrait painting, and landscapes, Kolhapur came to be known as "Kalapur" (city of art).[26] Princely support for the cinema can be seen as an extension of this artistic patronage: Rajaram and his sister, the rani of Dewas, lent the Prabhat crew resources such as palaces, costumes, animals, and soldiers for their shoots, as did the rani of Jath, who apparently lent them "four hundred spotless cows" to shoot *Gopalkrishna*; Rajaram is said to have arranged battle scenes and personally supervised their shooting (P. Kale 1979, 1512–13).

Painter, in particular, indexes the social mobility enabled by an intersection between royal patronage and professional and entrepreneurial support at the local level. Both Painter and Prabhat enjoyed strong backing from within Kolhapur: the Maharashtra Film Company was supported by the singer Tanibai Kagalkar (a professional woman with personal wealth) and Prabhat by the gold and silver merchant Kulkarni. To this extent Painter's Maharashtra Film Company (as opposed to Phalke's Hindustan Cinema Films), and then the Prabhat Film Company, working mostly in the Marathi language and with specifically Maharashtrian themes, reflected their more local alliances in contrast to the earlier pan-nationalism of Varma or Phalke, as well as to the wider circuits of the later, post-independence "Bollywood" cinema or the Sivakasi calendar industry. Kolhapur was a center of bazaar-style entrepreneurship in its capacity as a cotton-

producing center, providing a conducive environment for the new arenas of "industrial art." However, the participation in this arena of men from artisan-caste backgrounds (such as Painter and his cousin Anandrao) was also aided by the local rulers' explicitly anti-Brahmin agenda (both Dadasaheb Phalke and Vishnushastri Chiplunkar, the founder of Poona's Chitrashala Press, were Chitpavan Brahmins, as was Tilak). Opposed to what he saw as a Brahmin-Vaishya capitalist nexus represented by Tilak, Shahu Maharaj sought to forge a "soldier"-worker alliance: thus his attempts to develop professional opportunities for artisan castes, such as his implementation of reservations in educational institutions and the establishment of the Prince Rajaram Industrial School (P. Kale 1979, 1512). Baburao Painter balanced his anti-colonial nationalism with his concern with local politics: the allegorical *Sairandhri* (1919) paid public homage to Tilak, whom he invited to the film's Poona premier, while the realist *Savkari Pash* (1925) embodied an articulation between the sentiments of his royal patrons and his own caste and class interests.[27]

Artists such as Dhurandhar and Painter benefited from a conjuncture between the artistic academy's support of an "Indian" naturalism, the tastes of their elite patrons for Western-style portraiture and history painting, and the market's demand for naturalist commercial illustration. However, artists embarking on their careers in the late 1930s and 1940s, some after an enthusiastic pursuit of "realism" under Dhurandhar and others at the J. J. School of Art, found themselves at odds with a critical climate poised to embrace modernism. Amrita Sher-Gil, considered the harbinger of Indian modernism, had returned to India from Europe in 1934, exhibiting around the country from 1935 onward to critical acclaim from art societies (including the Bombay Art Society, which awarded her a prize in 1940). The turn to modernism is also attributed to the interventions of Rudy von Leyden, a Jewish emigré from Europe, who as art critic for the English-language *Times of India* strongly supported the modernist Progressive Artists' Group, which was formed immediately after independence. Modernism drove a wedge between the vernacular culture industries and the cosmopolitan realm of "fine art," forcing artists to choose between the naturalism sponsored by commercial interests and the modernism sponsored by the state and an English-educated nationalist elite. On one side of the wedge were artists such as the self-taught M. F. Husain (b. 1915), now one of the wealthiest and best-known living artists in India, who famously survived as a cinema billboard artist in Bombay until he started exhibiting as part of the Progressive Artists' Group. On the other side was a host of unknown or lesser known artists working across

a range of professional arenas: signboard painting, book and magazine illustration, technical drafting, photographic retouching, sets and publicity for the popular theater — and again, very commonly, the cinema and its spin-offs.

As the film industry consolidated itself in the centers of Bombay, Calcutta, and Madras (where the major art schools were located), it provided opportunities for aspiring artists from all over the country for work on makeup, sets and art direction, publicity banners and "showcards" (painted posters placed in the foyer and windows of the theater). A number of artists, many of them from art schools, who later went on to work for the more lucrative and stable calendar trade started out in the "film line" in the 1940s and 1950s. For instance, K. Madhavan (1907–79), who studied at the Madras School of Art, did sets and banners for the Gemini Studios in the 1940s (as well as his first calendar, for Burmah-Shell). S. Courtallam, also from the Madras School of Art, learned the art of makeup in Madras in the 1950s from "Haribabu," a leading makeup man of the time, who had himself studied at the Calcutta School of Art. The extraordinary Ram Kumar Sharma (b. 1923), a self-taught artist from Meerut, went to Bombay in 1941, eventually working as an art director at Filmistan from 1952 to 1960; a number of calendar artists, including J. P. Singhal, Ved Prakash, and Courtallam were his apprentices. Most celebrated of all in the calendar industry, though almost totally unknown in modernist circles, was a graduate from the J. J. School of Art, born a year after Husain, who began his commercial career in 1939 painting MGM showcards for Bombay's Metro Theatre: S. M. Pandit (1916–91). Pandit is cited as an influence and a source of inspiration by almost all of the calendar artists I have spoken to, and widely (albeit not universally) acknowledged in the industry as "the true successor" of Ravi Varma.[28]

Pandit was the very embodiment of Gladstone Solomon's "Superhuman Realist" (Solomon 1926, 115), his desire for naturalist technique taking him through three different art schools.[29] However, by now the only viable vehicles available for his passion for naturalism and skill in portraiture were film publicity and advertising. In 1938–39, Pandit co-founded the Young Artists Commercial Arts Studio, designing the publicity for Franz Osten's 1938 Bombay Talkies film *Bhabhi* and creating showcards featuring stars such as Greta Garbo, Norma Shearer, and Joan Crawford for MGM.[30] He continued to design posters at the first Indian-owned advertising agency, Ratan Batra's, which catered to several well-established Indian industrial houses; the accounts he worked on included textile mills such as Mafatlal, Kohinoor, and Khatau (the business family that had initially provided part of the capital for Ravi Varma's press). He also designed covers for

72. *Filmindia* magazine cover, August 1953, by Studio S. M. Pandit. (Courtesy of K. S. Pandit, S. M. Pandit Museum, Gulbarga)

Filmindia magazine, an English-language film monthly that began in 1935; its editor, Baburao Patel, also supplied him with other film industry contracts. By 1944 Pandit had set up his own studio in Bombay's Shivaji Park, producing film publicity for V. Shantaram (formerly of Prabhat), Raj Kapoor, and Sohrab Modi among others; Pandit was also visited here by Baburao Painter. One of Pandit's assistants here was Raghubir Mulgaonkar (1922–76), a self-taught artist from Goa, whose work appeared in *Filmindia* under the Studio S. M. Pandit signature. By 1945 Mulgaonkar left to set up his own studio in Bombay's Girgaum, where he expanded into illustrations for books and magazines; one of his main clients was Jayhind Prakashan, an inexpensive paperback publisher. Both Mulgaonkar and Pandit continued to work for *Filmindia* in a characteristic style similar to Hollywood posters of the 1930s and 1940s (fig. 72); after independence they were to carry this glamorous appeal, dramatic expressiveness, and bold, graphic composition across to the mythological prints that proved to be their most popular and influential legacy (figs. 73–78).

I have listed these players in some detail to provide a granular sense of the close interconnections, in the years immediately preceding independence, between the art schools, a Bombay film industry beginning to dominate both the Marathi cinema and Hollywood, commercial book and magazine publishing, and an Indian-owned commercial sector that was partly organizing itself along "Western" corporate lines with the use of advertising agencies. I also want to emphasize that many artists who were primarily known for their post-independence work in the arena of mythological prints and calendar art started out in other less stable and lucrative fields such as the cinema, where payments are still notoriously hard to extract.[31] This can be read as evidence of a sudden boom in corporate-sponsored publicity materials such as posters and calendars soon after independence, as Indian industries emerging from the colonial bazaar traded with new confidence in an economy of auspiciousness, addressing a wide-ranging national market through the truly "mass" medium of offset printing.

THE OFFSET ERA: THE MAKING OF THE "MASSES"

India's first offset press was set up in Calcutta around 1930, but soon after India gained its independence in 1947 there was a burst of growth in offset printing, as a result both of increased demand and of the availability of relatively affordable machines from Eastern bloc countries such as the German Democratic Republic that accepted payment in rupees.[32] So, for instance, after Partition the Brijbasi brothers moved back to Mathura and started the Brijbasi Fine Art Offset Press, resuming distribution from Mathura and then opening branches in Bombay in 1950 and Delhi in 1954. The first offset machine in Sivakasi was set up by the Coronation Press in 1950; in 1954 the Delhi-based Urdu *Tej* became the first newspaper to be offset printed. High-volume color offset printing made illustrated calendars and advertising posters affordable for trading and manufacturing firms dealing with pan-national, vernacular mass markets and widely dispersed small dealerships. For many this simply meant using new versions of the *pauranic* imagery used by earlier advertisers in this market. It also meant bypassing the advertising agencies, which mostly worked through the press and primarily catered to the more affluent consumers of goods produced by the multinationals and the larger, established domestic firms (such as those advertising with Ratan Batra listed above). This, then, ushered in the possibility of a common address to consumers ranging from those with the wherewithal to buy and frame chromolithographs such as those produced by Brijbasi, to those for whom the only access to printed *pauranic* images had been via labels on cheap com-

modities such as cloth and matches, and to those for whom even these were unaffordable. However, it was not until the 1960s and 1970s, with the pan-national expansion of the Sivakasi industry, its further cost reductions, and the imposition of its distinctive aesthetic on bazaar images, that this wide-ranging articulation (simultaneously under way in the Hindi cinema) began to be enacted, establishing the contours of a vernacular, non-secular, "popular" nexus alienated from the liberal, secular-modernist, English-educated elite. This was not a self-conscious political or cultural bloc: as Arvind Rajagopal has suggested, the self-consciousness of what he calls a "split public" would develop with the resurgence of Hindu nationalism in the late 1980s, aided in part by media relays of the idea of a collective televisual audience for epics such as the *Ramayan* (Rajagopal 2001, 151–211). But the shared familiarity with the visual idioms of these televised epics, which formed the basis for such a collective self-inscription, was largely established by the wide reach of the Sivakasi presses and the Bombay cinema.

The post-independence demand for commercial images, particularly mythological ones, meant that the print trade now sought to supplement existing suppliers such as the Nathdwara artists. So artists who had not necessarily dealt with mythological imagery before now turned a hand to these increasingly lucrative subjects. For instance, S. M. Pandit's first commercial foray into mythology was a version of *Shakuntala Patralekhan* for the Bombay Fine Arts Press, which was produced as a calendar in 1953. Soon afterward he was approached by Nagpur's Shiv-Raj Fine Arts Press to do a series of paintings based on themes from Ravi Varma, and from then on these presses supplied both Pandit and Mulgaonkar with orders for mythological advertisements and calendars. One of Pandit's most famous images was a painting of Sita pointing out the golden deer to Ram, used by the Bombay-based Parle confectionery and soft drink company on a calendar and packaging (see fig. 73). A later Pandit painting for Parle features Nala and Damayanti above a range of Parle products, including a toffee tin bearing the same Ram-Sita image (see fig. 74). Another huge hit was a painting of Ganesh for Ganesh Beedies, which found its way into *puja* rooms all over the country and is said to have provided the model for a marble Ganesh at a temple in Jaipur (Pai 1989; see fig. 75). These two images exemplify the two poles between which Pandit had to negotiate: narrative, mythological or text-based subjects that lent themselves to a more "realist" treatment, and frontal, iconic depictions of deities that evoked a liturgical context (see also fig. 11). Here it is no coincidence that the more narrative, realist, "civilizational" image advertised a product aimed at middle-class consumers and distributors of soft drinks, biscuits, and western-style sweets, while

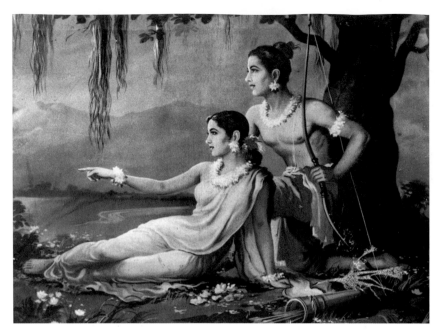

73. "Ram and Sita" by S. M. Pandit, poster painted for the Parle Company. (Courtesy of K. S. Pandit, S. M. Pandit Museum, Gulbarga)

74. "Nala-Damayanti" by S. M. Pandit, advertisement for the Parle Company. The tin in the foreground (left) features Pandit's famous Ram-Sita image (fig. 73). (Courtesy of K. S. Pandit, S. M. Pandit Museum, Gulbarga)

75. "Krishna Petitions Ganesh to Free Bondage," Mangalore Ganesh Beedies calendar for 1967–68 by S. M. Pandit. Compare the female figure here with that in Dhurandhar's calendar for Woodward's (fig. 53). (Smith Poster Archive, Special Collections Research Center, Syracuse University Library)

the more iconic image was associated with *beedies* (or *biris*), a product with greater mass appeal. In the case of framing pictures, which were purchased by their "end-users," it is possible that this kind of distinction reflected consumer demand. The calendars, in contrast, were mostly given away and were chosen by representatives of the firms that sent them out. So in the case of the calendars, the strategy of using iconic figures for down-market products indexes the widely adopted rhetoric associating poor and "uneducated" consumers ("the masses") with the devotional use of images. At the same time, it also stems from a devotional-ethical impulse on the part of the (wealthier, though not necessarily English-educated) manufacturers to use their commercial imagery as a means of pleasing their favored deity. As I elaborate in the next chapter, this contradiction signals a disavowal of the links being forged between these constituencies on the basis of their religiosity, and more generally on the basis of their common "failure" to play by the rules of a secular, bourgeois-liberal, public sphere.

Even within the iconic mode, however, the images produced by different artists in

76. *Shiva Ashirwad* [Shiva's blessing] by S. M. Pandit, offset print, Calco, Bombay.

the calendar and print industry were distinguished by degrees of "frontality" (G. Kapur 1993b, 20). Pandit's commitment to realism meant, for instance, that his iconic images did not exhibit the elaborate surface ornamentation characterizing framing pictures such as Brijbasi's. Indeed, the Nathdwara calendar painter Indra Sharma (who worked for Brijbasi) claimed, with some justification, that publishers sought him out rather than Pandit because Pandit's gods were *too* realistic, too much like ordinary men and women. More to the point, perhaps, Pandit's gods were too much like the movie stars that he had been painting for over a decade. The influence of Hollywood film posters, particularly the style associated with MGM, is evident in the treatment of his characters' faces and expressions, a soft-skinned, pink-cheeked, dewy-eyed, "made-up" look, with highlights bouncing off their lips and hair; in his depictions of Shiva as a bluish, muscular Tarzan-type hero clad in a leopard skin (see fig. 76); and in his Disney-like detailing of flowers and animals.[33] As with earlier appropriations from European academic painting

77. *Shakuntala-Bharat* by R. S. Mulgaonkar, printed at the Shiv Raj Fine Arts Litho Works, Nagpur.

and landscapes, Hollywood's representation of charismatic and libidinally invested figures also fed into the intensification of personalized affect in the representation of deities in the bazaar, even when they were realigned to conventional iconographic postures.

Mulgaonkar, too, brought this look to bear on mythological subjects (see fig. 77), taking the soft-focus look a step further with his use of the airbrush (a technique that eventually cost him his life: he died of lung cancer). In Mulgaonkar's case the more narrative impulse associated with film publicity also tied in with another context for his mythological work: his illustrations for a genre of vernacular Marathi-language magazines that were hugely popular between about 1946 and 1976. These were the annual "Diwali specials," with titles such as *Alka*, *Ratnadeep*, *Ratnaprabha*, *Mangaldeep*, *Deepawali*, and *Deeplakshmi*, which became synonymous with Mulgaonkar and the more formally experimentative artist Dinanath Dalal, who had been trained at the J. J. School of Art (see also fig. 67).[34] Intended as family fare, they catered to a vernacular, regional

78. *Gopi Vastra Haran* [Stealing clothes from the gopis] by R. S. Mulgaonkar, from *Ratnaprabha* magazine, 1974.

"*rasik*" sensibility—a kind of relaxed, sensual, often earthy aesthetic.[35] They featured stories, poems, articles on theater, cinema, music, science, religion, and culture, character sketches of illustrious personalities, satire, cartoons, and above all, both color and black and white plates.[36] Mulgaonkar's illustrations included the life of Krishna (fig. 78), the Ramayana, Kalidasa's *Meghdoot* and *Geet Govind*, biographies of the Marathi stage star Bal Gandharva, Shivaji, and Gautam Buddha, the saint-poets, and various manifestations of Indian Woman as a *nayika* (heroine) such as Pavitra or Mangala, as well as the usual Radha, Sita, Yashoda, and so on.[37] He also illustrated advertisements (fig. 79): his own publications promoted a Pune-based tooth powder manufacturer called Porwal and Company, and a Nasik-based chemical company called Bytco, which was run by Seth Jayarambhai Dayabhai Chauhan, who also commissioned Mulgaonkar to do a series of paintings for a Krishna temple built at Muktidham in Nasik in 1971. So, in another instance of a commercially mediated move from exhibition value back to cult

बिटको
ग्राइप

BYTCO-GRIPE

रोज देने से
छोटे बच्चे सशक्त निरोगी
और खुश रहते हैं

बिटको काली
टुथ पावडर

रोज इस्तेमाल करने से
दांत मोती जैसे स्वच्छ व चमकीले होते हैं

बिटको केमिकल इंडस्ट्रीज · नासिक रोड

79. An advertisement for Bytco gripe water and tooth powder by R. S. Mulgaonkar, from *Ratnadeep* magazine, 1963.

value, the Hollywood influenced, "realist" deities of both Pandit and Mulgaonkar were reincorporated to the ritual context of the temple.

While Diwali annuals such as *Ratnaprabha* depended on the custom of small local capitalists, other magazines also available to Maharashtrian readers after independence operated from a range of different power bases. Pan-national magazines such as *Kalyan*, or the later Hindi *Navneet* and the English-language *Bhavan's Journal* (both started in the early 1950s by the novelist K. M. Munshi under the auspices of the nationalist cultural institution the Bharatiya Vidya Bhavan), had the backing of the most powerful industrialists in the country, including G. D. Birla; the Marathi *Kirloskar* magazine, started in 1920 by another industrial giant, attempted to forge a kind of Maharashtrian "Protestant ethic" with its slogan of "inspiration-industry-success."[38] The light-hearted *rasik* flavor of the Diwali specials tapped a popular vein that aligned itself with the contemporary culture industry in a way that the more reformist high moral tone of the theological

80. The saint-poet Meerabai by R. S. Mulgaonkar, in an advertisement for Mangharam and Sons, Bangalore (manufacturers of biscuits and sweets), on the wall of a Sivakasi printers' office, 2001.

Kalyan and the culturally purist *Bhavan's Journal* tended not to.[39] But it was the large-circulation, pan- and transnational or institutionally backed illustrated magazines that survived the oil crisis of the 1970s, which made newsprint prohibitively expensive for the smaller journals. Color magazines all over the country had to raise their prices; some, like the Hindi *Dharmyug*, weathered a drop in circulation while others, like the Marathi Diwali specials, folded altogether. This regional, *rasik* facet of the "popular" in Maharashtra lost one of its print capitalist vehicles, temporarily ceding to pan-national idioms and/or to a regionalism mediated via an overarching national culture.

By now similar processes of consolidation within a post-independence national frame were also well under way in the calendar and print industries. While Pandit and Mulgaonkar were building careers based on the cinema, magazines, and advertising in Bombay in the 1940s, a small town called Kovilpatti in the Tirunelveli district of Tamil Nadu, less than fifty kilometers from Sivakasi, was also becoming a center for artists, whose work would meet up with that of Pandit, Mulgaonkar (fig. 80), Indra Sharma, Ram Kumar, Singhal, Rastogi, and dozens of others in the process rooms and offset presses of Sivakasi from the 1960s onward. Through the Kovilpatti artists the Sivakasi industry reconnected with the Tanjore tradition at its hereditary source, not just via the widespread influence of Raja Ravi Varma. The Kovilpatti "school" centered on the figures of C. Kondiah Raju (1898–1976) and his "successor," M. Ramalingam (1933–93; on Kovilpatti, see

Inglis 1995). Kondiah Raju came from a community associated with Tanjore painting and had been trained in that tradition before joining the Madras School of Art in 1916 (among his early mentors was N. Subba Naidu, the brother of Raja Ravi Varma's rival Ramaswamy Naidu of the Travancore court). Kondiah started his career with the government drawing maps for state highways, as art school policy had intended. However, he soon left his government job to join a touring drama company as a backdrop painter and occasional actor and musician.[40] In 1942 the company folded and several members of the group settled in Kovilpatti, painting portraits and religious icons under Kondiah's tutelage and the patronage of (among others) the maharaja of Ettaiyapuram. In 1944 Kondiah opened the Sri Devi Art Studio, which undertook photography, painting, and a combination of the two in the manner that had become characteristic of studio portraiture (Gutman 1982; Pinney 1997b). As I suggest in the case of reverse glass painting (in chapters 2 and 4), this work would also have equipped the Kovilpatti artists with the skill in retouching and working with negatives that was to become an integral part of the Sivakasi image-making process, giving Sivakasi prints the intense, saturated colors that characterized their distinctive "popular" look.

Up until the early 1950s Sivakasi's chromolithographic presses were still using copies of Ravi Varma prints in their advertising posters for southern companies such as Neepa (makers of soap and hair oil), but demand had grown enough by then to justify the introduction of offset machines and the recruitment of artists to produce new designs.[41] Around 1955–56 the work of the Kovilpatti artists began to appear in print (fig. 81), inaugurating Sivakasi's calendar era: Ramalingam's first printed work, for instance, was a 1956 calendar for Sri Ambal Coffee, Virudhunagar, printed by the National Litho Press. But if the Kovilpatti artists initiated the calendar boom for the printers of Sivakasi, it was people such as S. M. Pandit who really made their fortunes, shoring up the industry's pan-Indian reach. Pandit's work, for instance, was known as far away as Calcutta: Colonel Mohan of the Mohan Meakins liquor company (famous for its semi-erotic calendars of women), which had its headquarters in Calcutta, was a regular patron until 1978. It was not until the early 1960s that Sivakasi was able to approach artists such as Pandit, Mulgaonkar, and J. P. Singhal (by this time also with Bombay Fine Arts) and compete with the "quality" presses in the major centers. From the mid-1960s onward, northern and western calendar manufacturers and picture publishers such as Brijbasi began farming out their print orders to the centralized operation in Sivakasi, reserving their own presses for urgent or "quality" jobs for local clients. This paved the way for

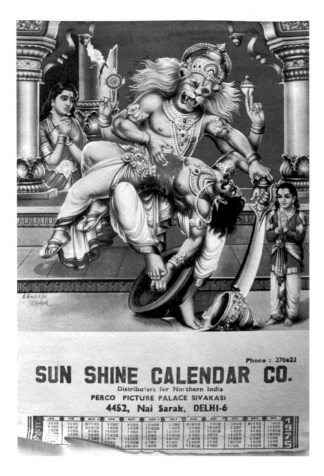

SUN SHINE CALENDAR CO.

Phone : 270622

Distributors for Northern India
PERCO PICTURE PALACE SIVAKASI
4452, Nai Sarak, DELHI-6

81. "Narasimha," signed "C. Kondiah Raju," followed by "T. S. Subbiah," and then "Kovilpatti." This image is part of a 1975 calendar from Sun Shine Calendar Co., Nai Sarak, Delhi. (Collection of JPS and Patricia Uberoi, Delhi)

the entry into the Sivakasi market of even more artists from all over the country. J. P. Singhal had moved to Bombay from Meerut with the help of Ram Kumar Sharma, but later Meerut artists such as Yogendra Rastogi and H. R. Raja, who started out as self-taught signboard artists, worked for Sivakasi from their home town. Sivakasi printers also got designs from artists as dispersed as Rangroop (Ram Singh) in Delhi, P. Sardar in Kolhapur, the Sapar Brothers in Sholapur, and Indra Sharma, who lives in Bombay but maintains strong links with his native Nathdwara. In the 1980s, as the Bengali market began to move its production over to Sivakasi, Calcutta artists such as Nirmala and her brothers Ramakrishna and Balakrishna also started to work for the pan-national or "English" market. At the same time "South Indian" designs were provided by local artists from Madurai, Kovilpatti (until 1993, when Ramalingam passed away), and Sivakasi (whose resident artists include Ravi and his pupil Murugakani).

Although these artists situated in or near Sivakasi are expected to cater to a specifically

82. *Folk Dancers* by V. V. Sapar, a 1996 four-sheeter calendar published by Coronation Arts and Crafts, Sivakasi. (Courtesy of Coronation Arts and Crafts and the artist)

"southern" regional iconography, the geographic dispersal of artists has not primarily fostered distinctive styles aligned to local traditions. Instead, it has served to satisfy the thematic or subject-centered logic of the calendar catalogues or files: for instance Babuline, a former Sivakasi customer, mostly ordered calendars featuring the child Krishna. While most artists address a wide range of themes, several of the northern and western artists have come to be known for their treatment of particular subjects. Rastogi has been dubbed the "Durga-maker"; Sardar, a Muslim, was particularly fond of painting the Hindu monkey-god Hanuman, of whom he was a particular devotee; Rangroop was sought after for his "Indian style" (neotraditional) "beauties." Among the Bombay artists, Singhal was famous for his photo-realist "beauties," S. V. Aras became the "baby artist," and S. S. Shaikh, also a Muslim, has been the only calendar artist to specialize in landscapes.

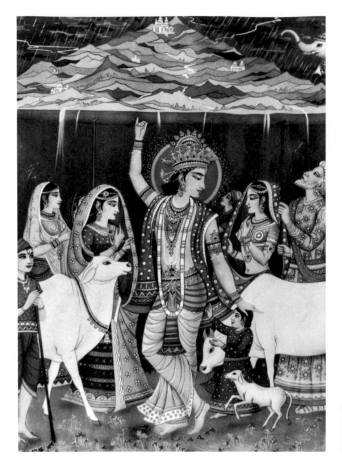

83. *Govardhan Hari* [Krishna, protector of the cows], print published by Swastik Picture House, Delhi.

Thus a range of styles and artistic traditions has converged into the thematic categories of the calendar publishers' files and the constraints of broadly defined regional iconographies: "realism" processed by artists trained in art schools and self-taught billboard painters; Nathdwara- and Tanjore-style devotional idioms with their own filtering of Western influences; "Indian" art in the style of the Bengal school. As I argued in chapter I, this convergence within the constraints of the pan-national market has not meant homogeneity or repetition. If there has been a cross-fertilization of existing styles, as is particularly evident in the work of younger artists such as Venkatesh Sapar, there has also been a marked openness to a range of influences, particularly through Sivakasi's heyday in the 1960s and 1970s. Some readily discernible influences in the work of that period include art-school modernism (fig. 82), particularly techniques such as "knife-work" and the processing of Indian "folk" forms; swirling psychedelic paisley patterns and bubbles refracted through transatlantic hippie culture (fig. 83); socialist realism from

84. *Young Farmer* by S. V. Aras, calendar design. (Courtesy of the artist)

Chinese and Soviet poster art (fig. 84); airbrush styles from foreign books and magazines on "fantasy" art; and landscapes and fauna from illustrated scientific books on prehistory (such as the one used by the artist Ravi as reference for the "mythological period").[42] Since then there have been even more appropriations and innovations, some of which will be discussed in later chapters. But just to provide a more recent instance of the way in which naturalism has been deployed at moments of market reconfiguration: at the turn of the millennium the most successful new themes in the Sivakasi-produced poster market were naturalist depictions of romanticized rural scenes (fig. 154). One context for these is the nostalgia that informs the Hindi cinema's expanded address to a market comprising India's resident post-liberalization middle class and its equivalents in the global diaspora. (I shall return to this in the conclusion.)

In this and the previous chapter I have traced just a few of the many strands that came together to make up the heterogeneous, shifting community of calendars bound up together in the Sivakasi printers' files. Here commodity aesthetics in the bazaar, largely characterized by an indexical economy of auspiciousness, converged with the

multiple modes of signification deployed by the culture industry: not just frontal icons but also naturalist allegories and narrative illustrations of "civilizational" texts. Indeed, I have suggested that naturalism and other new image-making techniques were useful for recoding existing forms in order to address expanding or deterritorializing markets, thereby setting in train a set of social reconfigurations. In the case of the Sivakasi calendars, this reconfiguration entailed defining consumers along broadly regional and more finely differentiated religious and secular axes within a pan-national frame. My point here is not simply to reiterate the commonplace notions that mass culture thrives on novelty or fosters homogeneity, but to suggest that novel formal means enable a decontextualization or deterritorialization that helps to reformulate social relations, bringing hitherto heterogeneous constituencies into an arena of common address. We have seen how such intertextually related forms in the culture industry worked at different moments to inscribe a range of reconfigured identities—national, local, gendered, caste-based, secular, religious—in a variety of registers, not all of them necessarily congruous with each other, or instituting a singular, fixed, consistent "subject." And yet printers, publishers, artists, and consumers deploy a common-sense construction of "the masses" and of "popular" taste, with discernible attributes, on the basis of which they take decisions affecting the circulation of images in the marketplace. What is more, in several respects this "popular" formulation of the popular overlaps with the discourse of scholars and journalists. To merely dismiss these as simplistic or mistaken formulations would be to pass up the potentially more productive option of asking how such categories of distinction are formulated in the calendar industry, and what is invested in their deployment. This is the question I turn to in the following chapter.

PART 2 ECONOMY

4

THE SACRED ICON IN THE AGE OF THE WORK OF ART AND MECHANICAL REPRODUCTION

I said, that is impossible, he is running after the deer.
How can even he—with half closed and half open eyes run after the deer!
(Laughs) It looks ridiculous!

RAM WAEERKAR, ILLUSTRATOR FOR THE MYTHOLOGICAL COMIC BOOK
SERIES *AMAR CHITRA KATHA*, ON BEING ASKED TO DEPICT THE GOD
RAM WITH A PERMANENTLY MEDITATIVE EXPRESSION

Venkatesh Sapar, arguably the most prolific and versatile calendar art-
ist of the late 1990s, was born in Sholapur in 1967 and studied fine
art at the Sir Jamsetji Jeejeebhooy (J. J.) School of Art in Bombay from
1984 to 1989. His father, Vishnu Sapar, is also a calendar artist, but he is
self-taught. Starting out as a mill worker at Sholapur's Lakshmi Vishnu
Mill, Vishnu Sapar worked on textile designs for the mill and then free-
lanced as a signboard painter, eventually teaming up with his brother
Bharat to provide calendars for the Sivakasi industry under the "Sapar
Brothers" signature. So Venkatesh and his wife, Maya, who studied ap-
plied arts at the J. J. School of Art, have joined the family business, to
which Venkatesh started contributing while still in high school. When I

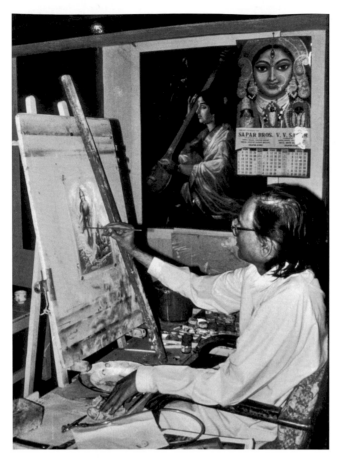

85. Bharat Sapar (Venkatesh Sapar's uncle, one of the "Sapar Brothers") at work in his studio, watched over by a calendar circulated by Sapar Brothers and V. V. Sapar, Sholapur, December 1995.

met the family in 1995 (fig. 85), they were all living together in a spacious home-cum-studio in a quiet, middle-class residential area of Sholapur, and work was pouring in: calendars for the "English" and "Bengali" markets (single-page designs, "sheeters," and customized calendars for specific companies), greeting cards for firms in Delhi, Calcutta, and Bombay, and illustrations for an edition of the Gita to be published by the Self Realization Center in California.

"KITSCH" *KUCHH KHOTA HAI*

In March 2001 a New Delhi show with the catchy, playful title Kitsch Kitsch Hota Hai [Kitsch happens] celebrated the influence of mass-cultural forms on contemporary Indian artists and designers working the gallery and boutique circuits.[1] Among them were several who had been trained in fine art at the J. J. School of Art, including Atul Dodiya, Meera Devidayal, and Anant Vasant Joshi; Joshi might well have overlapped with

Venkatesh Sapar at the J. J. There is, of course, a difference between the relationship of these modern and postmodern artists to what the show's curator chose to call "kitsch," and that of artists such as Venkatesh and Maya Sapar to the forms from which they derive their livelihood. One set of artists has the choice either to denigrate and marginalize these forms or to appropriate them on their own terms, celebratory, playful, critical, or otherwise. The other set of artists is required to reproduce a form like calendar art on *its* terms. But what are "its" terms, how do they relate to those of fine art, and how do its practitioners and consumers negotiate between these two systems of value and distinction, given that they are often familiar with both?

This may seem like a straightforward case of distinguishing between high and low culture or fine and commercial art. Certainly this is the approach adopted by the Kitsch Kitsch show, which situates itself within the familiar rhetoric of high and low even as it seeks to redeem mass-cultural forms as "vibrant," "contemporary," and "democratic" (M. Jain 2001). From the point of view of those functioning within the "art system" (Frow 1996, 179) and its frames of value this is a valid strategy, for there can be no doubt that calendar art has many elements of kitsch: it is cheap, mass produced, repetitious, and imitative (though not static, as I argue in chapter 1), and it deals in widely and easily accessible pleasures and affects. But in the course of my conversations with calendar artists, publishers, printers, and consumers I began to sense disjunctures between their discourse on images, what I had observed of the calendar industry's functioning, and these narratives of class, culture, and aesthetic distinction (high culture/low culture) borrowed from the specific — "provincial," if you will (Chakrabarty 2000) — self-descriptions of Euroamerican modernity. This makes obvious historical sense. The colonial context in which the largely vernacular arena of visual print capitalism took shape, as well as the powerful precolonial image cultures that informed it, make it unlikely that the social and ideological role of images in this context, or the frames of value within which they circulate, would follow the trajectory of post-Enlightenment bourgeois Europe. Specifying the nature and status of this divergence, however, is a far from straightforward matter. What complicates things is that, to varying degrees, the terms of a provincial-yet-universalizing post-Enlightenment system of aesthetic value form part of the self-understanding of many postcolonial subjects, particularly those who have attended art school or had an English education — including myself, the Sapar family, and those involved in the Kitsch Kitsch show.

In this chapter I use interviews with people in the calendar industry to examine the

ways in which their discourse and practices variously partake of, problematize, and reformulate some of the central categories in post-Enlightenment discourses of aesthetic value: artistic judgment and taste; autonomy as opposed to commercial and other forms of interest; authorship and originality. If it seems inappropriate to invoke the "aesthetic" to think about mass culture, I should emphasize that I am deploying this term not as a descriptor for fine or high art, but to describe a *system* of valuing images: in this instance, one that deploys a particular set of distinctions between aesthetic and ethical value, fine and commercial art, high and low culture, the "taste of reflection" and the "taste of sense" (Kant 1987; Bourdieu 1984). Thinking about aesthetic value in this broader sense can help to map the political and moral economies and forms of social distinction with which it is enmeshed. Here it provides an entry point for developing my characterization of the post-independence bazaar as a social and commercial context for image production, circulation, and consumption parallel to that of corporate advertising: as a site for what I have called vernacularizing capitalism (see chapter 1).

As with all such ethnographic materials, the status of the accounts emerging from my interviews is not so much that of transparent, consistent truths but of *narratives*, produced largely for my benefit, about things that people might not otherwise talk about, or even pay attention to, in the way that I was calling upon them to do. Accordingly, these accounts and their production are subject to reading, interpretation, and analysis as with any "text"—again, from the point of view of producing my own selective, contextual narrative. In the narrative that follows, I examine three sites at which the image culture of the bazaar has resisted, co-opted, or reformulated the institutionalization of a post-Enlightenment schema of aesthetic value. The first is the schema of social and aesthetic distinction deployed in relation to calendar art and its consumers; the second (discussed over two sections) is the set of formal constraints that the industry imposes on its artists and their images; and the third is the industry's practices regarding authorship and authorial property. My attempt here is to identify unwitting resistances and recastings as well as conscious ones, attending to rhetorical disavowals or inconsistencies between my informants' discourse and their practices, as well as to explicitly stated perceptions of stresses, compromises, and failures in their image-making practices.

I must emphasize, as I did in the previous chapter, that my intention here is not simply to celebrate these resistances as manifestations of an anti-colonial or anti-modernist subaltern consciousness but to trace their implications for post-independence contexts of image circulation as fields of power. The arena of the bazaar can be seen as subaltern

in relation to the colonially imposed—and colonially withheld—protocols of a globally dominant corporate capitalism. However, it is also a site of hegemonic formations *within* a national framework, with the post-independence calendar industry providing a shared "cultural" idiom for a widely dispersed domestic middle class and a broad spectrum of vernacular consuming publics, including the rural and urban poor. The interviews on which this chapter is based were conducted between 1994 and 2001, mostly with people who affect what calendar prints look like: artists, publishers, and printers. Many of them, therefore, provided a view from the era of liberalization back onto the "golden age" of calendar art in the 1960s and 1970s, an era of post-independence nationalist consolidation and domestic industrial growth. In the preceding chapters we saw how under colonialism the mobile networks of the bazaar mediated between colonial trading firms, largely based in the port cities, and "native" producers and consumers in the interiors. This activity provided the means for the bazaar communities to venture into manufacturing without severing their ties to trading and speculation, or to the bazaar's "informal" modes of social and economic organization. In the post-independence period, as an English-educated elite asserted its hegemony over the pan-national public sphere, this semi-formal parallel arena, reconfigured in the context of a national economy, continued to link firms of varying degrees of formality or corporatization to a predominantly vernacular network of agents, retailers, and consumers. This post-independence reconfiguration instituted an inter-vernacular but nevertheless centralized arena of image making, distinguished from the "English-medium" public sphere both by its fragmentation or particularity and by its continued production and mobilization (in both the literal and the rhetorical sense) of sacred icons in their ritual modality. In the process, it inscribed a pan-national, cross-class, cross-caste visual idiom that lent itself both to the bazaar's cultural-political nexus with the Nehruvian state and then to the more explicitly political deployments of Hindu nationalism from the late 1980s onward (I elaborate on this in chapter 6).

As I describe in the relation to the Sivakasi calendar industry, it is this persistence of religiosity in the public arena that underlies both the resistance to the institution of post-Enlightenment aesthetics *and* the desire for that aesthetic schema. In chapters 2 and 3 we saw how religious imagery was variously deployed during the colonial period, by colonizer and colonized alike, as a marker of cultural difference and national identity. At different moments, both nationalists and Orientalists valorized images that were seen as providing access to an "authentic" Indianness by illustrating civilizational texts, by invoking them via allegory, or by deploying neotraditionalist formal means. Meanwhile,

icons or ritually deployed indexical images were simultaneously denigrated in colonial discourse and cultivated by colonial firms that replicated the "much maligned monsters" (Mitter 1977) of Hindu iconography to their own ends, using them on product labels. So on the one hand mythic or sacred imagery, whether valorized or denigrated, was inscribed as an essential component of "Indian culture." But, on the other hand, the post-Enlightenment system of aesthetic value emanates from a bourgeois-liberal ethos predicated on the privatization or domestication of religion, the secularization of spectacles of power, and the temporal supersession of cult by art. In short, the public sphere has neither space nor time for religious images in their ritual modality. The contemporaneity and publicness of the sacred, I will argue, is the real scandal of calendar art: an index of its "alternative" modernity, which cannot be adequately described either by working entirely within *or entirely without* the terms of post-Enlightenment bourgeois aesthetics, or the modernist heuristic frame of "art" *versus* "kitsch."

DISTINCTION AS RHETORICAL PERFORMANCE

To return to the epigraph in the introduction, when I first introduced myself to a calendar manufacturer in Delhi's Chandni Chowk, around 1994, and told him that I was doing research for a Ph.D. on calendar art, his response was: "Aapko Madam is se aur koi ganda topic nahin mila?" (Madam, were you unable to find a worse topic than this?). Like most people I interviewed from the calendar art industry, particularly artists and publishers, as well as several consumers, this publisher was well aware of the inferior status of these cheap, mass-produced images within the vast and formidable panoply of "Indian culture." What's more, he wanted me to *know that he knew*. Publishers would immediately say that they only produced what "the market" or "the public" wants, while artists would emphasize that they felt restricted by the marketplace and only got into calendar work because of financial constraints. Thus the veteran Meerut-based artist Yogendra Rastogi's first question to me was: "Do you have some special interest? Because **calendar designing, commercial designing, is not exactly purely fine art.** . . . There are a lot of **boundations, limitations, and why we are bound to adopt it? Because of money.**"[2] Likewise, the Bombay artist S. S. Shaikh, who specializes in landscapes and other secular themes, immediately clarified that "I have done this from the **J. J. School of Arts** [*sic*], I have done **fine art.** And calendar art would be counted as **commercial art,** not as **fine art.**" Such caveats often surfaced at the very outset of a conversation, and I soon realized that this was most probably a response to my self-introduction as a

student in a department of fine arts.[3] The phrase "fine art" became a kind of seed-crystal toward which a whole set of other discursive elements came swimming out of the fluid of these encounters to rapidly form a neat little structure. With fine art comes its other, commercial art; with that comes the market, which is made up of the "public," an English word that in a Hindi-speaking context is often synonymous with *janata*, the "people" or the "masses," and aligned with a social distinction; with that comes the denigration of the popular realm of calendar images.

In the previous chapter I described the gulf that opened up around the 1930s and 1940s between a vernacular realm of commercial image production and an art system increasingly under the sway of modernism. However, the parallel realm of bazaar images was to maintain consistent links with the institutional realm of "fine" art and its terms of discourse, particularly via artists trained at the art schools of Bombay and Madras.[4] Most of these artists, notably Kondiah Raju and S. M. Pandit, inspired others through their work, or had apprentices or assistants who also went on to paint for calendars. Through individuals like these (or others like Ram Kumar Sharma, who did not attend art school but who has read widely about art and has been well acquainted with the national art scene), the stylistic and verbal vocabularies of the art system have come to circulate within the realm of calendar art. So, as we have seen, one option on calendar art's stylistic menu is an "Indian art style" — inspired by the "Bengal Renaissance" — that is defined by artists in terms of "Indian" line and decoration as opposed to "Western" mass and form: a formulation that took on institutional currency in the early twentieth century through Percy Brown, the principal of the Mayo and Calcutta Schools of Art (Brown n.d., 7). Another is "modern art," exemplified by free, bold brushstrokes, the use of techniques such as "knife-work" in applying paint, or the inclusion of geometric and semi-abstract forms to produce works such as Venkatesh Sapar's *Folk Dancers* (fig. 82), which the artist described as a "figurative abstract."

It is hardly surprising, then, that in elaborating the terms of the distinction between fine and commercial art, or between art and design or craft, artists largely drew on a modernist understanding of the aesthetic. The Nathdwara artist B. G. Sharma, for instance, invoked the notion of art as autonomous self-expression, an end in itself: "So he [the artist] has to satisfy his soul, that I have made this well, it's not as though he has to make it and **sell** it. So then — only that is **art.** The rest is — if you make it and take money for it, then — well, you have to fill your stomach . . . but the true one is he who makes it for his own wish and his own desire." B. G. Sharma, who was raised in

Nathdwara's icon-painting community, briefly attended art school in Bombay before becoming a very successful—and wealthy—calendar artist and printer. As with several other calendar artists who can now afford to do so, Sharma no longer paints calendars but has returned to "fine art"—though not, significantly (as I discuss below), of the modernist variety.[5] In his marble house-museum in Udaipur, Sharma exhibits what he calls his "classical" work: Nathdwara-style icons, cloth paintings or *pichhwais*, and miniature paintings, including tiny versions of Western masterpieces such as Leonardo da Vinci's *Last Supper*. Both he and Indra Sharma have also illustrated coffee-table books on Hindu deities, the Ramayana, and the Mahabharata produced by the California-based Mandala Publishing.[6]

The fine artist is "true" and the commercial artist, by implication, is compelled for the sake of his "stomach" to be false. Correspondingly, calendars are also short-lived and temporary (according to S. V. Aras, the "baby artist"). Furthermore, fine art requires attention on the part of the viewer (B. G. Sharma), or mediation by the intellect, whereas "in **popular art** [there is] a straight connection between the eyes and the heart" (J. P. Singhal). Almost all of the people I spoke with identified commercial art with the imperative to use bright, bold colors, variously denigrated as "cheap," "shouting," "thick or heavy" (*mote-mote*), or "gaudy." In short then, as S. S. Shaikh put it: "In our **line, calendar** means—we think of it as a very inferior [*ghatiya*] type of work. **Fine artists,** that is." These characterizations of fine art as autonomous, timeless, or eternal and the subject of disinterested contemplation or reflection ultimately derive from what has arguably been the most powerful and influential formulation of the aesthetic, Kant's *Critique of Judgment* (Kant 1987).[7] The Kantian formulation articulates with the emergence of "classical" bourgeois society at a particular moment of European modernity and then again with the modernist critique of mass culture. So the latter's valorization of an autonomous, critical avant-garde of art as opposed to a reified, retrogressive culture industry is often hard to distinguish from the former's division between high and low (see, for instance, Greenberg 1939). Pierre Bourdieu's *Distinction* (1984) is a detailed demonstration of how Kantian aesthetic categories are mapped onto the performance of social distinction via the alignment of specific classes with judgments of taste. Bourdieu's account, based on a (somewhat selective) study of French society in the 1970s, presents a hegemonic scenario where from primary school onward there is an internalization of social distinctions on the basis of taste right across the class spectrum, to the extent that even "the most politically conscious fraction of the working class remains profoundly subject,

in culture and language, to the dominant norms and values" (Bourdieu 1984, 396).[8] Here the inhabitants of the "lower" realms of taste are implicitly perceived as not possessing the requisite skills or predisposition to make what Kant formulates as an adequately "reflective," and therefore publicly valid, aesthetic judgment. They are doomed instead to the vulgar "taste of sense" with its more immediate, often corporeal, satisfactions, unmediated by the intellect—as in J. P. Singhal's "straight connection between the eyes and the heart."

Many of the artists and printers with whom I spoke used a similar framework of social distinction, citing determinants such as class, education, and even "IQ" to ascribe "unrefined taste" and religious credulity to the consumers of calendars, variously described as "ordinary people," "the masses," "villagers," or "the labor class." Or artists correspondingly denigrated printers and publishers: "They have no taste, they are merchants"; "They are traders [vyapari], not really lovers of art [kala premi kam hain]." But even as they were making these distinctions, my interviewees were more often than not sitting under the benign gaze of a printed deity, usually of the very type they were denigrating or equating with vulgar tastes (see, for instance, fig. 85). Most likely they also had similar images in a shrine or prayer room at home, before which they, or someone in their household, routinely prayed. So even as the high-low distinction has a certain discursive valency in the calendar industry, in practice these images are consumed across social strata. The same image of Ganesh, Lakshmi, or Vaishno Devi might be used on a calendar by the manufacturer of Sher Beedis as well as by the proprietors of Vohra Furniture House or Gupta Brothers Chemists; the calendar would be distributed to their business associates, who might then in turn pass it on to their customers, clients, or friends. It might also be sold as a poster or smaller "framing picture" at a temple, pilgrimage site, or local market. So the same image could end up anywhere, from a Brahmin hotel owner's kitchen to a tree in a vegetable market, from a neighborhood temple to the prayer room of my aunt's wealthy Marwari mother-in-law (fig. 86).

In other words, the correspondences between education, social status, wealth, and the consumption and classification of images are not quite as straightforward in postcolonial India as they appear to be in Bourdieu's class-based European mapping. What complicates the situation is the rogue element of religion, and the continuing relevance of ritual and devotional frames of valuing images that do not necessarily correspond to those of the aesthetic. It is evident from even the most cursory observation that calendar icons now form an integral part of contemporary religion, particularly Hinduism, and

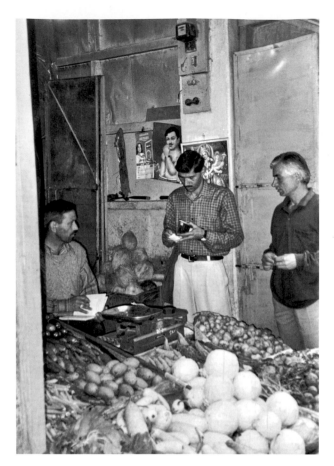

86. Vegetable stall, Landour Bazaar, Mussoorie, 2000; overlooking the transaction are, left to right, a calendar for a tea company, a poster of the freedom fighter Chandrashekhar Azad, and a calendar of the mother goddess Vaishno Devi.

that they (particularly the framing pictures) are used by a vast majority regardless of class or education. As the irascibly secular Ram Kumar Sharma pointed out, "However much they are **developed,** nobody **avoids religion.** The picture of Ramchandraji [the god Ram] will be up in the home of a man of a **modern progressive mind,** and in that of a **mythological** man as well. So it's just hanging there, there is no **artistic evaluation** of it, but . . . for a whole year you'll get an audience (*darshan*) with god, [so you say] well, okay, let's put it up. . . ." What are we to make of the apparent disjuncture between this acknowledgment from a calendar artist that religious images are used without "artistic evaluation" right across the spectrum of "development" or cosmopolitanism, and the rhetoric of others in the industry who deploy a distinction between "high" and "low" taste, aligning "low" taste with religiosity and a lack of education?

As I suggested earlier, the deployment of the high-low distinction has to be seen as a contextual, strategic response to someone perceived to be part of the art system: in this

case myself as a scholar of "fine art." Adopting the terms of the art system, and thus participating in a shared cosmopolitanism, meant that my interviewees had to disavow their own ritual use of images, displacing it onto others (the "masses," "illiterates," "villagers") whose lack of urbanity and education placed them outside our shared cosmopolitan space. In this respect it is significant that the person most ready to assert that calendar icons are in fact used universally was Ram Kumar Sharma, who was exempted from such a universal religiosity by his secular bent and therefore had no need to disavow his participation in it. (Indeed, the same could be said of my own relatively distanced view.) Ram Kumar had already told me that when he worked for calendars he had painted deities "without believing in any of them," soon getting fed up and going back to working for film and television. But this is not to suggest that the (unstated) disavowal of the use of calendar icons on the part of my other interviewees was a conscious prevarication. Instead, I read it as an attempt to function within the epistemological constraints imposed by the terms of aesthetic judgment in a postcolonial field where the "modern progressive mind" is valorized in opposition to a backward-looking "mythological" imagination.

These epistemological constraints derive, I would suggest, from the post-Enlightenment historical narrative of the supersession of the sacred by the aesthetic. A series of German scholars from Hegel (1975) through Walter Benjamin (1969) to Hans Belting (1987) have described how the aesthetic, exhibition value, and the work of art have taken the place of the sacred, cult value, and the icon. In a footnote to the "Artwork" essay Benjamin quotes Hegel on the transition from "the stage of reverence of works of art" to a "more reflective" relationship, as he in turn maps the secular-cultic opposition onto a public-private spatial axis, distinguishing between the "exhibition value" of the public, mobile work of art and the "cult value" of the ritual object anchored in its sacred space (Benjamin 1969, 223–26 and 244–46 n. 8). From the point of view of modern aesthetics, then, in the age of the work of art the sacred icon is either a thing of the past or inhabits cultic spaces concealed from public view.[9] There are only limited options, therefore, for accommodating publicly circulating contemporary religious images within the schemata of taste and aesthetic judgment. They can be aligned with the interested affections of the "taste of sense" and thus with "low culture," or they can be relegated to the past by categorizing them as "classical," or ethnologized — also an anachronizing move (Fabian 1983) — by subsuming them under the "folk" or "traditional." In my conversations with artists and publishers mass-reproduced calendar art icons were subject to the first option, while other kinds of images such as B. G. Sharma's Nathdwara-style miniatures (though not

his printed icons) were subject to the second, anachronizing option, by being described as "classical."

But once our shared speaking position as fellow cosmopolitans had been secured on this basis, another option also became available: to recognize that the discourse of taste and judgment has no place for religious icons. As Ram Kumar said, there is no "artistic evaluation" in a situation of ritual *darshan*; similarly J. P. Singhal observed that there is little place for critique when it comes to the gods: "For the people who buy them, nobody makes any **criticism** of religious pictures, well, whatever it is, it's god, what **criticism** will we make about god? That Ganeshji should not be like this but like that?" This recognition of the *irrelevance* of aesthetic judgment, however, was only possible *after* establishing a high-low distinction that *presupposed* the performance of aesthetic judgment. So what do these contradictions tell us about the status of taste and aesthetic judgment as a means of performing and enforcing social distinction?

I would argue that the frame of aesthetic judgment is being deployed here at a primarily rhetorical level, as a means of performing solidarity between educated, relatively cosmopolitan constituencies while simultaneously asserting distinctness from others of a greater degree of vernacularity. This guards against the threat of conflation with these social others through mass production's institution of a shared realm of image consumption. In other words, the rhetoric of aesthetic judgment is adopted in particular contexts to reinforce social distinctions that mass reproduction threatens to erode. Crucially, however, this rhetoric does not actually correspond to aesthetically enforced social distinctions: in practice, as publishers and artists acknowledge (and my conversations with consumers attest), aesthetic criteria are seldom deployed when choosing, using, or circulating religious icons, and these mass-produced images continue to circulate among all except a small but powerful section of the English-educated elite.

My contention here is not that social hierarchies do not exist in this context, but that social distinction is not *primarily performed* through the exercise of taste or aesthetic judgment, as might have been the case in bourgeois Europe. To this extent the ambiguities I have sought to identify in the social mapping of aesthetic distinctions present us with significant departures from Bourdieu's hegemonic scenario. First, the discourse of taste and the deployment of aesthetic categories emerge as relatively weak elements in the perpetuation and legitimation of dominant formations, which (as I elaborate in chapter 6) have more use for the contemporary, public presence of the sacred than post-Enlightenment narratives of aesthetic supersession can allow. Second, in this epistemi-

cally fraught postcolonial context, where both the field of "culture" and the categories of class are far less coherent than they appear in the world of Bourdieu's *Distinction*, it is possible that some constituencies might have internalized the discourse of taste and its social distinctions, while others might have remained impervious to aesthetic categories. But also, as we have seen, subjects do not behave in singular, consistent, self-identical ways but move strategically between contexts of engagement. In this light I think it is inaccurate and unproductive to try and "freeze" constituencies of aesthetic response in terms of class, caste, religion, region, urbanity, vernacularity, education, and so on. However, given that post-Enlightenment and other ways of relating to and talking about images coexist to differing degrees for the consumers of calendar images, as for the artists who produce them, what we *can* try and specify are the *terms of negotiation* between these modes of engagement with images: what it is that makes for the disjunctures, differences, and articulations between them.

WHEN COLOR SHOUTS, WHAT DOES IT SAY?

As we have seen, the calendar industry's non-self-identical, strategic deployment of the categories of high and low taste can be specified in terms of a mismatch between the contemporaneity of religion and historical narratives of its temporal supersession by art. Similarly, it can also be specified in terms of a mismatch between the publicness of the sacred and narratives of its secretion into the realm of the private. A manifestation of the first kind of epistemological gap was artists' and publishers' displacement of the consumption of calendar images away from people like themselves onto an illiterate, rural, or working-class audience. The second sort of gap is manifested in the contradiction between the almost excessive effort that the Sivakasi industry puts into intensifying the colors in calendar prints and the uniform denunciation of bright colors by artists, publishers, and printers (as well as some consumers).

Sivakasi prints are associated with a characteristic "look": very strong, deeply saturated, contrasting colors with bright highlights. This is achieved by extensive manual retouching of the color-separated negatives during the pre-press stage of the printing process, and the use of two blue and two red plates in addition to yellow and black. Retouching artists work on each film separation for anything from two to twenty hours, brushing on photo opaque and "pink wash" (for areas of tone) and scratching off the emulsion to achieve maximum saturation, tonal contrast, and strong highlights and shadows (fig. 87).[10] This is often also the stage at which a lot of the ornamental detail is added

87. A retouching artist at work on a calendar print, Sivakasi, 2001. He is using a blade to scratch away the emulsion, so that the color whose separated negative he is working on appears completely saturated. The pink areas are where that color is to be blocked out or subdued. The artist has the original artwork (painted by another artist) in front of him for reference.

to the picture, including an additional "golden" layer.[11] Several explanations were proffered about why such extensive manual retouching is needed. The technical reason cited was that it compensates for inadequate exposures during the color separation process, due to inferior quality filters (a lot of presses use gelatin instead of the more expensive glass), insufficiently sensitive film, uneven or fluctuating lighting, or inaccurate exposure times. Also, more convincingly, retouching and the use of two blues and reds was said to smooth out a lot of the screened dots that would otherwise appear on the image. However, I am not sure that this is enough to justify the additional expense of sending the separations out to a retouching studio or hiring skilled artists in-house, despite their low wages. And even if it is, this technical explanation is not the one most commonly offered. Sivakasi's colors are usually attributed to "South Indian taste," or that of "the common man": that imagined other created by mass culture. (I elaborate further on this notion in chapter 6.) So what might have started out as a technical solution has become an integral formal feature of the genre, for now that many printers have gone digital, they are using computer software such as Photoshop to achieve similar effects, even though digital scanning can produce perfect color separations. In short, retouching is not about

88. A printed version of a calendar design by Sapar Brothers depicting Hanuman (left) next to the original painting, Sivakasi, 2001. The retouching process gives the print greater saturation and color contrast, creating a sensation of clarity, depth, and luster.

faithful reproduction but primarily indexes the printers' perceptions of what they think their audience wants: intense contrast, smooth surfaces, deep, saturated color, and plenty of golden-yellow ornament.

These formal qualities cannot be achieved at the painting stage, only in the printing process. Many artists complained that Sivakasi's printers completely changed their original colors through retouching, making the backgrounds much deeper than they had intended and giving babies, gods, women, and freedom fighters alike bright red lips and pink cheeks (while this has largely been true, in more recent instances the effect is far more subtle: fig. 88). As the Meerut-based artist Yogendra Rastogi put it, "Even if it's Ramchandraji [the god Ram] they'll give him [the actress] Saira Bano's **lipstick** — I didn't put it there!" As I mentioned earlier, almost all of the artists I spoke with associated commercialism with this use of "cheap," "shouting," "thick" or "gaudy" colors. For Venkatesh Sapar, such colors were more strongly associated with framing pictures than with calendars: "Framing pictures, the taste is different — framing pictures, they always want bright colors, cut colors, like blue or something.[12] In that we have to sacrifice [laughs] — with our style and everything. . . . For the common people, or — the shopkeepers, they keep the god-picture in their house. . . . See, whenever they are in

the regular work, they always keep their mind to attract the god. That is why they want the bright colors. I think like that, huh? There may be a different reason." The venerable Nathdwara artist Indra Sharma also seemed to think like that, emphasizing the attention-getting aspect of gaudy, distracting (*chatkile bhatkile*) colors: "Whether or not your gaze wants to go there it still goes." The bright colors of the framing picture are perceived as clamorous, "shouting," attracting the gaze away from its "regular work": in other words, forcing the divine presence into the public arena.

So it is not icons' sacredness per se that associates them with "popular" taste, but their public claim for attention, indicated by this use of color. Both Sapar and Sharma described the more "artistic" use of softer colors as also associated with "godliness" (*devatva*: Sharma), bringing out the "sweetness" (*madhurya*) in the painting or the gentleness of Krishna's smile (Sapar). The notion of the need of "common people" or "shopkeepers" for images that attract their attention resonates with the association often made in the literature on *bhakti* (devotion) between the use of images as a support that the mind can use to steady itself in focusing attention on the divine and the needs of "ordinary people" who might otherwise find it hard to concentrate (see, for instance, Vyas 1977, 57). This idea that those unused to contemplation or meditation require stronger measures to turn their minds to god is easily cast in terms opposed to the "taste of reflection." In contrast, the association of soft colors with a gentle, sweet godliness closely approximates the appeal to the "higher" emotions, *bhava*—the category that Balendranath Tagore evoked in 1894 in extolling Ravi Varma's work, though as we will see in the next section, his formulation was somewhat different to that deployed by calendar artists (see chapter 2; Tagore 1894 cited in Mitter 1994, 230–33, and Guha-Thakurta 1992, 128–32).

The relegitimization of *bhava* during the colonial period as a category of "classical Indian aesthetics" provided a basis for the sacredness of the image to speak to the framework of art, taste, and its corresponding social distinctions. Again, this was an anachronizing, neoclassicist move, anchoring the expression of sacred affect in a classical past. But the endorsement of soft, "refined," quiet colors in the treatment of religious themes also speaks to the self-understanding of bourgeois religiosity as a private, intimate, and unworldly affair. The post-Enlightenment understanding of the aesthetic articulates with a separation between private and public, such that the spaces and times of the individual and family (domesticity and leisure) are opposed to those of the market, state, and civil society (public life, work). In this schema religion is relegated to the realm of the private, while "culture" and the aesthetic are seen as supplanting the sacred in the public arena.

So while the refined, subdued, private expression of *bhava* can be accommodated within this schema, the insistent clamor of color in Sivakasi's framing pictures asserts the presence of the sacred in the public arena, and the "failure" of its supersession or sublimation by the aesthetic.

The category of the aesthetic ambivalently refers both to a quality of the object and to an appropriate attitude of judgment (Harpham 1994, 124). The way an image looks, its color, "content," or "style," is indissociable from the way it is looked at, or the locations and modalities of its use. In the case of calendar art, then, the saturated colors of Sivakasi prints are imbricated with a way of looking that interrupts the space and time of everyday life, engendering a cross-contamination between the aesthetic, the sacred, and the everyday. Correspondingly, the taste-related distinction outlined by publishers and artists implicitly maps onto a distinction between publicness and privacy in religious performance. So even though prints that are tucked away in the domestic prayer rooms and kitchens of those with a "modern progressive mind" often have much the same provenance as those that watch over the cash drawers of small shopkeepers or the machines of factory workers, it is the latter constituencies that are described as "lower class" and "uneducated." The crucial difference lies not in the veneration of these images but in the ability to recognize or uphold the boundaries between private and public, spiritual and worldly.

The Sivakasi industry thrives on images that are predominantly religious but also circulate in commercial and institutional contexts. To this extent it perpetuates the presence of the sacred in the public arena (which thereby fails to qualify as a "rational," Habermasian public sphere), and in so doing it refuses to play by the teleological rules of Europe's narrative of history. But the powerful simulacra of that history pervade the postcolonial field, its desires, and the terms of its self-knowledge, playing this aspect of Indian modernity back to itself as a failure, an exception, a cause for disavowal, displacement, denigration. Sometimes in the course of my conversations with calendar artists, I would ask what work of theirs had given them the deepest pleasure and satisfaction. It was striking how many of them, in response to this question, showed me paintings or drawings that employed a somber, almost monochromatic palette reminiscent of black and white photographs. Astonishingly, both Yogendra Rastogi in Meerut and S. Courtallam in Sivakasi produced portraits of the Nobel prize-winning Bengali author Rabindranath Tagore (fig. 89), similar to one by C. N. Row that the Sivakasi artist Ravi had up next to his desk. (The art critic Balendranath Tagore, champion of *bhava*, was Rabindra-

89. A sketch of Rabindranath Tagore by S. Courtallam.

90. A gouache painting of Jayalalitha by S. Murugakani.

91. J. P. Singhal with one of his "tribal beauties." (Smith Poster Archive, Special Collections Research Center, Syracuse University Library)

nath's nephew; his writings were said to be greatly influenced by his illustrious uncle.) S. Murugakani, also from Sivakasi, showed me a demure early portrait of the actress-turned-politician Jayalalitha copied from a film magazine, again in shades of gray (fig. 90), while J. P. Singhal cited his paintings of *adivasi* (tribal) women, done in browns and blues (fig. 91). Ram Kumar Sharma described his most original work as a blending of "realistic anatomy" from "Western art" with the "decorative style" from "Indian art" to create his own "fantasy" or "poetic" style. Both Courtallam and Shaikh also treasured their paintings of rural scenery for their depiction of the atmospheric qualities of light and dust peculiar to Indian villages.

What these works had in common was not just their muted palettes but also their secular and at the same time unmistakably Indian themes. Even as the influence of Western art was clearly in evidence in these pictures, it was equally clear that they could have been created nowhere but in India. In both themes and techniques — and particularly

their colors—these pictures seemed to inhabit a highly specific, local, "fine art" imaginary, forming a heterotopia, an alternative space outside both the calendar industry and the mainstream art system, which grew in definition as artists talked about their work and careers.[13] Particularly significant here was their use of the term "realism," something to which they all aspired, and which emerged in these images as a simulacral naturalism: the realist depiction of ideal subjects. This is not to say, for instance, that there was no such person as Tagore, but that his portraits primarily enshrine a Nobel-prize-winning, internationally recognized (and recognizable) version of "Indian culture"—just as the other images enshrine a secular national culture in figures of woman, Orientalist poetic fantasy, or the romance of the Indian village. As naturalist simulacra these monochromatic, secular images are akin to the polychromatic deities of Sivakasi, even as they are direct inversions of them. But while the shouting god-pictures of Sivakasi belong to the "alternative" modernity of the post-independence bazaar, the calendar artists' private, hidden works represent a path not taken, that of a properly bourgeois modernity. It is more than fitting that the man so often chosen to figure forth this unfulfilled possibility was the grandson of Dwarkanath Tagore (whom we encountered in chapter 2), a merchant-entrepreneur, an equal partner in a British firm in the 1830s, and a patron of Western-style fine art: the emblem of a stillborn—because impossible—moment of universal "history." If realism was the privileged artistic mode of the European middle class, the Sivakasi calendar artists' shadowy, colorless portraits of Rabindranath Tagore are perfect embodiments of a postcolonial *Indian* realism: spectral projections of the historical bourgeois subject that India could never have.

A "SUPERHUMAN" REALISM

Realism haunts calendar art: it is what calendar artists desire most intensely, perhaps because the bazaar tantalizingly allows them to pursue it, only to be brought up short—as we will see—by iconographic imperatives enforced in the name of popular demand. But "realism" as it was deployed in calendar artists' discourse was not necessarily opposed to religious imagery per se. For instance, Indra Sharma, who as far as I know has seldom painted anything other than mythic and religious subjects, insisted at one point that his calendars were "absolutely realistic." In my conversations with artists, "realism" emerged as an often contradictory, highly overdetermined term, in Laclau's and Mouffe's sense as having a plurality of meanings, that was implicated in a number of symbolic structures, no one of which can ultimately be privileged over the others (Laclau and Mouffe

1985). Not only do calendar artists' multiple, overlapping mobilizations of realism bear the traces of several histories and systems of valuing images, but they are also a site of continuing struggle and coexistence between them.

The tension between colonially introduced aesthetic criteria and the frontal icons of the bazaar is one such struggle, where realism is bundled, against the sacral imperatives of the bazaar, with a post-Enlightenment schema of aesthetics, the historical imagination, and the secularization of everyday life. But at times calendar artists' characterizations of realism also mapped this tension onto other arenas of contestation in the symbolic realm. One of these arenas is a set of ongoing negotiations *within* the sacral arena, between a reterritorializing religiosity that harnesses devotional affect to institutional spaces, textual authority, and social hierarchy, and the deterritorializing, egalitarian impulses of personalized, often ecstatic forms of worship, of the kind made available (but also often quickly reinstitutionalized) by the *bhakti* or devotional movements arising at various times and places on the subcontinent.[14] Another such arena of symbolic struggle is the post-independence contest I have been describing between the culture of the English-educated national elite and of the realms of vernacular modernity represented in part by the bazaar. These overlapping contexts emerged when artists elaborated on what they considered to be opposed to realism: the commercial imperatives of the bazaar; "traditional" work, such as the Nathdwara icons; and "modern art." Even though the oppositions between iconic and realist imperatives were often framed in terms of the differences between "Indian" and "Western" art, in each of these instances the desire for realism also spoke to concerns that were not simply reducible to a desire for mastery of Western technique or to the attendant adoption of a post-Enlightenment aesthetic schema. When I asked Yogendra Rastogi the difference between commercial and fine art, he replied:

> It's very straightforward. One of our constraints is that a painting made for a calendar, whether it's Gandhi or a child, **XYZ,** or Nehru, or any other **subject,** a woman, a **beauty** . . . now that **beauty** is there, you want **publicity** for the *chappal-wala* (slipper man), she's putting on her slipper. Now whether she puts on her slippers, or makes a *beedi*, or washes clothes, for soap, she has to look at you. That child who is studying, if he's reading his eyes will be downcast, and if his eyes are downcast the calendar will not sell. . . . The general **public** over here . . . by and large they say one thing: "See here, sir, [god] isn't looking at us, and if he is not looking at us how will he bestow benevolence on us (*kripa kaise karenge*)?" When

this Lakshmi is not looking at us, there's no way she can bestow benevolence on us. So behind this is partly people's **ideology. . . . Bold colors, bold figures, front looking**—these are the most important things.

These imperatives of the bazaar are not always or necessarily reflected in the images themselves: these are primarily discursive categories, part of the bazaar's self-understanding. However, there is indeed an intense emphasis in calendar art on the face and eyes of the icon, both as vehicles of *bhava* or emotion and as a locus of the artist's originality and skill—to the extent that one printer singled out the treatment of the eyes as the clearest indicator of an individual artist's style. This emphasis accords with the iconic imperative of frontality in images meant for ritual *darshan*, where the devotee must be able not just to see but also be seen by the deity in order to receive its blessing. Indeed, the way in which calendar artists tend to paint the eyes last, as part of the master strokes of "finishing," coincides with other more overtly ritualized icon painting practices (such as the *netronmilana* ceremony in the establishment of Saivite icons: see Davis 1997, 35–36).[15]

Rastogi's problem with this iconographic imperative regarding the frontal gaze is akin to the problem of bright colors, for in both cases the gaze is spatially and temporally interrupted in its secular-realist course of action. Lakshmi, Gandhi, and the beauty putting on her slippers or watching television (fig. 92) must look out toward us from their business inside the picture, however lofty or banal; outside the frame, the picture's "bold colors" drag our gaze away from its "regular work" to meet their eyes. The picture's rude claim to our attention crosses the line between public and private, while the gaze from within it that acknowledges our presence returns us to the familiar lament of realism, foiled in its attempt to construct a transparent narrative of everyday life. The denigration of iconic frontality here resonates with the aesthetic unease with other characteristically frontal forms such as pornography, propaganda, and advertising, which delink the image from a self-contained diegetic world within the picture frame in order to exhort the viewer to a performative or embodied response. (I return to this moral-aesthetic unease with the viewer's corporeality in the following chapter.)

This is not just a spatial issue, for the temporal register of these iconic visualizations or materializations, and of the repetitious ritual engagements they invoke, also disrupts the vector of "history." Often, therefore, the tension between fine and commercial art, or between realism and the sacred imperatives of the bazaar, was mapped onto a contest between the authority of history and that of sacred texts. While Rastogi seemed poetically resigned to a compromised realism, Ram Kumar Sharma, with his immense erudition,

92. *Television*, a 1969 calendar design by R. Arts. The "front-looking" imperative means that the woman watching the game of cricket on television must do so out of the corner of her eye, her face turned toward the viewer of the calendar. Fortunately for us, the one-point perspective enables us to see both the woman and the game. (Collection of JPS and Patricia Uberoi, Delhi; also included in Fukuoka Asian Art Museum 2000.)

Romantic persona, and intense passion for history, was unable to reconcile himself to what he saw as the complete lack of "authenticity" in mythology.[16] He quit the calendar industry and returned to film and television, to work on storyboards and art direction for "historically authentic" period dramas such as *Ashoka* and *The Great Mughals*. Others attempt to reconcile mythic and historical time by treating the "mythological period" as more or less equivalent to the "prehistoric period." As I mentioned in the previous chapter, one of the books used as a reference for mythic landscapes by the calendar artist Ravi in Sivakasi is an illustrated popular science text on prehistory. Ram Waeerkar, who as its first illustrator established the style of the *Amar Chitra Katha* mythological comic series, also sought to co-opt mythic into historical time: "It means, mythological. So it's a prehistoric period, or something like that. It should look like — whatever the Ramayana period, or Mahabharata period, it is in that period. You can find out, no?" This has

proved a useful working principle to fill gaps in scriptural description.[17] However, where textual prescriptions do exist, they prevail over this attempted chronologization; here Waeerkar gives the example of how he had to depict horse-riding in the Mahabharata despite history's dictum that it was introduced to India much later by Alexander. For Anant Pai, the publisher of the *Amar Chitra Katha* comics, proper input from the *shastras* (sacred texts) has been crucial to the legitimacy of his retelling of the classics (see Pritchett 1995, 80, 88).

Some artists also place a similar emphasis on textual fidelity. Indra Sharma shores up his reputation as an icon painter (and, presumably, his status as a Chitrakar Brahmin) by invoking the *shastras*: "There's the whole description, for instance *kamalnayan* (lotus-eyed), *mrignayan* (deer-eyed). . . . Say I make a picture of god, of Vishnu. So I won't just make it from my imagination. If a proper (*sahi*) **artist** makes that picture, first what is written in our texts (*shastron mein*), that Vishnu's body is delicate (*sukomal*), yellow (*pitambar*) — there's a description of it, of the necklace, of the crown, so we follow — we go along with that, that's how we know how to make a picture of god." According to Indra Sharma the reason why people sought him out to paint religious subjects, as opposed to the more "realistic" S. M. Pandit, was that Pandit's figures look like people rather than gods: "Now the body is very strong, but we will not show the **anatomy.** For god's body, the description is of a gentle, beautiful (*sukomal*) body. . . . There won't be any **muscles,** we people avoid **muscles.**" The textual injunction against muscular gods was the first (and perhaps hardest) thing that Ram Waeerkar had to get used to when he started working for *Amar Chitra Katha.* This has been a common source of frustration, not only for Waeerkar (who developed his early skills in figure drawing from the *Tarzan* comics), but for all those artists who have studied human anatomy and feel unable to use or display their grasp of proportion and musculature. Yogendra Rastogi said he has had to modify the "correct" (human) proportions according to those of the icons to which people are accustomed: "If we don't make the **face proportionately** bigger, then the *bhavyata* (divine beauty) that people see in it — that *bhavyata* — if you make it absolutely **correct,** the right size, then people will say, Rastogi *sahib*, what have you done, how have you made the face, there's no power in it." If the face and eyes are made larger and more visible, it is to enhance the benevolent emotion, beauty, and power (*kripa, bhava, bhavyata, shakti*) centered there. And not only must the gods have smooth, gentle bodies and large faces, their expressions must be tranquil, almost meditative. For divine will, unlike that of the human, is not limited to the instrumentality of the human body, so as

93. *Ram Ravan Yuddha* [The battle between Ram and Ravan] by Mukesh, print by S. S. Brijbasi: even in battle, Ram and Lakshman have heavy-lidded eyes and benign countenances. (Courtesy of Brijbasi Art Press Ltd.)

Waeerkar puts it: "Bhagwan Krishna, Prabhu Ram . . . they have succeeded in fighting, but they are not fighters." This divine agency, at least in the case of Vishnu (of whom both Ram and Krishna are manifestations), is not so much a matter of labor but of *lila* (sacred "play," in both senses of the word). Thus Waeerkar's plight in the epigraph to this chapter, of trying to reconcile the textual description of Ram as having half-closed eyes with a plausible visual depiction of his pursuit of the golden deer. In the attempt to figure myth as history, such depictions of action, of bodily agency, render irreconcilable the differences between narrative "realism" and sacred textual imperatives: "It looks ridiculous!" (fig. 93).

Evidently, then, the formal imperatives of the bazaar enforce a distinction between humans and gods, and the difficulties encountered by artists in their quest to implement "realism" alert us to the precise nature of this distinction. One element of realism that encounters resistance in the commercial context of the calendar industry is the linear

time and perspectival space of the historical subject: this is interrupted, flattened, and hypostatized by bright colors, the absence of a middle ground, and the frontal gazes of icon and viewer meeting across temporalities. Here the potential ritual objecthood of the image and the viewer's implied performative response dissolve the boundaries between historical and mythic time, and between extra- and intra-diegetic space. Another element of realism that is resisted is the depiction of the bodily agency of the willing subject, as figured through the muscularity, non-frontal dynamic postures, and wide-eyed alertness of human instrumental action. (I return to the issue of muscularity and agency in chapter 7.) In these respects the realism desired by calendar artists is coextensive with the spatiotemporal schemata of post-Enlightenment thought and its human subjects.

At the same time, however, some artists saw their practice not so much in terms of a compromised realism but as a viable synthesis between "Western" realism and "Indian" or "traditional" art. Not surprisingly, this was particularly the case for Indra Sharma and B. G. Sharma from Nathdwara. As Indra Sharma put it: "I left [Nathdwara] because I had learned to work in the Nathdwara tradition here, and for five–six years I had worked here. Then I thought that I wanted to learn to work in the **Western** tradition . . . what we call **realistic** work: you are sitting there, I look at you and make a **portrait.** And for that, at the time the best **institute** in India [was] the **Sir J. J. School of Art.**" Both he and B. G. Sharma valorized realism, with its key elements of "**three dimens[ionality], likeness, naturality**" (B. G. Sharma), in opposition to the "**flat work**" of their "traditional" style, placing it firmly within the "Western" or "foreign" lineage (*paddhati*) made available by the art school (although Indra Sharma later pointed out that realism was found in Mughal painting as well). However, this opposition was articulated within the framework of an acceptable—indeed, desirable—synthesis. B. G. Sharma, describing the "classical" work in his gallery (of which he is justifiably proud), said: "So what I have seen is that you should look at all the **schools,** and extract from them (*unko nichod ke*) to start your own school. So whatever is there in that, **three dimens[ions], shade,** whatever, I extract them all and bring some **interest.**"

This confidence in a synthetic practice must owe something to the institutional legitimation, at least in Bombay, of "the Indian Art Student as the Superhuman Realist" (Solomon 1926, 115), following colonial debates over the relevance of Western naturalist techniques to Indian art education. W. E. Gladstone Solomon, the principal of the J. J. School of Art from 1920 to 1937, insisted that realism was an integral feature of Indian art and perfectly compatible with the kind of essentially Indian imagination and flair for

ornamentation valorized by colonial administrators such as G. M. Birdwood of the India Office (Birdwood 1880/1986). For Solomon, Indian art was characterized by "the union of nature-study and decorative feeling" (Solomon 1926, 118); he therefore supported the training of Indian students in both "Western" and "Indian" pictorial techniques, a skill set that was carried across into the realm of mass culture by students from the J. J. such as S. M. Pandit and Indra Sharma. While most calendar artists I spoke to would not have agreed with Solomon's polemical notion of an always, already realist Indian art, several spoke of their own work in terms of a similar synthesis between nature, or reality, and ornament, or decorativeness. J. P. Singhal, for instance, spoke of the way in which popular pictures "ornament reality" (*yathharth ko shringar karte hain*), giving it "a poetic form, a decorative form" (*alankrit roop*). Similarly, B. G. Sharma asserted the role of the artist's imagination in enhancing a merely photographic reality, while Ram Kumar described his "fantasy" style as a combination of "realistic" and "decorative" impulses.

What interests me here is the way in which these artists have taken on board colonial terms for categorizing the elements in the "East-West" synthesis but have then overlaid those terms with their own distinctions. For instance, Singhal also said that the ornamental or decorative aspect of images (*shringar paksh*) often came to dominate religious calendars at the expense of the emotional aspect (*bhava paksh*):

> Indeed I would say that in between — not just in between but even now, people — including some of my other painter brothers — from the beginning they put rather too much emphasis on **ornamentation** . . . **very heavy-heavy ornaments and backdrops,** very **decorated, overdecorated** . . . because there was just no other **scope** to do anything. . . . So because of that, the **figure,** its **face,** that emotional dimension (*bhava paksh*) of the picture that is — *was* — there, over that emotional dimension, the ornamental dimension (*shringar paksh*) came to predominate.

Singhal may well have been alluding here to the work of artists such as Indra Sharma or Kondiah Raju, whose Nathdwara- and Tanjore-inspired icons are markedly more ornate than the largely narrative paintings of Pandit and Mulgaonkar. As I mentioned earlier, Sharma had described his calendars as "absolutely **realistic,**" meaning that nothing of the Nathdwara style persisted in his work. Later, however, Sharma qualified this assertion in order to make space for his "traditional" skills: "But whatever — the tradition of doing work, and so on — whatever I learned over here [in Nathdwara] has had a big influence. That's bound to happen, bound to happen. . . . The influence [of the tradi-

tion] is that the kind of **finishing** we used to do, it's superior to what other artists do, why? Because there is a tradition of doing detailed work." What emerges here is an alignment of *bhava*, or the emotional dimension, with realism and the "genius" of the master artist, whereas "finishing" and the painting of ornaments (*shringar*) is aligned with craftsmanship and "tradition." Here again, as in the argument about color, *bhava* becomes the aesthetically acceptable aspect of the sacred icon, the site of a working synthesis between fine art/realism and iconography. In this case *bhava* is opposed to excessive ornament rather than loud colors, but it could be argued that as in the case of "shouting" color, the problem with ornamentation is one of an insufficiently self-contained or private sacrality: a conflation of the space and time of the image with everyday life outside the frame. The ornamentation within the picture stands in for, and gestures toward, the adornment (*shringar*) of the picture itself (as an embodiment of the deity or icon) during the prayer ritual, blurring the boundaries between the picture as object, the active presence of the viewer, and what is depicted "inside" the picture.

Here, however, I want to suggest that the post-independence calendar industry imparts a somewhat different coloring to *bhava* than Balendranath Tagore's colonially oriented, classicizing formulation. Tagore's notion of *bhava* as a key category of "Indian" aesthetics was derived from Sanskrit literature, the expression of "noble" sentiment or "the glow of divine inspiration" establishing a lofty academicist parallel between Hindu gods and those of Greece or Rome (Tagore 1894, 98–99, in Guha-Thakurta 1992, 131). But as it was deployed by calendar artists, the term appeared to draw more on the discourses of visual desire in the devotional *bhakti* movements than on the reformulation of India's "classical" heritage by the colonial elite: on the vernacular *bhajans* (devotional hymns) of saint-poets such as Surdas and Kabir, or verse epics such as Tulsidas's *Ramcharitmanas*, as well as retellings of the Sanskrit Puranas or the dramatic texts of Kalidas and Banabhatt. As active members of an artistic community closely linked to Nathdwara's Shrinathji temple, B. G. Sharma and Indra Sharma were particularly lucid in their articulation of the way in which the icon mediates the relationship of deity to devotee. B. G. Sharma described the icon as "a means to bring oneself to focus," to bring a centeredness (*ekagrata*) to one's "restless mind." Accordingly, in Indra Sharma's words, an image must be *aakarshak* (attractive), making the viewer *mugdh* (rapt) or *mohit* (seduced or enchanted). Similarly Yogendra Rastogi, analyzing the work of the Nathdwara artist Narottam Narayan, linked realism with the ability of artists to figure the *saumyata* (benevolence) or the *komalta* (gentleness) of the gods.

The stress here was not on the deity's grandeur, or on the allegorical role of gods

and heroes, but on the desires engendered by the intimate, personalized relationship between deity and devotee, powerfully imagined in many strands of *bhakti* as a yearning for *darshan*. The benevolence, gentleness, and seduction embodied in these images was not meant to provide a (neo)classical model for human conduct culled from the distanced, ideal realms of the aesthetic or the spiritual, but to facilitate a direct emotional connection between gods and humans. So even though I have argued that the bazaar's iconographic imperatives disrupt artists' aesthetic criteria by rendering present (in both senses) the space and time of ritual and the sacred, there is also a sense in which "realism" in this context is valorized for its ability to make manifest the benign, affective presence of deities. We might better understand this latter sense of the term with the help of the Hindi word that some artists occasionally used instead of the English "realism": *sajivta*, more accurately translated as "livingness" or "lifelikeness." At issue here is not the reality of the gods, but how alive they are: how the image brings them to life.

Not only did realism in this context have an affinity with sacred themes, it also carried a strong ethical charge. Both these aspects were highlighted by the terms in which many artists distanced themselves from "modern art," clubbing together what they saw as the desirable elements of realism and the traditional, Western and Indian, or art and craft, in opposition to modernism. Significantly, those artists who were relatively comfortable with modernism either do not paint icons (such as Shaikh, who specializes in landscapes), or do not paint them exclusively (such as the highly eclectic Sapar, or Aras the "baby artist"). But B. G. Sharma, who mostly paints religious images and describes himself as combining the "traditional" and the "realistic," was quick to correct me when I suggested that "ordinary people" might prefer his framing pictures to his "classical" work:

> **BGS:** Someone who comes to see my collection, will they not understand it? Or will they? What ordinary people don't understand, they don't understand **modern.**
>
> **KJ:** So you didn't go toward **modern** at all?
>
> **BGS:** Toward **modern?** See, **modern** doesn't have a **life** . . . With **modern,** it'll go, and something else will come to replace it, and a third will come to replace that. . . . Where is the work, the labor (*tapasya*) . . . more than **painting** a man has to give a **speech!**

I asked the young Nathdwara artist Raghunandan Sharma (Indra Sharma's nephew) the same question, to which his response was:

Actually the thing is that I don't understand what they are making, in **modern art.** What they are making, what they are trying to make . . . they just have **brush** — **color** in the **brush** . . . so you can't tell what's going on. So it's a matter of different tastes, there are those who like **modern,** and you get good money in **modern** as well. You don't get that much money for these **paintings.**

. . . Now a **modern painting** can be made in one or two days, four days. And then there are **exhibitions** after that, in Delhi and Bombay, [where] a painting sells for hundreds of thousands (*lakhs*) of rupees. For this **painting** [gesturing toward his own work] if you even ask for 50,000, they will say, what is there in this? Although there is a lot in it. From the point of view of effort (*mehnat*), there's a lot in it.

Others also expressed a concern with the way in which the "modern" subverts the hard, honest labor shared by both "realism" and "traditional art" (or, more specifically, the Nathdwara tradition): *tapasya* (privation), *mehnat* (effort), study, craftsmanship.

The terms in which these artists described their problems with "modern art" were as universal and as local as "modern art" itself: it is hard to understand, it changes with the times and has no lasting value, it often unjustly rewards little effort or a lack of skill. These opinions accord with the widespread populist view that an inability to understand the modern has less to do with the inadequacy of the viewer (and his or her "reflective" capacities) than with a fraudulent practice that takes the critics and the art market for a ride by using fancy rhetoric. Ram Kumar Sharma also brought up the apparent randomness of modern art, and the role played by language as opposed to labor and craftsmanship:

But if you have no **conception,** and you start applying **colors** and something is produced, and then you give it a **definition** . . . if that's **modern** then I don't understand it, I haven't understood it from the beginning, what the **definition** of **modern** is. Though there have been good people working with **color conceptions,** that you would call **modern,** but when there's no **basic conception,** I can't understand it. It's unsettling (*uljhan paida ho jati hai*).

. . . When the work of **foreigners** comes before us . . . it's such **studied** work, and we don't have that **study** over here. **Craftsmanship** — it just hasn't survived, has it? It's been spoiled by this **modern,** the **craftsmanship** in **painting** has been destroyed.

Revealingly, the modern here is not aligned with "foreigners" (a synecdoche for "Westerners"), for their "study" is that of "realism." Who, then, might embody the unethical

mystification of modernism, its lack of integrity and easy money? The name given time and again to this "unsettling" presence was that of the most famous modernist artist in India today, M. F. Husain, whose every canvas, sketch, and chalk mark trades for enormous sums—and who also happens to be a Muslim. A couple of publishers denounced Husain, with barely disguised anti-Muslim undertones, as an iconoclast in the most literal sense of the word, citing the way in which one of his artworks involved physically eradicating an image of the goddess Durga; since then Husain has been in the news again, this time when his work was vandalized by Hindu hardliners objecting to his "obscene" (that is, nude) depiction of Hindu goddesses. (I return to this episode in chapter 6.) But it would be counterproductive, not to mention heavy-handed, to overemphasize this communalization of the discourse around "modern art." If, not surprisingly, S. S. Shaikh (a Muslim) said that Husain, along with the early Indian modernist Amrita Sher-Gil, has been one of his greatest sources of inspiration, so did Venkatesh Sapar (a Hindu), listing Husain after Michelangelo, Leonardo, and Picasso. The resonance between the calendar industry's discomfort with "modern art" and the general scapegoating of Muslims by the Hindu Right cannot be taken to mean that this mistrust of modernism has an essentially communal basis.

Perhaps more germane to the industry's resentment of Husain, I would suggest, is the well-known fact that he hails from a similar socioeconomic background to artists in the calendar industry: he started out in the commercial arena, painting cinema banners before becoming a "modern" artist. For one artist this made Husain a particularly suitable example of the fraudulence of modern art: he described Husain as "just a **poster painter**" who "wasn't even able to make a **drawing**" when he started out; another claimed that he could have far outshone Husain if he had chosen the path of modern art. It is no coincidence that these sentiments issued from two self-taught artists, while the art-school-trained Shaikh and Sapar expressed admiration for Husain; by attending the J. J. School of Art, and excelling there, the latter two had enjoyed a privileged relationship to the elite, nonvernacular world of modernism. While this exclusive world requires a kind of social access that is relatively hard to obtain, the skill, craftsmanship, study, and labor required to master "realism" have been more readily available to self-taught artists from a range of backgrounds.

So what is it about "realism," as used in this context, that speaks both to artists' and viewers' understandings of the work of the image in a way that "modern art" does not? I would suggest that this realism is able to accommodate an ethical evaluation of the

image, both in the representational content of the pictures and in the practice of painting, in a manner that is abhorrent to modernist aesthetics. Bourdieu identifies a tendency in (what he categorizes as) "popular taste" to substitute ethical judgment for aesthetic judgment, which threatens the autonomy of the aesthetic by performing a " 'reduction' of the things of art to the things of life, a bracketing of form in favor of 'human' content, which is barbarism par excellence from the point of view of the pure aesthetic" (Bourdieu 1984, 44). Once again, it is the "livingness" of the image, its traffic with social life outside the frame, that both qualifies it as realist and disqualifies it from the realm of aesthetic judgment. Conversely, the formal experimentation of "modern art" removes any basis for ethical judgment, any "content" to be "understood"—or, as with Husain's goddesses (or, for that matter, Picasso's cubist women), it is seen as a perverse distortion of that content. Here calendar art is more in tune with the ideology of academic realism, whose equation between "the good, the true, and the beautiful," enabled the ethical and the aesthetic to be thought together. (Indeed it was precisely this ambivalent accommodation of such ethical demands that informed the modernist denigration of academicism as kitsch.[18]) However, as we have seen in both this chapter and the previous one, the mode of signification through which academic realism established the correspondence between art and life is not necessarily that of the "realism" of calendar art. If the former was mediated through allegory and historical reference, the latter often works in an indexical mode to embody not just an ethical idea or ideal but an efficacious presence. The motto of "Indian" ethical-aesthetic culture, *satyam shivam sundaram*," quoted by several artists I spoke with, does not exactly translate to "the true, the good and the beautiful": *shivam*, as auspiciousness (here I am following the translation of Sivaramamurti 1978, 1) is not quite equivalent to the moral "good" of the liberal ethos. (I return to the notion of auspiciousness in chapter 6.) For what it evokes is a divine presence embodied in the image: a presence that, I have argued, both underlies the aesthetic shortcomings of realism in this context and also defines this realism's ethical goal, the inculcation of a devotional attitude by bringing the gods to affective life.[19]

We are now in a position to understand why so many artists independently singled out for admiration, as faithful custodians of the legacy of Raja Ravi Varma and Narottam Narayan, the ethnically non-Indian U.S.- and U.K.-based artists of the International Society for Krishna Consciousness (ISKCON), also known as the Hare Krishnas.[20] (The artists who expressed this opinion included Indra Sharma, J. P. Singhal, Ranjit Singh, and Yogendra Rastogi.) The ISKCON artists do not need to produce commercially mar-

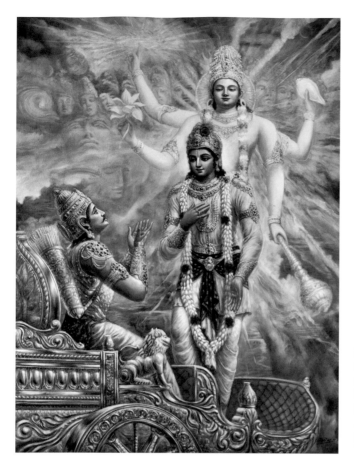

94. Krishna reveals his true form to Arjuna on the battlefield of the Mahabharat. (From the Krishna Gallery, www .krishna.com, © The Bhaktivedanta Book Trust International)

ketable devotional icons; their work is geared more toward illustrations for sacred texts (the Gita or the writings of their founder, Prabhupada) and promotional material. So, as with the earlier mythological oil paintings and prints that were also strongly positioned within the context of a revival of interest in and a retelling of *pauranic* narratives (see chapter 2), the ISKCON work is embedded in a textual arena. This enables it to take on many of the "realist" aspects that calendar artists must jettison for the sake of frontality—muted colors, subdued ornamentation, more "human" proportions, and dynamic agency—orchestrating these to create emotional intensity and lifelike presence (fig. 94). If the realism of the private, secular images that calendar artists paint for themselves constitutes a heterotopia in relation to both the mainstream art system and the bazaar, so does this brand of neospiritualist "superhuman" realism, circulating in a deterritorialized, global cultural economy.

THE REINCARNATION OF THE AUTHOR (OR,
NAKAL MEIN AKAL, "INTELLIGENCE IN IMITATION")

So far I have examined the social, aesthetic, and ethical aspects of the incongruent co-existence of cult or sacred value and a system of post-Enlightenment aesthetic value. In shifting my focus to political economy, I investigate what this coexistence does to notions of intellectual property in the calendar industry, through its discourses and practices relating to the artistic signature and the legal institution of copyright. In Walter Benjamin's account of the secularization of art, the unique qualities of the cultic or sacral image are displaced onto the authenticity of the work of art and the artist as a figure of creative autonomy and originality (Benjamin 1969, 244 n. 6). But what happens in a culture industry where ideas of auratic authorship have not entirely supplanted the cultic aura of the iconic image, and *both* authorial and cultic forms of value coexist in new, deterritorialized forms through the mass replication of images, shoring up the aura of the commodity? My observations suggest that the calendar industry is a site where the encounter between liberal ideas of authorial property and religiously inflected systems of value and power results in a set of mutual reformulations and accommodations—as with the mutual transformations of "realism" and the idioms of worship. And, as in the instance of realism, these reformulations occur at points of immanent stress—in post-Enlightenment schemata on the one hand and in existing social and political structures on the other.

Ever since the late nineteenth century, when Ravi Varma's prints were rampantly copied, imitated, or simply photographed and painted over as soon as they entered circulation, plagiarism and recycling have been a structural feature of the calendar print industry. The earlier lithographs from S. S. Brijbasi and Sons and the Ravi Varma Press carried copyright warnings and registration numbers; however, in the transition to off-set the copyright warnings tended to disappear, and most current Sivakasi prints only carry numbers for the purpose of identification. Very few court cases have been initiated to enforce copyright. The picture publishers S. S. Brijbasi and Sons were involved in an unsuccessful attempt in the 1950s; another failed attempt was made in the 1960s, in which Kondiah Raju was accused in the Madras High Court of "stealing" another artist's design (Inglis 1995, 74 n. 12); and an action was taken out in 1960 by Johnson and Johnson against the Bombay publisher of an Aras calendar alleged to have plagiarized the "Johnson's baby," also published by the same printer. In the latter case the printer

is said to have persisted in printing the controversial baby picture despite promises in court to the contrary, shoring up the common wisdom in the industry that copyright simply doesn't exist. It is significant that this case involved a multinational firm (and, presumably, an advertising agency) and therefore indexed a collision between two different types of corporate culture—for within the calendar industry, artists and publishers alike admit that everyone copies, so none of them can afford to point a finger at the others. Also significant—indeed, taking us straight to the heart of the difficulty in enforcing copyright in the calendar industry—is the fact that the picture involved was of a baby, not a religious icon, where "originality" is particularly hard to establish.

Particularly when it comes to religious calendars, customers often want pictures of the same deity year after year. Artists and printers are therefore obliged to provide a constant supply of "new" designs on the "same" subjects, and a common complaint in the industry is that beyond a point there is very little that can be new or different in pictures of gods and goddesses. As one Sivakasi printer disarmingly put it: "Even though we are purchasing new designs, in the market they are telling, why are you repeating old? Even though we purchase new designs, people are telling, you are giving the same type of designs. So then what is the use of purchasing new designs? . . . See, mythological means gods. In that we cannot change anything. Only colors we can change, dress we can change. Subject means same. Murugan means Murugan, Ganesh means Ganesh." Or according to J. P. Singhal: "In religious **subjects** there cannot be much change, you will have to make Krishna Krishna, you will have to decorate him (*shringar karna hoga*), because whatever change there is, it's in the decoration—what you do in the *shringar*, **ornamentation,** how you do it. . . ." In order to meet the market's demand for novelty within the constraints of the iconographic recognizability of gods, publishers mostly recycle existing designs with modifications in backgrounds, color, dress, and ornamentation (fig. 95). What is more, customers who buy or use a "ready-made" calendar from a publisher's annual catalogue do not choose it on the basis of the artist but of the "subject," privileging thematic content over formal treatment or authorial expression. As one pharmaceuticals trader in Old Delhi put it, "I have no relation with the artist, I have a relation with the picture." Most "end-users" would not be able to name any calendar artists beyond Ravi Varma or, at the most, S. M. Pandit, Kondiah Raju, or Mulgaonkar—the name they are more likely to be concerned with is that of the deity whose image they are after. The only people really concerned with identifying individual artists and their relative abilities, and who distinguish between "original" artists and mere "copy masters"

95. A work in progress by S. Murugakani, Sivakasi, 1995: in the foreground is the print from which this painting of the mother goddess is being adapted.

or hacks, are the publishers responsible for assembling designs for their files or "special parties" from the larger firms who commission their own customized calendars.

And yet, despite consumers' emphasis on subjects rather than authorial expressions almost all calendar paintings carry a signature. There is an excessive aspect to this appearance of the signature, and also to the ways in which signatures are used in the industry. What these practices exceed is the limiting of authorial property to a singular creative individual (or specifiable set of individuals). In this respect they depart from the schema of value associated with "fine art," which is fundamentally tied to notions of authenticity, uniqueness, originality, and creativity, and the assumption of a meaningful intentionality, cathected into the figure of the artist (a schema of value that persists in practice in the contemporary art market despite the postmodernist critique of these notions). Calendar artists' uses of the signature work to loosen the links between the signature, the work, and the artist as the unique producer of the work, layering onto the authorial schemata of "fine art" the logic of the brand name in a commodity economy, as well as the logics of patrilineal inheritance and the guru-apprentice system.

As it circulates from artist to publisher to buyer to end-user, the calendar icon slips from being an artwork to a commodity to a gift-cum-advertisement to an aesthetico-ritual object. So if the signature starts out for an artist in art school as the locus of authorial or artistic creativity, with respect to the publisher it functions more as a brand name for a particular type of work, and as it enters the marketplace for ready-made gods it is more or less evacuated of its significance. The classic example of the brand name in the Euroamerican culture industry is that of Walt Disney and the serialized production of cultural goods along Fordist lines, *authorized* by his personal signature. The production of goods in the name of Disney has continued well after his death. To this extent the Disney example encompasses both the "designer label" version of value, which flourishes around the persona of the creative individual and partakes of an authorial aura, and the more depersonalized value of a product brand. Similarly in calendar art, even though Kondiah Raju's illustrious pupil Ramalingam died in 1992, in 1994 Ramalingam's works were still being modified to produce "new" ones bearing his signature. Or again, I was told in Nathdwara that paintings bearing Indra Sharma's signature were being produced by his nephew, Raghunandan Sharma, presumably at Indra Sharma's behest, to keep up with demand as the older artist's eyesight failed (unfortunately he has now lost it altogether). According to Tryna Lyons (1997), certain Nathdwara merchants have routinely put their own signatures on paintings rather than those of the artists, while women painters would typically sign their work with their husband's names (although Lyons also describes some notable exceptions).

In other cases signatures closely resembling those of a well-established artist are employed by others, as in the case of "Ram Verma" or "Chandra Varma," signed in the same style as that of Ravi Varma (see fig. 70) or "Murugakani" in the style of "Mulgaonkar" (figs. 96 and 97); "S. PRAS," which could be mistaken for "S. ARAS"; or "Sapan Studio," which is very similar to "Sapar Studio."[21] Here the subject matter is also similar to that of the more well-known artist, so the signature becomes part of the genre rather than the index of a unique locus of creativity. Similarly, when artists want to experiment with styles other than those which have already proved successful in the marketplace, they themselves might use different signatures.[22] On the advice of one of his publishers, in 1994 Venkatesh Sapar was using the name of his five-year-old son Pratik when "signing" paintings of subjects he considers childlike (birds, butterflies, and so on; fig. 98), and likewise both he and his wife Maya use her signature on the more abstract or graphic designs, which are her forte (but which Venkatesh paints as well). So if any of these other types of subjects do not do well they will not detract from the aura of the signature on

96. R. S. Mulgaonkar, artist's signature.

97. S. Murugakani, artist's signature.

Sapar's more mainstream oeuvre of deities or his commissions for "special parties." (By the same token, artists producing highly identifiable work on a single subject, like Aras with his babies, must be careful that their pictures do not compete with each other in different publishers' files, thus splitting their publishers' profits and endangering future orders.) Here the strong alignment of a signature with a particular type of subject, de-linked from the artist's individual identity, points us away from an authorial "designer label" version of value and further toward the product brand version: the analogy here would be, say, Lever Kitchen producing both Omo and Drive laundry detergents.[23]

The easy yet paradoxical slippage between these two versions of value, that of the "autonomous" or "disinterested" artistic signature and the commercially motivated brand name, points to a certain immanent stress in the institution of the artistic signature. John

98. Detail of "Butterflies" by V. V. Sapar (signed "S. Pratik"), a four-sheeter calendar printed by Coronation Press, Sivakasi, 1996. (Courtesy of Coronation Arts and Crafts and the artist)

Frow has argued that this paradox with respect to the artistic signature goes to the very heart of the liberal conception of the subject, hinging around the way in which "the person is at once the opposite of the commodity form and its condition of existence, and in some cases enters directly into its philosophical rationale" (Frow 1996, 177).[24] On the one hand the person is thought of as, at core, a free, willing, self-determining agent. It is this subjectivity that underpins the self-definition of "fine art" as a sphere of image making autonomous from the market and the state, addressing itself through various modes of exhibition to a critical "public" (and that public's chosen spokespersons, critics, and art historians). Such a conception entails the valorization of the freedom, originality, and authenticity of the artist. On the other hand, this freedom is always already defined in economic terms as the ownership of oneself, such that one has proprietorial rights over — and thus the right to freely trade with — one's body and those unique forms of information that flow from it, like the signed "creative" work of art.[25] Thus "the signature

has become intrinsic both to aesthetic and to market value. As a metonym for the self-possessed, self-possessing person, it is the foundation of all intellectual property rights" (Frow 1996, 181).

What Frow is describing here is a point of stress in a formulation central to post-Enlightenment liberal discourse; once again, as with the mapping of aesthetic distinction onto the social, the predication of the aesthetic on the supersession of the sacred, and the separation of the aesthetic from the ethical, this formulation of authorial property and value begins to unravel in the postcolonial context. And again, the terms with which it operates do not disappear but undergo reformulation in an overdetermined field. The relationships between the signature, the work, and the identity of the artist as producer of the work are reconfigured as the artwork moves from the aesthetic realm to the commercial. But at the same time, other kinds of reconfigurations also occur as the image moves from a realm that valorizes the creative human individual to one that is concerned with familial and community lineage on the one hand and the agency of the divine on the other.

Take, for instance, the practice followed by Ramalingam and other disciples of Kondiah Raju, such as T. S. Subbiah, of signing their master's name to paintings they had worked on before being able to add their names to that of Kondiah (Inglis 1995, 63; see also fig. 81). Similarly Venkatesh Sapar, who is keen to acknowledge his father as his most important influence, had his paintings taken up for publication while he was still in high school, but until he graduated from the J. J. School of Art he signed his paintings "Sapar Son." The adoption of a senior artist's signature by a disciple marks the relationship of subordination of apprentice to master and a blurring of boundaries between their work. Of course, not all arrangements have been quite as happy as Sapar's. Voices were lowered in evident censure while making allegations about S. M. Pandit's secrecy and refusal to share his knowledge, which in one instance was explained to me in terms of caste, relating to the behavior of craftsmen. This is in pointed contrast to descriptions of Pandit's contemporary, Kondiah Raju, whose reputation as a teacher took on something of a Brahminical aura due to his "saintly" lifestyle. However, Kondiah was not immune to competitive tensions: just as Pandit's assistant Mulgaonkar got fed up of signing his work "Studio S. M. Pandit" and opened up his own "Mulgaonkar Art Studio" in Bombay around 1944, Ramalingam had a "painful and irrevocable" split with Kondiah in 1962 (Inglis 1995, 74 n. 12).

In pedagogic contexts supplementary to the art school, the imitation of senior art-

ists and their work is often as acceptable a mode of training as the more direct, personal interpretation of "life" or "nature." Almost all of the calendar artists I know of (including Ravi Varma) owe their skill, at least in part, to copying from artists they admire or observing them at work. What is more, many freely admitted to having done this as a legitimate form of learning. As B. G. Sharma put it: "You can copy someone, but in copying you need to be smart (*nakal mein akal chahiye*)! To copy is not a crime (*gunah*), but in copying also you need to be smart, so that it looks good. It should look good, but one shouldn't copy too much. Without copying an artist won't learn, anyone who has grown up and come into this line . . . copying is not wrong, but it's like this, as the aptitude (*hoshiari*) comes, he makes his own thing and carries on." Under negotiation here is an encounter between a (partially mobilized) notion of aesthetic information as the private property of the artist, as in the schema of authorial value outlined above, and the location of iconographic knowledge and painting techniques within something akin to a "commons" or realm of public ownership (in this case of cultural knowledge and practices) to which all, within a given frame of publicness, have access. Frow argues that if the commodity form transmutes such common resources or public goods into private goods and resources, it does so at different semiotic levels, which correspond to different historical "moments" (Frow 1996, 192–94). A distinction must therefore be made between industrialization or the serialized mass production of cultural goods (such as calendar icons) and the commodification of intellectual property, a second level related historically to the romantic formulation of authorship developing in eighteenth-century Europe, which also informed the category of "fine art." In this formulation of authorship an attempt is made to separate the information contained within the work into "ideas," belonging to the public domain, and their singular, unique, textual "expression" by an author, which is seen as an individual's private property, to be protected by copyright law: this distinction, as the current status of copyright as a legal minefield attests, is far from clear cut. (This is homologous to the equally fraught liberal split between the subject as part of a universal humanity, the "citizen," and the self- and property-possessing sovereign "subject.")

The use of multiple and varying signatures by artists in the calendar industry becomes a way of accommodating the—largely formal or simulacral—commodification of intellectual property alongside other regimes of transfer of intellectual goods. In these other regimes a trans-subjective "commons" of artistic techniques and knowledge of iconographic conventions ("ideas") is made available to an artistic community, family, or

99. "The Death of Jatayu," signed Kartik Das, calendar, date unknown (compare with fig. 48). (Collection of JPS and Patricia Uberoi, Delhi)

"school" by a teacher (who thereby gains a special standing in that community), *and/or by the mass reproduction and public circulation of images*. The "expression" of these ideas through individual artists' creative skill and ability to innovate is valorized and rewarded on an individual basis by the industry. If the very circulation of an image in the public domain implies its assimilation into the commons, thereby becoming a resource available to all, it could follow that the physical act of (re)creating that image would count as individual authorial "expression." And indeed, ever since the earliest days of calendar art artists have not hesitated to put their signatures on work that is clearly based on existing and often well-known prints (as with the almost straight copy of Ravi Varma's *Death of Jatayu* that appeared as a calendar in the mid-1950s, boldly signed "Kartik Das"; fig. 99). According to one version of intellectual property rights this appropriation of images from the public realm is plagiarism. However, it can also be understood in terms of a more artisanal approach to image production, which has not traditionally dealt in signatures precisely because iconographic knowledge and techniques are seen as part of a commons (albeit within a particular community or lineage).

In such a context of multiple, overlapping intellectual property regimes, the embodi-

ment of the commons or public knowledge within an individual, such as a teacher like Kondiah Raju (rather than an impersonal institution like the art school), can lead to complications. Kondiah Raju emerged from the pedagogical traditions of Thanjavur painting, which, in accordance with the idea of an iconographic "commons," did not (at that stage) feature the use of signatures. However, he also went on to attend art school, where signing one's work was standard practice. Kondiah's professional use of a signature, with its implication of a self-possessing subjectivity, aligned "his" aesthetic information with private property, which did not sit well with his more traditionally styled pedagogical role. In contrast, in those cases where rights to aesthetic information have coincided with patrilineal property rights (as with Sapar and Rangroop) the negotiation of commodification via the signature has been relatively free of conflict. Also, Kondiah Raju, who was teaching and working in rural Kovilpatti, did not (to my knowledge) think to use the depersonalizing word "studio," a strategy adopted by artists in the thick of Bombay's culture industry such as Pandit, Mulgaonkar, Singhal, Aras, and Rangroop (the late Ram Singh, who moved back to Delhi). This device accommodates the possibility that an artwork may be the result of a collaboration, with varying degrees of input from different artists. Thus when S. S. Shaikh at one stage painted backgrounds for J. P. Singhal's "beauties" or S. V. Aras's babies, these paintings were signed "Studio J. P. Singhal" or "Studio Aras"; similarly, Rangroop's sons and daughters all contribute to artworks signed "Rangroop Studio" (fig. 100).

Over the course of this chapter we have seen how, at various sites, the practitioners of calendar art negotiate between two poles: on the one hand the marketplace, translated as the desires of the consumer, and on the other a post-Enlightenment regime of aesthetic value and distinction embodied in the discourse and practices of "fine art," which are mobilized (in part) through institutions of a national modernity such as art schools and museums. The latter frame of aesthetic value is paradoxically bundled together with the forces of a powerful (though not omnipotent) global corporate ethos, via fundamental conceptions of subjectivity and value that inform them both. The continuing attempt to establish the hegemony of these notions of subjectivity and value is clear from the emphasis on patenting in trade forums such as GATT. But while the calendar industry's practices tend to blur the boundaries between an iconographic "commons" and individual intellectual property, even these traces of the commodification of authorship are meaningless for most "end-users" of calendar art. As far as they are concerned the singular "expression" of the common "idea" is located not in the persona of the artist but in the personality of

100. Artists Vijay Singh, his sister Rekha, and their brother Manav (back to the camera) at work, Rangroop Studio, Karol Bagh, Delhi, 1994.

the deity and the qualities of the image as object: in the difference of an image from that of the previous year, or its fulfillment of other aesthetic and/or ritual requirements such as the frontal imperative, iconographic accuracy, and the expression of *bhava*. The practices and self-reflexive discourse of artists and publishers create a performative field that brings these otherwise disjunct frames together, enabling us to apprehend how other forces operating in the postcolonial field recast the determinations of bourgeois modernity and othering in the colonial mirror. Thus the discussion on taste shifted the focus from the performance of class to the performance of distinctions between public and private religion, while the valorization of "realism" pointed toward an ethos predicated on an affective locus of exchange between the worlds of sacred and human subjectivity. The practices around notions of authorial property embodied in the signature suggested that the alignment of human subjectivity with the commodity relation must contend with a certain formulation of a cultural "commons," which may or may not coincide with the forms of publicness and commonality made available by either the state or "civil society."

However—and this is a crucial caveat—my use of the term "commons" in relation to iconographic image making in the age of technical mass reproduction does not imply that it can be romanticized as a pure space of communitarian resistance to the regime of the commodity. Here Frow's distinction between the commodification of goods and of intellectual property is key. If I have been describing the calendar industry's resistance to the commodification of intellectual property, this does not detract in any way from the fact that the bazaar print is a commodity, and that calendar images in particular, in their capacity as gifts and/or advertisements, are integrally bound up with a wider commodity culture. Also, as the term's association with feudal society suggests, a "commons" has its own rules and shores up its own power structures, its own regimes of value and exchange. In the instance of the calendar industry, these regimes are what resist the forces of a globalizing Euroamerican neoliberal capitalism. As we have seen, one of the main counterpoints to this globalizing force is the continued valency of the sacred in relation to aesthetics, ethics, and political economy. The next chapter will follow the leads provided here by calendar artists and publishers to explore the nature of the nexus embodied by calendar images between the realms of the sacred and the commodity, and to further specify the terms on which images circulate between heterogeneous frames of value.

5

THE CIRCULATION OF IMAGES AND THE EMBODIMENT OF VALUE

Main ek vyapari [I am a trader]
Vyapar mera karm [Trading my destiny]
Dukan mera mandir [The shop my temple]
Grahak mera devta [The customer my deity]
Mehnat meri puja [Hard work my prayer]
Grahakon ka santosh [The satisfaction of customers]
Yehi mera prasad [My only reward]

POSTER ON SALE AT A DIWALI MARKET, NEW DELHI, 1995

Dadu, if you recite Ram's name you keep everything,
your principal as well as your profit; if you do not recite it
you lose everything; awake O simpleton.

DADU DAYAL, SIXTEENTH CENTURY

There is a sequel to my anecdote about the Delhi calendar publisher who, on hearing that I was writing about calendar art, joked that I had chosen a singularly unattractive topic of research ("Aapko Madam is se aur koi ganda topic nahin mila?"). Several weeks after that initial encounter, I was sitting in his office on the eve of the festival of Diwali

(the Hindu festival of lights), and, in keeping with the occasion, we were talking about calendars in relation to ritual and religiosity. Diwali is a big day for calendar manufacturers, since, as the beginning of the Hindu financial and ceremonial year, it is when many businesses, particularly in the "bazaar" sector, distribute their calendars to their clients and associates. At one point the publisher asked his assistant to move a long calendar of Ganesh that had been hanging on the wall behind him, so that as he sat in front of it on a chair with his legs crossed his foot would no longer point disrespectfully at the deity (as it had probably done all year). Even though this sudden sensitivity and respect for the kind of image he had earlier joked about in derogatory terms almost certainly arose from our conversation, his explanation was directed not toward me but toward his assistant (who was at least ten years older than him, and no relation, but whom he nevertheless addressed as *"beta,"* son). This episode occurred as an aside to the conversation, not as part of it; unlike his earlier denigration of the genre, which established a certain shared cosmopolitanism, it seemed irrelevant whether or not I shared, understood, or even registered this very corporeal concern.

The corporeality involved here was not just that of the publisher and his foot, but also that of the image — its embodiment of a divine presence that demanded respect, and which in turn meant that it had to be physically moved. This embodiment was animated along both a spatial axis and a temporal one: the sacrality of the image was suddenly intensified on this ritual occasion, so that the same image in the same space took on a different meaning and value. On Diwali it is customary to (re)consecrate one's workspace and account books; in this publisher's case this included putting a ritual *tilak* mark of red powder on the foreheads of the deities on the calendars surrounding his desk and on the icons and photographs in the office shrine in a niche behind and above his head. Similarly, calendars and framing pictures that are treated with little respect as they lie around on the print shop's floor, or are bundled together by a publisher for dispatch, take on a new valency as they are given by a retailer to a customer, or brought home by a pilgrim for those who could not take the journey — or again when they are put up in people's homes and workplaces, garlanded, anointed, and ritually worshipped as sacred icons (fig. 101).

THE AESTHETIC'S EVIL TWIN

Images, particularly mass-produced images, are bodies that move: they move from sites of production to those of circulation and use; they move across the states of commodity,

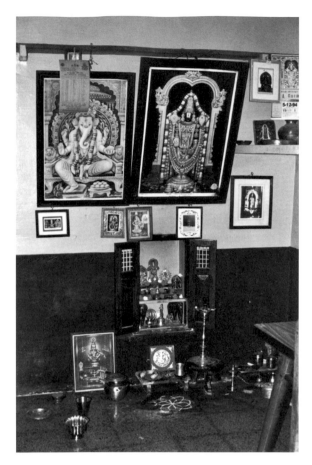

101. Prayer space outside the kitchen of a Brahmin household, Sivakasi, 1994.

gift, icon, ornament, waste; they move in and out of people's everyday lives and frames of value. In doing so they also move people in and out of their everyday lives, in and out of "history"; they act on bodies and create relationships between bodies. I argued in the previous chapter that it is this bodily intrusion of calendar images into everyday life, and the bodily responses they provoke, that condemns them to denigration within the terms of a post-Enlightenment aesthetic schema that makes a distinction between the "things of art" (aesthetics) and the "things of life" (ethics), or between the "taste of reflection" and the "taste of sense." A large part of the problem, I suggested, is that these terms of aesthetic value are predicated on the supersession of the sacred: on its relegation to a private, anterior and/or nonworldly sphere. They are also predicated on a particular formulation of the "free" productive individual as the authorial source and locus of value-creation, and hence as a locus of (potentially alienable) proprietorial rights over oneself, which need to be asserted and defended in the public realm. Walter Benjamin's analysis

of the secularization of art suggests that there is a relationship between these two features, in that the auratic qualities once embodied in the cultic object are now displaced onto the figure of the artist and the uniqueness of the artwork (Benjamin 1969, 244 n. 6). In other words, the value of the object now integrally derives from the qualities of its producer, rather than from a transcendent source. However, Benjamin acknowledges that a certain residue of "cult value" continues to inhere in the artwork even within a secularized schema: here he cites the collector, "who always retains some traces of the fetishist, and who, by owning the work of art, shares in its ritual power" (ibid.).

The previous chapter brushed against the grain of certain aspects of the post-Enlightenment formulation of the aesthetic in order to reveal something of the ethical and epistemological contexts in which bazaar images circulate. Here I undertake a similar procedure with another category that is closely linked with the aesthetic, but as its evil twin, its putatively lifeless but nevertheless uncannily animated doppelgänger: the fetish. Fetishism, I want to suggest, is the one post-Enlightenment category that speaks to images as animated and animating objects rather than as static signs, and therefore to the (tabooed) possibility that objects might embody value and power that do not derive solely from the qualities imparted to them by their agents of production at the moment of their creation. What interests me here is how and for whom this embodiment remains a fundamental source of not just aesthetic but moral unease: specifically, a source of anxiety that the value, power, and animation of objects exist at the expense of, or somehow substitute for, the inherent value, unity, consistency, and (re)productive capacity or agency of the sovereign subject. Thus in modernist thought the cultic or ritual power of religious objects becomes a figure for the way in which, in their capacity as commodities, "the products of the human brain appear as autonomous figures endowed with a life of their own," obscuring the role of labor (Marx 1976, 164–65). Similarly, as "Unsuitable Substitutes for the Sexual Object" (Freud 1979, 65–66) fetishes subvert the "normal," heterosexual reproductive order, introjecting putatively inanimate objects into the world of living beings and social relations. Even as bourgeois political economy from Ricardo onward has taken into account the importance of the sphere of circulation and exchange for the value of commodities, bourgeois moral economy has remained invested in the sovereign productive individual as the ultimate source of value. This tension between moral and political economy informs the terms of debate on the social, moral, aesthetic, and psychic evils of commodification and the marketplace to this day.[1]

To what extent do the moral economies in which calendar images circulate partake

of a similar unease with respect to the location of value in the sovereign productive individual? In this chapter I explore how bazaar icons, as publicly circulating material embodiments of the sacred, operate within frames of meaning and power that, unlike those of bourgeois moral economy, are underpinned by a trans-subjective, transcendent locus of value. Again my attempt here, as it has been throughout, is to map the ethos of a vernacular commercial arena whose mass-mediated modernity cannot be understood solely through a global narrative of *embourgeoisement*. To this extent my account supports those economic anthropologists and historians who argue for the continued "embeddedness" of modern capitalist markets in social relations and fields of power, against the idea that the market is an autonomous, impersonal, self-regulating mechanism—whether it is seen as having always been that way, as in Adam Smith's classical model, or as having become that way as the result of a historical transformation, as Karl Polanyi formulates it (Smith 1904; Polanyi 1944; on the culture-market relation, see Haskell and Teichgraeber 1993; Hefner 1998, who cites Granovetter 1985; Subrahmanyam 1990, 1994). Indeed, as Hefner points out, the characterization of "the" market has tended to be a universalizing extrapolation of one historical ideal type; however, while certain features such as the tendency to expand the domain of wealth production can be identified as specific to capitalism, capitalism is by no means a monolithic phenomenon, particularly in its "ethico-political entailments," its modes of social organization, and its moral economies (Hefner 1998, 11, 29). While the formal processes of economic globalization index the continuing clout of the dominant ideal type, the growing scholarship on local forms of capitalist enterprise (particularly in East and Southeast Asia) has also highlighted the ways in which global capital is not very fussy as to the moral and performative regimes, or types of ethos, under which its "axiomatic" unfolds.[2]

It is in order to pursue these "ethico-political entailments" that I wish to reclaim the notion of the ethos from its banishment by those Marxist economic historians of India who have been—quite rightly—keen to foreground the colonial economy and British protectionism over the Weberian argument that "caste restrictions or the other-worldly features of Indian value" were to blame for India's economic stagnation (see, for instance, Bagchi 1992, 157; Weber 1976). One problem for Weber in *The Protestant Ethic and the Spirit of Capitalism* was that he had only seen capital unfold and succeed within one particular ethos, the same one in whose terms the spirit of "capitalism" was defined. The other problem was the essentialist tenor of his characterization not only of "capitalism" but also of "Protestantism": for him *ethik*, far from describing the performative arena of

social practice, becomes an essence interchangeable with the smooth, ineluctable, impersonal vector of spirit or *geist*. I would like to reanimate the notion of the ethos, not as a cultural essence, but in its performative sense as a realm of practices, with their susceptibility to change as well as their gritty inertia.[3] In this latter sense the ethos becomes a heuristic category for thinking about the differential articulations of social, political, and moral regimes with capitalism, and, crucially, with each other. The interface between moral-ethical regimes is of central importance here. As I have argued throughout, the bazaar has to be seen as a product of the colonial encounter, and to this extent its ethos cannot be thought apart from its constitution within a field of colonial power and discourse. What is more, as William Pietz's indispensable history of the fetish reminds us (Pietz 1985, 1987, 1988), the traffic between bourgeois society and its others has flowed in both directions: the notion of fetishism, emerging from the context of intercultural trade, indexes the centrality of bourgeois society's others to its own self-definition.

In the first part of this chapter I locate the circulation of calendar art within the ethos of the bazaar, and specifically in its reliance on personalized networks of exchange to shore up an informal credit system. It is in this light that we can understand the continuing circulation of sacred imagery within the commercial arena despite the strong association of commodity culture with desacralization. But this does not amount to the reinstatement of "economic" imperatives as determining "in the last instance," for what emerges is an ethical system that confounds the separation, let alone the hierarchization, of commercial, sacred, and libidinal economies, or of "economy" and "culture." In the latter part of the chapter, then, I outline some of the specific forms of religiosity and of the social management of desire with which the bazaar's commercial culture has been enmeshed. Here I revisit in some detail the image culture of Pushtimarg, which has emerged in the preceding chapters as a major influence on calendar art since the 1930s. I end by considering the relationship between bourgeois moral economy and these other frameworks of value, meaning, and power that operate in the bazaar, arguing that their incommensurabilities are central to their mutual dependence, and to a coexistence that is intimately linked with the expansive movement of capital.

IS NOTHING SACRED?

The category of the fetish made its appearance in the European bourgeois public sphere in the late eighteenth century, at around the same time as modern formulations of art and the aesthetic and their correlate, the institution of authorial or intellectual property.

"Fetishism" first appeared as a theoretical term in print in 1760 (ten years after Baumgarten's *Aesthetica*) to describe an idolatrous relation attributing supernatural powers to a material object mistaken for the divine. Soon afterward, in 1764, Kant dismissed African fetish worship as devoid of any sense of the sublime and thus the most debased pole of the principle of the beautiful (Pietz 1985, 9).

As William Pietz has persuasively argued, the notion of fetishism, with its origins in the translations and transvaluations attendant on European merchant capitalists' adventures on West African slave routes, marks the centrality of intercultural encounters to the modern, post-Enlightenment delineation of subjects and objects and the relations between them (Pietz 1985, 1987, 1988). The fetish was initially taken up in the bourgeois public sphere as the transgressive other of Christianity's transcendental, abstract spirituality, and, indeed, as the antithesis of Enlightenment itself. However, through the nineteenth century it came, via the discourses of anthropology, art, psychoanalysis, and political economy, not just to describe the "primitive" other but to index the (disavowed) otherness *within* the bourgeois subject and liberal political economy.[4] For Freud, for instance, the targets of aberrant forms of desire were "likened to the fetishes in which savages believe that their gods are embodied" (Freud 1979, 65–66). By naming the possibility of a corporeal, affective, desiring engagement with an inanimate object, I would suggest (following Foucault) that this discursive frame of abnormality and moral censure enabled the fetish to become a productive category. Similarly, in Marx the category of the fetish *named and thereby (re)produced* an anxiety about how objects might come to embody the relations between people, such that ". . . the products of the human brain appear as autonomous figures endowed with a life of their own, which enter into relations both with each other and with the human race" (Marx 1976, 164–65). Here the *animation* of commodities ("a life of their own") dislodges the locus of value production in social labortime: their circulation and exchange establishes their potential equivalence to each other and thereby to capital as money, which is then seen as the ultimate source of value. The fetish par excellence is interest-bearing capital, a magically self-reproducing form of value often viewed with suspicion and mistrust (as with the hostility associated with the emergence of financial credit in Europe in the eighteenth century and the early nineteenth, its textual instruments seen almost as fiction: see Sherman 1996). Jean Baudrillard reads this Marxist characterization of commodity and money fetishism in bourgeois political economy as itself a "fetishization of the conscious subject or of a human essence," predicated as it is on a distinction between the false or magical (unnatural) efficacy of exchange

value, and the true, objective (natural) production of value by "real" labor or the agency of rational subjects (Baudrillard 1981, 89; also 1975).[5]

In a world flooded with seductive new objects by the twinned forces of imperialism and industrialization, discourses of the late nineteenth century and the early twentieth about the fetish worked to (re)inscribe the boundaries of realms of alienability and inalienability in bourgeois moral economy, asserting an inalienable realm of human creativity and social relations against the impersonal, alienable, and alienated world of commodities and the market. Most societies seek to prevent or restrict the occupation of the commodity state by certain objects, or to more narrowly demarcate them as "market-inalienable"; art and ritual often constitute such an "enclaved zone" (Appadurai 1986; N. Thomas 1991).[6] Indeed, for Durkheim, writing in the early twentieth century, such a separation formed part of the very definition of the sacred as a socially demarcated, protected, and restricted realm that has power and value in and of itself (Durkheim 1965). Hence the common association of "de-sacralization" with societies dominated by a capitalist system, which tends to expand the domain of commoditization, where value is said to be derived from "impersonal" exchange in the marketplace rather than from any "intrinsic" qualities of people or things (qualities often described in the anthropological literature in terms of the embodiment of a "spirit," as in the *hau* of the gift in accounts of Maori culture). At the same time, however, particularly in the case of liberal-bourgeois societies, the defense and reclamation of market-inalienability arguably becomes a particular focus of intensity, such that the human subject and its unique products (such as works of art) come to occupy the equivalent of a sacral "enclaved zone."[7] In this context the censure of fetishism, marking as unethical and immoral the blurring of the lines between the value of people and that of objects (or of their wholes and parts), or between social and market relations, shores up the construction of an inalienable, sovereign, and unified bourgeois subject as the ultimate source of value.

As we have seen, the post-Enlightenment schema of the aesthetic was predicated on a teleological supersession of the sacred. Similarly, the "sacralization" of the subject in bourgeois moral economy and the opposition between sociality and the market are based on a "post-sacred" universe where the enchantment of material things must be disavowed, however rampant it might be in practice. (Again, an exception here is the sanctifying association with persons, as in the case of art, gifts, or heirlooms.) As with the aesthetic, the continuing circulation of sacred imagery within the commercial realm of the bazaar confounds such a "post-sacred" teleology. However, in the case of the fetish there is a difference. As we saw in the previous chapter, the people I spoke with in the

calendar industry did to some extent take on the post-Enlightenment discourse of the aesthetic, deploying terms such as autonomy, originality, taste, and realism to register their discomfort with the iconographic-cum-commercial imperatives of the bazaar. But while many artists were keen to make a distinction between the realms of "commercial" and "fine" art, there were no such expressions of unease with the idea of worshipping or desiring images (except from secularists such as Ram Kumar Sharma), or with the use of sacred imagery in the marketplace. While the devotional use of images was associated with those incapable of "higher" forms of worship, it was nonetheless seen as a perfectly legitimate practice. In other words, fetishism and its moral denigration *do not* appear to be notions that inform the self-understanding of the calendar industry, even as their correlative, aesthetic distinction, does.

The "vernacular" commercial arena of the bazaar articulates with capitalism and its expansion of the commodity realm, but there is little sense here of a polarity between sociality and the market corresponding to that in bourgeois moral economy, no similar anxiety to displace the agency and sacrality of objects/ images onto that of subjects. The bazaar's commercially produced images of the divine make their presence felt not just in the domestic kitchen or prayer room, but also at the sites of the basic operations of quantification proper to the mass production and exchange of commodities. They appear on packaging, where consumer goods like *beedies*, fireworks, incense, tonics, and hair oil are held together in specified amounts; they watch over the machines that produce these and other goods and the vehicles that transport them, countering the risks of technology and travel (fig. 102), blessing the conversion of labor time into money. They sacralize the calendars where this time is marked out into the "homogeneous, empty" units of bureaucratic administration alongside the parallel demarcation of the sacred time of fasts and festivals; they grace the spot just above the cash register in the shops where commodities are sold, casting their benign aura over the day's business (see figs. 1, and 2). The typical pattern of worship for icons located in workplace shrines is once in the morning before starting work and then once at dusk when turning on the lights. The ritual usually involves lighting incense or a lamp, garlanding, and/or placing a *tika* or *tilak* on the image (anointing it with red powder), and on occasion offering sweets or fruit. Often shopkeepers also offer a quick prayer with their first earnings of the day (called *bohni* in the north), waving the money in a circle around the image before putting it away. How are we to understand this compact between capital and the sacred forged by mass-produced icons in the bazaar?

I would argue that while the Durkheimian view of the sacred as socially "set apart"

102. Japan Airlines calendar featuring an image of Ganesh, displayed in a shop in Chandni Chowk, Delhi, 1992.

can still be seen as salient to bazaar images, what does bear rethinking is the idea that relations of exchange in the capitalist marketplace are necessarily "impersonal." The enclaved—and hence sacred—character of bazaar icons needs to be understood not so much in terms of a radical spatial segregation from the world of commodity exchange in general, but in terms of a temporal and performative separation from *their own* commodity phase. As Igor Kopytoff has argued, in the course of its "cultural biography" an object can move in and out of the commodity state (Kopytoff 1986), so the fact that mass-produced images are associated with commodities, and briefly inhabit the commodity state themselves, does not mean that they are permanently consigned to this state. So the sacredness of the iconic image is suspended as it is produced and traded (on the artist's easel or the factory floor, in transit, or while displayed in a catalogue, shop, or stall; fig. 103), but it is able to return once the image leaves the realm of circulation. Thus in the story with which I began the moment of sacralization was marked by the calendar publisher's awareness of his disrespectful foot. In the case of both calendars and

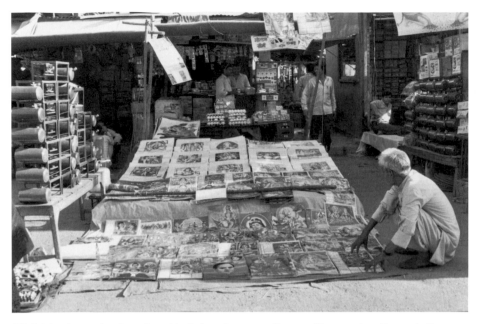

103. Prints of sacred and secular subjects for sale on a continuum with eggs, cigarettes, and other petty commodities, Delhi, 1994.

framing pictures the auspiciousness of the occasion on which they are bought or given (usually Diwali, but also other festivals such as Vishwakarma Jayanti), or, in the case of the almanacs and calendars, their association with time itself as the essential medium of festival and ritual imparts a kind of sacred contagion (another Durkheimian notion) to the image, smoothing its passage to a performative context of rhythmic ritual worship. Similarly, the trade in framing pictures has largely been associated with pilgrimage sites and powerful temple icons, partaking of the latter's more "properly" sacred aura, which often has to do with their putatively miraculous origins or powers. Neither of these, however, are essential preconditions—after all, they do not apply to images of gods and saints used on packaging (as in Ganesh brand *beedi*s, Lakshmi flour or fireworks, Kali cigarettes, Shri Ambal coffee, or Panchajanya incense that features an image of Krishna, see figs. 55, 56, 59, 61), from which I have seen the pictures carefully cut out, "framed" with colored insulating tape, and placed in a prayer niche for worship. In the final analysis, what renders the icon sacrosanct is its representation of a divinity, coupled with the worshipping viewer's ritual engagement with it as an object.

When I asked manufacturers whether the commercial use of sacred imagery was considered sacrilege, the only instance cited where popular disapproval had been widespread enough to affect consumption (and force a change in manufacture) was when an image of

the goddess Lakshmi had appeared not just on a fireworks package but on an actual firework and therefore got blown apart. In the same vein, in 1995 the No. 10 *beedi* company was giving away key rings with small metallic images of Shankar, Mata, and Hanuman packaged inside their bundles of *beedi*s, but the ashtrays with which they were gifting their "special clients" were not to carry sacred imagery. In other words, while the gods can help to *sell* cigarettes, fireworks, and other commodities, they cannot be blown up, or smoked, or have cigarettes stubbed out on them. What seems to be at work here is the enforcement of unwritten rules with respect to the cultural biographies of religious images in the marketplace, preventing their subjection to inappropriate uses *once they leave* the realm of circulation. One Sivakasi printer did cite an unsuccessful court action instigated by the Shiv Sena in Maharashtra against the manufacturers of the widely selling Ganesh brand *beedi*s. However, this too can be understood as a protest not against commercialization as such but against the use of iconic images in conjunction with inappropriate products (those that are ritually polluting, known to inflame the passions, or are otherwise associated with immorality — such as tobacco and alcohol). Similarly, the glee with which another elderly printer told me that the image of Mahatma Gandhi (an abolitionist and a paragon of purity) has been used on a label for country liquor signaled a *frisson* associated with the trespassing of boundaries.

The moral problem here lies with the forms taken by corporeal, performative engagements with the iconic image — the physical fate of the image, or its material association with polluting substances — rather than with the conceptual issue of instrumentalizing the gods to further worldly profit (thereby fetishistically conflating divine and mortal worlds).[8] The individual cultural lives of divine images have a relatively restricted commodity phase, but they have been used extensively in the bazaar in association with other commodities, as advertisements — particularly in the form of calendars — and as commercial giveaways such as key rings. To the extent that such "gift" objects facilitate other, "proper," commodity exchanges they occupy a special position as simultaneously meta-commodities and arch- (or indeed *arche-*) commodities.[9] In this capacity they do not merely precede or accompany but also *animate* other exchanges, other commodities, precisely *preventing* exchange from becoming "impersonal."

TO THE WORSHIPPER'S ETERNAL CREDIT

While the calendars produced in Sivakasi from the 1960s onward are undeniably advertisements, what they have tended to advertise is not primarily a product brand, or

the goods or services that a firm provides, but the company or business house itself. As mass-produced yet customized gift-cum-advertisements, such calendars are liminally placed between the "impersonal" form of generalized corporate publicity characterized as proper to capitalist mass production and the personalized networks of reciprocity and trust that, as I outline below, are seen as proper to the ethos of the bazaar. This liminality is enabled (as we saw in chapter 1) by a cumulative appropriation of technologies: by the persistence rather than obsolescence of the small-scale letterpress after the introduction of offset printing. The relative economy of short print runs on the letterpress allows for the personalization of the mass-produced image through the addition of the name of the firm that will distribute the calendar, often accompanied by the phrase "With Compliments of . . ." (fig. 23b). The embodiment of the firm through its name can be seen as imbuing the calendar with the "essence" of the donor, seen in the Maussian reading as comprising the "spirit of the gift" (Mauss 1967).[10] This permeation of commodity exchange by the spirit of the gift begins to make sense in the light of the historical and anthropological scholarship on business cultures and the morality of exchange in the Indian bazaar, which points to the centrality of informal, personal networks of exchange and a moral economy for which value emanates primarily from a diffuse or dispersed trans-subjective realm of circulation, rather than from a bounded, autonomous, and individualized locus of production.

In homing in on this distinction I am developing an argument that the anthropologist Jonathan Parry (1989) has made about the "ethical neutrality" of the realm of commerce, money, and the marketplace within what he—rather problematically—calls "Hindu thought." Despite the essentialist, overly polarized (and decidedly Brahmanical) character of his discussion, certain of Parry's insights are compelling because they help to characterize the moral-ethical schemata according to which sacred iconic images are able to nestle so comfortably in the spaces of commerce, and vice versa. Parry's main concern here is with the view taken by priests in Banaras in the late 1970s and early 1980s that ritual gifts or *dana* are morally "perilous" to them because by accepting them they are taking on the sins of the donor. It could be argued, along strictly functional lines, that in exchange for their intercession with the divine and the promise of salvation it entails for the householder, Brahmins are given the goods that provide for their subsistence. The social expression of such a view, however, would enact an untenable blurring of boundaries between the realms of the sacred and the commodity. So it is essential that the ideology of priestly transactions is that of the gift: the goods offered to Brahmins are called *dana*

(literally, "that which is given") or *dakshina* (more like a fee for a particular ritual), and both the giving and acceptance of *dana* is seen as a moral — indeed, sacred — obligation or duty.[11] This is in contrast to commerce (or the bazaar) per se, where exchange is not seen as morally perilous in this way; nor is it seen as inherently evil or polluting as it was in medieval Christian thought, where money, mercantile profit, and most of all usury were reviled as the work of the devil (as Parry puts it, "Incarnations of the gods do not roam about chasing money-lenders out of temples"; Parry 1989, 78).

Addressing this latter distinction, Parry relates the Christian suspicion of usury and a commodity economy to the rural valorization of self-sufficiency and production for the use or benefit of the producer, that is, the local community; the moral problem arose when trade went beyond that community, diluting local communal ties. In this moral schema, deriving a living from means other than productive labor, that is from trade or money-lending, was not only "unnatural" but equivalent to theft. Parry counterposes this "autarkic" ideology to that of an interdependent division of labor, such as that inscribed by caste, where the ties that bind communities and individuals together are embodied in the objects, including money, that circulate through socially defined relations of exchange. These exchanges are subject to the social and moral imperative of an incremental return on what is given. This not only serves to maintain an ongoing reciprocal flow of objects but also inscribes circulation as the realm where value is produced: every time you give something, you get more back (though not necessarily more of the same thing). Thus the very act of exchange adds value, but only insofar as it occurs within a context of sociality.

Even as we might not wish to align Parry's distinction with the monolithic categories of "Christian" and "Hindu" morality I think we can deploy it in a heuristic fashion to try and specify the terms on which the negotiation and expression of value has taken place at particular moments, and in the interest of certain constituencies. First, Parry's distinction between *moral* economies clarifies how an ethos of self-sufficiency and the sovereign productive body persists in the liberal formulation of the subject, even as bourgeois *political* economy has sought to overcome a feudal valorization of agricultural production and antipathy to mercantilism. Second, when it comes to South Asia, Parry's description of a moral schema based on the centrality of circulation is consistent with the work of scholars such as C. A. Bayly and Denis Vidal on the role of traders and money-lenders in late precolonial and colonial north India, and particularly their regulation of economic activity through the skilful manipulation of credit (Bayly 1983; Vidal 1997; see also Rudner

1994 on the Nattukotai Chettiars in colonial south India). At the local level the system of credit meant that an individual's spending could be relatively delinked from his or her available income and/or his or her direct capacity for production, thus balancing production and consumption across the social strata. Importantly, it also served to maintain a hierarchical social order by enabling the various local social groups to meet their expenditures on religious and social obligations, thus ritually reinscribing their status within the community. This form of "non-productive" consumption was integral to maintaining flows in the rural economy, since providing loans for spending on ritual obligations meant that the merchants were able to keep their hold on any future surplus (Vidal 1997, 97).

As we saw in chapter 2, on the strength of their reputations and alliances, merchants in the precolonial and colonial bazaar were able to connect the rural economy with vast trade networks stretching well beyond the subcontinent, combining the use of monetary forms with credit instruments such as *hundi*s (bills of exchange or promissory notes). The so-called informal trading systems (that is, not subject to a standard, centralized system of legal enforcement) through which these communities operated were able to persist alongside the formal market structure regulated by the colonial state: mutual adaptation and coexistence were in both sides' interests. The reliance on these informal long-distance networks of trust meant that participation in the ethos was crucial to, and indissociable from, business success.[12] A key notion emerging from C. A. Bayly's historical accounts of mercantile communities in northern and western India is that of *creditworthiness*, which depended on social, moral, and religious performance as much as economic performance, such that the moral qualities of piety and frugality would, somewhat paradoxically, translate into wealth and status (Bayly 1983 and 1986). As Philippe Cadène and Denis Vidal point out, the morally inflected ability to provide the relevant resources when required was integral to the social reputation of debtors as well as creditors, big and small (Cadène and Vidal 1997, 15). This social reputation depended not so much on having the resources yourself, but on being able to call on your networks whenever the occasion demanded. So participation in the bazaar's ethical-commercial system meant keeping these networks well oiled, as it were, maintaining a profile within the community, fulfilling your obligations, and generally maintaining the appearance (for here appearances are key) of being an honorable, morally upright, god-fearing — or rather god-loving and society-fearing — soul.

Within the mercantile ethos of the bazaar, notions of value in the marketplace as

they affected, say, interest rates or the conservation and mobilization of capital were inseparable from the moral economy that enabled the circulation of goods, money, *hundis*, and people: agents, marriage partners, migrating segments of families (see Bayly 1986, 394–426). This moral nexus between the marketplace and the sphere of religion and the sacred also tended toward a blurring of the boundaries between the corporate domains of merchants, ascetics (such as the *gosain*s who operated as traders and money-lenders between Bengal and the area of Mirzapur and Banaras in the eighteenth century and the early nineteenth; see Cohn 1964), and Brahmins (certain of whom, like the Saraswats and Chaubes, also came to participate in the activities of their merchant associates). Thus while most northern and western Indian merchants were adherents of Vaishnavism, and those emanating from the "Bania heartland" were grouped under the Vaishya caste category, the mercantile networks and marketing institutions through which this intermediate class between rulers and peasants took shape were also instrumental in extending what Bayly calls a "sense of moral community" across caste and sectarian boundaries to include ascetics (such as the Shaivite *gosain*s) and Brahmins. In Bayly's account, continuity between the moral-economic networks of the marketplace and the religio-political mobilization of this "moral community" developed through strong urban mercantile and religious corporate associations that engaged in activities of common "moral interest" such as the building of temples, *ghats*, *dharamshalas*, and *gaushalas* — activities that came to take on a communal dimension around issues such as cow protection.[13] There is a strong suggestion in Bayly's work that while this intermediate alliance did not consolidate itself into an indigenous bourgeoisie during the colonial period by channeling capital toward industrial production, as a moral community its ethos formed the basis for an alternative public sphere (alternative, that is, to the more secular liberal formulation of civil society as well as to the (post)colonial state) that has resurfaced from time to time as a sociopolitical presence. Bayly explicitly links this formation to the Hindu Mahasabha of the 1930s and the Jana Sangh of the 1970s, precursors of the later Hindu nationalist Shiv Sena, Bharatiya Janata Party (BJP), Rashtriya Swayamsevak Sangh (RSS), and Vishwa Hindu Parishad (VHP) (Bayly 1986, 449–57).

Returning to Parry's formulation in the light of this work on the bazaar, to the extent that religious, moral, ethical, and economic considerations were deeply interconnected in the bazaar economy I would suggest that the credit-driven realm of commerce was not so much ethically "neutral" as humming along in top ethical gear, fueled by the performance of social status and the need to establish and maintain one's creditworthiness.

104. Envelope for gifting money being sold on Delhi's Nai Sarak, January 1998.

Reading against the grain of Weber's specific argument about the rise of Euroamerican capitalism within the Protestant ethic, therefore, it is possible to retain his broader insight in stressing the ethical or performative dimension of a society's links with the axiomatic of capital by arguing that it is primarily a strong, resilient ethos—whatever its other characteristics—that provides the moral conditions of trust to enable the abstraction of capital as credit. Parry's account is useful for our purposes in that it describes an ethical system in which the inalienability of the sacred must be protected by ruling out any overt suggestion that divine power can be bought via the priest (that is, dragged into the realm of the commodity), but where at the same time commerce as such is not seen as inherently evil or polluted in a way that might prevent the presence of the gods in the spaces of trade, manufacture, and publicity. There is nothing about these spaces as such that makes them inherently unsuitable for the presence of icons, as long as it is possible to maintain the icons' inalienability and their ritual upkeep.[14]

My contention, then, is that the social lives of calendar icons index the further adaptation of the bazaar ethos, with its imbrication of sacred and commercial value (fig. 104), to industrialized mass production as it developed in the context of colonial and postcolonial India up until the era of liberalization. The flexible and expansive networks within which merchant communities operated continued their consolidation through the colonial period, proving resilient to the political upheavals of the eighteenth and nineteenth centuries and articulating the mercantile system of the bazaar with a colonial industrial economy and a capitalist labor market. In a discussion of the different forms of value at-

taching to cloth in Indian society from 1700 to 1930, Bayly (1986) has argued that over this period the mercantile ethos resisted the de-sacralization of things and persons associated with capitalism and "impersonal" exchange in the marketplace. For Bayly, however, this absence of the "mental and moral conditions of capitalism" qualifies the notion that the precolonial market system's extensive monetization, use of credit, and capital accumulation constitute a "proto-capitalist" formation (as suggested by Perlin 1983). If there has been a "de-sacralization" of attitudes toward commodities and the marketplace, Bayly concludes, "it is the very recent mechanization of production through factories, rather than pre-colonial merchants or the colonial state, that has effected the transformation" (Bayly 1986, 317).

This is where I depart from Bayly's otherwise convincing account, for here again, as with Weber, it would appear that capitalism is being defined in terms of one specific ethos, which does not take into account the other, nonbourgeois forms of power and social organization with which it has been closely imbricated and on which it has depended from the very outset. The issue of whether or not the bazaar constitutes capitalism proper or even proto-capitalism is something of a teleological red herring, for "proper" capitalism has always relied on "improper" relations of exploitation (feudal and colonial, as well as those based on race, caste, and gender): the more pertinent question is that of the relationship between these "proper" and "improper" forms.[15] Also, if "mental and moral conditions" are indeed so central to a "properly" capitalist transformation, it is unclear how the mechanization of production alone would result in such an ethical change. While a change in the commercial ethos might well be under way in India after liberalization, this too has to be seen as a result of ideological and institutional work—which might have gathered impetus in the post-independence period of industrial consolidation, particularly with the development of labor movements and trade unions, but which after liberalization has taken on a different character and a different order of intensity and momentum.

GIFT, COMMODITY, ADVERTISEMENT, ICON

So how does post-independence calendar art index a bazaar-style moral schema based on circulation and credit? The moral economy I have just described manifests itself at a number of levels when it comes to bazaar images: in their raison d'être, in their modes of production and circulation, and in the way they look (in both senses).

For a start, the annual distribution of calendars by a business house is a means of keep-

ing its social-commercial networks lubricated, of keeping open the channels along which resources will flow, particularly (contra Bayly) in a scenario where centralized mass production means that trading partners and other associates (bureaucrats, local politicians, members of community and business associations, extended kin) are likely to be scattered far and wide. In other words, the calendar stands in for a more local, immediate (that is, unmediated) sociality of exchange. It does so without *explicitly* asserting motivation (referred to in Hindi as *matlab*, literally "meaning") or the expectation of reciprocity, operating within the discursive and ideological framework of the gift and thereby forging and maintaining relationships that are as much social as they are commercial. Albeit no longer as a commodity per se (that is, in this phase, unlike the framing pictures, it is not exchanged for the "impersonal" medium of money), the calendar continues to circulate in the marketplace as an annually reiterated assertion of the ethical dimension within which the rest of a firm's commodities or services must be seen. As a demonstration of plenitude or excess it is an index of profit, signaling sound commercial practice. However, the harnessing of this profit to divine (or otherwise noble or sacred) content also indicates goodness or adherence to the ethos, while the act of giving reinforces the firm's goodwill toward its associates, as well as their mutual dependence.

The fact that this gifting often occurs on Diwali marks it as an auspicious ritual act, as does the auspicious nature of the images on the calendars: most obviously the deities, but also other potent or pleasant and fecund themes such as the babies, "leaders," "beauties," and landscapes (fig. 105). And of course, these are depicted in bright, cheerful, and auspicious colors, with a great deal of attention to surface decoration or ornament, which again evokes a ritual context. Here "auspicious," *shubh*, is a term of value that becomes efficacious, or gains a material force: the ethical and/or sacred nature of the representation in a calendar image, as well as its ritualized annual prestation, works to enhance the reputation and thereby the creditworthiness of the firm whose name is printed onto the calendar. (I return to the notion of auspiciousness in the following chapter.) What is more, the very newness of a calendar is auspicious in itself, not as ontological originality but as a renewal, indexing freshness, fecundity, plenitude. In this sense the auspiciousness of the calendar as an annually reiterated gift is directly enabled by the calendar industry's use of modern technologies of mass reproduction. And similarly, in relation to newness, I would suggest that even "secular" subjects in calendar art, such as the healthy babies playing with the apparatuses of modernity, the women pictured in fantasized middle-class living rooms or with modern modes of transport (see fig. 27, or fig. 92), or the views of

105. *Mamta* [Affection], a mother and baby calendar by Studio S. V. Aras, publisher unknown. (Courtesy of the artist)

cities (again featuring vehicles as signs of movement and progress; figs. 106 and 107) — in fact, the newness of modernity itself — can be understood within this not-quite-secular frame of the auspicious.

Conversely, iconographically incorrect, ugly, disproportionate, or otherwise depressing or violent depictions are seen as inauspicious, and this can often be the basis for a picture's rejection by publishers or their customers (figs. 108 and 109). Indeed, it appears that depictions of divine power that are not unambiguously benign, such as the inauspicious planetary deity Shani (Saturn), Krishna's awe-inspiring cosmic form revealed on the battlefield in the Mahabharata, or Kali in her more terrifying aspect, common in the early days of chromolithography (figs. 110 and 111), have gradually disappeared from commercial prints or have given way to interpretations with a quite different affective charge. Nowadays Krishna is portrayed much more as a sweet, seductive, androgynous youth, and similarly the sensuous treatment of Kali's tongue sometimes verges on soft-focus eroticism (figs. 112 and 113). My hypothesis is that this disarming of images started to occur after the early 1960s with the rise of the Sivakasi printing industry and the in-

106. A 1969 calendar for Navyug Calendar Corp., Patiala (Punjab). "Navyug" means "new era." (Collection of JPS and Patricia Uberoi, Delhi; also included in Fukuoka Asian Art Museum 2000)

107. "Two Friends"; the calendar design, artist, date (possibly 1960s), and publisher are unknown. (Collection of JPS and Patricia Uberoi, Delhi)

देश का धन और सन्तान की जंग
क शालास बचाप

108. A calendar design by K. C. Prakas, unfinished because it was rejected by the publisher, Sivakasi, 2001. While themes celebrating the militaristic defense of the homeland were popular in visual culture (particularly the cinema) after the 1999 conflict with Pakistan in Kargil, unlike some of Prakas's earlier work (see fig. 109) this calendar evidently did not strike the right balance, its inauspicious figuration of a threatened mother and child unmitigated by a more positive contextualization.

109. A 1974 calendar by Studio K. C. Prakas for Punjab Pen and Stationers, Ludhiana: here the inauspiciousness of scenes from the Bangladesh war is counteracted by the more dominant image of a smiling Indira Gandhi. (Collection of JPS and Patricia Uberoi, Delhi)

110. *Vishvaroop Darshan (Virat Svaroop)*, Krisha's universal form, an early print signed "K. G. Khatu" from Modern Picture Publishers, Bombay.

111. *Kali*, published by the Ravi Varma Press, Malavali, and distributed by Anant Shivaji Desai, Motibazaar, Bombay. (Collection of Bari Kumar and Samantha Harrison)

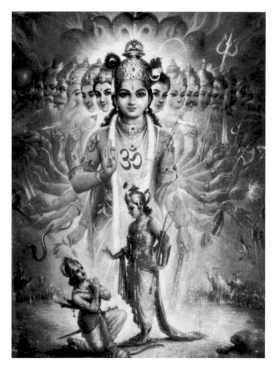

112. "Krishna ka Virat Roop" [Krishna's universal form], by R. S. Mulgaonkar, from *Ratnaprabha* magazine, 1974.

113. An early 1990s calendar design by V. V. Sapar for the "Bengali market," depicting Ramakrishna Paramhansa surrounded by seductive rather than terrifying Kalis. (Courtesy of the artist)

creasing use of calendars as gifts by companies and institutions in the growing domestic economy.

The significance of the calendars' auspicious newness as gifts means that they must be reproduced every year. Publishers said that even though clients often demand pictures of the same deity from year to year they cannot repeat exactly the same design, as it would not be "new." This is why by now thousands of iconic figures have been published with the same iconographic characteristics but with varying backgrounds, ornamentation, color schemes, and composition—and why there is a continuing role in the industry for the so-called copy masters or hack artists who churn out endless modifications of existing designs. One of the striking things about Denis Vidal's (1997) description of the role of Jain merchants in rural Rajasthan is his emphasis on rhythm: that is, the rhythms of spending and income, and their orchestration and manipulation by merchants through the provision of credit. Essential to this rhythm, as I pointed out above, is the cycle of religious and social observance for which spending is required, often beyond one's immediate means. The annual distribution of calendars thus emanates from and shores up a system that has crucially depended on widespread adherence to this ritual cycle. (I should emphasize here that I am not positing some kind of conspiracy on the part of merchants or money-lenders, only that the usefulness and desirability of the calendar becomes quite "natural" within this schema.) In this respect, even though illustrated calendars as a means of advertising were introduced into colonial India by the British early in the twentieth century, I would suggest that there is a continuity between the religious almanacs (which, as we saw in chapter 2, were one of the first local forms to appropriate print technology) and the mass-produced calendars that provide a proforma for religious observance alongside the marking of secular time.

Calendars reinforce social and trading relationships not only through their circulation as gifts-cum-advertisements by the firms who order them, but also in their capacity as commodities that are themselves produced and distributed through the bazaar's networks. The extensive system of agents or middlemen (a characteristic feature of the colonial bazaar) used to garner orders and distribute the calendars ensures a high degree of flexibility and responsiveness to customer demand at the most local level. The primacy of agents and middlemen within the bazaar has also meant that, as in other industries, there are often better profits to be had from trade than from manufacture (Cadène and Vidal 1997, 17). So even as calendar publishers might run their own presses, they continue to maintain a hold over distribution and often prefer to outsource their printing

114. A poster for Khurana traders, Delhi.

(as in the case of S. S. Brijbasi and Sons in Delhi, which has much of its calendar and poster printing done in Sivakasi). The trader is also not necessarily tied to one product: calendar agents might additionally deal in stationery, fireworks and other seasonal festive goods, various types of corporate giveaways, or political propaganda items (fig. 114); one agent I met also ran a local agricultural newspaper, collecting orders for calendars from traders who advertised in his paper. So, as I suggested earlier, the aim of advertising within the bazaar's networks (as in the case of the calendar) is to establish a personalized relationship with a firm, not necessarily with a product as such, for the vast majority of traders are not themselves producers.

In Parry's account the valorization of circulation is counterposed to the valorization of "autarkic" self-sufficiency and the centrality of production for the benefit of the producer. In the previous chapter we saw how the artistic signature in the calendar industry has been a site of disjuncture over where to locate productive value, its heterogeneous uses loosening the links between the work and the artist as producer of the work. The pedagogical and canonical traditions of iconographic image making make it difficult to locate the value of iconic images as emanating primarily from their origination by singular creative individuals such as those within the art system. Accordingly, I want to suggest that the bazaar's moral economy has a necessary blind spot, and that is its systematic

devaluing and/or elision of the productive body. This is necessary to the extent that it enables divine value to stand in for socially produced value without a social acknowledgment of the signifying process by which this occurs—in other words, it maintains the ideological inalienability of the sacred.[16]

This devaluation applies in particular to the working-caste or -class body and the female body. Unable to locate the source of productive or even reproductive power in the laboring body as such, the bazaar conceives of power and value in transcendent terms (as in its sacralization of the mother), while simultaneously inscribing the working-caste body as polluted and rendering abject or asocial the sexual body of woman. This, too, is reflected in calendar images, not only in their themes but also in the way they situate power in relation to bodily agency. In the previous chapter I described how several calendar artists expressed a certain frustration with the iconographic imperatives emanating from the bazaar, according to which iconic figures must be depicted with "disproportionately" large heads and eyes, must look directly at the viewer, and cannot be shown to have muscles. These imperatives conflicted with the demands of anatomical accuracy and the dictates of "fine art" and "realism." Unlike realism, this iconography works to shore up a transcendent locus of power and agency, for, as Anuradha Kapur (1993a) has brilliantly argued in relation to popular images of Ram, its representational strategies have been predicated on the idea that the power of deities is unlocatable in bodily instrumentality (until recently, that is; I discuss the historical trajectory of this formulation in more detail in chapter 7). This transcendent power is not of a physical order, and therefore it is not visibly manifested through the depiction of musculature or violent conflict, but through a kind of effulgence of benign affects via the face, eyes, gesture, radiance—and the highly worked decorative surfaces of the image. The stress on iconographic accuracy in these matters makes perfect sense in the light of the preeminence of circulation in the bazaar, for it is consistent with the moral and ethical burden the calendar carries as an object: to shore up a firm's reputation while lubricating its networks with a bit of divine effulgence.

I do not wish to suggest here that the bazaar in India has had an exclusive purchase on personalized networks of reciprocity in business dealings, or on the imbrication of moral and commodity economies. The gifting of calendars in the context of business is not exclusive to India: it has been a common practice in many parts of the world. Indeed, as we saw in chapter 3, the early advertising calendars in the Indian market were circulated by Western firms. Neighborhood butchers in Britain gave out calendars until at least the 1960s, as did large international companies such as Singer and Coca-Cola. This practice

still continues in several sectors where, it could be argued, ongoing relationships remain essential to the business; common Western examples include the printing and building industries. What does stand out in the Indian case, however, is the way in which sacred imagery has continued to figure as an integral element of this moral-commercial ethos. Even though there is a St. George Bank in Australia and "St. Michael" has been the brand name of the Marks and Spencer department store chain in Britain, societies adhering to the Protestant injunction against idolatry and the bourgeois horror of the fetish do not use images of holy figures in a commercial context. In this respect the Indian instance has closer parallels to the culture of business calendars in Mexico, Taiwan, or the Chinese diaspora, where religious icons figure alongside a range of secular themes. While such comparisons would require substantiation, the critical role of informal money markets and broad social networks based on *guanxi* (interpersonal relationships, connections, or worth) in Chinese "network capitalism" suggests a similar moral economy to that of the bazaar, where gift exchange is one way of maintaining and furthering interpersonal ties, with material objects and images serving as vehicles of auspiciousness and luck (see Hefner 1998, 15–17; Gold, Guthrie, and Wank 2001; M. Yang 1994).

The characteristics of a business ethos, however, are only one side of the coin when it comes to thinking about the presence of sacred imagery in commercial contexts. The differences between Protestant image cultures and those informing Indian, Mexican, and Chinese/Taiwanese commercial calendars suggest that this is also a matter of different modes of religiosity, and of the different social and institutional arrangements through which religiosity is enacted in specific contexts. If the question so far has been what kind of business ethos might allow for the circulation of iconic images in the spaces of commerce, it is equally pertinent to ask what structures of social power, and what formulations of the sacred, make this possible. To ignore these dimensions would be to fall back into the trap of economism and the mechanistic attribution of ultimate causality to "market forces."

RETERRITORIALIZED DEVOTION

Ever since the institution of image-based temple worship became prevalent by about the eighth century CE (Davis 1997; Inden 2000), temple icons all over India have been embedded within the kind of consecrated space described by Benjamin in his characterization of "cult value" (Benjamin 1969), with access and exhibition strictly regulated and mediated by priests. Social power in the Brahmanical schema has been based on priests'

privileged intercession with the divine and shored up by the restriction of public access to icons. How is it, then, that the bazaar formation is able to deploy mass-produced iconic images in the mobile, public manner I have been describing, making them available to all and sundry?

I want to suggest that the possibility of the circulation or mobility of sacred images arose in precolonial India as part of the political, social, and economic upheavals of the late medieval period, particularly in the north and west: conquest by invading forces; warring princely states forming and breaking alliances; challenges to caste hierarchy and gender roles and their reinstitutionalization; the movement of peoples displaced by war and opportunity; and ideas and goods circulating along with conquerors, preachers, traders, pilgrims, and refugees. Central to the reconfiguration of religious power in this scenario were the socioreligious *bhakti* movements, many of which espoused an unmediated, personalized devotional relationship with the divine, putatively delinking religious practice from the priesthood and the caste-based division of labor.[17] However, this delinking was mostly made possible by finding virtual *alternatives* to temple icons—and material images in general—by privileging poetry, song, and dance. The *bhakti* saint-poets either conjured their own ecstatic visions (as with Surdas, who was blind), or advocated the formlessness of the divine (as with Kabir). So the animation of material icons, I would contend, accompanied the *reinstitutionalization* of these *bhakti* cults and the attendant reterritorializing reimaging of the divine. This reterritorialization occurred in the context of an expanding bazaar economy that sought to reconfigure earlier forms of privilege and power through new alliances between merchants, Brahmins, kings, and, eventually, the agents of colonial incursion.

This process of refiguring the divine to address expanding constituencies and changing hegemonic formations has taken different forms at different moments. In chapter 3 I described one such moment in relation to Nathdwara artists and their use of new visual technologies ("realist" painting techniques, photography, and technological mass reproduction). However, in the case of Pushtimarg (the Krishna-worshipping sect for which Nathdwara is a primary shrine) the modern refiguring of icons by and for mass reproduction in the late colonial bazaar was preceded by an earlier moment of de- and reterritorialization involving the sect's temple-based idols, the sacred *svarupa* or living embodiments of Krishna. The temple-based institutionalization of Pushtimarg and its development of an elaborate culture of images and image worship can be seen as a recuperation of the radical impulses of *bhakti*, belying its egalitarian philosophy and inclusive

origins with its reinstatement of caste and, significantly, by its strict policing of access to its temple icons (both in terms of the social background of the viewer and the duration of viewing).

The message of god's love and grace (*pushti*) toward the lowliest of the low that was propounded in the sixteenth century by Pushtimarg's founder, Vallabhacharya, extended to untouchables and Muslims. In the mid-1970s, however, the anthropologist Renaldo Maduro described "burly Rajput warriors, weapons in hand" guarding the entrance to the Nathdwara temple to prevent the entry of "non-Hindus, tribals, untouchables and scheduled castes" (Maduro 1976, 31). (However, when I visited the temple in 1995 these strictures were officially announced only for non-Hindus, and there were no guards.) For those who are allowed into the temple, daily viewing of Shrinathji continues to be restricted to eight *darshan*s or *jhanki*s (literally "glimpses"), where the crowds are herded past the image by priests wielding cloth whips—although special prayers and individualized offerings can be arranged at a price. For Maduro this return of exclusivity and priestly control dates back to 1671, when the Shrinathji idol was relocated from the rural ambience of the Braj area near Mathura (where it had miraculously appeared around 1410) to Nathdwara, where it attracted a following among the wealthier Gujarati and Marwari mercantile communities (Maduro 1976, 30). Norbert Peabody provides a fuller understanding of this moment in his account of how the sacred power of such nomadic images, pushed into circulation as they fled the iconoclasm of the emperor Aurangzeb, was used to shore up political power during the unstable period from the late seventeenth century to the mid-nineteenth (Peabody 1991).[18] Peabody describes how Vallabha priests set up the icons known as the *nav nidhi* (the "nine treasures" of Pushtimarg) in a hierarchy of power and value through periodic rituals of refortification or empowerment (as well as daily worship), thus providing the basis for negotiation with successive rulers in the region over the location of these deities. Rulers (such as the rajas of Kota, Bundi, and Mewar) who could claim association with the mythic powers of the deity were able to validate and perpetuate their authority, while the priests were able to bargain for their own upkeep and that of the costly rituals required to maintain the potency of the images. In other words, then, the deterritorialization or circulatability of icons served to set in train their reterritorialization, or a reconfigured interface with social-political power, through a reintensified priestly control of images.[19]

Even as the booming pilgrim economy that these icons brought with them mediated these transactions between Vallabha priests, merchants, and kings, it maintained

the boundaries between sacred and commodity economies by upholding the ideological barrier against thinking of devotion either in terms of investment or of trade. Indeed, Pushtimarg, the "way of grace," is so called because nothing but the grace of god can assure liberation, so the devotee must simply love god without expecting anything in return, not even liberation: this was a crucial move (echoing Parry's account of *dana*) given the preoccupation of the sect's followers with trade and accounting. However, this unconditional investment of affect by pilgrims happened to be accompanied by donations to the temple and spending in the bazaar. A healthy bazaar meant greater contributions to royal taxes, all of which translated to greater donations to priests and the temple, providing the resources for the spectacular rituals that further shored up the power and reputation of the deity. The difference between this and more "territorialized" forms of priestly value production is the greater agency of the devotees themselves in exercising a choice as to which manifestation of the divine to worship, which is in turn related to a given icon's reputed power. For instance, the rulers of Mewar worshipped the Shaivite Eklingji as their territorial deity, but when Shrinathji was installed at Nathdwara and gained in popularity, they also became devotees of Shrinathji, adapting Eklingji rituals to Vallabhite worship through (among other things) the introduction of fixed *darshan* timings (Peabody 1991, 745). This relay through the public arena adds value to the cultic deity (or depletes it) in much the same way as value is produced in the realm of "circulation" (as opposed to "production") through publicity in the mass-mediated commodity economy. Here what is being consumed is not so much the commodity itself but the power of its popularity (the fascination, curiosity, and sense of participation evoked, for instance, by box-office success, high television ratings, notoriety, blockbuster sales, or public scenes of mass adulation), which constitutes a kind of meta-commodity. (I return to this formulation in the following chapter.)[20]

In other words, once icons are loosened from one set of cultic territorial links within a particular power formation, they become available to an expanded trans-subjective "public" realm, which mediates their reinstatement in the context of another territorialization, or a reformulated structure of social power.[21] In medieval Rajasthan, icons rendered nomadic by the threat of iconoclasm were appropriated to the reconfiguration of princely power in the region; in late colonial India the mobile icons made available by mass reproduction were harnessed to pan-Indian nationalist state formation as well as to the articulation of regional and communitarian identity (as described in chapters 2 and 3). The preeminence of Nathdwara and the Pushtimarg sect as a case study of these

processes of de- and reterritorialization is no coincidence, as it indexes the confluence of two features that lend themselves to such social-political reconfigurations. First, the Nathdwara icons were positioned at the expanding frontiers of commerce through their primary constituency from the late seventeenth century onward, the increasingly mobile yet tightly networked mercantilists of northern and western India. Second, their trajectories have also articulated with forms of religiosity that have a similarly expansive character to that of the commodity realm, driven by the possibility of universal circulation and generalized exchange. Specifically, I am suggesting that the universalizing theologies and visual-cum-libidinal attractions of image-based Vaishnava devotion, and especially certain strands of the Krishna-worshipping Bhagwat *bhakti* cults, have particularly lent themselves to a nexus with hierarchical social power and to dominance over the devotional modalities of other sects and religions (including those that eschew the use of images).[22] We have seen this at work in the case of the medieval worshippers of Eklingji; we have also seen (in previous chapters) how Muslim, Sikh, Shaivite, and other themes have been processed through Vaishnava iconic idioms such as those of Tanjore and Nathdwara, in an era of mass reproduction dominated by Vaishnava merchants and artists. So what is it about Vaishnava theologies that fosters an image culture with such expansive, hegemonic articulations?

FREE AFFECT: VAISHNAVA VISUALITY
AND ITS HEGEMONY

While most deities appear in several forms or *roop*, the multiple material incarnations of Vishnu have been particularly amenable to a culture of visual imaging. Vishnu has ten avatars or worldly manifestations as listed in the Vishnu Purana; one of these avatars, Krishna, the supreme locus of devotional desire, is celebrated for his self-replication for the benefit of his *ur*-devotees, the *gopi*s or cowgirls of Braj (during the dance known as the *ras-lila*), in what could be considered an instance of proto-mass-reproduction. Krishna is one of the principal characters in the Mahabharata, while Ram, another avatar of Vishnu, is the hero of the Ramayana; both of these epics have afforded rich possibilities for narration and illustration, readily lending themselves to reinterpretation, along with themes from the Puranas, whenever new formal means have become available. What is more, as we have seen, the predominantly Vaishnava mercantile communities have not only been associated with the circulation of prints (as with picture merchants such as Anant Shivaji Desai in Bombay, Hem Chander Bhargava in Delhi, S. S. Brijbasi in Kara-

chi, Harnarayan and Sons of Jodhpur, or Nathmal Chandelia of Calcutta and Jaipur), but have also figured prominently as consumers and as sources of capital for their mass production (as in the case of Ravi Varma's partner, Govardhandas Khatau Makhanji, or the Brijbasi brothers). Thus the first Brijbasi print was a depiction of the child Krishna, and popular plays by writers such as Radheyshyam Kathavachak and the earliest feature films, such as those of D. G. Phalke, revolved around episodes from the Ramayana and Mahabharata (*Pundalik*, often cited as the first Indian feature, told the story of a Vaishnava saint). Even the *Amar Chitra Katha* comics led with *Krishna*, followed again by themes from the two major epics. However, I want to suggest that the real index of Vaishnava hegemony is not so much the preponderance of Vaishnava imagery but the very framework of visuality, value, and power within which icons have been mobilized. Key to this framework is the way in which strands of *bhakti* such as Pushtimarg establish the sacred as a form of value to which all have access in principle but simultaneously mediate this access to the sacred through differentially accessible manifestations. (This is homologous to the way in which capital and the market are in principle universally accessible, but in practice access to credit is subject to constraints.)

According to the more influential formulations of *bhakti*, in principle anyone, regardless of social status or sectarian affiliation, can engage at some level in exchanges with the divine. Importantly, this is a matter of choice rather than an obligation attendant on a particular position within a fixed social structure. Indeed, here the most lowly or subaltern tend to occupy a (theoretically) privileged position (on the privileging of subalternity in Vaishnava *bhakti*, see Sangari 1990, particularly part 1, 1470). We might think of this relationship of the devotee with the deity in terms of an investment of free devotional affect or desire, much as the worker, released from feudal bonds in the Marxian formulation of the conditions of capitalism, is able to invest "free" labor.[23] The investment of free affect through the devotee's ritual performance provides the "necessary labor" to produce value in a sacred economy (where economy is understood broadly as a system of exchange). This labor activates or calls into being the power of the particular iconic object being worshipped *and* the more abstract deity of which that object is a manifestation: the Vedantist Absolute (god, the divine).[24] The publicness of this devotion or its circulation within the ethos increases the power of the deity and/or specific icon by enhancing its value to others, in effect creating a kind of surplus.

Crucial to the assimilation of other devotional forms and new constituencies to this socially expansive sacred economy has been the influential combination of Vedantist

non-dualism with image worship in Vaishnava *bhakti*. It has also been key to the ability of sects such as Pushtimarg to maintain the conceptual inalienability of the sacred while simultaneously bringing a universally accessible divine into a hierarchical frame of value, which articulates with social power. This latter move is enabled by those non-dualist theologies that slip between allowing for the votive use of images as *representations* and as *manifestations* or *embodiments* of the divine. In what follows I will briefly outline my understanding of the relevant aspects of these approaches; however, I should emphasize that this is necessarily a highly reductive and synthetic account of a set of complex, subtly differentiated, historically and regionally varying schools of thought.

The "pure" non-dualism (*shudhadvaita*) of Vallabhacharya (1479/81–1533 CE), the founder of Pushtimarg, is seen as a synthesis of the ascetic, aniconic non-dualism (*advaita*) of Shankara (eighth century CE) and the more sensualized, image-based "qualified" non-dualism (*visishtadvaita*) of the later Ramanuja (1017–37 CE). What all three have in common is a shift from Vedic polytheism and an emphasis on ritual to the more abstract conception of a single absolute or infinite reality (called Brahman), with which the soul or self seeks to be reunited in order to attain its true nature, or a state of bliss.[25] While the aniconic theologies hold that the supreme being is formless or *nirguna* ("without attributes"), in both Ramanuja and Vallabha as well as many *bhakti* poets the devotee's aspiration to the state of divine bliss is characterized in terms of a primarily visual desire, as *darshan* (sight or vision; the enjoyment of the sight of, or being in the presence of, the divine). Crucially, this is geared not so much toward an annihilation of the self in the ultimate union with an abstract Absolute beyond subject and object, as in Shankara, but to a kind of permanent intuition of a more or less personalized divinity, a pure gazing intensity.[26]

For Ramanuja, who sees icons as essential for the emotional sustenance of the devotee, visualizing the divine as a means of harnessing devotional intensity is geared toward a personalized *saguna* divinity (that is, possessed of qualities or attributes): the "qualified" form of the formless. Here the icon does have a representational (or iconic in the Peircian sense) aspect, but even in Ramanuja the understanding with regard to all descriptions and images as iconic signs is that while they are important as a means to ultimate *darshan*, no single one can ever be adequate or exhaustive.[27] Vallabha goes one further, arguing that the existence of manifestations does not necessarily impute attributes to the Absolute, so that the use of images does not conflict with a *nirguna* conception. Much of the literature on *bhakti* is at pains to emphasize that the icon is merely a support that the rest-

less mind can use to steady itself in focusing attention on god: in other words, its semiotic character is that of an indexical sign that points toward the true nature of reality. As I mentioned in the previous chapter in relation to the use of color in the calendar industry, this use of images as spiritual props is often seen as a particular need of those "ordinary people" (characterized as unused to meditative activity), hitherto excluded from temple worship, whom *bhakti* now welcomes to its fold (Vyas 1977, 57). Rather than doing away with images, however, on the contrary these arguments for the inadequacy of icons serve to sanction an infinite multiplicity of images, *all* of them inadequate.

Despite the iconic or *representational* inadequacy of all images, however, they are not all equally inadequate, for images can have differential values as *embodiments* of the divine or repositories of power: that is, as signifieds rather than signifiers. Although it could be argued that all manifestations of the infinite must be qualitatively equal, in their formulations of the relationship between the divine and the devotional subject both Ramanuja and Vallabha open up the possibility that things can contain the essence of the divine but be of a lesser formal or substantial order. Ramanuja compares the *jiva* (self or soul) to a spark emanating from the fire of Brahman; Vallabha, in a trope well suited to the mercantile constituency of Pushtimarg, likens the relation of god with the individual *jiva* to that of gold with golden ornaments (Chattopadhyay 1964, 73). So even as everything in the universe partakes of a divine essence, it is possible to distinguish between manifestations of this essence in quantitative terms (big or small sparks, ornaments containing more or less gold). Richard Davis has described how image-based Shaivite temple worship is predicated on a theological formulation of the iconic image as embodying a "special" or "marked" (*visishta*) presence of the divine (Davis 1997, 34; 1991, 119), which needs to be invoked or activated and maintained by the labor of priests. In effect, the Bhagwat *bhakti* sects reinstate this "special presence" by making visual and poetic images of deities available to affective investments that are simultaneously intensely personal and publicly mediated. Buying into a discourse of visual desire, therefore, leads the Bhagwat *bhakti* cults back into a realm where divine power can be converted into graded forms of value embodied by objects, and thence into social power (as in the case of the Pushtimarg *nav nidhi*). The extent to which a particular manifestation is imbued with divine power is reflected in the level of ritual expenditure or investment (of goods, money, time, psychic intensity) at the interface between sacred and commercial economies. So even as the socially acknowledged inadequacy of the idol as a *signifier* of the divine maintains the inalienability of the sacred, its performative efficacy as the *manifestation* of a divine essence simultaneously situates it on a sliding scale of value.

115. A shrine behind a calendar manufacturer's desk, New Delhi, 1994. The central photograph of the deceased patriarch is flanked by two- and three-dimensional images of Ganesh and Lakshmi.

Not only does this sliding scale place temple icons on a continuum with more informally sanctified objects, but it also allows for a catholic (or rather, Vedantist) incorporation of secular figures and icons from multiple religions, on the principle that all forms of worship ultimately lead to the same universal godhead. At the top of this scale today are hugely powerful icons such as Balaji, Vaishno Devi, and Srinathji in the inner sanctums of their temples, or cult leaders such as Sai Baba. These are followed by myriad greater and lesser manifestations in the form of temple deities, gurus, saints, and other public personages (such as politicians and film stars), as well as ancestors (fig. 115). The more powerful temple icons are usually associated with mythic origins, as in the Pushtimarg *svarupa* images, whose divine genesis means that they are already imbued with the divine essence. The man-made *murti*s (images or statues), in contrast, are seen in terms of a more temporary occupation by the deity and therefore require consecration by priests through the *pran-pratishtha* (life-breathing) ceremony, followed by constant ritual maintenance in order that they remain suitable residences for the deity (see Davis 1991). At the lower end are countless unconsecrated objects and natural beings: painted pilgrim souvenirs, clay figures produced by potters, sacred cows, rivers, trees, or stones with painted eyes, and of course the mass-produced calendar icons, key-rings, incense packages, and *beedi* wrappers. Their claims to sanctity rest either on iconic resemblance

or on an association with beneficial (or other) powers; their state of empowerment, such as it is, is maintained through myriad varyingly personalized, everyday ritual acts (see H. Smith 1995).

The potential inclusion of all the things of the world in a sacred economy points to a further homology between the expansive character of the sacred in these image-worshipping forms of *bhakti* and the de- and reterritorializing movement of capital, which strives "simultaneously for an even greater extension of the market and for greater annihilation of space with time" (Marx 1974, 539). Here we might profitably turn Marx's notion of commodity fetishism back on itself, using the commodity to describe (this particular case of) the "fetish," rather than the other way round. What emerges is a sacred economy where the production of value emanates from the general accessibility of icons, akin to the general circulation of commodities. Just as fetishized commodities are treated as though they have intrinsic value, iconic objects are "endowed with a life of their own" inasmuch as they are treated as manifestations of the divine. And just as exchange value in the capitalist schema thrusts people as labor into a qualitative equivalence with the commodity, the entry of icons "into relations both with each other and with the human race" is enabled by a common divine essence that establishes an equivalence between people, icons, and all of the other bodies in the world.

This theology of potentially universally accessible and sacralizable icons is one aspect of Vaishnava non-dualism's propensity for expansion. Another aspect, pertinent to late colonial and early post-independence nationalism, has been Vedanta's self-positioning as an overarching monotheism in the image of the other "world religions," assimilating the diverse forms of "Hinduism" (and indeed of Indian "spirituality" in general) within its fold. These (re)inscriptions of an essential Hinduism are not uniform but reflect the many competing strands of thought within Vedantism. One elite secular-nationalist strand, represented by the philosopher-president S. Radhakrishnan, has sought to recast *advaita* as a species of idealism constituting the great common denominator of "Hinduism" or "Indian philosophy."[28] Another version of Hindu nationalism represented by Tilak and Gokhale appropriated the Bhagwad Gita's formulation of *karmayoga* as a kind of Protestant ethic for an Indian middle class.[29] Yet others consolidated the alternative mercantile public sphere of caste and community associations by repudiating *advaita* monism in favor of the *prem marg* or *bhakti marg* (the path of love and devotion). As an instance of the latter, Vasudha Dalmia has traced how the negotiation of community identity by the Vaishnavas of Banaras, represented through the writings of "Bharatendu"

Harishchandra (himself a member of the Aggarwal trading community and a Pushti-margi) from 1869 to 1884, developed in relay with Orientalist and missionary discourse on Indian religion to inscribe Vaishnavism as the core faith of "Hinduism" (Dalmia 1995). Dalmia relates the hegemonic influence of this move both to the position of Banaras as a powerful source of sacral authority as well as to the legitimacy it drew from Orientalist scholarship. A key aspect of this assimilative Vaishnavism was the polemical stance of the *sanatan dharma* or conservative Hindu grouping (with which Harishchandra was aligned in his capacity as an official of the Kashi Dharma Sabha), against the more puritanical and reformist Arya Samaj, that the use of images in worship constituted an essential feature of Hinduism. Dalmia does not dwell on this aspect, concentrating instead on Vaishnava self-representation through written texts. But as we have seen, the articulation of the bazaar ethos with an increasingly generic icon-based Hinduism was also expressing itself in other areas of the print industry developing around the same time.

There is, however, a significant difference between the conscious, self-reflexive articulation of identity and communitarian interest in the polemical writings of the Vaishnava "middle class" and the far more polysemic products of the early culture industries. Bazaar prints, the popular theater, and the cinema inscribed a realm of address that exceeded that of the mostly urban literate public sphere of novels, journals, and caste societies (although, as I suggested in chapter 3, the real "massification" of calendar art did not occur until after independence, with the rise of offset printing and the Sivakasi industry). My emphasis here in describing the ethos of the bazaar has been on processes of reterritorialization. However, insofar as the powerful figures of resistance and forms of affect unleashed by the *bhakti* movements have continued to provide subaltern constituencies with a basis for social and political mobilization, there is also space for a redemptive, Benjaminian view of the expanded sphere of address enabled by new image-making technologies and the enriched sensorium that they call into being. Here the *sajivta* or "livingness" brought to images by illusionist techniques in painting, theater, and cinema (see chapter 4) can be seen as reanimating the affective registers of desire and wonder so intensely invoked by the oral traditions of *bhakti* poetry (verse recitation and *bhajan* singing). Similarly, the mass reproduction of images and the collective address of the mythological cinema, theater, and television replay a personalized relationship with gods rendered universally accessible within a devotional "commons." If, as I have argued here, the sacred economy of Vedantist *bhakti*, like capitalism, is characterized by an axiomatic of expansion and hence by twinned processes of de- and reterritializa-

tion, neither of these realms nor the media or cultural forms associated with them are inherently "progressive" or "regressive," egalitarian or hierarchical, hegemonic or resistant: their cultural forms have to be seen as variously aligned with both hegemonic and resistant processes at particular moments (for an elaboration of this in the context of calendar art, see chapter 7).

FETISHISM AND THE MANAGEMENT
OF EMBODIED DESIRE

In describing how commercial and power relations in the bazaar have articulated with the sacred economy of Bhagwat *bhakti* my aim is not to reduce all social exchange to commercial profit seeking or the pursuit of power, positing rational self-interest as the ultimate basis of the bazaar ethos and thereby re-universalizing the bourgeois subject.[30] This would be to ignore the discursive and ideological distinctions drawn by this ethos between sacral and commercial realms or between gifts and commodities, which, by underpinning the rules of exchange, mark the social trajectories not only of objects (see N. Thomas 1991), but also of subjects. To the extent that subjects in the bazaar operate within the kinds of devotional framework I have been describing, the ethics and aesthetics of their relations with objects and each other do not hinge on notions of willing agency, autonomy, and self-interested rationality associated with the post-Enlightenment bourgeois subject. Specifically, even as the "fetishistic" engagement addressed by images in the bazaar might be seen in functionalist terms as perpetuating a productive and reproductive socius, it is predicated on a corporeally permeable subject of ritual, devotional surrender or abjection, social obligation, and mutual interdependence.

If the blind spot of the bazaar ethos—that which it disavows—is the link between labor or bodily agency and the production of value, the blind spot of the bourgeois ethos is the role of social transactions in the process of constituting individual subjects and, concomitantly, in constituting the value inhering in or created by them. Both the valorization of sovereignty and the denigration of the fetish belong to this blind spot of bourgeois subjectivity, for the category of the fetish works to uphold a symbolic universe in which the autonomous, unitary subject is under constant threat of dissolution—particularly through its engagements with objects. The fetish attempts to police the boundaries of the locus of value, ensuring that it remains within sovereign, productive, and reproductive individuals and guarding against any interconvertibility or permeability between subjects and material things. The bourgeois socius therefore seeks to privatize affective and

ritual engagements with the divine and, in the public sphere, to supersede them with the aesthetic. The bazaar, in contrast, is happy to perpetuate, orchestrate, and indeed to intensify such engagements. To this extent the two kinds of ethos can be seen as articulating with different libidinal economies or structures for managing desire. The Oedipal bourgeois ethos represses fetishism as an abnormal or perverse form of desire; however, this discursive denigration only serves to mobilize the fetish in a psychic realm where desire (which never takes "no" for an answer) converts prohibition into another form of libidinal investment. The ethos of the bazaar, in contrast, harnesses the power of the fetish, and hence has no use for it as a discursive category.

Unlike the deterritorializing subject of *bhakti*, the reterritorialized subject of the bazaar can scarcely be idealized as a decentered, communitarian, egalitarian obverse of the bourgeois subject. Here my analysis departs from critiques such as that of the early Jean Baudrillard, where Bataillean notions of waste, loss, sacrifice, and excess are opposed to production, value, and an exploitative accumulation of power (here Baudrillard posits a continuity between bourgeois political economy's investment in the rational, self-interested, utilizing, or laboring body and what he sees as Marx's fetishization of production; Baudrillard 1975, also 1981). Baudrillard's critique, both of Marx and of capitalism, is based on an even more radical utopia than unalienated labor: the primitivist fantasy of what he calls symbolic exchange. What he does not account for is the way in which such "excessive" forms might be harnessed, as I would argue they are in the ethos of the bazaar, to generate value via a libidinal economy of the sacred that is interconvertible with power and value in political economy.[31] With the *bhakti* movements affective investment in the divine is freed from the constraints of priestly regulation, in a movement I have compared to the "freeing" of labor from feudal ties in bourgeois Europe. However, just as those productive, laboring bodies are set to work by the expansive movement of European industrial capitalism, the affective engagement with the divine is appropriated to an expansive sacred-commercial economy of ritual obligation and the circulation of credit in the bazaar.

Here again, one of the clearest instances of the social harnessing of "fetishistic" desire is Pushtimarg, specifically in its advocation of *nirodh*, the sublimation or channeling of "worldly" desires that must be recognized as nothing but the desire for god. Pushtimarg's ritual culture and theology of intense love for the divine have come to reflect a certain *rapprochement* with materiality and the senses, as distinct from the more ascetic and renunciative forms of *bhakti*. Consistent with the perpetuation of a (re)productive, business-

oriented socius, Pushtimarg does not favor giving up property, wealth, and family: one of its distinctive features has been a repugnance toward both asceticism and Vedic sacrifices, while the veneration of ancestors is an important part of Pushtimarg practice.[32] Vallabha has theorized a reconciliation with materiality as a manifestation of the divine, such that the socius—and with it the bazaar—becomes the object of preservation, not rejection. The position here is one of playing along, as it were, with Vishnu's game (*lila*), and preparing oneself, through uninterrupted love and devotion, for selection by the divine (Krishna) as worthy to behold him as revealed in his true, ultimate, transcendent state. Here the enjoyment of god's sensual attributes encourages the channeling of desires toward the divine, for the ascetic repression of desire is seen as counterproductive. As one English-language pamphlet on Pushtimarg being sold at the Shrinathji temple bookshop in 1995 put it:

> The desires may be compared with Hydra's heads, which will not be destroyed, even if they are cut. Frudians [*sic*] are also inclined to this view. By killing desires they are not killed but will rise again from their ashes. . . . So Vallabhacharya has advocated his theory of Nirodha, which teaches how to sublimate desires without suppressing them. . . . Change their focus only and the same desires, instead of being hostile will be friendly to you. . . . It prevents the mind from being attached to worldly objects and directs it towards God. It is a simultaneous process like tide and ebb. (Shah 1978, 131)

Instead of material renunciation, what is needed is mental discipline, *nirodha*, which sees property and wealth as transient, belonging if anything to god, and all desire as the desire for god.[33] Hence the extraordinary sensuality of Pushtimarg ritual, with its emphasis on painting, music, fine food, and rich textiles, all subtly attuned to the seasons and times of day, or the insistence on calling Krishna's abode at Nathdwara a *haveli* (palace or mansion) rather than a *mandir* (temple), and his Brahmin guardians, the *gosains*, *maharaj* (king) rather than *pandit* (priest, learned one).[34] The Shrinathji image in Nathdwara and the other Pushtimarg idols (*svarupa*) are seen as living embodiments of the god Krishna, and their worship—or rather their service (*seva*)—is one of the most important ways in which a devotee can attract the *pushti* (grace of the Lord). The temple rituals of Shrinathji include eight daily *darshan*s (public viewings); for these the image is specially dressed, ornamented, perfumed, and "fed" in accordance with the time of day and the season (fig. 116). Other forms of *seva* of the icon include musical performances and poetry recita-

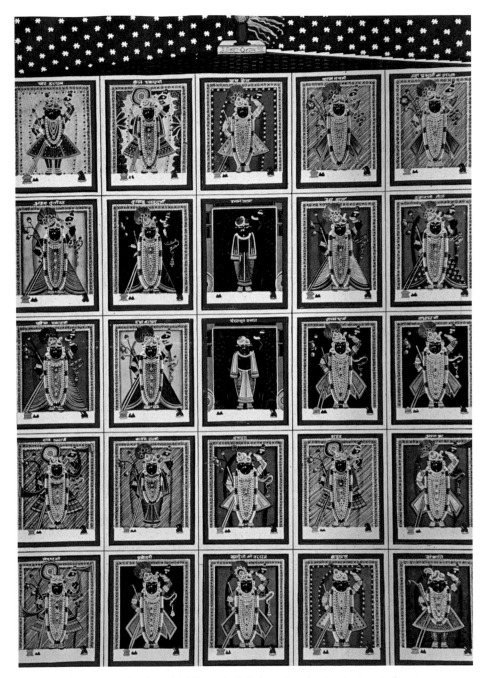

116. *25 Darshan*, a souvenir print sold at the main Nathdwara temple, showing twenty-five views or forms of Shrinathji, 1995.

tions, as well as thoughtful gestures such as leaving clothes and jewelry out in case Radha joins Shrinathji for the night, or ensuring that there are no obstacles in Shrinathji's path should he decide to visit Braj and play with the *gopis* (Ambalal 1987, 21–25).

The "problem" with fetishism for psychoanalysis is the short-circuiting of desire via the substitution of a part for the whole. This structure is preempted in Bhagwat *bhakti*, where the notion of manifestation or incarnation (a part) is coupled with an abject *jouissance* in the state of separation (*viraha*) from the divine (the [un]attainable whole). Worldly separation from the divine is posited as an originary lack, and the image as an inadequate representation of the deity recalls and recreates this separation. At the same time, as a material manifestation of the deity within the frame of ritual, the image holds out the promise of making good this lack. The conception of all the things of the world as part of the divine substance means that desire for the image is acceptable, as it does not detract from the ultimate religious goal (the "substitution" fear of iconoclastic religions; see Halbertal and Margalit 1992): this would be absurd, a case of the deity competing with itself, the part with the whole. And yet, the quantitative difference between manifestations of the divine, and their inadequacy to the whole, means that the image remains an inadequate object of desire—which, according to the "laws of lack" (Deleuze and Guattari 1987, 154) is the only sort there is. This *bhakti* has all its bases covered; by simultaneously acting as a ritually repetitive hook for desire and an inadequate object of desire, the devotional image conforms to the very definition of desire, becoming the object of desire par excellence.

So, for instance, one devotee, married into a Marwari family, rhapsodized to me about how the Shrinathji icon at Nathdwara "did something" to her, giving her goose bumps (*raungte*) in a kind of quickening all over the surface of her body; as she spoke she gave a little shudder. In contrast to this sensualized libidinal involvement with the icon, the post-Enlightenment aesthetic's "taste of reflection" is predicated on an autonomous subject that has self-critically distanced itself from its sensory passions, desires, and affects, even as sensual apprehension is acknowledged as their basis.[35] As we have seen, the frontal address of the bazaar image to a performatively engaged subject consigns it to the "taste of sense," and the "low" or "popular" pole of social distinction. Inasmuch as the "taste of sense" in the bourgeois ethos has strayed from the realm of the aesthetic it also has a morally suspect dimension, aligned as it is with sentiment, greed, excess, abandon, and indeed corporeality itself. Thus the film theorist Linda Williams has used the term "body genres" as a rubric for horror, melodrama, and pornography, whose depictions of ecstatic

117. *Ganesh Linga Puja*, a calendar by V. V. Sapar. (Courtesy of the artist)

bodies solicit uncontrolled bodily responses from the audience, provoking aesthetico-moral condemnation for their supposedly contagious mimetic effects (Williams 1991, 2–13). I would suggest that this schema could be extended to include advertising, with its frontal spectacle of ecstatic bodies of consumption, and "kitsch" iconic genres that both depict and address the ecstatic devotional body (see fig. 117).

Within the ethos of the bazaar, images are deployed in their capacity as objects of exchange, and bodily engagements with the image constitute an integral part of the intended "viewing" situation. Not only does the framework of *bhakti* informing bazaar images have little moral problem with the devotional "body genre," I would suggest that the very distinction between ocular reflection and corporeal performance has little salience here. For the gaze here is conceived not as a means of distanced contemplation, but as a fluid medium of desire that enables corporeal engagement and exchange. Through the simple acts that characterize the kind of demotic ritual made possible by bazaar images—joining one's hands in prayer, lighting incense, anointing with a *tilak*, garlanding with flowers—the image is consecrated and becomes an embodiment of the divine, with the gaze becoming a means of incorporating divine substance. Lawrence Babb describes a fluid "current of sight" (*drishti ki dhar*), which courses between the devotee and the guru in the Radhasoami sect's discourse of visuality: this current exerts a pull on

the devotee's "inner sight" while leaving particles of itself behind (Babb 1981, 391). Or, in a passage from the Kularnava Tantra, quoted by Ramnarayan Vyas in a treatise on the Bhagwat *bhakti* cults (Vyas 1977, 11–12), the image is "milked" by the devotee: "Just as the milk residing in the limbs of a cow comes out from the nipples of the cow, in the same way the all-pervading God appears through images. It becomes possible because of the unwavering faith, sincere meditation, and liking of the meditator."

At times there is an attempt to incorporate the power embodied in the image by means other than the gaze, as in the case of the Nathdwara painter who ingested a printed picture of the goddess of smallpox in an attempt to cure himself of the disease (Maduro 1976, 63), or Ruhani popular medicine in which sacred diagrams, drawn in ink, are dipped into water that is then drunk. And in the case of living embodiments or images of the divine (such as cult leaders and gurus), not only *darshan* but also listening to holy discourse is described as an internalization of fluid *amrit* or nectar (here again see Babb 1986 on the Radhasoamis). In the theological formulations I have considered here, devotional desire is also characterized as a fluid: for instance, Ramanuja describes the uninterrupted devotion required in order to attain god in terms of an unimpeded flow of oil (Chattopadhyaya 1964, 71). To this extent the image of *bhakti* can be thought of not so much in terms of the solidity of the idols of stone and wood that lump the "fetish" so clearly into the material realm, but as a permeable receptacle for fluid media, where the gaze is akin to water, fire, smoke, blood, wine, semen, cow's urine, milk, or, of course, money ("currency") as a vehicle for the transmission of powerful essences. As both signs to be interpreted and media to be physically encountered and incorporated (that is, in some way made one with the body), in a ritual context these fluids physically render transcendental, divine agency immanent to the social field, and vice versa. Permeated by these substances, the devotional subject is strung into networks of intersubjectivity, trans-subjectivity, and abjection.

Another ritual fluid that permeates this devotional subject is time. Earlier I mentioned the importance of rhythmic ritual observance to the system of credit and social obligation in the bazaar; there is also a libidinal aspect to the repetition inherent in ritual, with its cycles of intensification and deintensification. Like the Nathdwara temple's eight daily *jhanki*s, these libidinal pulsions constitute an endlessly repeated foretaste or promise of a permanent state of *darshan* (Bhagwat *bhakti*'s characterization of divine bliss), reawakening the desire for transcendence and liberation from the cycle of rebirth even as they inscribe the devotee as a member of the worshipping community in particular and

the socius in general. While some images are kept in a constant state of empowerment through regular worship and ritual management, others undergo intense, spectacular public investments for a delimited period, typically in an annual cycle. Examples of the latter include the actors in the Ramlila of Ramnagar who are treated as gods over the period of the performance, or the images in community-based shrines that are set up for the duration of particular festivals such as Durga or Ganapati Puja and are then taken out in great processions leading to the immersion of the icon in a body of water. The intensity (conceptualized as heat, energy, or power) generated in the course of the festival is channeled back to the great reservoir of lack: the more intense the outpouring of devotion on these occasions (often accompanied by states of trance), the more delimited their duration and the greater the imperative that they be given proper closure. And yet as public spectacles they are particularly susceptible to auratic contagions: to value switching tracks from the sacred to the political and commercial realms, or from one centralized sign formation to others.[36] The Ganapati festival in Maharashtra, for instance, has been a means of orchestrating and intensifying Hindu nationalism from the anti-colonial Tilak to the post-liberalization Shiv Sena (see Kaur, 2000), while sponsorship of Calcutta's Durga Puja has leapfrogged from neighborhood and community associations to corporations and advertising firms. This is no carnivalesque inversion of the status quo but the reinterpellation of devotional subjects by a libidinal economy that harnesses them back to a nexus between the sacred, political power, and commerce. At the same time, to the extent that they are caught in and driven by the cyclic pulsions of ritual temporality and fetishistic desire, these devotional, political, and consuming subjects are not quite the good bourgeois subjects of "history."

TRANSGRESSIVE INTIMACIES

The role of fluids in notions of ritual pollution and purification has been central to anthropological descriptions of South Asian society, particularly those of the Chicago school from the late 1960s to the mid-1980s. This literature abounds with descriptions of transactional "flows" of "biomoral" "substance-code" in every aspect of "Indian culture," where such processes are seen as a particular characteristic of "Hindu" life (see in particular Marriot 1976). This transactional and transformational approach has been invaluable in destabilizing the boundaries between the material and the ideal and between the hierarchical categories of caste. However, it has tended to locate this permeability in an essentialized, ahistorical, usually rural, Hindu/Indian/South Asian (the terms tend

to be collapsed), "dividual" subjectivity, whose flows of substance-code are, ironically (or perhaps appropriately, given that this is primarily Western scholarship), placed in binary opposition to the Western individual's dualistic rationality. But given the substantial history of exchanges between "India" and "the West," is such a stark opposition really tenable? Even if one were for a moment to accept the terms of this distinction, what about the possibility that the permeable Indian "dividual" might have to deal with permeation by Western codes and substances, or that the dualistic Western "individual" might be integrally constituted through a binary opposition to its others?

There are two concluding points I want to make in this context. First, I want to re-invoke the publisher with whom I began this chapter, and his foot, whose corporeal devotionalism suddenly kicked in on the eve of Diwali. If this foray into sacred and libidinal economy has somewhat better equipped us to specify the terms of negotiation between the universalizing self-representations of the bourgeois public sphere and the ethos of a bazaar historically imbricated with the sacred economy of Bhagwat *bhakti*, we need to remember that *both* of these systems are embedded in the postcolonial arena in which calendar art circulates. Subjects, like images, are able to move in and out of these economies and ethical frames, depending on contingent constellations of moving images, animated bodies, and the cycles and vectors of time. I have sketched a comparison here between the location of value as it pertains to images in two broadly delineated, ideal-typical forms of commercial ethos. However, while each arose in the context of specific hegemonic struggles at particular moments, colonialism in particular has meant that very soon neither of them could be completely contained within either a geographically or temporally specifiable site. In previous chapters we have seen how the colonial and postcolonial articulations between these moral-commercial cultures have varied, in different registers, from incorporation to disjuncture. In the context of post-independence calendar art, then, I want to emphasize that the negotiations between them are conducted not between hermetically sealed entities designated as "Indian" and "Western," but across or within (in)dividual subjects, like the Delhi publisher steering (and being steered) between contemporary, local modes of cosmopolitanism and vernacularity.

Second, I want to go one further and argue that the ethical systems I have described have always been more interdependent, if not mutually constitutive, than their differences might suggest — indeed, that their differences have been crucial to their coexistence. Here I would reinvoke the history of the fetish, particularly its multivalent role in bourgeois self-understanding from the late eighteenth century onward, which makes

it clear that liberal political economy and bourgeois morality are fundamentally predicated on an intimate working relationship with their others. Yet at the same time, as the index of a blind spot and a site of denigration, the fetish also reminds us that this intimacy with the other does not necessarily imply mutual recognition or regard, nor does it countervail inequalities in the relationship.

What brings these moral-commercial economies together, weaving the matrix of their coexistence, is the nomadism or circulation of objects, which links the expansive movement of capital with similar movements in other economies, such as the expansive economy of devotional affect or *bhakti*. William Pietz has described how seventeenth- and eighteenth-century European merchants and slave traders found themselves sealing contracts by swearing to African fetishes or some counterpart thereof (the Bible, for instance, but also a "potion" made from English beer), despite their discomfort with this overvaluing of what to them were trivial material objects (Pietz 1987, 43–44). With the illustrated "tickets," packaging labels, advertisements, and calendars depicting Puranic scenes and Hindu deities issued by British firms in the late nineteenth and early twentieth centuries (discussed in chapter 3; see figs. 55, 56, 59) we have seen how Protestant manufacturers did not merely compromise with a schema of value and image efficacy that was radically different from their own but were also instrumental in extending it into the arena of trade. In doing so they fundamentally configured the visual culture of "Indian" commerce as it, in turn, became enmeshed with nationalism. Here images and commodities as circulating objects rendered the putatively sovereign bourgeois subject heterogeneous and the permeable subject of the bazaar identitarian, stringing each into the other's economies. As the common elements between different constellations of value and signification, circulating objects draw these constellations into a relationship of exchange where it becomes possible for value to switch tracks, to jump from one economy to another, enmeshing their subjects in each other's networks. This relationship does not necessarily entail mutual translatability or the overcoming of difference: on the contrary, it works *with* and *on* difference, exploiting, perpetuating, and codifying it.

As I have argued, neither of the different schemas of value described above has an exclusive or privileged relationship to capitalism as such; indeed, I speculated that it might be the sheer strength of an ethos rather than its other features that provides the "internal" conditions for the consolidation of a capitalist economy. At the same time, however, it is the encounter with difference that has enabled both capital and the devotional economy to expand their frontiers. Modernity at its colonial interface perpetuated and benefited

from local modes of exploitation such as the bazaar economy's informal credit systems; at the same time, "Hindu" or Vaishnava devotionalism was being reinvigorated by image-making techniques appropriated from a "post-sacred" ethos. These genealogies of moral-ethical value and interfaces of exchange from the precolonial to the post-independence periods are now intricately crosshatched into the conduct of both commerce and the sacred in post-liberalization India. Players in these arenas, both formal and informal, have at their disposal an arsenal of moral-commercial codes and techniques of the image that they can mix and match to their best advantage. The next two chapters look in more detail at these processes of imbrication of moral economies and their image cultures in calendar art and the culture industries in the post-independence political arena. So far I have analyzed how the modernity of the sacred has posed a challenge to post-Enlightenment aesthetics and bourgeois moral economy. In this chapter I sketched an outline, albeit speculative, of the sacred, libidinal, and political economies that inform the field of calendar art. I now attend to the ways in which the efficacy of mass-produced images draws on their ability to sacralize—and libidinalize—the signs and forms of modernity.

PART 3 EFFICACY

<div align="center">

6

THE EFFICACIOUS IMAGE AND
THE SACRALIZATION OF MODERNITY

</div>

<div align="center">

DELIBERATE AND MALICIOUS ACTS INTENDED TO
OUTRAGE RELIGIOUS FEELINGS OF ANY CLASS BY INSULTING
ITS RELIGION OR RELIGIOUS BELIEFS.
Whoever, with deliberate and malicious intention of outraging the religious
feelings of any class of citizens of India, by words, either spoken or written,
or by signs or by visible representations or otherwise, insults or attempts
to insult the religion or the religious beliefs of that class, shall be punished
with imprisonment of either description for a term which may extend
to three years, or with fine, or with both.

INDIAN PENAL CODE 1860, SECTION 295-A

</div>

The artist S. M. Pandit (1916–91) has been widely celebrated in the Indian calendar industry for his "realistic" depiction of themes from Hindu mythology; almost all of the contemporary calendar artists I interviewed in various parts of the country cited him as a source of inspiration. Whether or not they are familiar with Pandit's name, many householders, particularly in Maharashtra (Pandit's studio was in Bombay), still recall his 1950s calendars for the Parle company, manufac-

118. "Krishna on the Battlefield at Kurukshetra," an oil painting by S. M. Pandit. (Courtesy of K. S. Pandit, S. M. Pandit Museum, Gulbarga)

turers of biscuits, soft drinks, and confectionery (a particular favorite was his depiction of Rama, Sita and the golden deer: see fig. 73). In an interview published in the Marathi-language *Maharashtra Times* in 1991, toward the end of his life, Pandit described a "strange experience" he had had when doing an oil painting of a scene from the Mahabharata: a huge (6 ft. by 8 ft.) canvas depicting the battlefield at Kurukshetra where the great war finally played itself out. Pandit characterized this painting as dominated by *vir rasa*, the "heroic" mood or sentiment as defined in "classical" Indian aesthetic theory.[1] Soon after he finished the painting, the Indian army stormed the Sikhs' Golden Temple in Amritsar. Code-named Operation Blue Star, the attack left six or seven hundred Sikh militants and eighty soldiers dead.[2] A few years later this painting was sold, and Pandit decided to paint another one, of a similar size, on the same theme (fig. 118). "The moment I put the last strokes to the picture, riots broke out in Bhiwandi. After these two tragic experiences I decided not to paint such pictures again. The second one was sold as well, and I started on a third, but I will not finish it. I'm afraid that if I finish this painting, riots and disturbances might break out somewhere" (*Maharashtra Times*, Marathi edition, 24 August 1991). (Bhiwandi is a satellite of Mumbai, which has a large Muslim population and a history of recurrent intercommunal clashes. Particularly horrific were the riots of May 1984, when the Hindu rightist Shiv Sena party went on a rampage of arson, shooting, stone throwing, and looting.[3])

THE MODERNITY OF THE SACRED;
THE SACREDNESS OF MODERNITY

What does Pandit's description of his "strange experience" tell us about his approach to the efficacy of images? For a start, this efficacy has to do with the way in which his painting mimetically reproduces a primordial scene of violence, the battle of the Mahabharata; this reproduction somehow calls forth further replications, or actualizations, of violence in the public realm. But Pandit's rationale in not finishing his painting is not quite the same as that of those who, for instance, seek to censor television violence on the basis that its viewers will either imitate it or become desensitized to the effects of violence and thereby more ready to use it. Even as the efficacy of Pandit's paintings depends on their mimetic resemblance to a scene of violence, it has nothing to do with the viewing of this representation by the subjects they affect (in Pandit's example, those involved in Blue Star or Bhiwandi). In Pandit's characterization of these paintings their power extends well beyond any immediate scene of viewing and emanates not so much from their effect on the viewer's senses or aesthetic sensibilities but from their very existence, or to be precise from something that happens at the moment of their completion. In short, then, there is a bit more going on here than meets the eye—or at any rate, the eye of the individual viewer-subject. Pandit's formulation of image efficacy cannot easily be mapped onto a model of "reception" that is primarily concerned with subjects and objects at sites of consumption (positioned in its turn against semiotic readings that privilege the site of production). There is no viewer or "end-user" here to convert the image into a polyvalent site of active meaning making. And yet, where else could its locus of efficacy reside?

Pandit's attribution of power to the image in its opacity as an object, practically impervious to the viewer, recalls the fetishism discussed in the previous chapter. Here again, Durkheim's conception of the sacred enables us to retain an anthropocentric view of this fetishistic power by locating it in the social, or more specifically in what I would want to call a "trans-subjective," realm: one where the subject's experience is constitutively caught up with that of others, as distinct from the "intersubjective" realm of processes occurring between or across bounded individual subjects (such as Kantian aesthetic judgment with its intersubjective validity). To follow Durkheim, via Michael Taussig, this trans-subjective arena is manifested in a society's sacred or magical icons, although the potency of these images and objects crucially depends on the social erasure of the social basis of their power (Durkheim 1965; Taussig 1993a). This formulation is pertinent to thinking not only about those domains designated as "religious," but also about collective

investments in forms engendered by the mass media, as well as about the sacral basis of nationalism and what Taussig calls the "magic of the state" (Taussig 1997, 1999). However, the post-Enlightenment pathologization of the fetish, twinned with the narrative of the death of the sacred and its succession by the aesthetic (as described in the previous two chapters), has meant that reception studies have tended to emphasize individual viewing subjects and sites of consumption at the expense of trans-subjective networks of circulation and exchange. Within these terms, in "properly" modern societies the trans-subjective valency of the sacred is rendered either as a psychic aberration on the part of individuals, that is as fetishism, or as an inadequate rationality on the part of a class, that is as "false consciousness." Meanwhile "improperly" modern societies whose moral, commercial, and libidinal economies continue to be imbricated with the sacred are relegated to a relativized realm of cultural otherness or anachronism.

But the modern Indian public sphere is riven by everyday tensions around issues of religiosity and the power of images that leave no scope for such spatial or temporal distancing. These tensions are indexed by the constant negotiation of the modernity of the sacred, both explicitly and implicitly, within the mass media themselves. For instance, in the interview I just cited Pandit himself says that this was a "strange" experience: he is evidently very aware of how this is coming across to his interviewer and to the Marathi-literate readers of the *Maharashtra Times*. The exchange immediately following his story is also revealing in the way it subtly enacts a strain between the secular, rationalist aspirations of the public sphere to which the *Maharashtra Times* addresses itself and the somewhat suspect forms of efficacy invoked by Pandit. Here the interviewer asks Pandit whether he believes in astrology and fortune-telling, framing Pandit's story within the realm of magic and superstition. Pandit replies that he is a follower of the goddess Kali, that he meditates and has *studied* astrology. In other words Pandit deftly recontextualizes astrology within a frame of devotional practice, meditation, and scholarship, or the "higher," abstract, philosophical (and to this extent Brahminical) end of religion: this legitimizing move is given a keener edge by his artisanal (hence "lower" caste) background. Pandit's description of his paintings as having an indirect, almost remote-control effect on public violence through their power as objects is framed by his interviewer in terms of a personal or "private" predilection for meditation, astrology, and tantric practices. However, as I have been arguing, there is a disjuncture between this narrative of the privatization or domestication of religion and the continued relevance of the sacred in the contemporary Indian public sphere. This means that Pandit's description

needs to be seen not just in the context of his "private" beliefs, but also in the context of his work for the calendar industry and that industry's formulation of the efficacy of the mass-produced image in its capacity as an object.

The previous chapter posited a broad continuity between precolonial, colonial, and post-independence scenarios in characterizing the axiomatic of an expansive devotional economy. I now focus more specifically on what I see as processes of mutual refashioning between the image cultures of a "vernacular" capitalism over the first half-century of Indian independence and a post-Enlightenment (and putatively post-sacred) version of modernity. Here and in the next chapter I investigate what happens when the sacral-commercial modes of engagement with images that I have been describing interface with what are seen as some of the classic features of modernity: industrial mass production and mass mediatization; the democratic quest for egalitarian social relations and non-hereditary, meritocratic forms of power; and the apprehension of time in terms of a "homogeneous, empty" simultaneity framed by the nation-space (Benjamin 1969, 261; Anderson 1991, 24). Each of these features has implications for the ways in which people apprehend and formulate their senses of community, subjectivity, and intersubjectivity: through constructions of collectivity engendered and relayed via the mass media, such as notions of the "mass" and the "public"; through the post-independence institutionalization of democratic nationalism with its inscription of citizen-subjects; and through the liberal-bourgeois distinctions between state and civil society, or between "public" and "private" spheres, that are presupposed by secular-modernist institutions and cultural forms. How do these formulations of subjectivity and intersubjectivity mesh (or not) with the modes of social exchange and hierarchy that I have been describing in relation to bazaar images, and the moral, libidinal, and political economies in which they circulate? I explore this question at two sites of the negotiation of modernity by images in the bazaar: the "public" domain of political power and the "private" realm of sexuality.

Several scholars, particularly those working on South Asia, have argued that the Habermasian characterization of the public sphere as a primarily secular forum for rational debate (Habermas 1974, 1989) does not hold in (post)colonial contexts, given that collective public activities such as religious festivals and processions also need to be recognized as political arenas where reason and devotional affect come together (see Freitag 1989, 1991a, 1991b; Masselos 1991). While these are valid heuristic critiques, these largely colonialism-centered accounts have tended to detract from an engagement with the ways in which introduced ideas, including post-Enlightenment conceptions of publicness, pri-

vacy, egalitarianism, and subjecthood (again, like notions of art and the aesthetic), have in fact entered circulation in postcolonial arenas only to undergo a process of vernacularization (as with realism, discussed in chapter 4). My attempt here is to trace some of these vernacularizing processes, arguing that while the features of modernity listed above inaugurate image regimes that challenge, transform, or coexist in tension with those of the bazaar, the reverse is also the case: the bazaar's sacral-commercial and libidinal image economies also reformulate and reappropriate the signs and structures of modernity. Just as the sacred is not timeless and essential but subject to reconfiguration, bourgeois modernity is neither simply accepted nor rejected, but, as I hope to show, comes to be sacralized and libidinalized in terms other than those associated with its post-Enlightenment European avatar.

In exploring these mutually transformative articulations I look at popular prints in relation to a wider image field encompassing cinema, television, painting, public statues, monuments, religious ritual, and pornography. The first part of this chapter traces how post-independence calendar art indexes the inequalities inscribed into post-independence formulations of the public, and in particular the forms of multi-tiered, hierarchical address adopted by the putatively secular, socialist, democratic nation-state and its subjects. Here I examine the visual idioms deployed in calendar prints of "leaders" and "babies" (as they are called in the industry), arguing that these two subgenres forge a nexus between the state and the bazaar by overlaying a modern developmentalist hierarchy onto a "feudal" formulation of transcendental state power.

I then shift the investigation of notions of publicness from the representational modes adopted by mass-produced images to discourses on image efficacy in the mass-mediated field. Elaborating on the trans-subjective conception of efficacy outlined above in relation to Pandit's painting, I discuss how the fetish quality of the image as object is brought into relay with the modern imaginary of a "mass" or "public" as implied by the mass address of the culture industries and, crucially, as discussed in the mass media. Central to this relay, I suggest, is a particular type of transitive or triangulated public discourse on the efficacy of images, which is predicated on viewers' awareness that others are seeing what they see. While this awareness characterizes mass-media viewership in general, the ways in which the gaze of others is imagined take socially and historically specific forms, as do ideas about the kinds of benevolent and malevolent effects images might provoke and how.

In the last section I explore some of the ways in which secular figures of modernity

in bazaar images and their visual intertexts take on a libidinal or sacral charge. Here my discussion of calendar prints is counterposed to an obscure archive of pornographic drawings, possibly also made by a calendar artist, that insistently feature signs of bourgeois modernity, including calendars, watches, and radios. The treatment of "aberrant" sexual practices in these drawings meant for limited private circulation enables a more nuanced understanding of the modalities of vision, desire, and efficacy at work in heteronormative, mass-produced, public bazaar images, in particular the association between pornography and frontality. Here again, I suggest that there is a sense in which privacy, like publicness (indeed, as its seamy underbelly) is vernacularized, or co-opted into the ethical regimes of the bazaar.

THE TRANSCENDENTAL SECULAR STATE

The crisis of secularism engendered by the resurgence of Hindu nationalism from the last decades of the twentieth century onward has been accompanied by a tendency to oppose Hindu nationalism to what is often called "Nehruvian secularism." In part this polarization stems from arguments linking more recent manifestations of Hindu nationalism to the economic liberalization of the late 1980s onward, with its emphasis on a cultural nationalism represented by the ideology of Hindutva as opposed to the more economy-based nationalism supported immediately before and after independence by the ideologies of Swadeshi and socialism. I do not want to take issue with the idea that the later forms of Hindu nationalism take on specific characteristics in articulation with the opening up of the economy to transnational processes and protocols; indeed, I make a similar argument in relation to bazaar images in the following chapter. At the same time, however, I also want to suggest that the "Nehruvian" state (which I take to mean the Congress-led state from 1947 to about 1977) cannot be seen as completely exempt from the genealogy of contemporary Hindu nationalism, despite Nehru's explicit defense of secular, socialist ideals.[4]

The "secular" regime that Nehru initiated did not rely solely on an English-educated elite; in addition, it relied on the state's hegemonic articulation with a powerful bloc of industrialists emerging from the more vernacular ambience of the bazaar, as well as with the peasantry and urban working classes that constitute the majority of the population. As we have seen, the Gandhian ideology of Swadeshi, with its inscription of the nation as an economic community, worked to co-opt bazaar industrialists and entrepreneurs (such as B. A. Oza, discussed in chapter 3) into the Congress-led nationalist movement,

despite Gandhi's explicit valorization of decentralized production in the style of cottage industries and Nehru's socialism. Rajat Kanta Ray describes how the potential ideological standoff between Nehru and the capitalists was consistently averted by Gandhi's ability to twin the economic argument for Swadeshi with an appeal to ethics, devotion, and morality: this appeal was understood and interpreted for his compatriots in the business community by Gandhi's fervent devotee, the Marwari industrialist Ghanshyamdas Birla (R. Ray 1979). In other words, Gandhi was able to work within the idiom of the bazaar, where moral, sacred, and commercial communities were inseparable, such that loyalty to the nation as an economic community also meant loyalty to a moral and ethical community, where the practice of capitalism included the performance of public devotion (to Gandhi and the nation) and charity (donation to the Swadeshi fund and other nationalist causes).

Gandhi's persuasive rhetoric, charismatic persona, and masterful use of symbolically loaded acts provided a powerful pre-independence site for laying the moral-ethical foundations for the post-independence state across a range of constituencies (see Amin 1984; Chatterjee 1986). Another site where the state has been able to draw on the bazaar's sources of legitimacy and authority, persisting after independence, has been the circulation of printed visual and textual materials emanating from (and, as I outlined in the previous chapter, enacting) the ethos of the bazaar. Specifically, the iconographic idioms used in bazaar images to visualize the nation-state and its representatives worked to give the power of the state a transcendental dimension, enabling it to share in a divine locus of agency. Through this constitution of the state as a form of transcendent agency within the ethical terms of the bazaar, the calendar industry reinforced the post-independence state's unwillingness or inability to constitute the majority of its citizens as willing, sovereign subjects, agents in producing the nation.[5] Instead, this state's transcendence implicated its subjects in a relation ranging from dependence to devotional abjection. This latter feature emerges more clearly from the mid-1960s onward, with the establishment of Sivakasi as a central hub of pan-national mass production based on offset printing and the continued expansion of the calendar industry's address to a much wider market than the earlier chromolithographs. It also coincides with the growing authoritarianism of the state under the regime of Indira Gandhi.

The nation has been sacralized in calendar art in several fairly explicit ways. From the late nineteenth century onward the cartographic shape of the nation has been harnessed to a series of symbols of powerful, sanctified maternal bodies that either contain and nur-

ture or destroy other bodies: woman as mother, *gau mata* (mother cow), demon-slaying mother goddess. Thus the various images of Bharat Mata (Mother India), which bring together the cartographic boundary and sometimes a suggestion of the Himalayas with a female figure, usually carry a flag and are often accompanied by a lion or tiger in the manner of the mother goddess (see Brosius 1997; Ramaswamy 2003). Elements of this imagery came to be associated with Indira Gandhi, particularly in the context of Bangladesh's 1971 war of independence (fig. 109; see Uberoi 1990, WS-45). The cow, which, as Christopher Pinney argues, came to be firmly aligned with the nation in the course of the pre-independence cow protection movement, also figures in post-independence calendars as a source of plenitude and the (Hindu) ground of national unity. An instance of the latter is the oft-repeated image where milk from its udders streams in four directions toward representatives of the Hindu, Muslim, Sikh, and Christian faiths (Pinney 1997a, 843–46).[6] In another set of instances from Pinney, it is not the imagery of the cow but the incorporative schema of the cow protection print *Chaurasi Devataon Wali Gaay* [Cow with eighty-four deities] that is echoed in an image of Gandhi and a map of India, each peopled with important nationalist figures in a manner similar to the cow (Pinney 1997a, 848). Similarly, a 1973 calendar in the Uberoi collection entitled *Bengal ki* [*sic*] *Anmol Moti* [The priceless pearl of Bengal] incorporates prominent figures from the religious and cultural life of Bengal into the face of the mother goddess Kali: Shiva inhabits the "third eye" on her forehead, the holy men Vivekananda and Ramakrishna look out from her huge circular eyes, the writer Rabindranath Tagore hangs on her protruding tongue, while four other male faces nestle between her neck and hair, their closed eyes and moustaches probably denoting martyred soldiers from the 1971 war (fig. 119). The maternalization and feminization of the ethical basis of the nation is echoed in Hindi film melodramas from the 1950s to the 1980s, where mothers and wives often figure as repositories of "traditional" or "Indian" morality and ethics or *dharma* in the face of the Western-style modernity in whose vector the male protagonists are caught. (For detailed discussions of representations of women in calendar art, see Uberoi 1990 and Guha-Thakurta 1991.)

However, the harnessing of symbols of the nation or region to transcendental sources of ethical legitimacy has not been confined to the signifying work of maternal, feminine, or otherwise holy bodies within the picture frame. As I have been arguing, the image takes on a performative significance within the ethos of the bazaar in its capacity as an object of ritual and exchange: accordingly, the pictorial frame itself also delineates a sanc-

119. *Bengal ki* [sic] *Anmol Moti* [Priceless pearls of Bengal], a 1973 calendar for Belgium Glass House, Ludhiana. (Collection of JPS and Patricia Uberoi, Delhi; also included in Fukuoka Asian Art Museum 2000)

tified space or body. Within this schema, the prominent political, religious, and cultural figures constituting the category of "leaders" soon came to be treated in bazaar images as privileged embodiments on a sliding scale of transcendental value (a feature of devotional visuality in the bazaar as outlined in the previous chapter). After some initial experimentation (see, for instance, the early *Way to Swaraj*, fig. 66), the presentation of these figures became more or less conventionalized within the formal terms of a visual economy of devotion where narrative realism gave way to frontal, iconographic depictions, allegorical renderings, and direct address to the viewer. Like deities, leaders came to be assigned well-defined iconographic traits: the rose, *sherwani* coat, and "Nehru" cap for Nehru; the round "Gandhi" spectacles, walking stick, moustache, loincloth, and loosely draped shawl for Gandhi; Tagore's beard; the white streak in Indira Gandhi's hair; M. G. Ramachandran's fur hat and sunglasses; and so on. Leaders are also often shown being blessed by some manifestation of divinity, engendering a kind of sacred contagion, as in

120. *Our Saviour*, print depicting Gandhi ascending to heaven. (Collection of Bari Kumar and Samantha Harrison)

the calendars from the 1970s that depict leaders in profile alongside steps leading up to a sacred figure such as Buddha or Krishna (shown more frontally in a blessing posture; see fig. 68). At the same time, the death of a leader is often rendered as an ascent to heaven (fig. 120). Elsewhere Gandhi is encased within a silhouette of the Buddha and flanked by Christ and Krishna (fig. 67). This compositional sacralization is often echoed in the way people commonly place prints of leaders alongside those of deities and deceased family members in their shrines and decorative arrangements. Another sacralizing strategy has been to show significant episodes from the narrative of a leader's life in smaller internal frames encircling the central, frontal figure in a visual treatment similar to the presentation of stories from the divine epics entitled *Ram Leela, Shiv Leela, Krishna Leela*, and so on (see figs. 121, 122, and 123). Here the multiple "frozen moments" of narrative realism are clearly subservient to the larger central icon, the carefully dated, historical, mortal parts to the transcendent, timeless whole.

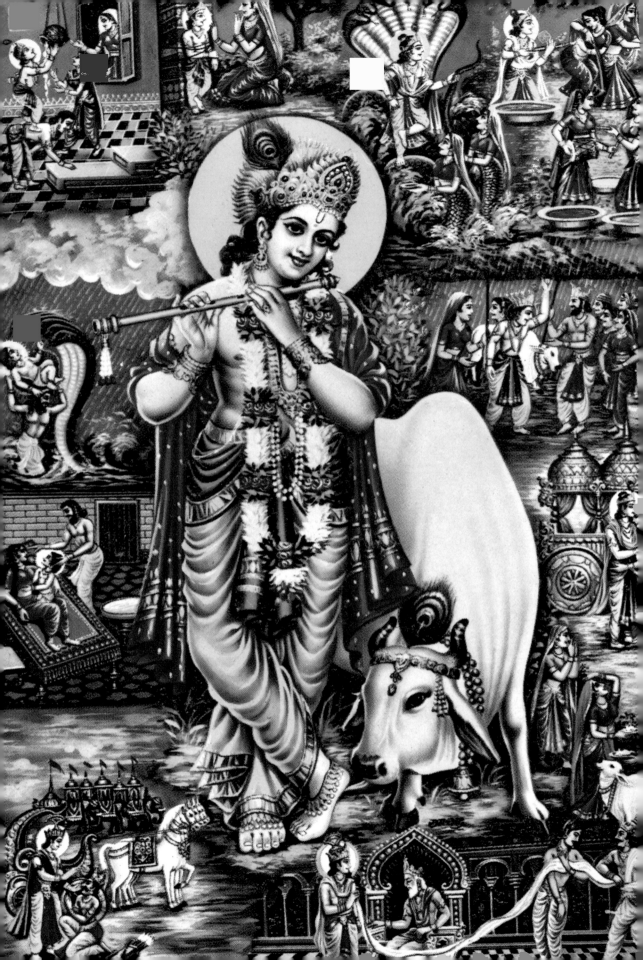

122. *Shrimati Indira Gandhi ki Jivani* [Mrs. Indira Gandhi's life story], a poster by N. L. Sharma, published by Jain Picture Publishers, Bombay and Delhi. (Collection of JPS and Patricia Uberoi, Delhi)

The precedence of frontal address is particularly clearly illustrated in a Sivakasi print entitled *God of Indian Children*, which explicitly inscribes the frontal image of a leader as belonging to a sacred economy. It depicts a child with hands folded in prayer before a framed picture of Nehru (fig. 124). The "representational dilemma" (G. Kapur 1989) here is whether to make the picture-within-a-picture of Nehru frontal to the worshipping child, in keeping with a realist mise-en-scène, or to us, the viewers outside the frame, in keeping with the devotional economy's performative demands on the image as object. There is also the question of the child's relation to us as against its relation to Nehru. The print makes a clear choice in solving these problems. The frontal relation of both child and Nehru to the viewer *outside* the frame is more important than a realist depiction of the frontal relation between the child and Nehru *within* the frame. The child is placed at a three-quarter angle, halfway between Nehru and us, and the perspective of the intra-diegetic picture is cleverly manipulated to situate its frame in a frontal relation to the

121. *Shri Krishna Leela*, artist unknown, published by S. S. Brijbasi and Sons, Delhi, on sale in the 1990s. (Courtesy of Brijbasi Art Press Ltd.)

123. "Ambedkar Leela" by K. P. Sivam, 1974 calendar for Indian Glass House, Ludhiana. The scroll at the bottom reads: "Dr. B. R. Ambedkar, M.A., Ph.D., D.Sc., L.L.D., D.Litt., L.L.B., Bar-at-Law. 1. One among the six intelligentsia of the world. 2. Genious [*sic*] and founder of the Indian Constitution. 3. Unique leader of the backward classes. 4. Labourers' leader who founded 8 hrs. Labour Act by the pen point." (Collection of JPS and Patricia Uberoi, Delhi)

child, while simultaneously maintaining the frontality of Nehru's face vis-à-vis us. Even as the child is not able to face Nehru directly, its (calendar "babies" are often ambivalently gendered) connection to Nehru is maintained by the metonymic rose between its hands, which visually occupies about the same spot as it would if it had been in Nehru's buttonhole.

The above instances demonstrate how the treatment of political leaders in bazaar prints deploys iconographic idioms and formal devices similar to those used in the treatment of deities, drawing them into a common devotional frame. However, I also want to suggest that in the latter part of the Congress era, as Indira Gandhi's increasing authoritarianism sought to shore up the party's political monopoly (culminating in the Emergency of 1975–77), the state's transcendental authority also came to be implicitly presupposed even in secular subjects. This is particularly evident in the "baby" calendars of the Sivakasi era from the early 1960s onward (a niche dominated by the Mumbai-based

GOD OF INDIAN CHILDREN

PICTURE PARADISE SOUTH CAR STREET, SIVAKASI

124. *God of Indian Children*, a print depicting a child worshipping Nehru, artist unknown, published by Picture Paradise, Sivakasi. (Collection of JPS and Patricia Uberoi, Delhi)

125. *Progressive India*, a calendar design by Studio S. V. Aras. (Courtesy of the artist)

"baby artist" S. V. Aras). These very healthy, very pink children are often shown happily playing at technological modernity: doctor and nurse babies playing with stethoscopes and needles; farmer babies driving tractors and holding sickles (fig. 84); soldier babies holding guns, planes, and battleships; engineer babies with spanners, screwdrivers, and clamps (fig. 125: this calendar is entitled *Progressive India*); photographer babies with a camera and a series of Indian views in the frames of a strip of film (fig. 126). In one, which I call "Mimetic Babies," a little girl with a Box Brownie camera stands with her forehead touching that of a friend in a mirrored pose; behind them are a clock, a tape recorder, and a television with a photographic baby on its screen. There are also religious and cultural babies, smiling and playing babies, sporting babies with footballs and cricket bats. These are all highly auspicious images (in keeping with the gift-giving aspect of calendars), based on the idea that we began with in the Pandit example, that what is represented will become real: in this case, that Indian babies are destined for a progressive, technologically functional future.

However, if calendar babies can be read as infantilized adults, I would contend that

बढ़िया ऑफसेट कलेन्डर एवं सुन्दर ताश (प्लेइंग कार्ड)
धर्म विज्ञापन तथा विवाह उपलक्ष्य में भेंट करने के लिए हमारे यहाँ पधारिये ।
प्रमुख विक्रेता उत्तरी भारत
ओरियन्ट लियो प्रेस व ओरियन्ट इन्डस्ट्रीज शिवकासी
मोती कलेन्डर कम्पनी (रजि॰)

126. "Photographer Baby," a 1969 calendar for the Moti Calendar Company, Nai Sarak, Delhi. (Collection of JPS and Patricia Uberoi, Delhi)

they do not simply hold out the promise of future participation in modernity but also *substitute* for the adult subjecthood made impossible by continued dependence on an iconic, maternal nation and an authoritarian, paternal state. Bazaar-style firms have typically been distinguished from "impersonal" managerial corporations by the ongoing centrality of the family, kinship, and filial inheritance. One way in which the "feudal," patriarchal, dynastic, and hierarchical forms of authority deployed in the bazaar articulate with modern, secular forms of state power is through a paternalist mode of address that uses tropes of development and progress to figure "the people" as underdeveloped and in need of (parental) guidance. The Sivakasi "baby" prints enact this articulation by figuring the perfect subject of the postcolonial state: both equipped with the accoutrements of modernity and progress and yet at the same time dependent on the authority of the state and its "leaders." State power here is based on a disciplinary, panoptic (rather than spectacular) but nevertheless transcendent mode of authority, for rather than being *incarnated*

in icons such as the quasi-sacred figures of Gandhi and Nehru, it is *presupposed* by the "baby" images, making its presence felt through the sense of an invisible, disembodied source of authority or agency.

Particularly pertinent here is the use of textual material within the frame, for literacy can in and of itself index participation in modernity (in this respect it both participates in and changes the "messianic" terms of the indexicality of texts in popular imagery as posited by Pinney 1997a, 851–52). This becomes apparent, for instance, in a 1974 calendar entitled *Satyam! Shivam! Sundaram!* (the ethico-aesthetic motto "Truth, Auspiciousness, Beauty") where a child is depicted reading a book, watched by a sulky-looking gorilla (fig. 127). The slogan in the child's book and on the blackboard reads: "Parho aur insaan bano" ("Study [or read] and become a human being"). A distinct evolutionary progression unfolds here, from the gorilla, through the child, to the disembodied voice of authority whose *mots d'ordre* ("order-words"; see Deleuze and Guattari 1987, 75–110) appear on the blackboard. There is an inherent paradox in this scene of viewing and reading, in that those who cannot read will not understand the textual order issued by the picture, while those who *can* read do not need it. The picture is aimed at an impossible viewer. We who can read the slogan come, through our literacy, to share in an authoritative gaze, our subjectivity profoundly implicated in its paternalistic authority and yet at the same time subject to it: a perfect Althusserian scenario of interpellation. Those who cannot read, write, or issue orders are, by implication, not yet *insaan*, not yet people. However, they do have a "choice": they can either identify with the gorilla and sulk on the margins of progress, or with the child and better themselves.

The disembodied voice in the picture can be read as that of the state at its nexus with the bazaar, and its addressee as the contradictory subject of a paternalist-yet-modern democratic state. This voice of authority is internalized and reproduced in the symbolic field of popular images, for as we saw in chapter 4, people within the calendar industry were quick to deploy categories of distinction based on "development," class, religiosity, literacy, urbanity, and so on to characterize the audience for calendar art as somehow inferior, even though they, too, were part of that audience.[7] This scenario of identification with the developmentalist discourse of state authority in order to shore up disidentification with the illiterate "masses" points to a crisis of equality at the heart of Indian democracy. Partha Chatterjee describes this crisis in terms of a distinction between the restricted, more privileged realm of "civil society" (in his specific, delimited sense of the term) and the broader arena of "political society" in the postcolonial Indian

127. *Satyam! Shivam! Sundaram!* [Truth! Auspiciousness! Beauty!], a 1974 calendar for Kisan Iron Stores, Hapud, U.P. (Collection of JPS and Patricia Uberoi, Delhi)

context (Chatterjee 1997).[8] One way to understand this distinction is to think about the two different connotations of the same English term, "public" in English-speaking and vernacular contexts. In a strictly English-speaking context "public," while connoting "audience" or "market," tends to refer to the Habermasian notion of a rational, secular, primarily bourgeois forum. When used in a vernacular context, however, it tends to stand in for a term such as the Hindi *janata*, connoting the masses or commoners as opposed to royalty. The democratic institutions of civil society exist for the public in its first sense, while the messy arena of "political society" is inhabited by the public in the second sense: those whose lack of cultural and social capital excludes or disqualifies them from participation in civil society.

In the discursive field of the *Satyam! Shivam! Sundaram!* image, only the educated have earned the right to be addressed by the state and to speak on its behalf: that is, to be human subjects of the state and partakers in its power. Similarly, in other calendar prints of the 1970s and 1980s, when the authoritative voice of the modern state (as opposed to the "traditional" nation, mostly figured through women) is given a body, or relayed through a human agent, that agent almost never appears as an anonymous adult citizen-subject. As we will see in the following chapter, adult bodies during this period, particularly male bodies, tend to be figured in a subservient, devotional relationship to the state, as in the images of farmers and soldiers illustrating the "Jai Jawan, Jai Kisan" theme.[9] The state's spokespersons, in contrast, appear as iconic leaders, often replete with microphones, or again, in an unusual instance, as yet another infantilized adult: another impossible citizen-subject of an unequal, stratified democracy (fig. 128). Here, in an S. S. Brijbasi print collected in the 1980s entitled *Garibi Hatao* [Remove poverty], the slogan of a 1971 election campaign that swept Indira Gandhi's Congress Party to power with a two-thirds majority, a painted child stands behind a railing high above a photomontaged audience stretching to the horizon. Tellingly, this composition echoes the iconography of worshipping audiences in the early print *Our Saviour*, representing the apotheosis of Gandhi (see fig. 120) and in *Ram Rajya Tilak*, a later framing picture published by Brijbasi but printed in Sivakasi (fig. 129). As with the benevolent gaze of Nehru in *God of Indian Children* (see fig. 124), the child's animated address is directed toward us, the viewers of the print, while the intra-diegetic audience also faces us from behind the child's back. And as with the slogan in *Satyam! Shivam! Sundaram!* it is we who get to read the banner with the order "Garibi Hatao" displayed in Devanagari and Roman scripts. We as viewers are invited to identify with the adoring masses, but at the same time, to the extent that we can read the

128. *Garibi Hatao* [Remove poverty], a print published by S. S. Brijbasi, ca. 1980s. (Smith Poster Archive, Special Collections Research Center, Syracuse University Library; courtesy of Brijbasi Art Press Ltd.)

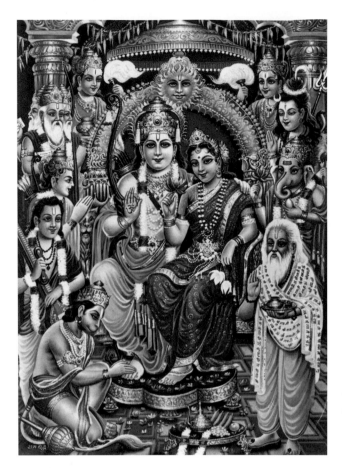

129. *Ram Rajya Tilak* [Ram's coronation] by Ramchandra, 1990s, published by S. S. Brijbasi, Delhi. (Courtesy of Brijbasi Art Press Ltd.)

slogan, to distance ourselves from them and identify with the infantile citizenship and subjecthood made available for us within the terms of a transcendent and patriarchal yet democratic state. Again, the figure of the child as both inheritor and agent of a modern, "developed" future free of poverty—here uncannily prescient of the entry into politics of Indira Gandhi's technologically savvy sons Sanjay and Rajiv—overlays the progress narrative of literate modernity onto the moral-ethical salience of filiation and kinship so crucial to the bazaar (see fig. 130).

MASS MEDIATION, IMAGINED PUBLICS, AND THE TRIANGULATED GAZE

The representation of the mass audience in the *Garibi Hatao* print indexes a recognition of this constituency within the symbolic schema of the bazaar, even as it does not figure as the child-speaker's primary "public" (that privilege is reserved for the literate viewers of

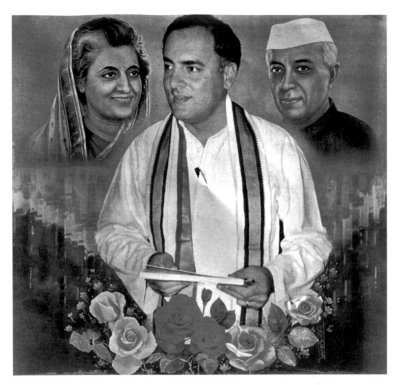

130. *Royal Family*, a calendar depicting members of the Nehru dynasty (Jawaharlal Nehru, Indira Gandhi, and Rajiv Gandhi) published by Ideal Products, 1991.

the print, both mirroring and distanced from the audience to which the speaker presents his or her back). As we have seen, one way in which the mass audience is incorporated into the bazaar's iconographic idioms is through a compositional arrangement similar to depictions of worshippers grouped around a central iconic figure, although such representations of the audience in secular contexts are relatively unusual. This formal device works to position the "masses" as devotional subjects in relation to the state and its representatives. However, I want to suggest that there is also another way in which ideas of the "masses" and/or the "public" engendered by technologies of mass reproduction and a democratic polity have been recuperated into the iconic image field of the bazaar, not so much through the images themselves, but through the structure of discourses about image efficacy. Here the "masses" are not taken for granted as devotionally subservient to divine or transcendental agency, but are positioned as key players in operationalizing the efficacy of images, in their capacity as consumers and as political beings — though again not as the rational subjects of a bourgeois public sphere. This positioning of the

"masses" as simultaneously subservient and powerful is consistent with the simultaneous disavowals, denigrations, and recognitions in the discourse of calendar artists and publishers about their "public" in the vernacular sense of the term (discussed in chapter 4). And, as I hope to show, the characterization of this constituency also speaks to the idea of a trans-subjective realm of circulation where the locus of efficacy of images exceeds the individual viewer, as in Pandit's example of the violence unleashed by his Mahabharat image.

Benedict Anderson's "print-capitalism" thesis addresses one aspect of multiple viewership, linking the apprehension of simultaneity to the sense of "imagined community" central to modern nationalism (Anderson 1991). However, as discussed in chapter 3, Anderson's "print-capitalism" is that of the newspaper and the novel, its secular rituals those of a literate public; he does not extend the implications of this simultaneity to the register of trans-subjective desire engendered by the public icon. Here a useful supplement to Anderson's account is Michael Warner's (1992) discussion of a public sphere where body images abound in the audiovisual mass media. Warner argues that iconic figures in the mass-cultural public sphere are situated at the intersection between politics and consumerist desire, taking on their own distinctive "logic of appeal" through the peculiar value embodied in publicity itself (as in the case of brand names). He illustrates this using the figure of Ronald Reagan, where after a point it is not Reagan's attributes that are important but the very fact of his popularity: what is at work is the popularity of popularity, a meta-popularity. Publicness generates a meta-popularity that imbues the iconic image with a kind of surplus value. There is a triangulation at work here, between the image, the viewer, and the viewer's sense of what *others* see, think, and feel. We might locate this surplus value in the triangular operation of what René Girard calls a mimetic desire, one that has no privileged object of its own but instead imitates another's desire (see Girard 1978, particularly chapter 3). So the desire for the icon as a locus of intensity is enhanced, even produced, by witnessing—or, crucially, even just imagining—the intensity and desire of others.

I want to suggest that a similar notion of a triangulated gaze informs a certain strand of discourse about the mass-mediated public gaze and the efficacy of images, deploying what Richard Davis has called the "aesthetics of presence," which has informed most practices of icon worship in South Asia since the medieval period (Davis 1997, 32–33). In Davis's account, this is the idea that the icon is a privileged housing or receptacle for the divine essence, an embodiment as much as a signifier or representation of the deity.[10]

Davis counterposes this "aesthetics of presence" to the "semiotic aesthetic" of medieval Christianity, where the image was emphatically seen as representational, that is, distinct from that which it depicted. Thus the argument used to enforce correctness in temple images is that if the image is iconographically or iconometrically inaccurate, ugly, or in some way inauspicious—that is, if it is an inadequate depiction of a deity—then that deity will not inhabit the image. This bears directly on conceptions of image efficacy, for both in the formally sanctioned ritual production of temple icons controlled by priests and in the context of the personalized rituals around bazaar images there is a strong sense that if an icon is not produced in accordance with iconographic prescriptions it will not "work" (that is, it will not accrue efficacy, value, and power)—or worse, it will have the opposite effect, becoming inauspicious and bringing bad fortune.

In an instance of the rhetoric of an "aesthetics of presence" in the calendar industry, one Sivakasi picture publisher told me that South Indians prefer seated images of Lakshmi, the goddess of wealth, while North Indians prefer images in which she is standing up. This was because "[in the] south they believe that if she sits down, wherever you keep the calendar, the god or goddess will stay in that place." This complicates the two-way trans-action between icon and devotee, triangulating it between the deity, the worshipper, and the iconic image as an object prior to its inhabitation. Before the deity gazes upon the worshipper through an icon it must first decide to inhabit that image. If Lakshmi sits in the image that depicts her sitting, it is her rather literal, indeed in a sense realist, reading of the image that enables it to embody what it portrays, for if she cannot recognize herself as represented in the image she will refuse to inhabit it. So in this formulation based on an aesthetics of presence, given the requisite elements of iconographic correctness it is the *deity's* (imagined) look of self-recognition that is seen as initially investing the image with efficacy, power, and value. To put a Durkheimian spin on this, the imagined gaze of the deity stands in for the repeated investment of ritual worship and devotional affect on the part of its worshippers. However, since this social production of the sacred cannot be publicly acknowledged, the deity's implied prior approval of the icon renders it always already pre-invested, already valuable. In other words, the icon's efficacy is that of the fetish: its value is seen as inherent rather than socially produced, even as (particularly in modern contexts of identity formation) icons come to represent specific configurations of community. In the example from Sivakasi, for instance, the printer is using this way of depicting Lakshmi to characterize "South Indian" as opposed to "North Indian" beliefs.

I want to reiterate, however, that in order for this formulation to work it is necessary

for the deity's gaze to be imputed with a certain literalism: a naïve realism that expects complete congruence between the image and what is represented. This imputation of literalism *on the part of another* is echoed in the printer's characterization of the southern market: notice that he says that in the south "they" have this belief about Lakshmi inhabiting an image that shows her as seated. But in both instances, that of the deity and of the southern consumer of calendars, there is every reason to cater to these imagined literalist desires, for the deity's displeasure in the image and refusal to inhabit it can have dire consequences for the devotee, just as the consumer's displeasure has adverse affects for the printer.

So although the calendar image is addressed to a viewing subject, most often a worshipper, its power and efficacy are primarily seen as deriving from the investment of a supra-personal or transcendental gaze, like that of a deity. Rather than instituting an individual viewing subject as the prime locus for the effect of the image, on the model of Cartesian perspectivalism (as with theories of the impact of television violence), here the image is presented to the viewer as always already valuable and powerful. This preexisting power stems from its mediation by an imagined prior act of transcendental seeing. My contention is that this formulation of image efficacy as located in the transcendental gaze of the sacred icon is echoed in the characterization of imagined publics in the modern discourse of efficacy engendered by mass mediation (I elaborate on this discourse below). I have just outlined how the imagined gaze of the deity stands in for multiple devotional engagements with the image in the trans-subjective realm of the sacred. Similarly, the sense invoked in the arena of mass reproduction that imagined others or an Other are looking at what one is seeing has generative effects over and above what happens to the individual viewer in isolation. In other words, the sense of "imagined community" is not simply engendered through multiple individual recognitions of commonality or simultaneity with others who consume similar mass-produced cultural goods. It is also mediated and intensified by a desire for iconic figures whose "meta-popularity" is actively maintained within economies of power and efficacy. In these economies the value generated by processes occurring in a trans-subjective domain is embodied in objects and images rather than in unitary producing subjects. Bazaar-style religiosity, closely imbricated with an ethical field where creditworthiness is a primary virtue (as described in the previous chapter), constitutes one such economy, while the advertising-based mass media in a consumerist marketplace, and the discourses they perpetuate about the efficacy of images, constitute another. Particularly salient here is the idea that images are

indeed efficacious, and the related notion that their efficacy depends on the literalist readings of imagined others. These are the basic premises of advertising, of the aesthetics of presence in a religious context, and of reputation ("name," "face") as an index of creditworthiness within the ethos of the bazaar.

These three economies come together in the use of images and rhetorics of image efficacy as political weapons whose power has been enhanced by mass-media technologies and the increased salience of consumerism. As we have seen (in chapters 2 and 3) the emergence of a vernacular arena of consumption and the concomitant circulation of mass-produced images were key to the orchestration of nationalist sentiments and identity formation during the independence movement and then again immediately after independence.[11] A similar articulation between politics, religion, and the mass media can be traced over the last decade of the 1990s, as the liberalization-led growth of media and advertising in India dovetailed with attempts by Hindu nationalist parties such as the Bharatiya Janata Party or BJP and the local Maharashtrian Shiv Sena to dominate the public sphere. To understand the form taken by this later articulation, however, it is important to recognize that apprehending simultaneity or imagining the gaze of others is not solely tied in with fostering commonality or solidarity; it can also become the ground for registering and negotiating difference or asserting power, often in violent ways. This is because meta-popularity, auspiciousness, and the aesthetics of presence have a malevolent underside: desecration, a site of violence common to many modern political arenas. (On the sacral power of desecration, particularly in "secular" societies, see Taussig 1999.) Presentation before the public gaze renders iconic images valuable and powerful, but by the same token it also renders them vulnerable to disinvestment. To the extent that an icon has been successfully harnessed as a symbol of a community its desecration is seen as violence against that community, demanding violent retribution. Central to the most well-publicized (that is, mass-mediated) instances of such violence has been the Shiv Sena, which asserted an increasing stranglehold over Mumbai through the 1980s and 1990s through intensive grassroots terror on the one hand and public spectacle on the other. The following brief examples illustrate how the Shiv Sena's discourse on the power of images and its uses of desecration and public protest in the 1990s worked to reinforce the links between communities and their icons and to actively create and maintain an economy of power, efficacy, and violence. They also demonstrate the imputation of an imagined public with a literalist gaze, homologous to that of Lakshmi in the printer's example.

In October 1996 Pramod Navalkar, Maharashtra's cultural affairs minister and a member of the Shiv Sena, filed a police case against M. F. Husain, a Muslim who is perhaps the most famous modernist artist in India. Under Section 295-A of the Indian Penal Code (see epigraph), Navalkar accused Husain of "provoking religious sentiments" with his "obscene" (that is, nude) depictions of the Hindu goddess Saraswati and the Mahabharata's heroine Draupadi—works done some ten years earlier. The Indian Penal Code itself formulates such offenses in a trans-subjective manner: the feelings "outraged" here are those of a "class," not an individual, so Navalkar could not just say that *he* was offended by these images; rather, he had to implicitly invoke the "public" as the vulnerable bearer of religious sentiments. (It was just as well, since apparently Navalkar had not actually seen the pictures at issue.) Two days later the Hindu nationalist paramilitary outfit the Bajrang Dal ransacked a gallery and burned Husain's paintings. The ensuing media debates commonly decried the violence against Husain while also condemning his offense against religion (see Juneja 1997). But would the paintings have caused outrage if Navalkar had not presented their "offensiveness" to the public in the first place? In this case, publicly voicing a protest in the name of the public did not simply register an act of desecration but actively constructed it and with it the possibility of retaliatory violence. Similarly, in December 1998 the Shiv Sena vandalized Mumbai cinemas that were screening Deepa Mehta's film *Fire*, objecting to its depiction of lesbianism in a Hindu family. In a provocation disguised as a counteroffensive, the Shiv Sena's unofficial leader, Bal Thackeray, declared that lesbianism does not exist in Hindu families, so *Fire*'s protagonists should have been given Muslim names, not those of the revered Sita and Radha.

The group's outrage against "provocations" to religious sentiments, however spin-doctored or retroactive, has not meant that the Shiv Sena refuses their logic. On the contrary, they perpetuate this logic, to their own ends. For instance, in July 1997, following a speech in the Maharashtra State Parliament by the minister Chhagan Bhujbal, who accused the Shiv Sena and the BJP of demolishing Dalit ("lower" caste) settlements in Mumbai, a statue of the Dalit leader B. R. Ambedkar was found "garlanded" with a string of shoes. This symbolism was particularly offensive given the designation of shoe-making as a "low" caste occupation. In the ensuing protests, ten people were killed and twenty-seven were injured by the State Reserve Police; a week later another Ambedkar statue was similarly desecrated in the Maharashtrian town of Nasik. The ground for violent gestures such as these has been laid by a more general attempt on the part of the

Shiv Sena, flowing on to the wider discourse on images, to reinforce the idea of icons as embodiments of the sacred and/or of community. Thus, as I mentioned in the previous chapter, the one instance that Sivakasi firework manufacturers could cite of public pressure to change their use of imagery was when a depiction of the goddess Lakshmi appeared on a firework: apparently the protest was initiated by the Shiv Sena, which objected to the image being blown apart. (This reasoning was echoed by the Mumbai-based manufacturers of Babuline Gripe Water when explaining why they used an image of Krishna on their advertising but not on their packaging, which would be thrown away.)

It is no coincidence that the Shiv Sena has been so adept in its uses and readings of imagery: its leader, Bal Thackeray, used to be a professional cartoonist. Pramod Navalkar claims to have written twenty novels about "under world adventure night life," and before becoming the minister of culture he is reported to have spent his evenings cruising Mumbai dressed up as Batman, "complete with flapping cape . . . 'busting' prostitutes, homosexuals and drunks" (Singh 1999).[12] But while the Shiv Sena's skirmishes with desecration have been the most well-publicized and systematically violent, it is important to recognize that the literalist discursive frame underpinning this violence has not been confined to the Hindu Right. Muslim groups protested against Mani Ratnam's 1995 film *Bombay* for dishonoring the Qur'an and the veil (in one scene the Muslim heroine throws off her veil to run toward her Hindu lover, while in another he wears a veil to be with her). Similarly, there were widespread protests from Indian and overseas Muslims over the depiction of a burning Qur'an in the 1997 Hindi film *Border*.

While these instances from the 1990s, as well as the terms of the Indian Penal Code (which was first enacted in 1860), place desecration in an explicitly religious frame, Nehruvian nationalism in the era of the Congress Party also instituted a secular equivalent in relation to images of the nation. This is exemplified by what filmmakers in particular recognize as the "proper light" syndrome, referring to the way in which certain images, especially documentaries and social-realist films that depict inauspicious themes such as India's poverty, are rejected, censored, or denigrated by representatives of the state because they "do not show India in a proper light."[13] A famous early example of this is the film star Nargis's public castigation of the director Satyajit Ray for his portrayal of rural poverty in the film *Pather Panchali*. Nargis, best known for her own iconic depiction of Indian womanhood in the 1957 film *Mother India*, mounted her critique of Ray in her capacity as a member of the Rajya Sabha (parliamentary upper house) who was affiliated with the Congress Party. Her fear as a nationalist was that Ray's films would confirm

the foreign perception that India was in an abject condition and could make no claims to modernity. Nargis expressed this anxiety at the loss of face—akin to defacement or desecration—in realist terms: she claimed that the films were not a realistic depiction either of India's poverty or of India's modernity and would lead foreign audiences to think that India had no schools, cars, or dams. (For a discussion of this debate in relation to realism, see Windsor 1998). Again, this anxiety returns us to the triangular structure of viewing that I have been alluding to: mediating between the viewer (Nargis) and the image (Ray's film) there is a third party standing in for the public (imagined in this instance as comprised of foreigners).

The discursive construction of this imagined third viewer as a place holder for the public gaze institutes the image as a pre-invested symbol of community or nation in the mass-mediated environment, just as the construction of an approving divine gaze preinvests the iconic image with power and value. And as with the goddess Lakshmi in the printer's example, this public gaze is constructed as peculiarly suggestible and vulnerable to misinformation. In all of the instances I have cited of an imagined public imaginary, the image embodies what it depicts with a literalism that no narrative context can counteract. It is no matter, therefore, that *Pather Panchali* could be seen as a nationalist film, that *Border* and *Bombay* were putatively pleas for communal harmony, or that Husain described his depiction of Saraswati as an attempt to reinterpret the goddess with "great respect and conviction" in "the modern language of painting."[14] The ostensible vulnerability of "the public" in this triangulated discourse of image efficacy constitutes the mass-cultural image as a medium of contagion, like air, water, or bodily fluids. For instance, while Bal Thackeray's critique of *Fire* is partly conducted in a realist register (in an echo of Nargis's critique of Ray), on the putative grounds that lesbianism cannot and does not exist in "the Hindu family," his claim that the film is "ushering in a wretched culture" also indexes the supplementary threat of contagion via the image. There is a similar excess at work in the rhetoric of the question Thackeray poses with respect to *Fire*: "Has lesbianism spread like an epidemic that it should be portrayed as a guideline to unhappy wives not to depend on their husbands?"[15] Here again there is a conflation between the logic of the epidemic or contagion, which does not necessarily occur through vision but through the mere presence of the image, and the logic of mimetic resemblance, or the following of visual "guidelines."

This excess points us to an oscillation between two formulations of the efficacy of the public image. On the one hand the image is seen as pre-invested, as inherently or imma-

nently powerful, its effects in the public arena emanating from its very presence like a contagion, or by remote control as with Pandit's Mahabharata painting. This formulation, I have suggested, is often mediated via the gazes of others or an Other in the public arena, even though this is not always explicitly acknowledged. On the other hand is the idea that the efficacy of an image stems from the effects of its work of representation on a viewing subject (albeit an uncritical subject who obediently follows "guidelines"). The doublespeak we have encountered on the part of the Shiv Sena and of Nargis attempts to reconcile the two, just as the aesthetics of presence speaks both to the image as a contagious object, an indexical embodiment of power, and to its mimetic visual resemblance to what it depicts. In this oscillating view of the image as a source of mimetic contagion, the imagined "public" is constituted not by critical, distanced, disinterested, willing subjects of rational debate or aesthetic judgment, but by subjects whose only choices are to be afflicted by the image as by a disease or a poison or to submit to its dictates with willing docility. Again, the moblike character of this vulnerable, yet threatening, imagined collectivity resonates with the vernacular Indian use of the English word "public." However, there is nothing specifically Indian about imputing a problematic subjectivity to the consuming masses of the culture industries. Publics everywhere have imagined mass media viewers in historically specific ways as the dystopic or dysfunctional others of particular modernities. If the mass-cultural other of industrial Europe was feminine "nature out of control" (Huyssen 1986) or the automaton, in the postindustrial United States it has been the disturbed individual or the child. In post-independence India, I would suggest, the subjects of media contagion have primarily been imagined as potential participants in communal riots: suddenly infected, poisoned, or inflamed into unreasoning violence.

If, as in the Pandit story with which I began, communal conflict is imagined as an effect of the violent image, it also figures centrally in public discourse as a potential—and remembered—scene of viewing. The form of violence discussed *in* the public sphere and the violence *of* the public sphere circle each other, inscribing the communal or caste riot as a key intertext for public visuality, if not its degree zero. This anxious discursive figuration of communal violence is directly proportional to—indeed, in the Foucauldian sense, produced by—official state taboos warning against its representation, such as section 295-A of the Indian Penal Code, or "guideline" xiii of the Indian Censor Board, proscribing "visuals or words which promote communal, obscurantist, anti-scientific and anti-national attitudes."[16] These taboos do not simply index the state's paternalistic secular modernism. One of their productive effects is to keep the rhetoric of communal

violence in circulation, making it available to both the perpetrators of such violence and its victims. Thus in January 1988, in the early days of commercially sponsored television in India, a private citizen appealed to the Bombay High Court to stay the screening of *Tamas*, a powerful television drama about the horrific riots during the partition of India and Pakistan. The plaintiff was a Muslim businessman who feared that it would *"poison the minds of the people,"* leading to a repetition of the communal violence it portrayed (Mankekar 1999, 295).

Tempting as it is, I do not wish to make a profound psychoanalytic or poetic connection between the repressed memory of the traumatic violence at the birth of the nation and its return in the public discourse on the efficacy of images. Unfortunately, there is a much more literal connection to be made between the riot as a privileged scene of trans-subjective viewing and the forms adopted by both state and nonstate power before and after independence (the Indian Penal Code was first enacted in 1860 under British rule—indeed, soon after the "Sepoy Mutiny" of 1857). Recall here that the forms of violence "caused" by Pandit's Mahabharata image were state-sanctioned communal violence (Operation Blue Star) and the caste "riot" (in Bhiwandi). This conjuncture in his story implicitly reveals the public secret that the state was not just born of communal violence but has continued to feed off it: that it needs the "riot" as much as—indeed *to the very extent that*—it warns against it. Four months after Operation Blue Star, Prime Minister Indira Gandhi was assassinated; everyone recognized the ensuing anti-Sikh violence as "communal riots," but soon everyone also knew that the source of the "contagion" that spread through the "mobs" was Indira Gandhi's Congress Party itself. Similarly, the story of the Ambedkar statue would be familiar to Mumbai residents as just one of many uses of a favorite Shiv Sena weapon, the "communal disturbance."

In other words, then, I am suggesting that the discursive anxiety around the vulnerable, threatening, mimetic subject of the mob, in public and state imaginings of the public viewer, has its own productive—or rather destructive—effects. First, it keeps in circulation an idea of violence with no apparent origin other than an image or event that acts as a remote-control mimetic trigger or as a source of visual infection. Violence becomes a disease contracted through the image: there is no space here for a critical response or a refusal to play by the rules of this visual economy, only for equally violent prophylaxis (censorship) or revenge (public protest). Second, and crucially, it keeps in circulation the idea that the image is indeed efficacious, as the obverse of the auspicious image with its benign effects. While there is a culturally and historically specific dimension to the *style*

of violence imagined in relation to the mimetically vulnerable mass viewer, the *positing* of such a viewer in order to operationalize the efficacy of the image is not necessarily specific to South Asian societies where religion permeates the public sphere. It is also endemic to all mass-mediatized, capitalist democracies to the extent that they, too, trade in icons and public spectacles. It was instructive, for instance, to hear George W. Bush and Al Gore "debate" the media's effects on children in the run-up to the 2000 U.S. election: both took it as a given that the media have strong, immediate impacts on children's behavior. After all, presidential campaigns, not to mention the raison d'être of the media carrying those campaigns—advertising—are predicated on the idea that images have mimetic effects, that they are both contagious in their publicness and act as "guidelines" for the consuming citizen-subject.[17] This belief in mimetic contagion at the heart of mass-mediated politics and the orchestration of consumerism points us back toward a certain residue of the sacral and trans-subjective processes that are kept in play even in modern polities that represent themselves as secular, and to a continuing dialectic between the bourgeois-modern "public" and what it construes as the crucial but irrational constituency of the "masses." The aesthetics of presence, then, emerges not as a feature of an essential, timeless South Asian religiosity, but as a mode of engagement with images that articulates with modern consumerism and mass-mediated politics to take on new, often pernicious, forms.

PRIVACY AS PORNOGRAPHY

So far I have described how the continuing political and commercial valency of a trans-subjective arena and sacral or feudal forms of power in the realm of mass-cultural images has posed a problem for the realization of the category of the "public" in its bourgeois-modern avatar. I now want to make a similar claim for the (non)institution of another key domain of bourgeois subjectivity: the private. Extending to calendar art Madhava Prasad's analysis of the status of private, autonomous coupledom in the post-independence Hindi cinema up until the late 1980s (Prasad 1993), I want to suggest that in actualizing the nexus between the bazaar and the state, bazaar images have also recuperated the post-Enlightenment distinction between public and private to the moral-libidinal codes of the bazaar by resisting the celebration of the private domain of the nuclear family and in particular of the secular conjugal couple. Indeed, on the contrary, there is evidence that this domain is identified as that of a certain perversion, much like the fetish in bourgeois moral economy.

At stake here is the possibility of distinguishing between the moral-libidinal codes of different kinds of patriarchalisms: distinctions that have largely been overlooked in feminist analyses of calendar art. Particularly in relation to images of women the focus of analysis has tended to be the "tropizing" or "iconicization" of woman as a figure of idealized nationhood (Uberoi 1990; Guha Thakurta 1991) or her "objectification" and "commoditization" in association with "fetishized objects of lower-middle class desire," which draws calendar art into the same ambit as advertising and pornography (Uberoi 1999–2000, 26, 33). The primary basis for the critique of these images is their frontal address to a proprietorial, desiring male gaze and their concomitant representational elision of female subjectivity. Prasad's analysis, however, does not take on the terms of feminist critiques that implicitly valorize a post-Enlightenment formulation of subjecthood and agency. Instead, in examining the informal, self-imposed censorship of the kiss in the Hindi cinema, he attends to the moral and symbolic codes of the culture industry itself, which enforces its own distinctions between those images it deems worthy of public circulation and those it does not (although the images it proscribes might nevertheless circulate in other, more restricted or more informal arenas). Such "internal" distinctions hold for the calendar industry as they do for the Hindi cinema: my attempt here is to tease out what they might imply for understanding the modes of vision, desire, and efficacy at work in bazaar images.

Very briefly, Prasad's argument with respect to the cinematic kiss centers on its representation of the self-enclosed private space of the couple, and the corresponding "transgression of the scopic privilege that the patriarchal authority of the traditional family reserves for itself" (Prasad 1993, 78). By prohibiting the kiss's visual indexing of the autonomous conjugal couple, the "traditional" (joint) family and community shores up its feudal (or what Prasad terms "pre-capitalist") patriarchal authority as the ultimate overseer in a context where the space of privacy and autonomy does not and cannot exist.[18] I have described above how this overseeing patriarchal authority, characteristic of the ethos of the bazaar, articulates in several ways with what I am calling the transcendental gaze of the post-independence state: through its privileging of filiation and patriliny as modes of legitimation, its enforcement of a hierarchy within the constituency of the public, and its perpetuation of a trans-subjective domain of image efficacy. In Prasad's instance of the prohibition on the kiss, the post-independence articulation between new and "traditional" elites resists the inauguration of a modern familial model where the joint family dissolves into the families of its children, who are all equal inheritors, rather

than conferring patriarchal authority on the eldest son (here Prasad cites Hegel 1967). This nexus also resists the institution of a post-despotic state with its fraternal, rather than patriarchal, social-political contract. The reproduction of the nuclear couple and the narrative of transition from the traditional family were central preoccupations of Euro-american culture industries such as the "classical" Hollywood cinema, pulp romances, popular music, and magazine illustration or advertising. By contrast, Prasad argues, the post-independence Hindi cinema's playing out of the romance of the modern family is "formal" rather than "real," enabling a feudal form of patriarchalism to coexist with modern modes of authority rather than being dissolved or subsumed by them.[19]

Because it appears as a key element of the Hollywood cinema, there are those in the Indian public sphere who know what the cinematic kiss might look like, even though it is occluded from the gaze of a generalized Indian public (in the sense of *janata* or the masses). Here Prasad gestures toward a double standard within this category of the public, such that foreign films, which are seen as catering to a "higher stratum of society," have not been subject to the same restrictions as the Hindi cinema (Prasad 1993, 72). But what might the proscribed equivalent to the kiss be in the case of calendar art: what kinds of representation does the bazaar, like the film industry, deem unacceptable for "public" circulation (at a certain level)?

We have seen how inauspicious, iconographically inaccurate, or de-sacralizing images are rejected by calendar publishers; again, as with the cinema, the only context in which such images might circulate is the elite — and controversial — arena of "fine art." Erotically charged spectacularization, however, particularly of women, has been a staple of calendar art, rendered publicly acceptable through various legitimizing associations. One is the association with devotional affect, as in the highly sensualized depictions of Meerabai or Radha and Krishna (or Ram and Sita, Shiva and Parvati), but also of other devotional figures such as Ganesh (see fig. 117). Another is the use of women in representing "tradition" or "civilization," as in the voluptuous, scantily clad divine *apsara*s or nymphs and "classical" mythic characters by artists from Raja Ravi Varma to S. M. Pandit, Mulgaonkar, and Rangroop (fig. 131). A third is the association with other secular symbolizations of nationhood, such as J. P. Singhal's and Yogendra Rastogi's urban, rural, and "tribal" "beauties" (see fig. 91). These figures of "traditional" Indian womanhood have worked in the post-independence era to shore up the bazaar's ethical codes through their association with sacral entities including the nation. Meanwhile, other feminine figures coded "Western" or "modern" have also reinforced the bazaar's ethical codes through their

131. *Vishwamitra and Menaka* by S. M. Pandit, a 1987 calendar for Hico Products, Bombay. The nymph Menaka is sent by the gods to seduce the sage Vishwamitra; she is successful and has a child, Shakuntala, whose story was also a favorite subject for early calendar prints. (Smith Poster Archive, Special Collections Research Center, Syracuse University Library)

adverse association with foreign commodities and symbols of westernized modernity (alcohol, mechanized vehicles, electrical appliances, and other domestic consumer goods such as radios; fig. 132). The libidinal charge of these latter depictions derives in part from the *frisson* of simultaneous enjoyment (of the spectacle of woman's body) and moral condemnation (of woman, Western goods, or "Western" habits such as drinking alcohol) akin to that of "paranarrative" elements in film melodrama (Elsaesser 1987; Vasudevan 1989), such as the "vamp" character or cabaret scene in Hindi films of the 1970s and 1980s. So even as certain aspects of modernity or westernization are subject to moral disapproval, they are not necessarily occluded from the scopic field of calendar images. And indeed, not all associations with Western modernity are coded as morally evil: as I pointed out in the previous chapter, there is a sense in which certain signs of modernity are co-opted into the frontal idioms of auspiciousness, sacrality, and devotional desire. These include foreign landscapes and cityscapes; other signs of technological progress, as evidenced in the "baby" pictures as well as some of the "beauties"; or the reincorporation of clock time to a sacralized nationalism through the watches on the wrists of "leaders."

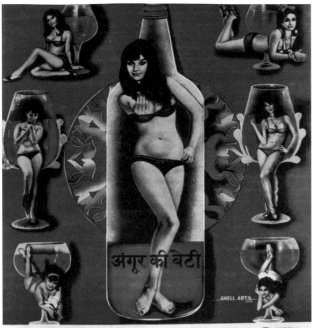

132. *Angoor ki Beti* (literally, "daughter of the grape") by Shell Arts, a 1981 calendar for the publishers Parkash Chand and Sons, Delhi. (Collection of JPS and Patricia Uberoi, Delhi; also included in Fukuoka Asian Art Museum 2000)

What makes eroticized depictions of women or couples acceptable for circulation in the bazaar is precisely what disqualifies them from feminist approval: their formal incorporation into a frontal compositional schema that interpellates viewers into a devotional engagement with the iconic image, and/or (following Prasad's analysis) into masterly identification with an overseeing patriarchal authority. While the frontality of religious icons invokes a devotional engagement (as described in the previous chapter), the frontality of the more secular subjects speaks to other aspects of the ethos of the bazaar, which index the reterritorialization of devotionalism by the culture industries. These aspects include patriarchal power relations, a trans-subjective locus of value production, and, relatedly, the authority of the communal over the conjugal or individual. The frontality of these more secular erotic images is not a matter of establishing the icon's *darshanic* gaze toward multiple individual devotees but of establishing communal scopic privileges, or the right to look, by disposing the gaze and/or the body of the intra-diegetic figure so as to address the viewing public. While this scopic privilege is undoubtedly established

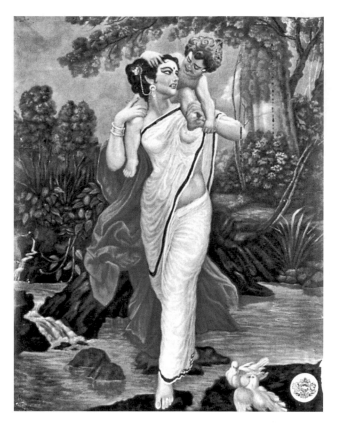

133. "Mother and Child" by Rajan, a 1968 calendar for the Mohan Meakins liquor company. (Collection of JPS and Patricia Uberoi, Delhi; also included in Fukuoka Asian Art Museum 2000)

primarily with respect to the body of woman, it also extends to other nonauthoritative figures such as children and the few secular adult male bodies represented in calendar art such as farmers and soldiers.

What *is* anathema to the moral-ethical schema of these images is voyeurism, or more specifically, the sense that the intra-diegetic figures might be more involved with each other than with the viewing public. For instance, in most depictions of mothers and infants, a favorite calendar theme that is well represented in the Uberoi collection (see Fukuoka Asian Art Museum 2000), the figures may appear to be absorbed in each other, but the mother's and/or the child's body is unambiguously presented to the viewer's gaze. Indeed, the more preoccupied they are with each other, the more explicit the invitation to viewers to exercise scopic authority. Thus in a print by the artist Rajan issued in 1968 by the liquor company Mohan Meakins (well known for its semi-erotic calendars of women), the mutual gazes of mother and child are offset by a frontal invitation to look at the woman's body through the translucent folds of her sari (fig. 133). Revealingly, one of

CHAPTER 6

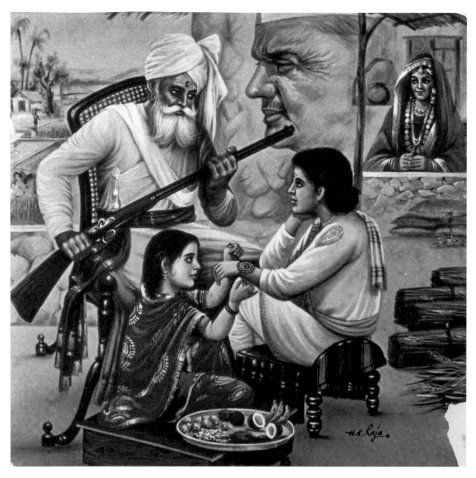

134. "Raksha Bandhan" by H. R. Raja, a 1978 calendar design. (Collection of JPS and Patricia Uberoi, Delhi; also included in Fukuoka Asian Art Museum 2000)

the few calendars in the Uberoi collection featuring two figures whose bodies and faces are both in profile (rather than having one or the other or both turned frontally toward the viewer) is *Raksha Bandhan* (fig. 134), a depiction of the festival when brothers renew their promise to protect their sisters. The absence of a frontal address to viewers by these two figures is compensated for — indeed, enabled — by the overarching presence of not just patriarchal but martial authority, embodied in an elderly Rajput (warrior caste) man, presumably a father or grandfather, replete with turban, moustache, and rifle. Crucially, the brother and sister do not engage each other's gazes: while the little girl looks adoringly at her brother, he looks up to the patriarch, as does a maternal figure peering out from an archway in the corner: in other words, the women gaze at the men, while the men

gaze at each other. What is more, the post-Emergency nexus of patriarchal authority with a violent state is reinforced through another presiding figure, depicted in ghostly monochrome as part of the background yet larger and higher than the other figures. This is a profiled face of Lal Bahadur Shastri, India's prime minister from 1964 to 1966 who was the overseer of the war between India and Pakistan and, appropriately for this rural yet martial scene, the propagator of the slogan "Jai Jawan, Jai Kisan" (Praise the Soldier, Praise the Farmer). Shastri, deep in thought, engages no one's gaze but is placed directly above the little boy, their echoing profiles establishing an affinity between the child and a transcendental state (as with the "baby" pictures described above), while the child's loyalty to the feudal order is simultaneously affirmed through his subservient regard of the patriarch. In the bazaar's scopic regime, then, figuring the "private" familial space even of siblings is only possible when it unfolds under the aegis of paternalist authority in all its despotic might.

Private spaces of conjugal intimacy are even further beyond the scope of publicly acceptable representations. Couples in calendar art have tended to appear either as divine *darshanic* icons presenting themselves to viewers for intra- or extra-diegetic worship, or as secular lovers, such as the protagonists of cinematic, historical, folk, or "classical" romances, wherein they mostly appear in public or outdoor spaces, accompanied by landscapes or monuments (much as they do in cinematic song and dance sequences; fig. 135). This association of couples with public spaces in calendar art and film is particularly striking when contrasted with an unsigned, undated archive of pornographic drawings found in a second-hand shop in Tanjore around 1994, which can be seen as a part of the underbelly of calendar art: its proscribed, albeit privately circulating, other.[20] Here twenty-two pages of figures, almost all (except in two instances) depicted in profile, are placed in middle-class domestic interiors as they engage in various kinds of sexual acts (figs. 136 and 137): both heterosexual and homosexual, and in all manner of positions, including some highly acrobatic ones, as well as onanism, bestiality, pedophilia, rape, and religious transgression (several drawings feature lustful priests or nuns). These amply furnished private interiors feature beds, tables, chairs, steel cupboards or "lockers," trunks or chests, doors and windows, almost always drawn with rulers; one image is set in a bathroom with an Indian-style toilet. The tables often carry displays of fruit, sweets, or other kinds of food; bottles and glasses; statues of deities; keys, cigarettes, and matches; books and pens, or radios; most of the male figures wear wristwatches. Such signs of middle-classness and modernity are often accompanied by signs of Western-style education: apart from the

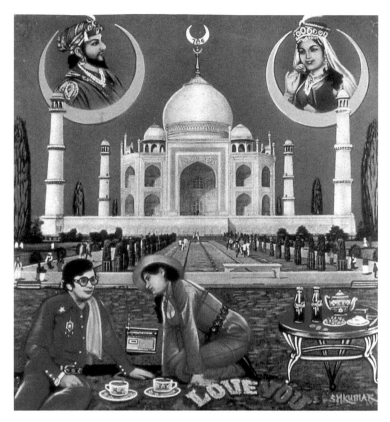

135. "I Love You" by S. M. Kumar, a 1976 calendar design. The figures resemble Rishi Kapoor and Dimple Kapadia, stars of the 1973 Hindi film hit *Bobby*. (Collection of JPS and Patricia Uberoi, Delhi; also included in Fukuoka Asian Art Museum 2000)

presence of books and pens, sometimes the backgrounds feature shields and trophies, while one drawing has two chests marked "MA" and "BA."

These symbols of education, like the statues of deities featured in the background of images that are depicting the sexual activity of religious figures, serve to highlight the transgressive nature of what is taking place in the foreground. There is an ambivalence here between a moralizing opposition of education and religion to sexual desire, and the suggestion that Brahminical religion and Western-style education are themselves "corrupting" forces. Either way, this is not happy, escapist, soft-focus soft porn: there is a strong sense across this oeuvre of internal tension and moral ambivalence with respect to these sexual scenes, foregrounded by the often grotesque, exaggerated, and distorting treatment of bodies, particularly those of women and priests. This sense of tension is also shored up by the remarkable presence within many of these drawings of calendars on

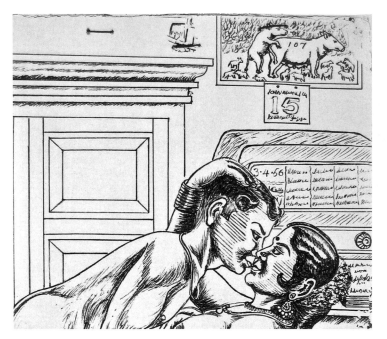

136. Couple having sex; in the background are a radio and a calendar depicting fornicating pigs. Note the woman's formal coiffure and jewelry. Detail of drawing (pen on paper), part of a series found in Tanjavur, artist unknown.

the walls, with large tear-off dates of the sort common in the south. The images on these calendars variously resonate with the action in the foreground, depicting animals such as pigs or dogs in similar positions and/or alternative combinations of people — particularly heterosexual couples in the background of homosexual images. These comparisons with dogs and pigs, considered unclean and ritually defiling, or with heteronormative (albeit private and lustful) sexuality institute the calendars as sites of moral-ethical, indeed political, comment in these drawings even as they further compound their overall sexual content. This occurs in a manner similar to "paranarrative" elements in film melodrama, but in reverse, such that elements representing the moral order are subservient to a transgressive overarching narrative. As with fetishism within a bourgeois moral order (as opposed to the legitimate, "normal" fetishism of the bazaar), what makes these images efficacious as pornography is their simultaneous reinforcement and transgression of moral codes.

These moral tensions are echoed by the formal tensions set up by the different kinds of line work deployed by the artist. The figures in the foreground are strongly defined with dark outlines and heavy shading, enhancing their deliberate grotesqueness. In the

137. Bald nun and priest having sex, overseen by a deity. Detail of drawing (pen on paper), part of a series found in Tanjavur, artist unknown.

backgrounds a further opposition unfolds between the uniform, ruler-drawn mechanical lines of the furniture or architectural elements and the quick, deft, light touch in the treatment of deities or the animals and humans in the wall calendars. The fluency in these latter areas strongly suggests that the artist was a professional, trained in the Tanjore tradition and/or very adept in producing religious figures, quite possibly for the calendar industry (given the strong presence of calendars in these images). The level of detail in the furniture elements also suggests some training in mechanical drawing. It is not surprising that the most labored elements in these drawings are those with which a commercial artist in the ambit of the Sivakasi industry would have the least familiarity: mutually absorbed, secular figures rendered in profile (indeed, an element of frontality persists in the way these "in your face" figures are squashed right up against the picture plane).

I have suggested that images that do not conform to the frontal imperative have tended not to appear for public circulation in the bazaar. In this unofficial, privately circulating oeuvre, the association of these figures with sexual excess and moral transgression is consistent with the post-independence bazaar's scopic regime and moral codes. This set of drawings does not share the frontal generic conventions characterizing much Western pornography since the eighteenth century and correspondingly informing official censorship guidelines on "full frontal" depictions. On the contrary, here the viewer's voyeuristic exemption from being implicated in the action is coupled with easy access to a safe position of moral condemnation. So the (relative) self-absorption of these images and their middle-class, modern, interior mise-en-scène establish the private and the modern as

sites to be pathologized even as—indeed, in order that—they also take on a libidinal charge. On this reading, the use of Brahminical and Western-educated bodies to perform the private could be read as a critique of the privileged relationship of these bodies to the fruits of modernity.

In other words, then, both the acceptable, generically frontal images publicly circulating in the bazaar *and* the proscribed or pathologized nonfrontal representations of domestic privacy index the post-independence bazaar's vernacularizing recuperation of the bourgeois private to its own moral-libidinal terms. There is a reversal here of the bourgeois abhorrence of the fetish (discussed in the previous chapter): within the bazaar's terms, the locus of (re)productive value and the site of "legitimate" desire is not the modern heterosexual nuclear family, which is lumped together with other sites of transgressive sexuality. Instead, it is located in a trans-subjective, public realm characterized by a devotional relationship to the sacred and the state and the perpetuation of "feudal" forms of patriarchal authority. Correspondingly, the frontal address of images within the bazaar's scopic regime is directed not just toward the individual viewer-subject and his mastery of the "objects" depicted within the frame, but toward an arena of communal judgment. The element of moral-ethical judgment makes its presence felt even in the pornographic images I have discussed, with the frontal address of the calendars and deities establishing a sense of triangulation, an awareness of an overarching context of communal or authoritative viewership. Even as pornography might *represent* a domain of private pleasures in opposition to the public spaces and gazes of calendar art, therefore, its performative space of viewing does not necessarily partake of or inscribe a similar arena of the private.

This is not to say that there have been no attempts to embrace the private or the space of the couple in the post-independence culture industries, particularly with post-liberalization corporate advertising's reintensified address to the family and the individual as units of consumption. From the late 1980s onward there has been a great deal of experimentation with modes of address in the culture industries, enabled in large part by the rapid spread of television with the popularity of mythological serials such as the *Ramayan* and then the introduction of satellite and cable services in the 1990s. However, this experimentation has also been accompanied by a strong reassertion of the bazaar's ethical claims to an arena of trans-subjective address, as illustrated by the instances from Maharashtra in the 1990s cited above, or in the rhetoric surrounding the blockbuster 1994 film *Ham Aapke Hain Koun* (HAHK), which was explicitly hailed for its appropri-

ateness to communal, family viewing (in contrast to many television programs or films depicting sex and violence that parents and children felt they could not watch together). It is no coincidence that this film was produced by Rajshri Films, a Marwari family firm (that is, emanating from one of the bazaar's core constituencies) established in 1947 by Tarachand Barjatya, whose grandson Suraj directed HAHK. The Rajshri Films website, which describes HAHK as a "celebration of Indian traditions," is perfectly happy to feature the following extract from a review in the *Times of India*'s Mumbai edition: "The appeal of the film must be its total familiarity. No ingredient is new, nothing disturbs. Its reassuring ethos is seductive and soothing, reversing the effects of the global invasion of our culture though not of our economy, implicitly asserting the permanence and stability of all the institutions that are at this moment under pressure: joint family, patriarchy, religion and the nation" (http://www.rajshri.com/hahk2.html). Here the website re-appropriates the review's implicit critique of the film's conservatism, positing that very conservatism and its attendant affects as ingredients of the film's strength.

But is this post-liberalization reassertion of the ethos of the bazaar of the same order as the assertions of identity expressed in the pre- or immediately post-independence culture industries? In this chapter I have traced some of the ways in which the bazaar has resisted and reformulated what are seen as some of the key features of modernity, incorporating them within its ethos. But this is where I would want to depart from Madhava Prasad's characterization of this resistance as an index of the "only formal, not real" nature of the feudal's subsumption by the modern (Prasad 1993, 77), which suggests that the formal is somehow superficial or without "real" efficacy. There is nothing "only" about the formal: in the next chapter I suggest that formal shifts can sometimes take on a performative valency and describe how elements of modernity have also worked to re-formulate canonical schemata in the bazaar, inaugurating profound shifts in its symbolic regime.

FLEXING THE CANON

In our time this desire that was set in motion by the multitude has been
addressed (in a strange and perverted but nonetheless real way) by the
construction of Empire. . . . The multitude called Empire into being.

MICHAEL HARDT AND TONI NEGRI, *EMPIRE*

My computer's screensaver, downloaded from an Internet site (www
.eprarthana.com, which offers various Hindu liturgical articles and
organizes long-distance prayers at over two thousand temples), cycles
through a succession of calendar-style Hindu gods. A German col-
league, dropping by my office, stared in fascination at the blue Shiva
floating diagonally across the screen, his long hermit's hair piled up in a
bun with a crescent moon caught in it. "Who is she?" my friend wanted
to know. It wasn't just the hair that caused the gender confusion here,
but also the huge kohl-rimmed eyes, the smooth skin, and the full, ruby-
red lips and pink cheeks that characterize Sivakasi prints. A similar
ambivalence attaches to other male deities, as well as to male heroes of
the pre-liberalization era in Indian cinema. For many people unfamil-
iar with that cinema's aesthetic codes their fleshy physiques, prominent
eyes, and full lips seem at best effeminate and at worst unattractive.

Gender is perhaps the most familiar category through which bodies have been understood as surfaces of social inscription and performative reinscription. These variations in social coding are what can make one woman's man (or rather, god) look like another woman's woman. But also, as feminist and queer theorists have argued, recognizing the performativity of categories like gender opens up the possibility of challenging their replication of the status quo. While unequal power relations are operationalized and institutionalized through performative reiterations of normative categories (Butler 1993), there are also repetitions with difference — such as mimicry, parody, or other forms of expropriation — whose subtle bending of the rules exposes the social conventions underpinning these normative categories and thereby renders them vulnerable to reformulation (Butler 1990a, 1990b; Case 1990). Such analyses of performative (de)stabilizations of power structures extend beyond the arena of gender to those of colonial and race relations (see, for instance, Baker 1987; or Bhabha 1994, following on from Fanon 1967).

This chapter uses mass-cultural representations of masculine bodies to explore how ideas about performativity might further illuminate the efficacy of inherently repetitious, mass-reproduced images such as the Sivakasi calendar prints. The previous chapter examined how the technologically aided replication of images has perpetuated powerful symbolic structures where religious and commercial practices are enmeshed with the social inscription of embodied categories such as gender and caste, with ramifications for the constitution of the body politic in post-independence India. But might not the very multiplicity of these mass-cultural images, driven by the cyclical imperative of ongoing replication, also engender contexts in which these powerful and seemingly inert symbolic structures prove unstable, vulnerable to reformulation? In this chapter I focus on one such reformulation, that of representations of the male body, to explore how mass-cultural images emanating from the bazaar can articulate with varying political currents to become both indices of and vehicles for symbolic change. As throughout, my concern here is with the material processes through which images affect other bodies — both virtual bodies (the referents of images) and actual ones (images as objects as well as flesh-and-blood human beings) — and vice versa.[1] In other words, I am interested in how the formal and symbolic work of an image comes to be actualized in and through bodies, and how forms of bodily performance come to manifest themselves in images. If the previous chapter demonstrated how taking into account the circulation of images as

objects in a trans-subjective arena troubles an ocularcentric model of image efficacy based on monadic individual subjects, here I further develop the critique of ocularcentrism through an emphasis on the mimetic mutability of embodied subjects, and on corporeal processes that are not necessarily mediated through conscious ideation.

In doing so I want to address two kinds of problems that commonly beset thinking about the work of images, and the conduct of cultural critique more generally. The first stems from the characterization of the link between images and social practices (and hence social change) as ideological, where ideology, as "meaning in the service of power" (J. Thompson 1990, 7), is seen as a primarily psychic, mental, or ideational category pertaining to the subject's "interior." This assumption is challenged by feminist scholarship that seeks to acknowledge the integral role of the body as the mediating ground of experience (see for instance Grosz 1994), moving beyond a masculinist mind-body dualism by recognizing the mutual inherence of the psychosocial and the corporeal. This feminist agenda resonates with Foucault's critique of ideology (Foucault 1980, 186) as well as Bourdieu's concern with the replication of power relations (other than gender) through social practices, and in particular the notion of "habitus" as the "embedding of social structures in bodies" (Bourdieu 2001, 40; see also McNay 1999).[2] As Bourdieu puts it (writing—ironically—in the context of the women's movement, in his only book to squarely address gender relations), "symbolic revolution . . . cannot be reduced to a simple conversion of consciousnesses and wills" (Bourdieu 2001, 41). Instead, it must be seen as gradually unfolding through embodied and trans-subjective transformations of the habitus. In other words, then, social and political changes flow from processes at the level of bodily practices as much as from changes in consciousness—indeed, the psychic and the corporeal cannot be thought apart from one another.[3]

What does this acknowledgment of the corporeal imply for our understanding of the work of images? For a start, we need to attend to the ways in which images themselves are bearers not just of "interior" meanings but of a habitus: they are bodies that actualize social structures, rendering these structures concrete through their engagements with other bodies (other images as well as flesh and blood beings)—that is, through their "social lives." Further, we need to attend to the corporeal registers in which these engagements occur, not just to their psychic (understood as mental) effects, or their conservative or transformative potentials at the level of ideas. Earlier in the book I described how ritual performance and commerce provide contexts for bodily exchanges with images, emphasizing the circulation of images between people and of ritual substances between

people and images. In this chapter I focus on processes of mimesis as a similar switching point at which images affect the realm of embodied practices and vice versa.[4] Several scholars have singled out the mimetic faculty, as "the nature that culture uses to create second nature" (Taussig 1993b, xiii), for the ways in which it troubles dualistic distinctions between culture and nature, voluntarism and determinism, psychic interior and corporeal exterior — or even, more radically, between organism and environment (Grosz 1994, 46). It plays a central part in forming the habitus, a realm of practices that similarly blurs the boundaries between social construction and biological determination: "embodied history, internalized as a second nature and so forgotten as history" (Bourdieu, 1990, 56). Mimetic encounters between bodies/images are a means by which the social field is reproduced, but, as I hope to show, they are also a means of destabilizing that field by inscribing ludic short circuits between image and practice, generating incongruent forms of habitus (McNay 1999). In so doing, mimetic processes hold out the possibility that in the realm of images "formal" changes might, in Pascalian fashion, prepare the ontological ground for "real" structural and symbolic changes. Further, I also want to argue that mimetic encounters render problematic the assumption that the illusionism of an image — its attempted (and supposedly successful) masking of its own facticity in presenting visual "evidence" — is at the heart of its power and efficacy. On the contrary, traditions of encounters with icons in India, particularly in ritual contexts, suggest that the recognition of the image *as* an image does nothing to impede its treatment as a being or body imbued with power (albeit one that is subject to special rules).

Attention to mimetic short circuits between image and practice does not obviate the need to attend to the ways in which the "effects" of images are also subject to linguistic or narrative mediation. This brings me to the second set of implications that ideas about performativity have for cultural critique. If speech is a performative act, what is said about an image — that is, critique — can have its own effects. These effects, however, cannot ultimately be dissociated from the effects of the image itself, for (as with the Heisenberg principle in nuclear physics) the very act of paying attention to an image and framing it in a particular way is an encounter or actualization that changes the character of the image. This was amply illustrated in the previous chapter in relation to Hindu nationalist framings of various public images and the violent responses they engendered. How might critical writing about images — in particular mass-cultural images — acknowledge and work with this performative dimension?

One way to do so, I would suggest, is to reframe one's task as constructive and creative

as well as analytical and deconstructive or (more accurately) demystifying.[5] Demystifying critical analyses that take it upon themselves to reveal the regressive subtexts of mass-cultural products seldom *seek* to offer counternarratives or counter-rhetorics that reframe those products in alternative ways (though they often end up doing so anyway). There seems to be an underlying assumption here that there is no need for such counternarratives or counter-rhetorics because demystification fosters a rational understanding of how mass culture works to perpetuate undesirable power structures, and it is primarily this consciousness that generates the political will to change the situation. In other words, the tendency here is to oppose reason to imagination and rhetoric, privileging reason. Indeed, there is the sense here of an active suspicion and mistrust of narrative, either stemming from the realist fallacy that narratives will be taken at face value, or, within a more postmodern frame, from the will to power attaching to any narrative competing with others to seduce its audience. Similarly, those more optimistic critical approaches that seek to uncover readerly reframings of meaning also tend not to want to generate their own alternative imaginaries — in this case because of the privileged status such approaches accord "real" readers or consumers, eliding the role of the critic in mediating meaning.

My premise in this chapter is that any image is the bearer of a multitude of possible meanings, both potential and actual, that vary over time and in different contexts. Potential meanings are actualized or operationalized in many ways, making a connection to the world (that is, to other bodies) through their psychocorporeal impacts on practices as well as through consciously articulated interpretations, whether oral or written, whether denigratory or celebratory. These actualized meanings require ongoing work in the realm of social practice to remain active; and, by the same token, they are always (potentially) subject to resignification. In this light, I see critical writing about mass-cultural images as having two types of tasks. First, rather than having to choose between (some version of) an Adornian condemnation of regressive ideology and a Fiskean celebration of resistance, it needs to identify *both* the regressive and the resistant potentials in an image, mapping the points at which they are actualized at specific moments and in specific contexts. And second, it needs to lend its own weight of actualization, such as it is, to those minoritarian potentials that remain underdeveloped or under-represented. So in generating an analytical framework as well as a resignifying counternarrative about a set of images, I proffer both in the spirit of a "what if?" — or rather an "as if" — that might, through its articulation, take on a life of its own. In the analytic mode I want

to emphasize that the argument in which I situate these images by no means exhausts or adequately represents the work that they have done and will continue to do. In the rhetorical mode, however, the narrative I present is a singular one, emanating from a specific political persuasion and set of interests and hence unapologetically indexing a certain will to power, but one that is intended to articulate with minoritarian forces. I believe that the deconstructive pressure this internal tension between analysis and rhetoric exerts on my text should suffice to signal its inherent instability; any further formal devices signaling fragmentation or absence of closure would be inappropriate for what amounts, in effect, to a counterpropagandist gesture.

I proceed by revisiting the discussion, conducted through the 1990s, of a figure that began to appear in Indian bazaar prints in the late 1980s in confluence with the Hindu nationalist Ramjanmabhumi movement: that of the god Ram as a muscular, aggressive, dynamic warrior.[6] While earlier debates on the significance of this shift in the iconographic canon centered on its indexing of a violent Hindu nationalism, I argue that it also needs to be examined in the wider context of ideas about masculinity and male embodiment, and in particular the ways in which male power has been embodied within the ethos—and the symbolic schemata—of the bazaar.[7] Here I suggest that the link between the Ram images and violence glosses over a more fundamental shift: that is, from a symbolic schema where power is not primarily signaled through visible bodily attributes attaching to gender, to one that instates muscularity as a visual index of masculinity and male power. I relate this back to my discussion in chapter 5 of the devaluing of productive and reproductive (that is, caste and gendered) bodies in the ethos of the bazaar, in keeping with the bazaar's location of value in a trans-subjective realm of circulation with a transcendental source of power rather than in a realm of production where power emanates from individual bodies. What was it within the realm of iconographic image production that allowed this significant symbolic change (that is, the appearance of muscular, aggressive icons of the god Ram) to occur, and what kind of transformation might this change signal in the ethos of the bazaar? The narrative I generate in response to these questions locates this change in mimetic encounters involving a specific Muslim body on the one hand and a "mass" of laboring bodies on the other, encounters that fundamentally reconfigure rather than simply perpetuate the visual forms of patriarchal, upper-caste Hindu authority. This narrative shifts the emphasis in thinking about South Asian masculinity away from the much discussed, primarily gender-inflected opposition between "martial" and "effeminate" male bodies in colonial discourse (see, for instance,

138. *Jai Shri Ram* [Praise to Ram], *janmabhoomi* campaign propaganda sticker, Delhi, 1994.

Sinha 1995) toward a more strongly caste- and class-inflected consideration of the value assigned to the instrumentality of laboring bodies in the post-independence period.

A REITERATION

To begin, I want to go back to a wonderfully insightful and erudite article from 1993 by Anuradha Kapur called "Deity to Crusader: The Changing Iconography of Ram" (A. Kapur 1993a). Here Kapur traces a marked iconographic shift in popular imagery from the earlier, textually sanctioned depictions of Ram as soft, smooth-bodied, almost pudgy, smiling, benign, and above all gentle and tranquil (see figs. 93 and 129), to the more recent muscular versions whose *rasa* or mood is (according to Kapur) predominantly *ugra*: "angry, exercised . . . punishing" (75), emphasizing his bow and arrows in their capacity as weapons rather than as mere iconographic markers (fig. 138). Kapur describes how the characterization of Ram as compassionate, tender, composed, and nonmuscular spans several different textual, pictorial, and performative cultural forms following the first written appearance of the Ramayana story sometime between 500 BCE and 300 CE. The departure from these established iconographic conventions, Kapur argues, is made possible by "the making of a virile Hinduism," which accompanies the encroachment of "realism," and particularly the depiction of a "virile" physiognomy, onto the mythic or iconic image. This "realism" is introduced during the colonial period by oil painting and

the Western pictorial convention of perspective, the proscenium stage, the technological mass production and marketing of images, and a consequent "standardization," not just of images but also of the "expectation" that they produce a "reality effect" (96–97). For Kapur this "realist" moment is inaugurated by figures such as the artist Ravi Varma and the playwright Radheyshyam Kathavachak, working in the early years of the twentieth century, whose "humanized" depiction of physiognomy and placement of iconic figures within a recognizable, quotidian, sensually appealing mise-en-scène served to make the gods more accessible and more "serviceable" to political ends.[8] The muscular Ram mobilized by the Hindu Right from the late 1980s onward can thus, in Kapur's account, almost be read as a teleological consequence of this "humanization," even as she locates these later Ram images as "images produced by a moment of violence," indexing a specific formation of Hindu absolutist aggression.

In his article "The Nation (Un)Pictured?," which also starts and ends with a reference to the recently muscularized Ram images, Christopher Pinney throws into productive disarray both the suggestion of a teleological progression in the work of images and the saliency of a "physiognomic" reading that "naively links formal content with ideological effect" (Pinney 1997a, 835). Tracing a genealogy of "commoditized propaganda" (836) in India, Pinney argues that mass-produced images are not sedimented into easily identifiable chronological and ideological strata, but instead their circulation, persistence, imitation, reuse, and reconfiguration has meant that they inhabit a complex, disjunctive, and recursive temporality. He further argues that the circulation of commoditized images, and their expression of a "messianic" nationalism, has long posed an alternative to a nation — and a modernity — imagined as secular, so in that general respect the recent flood of Hindutva imagery does not index a radical qualitative change (834–35). While I agree with these general arguments (albeit with some qualifications, as outlined in chapter 3), I do think that Kapur's much more specific observation about the strikingly new muscularity of the Ram image is worth pursuing for what it might tell us about the enabling conditions for the permissibility of such an image within the iconographic canon, and the symbolic upheaval that is indexed both by this expansion of the canon *and* by the violence that has accompanied it.

Thinking about change need not necessarily buy into a teleological narrative. Kapur is, in fact, at pains to emphasize the persistence of "older" bazaar images and popular forms of performance that do not buy into the aggressive muscularization of Ram, and to this extent she cannot be accused of deploying a logic of "sedimentation" of images

despite her overall frame of colonially imposed "realism." On the contrary, the problem with her narrative of "humanization" is the way it posits a misleading continuity between, for instance, Raja Ravi Varma's "realistic" depictions of Ram and the images of late-twentieth-century Hindutva. In fact, what disallows Varma's images from presenting the kind of physiognomy that we see almost a century later is precisely their "realism": in paintings by Varma like *Ram Breaking the Bow* or *Ram Vanquishing the Sea* the body of Ram is more that of a relatively scrawny, albeit lithe and athletic, Malayali male (that is, from Ravi Varma's own milieu) than the power-packed, muscle-bound, post-Schwarzenegger body of the post-Ramjanmabhumi prints.

The other difficulty with Kapur's narrative of "humanization" is that it makes too tight a connection between this "humanization" of the gods, the visual convention of perspective, a modernist notion of subjectivity, and a series of phenomena that Kapur seems to attribute exclusively to the colonial encounter with Western modernity: the political "serviceability" of images, their illusionism, commodification, and imaginary identification via the gaze. I would contend that many of these phenomena were already occurring in some form (though obviously not in strict conformity with these modernist descriptors) before the colonial period, while others, like imaginary identification via a "realist" gaze, have arguably never adequately described the engagement with popular images anywhere. What is missing here, for instance, is the history of kings and priests using icons to jockey for political power and/or material gain. (A good instance here is Norbert Peabody's account, cited in chapter 5, of how medieval Rajput kings vied with each other for the Pushtimarg *svarupa* images [Peabody 1991].) Or again, as I suggested in chapter 5, the "humanizing" aspects of the *bhakti* traditions, with their intense, sensual, and personalized modes of attachment to the divine, could be said to predate and inflect both "realism" and mass culture in the Indian context.

In other words, then, more work needs to be done to specify the mechanics whereby these muscular images of Ram have become widely acceptable relatively suddenly *after* more than a century of "realism" and mass reproduction, despite the fact that an often violent Hindutva also formed a basis for earlier, anti-colonial nationalism. What might have changed in the latter decades of the twentieth century to allow for the circulation of these images?

My interviews with calendar artists and picture publishers in the 1990s bear out Kapur's assertions as to the valency of textual injunctions against the depiction of deities such as Ram and Krishna with muscles. Indeed, rather than shoring up the idea that

Western-style "realism" strongly informs bazaar images (as Kapur's account suggests), the artists I spoke to placed iconographic injunctions in *opposition* to "realism," citing several instances where "realism" was forced to cede to iconographic prescriptions in order for a picture to succeed in the marketplace (see chapter 4). In this context, muscularity explicitly figured as a bone of contention (if you will forgive the anatomically mixed metaphor). Recall the frustration of Ram Waeerkar, the illustrator of the *Amar Chitra Katha* mythological comics, at not being able to depict Ram and Krishna with Tarzan-like muscles, or the calendar artist Indra Sharma's invocation of the iconographic injunction against musculature: "Now the body is very strong, but we will not show the **anatomy.** For god's body, the description is of a gentle, beautiful (*sukomal*) body. . . . There won't be any **muscles,** we people avoid **muscles.**" Here Sharma is speaking in Hindi but uses the English words "anatomy" and "muscles," and uses them pretty much interchangeably. Anatomy, the modern discipline of the body that brings medical discourse into constellation with that of art, is cathected into this one forbidden area of musculature.[9]

The textually specified iconography of divine bodies has also informed the representation of mythological figures in the cinema. This is particularly evident in the case of the star-politicians M. G. Ramachandran (also known as MGR), who was active in the Tamil cinema from the 1950s to the 1970s (fig. 139), and N. T. Ramarao (NTR), who worked in Telugu films from the 1950s to the early 1990s, both of whom started out by playing mythological roles and carried this iconography over to their portrayal of human heroes as well. Their physiognomies conformed closely to iconographic imperatives: soft and fleshy rather than muscular or skinny, with the face and eyes the most prominent features, emphasized by makeup. NTR is quoted as saying, "I realized that keeping a muscular body won't be nice, particularly for a character like Krishna. The body must look fine but not muscular. To keep that up, I took to *pranayam* [yogic breathing] and gave up physical exercises" (Venkat Narayan 1985, 212)

So why is divine muscularity such an oxymoron? Kapur's essay elaborates how, in the numerous textual and pictorial traditions within which the Ram story has been told, divine agency unfolds within a framework of transcendent power, whose ultimate source does not lie in physical strength even as it might have a physical effect. The gods do not have warriors' bodies, in accordance with the characterization of divine agency in the Vaishnava schema as more a matter of *lila*, sacred "play," than of labor.[10] Accordingly, if power is manifested through bodily signs it is more in the radiance of the deity's eyes and

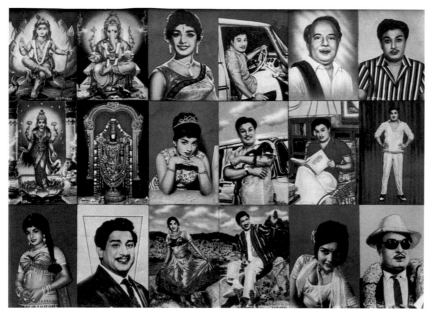

139. M. G. Ramachandran featured in one-third of the images on a sheet of designs for "fancy pocket diary wrappers" by K. C. Prakas (nos. 4, 6, 10-12, and possibly 18, counting left to right and top to bottom). (Collection of S. Courtallam)

smile, or the glow of the skin, all of which are highlighted in pictorial representations. It is primarily these attributes that have an impact on viewers, causing them, in Indra Sharma's words, to become *mugdh* (rapt) or *mohit* (seduced or enchanted). While a certain degree of muscularity is not inappropriate for Shiva given his association with yogic *tapasya* or penance, this too is not of the same order as instrumental human agency — and even in his case, muscular or lean depictions (such as S. M. Pandit's rendition from the 1950s, which adapted Hollywood's MGM poster style to recast Shiva in the Tarzan mold: see fig. 76) are less commonly seen than more smooth and rounded representations (see fig. 29).

For me, Kapur's most brilliant insight in this essay is in this distinction she posits between the power silently emanating from a still ("limpid"), disinterested, timeless, transcendent source and the noisy, aggressive force of a more instrumentalized, timebound, and goal-driven or agentive body (92–96). In effect, what Kapur is describing in the "older" Ram images is a symbolic complex around masculine power, particularly divine or divinely bestowed power, which does not express itself through bodily muscularity. That is, muscularity is not a universal, privileged defining attribute of masculine power in images. So it is possible that in certain constellations of images, such as those of

"bazaar" Vaishnavism, visible bodily attributes are not primarily charged with the burden of figuring masculinity as such—a scenario that is possible when there are plenty of other performative means available for reinforcing gendered structures of power. In such a scenario, where muscularity and male power are not necessarily bundled together, we could conceive of muscularity on the one hand and male bodies on the other as being available to do other kinds of symbolic work. Specifying this constellation should make it possible to trace what it is that changes when an ideological nexus (in the field of the image) *does* come to be forged among muscularity, masculinity, sexuality, and aggressive power, both mortal and divine. In what follows, I first want to explore the kinds of symbolic work that muscularity and male bodies have done in Vaishnava image traditions, including bazaar art. (On the hegemonic status of Vaishnava image traditions within the arena of mass culture see chapter 5.) This will provide the basis for an alternative understanding of the significance of the new Ram images in particular, as well as the more general shift in mass-cultural representations of male bodies.

MONKEY SEE, MONKEY DO

The one god for whom the depiction of musculature has been acceptable in calendar art since at least the early 1970s is the monkey-god Hanuman. Ram crucially depends on Hanuman's amazing strength: it is Hanuman whose monkeys construct a bridge across the ocean so that Ram's army can cross it, who spreads fire through the enemy's city with his tail, and who saves Lakshman's life by bringing him the life-giving *sanjivini* herb (as well as the entire mountain on which it grows; fig. 140). And yet Hanuman's powerful, muscular body poses no threat to the location of ultimate transcendent agency in the unlaboring, primarily affective body of Ram, for Hanuman's body is framed as that of an animal, a devotee, and a servant. In calendar images the utter subservience of Hanuman's body to Ram is evident in the way his body is often made up of Ram's name, or an image of Ram (with or without Sita and Lakshman) is shown to be embedded within his chest or forehead (figs. 141 and 142). If the expression of divine power in a transcendent, affective register delinks agency from muscularity, Hanuman's devotional body restores a certain value to physical agency, but only to the extent that it is harnessed to the frame of abjection before the divine. Joseph Alter, in his seminal work on Indian wrestling, stresses that *shakti* (divine life-force or power, as opposed to *bal* or brute force) and *bhakti* (devotion), the two qualities that make Hanuman the exemplary "warrior-devotee," cannot be thought apart. Hanuman's *shakti* can be seen as directly derived from his devotion

140. *Lakshaman Shakti* [Lakshman's strength] by Mukesh, print by S. S. Brijbasi, where a strong, muscular Hanuman flies above the soft, flabby, emotive Ram and Lakshman as he brings them the herb that will restore Lakshman to life (so the title of the print implies that Hanuman is Lakshman's strength). (Courtesy of Brijbasi Art Press Ltd.)

to Ram (Alter 1992, 208): "The more perfect his *bhakti*, the greater his strength; the more fabulous his strength the greater the magnitude of his *bhakti*" (Alter 1992, 199). In other words, there appears to be a correlation between devotion and the conversion of the valueless, if not denigrated, bestial *bal* into the venerated and sought after divine *shakti*.

Between corporeal animal strength and effulgent divine power, where might human bodies stand? First, when it comes to relationships between human bodies and the bodies in and of images, I want to suggest that in engaging with Vaishnava images, male bodies have been particularly mimetically malleable, becoming available to emulate iconic models of devotion such as Hanuman and Radha. Second, in the context of mass-cultural representations of male humans, I contend that the two canonical positions available to them have entailed either a devotional mode, again, or identification with the divine; in either case divine power is now channeled through the state.

141. *Sri Hanumanji*, a 1992 calendar design by Sapar Brothers for Ideal Products, Sivakasi. Hanuman tears open his chest to reveal the image of Ram within his heart. While this is described in the Tulsidas Ramayana, its visualization must also owe something to sacred heart imagery in Catholic prints from Austria and Germany that were circulating in India in the nineteenth century. (Courtesy of the artists)

While some form of ritual prayer is a common mode of relating to iconic images across the pantheon, it is characteristic of Vaishnava *bhakti*, and its mimetic relationship with models of devotion, that male devotees are able to identify with either Hanuman (in the case of Ram worship) or Radha (in the case of Krishna cults) at an embodied, performative level. This mimetic aspect of devotion is theorized in cultic texts such as those of Raganuga *bhakti sadhana*, a highly elaborated practice of devotional imitation (see Haberman 1988). These texts set out a schema of exemplars from the Krishna-*lila*, hierarchically categorized according to types of devotional love. Imitation of these exemplars becomes the starting point for a chain effect, wherein a particularly holy or accomplished practitioner of mimesis himself becomes the model for other devotees. Similarly, it is no coincidence that one of the key figures for devotional imitation is the monkey Hanuman,

142. *Sacred Heart of Jesus*, published by Shri Kalaimagal Industries, Madurai (purchased in Ludhiana, 2001).

for in the Valmiki Ramayana, monkeys have a privileged association with the capacity for metamorphosis or shape-shifting (as do *rakshasas* such as Ravana and Surpanakha): the text often refers to them as *kamarupin*, able to take on the form they desire.[11] In Joseph Alter's ethnography, Hanuman is a central figure in the construction of a wrestler's identity, providing a model of *shakti*, *bhakti*, and *brahmacharya* (celibacy). The wrestlers' relationship with this figure ranges across veneration of Hanuman's image, singing hymns or reciting poems in his praise, and worshipping and serving the guru, whose power is placed on a continuum with that of Hanuman. All of this amounts to what Alter describes as a "deeply felt private identification with Hanuman on a personal level" (1992, 201): ultimately these wrestlers worship Hanuman to be like him, to take on his qualities of devotion and strength. While wrestlers and devotees in general might worship Hanuman in order to take on certain of his qualities, the mendicants known as *bahurupias* (literally "of many forms") actually adopt the monkey form (among others), with black-

ened bodies, faces ringed by fur, wearing tails, and often gibbering and jumping about for further effect. Think also of the Bajrang Dal, the Hindu paramilitary group mobilized in the *janmabhumi* campaign, whose young men styled themselves after Hanuman's monkey army. As described in the previous chapter, in 1996 this group was particularly reviled for vandalizing a gallery carrying paintings by M. F. Husain because of Husain's "obscene" depictions of Hindu goddesses: again, this is a most emphatically embodied response to the image.

A similar mimetic relay with images has also occurred from the medieval period onward in the male body's devotional engagement with the modality of Radha, Krishna's cowgirl lover, as a vehicle of feminine desire. While there are ample examples in *bhakti* poetry of male poets writing in the female voice (see Sangari 1990), there have also been instances of male priests performing rituals dressed as women, particularly in Pushtimarg and some of the ecstatic Vaishnava sects. (See Haberman 1988, chapter 6, for a fascinating account of debates in sixteenth-century Gaudiya Vaishnavism over how literally male devotees should take the injunction to emulate the *gopis*.) In Renaldo Maduro's study of Nathdwara, Pushtimarg priests identifying with Radha reported intense sexual experiences before the image of Krishna (Maduro 1976, 32). An account of the Sakhibhava sect of Mathura and Brindavan, written behind an eighteenth-century painting of one of its members, describes how male devotees wore red loin cloths every month to simulate menstruation, and after this period was over: "In the manner of married women, anxious to be physically united with their husbands . . . they take to themselves . . . a painting of Shri Krishna, and stretch themselves, raising both their legs, utter 'ahs' and 'ohs,' adopt woman-like coy manners, and cry aloud: 'Ah, Lalji [i.e., Krishna], I die! Oh Lalji, I die'!" (K. Goswami 1982, 142, citing Goswami and Dallapiccola 1981, 10–11). Again, the relationship of the male body with the image in this instance exceeds the visual: the male *bhakta* performs an embodied identification with the image of Radha, while the image of Krishna in its capacity as an object comes to stand in for what it represents, that is, Krishna himself.

One significant feature of the Radha figure is that her affective and desiring body is not that of a wife (that is, not a wife to Krishna).[12] Radha, as a nonwife, expresses her desire for Krishna in excess of the imperative of wifely *duty* that defines social womanhood: here the reproductive body of woman is separated from her erotic, desiring body. The reproductive and morally pure iconic bodies of the wife and the mother are strongly territorialized within the patriarchal symbolic structures of family, nation, religion, and

morality.[13] Meanwhile Radha, as the deterritorialized, desiring feminine body, is freed from social convention only to be reterritorialized, in the pastoral idyll of Braj, by the logic of devotional abjection. This abject, nonreproductive female body is eminently suited to emulation by male bodies (though the delinking of devotional desire from reproductive sexuality is not exclusive to the nonreproductive body of Radha: as I mentioned above, one of Hanuman's exemplary attributes is his strict *brahmacharya* or celibacy, a concept whose saliency I shall return to a bit later on). While Radha's body has been available for identification by both male and female devotees, the more performative and embodied modalities of identification have been largely reserved for male bodies. Thus while *devadasi*s or temple dancers have been subject to moral suspicion, there has been a far greater acceptance of devotionally based cross-dressing by figures such as Chaitanya, Ramakrishna, and even, more recently, N. T. Ramarao (although with the increasing circulation in the Indian public sphere of relatively firm categories of identity based on gender and sexuality this acceptance may be on the decline).[14]

It is precisely the social debasement and valuelessness of the desiring or libidinalized female body that enables it to be inscribed as a model of devotion. If this body was not always already abject, it could not provide the basis for the valorization (within a reterritorializing devotional frame) of an evacuated will and a surrendering body, one that is utterly seduced and enchanted (*mohit*, *mugdh*). In other words, even as the mimetic mode has historically opened up a space for male bodies to legitimately inhabit the desiring femininity of Radha, it has also served to performatively reiterate the abjection and debasement of feminine desire within a patriarchal order. Similarly, I would suggest that what has enabled Hanuman's strong, muscular, agile male body to be inscribed as a model of devotional abjection is a symbolic schema where bodily force (*bal*) is denigrated—for instance, through its equation with animality. Thus even as Hanuman's devotion enables the conversion of the debased *bal* into the valorized *shakti*, this valorization of *shakti* reinscribes *bal* as always already subordinate, just as the laboring body is subordinate to the warring body within the schemata of caste. This modality of devotional embodiment is consistent with the ultimate location of power in a transcendent, divine source, which crucially cannot coexist with a notion of laboring, productive bodies as immanent sources of instrumental agency or as loci of value, a characteristic of the ethos of the pre-liberalization bazaar as described in chapter 5.

My point in describing these structures of abjection is emphatically *not* to cast the power of patriarchal or caste hierarchies in totalizing terms.[15] On the contrary, if I am

concerned with the ways in which the "always already" character of these structures is (re)produced by their reiteration through embodied practices, it is precisely because this performative arena is also where such structures can become vulnerable to reconfiguration, through differently articulated reiterations. That is the thread I want to follow here. However, before doing so I want to gesture toward another much more tenuous and enticing thread, where I would suggest that even within these structures there is scope to develop more subtle and complex conceptions of power and agency. For example, there is a sense in which the very abjection of the desiring devotional body in Pushtimarg actually comes to exert some kind of power over the divine.[16] Krishna is practically held ransom by the intensity of feeling in his devotees, who exercise something akin to the imperative of the prostitute in Lyotard's *Libidinal Economy*, "Use me!": this is a power in abjection that renders undecidable the question of dominance and submission (Lyotard 1993, 60–66).[17] Radha takes on such centrality here that the Shrinathji image of Krishna in Pushtimarg has itself been painted in *sakhivesh*, that is, dressed as one of Radha's female companions, although painting such images has been forbidden since the early twentieth century (see Ambalal 1987, 144 and 160). There are also depictions of Radha dressed as Krishna, such as the miniature from Bundi, ca. 1760 (reproduced in K. Goswami 1982, 141).

HANUMANS AND HUMANS

Here, however, I want to continue to track the mass-cultural images that lead us from a cross-dressing Krishna toward a muscular Ram—and indeed, toward a similarly muscular Krishna, for not long after the *janmabhumi* images of Ram began to appear, Krishna, too, began to be figured in a martial, muscular incarnation (fig. 143). This latter development would suggest that there is a kind of mimetic effect across iconic bodies (mediated, of course, by artists) such that a shift in the treatment of one canonical figure can be extended to others. Another instance of this is the way in which the *janmabhumi* campaign's imagery of the infant Ram, itself based on the baby Krishna, led to the appearance of plump baby images of Shiva and Ganesh. In this light we might think of the figure of Hanuman as a kind of Trojan horse (to mix animal metaphors), in its capacity as a locus at which muscularity came to be naturalized in the expressive vocabulary of bazaar artists, and thence became available for extension to other deities as the occasion arose. How this might have happened is worth examining, for even calendar Hanumans have not always been muscular (figs. 144 and 145).

205 SUDARSHAN KRISHNA S. S. BRIJBASI & SONS
22/1, FATEHPURI DELHI-6

143. *Sudarshan Krishna* by Mukesh, a Brijbasi print from the 1990s: Krishna's cosmic form on the battlefield of Kurukshetra (whether benign or terrifying) gives way to a Ram-style muscular warrior. (Courtesy of Brijbasi Art Press Ltd.)

Joseph Alter, in his study of wrestlers, remarks that "Hanuman's physique is not that of a bodybuilder, except as portrayed in some modern calendar art, but that of a wrestler" (1992, 56). He makes this observation in the context of the distinction that wrestlers make between their practices or their bodies and those of their more overtly muscular counterparts in the mostly secular arena of bodybuilding (56–57). This distinction mostly hinges around the bodybuilders' preoccupation with external form and their fragmentation of the body into distinct, bulging parts, as opposed to the wrestlers' holistic development of a "smooth, integrated . . . *ek rang ka sharir*, a body of one color and uniform texture" (57), through attention to the matter that goes into and comes out of it, and an exercise regime that is inseparable from devotion. Alter's remark regarding the portrayal of Hanuman's body as that of a bodybuilder in "some modern calendar art" most likely refers to the later work of the Kolhapur artist P. Sardar, a Muslim (born Sardar Mohammad Patel) who was without doubt the most celebrated painter and fervent

144. *Hanuman* by C. Kondiah Raju, Kovilpatti. Here a relatively soft, rounded, and furry Hanuman, framed within Ram's shadow, offers flowers in a gesture of devotion.

bhakta of Hanuman among calendar artists. In fact Sardar was himself a bodybuilder, who publishers described as modeling in the mirror for his paintings (fig. 146). While this may have been the case early in his career, certainly later on he worked primarily from photographs of himself, which were taken by his sons, who as children also served as his models.

Sardar's devotion to Hanuman is just one instance among countless others in the arena of Indian popular religion of an individual transcending religious boundaries. As I mentioned in chapter 1 (see note 25) Sardar's persona was particularly malleable, and self-reflexively so: early in his career he "passed" not just as a Hindu but as a Brahmin, and later in life he took it upon himself to comment on various public matters, including the negotiation of Hindu-Muslim difference, through letters to the local papers. But I want to suggest that Sardar's mimetic and therefore incongruent habitus, disrupting the boundaries between Hindu and Muslim — and between wrestler and bodybuilder —

145. "Lanka Dahan" [The burning of Lanka] by P. Sardar, an advertising poster for Kundan Lal Tek Chand, Dhuri (Punjab). This work by Sardar can be seen as a transition between the soft, furry iconography of Kondiah Raju (fig. 144) and the buffed muscularity of the Sapar Brothers (fig. 141). (Collection of JPS and Patricia Uberoi, Delhi)

was particularly significant because of its actualization through images. The mimetic aspect of Sardar's devotion, that is his identification with Hanuman through bodybuilding, served to set up a mimetic concatenation whereby his own performative adoption of a muscular (because devotional) body, reflected in the mirror or ingrained into photographic emulsion, transmuted onto paper, then replicated by the thousands, was able to turn that body into the icon worshipped and identified with by devotees, be they wrestlers or bodybuilders, Hindus or Muslims. So while Alter's anthropological narrative performatively reiterates the codification of distinctions (at least between wrestlers and bodybuilders), Sardar's transgressive devotional body and its mimetic actualization of Hanuman disrupts such categorizations. In doing so, this mimetic body subtly but significantly reconfigures the conventions of the medium of calendar art, becoming a link in the visual logic whereby muscularity of the bodybuilding variety—which is how we might further specify the body of the *ugra* Ram—becomes acceptable in calendar art.

146. P. Sardar posing for a photograph on which to base a painting of Hanuman. (Courtesy of Dara Sardar)

The instance of Sardar-Hanuman provides some sense of the way in which the arena of performance, and its enabling of differently embodied "speaking" positions (in this case, the devotee of Hanuman as a Muslim bodybuilder rather than a Hindu wrestler), can reconfigure a canon by actualizing a *reiterable version* of a new speaking position. (Here it is important to emphasize the partial and conditional nature of that version, so that what is reproducible about Sardar's body is his muscularity, rather than his Muslimness.) Such transgressive performances are often circumscribed by a ritual temporality, as in the case of carnivalesque "inversions" or theatrical impersonations of the divine, such as the Ramlila performances where the actors are worshipped as deities for the duration of the performance (see A. Kapur 1990; Schechner 1983). However, technologies of mass reproduction can enable images to migrate beyond such temporal boundaries — even as they might continue to be implicated in other forms of temporal, spatial, and semiotic reterritorialization. In this light, even as the body of Sardar-Hanuman reconfigured cer-

tain physiognomic qualities of Hanuman that might continue to have a detailed symbolic significance for wrestlers, this body still worked within the overall logic of devotional abjection, wherein the value and relevance of its strength cannot be thought apart from its role in reinforcing the greater value and power of a transcendent divine agency. So the question remains as to how this devotional muscularity comes to be translated to those figures who are primarily vehicles of transcendent power, the objects rather than the subjects of devotion. Here I want to posit one more link in the visual chain leading from the muscular body of Sardar Muhammad Patel to that of the *ugra* Ram: another shift in the canon, this time in the context of representations of male humans rather than of Hanuman.

In the previous chapter I described how, within the mass-cultural arena, a putatively socialist, secular post-independence state took on the idiom of transcendental, divine power. In this context the "baby" calendars figured a public that is yet to come of age, yet to attain full subjecthood, while representations of women served to shore up the ethical basis of the nation-state through their reiteration of "traditional" roles and values. When the transcendental power of the state was embodied in human form, it was manifested through iconic, quasi-sacred "leaders" rather than through generic adult subjects. So by and large, with the exception of a few backgrounds featuring lab-coated scientists or engineers, ordinary men or generic male subjects have only appeared in the calendars as farmers and soldiers of the "Jai Jawan, Jai Kisan" type, men whose unstinting devotion to the state makes them worthy of praise and emulation (*jai*) as model subjects (see fig. 26). In other words, figuring these strapping male bodies is legitimized by their servile, devotional relationship to the state in much the same fashion as the muscular *shakti* of Hanuman's body becomes permissible, and indeed available for mimetic incorporation, within the framework of his *bhakti*. The Jai Jawan soldier and the Jai Kisan farmer (and, indeed, the nativist hero of the contemporaneous Manoj Kumar films) thus occupy a homologous position to that of Hanuman within a structure of devotional abjection. Indeed, these figures emerging from the 1965 war with Pakistan may have preceded and possibly enabled the muscular depiction of Hanuman in calendar art: either way, the bare-chested farmer, more than the uniform-clad soldier, provided a similar opportunity for calendar artists to hone their neglected skills in the anatomically correct depiction of musculature. I want to emphasize, however, that this muscular peasant body cannot be seen as the subject of a "realism" of the type embodied, say, by Courbet's stone-breakers, for it relies for its existence on its incorporation within a sacred econ-

omy. In other words, the calendar industry's adoption of techniques from Western oil painting does not automatically inaugurate a Western-style, modern(ist), post-sacred subject that is seen as the putative locus of willing agency. Instead, it appropriates these techniques to the logic of devotional abjection through the circulation of images in the sacred-commercial economy of the bazaar.

While calendar art's figuration of the male subject of the state implicates him in an abject, devotional relationship with it, the hero of the post-independence and pre-liberalization cinema is more often able to represent the state, or at any rate the modernity that the state purports to usher in. Here there is a temporal distinction to be made between the kinds of narrative that frame the printed bazaar images on the one hand and the cinema on the other. The predominantly iconic calendar images, with their enduring material presence and invocation of a mythic or ritual temporality, held in place by textual and iconographic conventions, have been relatively stable and slow to change (though this is not to say that printed images do not allow for change: as we have seen, the annually produced calendars tend to admit more topical subjects than the framing pictures). Calendar art has therefore provided a continuing repository for the mythic basis of the nation, and concomitantly of the state's moral legitimacy and ultimately divine sources of power and authority; thus, for instance, the predominance in calendar art of religious imagery and of the figure of woman as an iconic vehicle of national "tradition."

In contrast, the national cinema of the post-independence period, particularly what Madhava Prasad calls the "feudal family romance" (Prasad 1998, 30–31), is characterized by melodramatic narratives that thrive on first positing, and then working through, the contradictions between "tradition" (a feudal patriarchal order, mostly aligned with notions of Indianness) and "modernity" (mostly aligned with the West). Here, while women continue to negotiate nationalism through "tradition," "culture," and domesticity, the male cinematic subject is set the task of mediating the historical, developmental axis of the secular state. While the Hindi cinema of the 1950s and 1960s has its share of nativist "sons of the soil" (personified into the 1970s by Manoj Kumar), it also sees the emergence of the male protagonist whom Sanjay Srivastava has called the "Five Year Plan hero" after the planning model adopted by Nehru from the Soviets (Srivastava 2004). His is an urbane, metropolitan (often "foreign-returned") presence, embodying a vectoral modernity through his association with roads, cars, trains, and movement in general; he is the bearer of a secular, rational, scientific "temper" and liberal values, and therefore often comes into Oedipal conflict with a patriarch embodying the traditional

order. However, it is also significant that this "Five Year Plan" man is generally smooth and fair, predominantly romantic, his affects centered on his eyes, face, and voice: again, more brains and heart than brawn. This suggests that the power of this modern male, and of the state that he represents, is, like that of the canonical Ram and Krishna, not located in the raw instrumentality of his body.[18] This aesthetic convention, then, returns this embodiment of the state to its nexus with the bazaar — and in particular the bazaar's devaluing of the laboring body. It also reminds us of the continuing relay between mass-cultural forms across the temporal distinctions I have been making with respect to narrative framing: cinema has always been informed by the mythic iconography circulated by calendar art (as in the case of N. T. Ramarao's eschewal of exercise), and calendar art has adopted figures made available by the cinema (such as Nargis's Mother India figure).

The pudgy romantic heroes of the Hindi cinema, like the "Jai Jawan, Jai Kisan" images, persisted into the 1980s, as did the heroization in calendar art of iconic leaders such as Gandhi and Nehru. Over the 1990s, however, the popularity of bazaar images depicting "leaders" declined steeply, while demand grew for large, glossy posters of film stars as well as the usual deities (predominantly but not exclusively Hindu) in all shapes and sizes. Rajiv Gandhi was the last of the "leaders" to be commercially viable as a calendar art icon. The increasing irrelevance of such incarnations of the state is often linked with the rampant corruption of electoral politics and a disillusionment with the state's capacity to keep the nation together in the face of the violence accompanying various ethnic secessionist movements all over the country, the resurgence of a militant Hindutva, and the demonstrations in 1990 following the Mandal Commission's recommendation to increase job reservation for Dalits. But I want to trace it back a bit further to the moment at which I would suggest the triumphal post-independence nexus between the bazaar and the state first comes under serious threat, as does the possibility of deriving the moral legitimacy of the state from a transcendental locus of power: the Emergency of 1975–77, and the political movements to which it was an authoritarian response.

Seemingly forgotten in the current preoccupation with globalization, liberalization, and their spectacularly visible indices of change is the immense symbolic upheaval set in train by the politicization in the early 1970s of the working classes and castes via, for instance, the trade unions, the Naxalite movements, Nav Nirman, and Jaiprakash Narayan's Sampoorna Kranti. It is in the concerted assault by these movements on the existing structures of class and caste, and on the state's collusion with these structures, that I want to look for the audience-driven revaluing of the male body in mass culture,

to which the muscular Ram images are, I would argue, a reactive (as well as reactionary), reterritorializing response. Specifically, I want to make the deliberately impertinent suggestion that the *ugra* or aggressive Ram of the Ayodhya campaign would neither have been possible, *nor necessary*, without the lean, active, hungry, fighting, and laboring, libidinalized screen presence of the Bombay cinema superstar Amitabh Bachchan and his resolutely nonabject embodiment of the urban working-class male from the early 1970s through the 1980s.

ENTER THE *MARD*

Amitabh Bachchan was the Bombay cinema's first, and so far its biggest, superstar. Establishing an early reputation playing romantic heroes consistent with his own elite social background (his father was a celebrated Hindi poet; he himself had worked as a company executive), he quickly distanced himself from that image through his enormous popular success as what Rajadhyaksha and Willemen call a "lumpen rebel-vigilante" (Rajadhyaksha and Willemen 1994, 49), or, as his defining cinematic persona is more commonly described in India, an "angry young man" (fig. 147). Indeed, by 1984 the director Manmohan Desai was saying that the only thing Bachchan *lacked* was "an out and out romantic image" (Vachani 1999, 207). Bachchan—and from now on this will primarily signify his film persona from the 1970s and 1980s (rather than that of his televisual reincarnation from 2000 onward, or his ensuing films, or, indeed, the "real-life" Amitabh Bachchan)—had neither the divine, iconic body of an M. G. Ramachandran (MGR) or an N. T. Ramarao (NTR), nor was he the soft, smooth hero of the Hindi cinema's "social" melodrama. Tall, angular, with a trademark deep voice, and noticeably darker than preceding heroes, he could not be described as muscular, but he is acknowledged as the Bombay equivalent to the contemporaneous macho action heroes of Hollywood. One of his scenes in *Naseeb* (1981), for instance, is modeled on a Charles Bronson film, and as I recall in the late 1970s and 1980s autorickshaws would often be decorated with pictures of Bruce Lee or Sylvester Stallone on one side and Amitabh on the other.[19]

But even as the Bachchan figure might have been informed by the Hollywood action cinema, it cannot be seen as a simple transplant, or even a consistent imitation. Again, this is an instance of selective, productive mimesis, as has been the case throughout the Bombay cinema's long history of appropriations from Hollywood—or, for that matter, as has been the case with Indian popular art's appropriation of the conventions of oil painting, and the troubled relationships of artists with musculature, such as that of Ram

147. Amitabh Bachchan as he appears in *Coolie* (1983), on the cover of a 1990s videocassette of *Deewar* (1975).

Waeerkar with the muscles of Tarzan. What is it that made it desirable and possible at that particular moment for Bachchan to take on and reinterpret the action hero persona, when Bombay had been far less sanguine in incorporating other aspects of Hollywood genre films into its mainstream (disaster movies, for instance)?[20] At issue here is not the comparison between Bachchan and the Hollywood action hero, but how the Bachchan figure was able to depart from both the transcendent and abject iconic bodies of a devotional economy to inaugurate a performative position hitherto unavailable to the male in Indian mass culture. I want to suggest that the Bachchan hero came to crystallize the political energies leading up to and away from the Emergency, and in particular the as- sertion of the value and power of working-class and working-caste male bodies, hitherto alienated from the Swadeshi-turned-totalitarian nexus between the power of the state and the morality of the bazaar.[21]

The Bachchan film narratives often entail a quest for upward mobility or justice, but the hero's means to success, and the code of honor according to which injustice is to be avenged, typically lie *outside* the law of the state (on Bachchan's "outsider" status, see Va- chani 1999). The state is often personified by a brother or friend in the police or the army (as in the seminal *Deewar* [1975], where his brother is played by the soft, romantic Sha- shi Kapoor), and the "traditional" locus of ethics by the mother.[22] While the Bachchan

hero fights to uphold "feudal" codes of honor and kinship, he does so outside the nexus of moral-cum-governmental authority forged between the mother and brother figures and thereby remains alienated from their universe: he often has no option within the narrative but to pay for his transgression and die (as in *Deewar*, *Sholay*, *Shakti*, and *Muqaddar ka Sikandar*). To this extent Bachchan is possessed by the unquiet ghost of the Sunil Dutt character in *Mother India*, the son punished with death by his own beloved mother for breaking the law to defend her honor.[23] In Bachchan's films, however, in the pathos wrought from the abjection of the Bachchan figure before his mother, it is Bachchan and his unfulfilled thirst — for justice, but also for maternal affection — that occupy center stage, not, as in *Mother India*, the mother's pain in choosing between love for her errant son and for the moral law.

I see this as a significant difference, precisely because what is so compelling about Bachchan is this propulsive thirst or desire. In this aspect of Bachchan we encounter the other of the body of *brahmacharya* or celibacy that the Banarasi wrestlers described above seek to emulate, and which, as Alter elaborates, forms the basis for a certain strand of discourse, and practice, of a virile yet celibate nationalism (Alter 1992, 1994).[24] Here the biomoral imperative of celibacy, specified as the conservation of semen, automatically translates into progressive citizenship: not so much through a process of willed self-control triumphing over an errant body, but of material control over the substance of the body itself, resulting in greater moral virtue (Alter 1994, 52). This modern discourse of *brahmacharya* is explicitly directed against what is seen as an immoral Western constellation of sexuality and individualism that manifests itself as self-gratification and self-indulgence (58). Such debauchery includes not just sexual practices as such but also a preoccupation with personal grooming, *filmi* hairstyles and artificial scents, fashionable and in particular tight and synthetic clothing, smoking, drinking, chewing tobacco, riding motorcycles, loafing about in public places — and, of course, going to the cinema (Alter 1992, 239–43).

Even as the Bachchan figure is hardly explicitly sexualized within the film narratives (though *Mard* [Male, or man], 1985, is a notable exception), he is the prototypical "self-indulgent" young, urban, working-class "loafer," replete with sartorial style (flared jeans, unbuttoned shirts, neckerchiefs, bow ties, longish hair), a *beedi*-smoking, liquor-swilling attitude, motorbikes, and girlfriends (some of borderline morality). Indeed, it is conceivable that the Bachchan phenomenon helped the ideologues of *brahmacharya* to flesh out their descriptions. As a teenager in the "Bachchan years" I remember vividly (most

likely, it now occurs to me, because of the sense of vulnerability it engendered in me, as a relatively well-off young woman) the way in which young men and boys on the streets adopted Bachchan's hairstyle, clothing, stance, "attitude," and gestures, punctuating their Bachchan-style fights with the obligatory *"dhishoom-dhishoom!"* sound effects, singing his songs, and, of course, reciting his trademark "dialogues" in an imitation of his deep, measured yet casual and colloquial, often cool and ironic delivery.[25] Imitating the mannerisms and intonations of film stars, and specially character actors, has always been part of Indian film culture: if it was mainly the street boys who imitated Bachchan, surely everyone imitated his foe in *Sholay* (1975), the villain Gabbar Singh, slurred and hiccupped like the drunk comedian Johnny Walker, danced like the "vamp" Helen, or risked neck sprains tossing their heads like the romantic heroes Shammi Kapoor and Dev Anand. But I know of no major hero before Bachchan to have entered such an intensive, and above all public, mimetic relay with the urban subaltern constituency represented by his screen persona.[26] While the young men on the street imitated him, his films drew on stories of pre-Emergency working-class agitations and subaltern heroism: the 1974 railway strike in *Coolie* (1983) and the 1975 Chasnala mining disaster in *Kala Patthar* (1979).

Crucial to this relay was a mutually imitable style, a mode of corporeal distinction that drew on the figure of the "loafer" but gave it a cosmopolitan edge. Significant here was Bachchan's ability, emanating from his middle-class but also Hindi-speaking background, to negotiate fluently between various local Hindi dialects (Bombayya, Banarasi, "Bihari") and impeccable English, often via humorous dialogues using Hindi-English word play, usually at the expense of English. Again, as in the case of Sardar, what we are seeing here is the generative force of a habitus that is not totally congruent with, or determined by, the social field from which it emerges. If Sardar's blurring of the boundaries between bodybuilder and wrestler, or between Muslim and Hindu set up a mimetic circuit that changed iconographic conventions, Bachchan's blurring of social distinctions, in particular those between vernacular and cosmopolitan, set off a mimetic circuit that inaugurated a new kind of Hindi film hero.

M. S. S. Pandian has described how M. G. Ramachandran (MGR), too, drew on the idioms of subaltern heroism, particularly folk ballads, to shore up his popularity with subaltern audiences (Pandian 1992). However, Pandian goes on to demonstrate how the appearance of social-political dissent in MGR's films is counteracted by achieving narrative resolution within the "moral economy of the system" and thereby preserving the status quo (69–73). Wicked Brahmins and landlords against whom MGR has fought in

his roles as a subaltern hero are simply given a chance to reform themselves as individuals, while in his elite roles MGR establishes his supreme virtue as a renouncer, giving away his wealth and status and marrying "lower"-caste or lower-class women. Even in his subaltern roles MGR is characterized by a certain *noblesse oblige*: while he is oppressed, he is not desperate, not *hungry*. Thus despite giving up mythological roles in accordance with the ideology of his party, the Dravida Munnetra Kazhagam (DMK), his preservation of the moral order, combined with his fair, soft, plumpish body and a rhetoric of renunciation that presupposes an elite speaking position, ultimately enabled MGR to be deified by his fans (113–17), rather than becoming the subject of mimetic identification.

Bachchan, in contrast, could not be described as a devotional icon in the manner of either MGR or NTR (who played predominantly mythological roles and, as suggested above, systematically shored up the image of himself as an avatar of Krishna). Even though the Bachchan hero often does originally have a patrimony, he has not willingly given it up: it has been stolen from him. Far from being a morally unimpeachable renouncer who has earned the right to criticize society (Alter 1994, 48), Bachchan's social critique stems from wanting more than he is legally allowed to have, even though it is justly his due. In this post-Emergency scenario where it is clear that the law and social justice are on opposite sides, with morality giving its blessing to the law, Bachchan does not emotionally preach moral reform (except, of course, to women), but uses his bodily force to fight for justice. This bodily strength does not fit within a model of devotion: he is not a Hanuman-like "Jai Kisan" or, indeed, the missing "Jai Mazdoor" (worker). Even as he is abject before the mother-figures in his films, his relationship with them is impossible, fraught, and alienated, for unlike the "good" brother he is no son of the paternal state: it is this deeply inscribed alienation that propels the narrative. In contrast, therefore, to the celibate wrestler whose strength derives from the moral purity, discipline, and devotion of his body and the matter that flows in and out of it, or the canonical Ram images with their calm, timeless transcendental agency, Bachchan's is a goal-driven, instrumentalized body, its noisy (*dhishoom-dhishoom!*) power derived from its own immanent hunger. Its aesthetic fascination is not so much that of the smooth, holistic "body of one color," or of the "disengaged," effulgent radiation of affects from within via the eyes and face (Bachchan is not a star of the facial close-up), but precisely that of its engagement with other bodies and objects, and the varying intensities of these encounters: shooting mangoes off a tree or cavorting on a motorcycle (*Sholay*, 1975), leaping out of a giant Easter egg (*Amar Akbar Anthony*, 1977), looking for a lost shoe (*Namak Halal*, 1982),

getting stuck in a yoga position while making an omelet or fighting the capitalist villains with a hammer and sickle (*Coolie*, 1983).

The feeling generated across the Bachchan oeuvre is that once attention has finally been focused on the body, there is a concerted attempt to explore just what that body can do. Despite his "angry young man" rubric, it is not just the fight sequences that draw attention to Bachchan's body and its capacities, but also other "paranarrative" elements such as his song and dance routines, where his long limbs are often used to comic effect, or his often very physical comedy routines.[27] To this extent, even as Bachchan's body is not reducible to a signifier of lumpen assertion, it becomes a site for polymorphous libidinal investments that are also not reducible to the kind of spectacular eroticization or sexualization that occurs with the overtly muscle-bound, singlet-wearing, bodybuilding film heroes of the post-liberalization period. Take, for instance, the way in which several Bachchan films are characterized by a focus on the chest. In the romance *Silsila* (1981), in a scene totally excessive to the narrative, Amitabh is lying under a tree with Rekha draped over him, ostensibly running her fingers through his chest hair. He asks her "Yeh tum kya kar rahi ho?" ("What is this you're doing?"), to which she replies "Aisa karna mujhe bahut achha lagta hai" ("I really like doing this"). In this film, we not only see him (that is, his top half) nude in the shower with his bosom buddy Shashi Kapoor, but he almost never wears a shirt under his suit jacket, so his chest becomes an intense libidinal focus for both the camera and Rekha (figs. 148 and 149).[28] This accords with a bodily schema in which the chest (in Hindi *chhati, seena*) is the privileged locus of a masculine essence and the qualities associated with it: devotion, friendship, bravery, pride, and also loyalty, the quality that is centrally at issue in this film. The occurrences on Bachchan's chest across several films are particularly interesting when contrasted to the iconography of Hanuman, whose chest, as we have seen, is occupied by the image of Ram. In *Namak Halal*, for instance, Bachchan tears his shirt open to reveal the heroine Smita Patil's face: human, heterosexual love replaces abjection before the divine. Or again, in *Mard* (1985), set in the colonial period, he plays a *tangewalla* (horse-cart driver) whose princely father was captured by the British when Amitabh was a baby and whose only patrimony therefore is the word his father had inscribed with a knife on his tiny son's chest: *mard*, man, not just a human but a sexual being (as we find out owing to the sadomasochistic efforts of the whip-wielding heroine Amrita Singh).

Even as Bachchan's chest visually paves the way for later, more sexualized and muscularized figures of virile masculinity, its resonance with the iconography of Hanuman

148. Shashi Kapoor and Amitabh Bachchan professing their friendship as they shower together, *Silsila*, 1981. (Courtesy of Yash Raj Films)

149. Rekha, Amitabh Bachchan (with chest on display), and Jaya Bachchan (nee Bhaduri): the love triangle in *Silsila*, 1981. (Courtesy of Yash Raj Films)

maintains a tie with the visual idioms of the bazaar. Once again, despite the goal-driven "individualism" and "self-indulgence" that ideologues of *brahmacharya* equate with the influence of the West, the figure of Bachchan does not invoke the kind of Western realist subject associated with the paintings of Courbet, the psychological novel or drama, or even the imaginary identification said to characterize the "classical" Hollywood narrative cinema. There is little sense in his films of an attempt to portray subaltern life accurately, no complete absorption of the viewer into the diegesis, no oblivion toward the facticity of the image, no preoccupation with the inner workings of the protagonist's mind. There are, instead, many instances of an irrealist, self-reflexive foregrounding in Bachchan films of the medium's own performativity: spectacular and "paranarrative" elements, direct address to camera, comments about the cinema, or, famously, the freeze-frame in the film *Coolie* at the point where Amitabh was injured in an accident during the shoot.[29] Or again, as part of the ongoing mimetic relay between Bachchan's virtual and actual personae, *Silsila* mirrored Bachchan's real-life romance with Rekha while he was married to Jaya Bhaduri, with both women acting in corresponding roles in the film.

Indeed, I would contend that mimetic identification with the Bachchan figure is enabled not by "realism" but, on the contrary, by the circuit this figure establishes between the facticity of the image — its material surface, its existence as an object in the present — and that which the image represents, refers to, resonates with, and brings into being: that is, between its actual and virtual aspects, holding both in view at the same time and making it possible to see how the one might transmute into the other.[30] It is in this respect that the mimetic engagement with Bachchan on the part of young urban men maintains its mass-cultural links with the devotional idiom of the bazaar, and with the genealogy of performative identification that I have traced above: wrestlers becoming the monkey-god through obeisance to the object that is his image, priests becoming desiring women clutching icons to themselves in ecstasy, the painter flexing his muscles in the mirror to become a calendar, the slum boy thrusting out his chin and chest, a picture of Amitabh stuck on his shirt pocket, next to his heart (fig. 150).

RAMIFICATIONS

At this point I must attempt to curb my own libidinal engagement with the image by stating (what I hope by now is) the obvious. My argument has been that the Bachchan persona made visible and available a bodily modality — and thereby a ground for subjectivity — where the male body became a libidinalized site for the production of value

150. A self-portrait by Vikram, a boy at a municipal primary school in Ahmedabad, produced at an art workshop I conducted there in 1984. Vikram had a picture of Amitabh Bachchan stuck on his shirt pocket; he has taken care to include it in his self-portrait, where it appears proportionally much larger than its actual size, indicating its importance to him and his sense of self.

through its engagement with other bodies and objects. In doing so it set in train a mimetic circuit that returned to the bodies of young urban men a growing assertion of the value of bodily agency and labor, lending itself to the politicization of the working classes and castes in the early 1970s: a deterritorializing movement. However, my intention is not for a moment to celebrate Bachchan as an inherently progressive figure of working-class and working-caste resistance. Looking at the image as a circuit between its virtual and actual aspects is precisely a refusal to implicate it within the moral terms of good and evil (progressive and regressive) or true and false; instead, it helps to trace some of the different, often contradictory directions taken by the political currents passing through this circuit. For the Bachchan figure has also been subject to reterritorializing movements, which have recoded and rehearsed this image and its energies in at least two (related) ways: through the articulation between instrumental muscularity and the twinned processes of economic liberalization and the reformulation of Hindu nationalism. As I have outlined, the Congress regime up until the Emergency was characterized by a nexus between

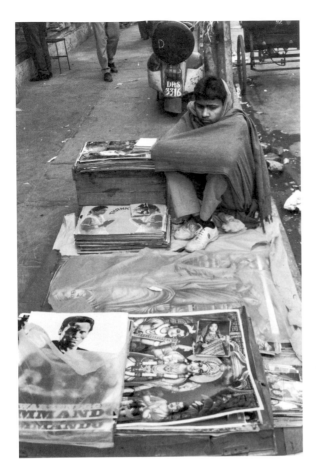

151. Models of masculinity, Delhi, 1991: a pavement poster seller with posters of Arnold Schwarzenegger in *Commando* (1985) alongside images of Satyanarayana (a form of Vishnu) and Swami Vivekananda.

the bazaar and the state that allowed for the culture industry's perpetuation of certain symbolic aspects of caste and class hierarchy, including the inscription of state power as emanating from a transcendental source. The Bachchan film persona challenged this transcendental form of state authority through its mimetic engagement with urban subaltern youths, which allowed for a nonabject *performance* of instrumental, adult, human embodiment hitherto unavailable within the ethos of Indian mass culture. This challenge, in turn, called forth new configurations of both state power and sacred power within the culture industries—which is not to say that they necessarily replaced the "old" ones, only that they, too, entered the fray (figs. 151 and 152).

With respect to the reconfiguration of the sacred, the popularity of this newly muscularized modality of bodily agency in the field of images posed a threat to a canonical symbolic order based on a transcendental source of power. The Hindu nationalist response to this was to take this new modality on board and reassert the supremacy of

152. A poster depicting Arun Govil and Deepika Chikalia as Ram and Sita in the *Ramayan* television series of the late 1980s, published by KCC (probably Kwality Calendar Corporation), Delhi. Unlike the Hindu Right's aggressive, martial Ram images, this series (which began under the auspices of a Congress government) did not seek to reconfigure the canonical iconography of Ram. (Collection of JPS and Patricia Uberoi, Delhi)

the gods within its terms of reference, by *defensively reappropriating* the muscular body in the form of the aggressive Ram. The *ugra* Ram can therefore be read as a way of harnessing the energies embodied in the figuration of a muscular, masculine, human force back to a sacred economy. This figure, in turn, engendered a new set of contradictions. If the question to be asked of the tranquil Ram is how exactly he is able to vanquish his enemies without the use of bodily force, one might equally wonder why, if the muscular Ram really is all powerful, he needed an army of human devotees to defend his birthplace in Ayodhya. Both these questions, however, are underpinned by—and obscure—the central issue of how a society is able to depend on the labor of the working castes without acknowledging this dependence, or the value of that labor. For what is at stake in the muscularity of Ram is not just how violence and aggression come to be made visible through the "virile" male body, it is also how male labor comes to be devalued and abjected even as it is made visible—and women's labor doubly so.[31] To overlook this

context for mass-cultural images is to continue to function within the terms set up for us by the culture industry and the ethos of the bazaar, as well as by the state's lingering taboo on acknowledging the persistence of caste. Taking this context into account, in contrast, means that instead of reading the muscularity of the Ram figure as a symptom of Hindu nationalist violence, we can read the violence of Hindu nationalism itself as an index of the upheaval in the existing order, owing in no small measure to the growing political assertion of the working castes.

With respect to the reconfiguration of state power, the disappearance of political "leaders" from the calendar and poster market suggests that the state is no longer able to draw on the iconic powers associated with the nation—although political propaganda, particularly that of the Hindu nationalist parties, strives valiantly to maintain that association. Here it is significant that there was a close association between Amitabh Bachchan and the last of the calendar art "leaders," Rajiv Gandhi. Bachchan used his film persona to help his real-life bosom buddy Rajiv, the latter appropriately cast in the Shashi Kapoor mold (fair, smooth, pudgy, cow-eyed, full-lipped). The film *Coolie* blatantly paved the way for the 1984 elections in which Bachchan was elected as a member of parliament representing Rajiv Gandhi's Congress(I): a party that had its basis in the feudal authority of a ruling family, but also, significantly, ushered in an era of economic reform that would open India's markets to global corporations, lending agencies, and regulatory institutions. In this context, the reformulation of the iconographic canon to incorporate instrumental muscularity into figures of power, status, and desirability can also be seen as part of the mutual accommodation between a reconfigured Hindu nationalism and the dominant moral economy of globalized corporate capitalism. For the reassertion of the value of the laboring body is also recuperable to liberal (that is, Lockean) notions of self-ownership that, within the institutions of global capital, translate on the one hand into the privileging of value creation by individuals or corporations rather than communities (that is, intellectual property regimes), and on the other hand into the commodification of the body (see Frow 1996). (These ideas are also discussed in chapter 4 in relation to authorial property.) This liberal package is incommensurable with the moral economy of bazaar Vaishnavism as described in chapter 5, where religious and commercial practices are imbricated with caste hierarchy and the location of value in the realm of circulation. However, this antagonism is contained by the reformulation of Hinduness/Indianness in terms of an overarching identity characterized by well-defined, discrete, visible or assertive, and portable "cultural" practices, such as the

Hindu wedding, which was the (local and diasporic) Indian culture industry's magnificent obsession through the 1990s: a fast-naturalizing reformulation that was palatable to Hindu nationalists and their opposition alike.[32]

What these reformulations have meant for mass-cultural images of male bodies and their exchanges with flesh-and-blood men deserves careful analysis; all I can offer here are a couple of observations. First, it is evident that the Bachchan figure (followed by Shah Rukh Khan) mediated between the romantic Five Year Plan heroes and a parade of buffed post-liberalization hunks in cinema, advertising, and music videos, whose appearance accompanied an intensified interest in gyms, bodybuilding, and men's fashion and cosmetics, as well as an era of male (and female) beauty contests. These muscular male bodies articulated both with a newly intensified commodity culture and with an explicitly violent nationalism, as evidenced in the rash of films related to border conflict and terrorism dating from the second half of the 1990s. Second, an added range of mimetic circuits came into play after liberalization, particularly owing to the enhanced presence of the media in everyday life, as well as to increased dealings with transnational corporations. To cite some instances here: in 1990 during the Ramjanmabhumi campaign L. K. Advani, the president of the Hindu nationalist Bharatiya Janata Party, led a chariot procession (*rath yatra*) across the country, where he appeared on a golden chariot dressed in saffron and holding a bow and an arrow in imitation of Ram (note, not of his devotee Hanuman): this was not a case of the "humanization of the gods," but of the apotheosis of a human. In the popular turn-of-the-millennium television talk show *Movers and Shakers* the comedian Shekhar Suman (who styled himself after Jay Leno) served up imitations of celebrities, particular favorites being the politicians Sonia Gandhi and the "backward" caste leaders Laloo Yadav, his wife Rabri Devi, and Mayawati. The *frisson* accompanying the mimicking of a "lower"-caste body by an "upper"-caste one was evidenced in the way reports were circulating (and being denied) in September 2004 about the casting of the beauty queen turned film star Aishwarya Rai as Rabri Devi in an upcoming film. Meanwhile, new generations of television-saturated toddlers took on the ability to replicate in uncanny detail the choreography of their favorite Hindi film songs; Silicon Valley started offering "Bollywood" dance classes; while in "offshore" call centers servicing U.S. firms young Indian men and women began to adopt North American names, accents, and (by all accounts) aspirations. These mimetic circuits inscribe on people's bodies the negotiations between the vernacular culture industries, Hindu nationalism, caste politics, and transnational economic flows.

The Bachchan star persona masterfully adapted itself to this changing context through Bachchan's phenomenal comeback in 2000 as the host of Star TV's *Kaun Banega Crorepati*, the Indian version of *Who Wants to be a Millionaire?* The reincarnated Bachchan became a brand ambassador par excellence, the "angry young man" morphing into a dapper, white-bearded elder statesman exhorting people to consume "because I say so" ("ham keh rahe hain," as he put it in the 2004 Nerolac Paints campaign): in other words, he became a new locus of pure, absolute, *nirguna* (that is, devoid of qualities or attributes) authority. The Bachchan persona's mix of vernacular and cosmopolitan in the 1970s and 1980s flexed the canon by unsettling the iconography of male power. In the post-liberalization era the mix of vernacular and cosmopolitan *is* the canon, flexing its muscles as it luxuriates in its newly found power and beauty; in the conclusion I assess what this might mean for what I have been calling the "vernacular" culture industries.

Anuradha Kapur, movingly searching for a redemptive note on which to end her essay, finds solace in the fact that the "older," compassionate images of a benign and gentle Ram are still in circulation and are unlikely to be driven out by the newer "images produced by a moment of violence." Similarly, the "older" Bachchan is very much in evidence, his classic films still circulating on television, video, and DVD. I have tried, through a narrative that is as tight and synthetic as the pants of a 1970s or 1980s "loafer," to show how cultural critique doesn't necessarily have to choose between the new and the old versions, both of which have their regressive and progressive, de- and reterritorializing aspects. It also has the option to expropriate such iconic images and performatively reimbue them with other, anti-canonical countermeanings — even if it takes a bit of productive mimesis, or monkey business, to do so.

CONCLUSION

This study of the networks of Indian calendar art has shown how the (post)colonial "bazaar" is a peculiarly slippery term, describing a formation constituted by and integral to colonial trade yet at the same time demarcated by colonial knowledge as a separate, "informal," "native" realm. As part of a vernacular arena, it is comprised of idioms "born in the master's house": that is, they are disjunct and subaltern yet contemporaneous and interconnected with the dominant discourse, engendering the coexistence of epistemologically parallel yet pragmatically and performatively interconnected worlds. This coexistence has persisted into the post-independence era, such that Indian subjects have had to negotiate their participation in various types of ethos, ranging between vernacular and cosmopolitan or "English-medium." This issue of the postcolonial disjuncture between knowledge formations and social practices underlies my analysis of how the production, circulation, and consumption of bazaar images confounds the modernist narrative of the supersession of the sacred by art, and with it the attendant distinctions between religion, art, and commerce, between fetish objects and (re)productive subjects, between the visual or ideational and the corporeal. Thus I have argued that these images signal some of the ways in which modernity exceeds its own—very powerful—stories about itself. On the way, I have also sought to demonstrate what is yielded

through a methodology that goes beyond a forensic-juridical approach to images by combining textual "readings" with attention to contexts of production and, in particular, the circulation of images. By way of conclusion, I aim to consider how this analysis might be relevant to understanding the post-liberalization scenario in India, and contemporary processes of globalization more generally. Further, I want to speculate about the issues it raises for art history and art practice in the present and the immediate future.

RAVI VARMA REDUX

Let me approach the first set of questions by returning to Sivakasi. In 1994 Srinivas Fine Arts was already one of the largest, most technologically advanced presses in Sivakasi; it was among the first to have introduced computerized scanning. I interviewed its managing director and co-owner, the most senior of seven brothers who oversaw different aspects of the firm, in a cramped (but air-conditioned) office amid the din of printing machines. On the wall was a sticker, commonly circulating at the time, declaring (in Hindi) "Garv se kaho ham vyapari hain, garv se kaho ham Hindu hain" ("Proudly declare that we are traders, proudly declare we are Hindus"). As we talked he continued to take business calls well after seven in the evening, speaking in a suppressed tone like that of Marlon Brando, which added to his somewhat "Godfatherly" aura, as did the presence of a close associate, a Gujarati man representing Srinivas's paper dealership in Bombay, who corroborated and expanded on what he was saying. He described how his firm had started in the late 1960s as a trading agency, dealing in boxes for incense and locally produced cosmetics, and packaging labels for other goods and printed stationery (particularly school exercise books and graph paper) for clients all over the country. In 1970 the firm began its own printing, further expanding into paper distribution as a response to the paper crisis of the early 1970s, thereby ensuring adequate stock for its presses. One of the brothers, a mechanical engineer, spent a couple of years in Germany with a printing machine manufacturing firm and came back to oversee machine maintenance at the press; the managing director's son had just returned from a training stint in the United Kingdom and was now in charge of its computerized section as well as spearheading its expansion into the export market. While Srinivas mainly catered to the domestic market for corporate promotional materials (packaging, calendars, and advertising materials such as point-of-purchase displays), it had doubled its exports over the previous year from 2.5 to 5 or 6 crore rupees (approximately U.S.$1 million). Capitalizing on India's low paper prices, Srinivas collaborated with the paper company ITC Bhadra-

chalam to provide notebooks to the U.S. market as well as printing stationery and books (particularly children's books) for the United Kingdom, the Middle East, Singapore, and other parts of Southeast Asia, dispatching shipments from Tuticorin and Chennai (then Madras). At this juncture the press was still a vivid exemplar of the mixed form of industrial organization I described in chapter 1, a family-owned and family-managed business combining a formal adherence to industrial tax and labor laws with a reliance on unorganized casual labor and small-scale, semi-formal or informal ancillary providers.

When I returned to Sivakasi in 2001, Srinivas Fine Arts had undergone a sea change, at least in its physical appearance. It now boasted a huge, spanking new building with marble floors, central air conditioning, open plan offices, a reception area, (plastic) pot plants in brass urns, skylights, coffee vending machines, and corporate signage; the Hindutva-inflected stickers had been displaced by an English-language "quality policy." Workers were in uniform, and trolleys and motorized carts had replaced head-loads for transporting stacks of paper and prints, although, tellingly, the number of full-time workers had not grown beyond the approximately six hundred enumerated at my previous visit (suggesting that subcontracting and casual labor were still significant but less visible). The attention to self-presentation here certainly surpassed that of any press I had seen in Sydney (where I worked for several years as a graphic designer). This time the front man was the managing director's son, a young man in his late twenties or early thirties, now just as busy as his father had been when had I met him. He told me that since I was last there the attempt had been to shift the focus of the company from simply filling print orders from other manufacturers or publishers to dealing more directly with the ultimate clients for printed products, particularly stationery and corporate gifts. The latter were now being produced under their own brand name of Nightingale, catering both to the retail market and to corporate clients. Styled after samples collected by some fourteen people who had traveled to research the markets in Asia (mainly China and Indonesia), the Middle East, the United States, and Europe, these were a far cry from the predominantly religious calendars and posters that had hitherto lubricated the networks of the bazaar (fig. 153). The glossy samples I was shown included *Our Love Story*, *My First Years*, *The Wedding Book*, and *Summer and Winter Recipes*, signaling an emphasis on Hallmark-style secular life-cycle rituals and seasonal events rather than religious ones. The responsibility for "blending" elements from overseas samples and coming up with Nightingale's products lay with an in-house designer, a young Sivakasi man with no formal design training who had picked up his skills at the press. While these stationery

153. A computer artist retouching the artwork for a calendar, Sivakasi, 2001.

products were mostly aimed at the domestic market, the press was continuing its expansion toward exports, with agents facilitating orders from Europe (particularly the United Kingdom) and the United States. The family firm was pursuing a long-term strategy of diversification, according to the Srinivas heir, since printing was a very "tight" business with high capital investment and low margins of return. Computers would eventually lead to a reduction in demand for stationery, he explained, while Chinese and Indonesian paper products were becoming increasingly competitive, so his firm was pursuing interests in other areas such as a textile mill and trading in consumer goods (he did not specify which ones).

In some ways the spectacular transformation of Srinivas Fine Arts, with its adoption of a certain generic corporate style within a default ethos of English-medium secularism, represents the visible manifestation one might expect of the impact of economic liberalization and the engagement of Indian manufacturing and markets with "global" protocols. However, such transformations tell only part of the story of the renegotiations being undertaken between global capital and what I have been calling the "vernacular" arena of the bazaar. For instance, as I left Srinivas I was kindly given a ride by one of the seven brothers, who told me that the managing director was away in Sabarimalai, the sacred hill at the center of the immensely popular southern Indian pilgrimage cult of Ayyappan. This was peak pilgrimage season (mid-January) and Srinivas had a stall there that was doing a roaring business in stationery, diaries, and calendars, which was worth

Rs. 2 crores (approximately U.S.$400,000) over the pilgrimage month. As he put it, his brother was "mixing some relaxation, business, and worship of the god." He added that the Sabarimalai pilgrimage, with its flow-through of approximately 10 million pilgrims, represented an enormous marketing opportunity for the "advertising media." In other words, not only was Srinivas still conducting a thriving business aimed at a religious constituency, but also (as I described in chapter 1) the corporate advertising media, which in the post-independence period had primarily been concerned with an English-speaking public, were now enthusiastically rediscovering the nonsecular, vernacular mass market.

The eager embrace of the vernaculars by advertising agencies and the media (particularly television), driven by transnational marketing interests keen to expand their consumer base, is reminiscent of colonial trading firms' use of popular Indian motifs on commodities for a mass market. Indeed, this provides grounds for conjecture that the processes unfolding in the interim period between independence and liberalization that produced the "split public" (Rajagopal 2001) were peculiar to a regime of economic nationalism, where the access of the "masses" to consumerist modernity was mediated by English-educated gatekeepers and a protective developmentalist state rather than flowing more directly from the market. In this scenario English education remained the prerogative of the elite. In the more recent scenario, local advertising professionals—still primarily English-educated, but now from a wider range of backgrounds—conduct the work of translation across moral and libidinal economies, naturalizing consumerism as a means of participating in "Indianness" (on the creation of the category of the "Indian consumer," see Mazzarella 2003).

Contrary, then, to the triumphal discourse of resistance to cultural imperialism, based on the oft-cited instances of MTV having to "Indianize" itself, or the proliferation of vernacular-language television channels (see, for instance, Page and Crawley 2001), what is under way in the post-liberalization era is not so much a case of resistance by a preexisting Indianness, but a concerted attempt to refashion the categories of "Indian" and "Western"—indeed of culture itself—to accommodate consumerism. Again, this process of selective reformulation is reminiscent of the work of the vernacular culture industries in forging national and other identities in response to the colonial encounter: asserting cultural difference, but through the adoption of formal idioms and epistemological frames that undermine this assertion. Much as Ravi Varma sought to incarnate Indianness through the idioms of European neoclassicism, taking on board colonial civilizational narratives, in many respects the post-liberalization Indian culture industries

are seeking to reformulate Indianness within India in consonance with the narrow characterization of culture informing metropolitan multiculturalisms. According to this characterization, "culture" describes circumscribed, globally portable signs of heterogeneity such as language, dress, food, music, art, rituals, and festivals that are grafted onto the protocols of a putatively universal, but in fact highly specific, or as Dipesh Chakrabarty puts it "provincial," modernity (Chakrabarty 2000). Circumscribing the domain of culture in this way allows the relegation of such visible, mobile forms of cultural difference to an arena of leisure separate from the concomitantly more homogeneous, more secular, and (putatively) less vernacular realm of work. It also enables the harnessing of cultural identity to the logic of niche marketing, whether of political messages (directed at "vote banks"), government policies, or consumer goods.

How have the post-liberalization culture industries worked to accommodate vernacular forms within the universalizing matrices of the dominant culture of globalized capital? There appears to be a double movement at work, such that one set of processes creates identifiable symbols of cultural identity while another lays down the universal ground within which these markers of difference operate. Take, for instance, the "sheeter" calendar for 2001 at the Coronation Press in Sivakasi, which features black and white illustrations celebrating the "Indian family" in a style reminiscent of the Hallmark sensibility in evidence at Srinivas Fine Arts. These images serve to construct a specifically Indian identity based on the popular Indian conception that the family is more important to Indians than to westerners, but in doing so they mobilize a (newly) borrowed formal idiom and resonate with a "universal" notion of "family values." Similarly, soap operas on television construct their versions of the culturally specific Indian (Hindu) family in the interstices of advertisements for consumer goods produced by transnational firms. And while the content of television shows and the print media caters to a range of linguistic and other identity projects, television programming schedules and advertising in general institute a universalizing regime that qualitatively denominates time and space in terms of ideas about the proper preoccupations of subjects according to age, gender, class, and so on. Or again, spectacular participatory events such as ceremonies and festivals are harnessed to national, regional, or sectarian "cultural" (in the narrow sense) identity projects while simultaneously serving as sites of intense consumption (as in the case of private weddings or festival parties) or opportunities for corporate sponsorship (as with the public, community-based displays for Durga Puja in Bengal or Ganapati Utsav in Maharashtra, and a plethora of other spectacular events such as fashion shows, concerts, beauty contests, and award ceremonies).

One impetus behind the establishment of markers of difference within a universal-izing matrix is the transnational spread of the knowledge formations of marketing and advertising, and their modes of classifying and constructing subjects. So, for instance, advertising agencies in India—the new Ravi Varmas, if you will—often use proprietary analytical models from their parent companies overseas, filling in the blanks with con-tent specific to Indian market segments. Also pertinent to this process of cultural self-definition within a circumscribed notion of culture are the circuits between India and the "diaspora," which meld the concerns of multicultural identity politics in various over-seas locations with assertions of identity in relation to the Indian nation-state. This is particularly evident in the commercial Hindi cinema, whose orientation shifted in the 1990s from extensive distribution to mass audiences within India toward the more lucra-tive metropolitan (and specifically multiplex cinema) audiences in India and overseas, telescoping together the resident and nonresident middle class. Some features that char-acterized this shift in the cinema include the hyper-elaboration and recodification of the "Indian" wedding, a prime instance of a globally portable marker of identity, as well as a site of exchange and networking between resident and nonresident Indians (see chap-ter 7 n. 32); the adoption of English phrases, Western references, and simplified Hindi, particularly in songs, such as "Urvasi, Urvasi" from *Kadhalan* (1994) or "I Love My India" from *Pardes* (1997), where Indian identity is expressed in nonvernacular terms; a pro-liferation of jingoistic themes; a stronger resonance with Hollywood-style generic dis-tinctions, as with the rise of horror and gangster films; and a self-reflexive nostalgia for earlier eras in the cinema that pervades film, television programming, and the music and DVD/video industries, as encapsulated in the "Woh Ladki Hai Kahan" song from *Dil Chahta Hai* (2001), which took a historical journey through Hindi film song and dance sequences.

This nostalgia for earlier products of the culture industries (including calendar art) speaks to a certain kind of historicism—again, a universalizing vector of linear time—that is instituted in parallel with the messy recursions at play in vernacular cultural pro-duction, which are of a different temporal order (see Pinney 1997a). In part this newly salient historicism enables the translation of historical value to financial value, as in the case of the recycling and repackaging of old Hindi films and film songs, or the Osian's exhibitions and auctions from 2001 onward that systematically set out to give value to film posters and calendar art in the collectors' market by placing them within a historical narrative (see chapter 1 n. 16). Circuits of migration and travel also give this historicism a spatial dimension, working with new intensity to cast nonmetropolitan India as anterior

along a developmentalist axis (this already informed cultural production in the era of post-independence nationalism, as discussed in chapter 5). Thus post-liberalization film, advertising, music videos, and calendar art have also been informed by another kind of nostalgia, tinged with exoticism, which recasts India as a land of idyllic, colorful villages and exquisite palaces. When I revisited the Sivakasi presses and northern Indian print retailers in 2001, the most popular new prints were those featuring idealized rural scenes from Punjab and Rajasthan: imagery that spoke at once to tourism, colonial stereotypes, and the nostalgia not only of overseas migrants but of internal migrants from rural to urban or industrial areas (see figs. 154 and 155, as well as fig. 24).[1]

THE LAST MILE

It is crucial to recognize, however, that these universalizing processes in the mediascape do not signal the demise of vernacular economies (whether or not they can still be classed as part of the bazaar formation), the total reification of difference, or the homogenization of moral, commercial, and libidinal economies. On the contrary, as with the colonial bazaar, the encounter between economies cuts both ways. At the level of economic organization, it is evident that the larger and more successful of the family businesses emerging from the bazaar are increasingly adopting "global" styles of corporate organization and management; the transformation of Srinivas Fine Arts can be seen as part of that mutation. However, this kind of corporate style, as well as the formal protocols of capitalism that are most visible and efficacious when they intersect with governmentality at the level of trade agreements, the stock market, and taxation, are progressively more subject to informal arrangements when it comes to the conditions of production or, at the other end, as they approach the "last mile": the individual consumer or end-user of goods and services. Like the bazaar communities in colonial trade, an intermediate entrepreneurial class has emerged in the "gray" zone between the formal corporate structures of transnational firms and first or last mile producers or consumers. Many of these entrepreneurs have made good on the strength of their ability to adapt new media and manufacturing technologies to "vernacular" systems of production and distribution.

A good instance of this interface with informality is the way in which cable television came to penetrate millions of urban households in India over the 1990s. At the broadcast network end, where players include the Murdoch-controlled Star TV, Sony Entertainment, the Discovery Channel, and so on as well as a number of India-based networks including the state channel, Doordarshan, the system soon conformed to most of the standard procedures for global corporate practice: a formal management structure,

154. Artwork for a calendar design by Aziz, conjuring up an exoticized Rajasthan indexed by camels, an itinerant musician, and a bejeweled, veiled woman, Sivakasi, 2001.

155. *Ancient India* by V. V. Sapar, a design for a four-sheeter 1996 calendar in the style of colonial prints such as those of the late-eighteenth-century, early-nineteenth-century Daniell brothers. (Courtesy of the artist)

"transparent" bookkeeping and annual reports, apparent adherence to labor and other corporate laws, observance of intellectual property rights, and so on. However, when it came to the distribution companies, the multiservice operators (MSOS) mediating between the networks and the neighborhood cable providers (last mile operators or LMOS), it has been a very different story. The neighborhood cable-wallas typically underreport the number of connections they have to the MSOS and the networks; they also charge on a nonstandard sliding scale depending on the wealth of the neighborhoods they are servicing. At this end the system's informality has often shaded into criminality: in the early 1990s, before the MSO providers were amalgamated under the umbrella of three or four large companies, there were several murders in connection with turf wars among cable operators. Cable operators have also been subject to extortion threats, particularly around important cricket matches: one prominent MSO I met in Ludhiana actually had his studio vandalized and was unable to broadcast an India-Pakistan match when he refused to hand over tens of thousands of rupees to extortionists. This MSO and others I met started out as independent television repair technicians or video rental and/or satellite connection providers (again, with a significant component of piracy). Another man who now runs a large television production studio and a DVD, video, and cassette distribution business in Mumbai started as a village grocer in Gujarat who then turned his hand to renting and pirating tapes. Significantly, very few of the people I met in these positions were totally comfortable in English; some of them, such as the man in Mumbai, spoke no English at all.[2]

In short, what the colonial moment reminds us when thinking about post-liberalization India is that while vernacular idioms are subject to "globalizing" processes, the penetration of these processes in turn relies on an articulation with "informal" and/or vernacular systems. There can be no doubt that such systems play a significant role in the way things actually function on the peripheries—and therefore at the heart—of "postindustrial" society. All over the world, the expansive movement of capital characterizing colonialism as well as later processes of national development and transnational globalization has been fed by this play of difference: the simultaneous articulation and tension between "formal" and "informal" commercial economies; between vernacular and cosmopolitan idioms; between liberal and variously illiberal moral economies and structures of social organization and exploitation. One end of the continuum of informality is illegitimate to the point of criminality: unauthorized labor, the trades in drugs, organs, and people, piracy, smuggling, environmentally hazardous practices, illegal con-

struction, slum landlordism, extortionism and protectionism, money-lending and other kinds of informal credit systems. Indeed, it could be argued that the policing of the formal economy pushes informal systems into criminality (as with the increasing association of the *hundi* system with criminal activities). Yet at the same time informal economies intersect with the formal economy and organs of government, whether in the production and delivery of goods and services or in issues of welfare and administration.

All of this is grist for the mill of cultural problem solving, and of value production as capital jumps back and forth, switching tracks between moral economies. In other words, as I elaborated in chapter 5, the encounter between different moral, commercial, and libidinal economies can be highly productive. The universalizing, deterritorializing aspects of capitalist expansion tend to make us forget that capital in its reterritorializing aspect thrives on difference: it is a difference-eating machine. In the process of exploiting difference, it networks its constituencies together into a relationship of deep interdependence—indeed, a mutual constitutiveness. And yet in order to maintain the play of difference—albeit progressively more circumscribed and reified—this interconnectedness must be subjected to a series of disavowals: the disavowal of the informal by the formal economy; the disavowal by various identity claims of their own derivativeness and interdependence; the mutual disavowals of modernity and the sacred. For the play of difference thrives on the discourse of difference, perpetuating the discursive formation of various others: colonialism's othering of the native in the instance of the bazaar, elite developmentalism's othering of the masses in the Nehruvian period, the auto-othering inherent to the culturalist identity projects (including cultural nationalism) proliferating in the era of neoliberal globalization. Such disavowals pose a practical, ethical problem to the extent that any policies or analyses that do not engage with the contemporaneous existence of epistemologically parallel economies are bound to fail, or worse, become pernicious. When the discourse of difference is not accompanied by a simultaneous recognition of mutual interconnectedness it engenders a distancing, reifying, and potentially antagonizing relativism: the discourse of "us" and "them," the "clash of civilizations," the other as an unfathomable, impossibly distant and hence threatening stranger. Against this, what is at stake here is understanding the nature of the global networks that we *all* inhabit, without reducing the nodes in those networks to a universalizing schema. Or put another way, it is about what becomes possible when one recognizes that the other, while different, is not such a stranger; it is one's stories about oneself that make the other strange.[3]

SOME UNFINISHED BUSINESS

One of the things this book has tried to do is show how a form such as Indian bazaar art, or calendar art, is just that kind of not-such-a-stranger to the disciplines of art and art history. From one point of view I have no business speaking of calendar images and art in the same breath—they are patently not the same thing. Calendar images are commercially driven and functional objects: that is, they are neither autonomously produced nor disinterestedly received; their imagery is in large part formally derivative and conservative rather than intensifying and expanding the ways in which we sense, think, and act in the world. By that measure, they inhabit a different frame than that of art proper. But, as we have seen, particularly in relation to calendar artists' intense valorization of "realism," they are not disconnected from the practice and discourse of art. Calendar artists have been to art schools or engaged in "fine art" practice, and they use terms from the language of art; "fine" artists have used calendar imagery in their work; and while bazaar images have been denigrated according to the criteria used to valorize art, more recently they have also been co-opted into the art collector's market. What might it mean for art practice, history, and criticism to acknowledge and forge a relationship with this offspring of their forgotten servants: this inassimilable supplement to the art historical narrative?

As I have outlined (particularly in chapter 4), one key element of the epistemological divide between calendar art and the discourses available to describe it is the contemporaneity of the sacred. From the point of view of modern aesthetics (that is, aesthetics since Hegel), in the age of the work of art the sacred icon is either a thing of the past or inhabits cultic or private spaces concealed from public view. In other words, the artist is by definition unable to trade in the kinds of powers and pleasures that religious icons can invoke (fig. 156). This is consistent with the idea of art as a critical, autonomous, disinterested practice that speaks to the soul of a public sphere understood as a community based on more or less rational intersubjective communication, where there is literally no place for public religiosity. Following this formulation, when the trans-subjective efficacy of the ethical and the sacred is sequestered within the intersubjective space of the aesthetic, the result cannot but be kitsch. If dirt, as Mary Douglas famously observed, is "matter out of place" (Douglas 1980, 40), kitsch is spirit out of place. The unquiet spirit of the sacred continues to haunt public art and monuments everywhere (see Taussig 1999), as well as unsettling the modernity of popular or mass-cultural forms—it is the key, for instance,

156. Tea stall, Sivakasi, 2001, with a sign showing a relaxed Ganesh holding a cup of tea.

to both the pleasures and the denigration of melodrama (Brooks 1975). So in India, at any rate, it seems as though the prerequisite for being taken seriously as a modern artist is the adoption of a secular stance. Take, for example, the compelling sculptural work of Ravinder Reddy, whose giant heads of women derive their power on the one hand from their referencing of contemporary South Indian religious sculpture, and on the other hand from their mediation of sacred symbols and meanings to secular effect. Work like this comes as close as art can to deploying a vernacular idiom, but it cannot but effect a translation from vernacular idioms into the cosmopolitan language of modernist art practice. What is more, it seldom if ever circulates within the economies of formations like the bazaar: these formations and the art system appear to be mutually exclusive. To cite just one instance of the disjunctures between them, as I described in chapter 4 the tenets of authorial property on which the art system is founded (and which also inform the commodification of intellectual rights through patenting in international trade forums) have not carried the same juridical weight in the bazaar and other vernacular commercial arenas.

In other words, to reframe the issue in deliberately provocative terms, any artist worth the name is always already hamstrung by epistemological constraints deriving from the post-Enlightenment historical narrative of the supersession of the sacred by the aesthetic. Commerce, as that which flies in the face of art's jealously defended autonomy,

is art's most well-recognized other. The sacred (and/or the ethical) is another kind of other, its disjunctive temporality compounding its imbrication, in the case of the bazaar, with commerce. So the more specific question I want to open up here is that of how art practice might be affected by acknowledging the contemporaneity of the sacred (not just allowing it in through the back door, as melodrama does) and by actively engaging with and participating in informal and/or vernacular economies. While this question arises from a theoretical frame, it is clear that the answers to it can only be generated from within art practice, the realm not just of the virtuoso but also of the virtual in the Deleuzian sense: that is, not merely the possible (see Deleuze 1994). If, as I have argued (particularly in chapters 5 and 7), the efficacy of images accrues and devolves in large part through their circulation as objects or bodies, it is only in the processes of taking form, coming to presence, encountering bodies, and finding channels of movement between them that this engagement can unfold. Is it at all reasonable, let alone polite, to wish for art practice to address the unfinished business between art and the sacred: to engage with and thereby—and this is crucial—be fundamentally altered by its other(s)? Almost certainly not. But I want to propose that such an encounter, while always vulnerable to recuperative forces (in this instance those of the art system and institutionalized religion), also holds out the extraordinary hope of amplifying the joyful, productive, minoritarian impulses inherent in both art and practices of the sacred.

As I have contended, economic liberalization and the advent of globalization in India have not meant the decline of "informal" or vernacular economic arrangements, nor of religion—only their transmutation and reconsolidation. Consider the images/objects in whose presence and circulation subjectivities in India continue to be enmeshed, willy-nilly. Up until the early 1990s bazaar art and the cinema were the primary players in visual mass culture in India. Bazaar art indexed a vernacular commercial culture thriving under economic nationalism that was deeply imbricated with the sacred (gods in the bazaar); the cinema similarly indexed the interface between formal and informal economies. The sensorium of post-liberalization India is increasingly dominated by the visually distinct—albeit ideologically and experientially complementary—forces of Hindutva and "globalized" consumerism, unfolding through an intense and creative use of every medium available: not just prints and cinema, but also television, billboards, vehicles, spectacular events, public spaces, and monumental structures. The continuing symbiosis between religion and the newly buoyant economy has been graphically indexed since the early 1990s by the simultaneous thrust into the skyline by enormous shopping malls

and the gigantic religious icons proliferating above parks, temples, and highways all over the country. Several of these mega-icons are privately funded by businesspeople or community groups profiting from the post-liberalization economy, either working independently or in conjunction with temple institutions or civic authorities, at varying levels of formality. One instance of a relatively "informal" icon is the hundred-and-eight-foot high concrete statue of Krishna that fell as it neared completion at Narsinghpur, Gurgaon (on the outskirts of New Delhi) in January 2003, killing three people; apparently the statue was funded by people from the village and surrounding areas. (The designer of the statue was a traditional *murtikar* or icon maker with no formal training in architecture or engineering, but who had earlier successfully built an eighty-foot Shiva and a sixty-foot Hanuman.) Similarly, though in closer collaboration with municipal authorities, in 2004 a thirty-one-foot Hanuman statue was being built at Hanuman Park in the beautiful northeastern Himalayan town of Kalimpong with funds gathered from residents, with 80 percent of the contribution coming from local Marwaris (as we have seen, a prominent, highly mobile trading community of the bazaar).

While these instances of icon building articulate with the identitarian project of Hindutva, equating "Indian" with "Hindu" by dint of their sheer size and dominance of the landscape, they also speak to an ongoing participation in the kinds of economies I have described in this book, whose moral, commercial, and libidinal aspects are closely intermeshed. It is only by acknowledging these economies, in particular the libidinal, in their entanglement that we might begin to approach afresh well-worn issues such as why villagers or small-town traders are pooling together their earnings to build gigantic icons when they could be funding, say, much needed water harvesting or sanitation systems. I have argued against having to choose between the positions most readily occupied by critique on such questions: on the one hand the elitist view that imputes subjects with false consciousness, or the inability to act in their own best interests (which must be countered by education from the enlightened elite), and on the other hand the populist view that identifies and celebrates primarily individual practices of micro-resistance that do not necessarily impinge on political economy. Both these positions tend to confine the efficacy of images to their impact on distinct, "self"-contained subjects and objects, overlooking the trans-subjective processes (described in chapters 5, 6, and 7) that interpenetrate subjects, objects, and the economies in which they are enmeshed, confounding the boundaries between them.

To acknowledge such trans-subjective processes is not to abdicate the task of critique

or the ethical demand on subjects; indeed, ethics can be seen as the practical responsi- bility of subjects toward the trans-subjective arenas they inhabit. The suggestion that we as art critics, historians, and practitioners need to reengage with the sacred, the informal, and the vernacular does not condone religious absolutism, nor does it index nostalgia for the bazaar formation or indeed for the era of economic nationalism. The issue for critique is not whether the sequestered forms of culture that characterize the post-liberalization scenario are better or worse than the earlier, more "organic" imbrications of the bazaar. After all, if the post-liberalization period has witnessed the rise of the Hindu Right on the one hand and the further dominance of English education on the other, it has also seen the emergence of formidable "backward" caste and Dalit parties onto the political stage. This can be seen as an index of a profound—and salutary—challenge to the moral economy of the bazaar ethos, an ethos that (as I suggested in chapter 3), while subaltern in relation to the regnant style of capitalist expansion, is a hegemonic formation in itself and therefore should not be romanticized in the name of the popular. As I sought to demonstrate in chapter 7, by reframing Hindu-hegemonic mass-cultural images in terms of not just the power but also the vulnerability engendered by their mass circulation (thereby challenging their basis in caste and patriarchal privilege), images articulate with both de- and reterritorializing movements. It is the critic's task to identify these move- ments as they become apparent and to lend the performative weight of her analysis to the minoritarian elements in them.

That is what I seek to do here with respect to a few fragile, barely perceptible strands in artistic practice. The issues I am raising cannot lay claim to the status of a manifesto, for I cannot presume to preempt what artists may already be doing in their own perfor- mative registers. Yet there is very little existing work that I can actually cite, for these minoritarian strands do not always see the light of day, or they surface briefly only to disappear unacknowledged and uncelebrated "in the master's house." This is at least in part because their engagements with the sacred do not speak to the conservative en- thusiasms of majoritarian discourses of religion, or to anti-fundamentalist doxa, or, of course, to the secular presuppositions of art and modernity. And to the extent that such work *is* valorized in the critical arena, it remains subject to the constraints of its concep- tion and circulation within the frame of the art system. In the latter category, my own eclectic, limited, personal list includes fragments from my memory of Kamal Swaroop's generically eccentric film *Om Dar-B-Dar* (1988), based on the eponymous book by the Hindi writer Bhishm Sahni, which describes the vernacular ethos of a provincial town

through the eyes of a young boy; what little I know of Kumar Shahani's proposed film on the female devotional poets Meerabai and Andal, particularly in its intended deployment of well-known stars; and the paintings of Bhupen Khakhar, which at their most gracious and powerful tap into and rechannel the libidinal currents of devotion while compassionately exploring a vernacular modernity, exemplifying the absence of tension between these two projects. But perhaps a better, less limited example would be the performative work of Khakhar's very persona, with its ceaselessly imaginative networking together of vernacular and cosmopolitan worlds in material, corporeal registers (see G. Kapur 2002). Another more radical instance is a proposed work by the artist Simryn Gill, destined for circulation in informal markets across Asia, that is not quite under development (and therefore unfortunately not yet describable). Much of Gill's work has been about returning various forms of artifice (including artworks) to nature; this project holds out the promise of returning them to the equally indomitable realm of the transsubjective. From a different context, a project by the transborder architect Teddy Cruz demonstrates how an engagement with informal economies exerts a productive pressure on the idea of what art could be, finding new ways for it to fulfill its promise to push the limits of the possible: his proposal for a multi-use informal market-cum-residential project at San Ysidro in California near the U.S.-Mexico border flew in the face of civic zoning regulations and building codes, so Cruz sought funding for it under the rubric of public art.

I do not see this as a cynical move on Cruz's part, for the project—like the other works I have cited—does in fact fulfill its mandate as art by fostering an imaginative realm for which modernity as we know it has provided no template, no sense of the possible. The political promise of these works resides in this active charge to the imagination, which needs to continue alongside the work of bearing witness and reactive forms of critique. Their temporality deploys living, non-nostalgic, indeed nonhistorical forms of memory that flash up to creatively illuminate the contemporary. In so doing it addresses what is missing in Jawaharlal Nehru's oft-(mis)quoted description of dams as the temples of modern India, with its standard modernizing procedure of progressing from the sacred to the secular along the vector of time (Nehru 1980, Gopal 1984).[4] In this vision, temples are *replaced* by dams, the shrines of modernity: it does not attempt to imagine what temples *themselves* might look like. As a result of elisions such as these, and the more recent insistence by worried secularists on tarring every form of religiosity with the brush of fundamentalism, the powerful and vital realm of the sacred has been

ceded to institutionalized religion and political opportunism. Indeed, the latter forces are strengthened by the secular mistrust of all forms of contemporary religiosity, for (as I argued in chapter 6) discourses about the power of images themselves have a certain political effect, setting up images as channels for political energies in the public arena.

Images are not powerful in and of themselves. It is we—iconolaters and iconoclasts, devotees and secularists alike—who make them powerful through what we do with them and what we say about them. But the plural "we" here is critical, for to the extent that this power unfolds in a trans-subjective arena it is not fully controllable by individual subjects, whether at the point of "production" or of "reception": to create images is to play with magic, with fire. In this sense the gallery, the catalogue, and the lecture hall can be seen as controlled environments—laboratories, if you will—in which to experiment with these volatile forces. But, as the inferno rages outside, impossible to douse by reason alone, another choice presents itself to those willing to take the risk (including, in the current environment, the risk to their personal safety): to get out there and fight fire with fire, black magic with white; to create other channels for Hydra-headed desire (as Pushtimarg characterized it, both before and after Freud: Shah 1978, 131; see also chapter 5). For art to do this would be not so much to repudiate postmodernism but to push its critiques far beyond their compromise with globalized capitalism and their re-territorialization onto the art system. So, for instance, it would mean not just endlessly playing with, repeating, and creating a certain kind of exchange value from problema-tizations of the author, or the gallery space, or the relation between art and commodities, but *really* running with these issues into a territory where "alternative" practices already exist. Engaging with the vernacular does, after all, require learning—and using—a new language. In a sense, this would bring us back to the ultimate promise of modernity itself, for the impulse to give the *differend* its due is also driven by the engine of modernity: its dynamic and expansive notion of justice that unfolds alongside the expansive movements of capital and desire.[5] Art for the moderns has been an inherently minoritarian practice, positioning itself as a supplement to the dominant post-Enlightenment ethos while also adhering to modernity's non-negotiable imperative of dynamic justice. As a similarly supplementary formation, could the postcolonial "bazaar"—and now I am using this as shorthand for the vast range of informal and unofficial practices that have accompanied the global spread of capital everywhere—articulate with and accommodate this impulse in artistic practice? At its best, this peripheral location might enable such a practice to resonate with the oppositional forms developed by the devotional revolutionaries of the

bhakti movements, and particularly with their ability to channel the libidinal economies of devotion toward radical social protest.

This, then, is the ongoing challenge, or rather the invitation, from the bazaar: to reconfigure our narratives and practices of modernity by reclaiming ownership of the sacred; that is, to reimagine temples, icons, rituals, events, images, bodies, fetishes, prayers, devotional texts, and community practices that are sacred and libidinally charged but still foster social justice: not only through conscientization, but also through the kinds of corporeal, sensual, mimetic, performative exchanges in whose circuits calendar art's luminous banality has ensnared us all.

NOTES

INTRODUCTION

1. The title of the next section alludes to Jean-Luc Godard's famous saying, "Not a just image, just an image" ("Pas une image juste, juste une image"; a more accurate translation of "juste" in the first instance would be "correct" rather than "just"); Godard quoted by Gilles Deleuze (Deleuze 1995, 38). "[A] 'just image' is an image that exactly corresponds to what it is taken to represent, but if we take images as 'just images' we see them precisely as images, rather than correct or incorrect representations of anything" (translator's note: Deleuze 1995, note 1, 190).

2. "A case of differend between two parties takes place when the 'regulation' of the conflict that opposes them is done in the idiom of one of the parties while the wrong suffered by the other is not signified in that idiom. . . . The differend is signalled by this inability to prove. The one who lodges a complaint is heard, but the one who is a victim, and who is perhaps the same one, is reduced to silence" (Lyotard 1988, 9–10). Gayatri Spivak's famous essay "Can the Subaltern Speak?" (Spivak 1988) can be seen as elaborating on this formulation.

3. Anand Patwardhan, personal communication via email, 2001.

4. For the colonial administration, managing racial/cultural difference (the two were typically conflated) meant that the public sphere to which it addressed itself could not simply take on the terms of the bourgeois public sphere in Europe, as described by Jürgen Habermas (Habermas 1989, 1974). Habermas's neo-Kantian formulation has been subject to criticisms on several fronts (including by Habermas himself). However, for my purposes its valency does not lie in its status as an accurate empirical account but in its status as a normative framework for European modernity's self-descriptions, from which modes of publicness in the postcolonial nation-state (and indeed in the centers of colonial power) can be seen to depart—in both senses, as beginning and as divergence.

5. This is most clearly evident in the work of Jean Baudrillard, whose cool tone barely contains its keening for the real.

6. My use of the term "ethical" relates to the ethos as an arena where moral economies are put into performative practice: I elaborate on this further in chapter 5.

7. For a succinct discussion of the problems with notions of indigenousness, see Gupta 1998, 18–20.

8. These "degrees of vernacularity" are akin (though opposite in desirability) to the "degrees of whiteness" that Ghassan Hage elaborates in relation to minorities in multicultural Australia (Hage 1998), insightfully describing the processual cultural gradient between the categories of "white" and "black" otherwise seen as binary racial opposites. "Whiteness" here is a marker not just of race but of cultural-political dominance and national belonging.

9. This formulation of genre is primarily informed by film studies: see Gledhill 1985; Neale 1980; Stam 2000.

10. As with all ethnographic encounters, my own deployment of these interviews carries the danger of subjugating these "vernacular" accounts to an academic "master" narrative. Here I can only invoke Deleuze's reading of the Spinozan notion of ethical encounters: every encounter is necessarily criss-crossed by power relations, but the question is whether the resultant force amplifies the productive, "joyful" forces in the bodies involved or diminishes their capacities (Deleuze 1988, 27–28).

11. Of course, art history has analyzed and acknowledged its deep complicity in the teleological project of European modernism. It has also been interested in questions of mass reproduction, commodification, and the wider networks in which images circulate ("visual culture" addresses these issues among others), and in critiques of ocularcentric visuality and the forms of modern subjectivity it inscribes. But art history has been one of the slower disciplines to actualize the radical potential of these challenges in its institutional practices, probably because of its close articulation—particularly ironic given the putative autonomy of the art objects on which it is centered—with the heavy institutional machinery of art markets, publishing, museums, and other culture and heritage organizations, and *their* continuing investments in civilizational narratives and notions of auratic originality, authorial genius, uniqueness, and representational expressivity.

12. My starting point is "India" rather than "South Asia," given that the latter category tends to ignore the differential histories of state-formation in the region over at least the past fifty years.

13. My account is largely based on interviews with artists, publishers, printers, and consumers, and firsthand observation of various aspects of the industry. Field research was conducted between 1994 and 2001; I also build on work I did in 1991–92 for my master's dissertation (K. Jain 1992, published 1995). This, in its turn, built on eight years of participant observation, as it were, of the visual field in India, both as a student of visual communication and as a design professional. The little quantitative information I gleaned about this largely informal industry is too inaccurate and conflicting to use, so any estimates of numbers must be seen as little more than educated guesswork: the process of finding—or generating—accurate quantitative data would have been disproportionate to the aims of my project. For the same reason, pre-twentieth-century historical data is mostly from secondary sources.

14. Of course this is not necessarily so: a case in point was the untiring political work of Edward Said, who was the first to insist that he was not a scholar of the Middle East (for after all, Orientalism is about the Western imperial imaginary), but who did not cease to engage publicly with its contemporary condition.

1. VERNACULARIZING CAPITALISM

1. Geeta Kapur identifies "frontality" as a formal category central to what she terms "the aesthetics of popular art in India," which includes both images and more "properly" performative cultural forms (the *patua*s, for instance, who tell stories using painted scrolls, have traditionally combined image making and performance). Its features include "flat, diagrammatic and simply contoured figures . . . a figure ground with notational perspective . . . the repetition of motifs within ritual 'play' . . . a space deliber-

ately evacuated to foreground actor-image-performance . . . [and] stylized audience address" (G. Kapur 1993b, 20).

2. See Christopher Pinney (1997a) on the "intricate recursions" that characterize bazaar images, making it difficult to formulate a "sedimentary" narrative of stylistic evolution. Pinney also problematizes the centrality of Ravi Varma to popular images, emphasizing instead the dominance of the Nathdwara image-making tradition. (I describe this tradition in the following chapter.) I would suggest—and my account in the following chapters will bear this out—that Nathdwara's influence has been more significant for the chromolithographs or "framing pictures," which are his main concern, than for the broader field, which includes calendars and posters.

3. Both Adorno and Benjamin, in their writings about mass culture, are critical of the way in which novelty masquerades as progress: it is in this context that they invoke the "eternal sameness" that characterizes mass production in general and the culture industry in particular (Adorno 1991, 87; Benjamin 1985, 32–58). As the work of both thinkers attests, this does not imply that there is no need to attend to the history of mass-cultural forms, or to their relationship to changing modalities of perception and sensation.

4. Here I am drawing on Foucault's notion of genealogy as history that refuses a grounding in metaphysics, or in the teleological unfolding of potentials inhering in an originary essence. Foucauldian genealogy questions the investment in the origin as "a metaphysical extension which arises from the belief that things are most precious and essential at the moment of birth" (Foucault 1977, 143). Genealogy dismantles narratives based on unities and continuities, troubling our most naturalized working assumptions: "Nothing in man—not even his body—is sufficiently stable to serve as the basis for self-recognition or for understanding other men" (Foucault 1977, 154).

5. I am deeply grateful to H. Daniel Smith for his great generosity and enthusiasm in sharing and discussing his observations on the calendar industry, including his 1988 field notes (I will refer to these as Smith 1988) and related correspondence for a project entitled "Indian Poster Art in Relation to Contemporary Hinduism," now housed in the Smith Poster Archive, Special Collections Research Center, Syracuse University Library.

6. To this day the only mechanized process in Sivakasi's match industry is the mixing and grinding of chemicals, where a manual process would simply not provide an adequately blended mixture.

7. According to P. Dharmar, the senior partner at National Litho Press in Sivakasi, until 1991 Sivakasi was classified as part of a "backward area" and therefore attracted a 15 percent subsidy on investment in buildings and machinery, which was revoked in 1991 when Sivakasi was declared to be "developed."

8. To list some of the most evident problems: the match industry mostly employs women and children who do piecework at home involving long hours of repetitive, jerky movement; explosions are a common occurrence in the firework factories; the printing industry also employs children for piecework; at almost every press I visited I met people who had sustained injuries (particularly from cutting machines) and who work with toxic inks and glues in hot, unventilated spaces, or with metallic powder without adequate protection of their hands, eyes, and mouths.

9. Anand Vardhan lists these processes as "treadle printing, cutting and creasing of box board carton, wax coating, varnish coating, die punching of labels, tin mounting of calendars, date pad gathering contracts and sticking paper fans with bamboo, cover and box pasting and book binding" (Vardhan 1980). Among others that I saw in 1994 were collating and folding of printed pages for books and gold stamping (the application of golden colored powder onto printed calendars).

10. To this extent I do not subscribe to "Cambridge school" narratives of continuity in an "indigenous" eco-

nomic culture that tend, as Partha Chatterjee points out, to erase the "violent intrusion of colonialism" (Chatterjee 1997, 27–33).

11. Among the earlier picture publishers are S. S. Brijbasi (Karachi, 1922), Harnarayan and Sons (Jodhpur), Hem Chander Bhargava (Delhi, 1900), Ghosh Mazumdar and Co. (Calcutta, 1915), Gaya Art Press (Calcutta, 1925), Hindustan Art Engraving Co. (Calcutta, 1933), and Anant Ram Gupta (Delhi, 1935). Publishers emerging after independence include Mahalaksmi Picture Publishers (Delhi, 1947), Roshan Lal Bros. (Delhi, 1948), Brijbasi's branches in Bombay (1950) and Delhi (1954), Bombay Picture House (Ahmedabad, 1950), Bombay Glass House (Ahmedabad, 1950), Bharat Picture Publishers (Delhi, 1951), and Sharma Picture Publication (Bombay, 1955).

12. H. Daniel Smith lists several firms with the word "calendar" in their name that produced calendars at one point but then moved on to a different business altogether, such as Mumbai's Calendar Makers Corporation, which in 1988 was making computers (H. Smith 1994, 24). Among those firms operating in Delhi in the late 1990s were Calendar Manufacturers Pvt. Ltd., established in 1967, Kawality Calendar Co., established in 1969, Subhash Calendar Co., established in 1971, and Sunshine Calendars, established around 1975. Associated Calendars of Sivakasi, with branches in Calcutta and Delhi, was founded in 1970. Earlier calendar companies include the Ajanta Art Calendar company, a firm in Delhi that had folded by the second half of the twentieth century, Shree Ram Calendar Company in Bombay, and Navyug Calendars in Jhansi, which was known to have been producing calendars in 1959–60.

13. Picture publishers in and around Delhi's Nai Sarak include S. S. Brijbasi and Sons and Mahalakshmi Picture Publishers in Fatehpuri, Hem Chander Bhargava in Chandni Chowk, Jain Picture Publications in Jogiwara (Nai Sarak), and Subhash Calendar Company in Nai Sarak.

14. Other exporters in 1988 included Sree Kalaimagal Industries and Kumarappa Industries (see H. Smith 1988, in particular 29–31). In January 2001 I was unable to locate Sree Lakshmi Agencies; it is possible that it has folded.

15. According to Rush, while the older prints probably came directly from India, the newer stocks are imported from Nigeria and England, although she does not specify whether they are actually printed there (Rush 1999, 63–64).

16. As Neville Tuli, the curator, founder, and chairman of Osian's, a private arts institution and auction house, put it, "We are trying to give financial value to a unique art form" (www.newsindia-times.com/2002/03/08/cinema-vintage.html#). Starting in 2001, Osian's mounted a series of auctions of film posters, calendar art, and paintings, accompanied by preview exhibitions, handsome catalogues, and lectures by Tuli in New Delhi, Mumbai, London, New York, and Dubai. Part of the strategy to "give value" was to frame these images within a narrative of historical significance, as evidenced by the titles of Osian's exhibition-auctions—India: A Historical Lila (October 2001), A Historical Mela: The ABC of India (March 2002), and A Historical Epic: India in the Making 1757–1950 (August 2002).

17. Among those agents dealing with the Calendar Manufacturers Pvt. Ltd. in Delhi's Chandni Chowk in 1995, one man from Gwalior, operating in Madhya Pradesh and Uttar Pradesh, also collected orders for other kinds of corporate gift items such as key chains and ashtrays, as well as printed polythene bags. Another agent, covering Haryana, had a campus bookshop and ran a sideline trading in stationery and books, while two other agents covering Punjab and Haryana were the Patiala editors of a trade newspaper called *Vyapar Bharati* and collected advertisements for the paper while soliciting orders for calendars.

18. The rates charged by Delhi's Calendar Manufacturers Pvt. Ltd. in 1996 for its Sivakasi calendars ranged

from Rs. 1,200 per 1,000 for 16" × 22" single-sheeters on map litho (the cheapest option), to Rs. 11,850 per 1,000 for 15" × 22" four-sheeters on Indian Real Art paper, to Rs 17,500 for 18" × 40" calendars on "Pearl Foam." They also supplied 18" × 40" calendars printed at local "quality" presses on "Thick Paper" at Rs. 30 each.

19. Offset printing is perhaps the most common mass-scale printing technology in use today: here the matter to be printed is photographically transferred to a flat metal or plastic plate and then to a rubber blanketed cylinder before being impressed on paper. Letterpress is an older technology, using smaller and less expensive machines. Here lead types and photographic "blocks" are manually set in a tray, which is then inked and impressed on paper.

20. The use of letterpress accounts for the relatively unchanging typefaces used in the calendars: printers are confined to the fonts available for letterpress, as opposed to the wider range available for digital typesetting.

21. Many calendars combine the Gregorian calendar with various other calendrical systems: while most carry the "Hindu" luni-solar Vikrami calendar along with the Western calendar, the extremely popular *Kalnirnaya* calendar (see fig. 38) carries important dates from the Jain, Parsee, Sikh, and Muslim calendars as well. It does not carry a picture but instead devotes the entire page to the dates themselves, while printed on the back of each month's calendar are recipes, stories, poems, domestic tips, and other items of general interest.

22. "Jai Jawan, Jai Kisan" [Victory/Praise to the Soldier, Victory/Praise to the Farmer] was the slogan raised in response to the 1965 war with Pakistan by the then prime minister Lal Bahadur Shastri. It emphasized the importance of food production alongside the defense of the nation.

23. Patricia Uberoi makes the point that these are all "consumer items that typically *go along* with women in the material transactions that accompany Indian marriage": in other words, they are part of the expected middle-class dowry (Uberoi 1990, WS-45; emphasis in the original). While this is a persuasive reading, I think that there is scope for more work on contextualizing these images within the particular social and historical moments of their circulation and disappearance.

24. Although artists operate within a strong set of formal and iconographic imperatives, this does not constitute a "formula," for there is still enough variation for particular designs to meet with tangible success or failure in the marketplace. Many publishers complained that market trends for the cheaper single-sheeters were impossible to predict. As one printer put it, for a few years dark backgrounds might be all the rage and then suddenly demand might inexplicably swing toward light backgrounds. Success seems totally random, to the extent that printers sometimes recycle a "failed" design after a few years, and it often does better the second time around.

25. P. Sardar, the renowned painter and devotee of the Hindu monkey-god Hanuman, started life as Sardar Muhammad Patel. On entering professional life he dropped the telltale Muhammad and abbreviated the "P" from the caste name Patel; his son Dara drew an analogy here with the famous Maharashtrian (Hindu) filmmaker V. Shantaram, who abbreviated his name from Rajaram Vankudre Shantaram. When Sardar first moved from Kolhapur to Bombay to start his career he found accommodation in a Brahmin lodging house, where he and his wife passed as Brahmins for several years until a letter arrived for him bearing his original name. In the course of my conversation with Dara Sardar it emerged that even now their neighbors did not necessarily know that they were Muslims; people giving me directions to P. Sardar's residence called his younger son Haroun "Arun" (a Hindu name)—perhaps again pointing to a deliberately ambivalent choice on Sardar's part.

26. "Secular icons" might seem like an oxymoron; however, as I shall argue in more detail in chapter 6, there is no easy distinction to be made between sacred and secular in the performative context of these images. In my observation of the "English market" from 1993–2000, the vast majority of framing pictures were religious, with the various Indian religions represented in about the same proportions as in the calendar files, although with a greater number of designs within each category. The few secular images sold as small framing pictures depicted either "leaders" or (very occasionally) film stars, though publishers said that the leaders were declining in popularity.

27. In chapter 7 I will revisit the debates surrounding a spate of muscular Ram images in the early 1990s, set against the projected temple at the site of the destroyed Babri mosque in Ayodhya. These images traveled back and forth between calendar prints and the various forms of propaganda—pamphlets, posters, stickers, banners, videos, hoardings—used by the Hindu Right in the Ramjanmabhumi movement. Similarly, the movement's evocation of Ayodhya as Ram's birthplace gave rise to images of the infant Ram along the lines of the usual baby Krishna (for instance, in the Sangh Parivar's propaganda videos such as *Bhaye Prakat Kripala*); soon afterward this new imagining spread to other deities, and calendar artists began to depict other baby male gods such as Shiva and Ganesh. Or conversely, with the resurgence of "Ram Durbar" images following the success of the televised *Ramayan*, artists came up with the idea of painting a "Krishna Durbar."

28. The Sholapur artist Venkatesh Sapar, for instance, said that he charged Rs. 4,000–5,000 per painting for single paintings and Rs. 8,000–10,000 per painting for "sheeters" in 1995. In 1994–95 the rates that other artists told me they charged also ranged between Rs. 4,000 and 10,000 (although one said that he asked for Rs. 20,000 for one painting). Some Sivakasi publishers, however, said that they paid between Rs. 2,000 and 5,000, and that they could not afford Rs. 10,000 for a painting.

29. This information was transmitted during an interview with Vijay Singh of Rangroop Studio, a family business engaged in painting greeting cards as well as calendars and one-off portraits (11 January 1994). This characterization of greeting cards as a testing ground for new designs was corroborated by Jawahar Ganesh of Coronation Arts and Crafts, Sivakasi.

30. In 1994 firms such as Air India, Grindlays Bank, and the Housing Development and Finance Corporation spent an average of Rs. 10–20 lakhs (Rs. 1–2 million) on calendars, with print runs of 10,000–20,000 each, bringing the unit cost to about Rs. 150 (Krishnamoorthi, 1994–1995).

31. Of course there were exceptions, too, notably the VIP underwear advertisements and a spate of campaigns for local brands such as Promise, Vicco Vajradanti, and the legendary Nirma with the spread of television in the 1980s. Until then vernacular radio had been the primary medium for advertising goods aimed at a mass market: brands such as 555 detergent or Zandu balm.

32. Gurcharan Das makes the point that family businesses are by no means exclusive to India: in 1996 80 percent of enterprises in the United States were family run, accounting for 40 percent of the GNP (G. Das 1999, 12).

33. Babli Moitra Saraf has argued that this dominant English-speaking ethos in the agencies meant that agency advertising in the vernaculars tended to be translated from English rather than developed in those languages (Saraf 2002). Saraf's argument is borne out by my own observations of the industry and interviews conducted with advertising personnel in 2000–2001 (including some people who are, not unsurprisingly, part of my own kin network), which indicated that the post-liberalization marketplace was pushing the industry to recognize this situation and address it.

34. This supports Arvind Rajagopal's suggestion that the status and power of English relative to the vernaculars actually increased after independence (A. Rajagopal 2001, 159).

35. For instance, in his otherwise carefully nuanced account, Arvind Rajagopal is a little too quick to differentiate between the initially limited circulation of the print media vis-à-vis the immediately national reach of television: this is truer of the text-based press than of image-based prints. Similarly, he claims that the "more densely material form of print commodities makes for a more limited circulation" than the electronic media. I suggest that this limited circulation is again more a function of the text-based nature of the press than of its materiality, given the counterexample of the calendar whose very materiality is key to its circulation as a gift (A. Rajagopal 2001, 154–55).

2. WHEN THE GODS GO TO MARKET

1. Something of this static characterization persists in the notion of "diaspora" too: Markovits makes the important point that the South Asian merchant diaspora is better understood in terms of "circulation" than of "migration," for there is a constant flow back and forth from the place of origin (Markovits 2000, 4–5).

2. Regarding the highly contentious issue of whether or not the bazaar in the precolonial period forms a "proto-capitalist" formation, I support Partha Chatterjee's critique of the implication that colonialism was a mere hiccup in a process that would have occurred anyway (Chatterjee 1997, 27–32).

3. The managing agency is "the vesting of the management of a joint-stock company in the hands of a firm of professional managers" (Kling 1992, 82). This system has been common in Indian business organization since the 1830s when managing agencies were set up in Indian port cities to look after the interests of British companies, particularly the tea, jute, indigo, sugar, opium, and mining industries, as well as allied activities such as shipping, banking, and insurance. One of the earliest managing agencies was Carr, Tagore and Company, founded in 1834, an instance of equal partnership between an Indian (Dwarkanath Tagore, grandfather of the Nobel laureate Rabindranath Tagore) and Europeans, which, while possible in the first half of the nineteenth century, did not survive the mid-century segregation of the economy along racial lines (R. Ray 1992, 18–30).

4. The terms deterritorialization and reterritorialization have been adopted by disciplines as diverse as literary studies, cultural geography, and business management, most often in the context of arguments for the increasing irrelevance of the nation-state as a form of territoriality under the dominant regime of "globalized" capitalism. My use of these terms here should not be taken as an endorsement of those arguments, for as I understand them Deleuze and Guattari describe the expansive dynamic of capitalism as a simultaneously deterritorializing *and* reterritorializing movement, as both sweeping away *and* re-instituting "territorial codes" (Deleuze and Guattari 1977, 1987). I find these terms useful because they dynamize the conception of social-political, economic, and ideological formations, in both historical and spatial terms, bringing together ideas of movement or flow (of people, ideas, objects, images, capital) with the institution and performance of symbolic structures.

5. These were manufactured in Canton, mainly for trade, and can be seen as the Chinese equivalent of Indian "Company school" paintings (made by Indians for a predominantly British clientele). The technique originated in Bohemia and Germany before the eighteenth century, from where it spread all over Europe and eventually, via the Jesuits, to China (Appasamy 1980a, 1–4, 1980b, 69–73; Mitter 1994, 215 and 414 n. 122; Soame and Jenyns 1980, 102).

6. Thanjavur's prior development as an artistic center dates from the early sixteenth century with the patronage of the Nayak kings; it continued with their successors, the Marathas, who ruled Thanjavur from 1676 until 1799 when it became part of the British Madras Presidency. This courtly patronage, and then that of the British, attracted communities of artists from the Andhra region such as the Rajus, who

settled in Thanjavur and Trichinopoly, or the Naidus of Madurai (on Tanjore painting, see Appasamy 1980b; on glass painting, see Appasamy 1980a and Guha-Thakurta 1986). Among the artists from these communities employed at the courts were Alagiri Naidu, who moved from Madurai to the Travancore court and is said to have trained Raja Ravi Varma's uncle, Raja Raja Varma, in ivory painting (Mitter 1994, 184), and Alagiri's successor Ramaswamy Naidu (or Naicker), who famously refused to teach Ravi Varma the secret of oil painting. Artists of Thanjavur also received patronage from temples and merchants. Apart from painting temple murals and sculptures, decorating festive processional vehicles, and making portraits, they produced sacred icons on panels of wood, often embossed with gold and silver and studded with jewels, to adorn temples, community prayer halls, and domestic shrines.

7. Painters working in the sixteenth- and seventeenth-century Mughal courts eschewed the "frozen moment" of the perspectival tableau but used graded tones (sfumato, or modeling) and perspectival depth effects to enhance the naturalist characterization of figures and their spatiotemporal relationships within the context of a narrative to be processually read or scanned (Sheikh 1993, 145–48). These court artists were familiar with European engravings, mostly religious images brought to India by Jesuit missionaries over the second half of the sixteenth century, as well as prints depicting nonreligious subjects including maps and classical nudes (Minissale 2000).

8. The "Nathdwara style" thus evolved in the tradition of Rajasthani miniature painting, with its detailed decorative elements and use of an extensive palette of stone and vegetable pigments, although Nathdwara is distinguished from other schools by its particularly stocky figures and use of bold, contrasting colors (Ambalal 1987, 80, and interview with Indra Sharma, Nathdwara, November 1995).

9. Frequent pilgrimages and donations for the upkeep of the temple and its images have been an essential element of Pushtimargi practice. Images have played a central role in Pushtimarg: Shrinathji and the other Pushtimarg idols are seen as living embodiments (svarupa) of the god Krishna, and their worship—or rather their service (seva)—is one of the most important ways in which a devotee can attract the pushti or grace of the Lord.

10. Formulations of genre deployed in film studies see genre as a constantly shifting contractual relationship between producers, consumers, and critics; to this extent these formulations address the social and historical variations and complexities within the "processes of systematization" (Neale 1980, 51) of images aimed at mass audiences.

11. Unlike larger centers such as Calcutta where woodblock illustration mostly catered to the book and almanac trade, Nathdwara was too small a town to have warranted the development of printing skills and infrastructure; even now the reproduction of work by Nathdwara's artists is done in Mumbai and Sivakasi. And while other sacred centers catered to pilgrims from a broad spectrum of backgrounds, Nathdwara had no need to provide cheap souvenirs, given its patronage by local kingdoms and merchant pilgrims that were becoming increasingly wealthy under the colonial administration.

12. Gosains and wealthy devotees who performed a special seva of Shrinathji, called a manoratha, would commemorate this once-in-a-lifetime event by commissioning a painting depicting themselves and their families standing in worship on either side of Shrinathji. As with the corresponding genre of votive Vaishnava images from Tirupati and Thanjavur, such paintings demanded a skill in portraiture that not all artists could provide, and they became a site for Nathdwara's appropriation of photography around the turn of the century (Ambalal 1987, 80). The photographs, printed on special imported matt paper (which enabled overpainting), would have much of their backing scraped away to make them as thin as possible before they were carefully pasted in place and overpainted to merge with the rest of the paint-

ing. Variations of this practice persist in the studio portraits where pilgrims can be photographed with a painted backdrop of Shrinathji, and in the creation of color portraits from black and white photographs in which some painters (such as Damodar Gaud and Narottam Sharma) currently specialize. This information came from Ramchandra Paliwal, Geeta Studio, Nathdwara, 1995.

13. The Kalighat paintings were produced by rural *patuas* attracted to settling around the Kali temple in the "native" area of southern Calcutta after it was rebuilt around 1820 (Khanna 1993, 30). To cope with the demand for inexpensive images, the *patuas* switched from scrolls to single frames, from cloth to paper, and from tempera to watercolor (Guha-Thakurta 1992, 18–27). From around the 1860s these painted images were displaced by even cheaper woodblock prints produced by illustrators from the northern Battala area of Calcutta (near another pilgrimage center, the Chitteswari temple at Chitpur), which by 1830 had become the center of woodblock printing and the Bengali book and almanac trade. These were themselves displaced by chromolithographs through the 1880s.

14. Handwritten and illustrated almanacs (*panjika* in Bengali or *panchanga* in Sanskrit and Hindi) were already being sold for a living by Brahmins before they first appeared in print on the early letterpress machines in Bengal around 1819 (Pattrea 1983, 54). Krishnachandra Karmakar produced the first illustrated almanac, the highly popular *Natun Panjika* [New almanac], which was published in 1838 by the Chandrodaya Press in Serampore. (The Serampore Mission's printing press, set up in 1800 by the Reverend William Carey, printed translations of the Bible in forty-five different languages, most of them Indian: Kesavan 1985; Pattrea 1983). Woodblock illustrations began to appear in Bengali books in 1816; Battala's early woodblock artists mostly emerged from metal-working communities whose skills had been utilized for carving typefaces by English printers since they first set up their presses in India in 1778.

15. For instance, the intimate two-way exchanges between Kalighat paintings and Battala woodblocks over most of the nineteenth century index not so much the "fluidity" of the "boundaries" between painting and mass reproduction but the irrelevance of such a distinction to the contexts in which these images circulated. Thus manual and mechanical techniques were combined in an intermediate form where woodcuts were hand-colored with quick washes; the early Battala woodblock illustrations drew heavily on the imagery and stylistic features of *pat* paintings, combining these with the hatching proper to the engraving technique. Conversely, the hatching and repetitive lines in some of the Kalighat *pats* seem to have been imported from the woodcuts.

16. An earlier art school was started in Pune around 1798 by the British Resident, with the aim of training local painters to assist visiting British artists, but it did not run for more than a few years (see Mitter 1994, 30). Indian artists began to experiment with oil painting, a medium that carried its own powerful aura, well before the 1850s (M. Archer 1979, 141; Appasamy 1985, 5–6). This use was not restricted to making portraits and copying European paintings but extended to the depiction of religious and mythological themes (Guha-Thakurta 1992, 35–44, esp. fig. 12; Mitter 1994, 20 fig. 6). The little that is known about the non-art-school painters is mostly from the catalogues of the fine arts exhibitions where their work was shown.

17. The elite's interface with westernized arenas did not necessarily entail relinquishing existing practices. Tapati Guha-Thakurta (1992, 52–53) observes that while the nineteenth-century Bengali aristocracy patronized Western visual art, its tastes in literature, theatre, and music remained attuned to vernacular traditions: the public or domestic display of works of "art" was a novel concept grafted onto existing cultural practices (one that, I would add, could signify westernization without requiring mastery of a new language). By the same token, paintings by Indian artists on religious themes, even those that

appropriated European elements and techniques, remained objects of devotion rather than works of "art," and their elite patrons did not display them in the more public areas of their households (Guha-Thakurta, 1992, 43–44; also 1994). In other words these pictures were being classified within the terms of an "art system" that distinguished between a public, cultural realm and a private or "inner" domestic realm of religion.

18. "The prejudice in favor of the comparative respectability and gentility of mere draughtsmanship by which mechanical drawings with compasses is usually understood over practical works, acts as a minor hindrance especially with regard to clay and plaster. Modeling is considered to be potters work. . . . On my suggesting to a student that he . . . should get a cube of wood and having cut it to these forms he should draw them in perspective and elevations, he replied with some hauteur — 'But that is Carpenter's work' " (J. L. Kipling, 1876–77, quoted in Choonara 2003).

19. *Pauranic* or *puranic*: pertaining to the Puranas, a collection of mythological stories written in the form of Sanskrit verses, elucidating aspects of the Vedas to the laity. There are eighteen major Puranas, the oldest of which is thought to date back to 300 CE, and the most recent to 1300–1400 CE. The most recent and most popular Purana is the Bhagvat or Bhagwad Purana, also known as the Shrimad Bhagavata.

20. Mythological works by another art-school trained artist, Bamapada Bannerjee (1851–1932) are also known to have been sent to Germany in 1890 to be "oleographed." German and Austrian oleographs, chromolithographs with a glossy finish that simulate the appearance of oil paintings, were by now circulating in Indian markets, depicting Roman Catholic and erotic subjects (Mitter 1994, 174, 209).

21. Ravi Varma's son, Rama Varma, is quoted as saying that Varma set up his press in Bombay partly because "people had to be weaned" from the "atrocious" and "distorted" Poona pictures (Nayar 1953, 122–23, quoted in Guha-Thakurta, 1986, 186 and Mitter 1994, 209).

22. Christopher Pinney has an example of a Chitrashala print of Markandeya, which is later developed in a Calcutta print such that Yamaraj is an Englishman (Pinney 2004, 114–15); Partha Mitter's caption for a reproduction of a Chitrashala Narasimha is "lithograph of a Hindu deity in a conventional pose," but it seems highly likely that the demon being torn apart was intended to be read as a British officer (Mitter 1994, 176 fig. 113).

23. These movements gained momentum from the changing economic and social arrangements under colonialism (not unlike identitarian movements fueled by multicultural politics in the diaspora and the perceived threat of "globalization" within India a century later). Thus, for instance, if the Aligarh movement in Uttar Pradesh appealed to a declining Muslim elite threatened by increasingly prosperous and assertive Hindu traders, money-lenders and professionals, the Arya Samaj in Punjab gained followers among the Hindu bazaar communities in part because of the increasing business and professional dominance of Muslims (Sarkar 1983, 77).

24. As with European neoclassicism, there was an ongoing relay between expressive conventions, gestures, costumes, and mise-en-scène in the theater and painting (see A. Kapur 1993b; Awasthi 1993; G. Kapur 1989). The close relationship between Orientalist scholarship, fine art, and a wider realm of vernacular cultural production during this period is evident from the epic themes taken up for artistic revisualization. One of the most popular was the story of Shakuntala, based on the Sanskrit play *Abhijnana Shakuntalam* by Kalidasa (400–500 CE), translated into English by William Jones in 1789; this was followed by vernacular translations and theatrical productions (a Marathi version was staged in Bombay in 1867; A. Kapur 1993b, 90). A translation by Kerala Varma Valia Koil Thampuran, Raja Ravi Varma's brother-in-law, inspired one of Varma's most celebrated paintings, *Shakuntala Patralekhan* (Guha-Thakurta 1986,

182). One of Varma's many versions of this painting was used as the frontispiece for the 1887 edition of Monier Williams's translation of *Abhijnana Shakuntalam*. Another popular theme for lithographs was *Nala Damayanti*, also translated by Williams and then taken up by the local Calcutta playwright Girish Chandra, whose staging ran from 1883–87 (Pinney 1997a, 838 n. 12).

25. In practice this liminality persists today in calendar art, whose consumption, as I argue in chapter 4, does not buy into the neat terms of a "high culture/popular culture" divide. However, inasmuch as twentieth-century modernist ideas about mass culture do inform the terms of debate in the postcolonial public sphere, mass-produced prints have tended to be discursively positioned within the realm of the popular or of mass culture.

26. There is by now a substantial literature on Raja Ravi Varma, so I will not repeat the details of his biography here (see G. Kapur 1989; Rajadhyaksha 1993b; Mitter 1994; Uberoi 1990; Guha-Thakurta 1986, 1991; and Sharma and Chawla 1993). Kapur, Guha-Thakurta, and Uberoi have all convincingly discussed Varma's use of the figure of woman to embody the nation; again, I will not repeat their arguments here.

27. By all accounts Varma's search for pan-national, "Indian" content was a self-conscious project. In preparation for his most important commission, a set of fourteen *pauranic* paintings for the new Lakshmi Vilas palace at Baroda, he hired a narrator of the classics to help identify themes (Mitter 1994, 202); to find appropriate costumes and physiognomies to portray the ideal types of mythology, he and his brother undertook a grand tour of India, just as British neoclassical painters had toured Italy for inspiration. Their quest, needless to say, was futile: they found nothing that was both authentic and universal enough for their purposes and concluded that the absence of a singular, authentic Hindu "face" was the result of Muslim "effacement" (R. Chatterjee 1993, 145–46).

28. Ravi Varma's sister, Mangalabai Tampuratti, is known to have been a painter as well, assisting the brothers in their commissions, although she did not travel with them (Ramachandran 1993, 22; Mitter 1994, 204).

29. For Balendranath, while the "Mytho-Pictures" were overly literal in their interpretation of textual descriptions (particularly of colors), Varma's relative naturalism remained true to the spirit and mood evoked by literary metaphors. "Gouranga is colored a shocking yellow, just because, in literature, his fair complexion is compared with the hue of burnished gold . . . Sri Krishna . . . appears over the ages to have vigorously rubbed his whole body with blue colored pencils" (Tagore 1894, cited in Guha-Thakurta 1992, 131).

30. According to Percy Brown, the principal of the Mayo School of Art in Lahore and then of the Calcutta School from 1909–27, "As the painting of the West is an art of 'mass,' so that of the East is an art of 'line.'. . . In other words, the Eastern painter expresses form through a convention—the convention of pure line—and in the manipulation and the quality of this line the Oriental artist is supreme" (Brown, n.d., 7).

31. Apart from the compatibility of dates, his tentative involvement with the Ravi Varma Press is consistent with Tripathi's and Mehta's account of the Khataus, which characterizes them as cautious participants in industry at that stage, still somewhat overshadowed by the trading ethos from which they emerged and preferring to ride on the initiatives of others than to take bold entrepreneurial risks of their own (Tripathi and Mehta 1990, 76–87).

32. Varma left much of the running of the press to his partner and employees while he continued with his painting career. Financial and labor problems for the press caused Varma to dissolve his partnership and move the press to Malavali, but it continued to make losses. In 1903 the Varma brothers bailed out

altogether, selling the press to their German assistant, Fritz Schleicher (or Schleizer), along with the rights to eighty-nine of his prints (R. Rajagopal 1993, 137). After Varma's death in 1906 his main distributor, Anant Shivaji Desai, gained the rights to Varma's Mysore and Baroda works, publishing them under that imprimatur until the firm went out of business around 1945 (Mitter 1994, 212; H. Smith 1994, 17). The name of the press as it appears on the prints evidently changed as the press moved and the rights changed hands: the names used include "Ravi Varma Press," "Ravi Varma F.A.L. Press," and "Ravi Varma Press Pictures Depot."

33. Other similar-sounding presses, such as "Ravi Uday Press" and "Ravi Vijaya Press" (both in Ghatkopar) were most likely entirely different operations trading on Varma's name and possibly plagiarizing his prints, a common practice then as now. Among the larger presses known to have plagiarized Varma's work were the Chitrashala Press in Pune and the Bhau Bul Co. of London; Ravi Varma asked the India National Congress leader Gopal Krishna Gokhale to pass a bill against plagiarism, but to no avail (Mitter 1994, 214). Legal rights to Varma's work were acquired by the Indian Press in Allahabad and U. Ray in Calcutta (who introduced halftone reproductions of Varma's work in the Bengali journal *Pradip*; Guha-Thakurta 1986, 187; Mitter 1994, 214 and 414 n. 120).

34. Tapati Guha-Thakurta relates Varma's decision to set up a press to the response generated by the public showing of his Baroda pictures in Bombay in 1891 (Guha-Thakurta 1992, 106). He was already in the practice of making painted copies of his work for demanding patrons; at the Bombay exhibition, photographs of the Baroda paintings, which included iconic images of the goddesses Saraswati and Lakshmi, sold in their hundreds (Venniyoor 1981, 29–30).

35. The Parsi theater originated around the 1850s when Parsi mercantilists in Bombay began to back amateur and professional theater companies that had hitherto catered to largely British audiences. It utilized Victorian theatrical conventions (such as the proscenium arch) and techniques gleaned from touring English companies to perform *pauranic* tales, translations of Sanskrit and Shakespearean "classics," as well as original plays in Hindi, Marathi, Gujarati, and Urdu.

36. This was not confined to visual forms but extended to aural media as well, as in the case of the Sufi who went into an ecstatic trance in a cinema on hearing a devotional film song and had to be taken home (Qureshi 1995, 165).

37. To cite a few well-known examples, Calcutta's Durga Puja, initially celebrated by the Bengali elite from the mid-eighteenth century, became a community or neighborhood festival around 1918; Maharaja Ishvariprasad Narain Singh of Banaras (1835–89) "massively reworked" the Ramlila during his reign (Hansen 2001, 79); Tilak introduced the Ganapati and Shivaji festivals as devices for nationalist mobilization in late-nineteenth-century Maharashtra.

38. I thank Dayanita Singh for her observation of this relay, based on her experience of photographing middle-class families in India in the 1990s.

3. NATURALIZING THE POPULAR

The epigraph to this chapter is from S. M. Pandit's inaugural speech for the twenty-second Maharashtra State Arts Exhibition, 7 November 1981. I thank Baburao Sadwelkar for providing me with a copy of this speech and Namrata Satdeve for her assistance in translating it from Marathi.

1. *Swadeshi* literally means "of one's own country." The Gandhi-led Swadeshi movement, which advocated the boycott of foreign manufactured goods, invoking economic self-reliance through the performative symbol of spinning on a *charkha* (spinning wheel), became part of the official political platform of the

Indian National Congress in 1905. Its inscription of the nation as an economic community worked to co-opt indigenous capitalists (particularly "bazaar" industrialists like the Birlas and Shri Rams) into the Congress-led nationalist movement, despite Gandhi's explicit valorization of decentralized, "cottage industry" production and Nehru's socialism.

2. Between the early 1990s, when I first started working on calendar art, with no inkling of how central the idea of the bazaar would become to my project, and now, a decade later, there has been an explosion of Internet websites dedicated to Indian business and marketing. These sites are run by business magazines, advertising firms, market research organizations, investment companies, and, as with the Babuline site, corporations themselves. This example demonstrates how Indian companies do not necessarily subscribe to some kind of uniform "global" corporate aesthetic (or ethos) on the Internet. On the contrary, styles of presentation and the information chosen to present vary greatly depending on the degree to which a company participates in, or chooses to distance itself from, the ethos of the bazaar. A study of corporate self-representation by Indian firms on the Internet would be a worthwhile project in its own right.

3. Deshpande argues that commodities served to inscribe a spatial imaginary of the nation—and the world—through their association with specific sites of production. I would suggest, however, that it is the nationalist philosophy of Swadeshi that puts a territorial spin on the spatial imaginary evoked by commodities, rather than the other way around. Without a prior sense of the boundaries of the nation-space Samarkand and Manchester are in a sense equivalent to Moradabad or Kanchipuram: it is the nation that gives consistency to the categories of "global" and "local."

4. While I shore up this assertion below in relation to naturalism and nationalism, this point has already been made in a number of different ways, particularly in relation to the libidinal-sacral underbelly of Enlightenment thought (I am thinking here of work by thinkers associated with surrealism such as Bataille and Caillois) and the mimetic-performative aspects of encounters with the other (see Taussig 1993b).

5. I should emphasize, however, that despite my use of the same terms as Adorno and Horkheimer I do not subscribe to the idea that these irrational forms constitute a false consciousness that can be overcome through the exercise of reason.

6. In this respect my concerns here are similar to Ashish Rajadhyaksha's in his early article "Neo-Traditionalism: Film as Popular Art in India" (Rajadhyaksha 1986). My need to reiterate them two decades later is evidence of his accuracy in identifying these more "local" concerns as ones that even an interested Western readership might not share. However, unlike this article, despite my heuristic separation of colonial and vernacular arenas I would not consider the trajectory of "popular" traditions entirely a matter of "internal contradictions" as opposed to "external factors" such as colonialism: the bazaar in my account is a specifically colonial and hence inter-"cultural" formation. For the same reason, the bazaar communities cannot be equated to an indigenous "bourgeoisie" with universal class characteristics that embarks on a known path to development and liberalism: as an arena marked by colonial difference the bazaar has no straightforward teleological claim to embourgeoisement. On the contrary, the process of embourgeoisement or "liberalization" is involving a great deal of hard ideological and coercive work on the part of transnational corporations and "global" regulatory institutions such as GATT, the IMF, and the World Bank.

7. Given the use of Portuguese it is conceivable that the calendar was aimed at European residents in other contexts beyond that of India.

8. Describing the press in Punjab after the First World War, Prakash Ananda notes that "in none of the

Indian-owned papers did advertisements occupy an important place. The major advertisers were British commercial firms which, understandably, patronized their own Press. It was rarely that a foreign advertisement appeared in the Tribune" (Ananda 1986, 77). Ananda then goes on to describe an advertisement in the *Tribune* for "Mr. Bose's Kuntaline and Deklhosh" comprising a written testimonial from Lala Lajpat Rai that "they are in no way inferior to similar articles prepared by European manufacturers" (78–79).

9. Later Euroamerican examples of the capitalist reappropriation of oppositional movements include the commodification of feminism, youth subcultures, environmentalism, multiculturalism, and gay and lesbian activism.

10. Bharat Oza (the grandson of Babubhai and currently part of Babuline's management), personal communication (July 2002); I thank Shri Oza for his assistance. However, this is a retrospective explanation, and I would suggest that it belongs to a later discourse on the efficacy of images, associated in part with the resurgence of Hindu nationalism. I discuss this more recent phenomenon in chapter 6.

11. The poster probably dates from between 1903 and 1928, as this is when the name Asiatic Petroleum Co. was used. Rising Sun Oil was Russian kerosene that Marcus Samuel Jr. (the son of Shell's founder) delivered to Singapore, Thailand, India, and Japan (hence the brand name, true to colonial stereotype — but note the poster's textual simplification from "Rising Sun" to "Sun brand" in the South Asian context). In 1903 Samuel's Shell Transport and Trading Company joined hands with Royal Dutch Petroleum to form the Asiatic Petroleum Co., and in 1928 Asiatic Petroleum (India) and the Burmah Oil Company merged to form the Burmah-Shell Oil Storage and Distribution Co. of India Ltd.

12. Nor is it necessarily the case that the use of mythic figures for advertising and branding in the Euroamerican context, in the few instances where this does occur (as in the case of the St. George Bank, or Marks and Spencer's brand name of St. Michael's), adopts this kind of allegorical mode. Indeed I would suggest that this kind of allegorical deployment was a particular feature of the "intercultural" articulation of consumers attempted by firms such as Woodward's and Mellin's, deploying allegory's openness to multiple interpretations to make several different kinds of representational sense to different constituencies of consumers.

13. Partha Chatterjee puts it succinctly: colonial power in its "true form" was "a modern regime of power destined never to fulfill its normalizing mission because the premise of its power was the preservation of the alienness of the ruling group" (Chatterjee 1997, 18).

14. The Calcutta Art Studio and the Chitrashala Press in Pune began production in 1878, while the Karachi firm of S. S. Brijbasi began its chromolithographic reproduction of images from Nathdwara in 1927.

15. I am grateful to Aruna Harprasad for information about the Jhalawar collection of postcards.

16. Among those painters whose work and methods Narottam Narayan and Ghasiram would almost certainly have heard of, if not observed directly, were Raja Ravi Varma, who visited the court of Udaipur in 1901 to work for Maharana Fateh Singh, and the chief painter at that court, Kundanlal Mistri (also known as Master Kundanlal), Ghasiram's maternal uncle, who in 1893 had been sent to England to study for three years at the Slade School of Art. While Kundanlal may have been an indirect source of inspiration for Nathdwara artists, it was Ghasiram, in his capacity as head painter at the Shrinathji temple, who was to have a more pervasive influence.

17. In keeping with the primacy accorded to visuality and the image in Pushtimarg, and particularly the emphasis on portraits of the *gosains* or high priests, Vallabha priests enthusiastically embraced photography, patronizing it in the manner of rulers and merchants. Thus among the photographic portraits taken

around 1863 by the early Bombay photographer Narain Dajee is a group of "Vallabhacharya Mahara-jas" (Falconer 1995, 47, plate 4.4); by the turn of the century the *gosains* of Nathdwara and Kankroli (another nearby Pushtimarg center) had employed their own photographers to document functions, fairs, and festivities, and make portraits of the priests, their patrons, and associates. One of these was Parasram Paliwal (1889?–1977), who was sent by Balkrishnalalji of Kankroli to be trained in Madras: after many years of working for the temple he eventually set up the Geeta Studio in Nathdwara around 1960. Interview with Ramchandra Paliwal (Parasram's grandson) and his father Kanhaiyalalji, Geeta Studio, Nathdwara, 1995.

18. In this respect, again, I would want to nuance Pinney's implicit alignment of the devotional use of images with "rural" consumers (which also features in the discourse of artists and publishers, as we will see in the following chapter). He writes: "Rather than a window on reality, the images become icons whose foundational rationale is an engagement with the viewer. This can partly be explained through the growth of an increasingly rural market for images, for which their ritual utility became paramount" (Pinney 1997a, 860). I would contend that the rural location of consumers is not the key factor here, but rather their class and caste backgrounds. There is a distinction to be made between the social profile of those pre-independence consumers, both rural and urban, who used prints in a ritual capacity and influenced the early adoption of iconic features by chromolithographs, and the far more expansive post-independence mass market for prints, which may well have become predominantly rural, but only after the prints had *already* taken on their ritual form.

19. The "Brijbasi" brothers, Shrinathdas (or Nathudasji) and Shyamsundarlal (hence "S. S.") came, as their names suggest, from a Pushtimargi family of Mathura, where they ran a cotton yarn business. The elder brother moved to Karachi in search of opportunities in 1918, and in 1922 he started a picture framing shop. In 1927, having come into contact with representatives of German picture publishing firms, the brothers decided to print their own images, soon finding a steady source in the artists of Nathdwara (which they would have already visited as pilgrims); Shrinathdasji took several trips to Nathdwara every year to work with the artists. The brothers moved back to Mathura just before Partition and then opened branches in Bombay and Delhi. In the 1990s their printing operations were divided between Sivakasi and a family-owned press in Delhi's Okhla industrial area. Their Delhi trade seemed to be flourishing, particularly in larger wall posters as well as in the staple framing pictures and calendars.

20. As Solomon elaborated in a section of his 1926 book *The Charm of Indian Art*, entitled "The Indian Art Student as the Superhuman Realist": "I do not believe that the thirst for Realism will ever outrun the imaginative element in Indian Art. I believe that the latter remains as it has ever been the guardian-sense in the Indian artist's mind. . . . If we would disprove the Indian student's right to study form in the "European" style (as it is termed) we must deny the beauty of the Sanchi sculptures and the Ajanta frescoes, both born of the union of nature-study and decorative feeling" (Solomon 1926, 118). Accordingly, Solomon was the first to introduce a life study class into the curriculum, along with a rather literal-minded but politically invaluable Ajanta-inspired mural painting course. (The mural painting course enabled Solomon to bring his students' work into the governor's residence, onto the streets of Bombay for the visit of the Prince of Wales, and over to Wembley Park for the British Empire Exhibition of 1924: Solomon 1924?)

21. Dhurandhar's "fine art" oeuvre included paintings in oil and watercolor, which were reproduced along with those of Ravi Varma and Bamapada Bandopadhyay by U. Ray in Calcutta for critical "high art" journals such as the Bengali *Prabasi*. His oil painting *Have You Come Lakshmi?* won the first prize at the

Bombay Art Society's exhibition in 1895, making him the first Indian gold medalist in its history. He was also commissioned to paint watercolors for the maharajas of Kolhapur and Aundh depicting episodes from Maratha history.

22. However, even here the unusual placement and foreshortened treatment of the "Om" symbol suggests an experimental approach to iconographic convention, if not a hint of irreverent humor and irony.

23. This print appears to have enjoyed a relatively short shelf life. Unlike other Ravi Varma prints, but like the Woodward's calendar, I have not seen it in picture framers' shops, on the collectors' market, or in private collections, but only in an album kept by the artist's granddaughter, Ambika Dhurandhar (whom I thank for her time and generosity). Despite its frontal, iconic composition, perhaps its indexing of an active renegotiation of gender roles and of the performance of modern, nuclear-family domesticity did not sit easily in the market for framing pictures. (This would resonate with Madhava Prasad's reading of the injunction against the kiss in Hindi cinema [Prasad 1998].) The print depicts a Maharashtrian but semi-westernized ("modern") couple with a baby in a domestic interior cluttered with books and Western-style furnishings, including the mandatory clock. The husband, sporting an identifiably "Maratha" moustache and a red *tilak* on his forehead, wears a European-style shirt and waistcoat over his *dhoti* and rests his foot on a footstool as he cradles the baby. The wife, dressed in a sari, also looks down at the baby as she stands behind her husband with her hand resting on his back, this gesture of intimacy again indexing the modernity of this relationship. An ancestral portrait on the wall bears witness to this cozy little scene, the composition of the figures echoing the contours of the map of India, a subject of intense improvisation and high visibility at the time.

24. Phalke's explicitly Swadeshi, pan-national vision (as epitomized in the name of his company, Hindustan Cinema Films) combined the use of *pauranic* and "classical" imagery inspired by Ravi Varma with the use of cinematic illusions inspired by Meliès. As Phalke put it, "My films are *swadeshi* in the sense that the capital, ownership, employees and stories are *swadeshi*" (quoted in Rajadhyaksha 1993b). Painter's *Sairandhari*, 1919, was based on the controversial play *Kichakavadha*, which was banned by the colonial government for its political allegorization of an episode from the Mahabharata epic; the film, too, was censored for the graphic violence of the scene where Bhima (representing the nationalist leader Tilak) kills the evil Kichak (read as Lord Curzon). Painter's *Savkari Pash*, 1925, about a peasant's exploitation by a greedy money-lender, is seen as establishing the genre of the social melodrama (Rajadhyaksha and Willemen 1994). The "saint" films of Prabhat retold the stories of Maharashtrian and other saint-poets such as Tukaram, Janabai, Tulsidas, Narsi Mehta, and Dnyaneshwar, taking up the egalitarian and anti-Brahmin themes of the *bhakti* movements and often playing on their resonance with contemporary issues (for instance, in Prabhat's *Dharmatma*, 1935, Gandhi is compared to the *bhakta* poet Eknath).

25. These early filmmakers often embodied the close links between technological innovation, illusionism, and spectacle, and the continuum between painting, printing, photography, theater, and film. Phalke had been trained as a painter at art school, studied architecture, ceramics, photolithography, and block making, and worked as a photographer, stage makeup artist, magician's assistant, and printer before going to London to learn about film technology and buy equipment (Rajadhyaksha and Willemen 1994, 164). Painter came from a less privileged craft background and had taught himself Western-style painting and sculpture, working as a professional portrait and landscape painter and running a photographic studio before working with V. G. Damle to assemble his own camera. Damle's associate Sheikh Fattelal had been apprenticed to the painter Abalal Rahiman.

26. Another center for Maratha patronage of Western-style painting was Aundh, near Satara, particularly

under Balasaheb Pantapratinidhi, himself an amateur painter of mythological subjects. In 1938, to "improve the tastes of his subjects" (as Partha Mitter [1994] puts it) Balasaheb Pantapratinidhi set up the Shri Bhawani museum, which still houses a large collection of European art and Indian oil painting.

27. In this sense his deployment of two distinct modes of signification for these different political agendas anticipates the later distinction between Bollywood melodrama as a pan-national commercial form and realism as the preferred form of the post-independence "developmentalist" elite (Prasad 1998) — though with the important difference that Painter himself came from one of the communities for whose cause realism was being deployed.

28. As with Ravi Varma, several myths are attached to the life and career of Sambanand Monappa Pandit, beginning with his birth into an artisan family of Gulbarga in present day Karnataka. (Pandit's grandfather had been a *kansagar* or manufacturer of copper vessels; his son described their community as "Vishwakarma" — the name of the god of crafts.) His mother was fetching water one day when someone hailed her: it was the renowned sage Sidappa Maharaj of Lachhan passing by in his palanquin. He took out some *prasad* and put it in her water jar, saying that she would give birth to a "jewel of a son" who would encounter "as many ladies as he has hairs on his head." The "official" interpretation of this prophesy is that it refers to his numerous paintings of women, certainly the subject for which he is best known but about whose eroticism there is a certain ambivalence. Information on Pandit is based on interviews with his son, K. S. Pandit, and his wife, Nalini Pandit, Gulbarga, 1995; also V. T. Kale 1989; Khadilkar 1991; Pai 1989.

29. He graduated from the Madras School of Art in 1931, and then from the J. J. in 1936, when Dhurandhar was the headmaster (followed by an additional year of the J. J. course in mural painting in 1937); while at the J. J. he also studied with G. S. Dandavatimath at Nutan Kala Mandir. Pandit's very first mentor in Gulbarga, Shankar Rao Allandkar, had been trained at the J. J. and ended up making a living teaching drawing at a local school and designing showcards for Gulbarga's Lakshmi Theatre.

30. Film posters were usually done in oils on cloth (like stage backdrops), a slow technique requiring a good deal of control. Instead Pandit began to use the quicker drying gouache (still on cloth), while retaining the illusionist techniques associated with oils, an innovation that became his trademark and paved the way for later artists' use of the airbrush.

31. Several artists explicitly stated this as the reason for moving from the "film line" to the "calendar line." Here again more work needs to be done on the moral-commercial economies of the Indian film industry: it is possible that dealings in the industry were initially more transparent than they were once film funding became a means of money laundering (see Vitali 2005) and the Bombay underworld got involved, although it is evident from the preceding account that an informal economy of favors and patronage operated right from the start.

32. Information from P. Dharmar, National Litho Press, Sivakasi, 1994.

33. Recall that Pandit started his career painting showcards for MGM, producers of the Tarzan films. As distinct from the film posters of RKO, Paramount, or Warner Brothers, MGM's were characterized by their brightness and simplicity, often featuring portraits of the stars against simple monochrome backgrounds (Edwards 1985, 68).

34. *Alka*, started by the Marathi poet Shrikrishna Powale, was the first one for which Mulgaonkar provided illustrations. *Ratnadeep* was started in 1956 by Mulgaonkar's cousin Nalini; *Ratnaprabha*, which ran from 1966–76, was published by Mulgaonkar himself, while *Deepawali* was Dalal's. Similar Diwali special issues were produced in several other Indian languages as well, including Hindi, Gujarati, and Tamil.

35. A *rasik* is one who partakes of *rasa*, meaning enjoyment or flavor, connoting aesthetic pleasure in a manner more akin to the earlier Greek meaning of *aesthesia* with its emphasis on the senses.

36. The Diwali specials were printed using a mixture of letterpress and offset: the artwork for the text pages and monochrome halftone illustrations was prepared on letterpress and offset printed on newsprint, while the color plates were offset printed separately on art paper. The 1968 issue of *Deepawali* provides five different addresses, for the publisher, offset printer, color printer, block maker, and (presumably letterpress) "printer."

37. Like other magazines proliferating after independence, the popular Marathi magazines of the 1950s and 1960s were sites for the delineation of an Indian modernity where "Indian" religion and culture, often formulated in opposition to a decadent, materialistic "West," negotiated its relationship with the discourses of science, technology, and progress, the practices of commercial and industrial capital, or models of gender and sexuality. The Diwali specials often carried articles on the lives of prominent industrialists, on Western influences on modern youth, or celebrations of Indian womanhood, as well as meditations on, for instance, space exploration and atomic energy in relation to Indian philosophical treatises.

38. Pramod Kale cites the *Kirloskar* magazine as a possible inspiration to V. Shantaram in his "rags to riches" success (P. Kale 1979, 1515). The *Kirloskar* carried articles on "scientific, social and industrial matters . . . [and] was seen by the reading public not merely as the messenger of a business group and its products, but also as an instrument of social change" (Tripathi and Mehta 1990, 139). Its success encouraged the Kirloskars to start *Stree*, for women, and *Manohar*, an artistic and literary magazine, both in Marathi. Laxmanrao Kirloskar, the founder of the Kirloskar industrial house, had attended the J. J. School of Art; his first job was as a mechanical drawing teacher at the Victoria Jubilee Technical Institute (vjti) in Bombay. He was assisted in the early stages of his entrepreneurial efforts (producing ploughs) by his friend from vjti, Balasaheb Pantapratinidhi, who provided a factory site in his principality at Aundh. This later grew into the township of Kirloskarwadi.

39. Neither of the latter, for instance, gave much credence to cinema as a cultural form, whereas the 1963 issue of *Ratnadeep* carried a debate on the impact of film music on musical culture, with contributions from the film industry as well as champions of classical music. In their illustrations, too, neither would include the kind of eroticized *nayika*s whose bosoms obtruded from the pages of the Diwali specials; the *Bhavan's Journal* in the 1950s featured art plates on its back covers and in its annual issues, but these were usually "fine art" works by contemporary artists such as Chughtai and Haldankar or "traditional" miniatures.

40. Such companies were a common source of entertainment in the early twentieth century: Kondiah's was one of several that toured Tamil-speaking areas as far as Sri Lanka and Singapore. (A few companies still survive but can now only afford to perform part time; see Seizer 2005.) It was from one of these companies, with their mix of mythological epics and Tamil folk narratives, that one of the most powerful products of the culture industry, the film star-cum-politician M. G. Ramachandran, emerged into the Madras cinema in 1936. Among other calendar artists who started out in theater companies were T. Subbiah, initially a theater electrician, and K. Madhavan (mentioned above).

41. By 1949 Sivakasi had enough work to be able to advertise in Madras for commercial artists who could produce designs as well as transfer them to blocks. One artist who moved to Sivakasi as a result was Ravi (b. 1929), originally from Kerala, who learned his trade in Madras working with K. Madhavan in films and advertising before joining Sivakasi's Raja Litho Works.

42. Two reference books used by Ravi were Vallejo 1985; Augusta and Burian 1960.

1. The title of this section in the chapter literally means "kitsch loses something": something is lost or missed by using the word "kitsch." This is a play on the title of a show of contemporary art and design inspired by bazaar imagery called Kitsch Kitsch Hota Hai (loosely translatable as "Kitsch Happens"; India Habitat Centre, New Delhi, March 2001), which in turn plays on the title of a popular Hindi film, *Kuchh Kuchh Hota Hai* (literally, "Something Happens"), 1998 (dir. Karan Johar).

2. In all translations from Hindi, words originally spoken in English are indicated in bold, while original Hindi words are added in italics wherever I feel they are particularly relevant or untranslatable. None of the names of the artists interviewed here have been changed, in keeping with the disciplinary conventions of art history rather than of anthropology. I have been less forthcoming about naming individual printers and publishers, because unlike artists they have not already elected to circulate their "private" names in the public sphere (although even the way in which this occurs with artists is, as we shall see, far from straightforward).

3. When I was conducting most of my interviews I was a Ph.D. candidate in the University of Sydney's Department of Fine Arts, which changed its name in 1997 to the Department of Art History and Theory.

4. S. M. Pandit studied at Bombay's J. J. School of Art in the 1930s, as did Indra Sharma and B. G. Sharma from Nathdwara and S. V. Aras (the "baby artist") in the 1940s and 1950s, the landscape specialist S. S. Shaikh in the early 1960s, and Maya and Venkatesh Sapar in the 1980s. S. M. Pandit attended three art schools: the Madras School of Art, the J. J. School of Art, and G. S. Dandavatimath's Nutan Kala Mandir in Bombay. Other calendar artists who studied at the Madras School of Art include C. Kondiah Raju, who began his studies there in 1916, K. Madhavan, who studied there in the 1930s, and S. Courtallam, who studied under Debiprasad Roychowdhry (who moved from the Calcutta School of Art to become the principal of the Madras school in 1928) in the 1950s.

5. S. M. Pandit decided to give up commercial painting to concentrate on his own work, including portraits and mythological subjects such as the Mahabharat war (on which more in chapter 6). Indra Sharma and S. S. Shaikh said they preferred to take up commissions for personal clients or to do interior murals for luxury hotels (although Sharma's eyesight was failing when I met him and he was spending an increasing amount of time with his daughter in the United States; sadly he is now blind). J. P. Singhal, in contrast, has switched almost entirely to studio photography, for which he is now well known and well regarded in Bombay film circles.

6. Some titles, all from Mandala Publishing in San Rafael, include Swami B. V. Tripurari and B. G. Sharma, *Form of Beauty: The Krishna Art of B. G. Sharma*, 1998; Indra Sharma, *In a World of Gods and Goddesses: The Mystic Art of Indra Sharma*, 2003; B. G. Sharma and Indra Sharma, *Beauty, Power and Grace: The Many Faces of the Goddess*, 2004; B. G. Sharma and Ranchor Prime, *Prince of Dharma: The Life of the Buddha*, 2004; and B. G. Sharma and Ranchor Prime, *Ramayana: A Tale of Gods and Demons*, 2004.

7. I must emphasize that in my usage here am I reducing the "aesthetic" to just one of its historical avatars, one that subjects its Greek forebear *aesthetikos* or sense perception to "the colonization of reason" (Eagleton 1990, 15). Even the version of the aesthetic in Kant that I am engaging with has to be understood as a very particular version, often construed as a misreading of Kant, but nonetheless a misreading that has taken on enormous currency. Martha Woodmansee describes in detail how Kant's text took on an afterlife in publicly circulating ideas about art and the aesthetic in Britain and Germany in the late eighteenth century and shows how these ideas were closely imbricated with the growing culture of

the book and debates around authorial property rights (Woodmansee 1994). It is these ideas (rather than Kant's text as such) that then came to be mediated by a colonial realm of art discourse to impinge on the calendar industry.

8. Ethnicity is not a variable in Bourdieu's overwhelmingly class-centered research. We therefore get little sense from him of where, say, the Algerian or Turkish immigrant population in France stood in relation to these categories of distinction.

9. At the same time, however, in these thinkers there is a certain resistance to this historical narrative of the supersession of the sacred, so the unraveling of this narrative in the postcolony takes place at an immanent point of stress. In both Benjamin and Belting, to different degrees, there is a trace, if not an acknowledgment, of a certain unfinished business between the aesthetic and the sacred. Benjamin's account of cult value and exhibition value is sensitive to the auratic artwork's ambivalent location across these two modalities of reception despite their posited polarity. He writes of "a certain oscillation," which crucially hinges around the changing contexts of the image (his example is Raphael's *Sistine Madonna*, whose removal to an obscure location circumvented the church's injunction against using at the altar images that had been associated with obsequies; Benjamin 1969, 245 n. 8). Also, as he points out, within a Hegelian idealist frame this polarity can never be fully realized; so the cultic basis of the artwork is not actually *replaced* in the progression to "exhibition value" but *persists* within a fine art conceived as a "secular cult of beauty" (Benjamin 1969, 224). Along similar lines, Belting speaks of the aesthetic sphere as "a kind of *reconciliation* between the lost way of experiencing images and the one that remained" (Belting 1987, 16). Revealingly, just as he finishes describing how the Reformation entailed a loss of power for cultic images, which were then seen as artworks, Belting distances himself from what he calls the "element of exaggeration" inherent in historical narrative. It is as though the vector of historiography is making him say things he doesn't fully endorse, but he can't do without it either — for, as he says, in a peculiarly tautological sentence: "The history of religion or the history of the human subject, both of which are inseparable from the history of the image, cannot be narrated without a schema of history." Perhaps this is just a bad translation, but it does seem to index an anxiety about the "schema of history."

10. This procedure is in part related to the touching up or coloring of black and white photographs, a common practice in India from the beginnings of photography up until the rise of cheap automatic color labs in the 1980s. But as I suggested in chapter 2, I think it also relates to the South Indian reverse glass painting tradition (which came from Europe via China around the late eighteenth century), particularly since some artists from communities associated with Tanjore glass painting are known to have found employment with the Sivakasi presses, sometimes after a stint at a photographic studio. In reverse glass painting, the finishing lines were painted first and the background colors last. For this process artists needed a strong visual memory and a grasp of layering and negative space, which would have easily transferred to retouching the glass plates initially used for color separations in offset printing.

11. For those consumers paying for "glossy" or "fancy" calendars, a separate plate is prepared for areas of gold, which are picked out with a layer of golden powder (the golden plate designates areas where an adhesive is printed onto the calendar; these areas are then manually dusted with powder by workers hired by the hour).

12. The phrase "cut colors" is most likely a reference to the physical scraping of the emulsion off the color-separated negative with a surgical knife in order to achieve a 100 percent color saturation.

13. Foucault defines "heterotopology," or the systematic description of heterotopias, as "a simultaneously mythic and real contestation of the space in which we live." The notion of the "heterotopia" is elabo-

rated in a posthumously published essay by Foucault describing "a kind of effectively enacted utopia in which . . . all the other real sites that can be found within the culture, are simultaneously represented, contested and inverted" (Foucault, 1986, 24).

14. During the late colonial and early post-independence periods these latter forms, particularly those inflected by Vedantist ideas, gained legitimacy as modern reformulations of the essence of Hinduism via influential thinkers such as Gandhi, Vivekananda, and S. Radhakrishnan.

15. "Finishing" is the term used for the painstaking surface effects in which the artist's labor is most clearly evident: the fine, smooth brushwork used to add subtle tints and highlights to the picture after the basic color scheme has been put in place. While this is one of the most important skills on which a calendar artist's quality is judged by the industry, often the more tedious parts of "finishing," such as the details of jewelry, textiles, or architectural ornaments, are delegated to assistants. However, the final touches to the face and eyes, which breathe both emotional and sacred life into the figure, are handled by the artists themselves.

16. Rastogi said, "It's a bit different for someone who doesn't even know he's made a mistake. But the one who understands, he suffers. So now this suffering of mine has turned into a habit, now there's no suffering."

17. Such a strategy of equating mythic and prehistoric epochs is also evident in the presence of dinosaurs in the Ramayana (or Ramakien) mural adorning the Wat Phra Kaew at the Royal Palace in Bangkok. Here, as in the comic book form, a mythological narrative unfolds in a form situated between the mythic still frame's frontal interruption of history and the restoration of linear narrative through the moving image.

18. European commentators on realism were to look back on it in terms that emphasized this crossing of boundaries between the "things of art" and the "things of life." Thus, for instance, in the 1950s the French art historian Germain Bazin dismissively wrote: "Realism pandered to the lazy imagination of the middle class, by making art a means of reproducing the material world which was all they cared about" (Bazin 1968, 396–97).

19. Some artists, such as Venkatesh Sapar and Indra Sharma, felt that they were able to achieve this goal in their own work. Both strongly emphasized the close link between the devotional feeling communicated by their paintings and that in their own "hearts"; Venkatesh Sapar's most satisfying work so far, he said, was a recent commission for a series of illustrations of the Gita for a Californian Hindu organization. Others, however, confessed—sometimes with evident regret—to seeing icon painting in a more detached, "professional" manner (so even if they did perform some kind of ritual before starting work, it was more to do with the sanctity of work itself rather than with the subject matter of their paintings).

20. However, the work of these artists is based on inputs from artists such as Indra Sharma, who was invited to Los Angeles in 1979 as a consultant to ISKCON artists.

21. There is a continuity here with the tradition of early chromolithographs produced in India, which sometimes bore the legend "Made *as* Germany" (here, obviously, the emphasis is mine), which continued in all manner of Indian imitations labeled "Made as Japan" or "Made as USA." In another pre-liberalization variation, the acronym in "Made in USA" was commonly known to stand for "Ulhasnagar Sindhi Association."

22. Many calendar artists extend their range to a number of different subjects, each with its own appropriate style, in the manner of designers or art directors rather than "fine" artists. (S. V. Aras said, "Actually, we are not painters, we are designers.") As Venkatesh Sapar put it: "That is why—the main, what I am today—I am not stuck in any particular style. I always keep changing. I really want to fulfill the

demand of those people, printers, I always think about that, that is why." Thus Sapar's work for the 1996 "English" season included an "Indian art style" Omar Khayyam four-sheeter series, the "figurative abstract" series depicting folk dancers in a "modern" style, a series of late-nineteenth-century "picturesque" views (entitled *Ancient India*) in the style of colonial lithographs (see fig. 155), and a series of what he termed "Chinese style" illustrations of flowers and butterflies. This was all in addition to the usual gods and goddesses in a "realistic" style. Yogendra Rastogi, too, has been able to combine the staple of deities with photo-realist "beauties" and "babies," more recently turning his hand to neotraditionalist miniature-style depictions of the Radha-Krishna theme (fig. 24), and even a more abstract graphic design in response to a client's demand for something a bit more "disco."

23. Similarly in the Euroamerican culture industry best-selling authors have written in different genres under different names (I thank Jennifer Milam for pointing this out to me). Instances of these include Stephen King writing as Richard Bachman and Anne Rice writing as A. N. Roquelaure and Anne Rampling.

24. Frow (1997b) develops this formulation at length in relation to the gift and commodity economies and the encroachment of commodification onto human bodies and ideas. My schematization here hardly does justice to Frow's complex, nuanced and far-reaching argument, which reintroduces an economic dimension into post-Enlightenment critiques of the rational subject.

25. Frow locates this formulation of the liberal subject in relation to property in Locke, while the notion of authorship develops in post-romantic thought: to this extent, as Etienne Balibar argues, the modern subject can be seen as "invented" by Kant across his three *Critiques* (Balibar 1994). Frow's argument here has strong parallels with that of C. B. Macpherson, who similarly sought to demonstrate the imbrication of liberal ideas of subjecthood (particularly those of Hobbes, Harrington, and Locke) with contemporaneous ideas about markets and value (Macpherson 1962).

5. THE CIRCULATION OF IMAGES

The first epigraph to this chapter refers to *prasad*, an offering of food made to the deity by the devotee (usually via a priest); this is blessed or sanctified by the priest and redistributed to devotees as they conclude their worship or make monetary offerings. The second epigraph to this chapter is translated from the Hindi by Harbans Mukhia in Mukhia 1976, 449.

1. The political historian J. G. A. Pocock identifies a central tussle in the development of a modern secular, political, and historical self-consciousness, between "virtue" and "providence" on the one hand and "corruption," "commerce," and "fortune" on the other. Here an ethos in which men of virtue earn the right to reap the steady benefits of divine providence or nature is confronted with fickle forms of wealth that appear and disappear as though out of nowhere (Pocock 1975).

2. According to Deleuze and Guattari, the flow of commodity exchange coupled with the flow of free labor institutes the "axiomatic" of capital, driven by the mutual tension between its two poles (their emphasis here is not so much on production but on circulation: capital as a system of metamorphoses). At one pole, capital is a self-perpetuating deterritorializing "machine" designed to surpass all limits. At the other, however, because it institutes itself at the site of previous territorializations, its axiomatic comes up against immanent limits: while not allowing previous codings to subsist it must still incorporate them in some way. These codes must therefore be reinscribed, "reterritorialized" in a manner that necessarily circumscribes some kind of transcendent organic body, maintaining the structural integrity of the socius by perpetuating and reinforcing its psychic and material networks (Deleuze and Guattari 1977, 1987).

3. An ambiguity is built in to the notion of the ethos, which Jakob Wisse identifies in a discrepancy between Aristotle's uses of the term in the *Rhetoric* and the *Ethica Nicomachea* (Wisse 1989, 29–31). Between the *Ethica* and the *Rhetoric*, *ethos* subtly slips between referring to essential, inherent moral qualities and referring to the performance of such moral qualities in a supplementary register of persuasive practice. The ethical slips between that which simply "is" and that which must be continually pointed toward, (re)asserted, (re)established, (re)made, in a realm of repetition into which the potential for difference is thus structurally inscribed.

4. In this scenario, as several commentators have pointed out, the disavowal embodied by the fetish, which takes the properly ideological form "I know, but even so . . ." (in Oedipal terms, the disavowal of the threat of castration represented by the mother's missing penis), itself becomes the subject of a fetishistic disavowal: (I know) the fetish does not exist, but (even so) the fetish must not be allowed to subsist (see, for instance, Baudrillard 1981, 90; Taussig 1993a).

5. This is not necessarily to endorse the way in which Baudrillard develops his semiological reading of Marx, replacing the fetishism of the signified with a fetishism of the signifier, a passion for the code itself. Indeed my attempt here in working with the notion of material incarnations is precisely to counter such a recuperation by signification (for a materialist critique of semiological readings of Marx's notion of fetishism, see Pietz 1993).

6. Nicholas Thomas (1991) argues for a recognition of the ways in which societies distinguish the market from other social and cultural realms, marking out objects as market alienable or inalienable—for instance, by making a distinction between gifts and commodities. Arjun Appadurai's discussion of the politics of value in relation to the "social life of things" (Appadurai 1986) takes up Bourdieu's (1977) extension of Mauss's argument that gift exchange is never devoid of economic interest or calculation by expanding the economic realm to include nonmaterial (social, cultural) realms of value. Thomas, however, argues against abandoning the social distinction between gifts and commodities, as this would "obscure precisely the factors which mark the biographies of objects and sometimes break them apart through recontextualization and transgression."

7. Durkheim himself observes that moral individualism has a religious dimension: "Whoever makes an attempt on a man's life, on a man's liberty . . . inspires in us a feeling of horror analogous in every way to that which the believer experiences when he sees an idol profaned" (Durkheim 1973, 46). (Durkheim's critics, however, accuse him of deifying society, rather than the individual, in just the same way; see Taussig 1993a, 226–29). In the case of the "secular cult" of the aesthetic object within the liberal ethos the negotiation of the boundary between commerce and the autonomous space of art has itself become a major preoccupation of artists. John Frow (1997b) argues that the expansion of commoditization is a systemic—not to be conflated with ineluctable—feature of contemporary capitalist societies; he traces this process through an examination of changes in legal doctrine pertaining to the sale of parts or functions of the human body, an issue fraught by the dual nature of the individual in liberal thought as the ultimate repository both of inalienability and of the right to property.

8. The issue of pollution also bears on whether and/or how such images are thrown away. Printed icons are either disposed of through ritual "cooling" (immersion in a body of water such as a river or lake) or simply passed on to others (this is particularly the case with calendars). It is considered inappropriate to put images of deities in the garbage, as a friend in Delhi found out when she was photocopying an article on popular icons for me and put some rejected photocopies of pictures in the wastebasket: the man in charge of the machine ran after her and handed them back.

9. The reference here is to the Derridean notion of "arche-writing," writing understood not simply as an

inadequate derivative of speech but in terms of the practices of differentiation, appellation, and classification at the basis of both writing and speech (Derrida 1976, 109–12). Similarly, it is the social mobilization of objects that is at the basis of both gift and commodity exchange: in this sense one cannot conceive of a society without the (arche-)commodity (just as one cannot conceive of a society without arche-writing).

10. "To give something is to give a part of oneself . . . what is in reality a part of one's nature and substance, while to receive something is to receive a part of someone's spiritual essence" (Mauss 1967, 10).

11. For wider evidence of such a denial of reciprocity or exchange, one need look no further than the religious advertisements in the *Bhavan's Journal*. Here contemporary devotees are, for instance, exhorted to "streamline the fulfillment of your religious *obligations*" (emphasis added) by the Dhanalakshmi Bank, which automatically forwards the interest on deposits to the Kanchi, Sringeri, or Rama Vittala *maths* (religious institutions) to pay for rituals. The advertisement even goes on to reassure us that we will receive something in return: "Prasadams for your offerings will reach you from HIS HOLINESS" (*Bhavan's Journal* 30 [10] [16 December 1983]: 48). The denial of exchange thus persists as a Zizekian "meaningless prohibition" (the prohibition of something that is not supposed to exist) even as the interface between commercial and sacred economies readily appropriates "impersonal" mechanisms of the capitalist marketplace such as advertising, banking, and the commoditization of ritual (Žižek 1989, 36–47).

12. Similarly, Clifford Geertz describes the Moroccan bazaar economy as one where reliable information, personal relationships, and exchange skills are at a premium precisely because the quality, value, and availability of commodities is not standardized (Geertz 1979).

13. *Ghats* are steps leading down to a body of water to facilitate washing and bathing; a *dharamshala* is a rest house for pilgrims, often free or only accepting a token fee for lodging; a *gaushala* is a holding place for stray cattle.

14. Again, it is important to keep in mind that the ethos of the bazaar is not that of a generalized "Hindu" culture (although, as I argue below, the bazaar does come to lay a hegemonic claim to the representation of such a generic Hinduism). In other words, this does not mean that there has never been any form of moral opposition to money and the marketplace. Sanjay Subrahmanyam, for instance, suggests that devotional poetry from the fifteenth to the seventeenth centuries reflects an ambivalent set of attitudes toward the market (Subrahmanyam 1994, 22–28). Thus poets such as the fifteenth-century Kabir explicitly shun wealth and the bazaar as spaces of worldly illusion, but at the same time Kabir himself, like later poets such as Dadu (cited in the epigraph to this chapter), also deploys mercantile and commercial metaphors to describe the virtues of a "spiritual" path.

15. Deleuze's and Guattari's characterization of "capitalism" in terms of a generalized axiomatic characterizes specific social formations as "models of realization" that remain fundamentally heterogeneous even as they tend toward "isomorphism" with a global capitalist axiomatic. But simultaneously, at the "peripheries" where capital encounters and repels its own immanent limits, social formations also exhibit a certain organizational "polymorphy" or "heteromorphy." These "*certainly do not constitute vestiges or transitional forms* since they realize an ultramodern capitalist production . . . but . . . are nonetheless precapitalist, or extracapitalist, owing to other aspects of their production and to the forced inadequacy of their domestic market in relation to the world market" (Deleuze and Guattari 1987, 436, emphasis in the original; see also 464–46).

16. Here I am drawing on Michael Taussig's reading of Durkheim's *Elementary Forms of Religious Life*, where Taussig formulates Durkheim's sacred object (which Taussig calls the fetish) as "where thought and

object interpenetrate in the significance of collective sentiment" (Taussig 1993a, 233). Here he quotes Durkheim: "In general a collective sentiment can become conscious of itself only by being fixed upon some material object; but by virtue of this very fact, it participates in the nature of this object, and reciprocally, the object participates in its nature" (Durkheim 1965, 269). The sacredness of the object thus inheres in the way in which it simultaneously inscribes the social and erases the social nature of this inscription.

17. The *bhakti* (devotion) movements are thought to have emerged more or less independently in various parts of the country, arising first in the south around the eighth century and moving northward during the fifteenth and sixteenth centuries. Mostly centered around the teachings of particular gurus or saint-poets, these movements have not been exclusive to "Hinduism" (*bhakti* is central to Sufism, for instance, and to the Sikh followers of Guru Nanak); elements of *bhakti* have cropped up at different times in various Hindu, Muslim, and Christian sects. The emphasis in *bhakti* on ecstatic, personalized forms of devotion, often expressed through poetry, song, and dance as well as pilgrimage, sought to establish a universally and unmediatedly accessible divinity as an alternative to dependence on intercession by the priestly class (or the lack thereof, for those denied access to temples). Their egalitarianism, challenging caste and other hierarchies (class, patriarchy), has been related, on the one hand, to the influence of Islam and, on the other hand, to the rising aspirations of an artisanal class becoming increasingly affluent through technological development and increased production during the twelfth and thirteenth centuries (Habib 1965, cited in Mukhia 1976, 451).

18. Peabody's article is entitled "In Whose Turban Does the Lord Reside?: The Objectification of Charisma and the Fetishism of Objects in the Hindu Kingdom of Kota," referring to the way in which the smaller of these icons were often carried from place to place hidden in someone's turban. His analysis develops the work of S. J. Tambiah on sacra in the service of political power (particularly Tambiah 1984).

19. This is not to say that notions of sacred territoriality were no longer powerful: on the contrary, these were used as a means of legitimizing the "deterritorialized" idol. Thus myths attached to Shrinathji (as indeed to other Krishna idols shoring up the authority of the medieval kingdoms of Rajasthan and Bundelkhand) link the idol to the sites of Braj, such that at certain times the idol was said to fly back there to play with the *gopi*s.

20. On the formulation of the triangular operation of desire, where desire is fundamentally imitative of other desires, that is, mimetic and mediated, see Girard 1978 (particularly chapter 3). Here I am also drawing on Michael Warner's observations on the "metapopularity" of Reagan, wherein "the myth of Reagan's popularity is itself 'ever popular.'. . . The major task of Western leaders has become the task of producing popularity, which is not the same as being popular" (Warner 1992, 391).

21. The phrase "public" is in scare quotes here because this religious, affective community cannot be conflated with the Habermasian characterization of the "public" as a realm of rational debate in the context of bourgeois Europe (Habermas 1989). Similarly, I use the term "trans-subjective" rather than "inter-subjective" in order to take into account phenomena associated with a community as such rather than as an aggregation of individuals. (I return to this notion in the following chapter.)

22. The Bhagwat or Bhagwata *bhakti* cults are those centered around devotion to Krishna as outlined in the Bhagwat(a) (also Bhagvat or Bhagwad) Purana, also known as the Shrimad Bhagavata, the most popular of the Puranas (also the most recent, dating from about 1300–1400 CE).

23. Again, this is a heuristic analogy whose explanatory power rests on a Durkheimian social interpretation of the sacred. I should also emphasize here that the word "affect" is not synonymous with "emotion": I

am using it in its specific sense as a form of experience that radically calls into question the individual subject as the repository of identity and consciousness (see Massumi 1995, who goes so far as to characterize affect as autonomous). This is important, as it signals a major difference between the "subject" of free affect and that of free labor.

24. The philosophy of Vedanta (literally, "end of the Veda") is so called because it is centered on the Upanishads, texts seen as the last portion of the Vedas and thought to have been composed between about 1000 and 300 BCE, that is, predating the rise of Buddhism. Perhaps the most influential interpretations of the Upanishads, and particularly their distillation in the Brahma-Sutra or Vedanta-Sutra (as well as of other texts informing *bhakti* practice such as the Bhagwad Gita and the Bhagwat Purana), representing two distinct viewpoints, have been Shankara's non-dualism (*advaita*) and Ramanuja's "qualified" non-dualism (*visishtadvaita*).

25. The varying characterizations by Vedantist philosophers of the world, the self, and the absolute and the relationships among them have meant different levels of emphasis on *bhakti*, with its connotations of love, devotion, and surrender as the primary path toward the Absolute. A key area of divergence is the concept of the world as part of the web of *maya*, or illusion. This is a realm of pain, finitude, and false desires, from which humans seek liberation, a return to the divine essence of which they are a part. The divine is immanent in all things, but *maya* intervenes to introduce a separation from god. *Maya* for Shankara is an illusion: the path to attaining the truth beyond *maya* and becoming one with god is to shun worldly desires and ignorance and become pure of mind, body, and soul. Shankara therefore advocates a path of ascetic renunciation and the pursuit of knowledge to attain liberation. In the *bhakti marga* (way of devotion) advocated by Ramanuja and Vallabha, while worldly experiences are an illusion, this world is equally a manifestation of god, the *lila* or play of Vishnu (Vishnu as Krishna is seen as the supreme being in the Bhagwat *bhakti* cults). All that devotees can do, therefore, is to stay pure of heart and abandon themselves to god's mercy, dedicating all of their practices and harnessing all of their desires to the love of god.

26. This formulation of the relationship of the human soul or self to Brahman, centering on the interpretation of the Vedantic principle "*tat tvam asi*," "thou art that," is what constitutes the "qualified" aspect of Ramanuja's monism (*visishtadvaita*), which it shares with Vallabha's "pure" monism (*shudhadvaita*). While Shankara's *nirguna* Brahman is the only reality, indeterminate and formless, which is obscured by ignorance or *maya*, Ramanuja and Vallabha query the status of this *maya*: after all, it too must be part of god in some way. For Ramanuja Brahman *can* be internally differentiated, the world of souls and matter constituting a somehow less pure part of his body, thus "qualifying" the divine. For Vallabha, however, nothing can taint the purity of Brahman, and the world as *jagat* is a real manifestation of the divine, as opposed to Shankara's purely imaginary construct—though he does accommodate Shankara's schema as well by employing the further category of *samsara* for the world imagined by the soul due to ignorance. These two conceptions of the world in Vallabha enable a liminal zone (*jagat*) between immanence and transcendence, enabling a slippery formulation of the devotee in the state of blissful enjoyment of the divine. This devotee has not vanquished desire by merging in the cosmic absolute. Here the devotee remains a distinct subject, for in order to perceive or experience this enjoyment she or he cannot be completely continuous with the divine—as one poet put it, "I want to eat sugar, and do not want to become sugar" (cited in Radhakrishnan 1948, 242)—yet at the same time there is no longer a "subject" in that it now has no other existence, purpose, essence, or consciousness.

27. The key formulation here is the interpretation of a section of the Brihadaranyaka Upanishad, which

describes Brahman as having two modes (the gross and subtle universes) and five colored forms, followed by the phrase *"neti neti,"* "not this, not this." For Shankara, the latter is an absolute negation of any attributes, while for Ramanuja *neti* is broken down as *na + iti*, to read as "not *only* this," serving thereby to warn of the limits of representation. (Brihadaranyaka Upanishad IV.4.22, see also III.9.26; Basu 1916/1974).

28. In Radhakrishnan's authoritative version of Indian philosophy, "monistic idealism . . . is the highest truth revealed to India. . . . If we can abstract from the variety of opinion and observe the general spirit of Indian thought, we shall find that it has a disposition to interpret life and nature in the way of monistic idealism, though this tendency is so plastic, living and manifold that it takes many forms and expresses itself in even mutually hostile teachings" (Radhakrishnan 1948, 32). A later Marxist tradition in the interpretation of Indian philosophy, represented particularly by Debiprasad Chattopadhyaya and Rahul Sankrityayana, has opposed this idealist valorization of Advaita Vedanta, foregrounding the more "materialist" movements (see, for instance, Chattopadhyaya 1992).

29. Tilak's *Bhagwad Gita Rahasya* was a particularly influential reinterpretation in this vein, shored up by the ideas of Vivekananda and Gokhale among others (see Subramanian 1987). The industrialist G. D. Birla's writings index how the notion of *karmayoga* as selfless action had enduring appeal as a legitimating ideology for indigenous capitalists (see for instance Birla 1994, 64–69). The *Bhavan's Journal*, a major contributor to this reinscription, in its turn described "Poojya (literally "worthy of worship") Shri Ghanshyamdasji Birla" as a "Karma Yogi" (Ramakrishnan 1983, 9). This appropriation of the Gita extends to the deterritorialized diasporic imaginary of a portable *karmabhoomi* (realm of action), now seen as separable from the *janmabhoomi* (birthplace; here I am citing the description of his own situation by a U.S.-based Saraswat Brahmin cousin). The latter formulation draws on the nationalist middle-class reinscription of *karmayoga* even as it dissociates sacred value from the nation-space.

30. I am grateful to Whitney Davis for alerting me to this danger as part of his generous and incisive feedback on portions of this chapter presented as a seminar at the Getty Research Institute.

31. In this respect Baudrillard is uninterested in systems that are not idealized inversions of bourgeois society, or in the varied ways in which these other systems might articulate with the axiomatic of capital. The implication of his semiological reworking of Marx is that all societies interfacing with capitalism eventually succumb to the fetishism of the code. Here an ethnographic approach to material cultures is useful in shifting the emphasis from the semiotic constitution of subjects to the performative mechanics by which this constitution takes place and is undone.

32. The early development of the craft of portraiture using painted photographs responded to Pushtimargi merchant families' desire for images of their ancestors, as well as to the *gosains'* need to continually reassert their descent from Vallabhacharya and thus reinforce their aura. (On the role of images and official genealogies in shoring up the legitimacy and authority of the *gosains*, see Peabody 1991, 741.)

33. Nirodh is also the brand name of the first government-subsidized condom to be made widely available in India as part of the "family planning" initiative of the 1970s, and therefore in India the word *nirodh(a)* has to some extent become synonymous with "condom."

34. Similarly, the sixteenth-century *bhakti* poet Dadu refers to god in kingly terms, as "Sahib," "Sultan," "Maharaj," "Malik," or "the Rao of Raos," while addressing the merchant in the vocabulary of trade (as in the verse cited at the head of this chapter; Mukhia 1976, 447).

35. In one of Kant's slipperiest moves, the "subjective" judgment of beauty must be intersubjectively validated, but without resorting to reason and concepts. This shared critical understanding guards against

an overly intellectual engagement with the object as well as an overly *interested* one, which threatens the autonomy of the aesthetic by dragging the object into a realm of instrumentality that includes purveying commercial value, pleasure, satisfaction, and even meaning. So even as the intersubjective validity of judgment means that the art object takes on a communicable, shared value and thereby becomes exchangeable, it becomes vulgar to think of an art object in terms of its value as a commodity (though in the age of the blockbuster exhibition such squeamishness seems increasingly quaint and old-fashioned).

36. Different centralized sign formations are able to make metaphoric, metonymic linkages with each other (god-father-state-capital) at the transcendent level of symbolic representation (Massumi 1992, 112–13). Thus the nation-state constitutes itself as a circumscribed body of devotees (of a nation defined in terms of a primordial "Hindu" identity), children (of Bharat Mata, Mother India), or consumers and producers (of Swadeshi, "ethno-chic," or the products of a global marketplace).

6. THE EFFICACIOUS IMAGE

1. The theory of *rasa* as a set of emotional principles or dominant moods characterizing artistic production received its first known systematic formulation in Bharata's *Natyashastra*. It was inscribed as one of the essential elements of Indian art by Ananda Coomaraswamy and other Orientalist scholars around the turn of the century (see, for instance, Coomaraswamy 1956; Goswami 1986).

2. Operation Blue Star was carried out in 1984 in an attempt by Indira Gandhi, who was the prime minister at the time, to assert the central government's authority over Sikh militants, who were demanding a separate homeland in Punjab. The militants were using the Golden Temple in Amritsar, the most important shrine of the Sikhs, as a hideout and cache for weapons. Four months later Indira Gandhi was assassinated by a Sikh bodyguard, triggering anti-Sikh violence in which Congress Party workers are known to have played a significant part.

3. I have been unable to identify the particular incident Pandit is referring to here, "a few years" after 1984. However it is possible that "Bhiwandi" in this narrative has come to stand in for communal violence in general, with Pandit invoking it by association (given that the infamous Bhiwandi riots of 1984 occurred in the same year as Operation Blue Star).

4. There is a case to be made for distinguishing between the early Congress regime under Nehru and the later phase under Indira Gandhi; my reading of bazaar images as manifestations of a hegemonic compromise formation is more pertinent to the later period, after the mid-1960s.

5. My argument in this section needs to be read as specific to the calendar industry and the circulation of discrete printed images, even though there may be parallels in other vernacular culture industries. To reiterate the point made in chapter 3, despite the apparent homogenization of the vernacular culture industries under the sign of the "masses" this arena was in fact one of variegated address, which included strands of vernacular secularism (as in the writings of Premchand, Bhagwaticharan Verma, Yashpal, and Amritlal Nagar) and articulations of socialism with alternative nonsecular traditions such as Buddhism (as in the work of Rahul Sankrityayan). What is thought of as Nehruvian secularism is not exclusively a phenomenon of the English-educated elite, nor can we easily posit a divide between a "regressive" vernacular realm and that of a "progressive" English-medium liberalism.

6. Pinney traces how this image is transferred from the specific context of cow protection imagery in the late nineteenth century to the more generalized context of national integration in the 1960s, now accompanied, in an image from Sapan Studio, by the slogan "Desh dharm ka nata hai, gai hamari mata hai" [Nation is kin to religion, the cow is our mother] (Pinney 1997, 843–46). Patricia Uberoi also describes

this Sapan Studio image in conjunction with another print in which women of the same four faiths (shown against their respective places of worship) are shown with four paths each leading to a central lamp, arguing that both the lamp and the cow have a specifically Hindu ritual symbolism and to this extent are signs of Hindu dominance (Uberoi 1990, WS-46).

7. Recall the developmentalist terms of Ram Kumar Sharma's secularist discourse, cited in chapter 4: "However much they are **developed,** nobody **avoids religion.** The picture of Ramchandraji [the god Ram] will be up in the home of a man of a **modern progressive mind,** and in that of a **mythological** man as well."

8. Chatterjee's delimitation of the term "civil society" anchors it firmly within the specific historical and cultural genealogy of the bourgeois public sphere in Europe. However, others such as Sandria Freitag seek to redefine the term in a manner that encompasses what Chatterjee is calling "political society," arguing that the Habermasian distinction between "civil" and "political" society, formulated in relation to the bourgeois public sphere, is untenable when thinking about public arenas in South Asia (see, for instance, Freitag 1991a; I thank Sandria Freitag for pushing me to clarify this difference). While Freitag's usage is perhaps more common, as is reflected, for instance, in the current parlance of nongovernment organizations, Chatterjee's usage has the virtue of taking into account the continuing discursive and institutional valency of "civil society" in the restricted (and restrictive) sense, thereby foregrounding the historical circumstances of its discursive and institutional introduction into the Indian context.

9. See chapter 1, note 22 for an explanation of the phrase "Jai Jawan, Jai Kisan."

10. The icon's embodiment of divine presence is closely aligned to the notion of *darshan*, a central term in the literature on modes of engagement with sacred temple images on the subcontinent, which has also come to be commonly extended to otherwise powerful iconic figures (see Eck 1985; Prasad 1998, 74–78). While *darshan* literally means sight or vision, it describes a two-way visual transaction between icon and devotee, where the point is as much (if not more) to be seen by the deity as to see it. What is irreducible in this transaction is actually being in the presence of the divine in the form of the icon: here visuality and corporeality are indivisible.

11. This is not to say that the mass media have been the only sites for the political use of images, which have typically extended to performative arenas at the community level such as processions, spectacles, and statues. The Ganapati festival in Maharashtra has a long history of such political deployment: revived in the 1890s by the anti-colonial extremist leader Tilak as a means of nationalist mass mobilization, it was redeployed a century later by both the Congress Party and the Shiv Sena. It is no coincidence that Tilak's harnessing of the power of iconic images came not long after the first presses producing mythological and iconic prints were set up around Bombay and Pune, nor that the later intensification of involvement in the festival followed, and indeed articulated with, the video, television, and print media boom of the 1990s (Kaur 2000).

12. For Pramod Navalkar's description of his novels, see zeelearn.com's transcript of a chat session with him at http://www.zeelearn.com/newsevents/chattrans/mrpramodnavalkar.htm.

13. I thank the filmmaker Nilita Vachani for first bringing this phrase to my attention.

14. "The M. F. Husain Chat," Rediff on the Net, Friday, 21 November 1997, 20:37 IST; http://www.rediff .com/chat/21111chat.htm.

15. "*Firepariksha*—Replace Radha with Shabana: Thackeray," *Financial Express*, Mumbai, 14 December 1998.

16. Revised censorship guidelines, 6 December 1991; guideline no. xii asks that "visuals or words contemptuous of racial, religious or other groups not [be] presented."

17. My intention here is not to imply that images have no mimetic effects but to criticize the construction of mimesis as a reproductive rather than productive encounter. I elaborate on this in the following chapter.

18. Here again, as throughout, I would want to resist the characterization of this form of social authority as "precapitalist," as it assumes a unitary, teleological conception of the social forms of capitalism based on Euroamerican self-descriptions of bourgeois modernity. These self-descriptions, as I have argued, tend to gloss over the constitutive and continuing imbrication of "official" or "formal" capitalism with "precapitalist" forms of power.

19. To this extent the distinction between "formal" and "real" suffers from the same problems of teleology outlined in the previous note.

20. I am greatly indebted to the collector (who prefers to remain anonymous) who very generously shared not just the archive but also insights and observations about the images.

7. FLEXING THE CANON

1. By including the virtual here my attempt is to take up the feminist philosopher Elizabeth Grosz's call for a "materialism beyond physicalism": a materialism that moves beyond the dualism between mind and body, reconceiving corporeality in a way that takes into account "animate materiality and the materiality of language in interaction" (Grosz 1994, 22).

2. Those feminist scholars who find Bourdieu useful are at pains to emphasize the generative rather than determining nature of Bourdieu's formulation of the habitus (McNay 1999). (Here McNay also outlines some important differences between Foucault's and Bourdieu's emphases on the body.)

3. In this context Elizabeth Grosz's use of the Mobius strip as a figure for the relationship between the "inside and the outside of the subject . . . the torsion of one into the other" (Grosz 1994, xii) is suggestive for reconceptualizing the ways in which embodied practices and psychical, symbolic structures are intertwined: they are neither monistically reducible to a singular essence nor placed in binary opposition, but are mutually inherent and insistent on each other.

4. Here I am following Michael Taussig's enormously useful rereading of Adorno and Benjamin, which reanimates the notion of mimesis as a productive, performative encounter rather than as a matter of accurate reproduction or verisimilitude and elaborates on how technologies of mass reproduction have worked to reactivate a fundamental "mimetic faculty" within the modern sensorium (see, in particular, Taussig 1993b). I would also like to acknowledge a mimetic contagion from Laleen Jayamanne's work on mimesis in the cinema (see, for instance, Jayamanne 1999).

5. Deconstruction is far from unconstructive or uncreative. As Derrida has put it, "Deconstruction is not an enclosure in nothingness, but an openness to the other" (Kearney 1984, 124).

6. In the late 1980s the rallying point for the Hindu Right was a call for the destruction of the Babri mosque in Ayodhya, allegedly built on the site of Ram's birthplace (*janmabhumi*), and for its replacement by a Hindu temple. In October 1990 the BJP leader L. K. Advani led a *rath yatra* or chariot procession from Somnath (the site of well-known medieval attacks on Hindu temples by Muslim raiders) to Ayodhya to muster support for this cause. On 6 December 1992, the Babri mosque was destroyed as the "secular" state's forces stood by. Ensuing protests by the Muslim community were answered with organized attacks on Muslim persons and property by Hindu mobs, especially in Bombay, which has a particular history of such violence.

7. Again, I should emphasize that my concern here is with masculinity as actualized in images at their intersection with social performance, not with an idealized notion of masculinity predicated on gender having a being prior to its embodied manifestation.

8. This argument with regard to "realism" is elaborated in greater detail in another piece by Anuradha Kapur (A. Kapur 1993b); a similar line is taken by Ashish Rajadhyaksha (Rajadhyaksha 1993b). I have been placing the term "realism" in scare quotes given that it is conceivably not the most accurate term to use in relation to pictures of the gods. (For an analysis of the way the term "realism" is used by calendar artists see chapter 4.)

9. Significantly, there seems to be no colloquial Hindi equivalent for muscles: the dictionary translation is *manspeshi*, which no one I have asked has heard in everyday speech, while "muscular" is *shaktishali*, or powerful (Raker and Shukla 2002). Thus, for instance, Steve Derné cites a passage in the Hindi cinema fan magazine *Filmi Kaliyan* on actor Sunny Deol's display of his muscular body (the issue here was the "effeminacy" of this display), in which the English word "muscles" has been transliterated into Hindi (Derné 2000, 161). While Derné does not comment on this, I would suggest that it might indicate the relatively recent entry of muscularity as we know it into vernacular discourses of the male body.

10. This does not preclude the possibility that Ram might appear to have terrifying strength in the eyes of his adversaries. (I thank Philip Lutgendorf for pointing out how this is evident in sections of the Tulsidas Ramayana.) However, Kapur's emphasis here is on how the *devotional* address of verbal and visual icons of Ram has worked to inscribe him as primarily benevolent and sympathetic.

11. I am grateful to Philip Lutgendorf for this information. See Lutgendorf 2001 for a detailed discussion of representations of Hanuman in calendar art.

12. Again, see Haberman (1988, 37–47), on the Gaudiya Vaishnava valorization of the Krishna-love of the *gopi*s, who are described as *parakiya* (belonging to another) over that of the *svakiya* women (the queens of Dwarka) who are married to Krishna. See also Kakar (1986, 75–94) for an account of the significance of adultery and transgression in the Radha-Krishna narrative.

13. I thank Kalpana Ram for reminding me that devotional excess is already built in to conceptions of maternal love, so maternal devotion and duty do not follow the pattern of tension between desire and wifely *dharma* (each of which also has its own modes of affective excess).

14. That said, however, devotional cross-dressing has also had a longer history of controversy and censure, one that deserves to be examined in greater detail. Haberman, for instance, describes how the ideas of the Gaudiya Vaishnava scholar Rupa Kaviraj, who advocated the literal, physical imitation of the *gopi*s, were censured by a council in Jaipur in 1727; studying and teaching his works became a crime punishable by the maharaja (Haberman, 1988, 98–104). On paradigms of "transvestic" display in Hinduism, see also Paroma Roy, "As the Master Saw Her" (Roy 1998, 96–100).

15. I must emphasize that throughout I am using the term "abjection" in its specific philosophical sense, as it unfolds via Georges Bataille, Julia Kristeva, and subsequent critiques of Kristeva by Hal Foster, Rosalind Krauss, and others (Krauss 1996; Foster 1996). If the abject is that which is cast out by society or the subject, for Kristeva this very operation of exclusion is crucial to the maintenance of normative sociality and to the integrity of an autonomous, bounded subjectivity. In other words, that which excludes the abject thereby also fundamentally depends on the abject for its very existence and must, in denying this dependence, do a great deal of work to control it. Krauss and Foster complicate what Foster calls Kristeva's "conservative, even defensive" formulation of the abject (and the normativity it enables) by attending not so much to the abject as substance or essence but to abjection as a *process*: an "alteration" that renders unstable the very terms of exclusion and inclusion, remobilizing the heterogeneity at the heart of the dominant order. My argument here can in part be seen as fleshing out this latter position. For while the abjection of laboring and feminine bodies is formalized in the devotional schema, as we

will see, the alteration enabled by devotional identification with abject bodies rebounds on symbolic conventions.

16. "The nature of Pusti or God's Grace is that the Lord in a sportive manner assumes dependence on His devotees and transgresses the limit put by Himself on his own nature. Therein consists the real majesty of the Lord, in that He does not lose His sovereignty while going against the mandates pertaining to His nature" (Vitthalanatha, *Vidvanmandanam*, quoted in Marfatia 1967, 278). Vitthalanatha was the second son of Vallabhacharya, the founder of Pushtimarg, and it is to him that the high priests of Nathdwara, the Goswami maharajas, trace their lineage.

17. This undecideability can be seen as an operation of abjection as process, resonating with the Bataillean notion of the *informe* (see note 15 above).

18. Of course, Indian cinema has had its share of brawny heroes (I thank Tejaswini Ganti for this reminder). From the 1930s to the 1960s the Wadia brothers, best known for their films starring "Fearless Nadia," also produced several versions of the Tarzan films, starring John Cavas and later the famous wrestler Dara Singh (with whom P. Sardar was photographed). However, as Rosie Thomas describes, these "B" and "C" circuit films represent a parallel strand to the images under discussion here and do not so clearly index the nexus between the hegemony of the bazaar and the dominance of the state. Thomas points out that the Wadia films, hugely popular with subaltern audiences, represented "much that was, in practice, peripheral within the nationalist project (Parsees, Muslims, Christians)" (R. Thomas 2005).

19. On the relay between Bombay cinema, Hong Kong cinema, and Hollywood, see Vitali 2006.

20. The issue of genre and the relationship between Hollywood and Bombay cinemas is a complex one that deserves treatment in its own right (see Gopalan 2002 for an admirable step in this direction). Suffice it to say that the post-liberalization—and post-satellite television—scenario is very different from the period under discussion here: genres such as suspense and horror are emerging far more clearly in the Bombay cinema, possibly owing to the increased generic differentiation under way with television audiences.

21. In his illuminating discussion of Amitabh Bachchan's centrality to a populist "aesthetics of mobilization," Madhava Prasad formulates the film industry's deployment of Bachchan's star persona as a response to the demands of a politically mobilized audience and a push toward cultural segmentation arising from a fragmentation in the post-independence political consensus (Prasad 1998). My argument similarly locates the Bachchan figure and its address to subaltern audiences within the context of this crisis (though Prasad dates it from the mid-1960s). In this respect the "bazaar" in my account provides an institutional locus for the modes of pleasure and legitimation Prasad identifies with a maternalized "community" counterposed to (and thereby perpetuating) a paternal Law. But while Prasad stresses the star vehicle's role in the film industry's ideological containment of "centrifugal tendencies to segmentation" (159), my emphasis on sites of performative actualization maintains a gap—and hence allows for contradictions—between the industry's interpellation of the subject-as-viewer and the viewer's interpellation by, and performative transformations of, institutionalized modes of corporeal engagement with images. So in contrast to my account, Prasad reads the industry-led populism of the Bachchan films as reinstating Bachchan as the transcendental object of a "*darsanic*" gaze (77).

22. In his first "angry young man" film, *Zanjeer* (1973), Bachchan starts out as a policeman who then forges alliances with the underworld; in the later films the policeman becomes a brother, like the Shashi Kapoor character in *Deewar*, from whom Bachchan is typically separated at birth to grow up fighting for survival on the streets.

23. Here I am taking up Parama Roy's trope of haunting in relation to identities that are repressed by an "Indian (Hindu) psyche/polity": her instance is that of the "good Muslim," to which I wish to add here the productive working-class and/or working-caste body (Roy 1998, 173). The plot of *Mother India* was the model for *Deewar* (Rajadhyaksha and Willemen 1994, 326); there is also a resonance between the impotent armless patriarchs of both *Mother India* (Raj Kumar) and *Sholay* (Sanjeev Kumar), the other seminal Bachchan film made in the same year as *Deewar* (1975).

24. I must emphasize that this represents just one strand of political discourse, for as Lawrence Cohen has shown, the metaphorics of sexual aggression are alive and kicking in the "*chhoti* line" political cartoons and editorials in the Banarasi popular press (Cohen 1999).

25. *Dhishoom-dhishoom* became the commonly accepted onomatopoeia for the sound of fighting (punching, kicking, and throwing things at people as well as shooting), as well as a metonym for the action film. I think it must be seen as specific to the Bachchan era, as it was replaced through the 1990s by other phrases, particularly those circulated through advertising, such as *dhamaka* ("explosion": significantly, referring not to human force but to some kind of external agency).

26. One manifestation of this mimetic circuit was the Bachchan character's canny adoption of 786 as the number on his porter's badge in *Deewar*. That number is a numerological formula for the first lines of the Qur'an: according to my observations around the city of Ahmedabad, after the film was released the number acquired a new lease on life as a lucky charm among urban Muslims, as well as gaining more general recognition, reappearing on autorickshaws, key rings, lockets, and of course as part of calendar images.

27. Ravi Vasudevan has argued, following the work of Thomas Elsaesser on Hollywood family melodramas, that the Hindi film melodrama is characterized by strong "paranarrative" elements, like the song and dance sequence, whose pleasures often run counter to the status quo resolutions of the narrative—for instance in the song sequence the otherwise demure and submissive heroine gets to flaunt her body and declaim her desire in an open, if not always public, space (Vasudevan 1989). Rajadhyaksha and Willemen seem to suggest that such paranarrative elements are crucial to Bachchan's "brand image," particularly in the films directed by Manmohan Desai from *Amar Akbar Anthony* (1977) onward, which are essentially conceived as a series of "highlights" strung together with little regard for plot coherence (Rajadhyaksha and Willemen 1994, 401).

28. Several Bachchan films are subject to homoerotic readings, particularly *Sholay*, in which the intimacy between Dharmendra and Amitabh is celebrated in the "Yeh Dosti" song sequence. This added dynamic is particularly evident in the "multi-starrers" of the mid-1970s onward.

29. For a listing of such instances, see Vachani 1999, 218–21. However, I disagree with Vachani's characterization of these irrealist devices in Bachchan films as "an appropriation of 'Brechtian' techniques" (219): I would contend that they are drawing on a much longer history of "frontality" in Indian popular culture as elaborated by Geeta Kapur (G. Kapur, 1993b, 20).

30. My use of the term "virtual" is informed by the philosophy of Gilles Deleuze, for whom it is a central and recurrent concept. The virtual is not opposed to the real but to the actual; nor is it to be conflated with the possible (see Deleuze 1994). I find this term particularly useful for the way in which it brooks no possibility of dismissing the image as "false" or "unreal," but, on the contrary, sees the falsity of the image in terms of a "power that makes truth undecidable" (Deleuze 1995).

31. Here I must thank Nita Kumar for her cautioning on the use of the terms "labor" and "work" in a manner that yokes them to a liberal-modernist understanding, one that has also inflected the reading of these

categories in Marx. Yet we also need to recognize that such an understanding of these terms is constantly reinscribed and remobilized through governmentality, the organization of industrial labor, and, indeed, the trade unions. As Dipesh Chakrabarty argues, the attempt of description must be to hold open the gap between such coexistent but heterogeneous forms of temporality, practice, and understanding (see, in particular, Chakrabarty 2000, chapter 3).

32. The salient films here are *Ham Aapke Hain Kaun* (Suraj Barjatya, 1994), *Dilwale Dulhaniya Le Jayenge* (Aditya Chopra, 1995), *Kabhi Khushi Kabhi Gam* (Karan Johar, 2001), *Monsoon Wedding* (Mira Nair, 2001), *Bend It Like Beckham* (Gurinder Chadha, 2002), and *Bride and Prejudice* (Gurinder Chadha, 2005). Of course, the hyper-elaboration of the wedding has not been confined to the cinema: it has spawned dedicated magazines, boutiques, event management firms, and so on. It has also transformed the Indian urbanscape, where "palaces" and "resorts" dedicated to celebrating weddings have mushroomed on the urban peripheries.

CONCLUSION

1. While Rajasthan has been the primary source for colonial and touristic images of princely splendor, as I have argued elsewhere Punjab with its history of refugees from the Partition and extensive overseas migration has emerged as a hegemonic site for constructing both national and diasporic imaginaries in Indian popular culture, particularly film, "Indi-pop" music, and television (K. Jain 2003).

2. My interviews with MSOs, neighborhood cable operators, and television producers were conducted as part of a postdoctoral research project on television and globalization in India that was funded by the Australian Research Council. In many ways television can be seen as another frontier of the bazaar. It is now an equally if not more desirable medium for advertising at all levels, formal and informal (such as the "crawler" ads inserted by cable television operators), large scale and small. It has also become a privileged site for various types of identity projects, as well as for experimentation with multiple formal idioms, as was the case with print media from the mid-nineteenth century onward.

3. I want to thank the artist Dennis Adams for a question he asked at a conference titled "Art and the Fragmentation of Urban Space" at the University of San Diego (5–6 November 2004) that helped to crystallize this formulation.

4. Nehru's speech at the opening of the Bhakra Nangal dam on 8 July 1954 did not contain the phrase "dams are the temples of modern India." His references to the sanctity of the dams are more inclusive, both of non-Hindu religions and of religiosity itself: "These days the biggest temple and mosque and gurdwara is [*sic*] the place where man works for the good of mankind. . . . Where can be a greater and holier place than this, which can we regard as higher?" (Nehru 1980, 214). The sound bite circulating in the public arena possibly derives from a later remark, "whispered to himself" (but reported in *The Hindu*) made while surveying the same dam in 1956: "These are the new temples of India where I worship" (Gopal 1984, 111). If the public sphere has seized on the latter formulation to characterize Nehru's developmentalism, dropping his personal voice and adding the word "modern," this attests both to the power of the temple as a trope and to the ongoing discursive work of aligning the new, the modern, and the secular.

5. Agnes Heller characterizes modernity in terms of a dialectical dynamic whose "main carrier" is "dynamic justice" (while at the same time it depends on a social arrangement based on "symmetric reciprocity"; Heller 1992). According to Lyotard, giving the differend its due would mean "instituting new addressees, new addressors, new significations, and new referents" for the phrases of the victim (Lyotard 1988, 13).

WORKS CITED

Adorno, Theodor. 1991. "Culture Industry Reconsidered." In *The Culture Industry: Selected Essays on Mass Culture*, ed. J. M. Bernstein, 85–92. London: Routledge.

Adorno, Theodor, and Max Horkheimer. 1972. *The Dialectic of Enlightenment*. New York: Continuum.

Ahmed, Aijaz. 1989. " 'Third World Literature' and the Nationalist Ideology." *Journal of Arts and Ideas* 17–18 (June): 117–35.

Alter, Joseph S. 1992. *The Wrestler's Body: Identity and Ideology in North India*. Berkeley: University of California Press.

———. 1994. "Celibacy, Sexuality and the Transformation of Gender into Nationalism in North India." *Journal of Asian Studies* 53 (1) (February): 45–66.

Amariglio, Jack, and Antonio Callari. 1993. "Marxian Value Theory and the Subject." In *Fetishism as Cultural Discourse*, ed. Emily Apter and William Pietz, 186–216. Ithaca, N.Y.: Cornell University Press.

Ambalal, Amit. 1987. *Krishna as Shrinathji: Rajasthani Paintings from Nathdwara*. Ahmedabad: Mapin.

Amin, Shahid. 1984. "Gandhi as Mahatma: Gorakhpur District, Eastern UP, 1921–22." In *Subaltern Studies III: Writings on South Asian History and Society*, ed. Ranajit Guha, 1–61. Delhi: Oxford University Press.

Ananda, Prakash. 1986. *A History of the Tribune*. New Delhi: The Tribune Trust.

Anantharaman, S. C. 1980. "The Match Makers of Sivakasi—III: The Move into Printing." In *Sivakasi— Where Light and Sound Are Packaged: A Panorama of the Match, Fireworks and Printing Industries of South India*, ed. All India Chamber of Match Industries. Sivakasi: All India Chamber of Match Industries. Originally published in *Business Standard*, 10 March.

Anderson, Benedict. 1991. *Imagined Communities*. London: Verso.

Appadurai, Arjun. 1986. "Introduction: Commodities and the Politics of Value." In *The Social Life of Things*, ed. Arjun Appadurai, 3–63. Cambridge: Cambridge University Press.

———. 1995. "The Production of Locality." In *Counterworks*, ed. Richard Fardon, 204–23. London: Routledge.

———. 1996. *Modernity at Large: Cultural Dimensions of Globalization*. Minneapolis: University of Minnesota Press.

Appasamy, Jaya. 1980a. *Indian Paintings in Glass*. New Delhi: Indian Council for Cultural Relations.

———. 1980b. *Tanjavur Paintings of the Maratha Period*. New Delhi: Abhinav Publications.

———. 1985. "Early Oil Painting in Bengal." *Lalit Kala Contemporary* 32 (April).

Appaswamy, A. J. 1970. *The Theology of Hindu Bhakti.* Bangalore: Christian Literature Society.

Archer, Mildred. 1979. *India and British Portraiture.* London: Sotheby Parke Bernet.

Archer, Mildred, and W. G. Archer. 1955. *Indian Painting for the British 1770–1880.* London: Oxford University Press.

Archer, W. G. 1971. *Kalighat Paintings.* London: Her Majesty's Stationery Office.

Asendorf, Christoph. 1993. *Batteries of Life: On the History of Things and Their Perception.* Trans. Don Reneau. Berkeley: University of California Press.

Augusta, J., and Z. Burian. 1960. *Prehistoric Man.* London: Paul Hamlyn.

Awasthi, Suresh. 1993. "Theatrical Connections with Ravi Varma's Paintings." In *Raja Ravi Varma: New Perspectives* (exhibition catalogue), ed. R. C. Sharma and Rupika Chawla, 110–15. New Delhi: National Museum.

Babb, Lawrence. 1981. "Glancing: Visual Interaction in Hinduism." *Journal of Anthropological Research* 37 (4): 378–410.

———. 1986. *Redemptive Encounters: Three Modern Styles in the Hindu Tradition.* Berkeley: University of California Press.

Babb, Lawrence, and Susan S. Wadley, eds. 1995. *Media and the Transformation of Religion in South Asia.* Philadelphia: University of Pennsylvania Press.

Bagchi, Amiya Kumar. 1992. "European and Indian Entrepreneurship in India, 1900–30." In *Entrepreneurship and Industry in India 1800–1947*, ed. Rajat K. Ray, 157–96. Delhi: Oxford University Press.

Baker, Houston. 1987. *Modernism and the Harlem Renaissance: Race, Gender, and Power in Modernism and the Harlem Renaissance.* Chicago: University of Chicago Press.

Balibar, Etienne. 1994. "Subject and Subjectivation." In *Supposing the Subject*, ed. Joan Copjec, 1–15. London: Verso.

Basu, Major B. D., ed. 1916/1974. *The Sacred Books of the Hindus.* Vol. 14, *The Brihadaranyaka Upanishad with the Commentary of Sri Madhavacharya.* Trans. Rai Bahadur Sris Chandra Vasu and Pt. Ramaksya Bhattacharya. Vidyabhusana, Allahabad: Panini Office, Bhuvaneswari Ashram. Repr. New York: AMS Press.

Baudrillard, Jean. 1975. *The Mirror of Production.* Trans. Mark Poster. St. Louis: Telos Press.

———. 1981. *Towards a Critique of the Political Economy of the Sign.* Trans. Charles Levin. St. Louis: Telos Press.

———. 1987. "The System of Objects." Trans. Penny Sparke. In *Design after Modernism*, ed. John Thackara, 171–83. London: Thames and Hudson.

———. 1990. "Mass Media Culture." In *Revenge of the Crystal*, ed. and trans. Paul Foss and Julian Pefanis, 63–97. Sydney: Pluto Press.

Baxandall, Michael. 1985. *Patterns of Intention: On the Historical Explanation of Pictures.* New Haven, Conn.: Yale University Press.

Bayly, C. A. 1983. *Rulers, Townsmen and Bazaars: North Indian Society in the Age of British Expansion, 1770–1870.* Cambridge: Cambridge University Press.

———. 1986. "The Origins of Swadeshi (Home Industry): Cloth and Indian Society, 1700–1930." In *The Social Life of Things*, ed. Arjun Appadurai, 285–321. Cambridge: Cambridge University Press.

Bazin, Germain. 1968. *A Concise History of Art*, part 2. London: Thames and Hudson.

Belting, Hans. 1987. *The End of Art History?* Chicago: University of Chicago Press.

Benjamin, Walter. 1969. *Illuminations.* Ed. Hannah Arendt. Trans. Harry Zohn. New York: Schocken Books.

———. 1985. "Central Park." *New German Critique* 34 (winter): 32–58.

Bhabha, Homi K. 1984. "Of Mimicry and Man: The Ambivalence of Colonial Discourse." *October* 28 (spring): 125–33.

———. 1994. *The Location of Culture*. London: Routledge.

Bhalekar, Vasant. 1976. "Chitra Samrat Raghuvir Mulgaonkar." *Deepalakshmi* 204 (May): 12–16.

Bharucha, Rustom. 1993. *The Question of Faith*. New Delhi: Orient Longman.

Bhuvanesh, Kamal. 1996. "Calendar Badalne ke Pher Mein Karodon ke Vaare-Nyaare" [Transactions worth crores in the business of changing calendars]. *Jansatta* (Hindi), 9 December.

Birdwood, G. C. M. 1880/1986. *The Arts of India*. Repr. Jersey: British Book Company.

Birla, G. D. 1994. "Karma Yoga in the Gita (Krishnan Vande Jagadgurum—15)." *Bhavan's Journal*, 31 December, 64–69.

Bloch, M., and J. Parry. 1989. "Introduction: Money and the Morality of Exchange." In *Money and the Morality of Exchange*, ed. J Parry and M. Bloch, 1–32. Cambridge: Cambridge University Press.

Bourdieu, Pierre. 1977. *Outline of a Theory of Practice*. Cambridge: Cambridge University Press.

———. 1984. *Distinction: A Social Critique of the Judgement of Taste*. Cambridge, Mass.: Harvard University Press.

———. 1990. *The Logic of Practice*. Stanford, Calif.: Stanford University Press.

———. 2001. *Masculine Domination*. Trans. Richard Nice. Stanford, Calif.: Stanford University Press.

Brooks, Peter. 1975. *The Melodramatic Imagination: Balzac, Henry James, Melodrama, and the Mode of Excess*. New York: Columbia University Press.

Brosius, Christiane. 1997. "Motherland in Hindutva Iconography." *The India Magazine* 17 (12): 22–28.

———. 1999. "Is This the Real Thing? Packaging Cultural Nationalism." In *Image Journeys: Audio Visual Media and Cultural Change in India*, ed. Christiane Brosius and Melissa Butcher, 99–138. New Delhi: Sage.

Brown, Percy. n.d. *Indian Painting*. London: Oxford University Press.

Bryson, Norman, Michael Ann Holly, and Keith Moxey, eds. 1994. *Visual Culture: Images and Interpretations*. Hanover, N.H.: University Press of New England / Wesleyan University Press.

Butler, Judith. 1990a. *Gender Trouble: Feminism and the Subversion of Identity*. New York: Routledge.

———. 1990b. "Performative Acts and Gender Constitution." In *Performing Feminisms: Feminist Critical Theory and Theatre*, ed. Sue-Ellen Case, 270–82. Baltimore: Johns Hopkins University Press.

———. 1993. *Bodies That Matter: On the Discursive Limits of "Sex,"* New York: Routledge.

———. 1997a. *Excitable Speech: A Politics of the Performative*. London: Routledge.

———. 1997b. *The Psychic Life of Power: Theories in Subjection*. Stanford, Calif.: Stanford University Press.

Cadène, Philippe, and Denis Vidal. 1997. "Kinship, Credit and Territory: Dynamics of Business Communities in Western India." In *Webs of Trade: Dynamics of Business Communities in Western India*, ed. P. Cadène and D. Vidal, 9–22. Delhi: Manohar/CSH.

Calhoun, Craig, ed. 1992. *Habermas and the Public Sphere*. Cambridge, Mass.: MIT Press.

Carter, Michael.1997. *Putting a Face on Things: Studies in Imaginary Materials*. Sydney: Power Publications.

Case, Sue-Ellen, ed. 1990. *Performing Feminisms: Feminist Critical Theory and Theatre*. Baltimore: Johns Hopkins University Press.

Chakrabarty, Dipesh. 1992. "Postcoloniality and the Artifice of History: Who Speaks for 'Indian' Pasts?" *Representations* 37 (winter): 1–26.

———. 1993. "Marx after Marxism: A Subaltern Historian's Perspective." *Economic and Political Weekly*, 29 May, 1094–96.

———. 2000. *Provincialising Europe: Postcolonial Thought and Historical Difference*. Princeton, N.J.: Princeton University Press.

Chakravarti, V. R. Srisaila. 1974. *The Philosophy of Sri Ramanuja (Visistadvaita)*. Madras: Bharati Vijayam Press.

Chatterjee, Partha. 1986. *Nationalist Thought and the Colonial World: A Derivative Discourse?* London: Zed Books.

———. 1993. *The Nation and Its Fragments: Colonial and Postcolonial Histories*. Princeton, N.J.: Princeton University Press.

———. 1994. "Secularism and Toleration." *Economic and Political Weekly*, 9 July, 1768–77.

———. 1997. "Beyond the Nation? Or Within?" *Economic and Political Weekly*, 4–11 January, 30–34.

Chatterjee, Ramananda. 1993. "Ravi Varma." In *Raja Ravi Varma: New Perspectives* (exhibition catalogue), ed. R. C. Sharma and Rupika Chawla, 144–46. New Delhi: National Museum. Originally published in *The Modern Review*, January 1907.

Chattopadhyaya, Debiprasad. 1964. *Indian Philosophy: A Popular Introduction*. New Delhi: People's Publishing House.

———. 1992. *Lokayata: A Study in Ancient Indian Materialism*. New Delhi: People's Publishing House.

Choonara, Samina, ed. 2003. *"Official" Chronicle of the Mayo School of Arts: The Formative Years under Lockwood Kipling (1875–1993)*. Lahore: National College of Arts.

Clark, John. 1989. *Indian Popular Images (Basham Collection)*. Catalogue and notes for an exhibition in Menzies Library, Department of Art History, Australian National University, August 1989.

Clarke, David. 1992. "The Icon and the Index: Modes of Invoking the Body's Presence." *The American Journal of Semiotics* 9 (1): 49–82.

Cohen, Lawrence. 1998. *No Aging in India*. Berkeley: University of California Press.

———. 1999. "Manmohan's Secret: Homosex and Indian Modernity." Paper presented at conference titled "Sexualities, Masculinities and Culture in South Asia: Practices, Popular Culture and the State," Melbourne, 6–8 July.

Cohn, Bernard S. 1964. "The Role of the Gosains in the Economy of Eighteenth- and Nineteenth-Century Upper India." *Indian Economic and Social History Review* 1 (4): 175–82.

Coomaraswamy, Ananda K. 1907/1993. "The Present State of Indian Art." *The Modern Review*, August 1907. Repr. in *Raja Ravi Varma: New Perspectives* (exhibition catalogue), ed. R. C. Sharma and Rupika Chawla, 154–55. New Delhi: National Museum.

———. 1923. *Introduction to Indian Art*. Madras: Theosophical Publishing House.

———. 1956. *The Transformation of Nature in Art*. New York: Dover Publications.

Cooper, Ilay. 1995. "A Trade War in Pictures." *The India Magazine*, February, 6–15.

Coronil, Fernando. 1997. *The Magical State: Nature, Money, and Modernity in Venezuela*. Chicago: University of Chicago Press.

Crow, Thomas. 1996. "Response to Visual Culture Questionnaire." *October* 77:43–36.

Dalmia, Vasudha. 1995. "'The Only Real Religion of the Hindus': Vaishnava Self-Representation in the Late Nineteenth Century." In *Representing Hinduism: The Construction of Religious Tradition and National Identity*, ed. V. Dalmia and H. von Stietencron. New Delhi: Sage.

Daniel, E. Valentine. 1984. *Fluid Signs: Being a Person the Tamil Way*. Berkeley: University of California Press.

Das, Gurcharan. 1999. "The Problem." *Seminar* 482 (October): 12–21.

Das, Veena. 1982. "The Mythological Film and Its Framework of Meaning: An Analysis of *Jai Santoshi Ma*." *India International Centre Quarterly* 8 (1): 43–56.

———. 1990. "Our Work to Cry: Your Work to Listen." In *Mirrors of Violence: Communities, Riots and Survivors in South Africa*, ed. Veena Das, 345–95. Delhi: Oxford University Press.

Davis, Richard. 1991. *Ritual in an Oscillating Universe*. Princeton, N.J.: Princeton University Press.

———. 1997. *Lives of Indian Images*. Princeton, N.J.: Princeton University Press.

Deleuze, Gilles. 1983. "Plato and the Simulacrum." Trans. Rosalind Krauss. *October* 27 (winter): 45–56.

———. 1988. *Spinoza: Practical Philosophy*. Trans. Robert Hurley. San Francisco: City Lights Books.

———. 1994. *Difference and Repetition*. Trans. Paul Patton. New York: Columbia University Press.

———. 1995. *Negotiations, 1972–1990*. Trans. Martin Joughin. New York: Columbia University Press.

Deleuze, Gilles, and Felix Guattari. 1977. *Anti-Oedipus*. Trans. Robert Hurley, Mark Seem, and Helen R. Lane. New York: Viking Books.

———. 1987. *A Thousand Plateaus*. Trans. Brian Massumi. Minneapolis: University of Minnesota Press.

de Man, Paul. 1982. "Sign and Symbol in Hegel's *Aesthetics*." *Critical Inquiry* 8 (summer): 761–75.

Derné, Steve. 2000. *Movies, Masculinity, and Modernity: An Ethnography of Men's Filmgoing in India*. Westport, Conn.: Greenwood Press.

Derrida, Jacques. 1976. *Of Grammatology*. Trans. Gayatri Chakravorty Spivak. Baltimore: Johns Hopkins University Press.

———. 1978. "Structure, Sign and Play in the Discourse of the Human Sciences." In *Writing and Difference*, trans. Alan Bass, 278–94. Chicago: University of Chicago Press.

———. 1988. "Signature, Event, Context." In *Limited Inc*. Ed. Gerald Graff. Trans. Samuel Weber and Jeffrey Mehlman, 1–23. Evanston, Ill.: Northwestern University Press.

Deshpande, Satish. 1993. "Imagined Economies: Styles of Nation-Building in Twentieth-Century India." *Journal of Arts and Ideas* 25–26 (December): 5–35.

Dhareshwar, Vivek. 1995a. "Our Time: History, Sovereignty, Politics." *Economic and Political Weekly*, 11 February, 317–24.

———. 1995b. "Postcolonial in the Postmodern, or, The Political after Modernity." *Economic and Political Weekly*, 29 July, PE104–12.

Dhareshwar, Vivek, and Tejaswini Niranjana. 1996. "Kaadalan and the Politics of Resignification: Fashion, Violence and the Body." *Journal of Arts and Ideas* 29 (January): 5–26.

Douglas, Mary. 1980. *Purity and Danger: An Analysis of the Concepts of Pollution and Taboo*. London: Routledge and Kegan Paul.

Drewal, Henry. 1988. "Performing the Other: Mami Wata Worship in Africa." *Drama Review* 32 (2) (summer): 160–85.

Durkheim, Emile. 1965. *The Elementary Forms of the Religious Life*. New York: Free Press.

———. 1973. "Individuals and the Intellectuals." In *Emile Durkheim on Morality and Society*, ed. Robert Bellah. Chicago: University of Chicago Press.

Eagleton, Terry. 1990. *The Ideology of the Aesthetic*. Cambridge, Mass.: Basil Blackwell.

Eck, Diana L. 1985. *Darsan: Seeing the Divine Image in India*. Chambersburg, Pa.: Anima Books.

Edwards, Gregory J. 1985. *The International Film Poster*. London: Columbus Books.

Fabian, Johannes. 1983. *Time and the Other: How Anthropology Makes Its Object*. New York: Columbia University Press.

Falconer, John. 1995. Essay in *A Shifting Focus: Photography in India 1850–1900* (exhibition catalogue), 9–22. London: The British Council.

Fanon, Frantz. 1967. *Black Skin, White Masks*. Trans. Charles Lam Markmann. New York: Grove Press.

Fiske, John. 1989. *Understanding Popular Culture*. Boston: Unwin Hyman.

Foster, Hal. 1996. "Obscene, Abject, Traumatic." *October* 78 (fall): 107–24.

Foucault, Michel. 1970. "Representing." In *The Order of Things*. London: Tavistock Publications.

———. 1977. "Nietzsche, Genealogy, History." In *Language, Counter-Memory, Practice: Selected Essays and Interviews*, ed. Donald F. Bouchard, trans. Donald F. Bouchard and Sherry Simon, 139–64. Oxford: Basil Blackwell.

———. 1980. *Power/Knowledge: Selected Interviews and Other Writings, 1972–77.* Ed. Colin Gordon. New York: Pantheon.

———. 1986. "Of Other Spaces." *Diacritics* 16 (1) (spring): 22–27.

Freitag, Sandria, ed. 1989. *Culture and Power in Banaras: Community, Performance and Environment, 1800–1980.* Berkeley: University of California Press.

———1991a. "Introduction." Special issue on "Aspects of 'the Public' in Colonial South Asia," *South Asia* 14 (1) (June): 1–13.

———. 1991b. "Enactments of Ram's Story and the Changing Nature of 'the Public' in British India." *South Asia* 14 (1) (June): 65–90.

———. 2001. "Visions of Nation: Theorizing the Nexus between Creation, Consumption, and Participation in the Public Sphere." In *Pleasure and the Nation: The History, Politics, and Consumption of Public Culture in India*, ed. Rachel Dwyer and Christopher Pinney, 35–75. New Delhi: Oxford University Press.

Freud, Sigmund. 1963. *Jokes and Their Relation to the Unconscious.* New York: Norton.

———. 1965. *The Interpretation of Dreams.* New York: Avon Books.

———. 1979. "Three Essays on the Theory of Sexuality." In *On Sexuality.* Vol. 7 of the Pelican Freud Library. Harmondsworth: Penguin Books.

Frow, John. 1996. "The Signature: Three Arguments about the Commodity Form." In *Aesthesia and the Economy of the Senses*, ed. Helen Grace, 151–200. Nepean: PAD Publications/University of Western Sydney.

———. 1997a. "Is Elvis a God? Cult, Culture, Questions of Method." Paper presented at the Cultural Studies Association of Australia conference, Melbourne, December.

———. 1997b. *Time and Commodity Culture: Four Essays.* Oxford: Clarendon Press.

Fukuoka Art Museum. 2000. *From Goddess to Pin-Up: Icons of Femininity in Indian Calendar Art (Arts of People I).* Catalogue for exhibition curated by Patricia Uberoi and Pooja Sood. Fukuoka, Japan: Fukuoka Art Museum.

Geertz, Clifford. 1979. "Suq: The Bazaar Economy in Sefrou." In *Meaning and Order in Moroccan Society*, ed. C. Geertz, H. Geertz, and L. Rosen, 123–225. Cambridge: Cambridge University Press.

Geetashri. 1981. "Chitrakar S. S. Shaikh" [The artist S. S. Shaikh]. *Navneet* (Hindi), September, 45–49.

Ghosh, Shalil. 1978. "In Defence of Calendar Art." *Illustrated Weekly of India*, 26 March, 32–35.

Gilpin, William. 1794/1972. "Essay I: On Picturesque Beauty." In *Three Essays.* Repr. Westmead: Gregg International Publishers.

Girard, René. 1978. *To Double Business Bound.* Baltimore: Johns Hopkins University Press.

Gledhill, Christine. 1985. "History of Genre Criticism." In *The Cinema Book*, ed. Pam Cook, 52–71. London: BFI.

Gold, Thomas, Douglas Guthrie, and David Wank, eds. 2001. *Social Networks in China: Institutions, Culture, and the Changing Nature of Guanxi.* Cambridge: Cambridge University Press.

Gopal, Sarvepalli. 1984. *Jawaharlal Nehru: A Biography, vol. 3, 1956–1964.* London: Jonathan Cape.

Gopalan, Lalitha. 2002. *Cinema of Interruptions: Action Genres in Contemporary Indian Cinema*, London: BFI.

Goswami, B. N. 1986. *Essence of Indian Art.* Ahmedabad: Mapin/Asian Art Museum of San Francisco.

Goswami, B. N. and A. L. Dallapiccola. 1981. "Anmerkuugen über eine serie von indischen Miniaturen aus dem XVIII Jahrundert." *Zeitschrift fur Religions — und Geistesgeschichte* 33 (1): 3–41.

Goswami, K. 1982. "The Cult." In *Krishna the Divine Lover: Myth and Legend in Indian Art*, ed. Enrico Isacco and Anna L. Dallapiccola, 123–42. Delhi: B.I. Publications.

Goswami, Omkar. 1992. "*Sahibs, Babus* and *Banias*: Changes in Industrial Control in Eastern India, 1918–50." In *Entrepreneurship and Industry in India 1800–1947*, ed. Rajat K. Ray, 228–59. Delhi: Oxford University Press.

Granovetter, Mark. 1985. "Economic Action and Social Structure: The Problem of Embeddedness." *American Journal of Sociology* 91 (November): 481–510.

Greenberg, Clement. 1939. "Avant-Garde and Kitsch." *Partisan Review* 6 (5) (fall): 34–49.

Grosz, Elizabeth. 1994. *Volatile Bodies: Towards a Corporeal Feminism*. Sydney: Allen and Unwin.

Guha-Thakurta, Tapati. 1986. "Westernisation and Tradition in South India Painting in the Nineteenth Century: The Case of Raja Ravi Varma (1848–1906)." *Studies in History* 2 (2): 164–98.

———. 1991. "Women as Calendar Art Icons: Emergence of Pictorial Stereotype in Colonial India." *Economic and Political Weekly of India*, 26 October, WS-91-99.

———. 1992. *The Making of a New "Indian" Art: Artists, Aesthetics and Nationalism in Bengal, c. 1850–1920*. Cambridge: Cambridge University Press.

———. 1994. "Bringing Gods to Life." *Seminar* 429 (November): 14–18.

———. 1995. "Visualizing the Nation: The Iconography of a 'National Art' in India." *Journal of Arts and Ideas* 27-28 (March): 7–40.

Gunning, Tom. 1989. "An Aesthetic of Astonishment: Early Film and the Incredulous Spectator." *Art and Text* 34 (spring): 31–45.

Gupta, Akhil. 1998. *Postcolonial Developments: Agriculture in the Making of Modern India*. Durham, N.C.: Duke University Press.

Gupta, Akhil, and James Ferguson. 1997. *Culture, Power, Place: Explorations in Critical Anthropology*. Durham, N.C.: Duke University Press.

Gutman, Judith Mara. 1982. *Through Indian Eyes: Nineteenth and Early Twentieth Century Photography from India*. New York: Oxford University Press/International Center of Photography.

Haberman, David. 1988. *Acting as a Way of Salvation: A Study of Raganuga Bhakti Sadhana*. New York: Oxford University Press.

Habermas, Jürgen. 1974. "The Public Sphere: An Encyclopedia Article." *New German Critique* 3 (fall): 49–55.

———. 1989. *The Structural Transformation of the Public Sphere*. Trans. P. Burger and F. Lawrence. Cambridge, Mass.: MIT Press.

Hage, Ghassan. 1998. *White Nation: Fantasies of White Supremacy in a Multicultural Society*. Sydney: Pluto Press.

Halbertal, Moshe, and Avishai Margalit. 1992. "Idolatry and Representation." *Res* 22 (autumn): 19–32.

Hansen, Kathryn. 1989. "The Birth of Hindi Drama in Banaras, 1868–1885." In *Culture and Power in Banaras: Community, Performance and Environment*, ed. Sandria Freitag, 62–92. Berkeley: University of California Press.

———. 2001. "The Indar Sabha Phenomenon: Public Theatre and Consumption in Greater India (1853–1956)." In *Pleasure and the Nation*, ed. Rachel Dwyer and Christopher Pinney, 76–114. Delhi: Oxford University Press.

Hansen, Miriam. 1993a. "Early Cinema, Late Cinema: Permutations of the Public Sphere." *Screen* 34 (3) (autumn): 197–222.

———. 1993b. "Of Mice and Ducks: Benjamin and Adorno on Disney." *South Atlantic Quarterly* 92 (1) (winter): 28–61.

Hansen, Thomas Blom. 1999. *The Saffron Wave: Democracy and Hindu Nationalism in Modern India*. Princeton, N.J.: Princeton University Press.

Hardgrave, Robert L., Jr. 1969. *The Nadars of Tamilnad: The Political Culture of a Community in Change*. Berkeley: University of California Press.

Hardgrove, Anne. 2002. *Community and Public Culture: The Marwaris in Calcutta c. 1897–1997*. New York: Columbia University Press.

Hardt, Michael. 1993. *An Apprenticeship in Philosophy: Gilles Deleuze*. Minneapolis: University of Minnesota Press.

Hardt, Michael, and Toni Negri. 2000. *Empire*. Cambridge, Mass.: Harvard University Press.

Harpham, Geoffrey Galt. 1994. "Aesthetics and the Fundamentals of Modernity." In *Aesthetics and Ideology*, ed. George Levine, 124–49. New Brunswick, N.J.: Rutgers University Press.

Haskell, T. L., and R. F. Teichgraeber III. 1993. "Introduction: The Culture of the Market." In *The Culture of the Market: Historical Essays*, ed. T. L. Haskell and R. F. Teichgraeber III. Cambridge: Cambridge University Press.

Havell, E. B. 1908. *Indian Sculpture and Painting*. London: John Murray.

Hawley, John Stratton. 1995. "The Saints Subdued: Domestic Virtue and National Integration in *Amar Chitra Katha*." In *Media and the Transformation of Religion in South Asia*, ed. Lawrence Babb and Susan S. Wadley, 107–34. Philadelphia: University of Pennsylvania Press.

Hefner, Robert W. 1998. Introduction to *Market Cultures: Society and Morality in the New Asian Capitalisms*, ed. Robert W. Hefner, 1–40. Boulder, Colo.: Westview Press.

Hegel, G. W. F. 1967. *The Philosophy of Right*. Trans. T. M. Knox. Oxford: Oxford University Press.

———. 1975. *Aesthetics, Lectures on Fine Art*. Trans. T. M. Knox. Oxford: Clarendon Press.

Heller, Agnes. 1992. "Modernity's Pendulum." *Thesis Eleven* 31:1–13.

Horstmann, Monika. 1995. "Towards a Universal Dharma: *Kalyan* and the Tracts of the Gita Press." In *Representing Hinduism: The Construction of Religious Tradition and National Identity*, ed. V. Dalmia and H. von Stietencron, 294–305. New Delhi: Sage.

Huyssen, Andreas. 1986. "Mass Culture as Woman: Modernism's Other." In *After the Great Divide: Modernism, Mass Culture, Postmodernism*. Bloomington: Indiana University Press.

Inden, Ronald. 2000. "Imperial Puranas: Kashmir as Vaisnava Center of the World." In *Querying the Medieval: Texts and the History of Practices in South Asia*, ed. Ronald Inden, Jonathan Walters, and Daud Ali, 29–98. Oxford: Oxford University Press.

Inglis, Stephen. 1995. "Suitable for Framing: The Work of a Modern Master." In *Media and the Transformation of Religion in South Asia*, ed. Lawrence Babb and Susan S. Wadley, 51–75. Philadelphia: University of Pennsylvania Press.

Jain, Jyotindra. 1999. *Kalighat Painting: Images from a Changing World*. Ahmedabad: Mapin Publishing.

Jain, Kajri. 1995. "Of the Everyday and the National Pencil: Calendars in Postcolonial India." *Journal of Arts and Ideas* 27–28:57–89.

———. 1996. "Calendar Art: A 'Background.'" In *Of Women: Icons/Stars/Feasts* (catalogue for exhibition curated by Pooja Sood). New Delhi: Eicher Gallery (with Kali for Women).

———. 1997. "Producing the Sacred: The Subjects of Calendar Art." In "Sites of Art History: Canons and Expositions," ed. Tapati Guha-Thakurta, special issue, *Journal of Arts and Ideas* 30–31 (December): 63–88.

———. 2003. "Imagined and Performed Locality: The Televisual Field in a North Indian Industrial Town." Unpublished paper.

Jain, Madhu. 2001. "Kitsch Kitsch Hota Hai: Kitsch and the Contemporary Imagination." In *Kitsch Kitsch Hota Hai* (exhibition catalog), ed. India Habitat Centre. New Delhi: India Habitat Centre.

Jameson, Fredric. 1986. "Third World Literature in the Era of Multinational Capital." *Social Text* 15 (autumn): 65–88.

Jay, Martin. 1993. *Downcast Eyes: The Denigration of Vision in Twentieth-Century French Thought*. Berkeley: University of California Press.

———. 1996. "Response to Visual Culture Questionnaire." *October* 77:44.

Jayamanne, Laleen. 1999. "A Slapstick Time: Mimetic Convulsion, Convulsive Knowing." In *Falling for You: Essays on Cinema and Performance*, ed. George Kouvaros and Lesley Stern, 105–45. Sydney: Power Publications.

Jenyns, R. Soame. 1980. *Chinese Art III*. New York: Rizzoli.

Juneja, Monica. 1997. "Reclaiming the Public Sphere: Husain's Portrayals of Saraswati and Draupadi." *Economic and Political Weekly*, 25 January, 155–57.

Kakar, Sudhir. 1986. "Erotic Fantasy: The Secret Passion of Radha and Krishna." In *The Word and the World: Fantasy, Symbol and Record*, ed. Veena Das, 75–94. New Delhi: Sage.

Kale, Pramod. 1979. "Ideas, Ideals and the Market: A Study of Marathi Films." *Economic and Political Weekly*, 1 September, 1511–20.

Kale, V. T. 1989. *S. M. Pandit: A Biography*. Bangalore: Karnataka Lalithakala Academy.

Kant, Immanuel. 1987. *Critique of Judgment*. Trans. Werner S. Pluhar. Indianapolis: Hackett.

Kapur, Anuradha. 1990. *Actors, Pilgrims and Gods: The Ramlila at Ramnagar*. Calcutta: Seagull Books.

———. 1993a. "Deity to Crusader: The Changing Iconography of Ram." In *Hindus and Others*, ed. Gyanendra Pandey, 79–109. New Delhi: Viking.

———. 1993b. "The Representation of Gods and Heroes: Parsi Mythological Drama of the Early Twentieth Century." *Journal of Arts and Ideas* 23–24 (January): 85–107.

Kapur, Geeta. 1989. "Ravi Varma: Representational Dilemmas of a Nineteenth-Century Indian Painter." *Journal of Arts and Ideas* 17–18 (June): 59–80.

———. 1993a. "Ravi Varma's Unframed Allegory." In *Raja Ravi Varma: New Perspectives* (exhibition catalogue), ed. R. C. Sharma and Rupika Chawla, 96–103. New Delhi: National Museum.

———. 1993b. "Revelation and Doubt: Sant Tukaram and Devi." In *Interrogating Modernity: Culture and Colonialism in India*, ed. Tejaswini Niranjana, P. Sudhir, and Vivek Dhareshwar, 19–46. Calcutta: Seagull Books. (Revised version of "Mythic Material in Indian Cinema," *Journal of Arts and Ideas* 14–15 [1987]: 79–108.)

———. 2002. *Bhupen Khakhar*. Exhibition catalogue for retrospective show on Bhupen Khakhar, Museo Nacional Centro de Arte Reina Sofia, Madrid.

Kaur, Raminder. 2000. "Rethinking the Public Sphere: The Ganapati Festival and Media Competitions in Mumbai." *Polygraph* 12:137–58.

Kearney, Richard, ed. 1984. *Dialogues with Contemporary Thinkers*. Manchester: Manchester University Press.

Kesavan, B. S. 1985. *History of Printing and Publishing in India*. Vol. 1. New Delhi: National Book Trust.

Khadilkar, Shriram. 1991. "Aata Keval Swatah Satheech Painting Karnar" [Now I shall only paint for myself]. *Maharashtra Times* (Marathi edition), 24 August.

Khanna, Balraj. 1993. *Kalighat: Indian Popular Painting 1800–1930*. Boston: Redstone Press.

Kling, Blair. 1992. "The Origin of the Managing Agency System in India." In *Entrepreneurship and Industry in India, 1800–1947*, ed. Rajat K. Ray, 83–98. Delhi: Oxford University Press.

Kopytoff, Igor. 1986. "The Cultural Biography of Things: Commoditization as Process." In *The Social Life of Things: Commodities in Cultural Perspective*, ed. Arjun Appadurai, 64–91. Cambridge: Cambridge University Press.

Krauss, Rosalind. 1996. "*Informe* without Conclusion." *October* 78 (fall): 89–105.

Krishnamoorthi, Janaki. 1994–1995. "Wall Art." *Metropolis on Saturday* (India), 31 December–1 January.

Kumar, Nita. 1988. *The Artisans of Banaras: Popular Culture and Identity, 1880–1986*. Princeton, N.J.: Princeton University Press.

———. 2000. *Lessons from Schools: The History of Education in Banaras*. New Delhi: Sage.

Laclau, Ernesto, and Chantal Mouffe. 1985. *Hegemony and Socialist Strategy*. London: Verso.

Lash, Scott, and John Urry. 1987. *The End of Organised Capitalism*. Madison: University of Wisconsin Press.

Lefort, Claude. 1986. "The Image of the Body and Totalitarianism." In *The Political Forms of Modern Society*, 293–306. Oxford: Polity Press.

Lingis, Alphonso. 1994. "Faces, Idols, Fetishes." In *The Community of Those Who Have Nothing in Common*, 39–67. Bloomington: University of Indiana Press.

Lutgendorf, Philip. 1995. "All in the (Raghu) Family." In *Media and the Transformation of Religion in South Asia*, ed. Lawrence A. Babb and Susan S. Wadley, 217–53. Philadelphia: University of Pennsylvania Press.

———. 2001. "Evolving a Monkey: Hanuman, Poster Art and Postcolonial Anxiety." In *Beyond Appearances*, ed. Sumathi Ramaswamy, 71–112. New Delhi: Sage.

Lyons, Tryna. 1997. "Women Artists of the Nathadwara School." In *Representing the Body: Gender Issues in Indian Art*, ed. Vidya Dehejia, 102–123. New Delhi: Kali for Women.

Lyotard, Jean-François. 1977. "Energumen Capitalism." *Semiotext(e)* 2 (3): 11–26.

———. 1988. *The Differend: Phrases in Dispute*. Trans. George Van Den Abbeele. Manchester: Manchester University Press.

———. 1993. *Libidinal Economy*. Trans. I. H. Grant. Bloomington: Indiana University Press.

Macpherson, C. B. 1962. *The Political Theory of Possessive Individualism: Hobbes to Locke*. Oxford: Clarendon Press.

Maduro, Renaldo. 1976. *Artistic Creativity in a Brahmin Painter Community*. Berkeley: University of California Press.

Mahadevan, Raman. 1984. "Entrepreneurship and Business Communities in Colonial Madras, 1900–1929: Some Preliminary Observations." In *Business Communities of India: A Historical Perspective*, ed. Dwijendra Tripathi. New Delhi: Manohar.

Mani, Lata. 1998. *Contentious Traditions: The Debate on Sati in Colonial India*. Berkeley: University of California Press.

Mani, V. R. 1995. "Admirers Deify Shorthand Inventor." *The Times of India*, 7 July.

Mankekar, Purnima. 1999. *Screening Culture, Viewing Politics: An Ethnography of Television, Womanhood and Nation in Postcolonial India*. Durham, N.C.: Duke University Press.

Marfatia, Mridula I. 1967. *The Philosophy of Vallabhacharya*. Delhi: Munshiram Manoharlal.

Marjit, Sugata. 1994. "Trade Related Intellectual Property Rights and GATT: A Theoretical Evaluation." *Economic and Political Weekly*, 31 December, 3327–32.

Markovits, Claude. 2000. *The Global World of Indian Merchants, 1750–1947*. Cambridge: Cambridge University Press.

Marriot, McKim. 1976. "Hindu Transactions: Diversity without Dualism." In *Transaction and Meaning: Directions in the Anthropology of Exchange and Symbolic Behaviour*, ed. Bruce Kapferer, 109–42. Philadelphia: ISHI.

Marx, Karl. 1974. *Grundrisse: Foundations of the Critique of Political Economy.* Trans. Martin Nicolaus. Harmondsworth: Penguin Books.

———. 1976. *Capital.* Vol. 1. Trans. Ben Fowkes. Harmondsworth: Penguin/New Left Review.

Masselos, Jim. 1991. "Appropriating Urban Space: Social Constructs of Bombay in the Time of the Raj." *South Asia* 14 (1): 33–63.

Massumi, Brian. 1992. *User's Guide to Capitalism and Schizophrenia.* Cambridge, Mass.: MIT Press.

———. 1995. "The Autonomy of Affect." *Cultural Critique* (fall): 83–109.

Mauss, Marcel. 1967. *The Gift: Forms of Exchange in Archaic Societies.* Trans. Ian Cunnison. New York: Norton.

Mazzarella, William. 2003. *Shoveling Smoke: Advertising and Globalization in Contemporary India.* Durham, N.C.: Duke University Press.

McDowell, Stephen D. 1997. "Globalization and Policy Choice: Television and Audiovisual Services Policies in India." *Media, Culture and Society* 19 (2) (March): 151–72.

McLeod, W. H. 1991. *Popular Sikh Art.* Delhi: Oxford University Press.

McNay, Lois. 1999. "Gender, Habitus and the Field: Pierre Bourdieu and the Limits of Reflexivity." *Theory, Culture and Society* 16 (1): 95–117.

Minissale, Gregory. 2000. "The Synthesis of European and Mughal Art in the Emperor Akbar's Khamsa of Nizami." *Asianart.com,* http://www.asianart.com/articles/minissale (accessed 31 August 2006).

Mirzoeff, Nicholas. 1999. *An Introduction to Visual Culture.* London: Routledge.

Mitchell, W. J. T. 1994. *Picture Theory: Essays in Verbal and Visual Representation.* Chicago: University of Chicago Press.

Mitter, Partha. 1977. *Much Maligned Monsters: History of European Reactions to Indian Art.* Oxford: Clarendon Press.

———. 1994. *Art and Nationalism in Colonial India, 1850–1922: Occidental Orientations.* Cambridge: Cambridge University Press.

Modi, Balchand. 1940. *Desh ke Hihas Mein Marwari Jati Kasthan.* Calcutta.

Mukhia, Harbans. 1976. "The Ideology of the Bhakti Movement: The Case of Dadu Dayal." In *History and Society,* ed. Debiprasad Chattopadhyaya. Calcutta: K. P. Bagchi.

Naipaul, V. S. 1979. *India: A Wounded Civilization.* Harmondsworth: Penguin.

Neale, Stephen. 1980. *Genre.* London: BFI.

Needham, Gerald. 1988. *19th Century Realist Art.* New York: Harper and Row.

Nehru, Jawaharlal. 1980. Speech at the opening of the Nangal Canal, 8 July 1954. In *Jawaharlal Nehru: An Anthology,* ed. Sarvepalli Gopal, 213–15. Delhi: Oxford University Press.

Nivedita, Sister. 1993. "The Function of Art in Shaping Nationality." In *Raja Ravi Varma: New Perspectives* (exhibition catalogue), ed. R. C. Sharma and Rupika Chawla, 147–53. New Delhi: National Museum. Originally published in *The Modern Review,* January 1907.

Nochlin, Linda. 1971. *Realism.* Harmondsworth: Penguin Books.

O'Neil, W. M. 1975. "Indian Calendars." In *Time and the Calendars.* Sydney: Sydney University Press.

Pachori, Satya A., ed. 1993. *Sir William Jones: A Reader.* Delhi: Oxford University Press.

Page, David, and William Crawley. 2001. *Satellites Over South Asia: Broadcasting, Culture and the Public Interest.* New Delhi: Sage.

Pai, Shirish. 1989. "Chitrakaleche 'Pandit'—S. M. Pandit" ["Pandit" of fine arts—S. M. Pandit]. *Loksatta* ("Kala Kunj" section), 28 January.

Paliwal, Vidya. n.d. "Bio-data of Shri B. G. Sharma." Handout of the B. G. Sharma Art Gallery handout. (Also published in Hindi as "Anutha Hai B. G. Sharma ka Chitra Sansar," 31 July 1994.)

Pandey, Gyanendra. 1990. *The Construction of Communalism in Colonial North India*. Delhi: Oxford University Press.

Pandian, M. S. S. 1992. *The Image Trap: M. G. Ramachandran in Film and Politics*. New Delhi: Sage.

Pandit, S. M. 1981. Inaugural speech (Marathi) for the 22nd Maharashtra State Arts Exhibition, 7 November, courtesy Baburao Sadwelkar.

Panofsky, Erwin. 1955. "Iconology and Iconography: An Introduction to the Study of Renaissance Art." In *Meaning in the Visual Arts*. New York: Doubleday.

Parry, Jonathan. 1986. "*The Gift*, the Indian Gift and the 'Indian Gift.' " *Man* 21 (3): 453–73.

———. 1989. "On the Moral Perils of Exchange." In *Money and the Morality of Exchange*, ed. J. Parry and M. Bloch. Cambridge: Cambridge University Press.

Pattrea, Purnendu. 1983. "The Continuity of the Battala Tradition: An Aesthetic Revaluation." *Woodcut Prints of Nineteenth-Century Calcutta*, ed. Asit Paul, 50–79. Calcutta: Seagull Books.

Paul, Ashit, ed. 1983. *Woodcut Prints of Nineteenth-Century Calcutta*. Calcutta: Seagull Books.

Peabody, Norbert. 1991. "In Whose Turban Does the Lord Reside?: The Objectification of Charisma and the Fetishism of Objects in the Hindu Kingdom of Kota." *Comparative Studies in Society and History* 33 (4): 726–54.

Perlin, Frank. 1983. "Proto-Industrialisation and Pre-Colonial South Asia." *Past and Present* 98 (February): 30–95.

Pietz, William. 1985. "Problem of the Fetish." Part 1. *Res* 9 (spring): 5–17.

———. 1987. "Problem of the Fetish." Part 2. *Res* 13 (spring): 23–45.

———. 1988. "Problem of the Fetish." Part 3a. *Res* 16 (autumn): 105–23.

———. 1993. "Fetishism and Materialism." In *Fetishism as Cultural Discourse*, ed. Emily Apter and William Pietz, 119–51. Ithaca, N.Y.: Cornell University Press.

Pinney, Christopher. 1997a. "The Nation (Un)Pictured? Chromolithography and 'Popular' Politics in India, 1878–1995." *Critical Inquiry* 23 (summer): 834–67.

———. 1997b. *Camera Indica: The Social Lives of Indian Images*. London: Reaktion, 1997b.

———. 1999. "Indian Magical Realism: Notes on Popular Visual Culture." In *Subaltern Studies X*, ed. Gautam Bhadra, Gyan Prakash, and Susie Tharu, 201–33. New Delhi: Oxford University Press.

———. 2004. *"Photos of the Gods": The Printed Image and Political Struggle in India*. London: Reaktion Books.

Pocock, J. G. A. 1975. *The Machiavellian Moment: Florentine Political Thought and the Atlantic Republican Tradition*. Princeton, N.J.: Princeton University Press.

Polanyi, Karl, 1944. *The Great Transformation*. New York: Rinehart.

Prakash, Gyan. 1999. *Another Reason: Science and the Imagination of Modern India*. Princeton, N.J.: Princeton University Press.

———. 2002. "The Urban Turn." In *Sarai Reader 2002: The Cities of Everyday Life*, 2–7. Delhi: Sarai: The New Media Initiative; Amsterdam: Society for Old and New Media.

Prasad, M. Madhava. 1993. "Cinema and the Desire for Modernity." *Journal of Arts and Ideas* 25–26 (December): 71–86.

———. 1998. *Ideology of the Hindi Film: A Historical Construction*. New Delhi: Oxford University Press.

Preziosi, Donald. 1998. "The Art of Art History." In *The Art of Art History: A Critical Anthology*, ed. Donald Preziosi. Oxford: Oxford University Press.

Pritchett, Frances W. 1995. "The World of Amar Chitra Katha." In *Media and the Transformation of Religion in South Asia*, ed. Lawrence Babb and Susan S. Wadley, 76–106. Philadelphia: University of Pennsylvania Press.

Qureshi, Regula Burckhardt. 1995. "Recorded Sound and Religious Music: The Case of Qawwali." In *Media and the Transformation of Religion in South Asia*, ed. Lawrence Babb and Susan S. Wadley, 139–66. Philadelphia: University of Pennsylvania Press.

Radhakrishnan, S. 1948. *Indian Philosophy*. Vol. 1. London: George Allen and Unwin.

Radhakrishnan, S., and Charles A. Moore. 1957. *A Sourcebook in Indian Philosophy*. Princeton, N.J.: Princeton University Press.

Rajadhyaksha, Ashish. 1986. "Neo-Traditionalism: Film as Popular Art in India." *Framework* 32–33:20–67.

———. 1990. "Beaming Messages to the Nation." *Journal of Arts and Ideas* 19 (May): 33–52.

———. 1993a. "The Epic Melodrama." *Journal of Arts and Ideas* 25–26 (December): 55–70.

———. 1993b. "The Phalke Era: Conflict of Traditional Form and Modern Technology." In *Interrogating Modernity: Culture and Colonialism in India*, ed. Tejaswini Niranjana, P. Sudhir, Vivek Dhareshwar, 47–82. Calcutta: Seagull Books. (Revised version of earlier article with the same title, *Journal of Arts and Ideas* 14–15 [1987]: 47–78.)

Rajadhyaksha, Ashish, and Paul Willemen, eds. 1994. *Encyclopedia of Indian Cinema*. New Delhi: Oxford University Press and BFI Publishing.

Rajagopal, Arvind. 1993. "The Rise of National Programming: The Case of Indian Television." *Media, Culture and Society* 15 (January): 91–111.

———. 1994. "Ram Janmabhoomi, Consumer Identity and Image-Based Politics." *Economic and Political Weekly*, 2 July, 1659–68.

———. 2001. *Politics after Television*. Cambridge: Cambridge University Press.

Rajagopal, Ranjani. 1993. "Ravi Varma: A Biographical Sketch." In *Raja Ravi Varma: New Perspectives* (exhibition catalogue), ed. R. C. Sharma and Rupika Chawla, 126–42. New Delhi: National Museum.

Raker, Joseph W., and Ramashanker Shukla. 2002. *English-Hindi/Hindi-English Dictionary*. Delhi: Star Publications.

Ramachandran, A. 1993. "Raja Ravi Varma Exhibition—A Prologue." In *Raja Ravi Varma: New Perspectives*, ed. R. C. Sharma and Rupika Chawla, 13–23. New Delhi: National Museum.

Ramakrishnan, S. 1983. "Shri Ghanshyamdasji—Some Glimpses." *Bhavan's Journal*, 1 June, 8–22.

Ramalingam, Aparna. 2001. "From Porn to Vern." *Business Today*, 2 June. http://www.india-today.com/btoday/20010206/dotcom2.html (accessed 31 August 2006).

Ramaswamy, Sumathi. 1997. *Passions of the Tongue: Language Devotion in Tamil India, 1891–1970*. Berkeley: University of California Press.

———. 2003. "Visualising India's Geo-Body." In *Beyond Appearances: Visual Practices and Ideologies in Modern India*, ed. Sumathi Ramaswamy 151–90. New Delhi: Sage.

Ray, Niharranjan. 1973. *Idea and Image in Indian Art*. Delhi: Munshiram Manoharlal.

———. 1974. *An Approach to Indian Art*. Chandigarh: Panjab University.

Ray, Pranabranjan. 1983. "Printmaking by Woodblock up to 1901: A Social and Technological History." In *Woodcut Prints of Nineteenth-Century Calcutta*, ed. Ashit Paul, 80–107. Calcutta: Seagull Books.

Ray, Rajat Kanta. 1979. *Industrialization in India: Growth and Conflict in the Private Corporate Sector: 1914–47*. Delhi: Oxford University Press.

———. 1984. "The Bazaar: Indigenous Sector of the Indian Economy." In *Business Communities of India: A Historical Perspective*, ed. Dwijendra Tripathi, 241–67. Delhi: Manohar.

———. 1992. Introduction to *Entrepreneurship and Industry in India 1800–1947*, ed. Rajat Kanta Ray, 1–69. Delhi: Oxford University Press.

Rossi, Barbara. 1998. *From the Ocean of Painting: India's Popular Paintings, 1589 to the Present*. New York: Oxford University Press.

Roy, Parama. 1998. *Indian Traffic: Identities in Question in Colonial and Postcolonial India*. New Delhi: Sage.

Rudner, David West. 1994. *Caste and Capitalism in Colonial India: The Nattukottai Chettiars*. Berkeley: University of California Press.

Rush, Dana. 1999. "Eternal Potential: Chromolithographs in Vodunland." *African Arts* 32 (4) (winter): 60–75.

Sangari, Kumkum. 1990. "Mirabai and the Spiritual Economy of *Bhakti*." Parts 1 and 2. *Economic and Political Weekly*, 7 July, 1464–75; 14 July, 1537–52.

Saraf, Babli Moitra. 2002. *Language, Advertising and Society: An Analysis of Language Change in the Advertising Industry in India 1984–94*. New Delhi: Department of Sociology, Jamia Millia Islamia University.

Sarkar, Nikhil. 1983. "Calcutta Woodcuts: Aspects of a Popular Art." In *Woodcut Prints of Nineteenth-Century Calcutta*, ed. Ashit Paul, 11–49. Calcutta: Seagull Books.

Schechner, Richard. 1983. *Performative Circumstances from the Avant-garde to the Ramlila*. Calcutta: Seagull Books.

Sedgwick, Eve Kosofsky. 1990. *Epistemology of the Closet*. Berkeley: University of California Press.

Seizer, Susan. 2005. *Stigmas of the Tamil Stage: An Ethnography of Special Drama Artists in South India*. Durham, N.C.: Duke University Press.

Shah, J. G. 1978. *Shri Vallabhacharya and God-Realisation*. Patan: Pushti Margiya Pathshala.

Sharma, R. C., and Rupika Chawla, eds. 1993. *Raja Ravi Varma: New Perspectives* (exhibition catalogue). New Delhi: National Museum.

Shaviro, Steven. 1993. *The Cinematic Body: Film Theory and Visual Fascination*. Minneapolis: University of Minnesota Press.

Sheikh, Gulam Mohammed. 1993. "Ravi Varma in Baroda." In *Raja Ravi Varma: New Perspectives* (exhibition catalogue), ed. R. C. Sharma and Rupika Chawla, 77–85. New Delhi: National Museum.

Sherman, Sandra. 1996. *Finance and Fictionality in the Early Nineteenth Century: Accounting for Defoe*. Cambridge: Cambridge University Press.

Singh, Ajay. 1999. "Burned by Home Fires." *Asiaweek*, 15 January. http://www.asiaweek.com/asiaweek/99/0115/feat4.html (accessed 28 August 2006).

Sinha, Mrinalini. 1995. *Colonial Masculinity: The "Manly Englishman" and the "Effeminate Bengali" in the Late Nineteenth Century*. Manchester: Manchester University Press.

Sinha, Narendra Krishna. 1992. "Indian Business Enterprise: Its Failure in Calcutta (1800–1848)." In *Entrepreneurship and Industry in India: 1800–1947*, ed. Rajat K. Ray, 70–82. New Delhi: Oxford University Press.

Sivaramamurti, C. 1978. *Chitrasutra of the Vishnudharmottara*. New Delhi: Kanak Publications.

Smith, Adam. 1904. *An Inquiry into the Nature and Causes of the Wealth of Nations*. London: Methuen.

Smith, H. Daniel. 1988. Field notes for project titled "Indian Poster Art in Relation to Contemporary Hinduism." Smith Poster Archive, Special Collections Research Center, Syracuse University Library.

———. 1994. *The Smith Poster Archive, A Study Collection: User's Guide*. Syracuse, N.Y.: self-published.

———. 1995. "Impact of 'God Posters' on Hindus and Their Devotional Traditions." In *Media and the Transformation of Religion in South Asia*, ed. Lawrence Babb and Susan S. Wadley. Philadelphia: University of Pennsylvania Press.

Solomon, W. E. Gladstone. 1924? *The Bombay Revival of Indian Art: A Descriptive Account of the Indian Room Constructed and Decorated by the Staff and Students of the School of Art*. Bombay: J. J. School of Art.

———. 1926. *The Charm of Indian Art*. London: T. Fisher Unwin.

Spivak, Gayatri Chakravorty. 1985. "Scattered Speculations on the Question of Value." *Diacritics* 15 (4) (winter): 73–93.

———. 1988. "Can the Subaltern Speak?" In *Marxism and the Interpretation of Culture*, ed. Cary Nelson and Lawrence Grossberg, 271–313. London: Macmillan.

Srinivas, S. V., 1996. "Devotion and Defiance in Fan Activity." *Journal of Arts and Ideas* 29 (January): 67–83.

Srivastava, Sanjay. 2004. "Voice, Gender and Space in the Time of Five-Year Plans: The Idea of Lata Mangeshkar." *Economic and Political Weekly*, 17 February: 2019–28.

Srivatsan, R. 1991. "Looking at Film Hoardings: Labour, Gender, Subjectivity and Everyday Life in India." *Public Culture* 4 (1) (fall): 1–23.

———. 1993. "Imaging Truth and Desire: Photography and the Visual Field in India." In *Interrogating Modernity: Culture and Colonialism in India*, ed. Tejaswini Niranjana, P. Sudhir, and Vivek Dhareshwar. Calcutta: Seagull Books.

Stam, Robert. 2000. *Film Theory*. Oxford: Blackwell.

Stoler Miller, Barbara. 1992. *The Powers of Art: Patronage in Indian Culture*. Delhi: Oxford University Press.

Subrahmanyam, Sanjay. 1990. Introduction to *Merchants, Markets and the State in Early Modern India*, ed. Sanjay Subrahmanyam, 1–17. Delhi: Oxford University Press.

———. 1994. Introduction to *Money and the Market in India 1100–1700*, ed. Sanjay Subrahmanyam, 1–56. Delhi: Oxford University Press.

Subrahmanyam, S., and C. A. Bayly. 1990. Portfolio Capitalists and the Political Economy of Early Modern India." In *Merchants, Markets, and the State in Early Modern India*, ed. Sanjay Subrahmanyam, 242–65. Delhi: Oxford University Press.

Subramanian, V. 1987. "Karmayoga and the Rise of the Indian Middle Class." *Journal of Arts and Ideas* 14–15 (July–December): 133–42.

Sunder Rajan, Rajeshwari. 1993. *Real and Imagined Women: Gender, Culture and Postcolonialism*. London: Routledge.

Swami, M. M., ed. 1994. *Sivakasi Mini Japan: Directory 1994*. Sridevi Publications: Sivakasi.

Swaminathan, J. 1963. "Manifesto." In exhibition catalogue for Group 1890 show, Rabindra Bhavan, New Delhi.

Tambiah, S. J. 1984. *The Buddhist Saints of the Forest and the Cult of the Amulets*. Cambridge: Cambridge University Press.

Taussig, Michael. 1993a. "*Maleficium*: State Fetishism." In *Fetishism as Cultural Discourse*, ed. Emily Apter and William Pietz, 217–47. Ithaca, N.Y.: Cornell University Press.

———. 1993b. *Mimesis and Alterity: A Particular History of the Senses*. New York: Routledge.

———. 1997. *The Magic of the State*. New York: Routledge.

———. 1999. *Defacement: Public Secrecy and the Labor of the Negative*. Stanford, Calif.: Stanford University Press.

Templeman, Dennis. 1996. *The Northern Nadars of Tamil Nadu: An Indian Caste in the Process of Change*. Delhi: Oxford University Press.

Tharu, Susie, and K. Lalitha. 1995. "Literature of the Ancient and Medieval Periods: Reading Against the Orientalist Grain." In *Women Writing in India: 600 B.C. to the Present*, ed. Susie Tharu and K. Lalitha, 41–64. Vol. 1. Delhi: Oxford University Press.

Thomas Elsaesser. 1987. "Tales of Sound and Fury: Observations on the Family Melodrama." In *Home Is Where the Heart Is: Studies in Melodrama and the Women's Film*, ed. Christine Gledhill, 43–69. London: BFI.

Thomas, Nicholas. 1991. *Entangled Objects: Exchange, Material Culture, and Colonialism in the Pacific.* Cambridge, Mass.: Harvard University Press.

Thomas, Rosie. 2005. "Zimbo and Son Meet the Girl with a Gun." In *Living Pictures: Perspectives on the Film Poster in India*, ed. David Blamey and Robert D'Souza, 27–44. London: Open Editions.

Thompson, E. P. 1991. *Customs in Common.* London: Merlin Press.

Thompson, John B. 1990. *Ideology and Modern Culture: Critical Social Theory in the Era of Mass Communication.* Oxford: Polity Press.

Tillotson, G. H. R. 1991. "The Indian Picturesque: Images of India in British Landscape Painting, 1780–1880." In *An Illustrated History of Modern India: 1600–1947*, ed. C. A. Bayly, 141–51. Bombay: Oxford University Press.

Timberg, Thomas A. 1978. *The Marwaris: From Traders to Industrialists.* New Delhi: Vikas.

———. 1992. "Three Types of the Marwari Firm." In *Entrepreneurship and Industry in India, 1800–1947*, ed. R. K. Ray, 127–56. Delhi: Oxford University Press.

Tripathi, Dwijendra, and Makarand Mehta. 1990. *Business Houses in Western India: A Study in Entrepreneurial Response, 1850–1956.* London: Jaya Books.

Tuli, Neville. 2002. *India: A Historical Lila.* Ahmedabad: Mapin Publishing.

Turner, Victor, and Edith Turner. 1978. *Image and Pilgrimage in Christian Culture.* New York: Columbia University Press.

Tyler, Stephen A. 1984. "The Vision Quest in the West, or What the Mind's Eye Sees." *Journal of Anthropological Research* 40 (1) (spring): 23–40.

Uberoi, Patricia. 1990. "Feminine Identity and National Ethos in Indian Calendar Art." *Economic and Political Weekly*, 28 April, WS41–48.

———. 1996. "From Goddess to Pin-Up: Icons of Femininity in Indian Calendar Art, 1955–1995." In *Of Women: Icons/Stars/Feasts* (catalogue for exhibition curated by Pooja Sood). New Delhi: Eicher Gallery (with Kali for Women).

———. 1999–2000. "Times Past: Gender and the Nation in 'Calendar Art.'" *Indian Horizons* 46 (4) and 47 (1): 24–39.

Vachani, Lalit. 1999. "Bachchan-alias: The Many Faces of a Film Icon." In *Image Journeys: Audio-Visual Media and Cultural Change in India*, ed. C. Brosius and M. Butcher, 199–232. New Delhi: Sage.

Vallejo, Boris. 1985. *Fantasy Art Techniques.* New York: Arco Publications.

Vardhan, Anand. 1980. "Mini-paper Plants in Sivakasi Soon." In *Sivakasi — Where Light and Sound Are Packaged: A Panorama of the Match, Fireworks and Printing Industries of South India*, ed. All India Chamber of Match Industries. Sivakasi: All India Chamber of Match Industries. Originally published in *Economic Times*, 10 March.

Vasseleu, Cathryn. 1998. *Textures of Light: Vision and Touch in Irigaray, Levinas and Merleau-Ponty.* London: Routledge.

Vasudevan, Ravi. 1989. "The Melodramatic Mode and the Commercial Hindi Cinema: Notes on Film History, Narrative and Performance in the 1950s." *Screen* 30 (3): 29–50.

Venkat Narayan, S. 1985. "The Phenomenon Called N.T.R., Actor-Turned-Politician." In *70 Years of Indian Cinema (1913–1983)*, ed. T. M. Ramachandran, 203–14. Bombay: Cinema India-International.

Venniyoor, E. M. J. 1981. *Raja Ravi Varma.* Trivandrum: Government of Kerala.

Vidal, Denis. 1997. "Rural Credit and the Fabric of Society in Colonial India: Sirohi District, Rajasthan." In *Webs of Trade: Dynamics of Business Communities in Western India*, ed. P. Cadène and D. Vidal, 85–107. Delhi: Manohar/CSH.

"Visual Culture Questionnaire." 1996. *October* 77:25–70.

Viswanathan, Gauri. 1989. *Masks of Conquest: Literary Study and British Rule in India*. New York: Columbia University Press.

Vitali, Valentina. 2005. "Hong Kong-Hollywood-Bombay: On the Function of 'Martial Art' in the Hindi Action Cinema." In *Hong Kong Connections: Transnational Imagination in Action Cinema*, ed. Meaghan Morris, Siu-Leung Li, and Stephen Chan Ching-kiu, 125–50. Durham, N.C.: Duke University Press.

Vitsaxis, Vassilis G. 1977. *Hindu Epics, Myths and Legends in Popular Illustrations*. Delhi: Oxford University Press.

Vuthikrisam, Ruengvuth. 1997. "*The Good Woman of Bangkok*: Looking Back and Forth." In *The Filmmaker and the Prostitute: Dennis O'Rourke's "The Good Woman of Bangkok*," ed. Chris Berry, Annette Hamilton, and Laleen Jayamanne, 202–7. Sydney: Power Publications.

Vyas, Ramnarayan. 1977. *The Bhagavata Bhakti Cult and Three Advaita Acaryas: Sankara, Ramanuja and Vallabha*. Delhi: Nag Publishers.

Warner, Michael. 1992. "The Mass Public and the Mass Subject." In *Habermas and the Public Sphere*, ed. Craig Calhoun, 377–401. Cambridge, Mass.: MIT Press.

Weber, Max. 1958. *The Religion of India: The Sociology of Hinduism and Buddhism*. Trans. and ed. Hans H. Gerth and Don Martindale. New York: Free Press.

———. 1976. *The Protestant Ethic and the Spirit of Capitalism*. Trans. Talcott Parsons. London: George Allen and Unwin.

Weber, Samuel. 1996. "Television: Set and Screen." In *Mass Mediauras: Form, Technics, Media*, 108–27. Sydney: Power Publications.

Willemen, Paul. 1993. "Negotiating the Transition to Capitalism: The Case of *Andaz*." In *Melodrama and Asian Cinema*, ed. Wimal Dissanayake, 179–88. Cambridge: Cambridge University Press.

Williams, Linda. 1991. "Film Bodies: Gender, Genre and Excess." *Film Quarterly* 44 (4): 2–13.

Windsor, David. 1998. "Nargis, Ray, Rushdie and the Real." *South Asia* 21 (1): 229–42.

Wisse, Jakob. 1989. *Ethos and Pathos from Aristotle to Cicero*. Amsterdam: Adolf M. Hakkert.

Woodmansee, Martha. 1994. *The Author, Art and the Market: Rereading the History of Aesthetics*. New York: Columbia University Press.

Yang, Anand A. 1998. *Bazaar India: Markets, Society, and the Colonial State in Bihar*. Berkeley: University of California Press.

Yang, Mayfair Mei-hui. 1994. *Gifts, Favors and Banquets: The Art of Social Relationships in China*. Ithaca, N.Y.: Cornell University Press.

Žižek, Slavoj. 1989. *The Sublime Object of Ideology*. New York: Verso.

———. 1991. *For They Know Not What They Do*. London: Verso.

———. 1993. *Tarrying with the Negative: Kant, Hegel and the Critique of Ideology*. Durham, N.C.: Duke University Press.

INDEX

Page numbers in italics refer to figures.

Performativity, 316–21, 347. *See also* Corporeality; Habitus; Mimesis and mimetic exchanges; Performative work of images

Perspective and perspectivalism, 80–81, 92, 104, 118, 123, 134–39, *193*, 196, 281, 294, 322, 323. *See also* European art and image techniques, encounter of Indian artists with

Phalke, D. G., 149–51, 250

Photography, 7, 63–64, 74, 80, 82, 89, 92, 113–14, 135, 138, 163, 284, *285*, 388–89 n. 17

Pietz, William, 222–23

Pilgrimage, 85–90, 218, 247–48

Pinney, Christopher, 16, 118, 135–38, 277, 286, 322, 389 n. 18

Polanyi, Karl, 221

Popular, the, 118–20, 124, 144. *See also* Mass Culture

Pornography, 260, 274–75, 302, 308–12

Post-sacred, 128, 134, 137, 224, 266, 273. *See also* Sacred

Prabhat Film Company, 149–50

Prakash, Ved, 152

Prasad, Madhava, 301–5, 313, 406 n. 21

Print capitalism, 80, 116–18, 135, 149, 162, 292

Processions, 110–12

Protestant ethic, 132. *See also* Weber, Max

Public, 93, 149, 155, 175–77, 191, 209, 211, 214, 232, 272–74, 274, 288, 290–302; consumption and, 82, 114, 292, 301, 359–60; private and, 183–90, 214, 219, 272–75, 292, 301–13. *See also* Publicity or publicness

Publicity or publicness, 68–76, 248, 250, 252, 263. *See also* Public

Pushtimarg, 86–90, 101, 141–43, 222, 246–63, 330, 332, 372. *See also* Nathdwara; Shrinathji; Vallabhacharya

Radha, 55, 59, 260, 303, 327–32

Radhakrishnan, S., 254

Raja, H. R., 61, 164, *307*

Rajadhyaksha, Ashish, 37, 118, 143, 387 n. 6; Paul Willemen and, 340

Rajagopal, Arvind, 70, 155, 359, 381 n. 35

Rajshri Films, 313

Raju, C. Kondiah, 31, 83, 162–63, *164*, 177, 197, 204–13, 334

Ram, 27, *66*, *74*, 195, 244, 249, 290, 320–40, 350–53

Ramachandran, M. G., 278, 324, *325*, 340, 343–44

Ramakrishna (artist), 87, 164

Ramakrishna (Paramhansa), 98, 241, 277, 278, 331

Ramalingam, M., 162–64, 207, 210

Ramanuja, 251–52

Ramarao, N. T., 324, 331, 339, 340, 344

Ramaswamy, Sumathi, 124, 130, 144

Ramayan, 64, 155, 312, 350

Ramjanmabhumi movement, 64, *66*, 320, 321, 332, 350, 352, 404 n. 6

Ramleela, 110–11

Rangroop (Ram Singh), 102, *103*, 164–65, 213, 303. *See also* Rangroop Studio

Rangroop Studio, 213, *214*. *See also* Rangroop

Rao, Madhava, 99

Rastogi, Yogendra, 55, 59, 60, 162–65, 176, 185, 187, 191–94, 198, 202, 303

Ravi (artist), 164, 167, 187, 193

Ray, Rajat Kanta, 78–80, 124, 276

Ray, Satyajit, 297–98

Realism, 7–12, 26, 81–82, 103, 134, 147, 155–61, 166, 190–203, 225, 294, 298, 321–24, 337, 347, 366. *See also* Naturalism

Reception, 20, 149, 271–72, 312, 372. *See also* Calendar art or bazaar art: contexts of use; Corporeal responses to images; Efficacy of images; Gaze; Religious engagements with images

Reddy, Ravinder, 367

Religious engagements with images, 7–10, 48, 63–64, 69, 71, 82–92, 97–98, 103, 109–10, 135–49, 157, 175–215, 218–66, 271–301, 318, 366–73. *See also* Aesthetics of presence; Auspiciousness; Corporeal responses to images; Darshan; Efficacy of images; Frontality; Iconicity; Iconography; Indexicality; Jhanki; Sacred

Repetition. *See* Replication

Replication, 31–36, 87, 89, 99, 122–23, 136, 142, 166, 182, 204–15, 229, 235, 242, 249, 255, 316, 335–36

Reterritorialization, 81, 381 n. 4, 90–92, 93, 100, 112, 120, 144, 246–49, 254–55, 305, 321, 336,

340, 348, 353, 365, 370, 372, 381 n. 4. *See also*
Capitalism; Deterritorialization; Globalization
Rush, Dana, 44–45

Sacred, 17, 181, 191, 204, 215, 219–66, 271–74, 271–
301, 349–50, 365–73. *See also* Aesthetics of
presence; Auspiciousness; Darshan; Efficacy
of images; Frontality; Iconicity; Iconography;
Indexicality; Jhanki; Post-sacred; Religious
engagements with images
Sapar, Maya, 171–73, 207
Sapar, V. V., 60, 66, 102, *165, 166,* 171–73, 177,
185–86, 199, 201, 207–13, 241
Sapar Brothers (Bharat and Vishnu Sapar), 164,
171, 172, 207, *328*
Sapna Ads, 35
Saraswati, *31–36,* 132, 296, 298
Sardar, P., 61, 164–65, 333–37, 343, 379 n. 25
Sati images, 7–10
Sceneries, 56, *57. See also* Landscape
Seriality. *See* Replication
Shahani, Kumar, 371
Shahu Maharaj, Chhatrapati, 150–51
Shaikh, S. S., 61, *67, 73,* 165, 176, 178, 189, 199, 201,
213
Shankara, 251
Sharma, B. G., 177–78, 181, 196–99, 211
Sharma, Ghasiram Hardev, 138, *140,* 147
Sharma, Indra, 138, 158, 162, 164, 178, 186, 190, 194,
196–99, 202, 207, 324–25
Sharma, Narottam Narayan, 135–37, 142, 198
Sharma, Raghunandan, 199–200, 207
Sharma, Ram Kumar, 152, 162, 164, 177, 180–82,
189, 192, 197, 200, 225
Shastri, Lal Bahadur, *307,* 308
Shiva or Shankar, 59, *47, 84,* 126, *158,* 277, *278,* 315,
325, 332, 369
Shiv Sena, 27, 228, 232, 263, 270, 295–300. *See also*
Navalkar, Pramod; Thackeray, Bal
Sholay, 342–44
Shrinathji, 86, *127,* 138, 247–48, 253, 258–60, 332.
See also Krishna
Sikh images, 90, *91, 162*
Silpi (P. M. Srinivasan), 63

Silsila, 345–47
Singh, Ramu (Rangroop Studio), 87
Singh, Ranjit, 202. *See also* Rangroop Studio
Singhal, J. P., 152, 162–65, 178–79, 182, 189, 197, 202,
205, 303
Sivakasi, 24–25, 39–76, 83–84, 90, 117, 140–41, 144,
154–55, 162–68, 183–89, 236, 243, 276, 282, 297,
311, 315, 356–60, 367
Smith, Adam, 221
Smith, H. Daniel, 16, 38, 44
Solomon, W. E. Gladstone, 121, 145, 152, 196, 389
n. 20
Srivastava, Sanjay, 338
S. S. Brijbasi and Sons, *34, 43,* 44,77, *88, 91,* 135–44,
147, 154, *163, 195,* 204, 243, 249–50, *280,* 288–90,
327, 389 n. 19
Subbiah, T. S., *164,* 210
Sunder Rajan, Rajeswari, 9–10
Swadeshi, 115–17, 121, 130, 139, 150, 275–76, 341,
386–87 n. 1
Swaminathan, J., 102
Swaroop, Kamal, 370

Tagore, Abanindranath, 102
Tagore, Balendranath, 101, 186, 187, 198
Tagore, Dwarkanath, 94, 190
Tagore, Rabindranath, 187–90, 277, *278*
Tamas, 300
Tanjore (or Thanjavur) painting, 44, 83–89, 101,
107, *111,* 119, 162–63, 166, 197, 213, 311, 381–82
n. 6. *See also* Glass painting
Tarzan, 159, 194, 324–25, 341
Taussig, Michael, 13, 100, 271–72, 295, 318,
404 n. 4
Television, *193,* 360, 362–64
Thackeray, Bal, 296–98
Tilak, B. G., 96–98, 151, 254, 263
Trans-subjectivity, 211, 221, 229, 248, 262, 271–
72, 292, 294, 300–302, 305, 312, 317, 320, 366,
369–70, 372, 399 n. 21
Trial by Fire, 7–9

Uberoi, Patricia, *47,* 139
Uberoi calendar collection, 47, 306–7

Kajri Jain is an assistant professor of film studies and visual arts at the University of Western Ontario.

Library of Congress Cataloging-in-Publication Data

Jain, Kajri.

Gods in the bazaar : the economies of Indian calendar art / Kajri Jain.

p. cm. — (Objects/histories)

Includes bibliographical references and index.

ISBN-13: 978-0-8223-3906-9 (cloth : alk. paper)

ISBN-13: 978-0-8223-3926-7 (pbk. : alk. paper)

1. Calendar art — India. 2. Commercial art — India. 3. Art and popular culture — India.

4. Gods in art. 5. Idols and images in art. I. Title.

NC1002.C3J35 2007

741.6'820954 — dc22 2006034056